DENA'INAQ' HUCH'ULYESHI

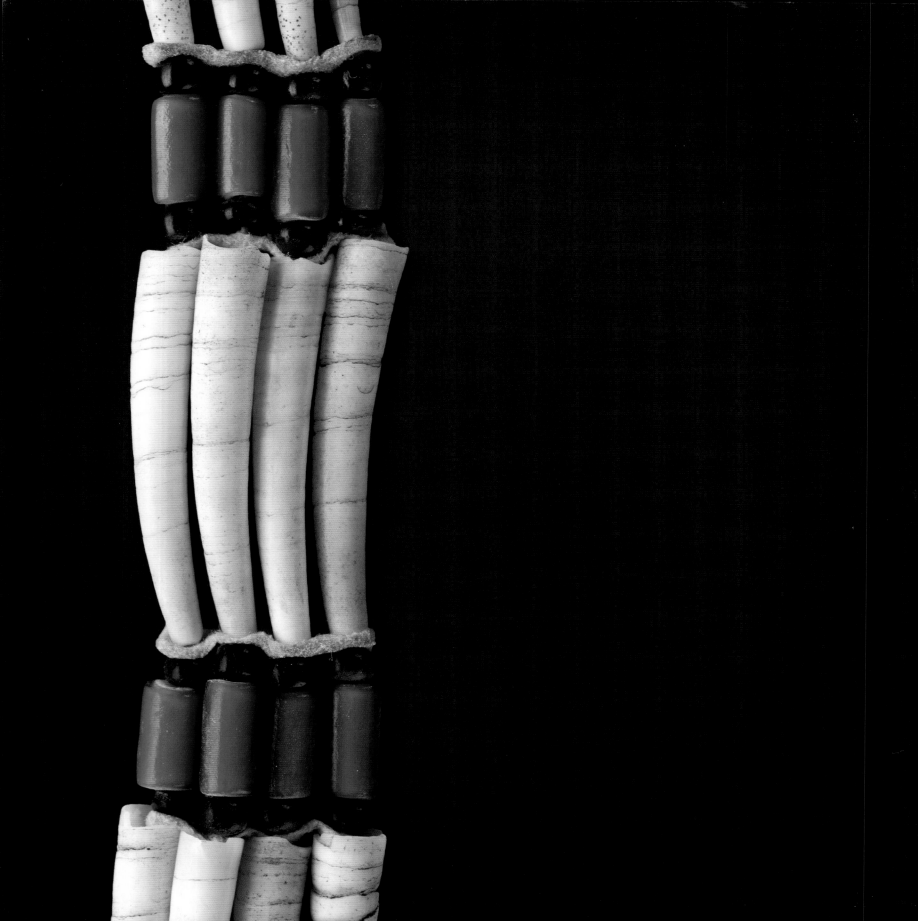

DENA'INAQ' HUCH'ULYESHI

The Dena'ina Way of Living

Suzi Jones, James A. Fall, Aaron Leggett, Editors

University of Alaska Press
Fairbanks, Alaska

in association with the Anchorage Museum

University of Alaska Press
P.O. Box 756240
Fairbanks, AK 99775-6240

ISBN 978-1-60223-207-5

Library of Congress Cataloging-in-Publication Data

Dena'inaq' huch'ulyeshi : the Dena'ina way of living / Suzi Jones, James Fall, Aaron Leggett, editors.
 pages cm
 Includes bibliographical references and index.
 ISBN 978-1-60223-207-5 (pbk. : alk. paper)
 1. Dena'ina Indians—History. 2. Dena'ina Indians—Material culture. 3. Dena'ina Indians—Social life and customs. I. Jones, Suzi.
 E99.T185D48 2013
 305.89'9720798—dc23
 2013001146

Cover and text design by Paula Elmes

Front cover illustration: **Detail of dentalium necklace**, Kenai Peninsula, early 20th century. Anchorage Museum, 1979.085.003. Photograph by Chris Arend.

Back cover illustrations (left to right):

 Ghelch'ehi, **birch bark container**. Burke Museum of Natural History and Culture, catalog no, 1.2E1179. Photograph by Chris Arend (see figure 1.29).

 Ts'en yił, **drinking tube**. Anchorage Museum, 1997.048.004. Photograph by Chris Arend (see figure 1.6).

 Kił dghak'a, **man's summer tunic (detail of breast band)**. © Finland's National Board of Antiquities/Picture Collections, VK167A. Photograph by István Bolgár (see figure 13.0).

 Dalch'ehi, **horn bowl**. © The Trustees of the British Museum, NWC33 (see figure 1.52).

 Izin, **arrows**. Staatliche Museen zu Berlin, Ethnologisches Museum, IVA 6082, 6083, and 6086. Photograph by Chris Arend (see figure 1.35).

This publication was printed on acid-free paper that meets the minimum requirements for ANSI / NISO Z39.48—1992 (R2002) (Permanence of Paper for Printed Library Materials).

Printed in South Korea

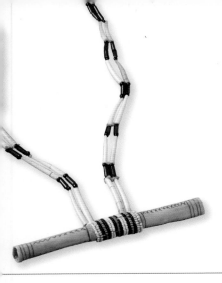

Contents

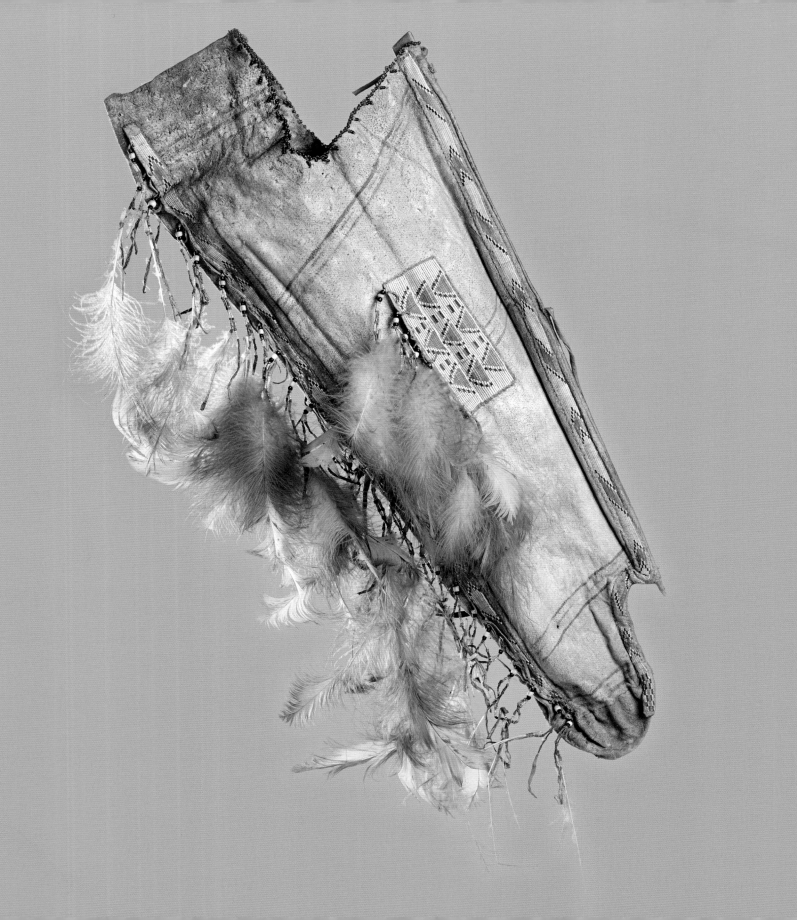

Yagheli Du!

Welcome, distinguished elders and friends!

Life takes time. Things take time. I know this in my head, but I don't always believe it in my heart. A dear friend and elder used the phrase "when I come back to myself" whenever she spoke of returning home from boarding school. The exhibition and book, *Dena'inaq' Huch'ulyeshi: The Dena'ina Way of Living*, make me feel a bit like that.

Like many of you, I grew up when tribal life, our culture, our way of life, was slipping away. I was at home, but where did my place go? Over time, we had become invisible as a people and sadly isolated from each other. I went away for many years, but somehow I knew it was time to come home, and the struggle to forge new paths has been worth it.

Dena'ina live in the seasons, and we know that time is our friend. We understand that, like the tides, we must move when the time is right. The Dena'ina exhibition and this book that accompanies it show us that our time is here. *Tsitatna,* our ancestors, the creators of these artifacts, have provided the resources. Dena'ina elder Peter Kalifornsky's song, "Potlatch of the Lonely Man," rejoices: "Our relatives have come back to us...Our friends with cheer have come back to us."

As we wonder at these objects of our past, our ancestors touch us. We hear their words again, feel their strength, their artistry and spirit. This is more than just remembering, it is the way of knowing. We come back to ourselves.

Chiginik!

—Clare Swan, Dena'ina elder and chair of the
Dena'ina Exhibition Advisory Committee

A.1 *Q'us*, **quiver, Holmberg Expedition, Kenai, 1853.** L 71 cm. Caribou hide, eagle feathers, porcupine quills, sinew. National Museum of Denmark, Hb117. Photograph © The National Museum of Denmark, Ethnographic Collection. Photograph by Arnold Mikkelsen.

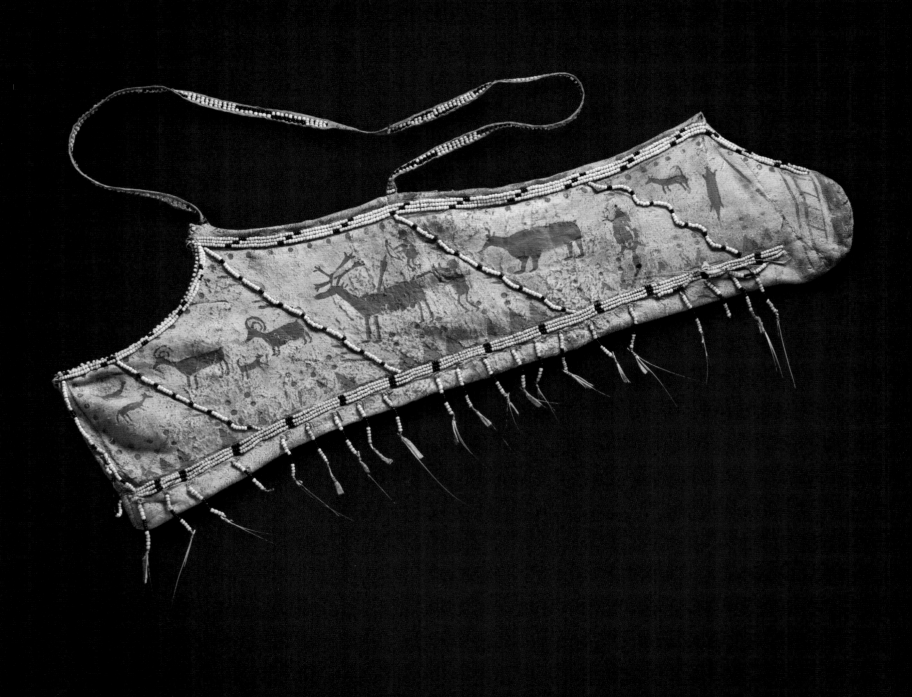

Foreword

The Anchorage Museum at Rasmuson Center is honored to coproduce and premiere the exhibition *Dena'inaq' Huch'ulyeshi: The Dena'ina Way of Living*. This endeavor represents the first major exhibition to examine and celebrate the cultural lifeways, past and present, of the first people of the Cook Inlet region of Southcentral Alaska. It is appropriate that this exhibition debut in the heart of the Dena'ina Athabascan homeland and in a venue rooted in the very ground stewarded for well over a thousand years by countless generations of Dena'ina people.

The year 2015 marks the centennial of the founding of the city of Anchorage. It began as a tent city on the banks of Ship Creek housing a transient population of a few thousand job seekers, mainly white North Americans and Europeans, making their way to the coalfields and gold claims on the newly established Alaska Railroad. Today, the population of Anchorage and the surrounding region has grown to more than 400,000, representing more than half the citizens of the entire state of Alaska. With an influx of people from the contiguous forty-eight states, along with many others from Europe, Asia, Africa, and the Pacific Islands looking to find prosperity in this subarctic region, the once dominant Dena'ina now represent less than 1 percent of the overall population. Over the course of one hundred years the Dena'ina have become an "invisible" people within their own traditional territory.

With each passing generation, more and more cultural knowledge is being lost, and fewer and fewer members of the community are fluent in the Dena'ina language. An assembly of Dena'ina elders and community leaders, through the auspices of the Cook Inlet Tribal Council, approached the Anchorage Museum in the fall of 2006 with the concept of developing an exhibition and catalog to present, preserve, and perpetuate the history and contributions of the Dena'ina people. In addition, the project would educate the area citizenry about the existence of the Dena'ina and the continuity of a rich cultural legacy on the eve of the Anchorage Centennial, the celebration of which would be hollow without the inclusion of the story of the region's first inhabitants.

The exhibition, *Dena'inaq' Huch'ulyeshi: The Dena'ina Way of Living*, and accompanying catalog represent many years of research and development by a unique collaborative of museum staff, scholars, and Dena'ina community members serving as co-curators. Many of the finest examples of Dena'ina material culture were acquired and distributed to European museums and repositories during the Russian-American period of the mid-nineteenth century. The collaborative faced many challenges during the exhibition development process, including finding, cataloging, and borrowing these objects from various institutions in Europe and North America. The result of this effort is the most

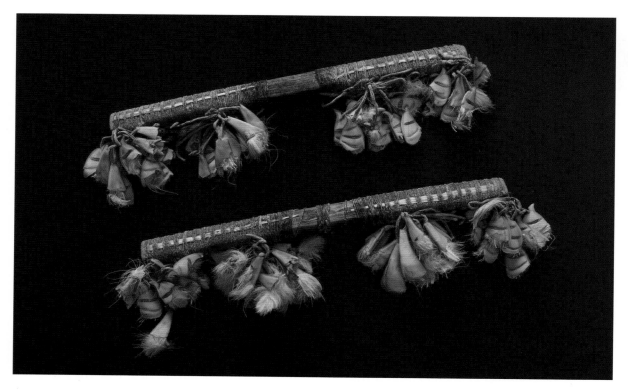

A.3 *Ts'dulaɬi,* **puffin beak rattles, once owned by Gabriel Trefon, a** *qeshqa* **in Nondalton, early 20th c.** L 30 cm. Puffin beaks, long bird quills, sinew, wood. Private collection. Photograph by Chris Arend.

A.4 *Chijeɬ,* **feather headdress, once owned by Gabriel Trefon, a** *qeshqa* **in Nondalton, early 20th c.** H 34 cm. Bald eagle feathers, down, porcupine quills, sinew. Private collection. Photograph by Chris Arend.

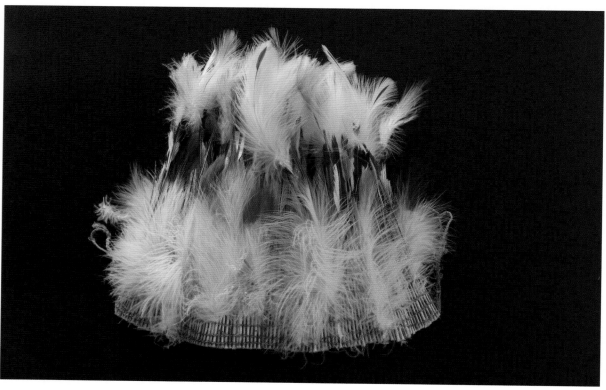

comprehensive collection and documentation of Dena'ina history, lifeways, and material culture ever produced.

The Anchorage Museum is grateful to the various institutions that have graciously loaned precious and fragile objects for the exhibition and to the many donors who have generously supported this project. Major donors include the Institute of Museum and Library Services; Rasmuson Foundation; Cook Inlet Tribal Council, Inc.; CIRI Foundation; Atwood Foundation; CIRI; National Endowment for the Arts; Tyonek Native Coproration; Eklutna, Inc.; and BP. Special acknowledgment goes to Deb Call,

chair of the project's Fundraising Committee, and to the Cook Inlet Historical Society and the Alaska Humanities Forum for their support in publishing the exhibition catalog. We are honored to have the University of Alaska Press as the publisher of the exhibition catalog. May the exhibition, *Dena'inaq' Huch'ulyeshi: The Dena'ina Way of Living,* and the accompanying catalog enlighten the Anchorage Museum's many visitors regarding the presence and rich history of the Dena'ina people and serve as inspiration for current and future generations of Dena'ina.

—James Pepper Henry, Museum Director

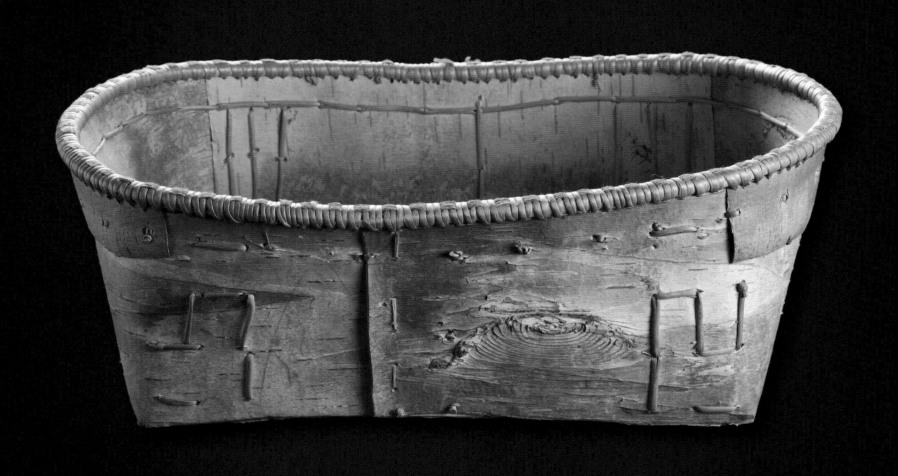

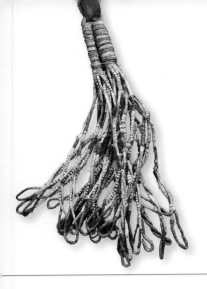

Elders, Advisers, and Lenders to the Exhibition

A.5 Q'ey hagi, birch bark container, Tyonek, 1883. L 33 cm. Birch bark, root, yarn, ochre. Ethnological Museum Berlin, IVA 6128. Photograph courtesy of the Staatliche Museen zu Berlin, Ethnologisches Museum. Photograph by Chris Arend.

The construction of this basket is unusual and more complex than that of many baskets.

Exhibition Advisory Committee

Chair, Clare Swan
Salamatof, Kenai
Chair, Cook Inlet Tribal Council

Gloria O'Neill
President and CEO, Cook Inlet Tribal Council

Jonathon Ross
Salamatof, Kenai
Former President and CEO, Alaska Native
Heritage Center

Ethan Petticrew
Vice President of Cultural and
Educational Services
Alaska Native Heritage Center

Alexandra Lindgren
Kenaitze Indian Tribe, Cultural Director

Debra Call
Knik, President and CEO, Calista Heritage
Foundation

Patricia Partnow
Partnow Consulting

Karen Evanoff
Nondalton, Cultural Anthropologist,
Lake Clark National Park

Michelle Ravenmoon
Nondalton

Donita Slawson
Former Dena'ina Language Project Manager,
Alaska Native Heritage Center

Consulting Dena'ina Elders

Andrew Balluta (d. 2011), Nondalton
Helen Dick, Lime Village
Gladys Evanoff, Nondalton
A. Debbie Fullenwider, Eklutna
Mary Hobson, Nondalton
Pauline Hobson, Nondalton
Steve "Butch" Hobson, Nondalton
Alberta Stephan, Eklutna
Clare Swan, Kenai

Lenders to the Exhibition

Alaska Native Heritage Center
Alaska State Museum
American Museum of Natural History
British Museum
Burke Museum of Natural History and Culture
Cook Inlet Tribal Council
Ethnological Museum Berlin
Hämeenlinna High School
Kenai Visitors Center
Lake Clark National Park
Museum of Cultures, National Museum of Finland
National Museum of Denmark
Smithsonian National Museum of the
American Indian
Seward Community Museum and Library
Tebughna Foundation
University of Alaska, Museum of the North
Herbarium (ALA)
Yale Peabody Museum of Natural History
Private Collections (10)

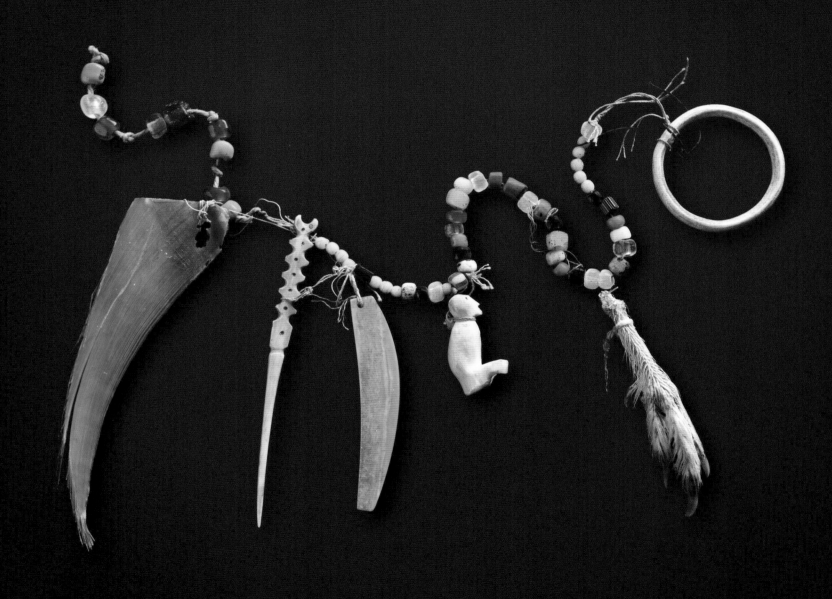

Introduction and Acknowledgments

A.6 *Nunk'yulyuyi*, **baby amulets, Sunrise, c. 1900.** L 45.7 cm. Beads, baleen, walrus ivory, bone, sinew, string, pigment. Anchorage Museum, 1997.002.004. Photograph by Chris Arend.

In August 2006, Anchorage Museum staff were invited by Gloria O'Neill, the president and CEO of Cook Inlet Tribal Council, to meet with a Dena'ina advisory group gathered to explore the possibility of organizing an exhibition about the Dena'ina people of Alaska. An exhibition would be one of several coordinated efforts undertaken to raise the public visibility of the Dena'ina people in the region and to educate those here and elsewhere about their history and culture. Other projects included the naming of Anchorage's new convention center and work with various agencies to post interpretive signage at historic Dena'ina sites.

The Dena'ina individuals gathered around the conference table that August talked about the need for an exhibition to teach their children as well as others about the depth of Dena'ina occupation in Southcentral Alaska. They wanted to see an exhibition that would take Dena'ina people "off the pages" and bring Dena'ina history and culture to life—an exhibition that might show the remarkable tenacity and adaptability of Dena'ina culture and the creative responses to dramatically changed circumstances. They thought it was important to convey the intensity of change that was experienced by Dena'ina people in the past two centuries. They mentioned the critical role that Dena'ina had played in the formation of the Alaska Federation of Natives, creating the foundation for united Alaska Native participation in the development of the landmark Alaska Native Claims Settlement Act in 1971.

As a consequence of living in the most populous region of Alaska, the Dena'ina people became less visible beginning in the late nineteenth century, in part because they adopted Western clothing and material culture from early contact, unlike other Alaska Native groups living in more isolated regions. Several Dena'ina committee members were aware that examples of traditional Dena'ina clothing—and many treasures of early Dena'ina material culture—were preserved in European museums. They hoped this exhibition might be a vehicle to bring some of those masterpieces back for a time to Alaska. For instance, they wanted their children to see the spectacular woven quillwork that beautifully adorns older Dena'ina caribou skin clothing—a form of material culture and a technology that have not been known for generations. Through an exhibition, these expressions of Dena'ina culture might become visible once again and assume their place in a new Dena'ina art history.

In reviewing the sorts of objects to be shown in the exhibition, the Dena'ina advisers, however, were clear they did not want merely the artifacts of the past. They asked that the exhibition also show Dena'ina people today. In fact, for a time, an exhibition title under discussion was "We're Still Here." We have strived to honor these considerations as

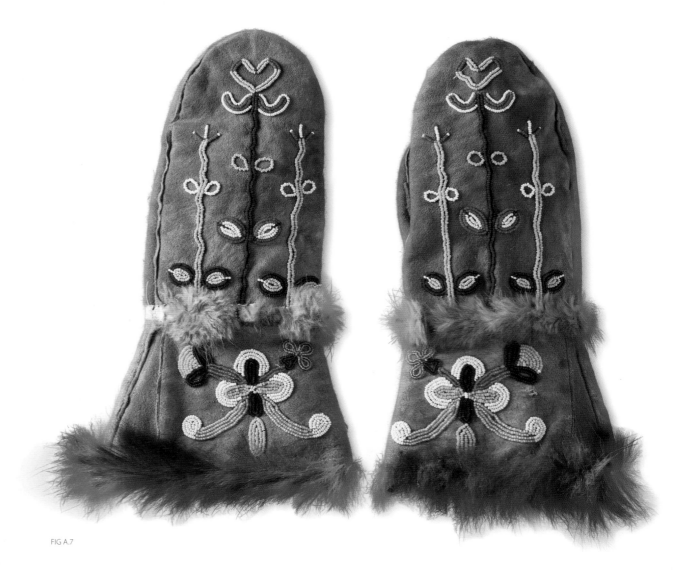

FIG A.7

 These beaded moose hide mittens were collected by Cornelius Osgood in the Upper Susitna region during his Alaska fieldwork among the Dena'ina. Osgood's collection of Dena'ina material culture, which he made for the Peabody Museum of Natural History at Yale University and which is well documented in _The Ethnography of the Tanaina_, is one of the most significant collections of twentieth-century Dena'ina material.

we have developed the exhibition, and the opening scene depicts a contemporary Dena'ina family fish camp based on the Evanoff fish camp as it was documented in 2010–2011.

One of the most strongly expressed desires of the Dena'ina exhibition advisers was that the exhibition emphasize the Dena'ina language. Since the 1970s, Dena'ina communities, working together with linguists, have initiated institutes and workshops to strengthen and reintroduce the Dena'ina language, but the number of fluent speakers is small. One resource for the Dena'ina language

survival is the outstanding audio archive that has been assembled through the work of linguist James Kari and others and is archived at the Alaska Native Language Center. Kari's _Dena'ina Topical Dictionary_, published in 2007, has become invaluable to our exhibition research in Dena'ina material culture and our ability to present object names in the Dena'ina language, both in the exhibition and in the catalog. Diligent readers of this catalog may observe that different Dena'ina words are at times used for the same type of object. This reflects differences among regional dialects of Dena'ina and the

editorial decision to use the term appropriate to the area from which the object was collected.

The exhibition installation also enables visitors to experience the Dena'ina language by listening to stories in a traditional *nichił* (winter house), learning the Dena'ina names for the parts of the moose, and eavesdropping on a Dena'ina dinner table conversation via an overhead video projection that shows a meal of moose nose soup, roasted beaver, fried spruce hen, and other traditional Dena'ina foods being consumed.

The initial exploratory committee that first met in 2006 soon became an ongoing advisory committee for the exhibition. Soon this advisory process was supplemented through a Dena'ina Elders Summit organized by the Alaska Native Heritage Center and held at the museum, by a series of workshops with National Park Service staff who worked in the Lake Clark area, and by extended consultation with several Dena'ina elders. Our Dena'ina advisers during the six years of exhibition development have included Clare Swan, the late Andrew Balluta, Alberta Stephan, Helen Dick, Gladys Evanoff, Jon Ross, Sasha Lindgren, Donita Slawson, Karen Evanoff, Michelle Ravenmoon, Debra Call, Yvette Evanoff, Vernajean Kolyaha, Marilyn Balluta, Emil McCord Jr., A. Debbie Fullenwider, Mary Hobson, Steve "Butch" Hobson, and Pauline Hobson. Their participation in the exhibition has been essential. They have provided themes, goals, ideas, interpretive strategies, and resources of all kinds, as well as inspiration and wisdom.

The exhibition's curatorial team includes cultural anthropologist James Fall, Dena'ina cultural historian Aaron Leggett, and the museum's deputy director and Alaska Native arts specialist, Suzi Jones.

The curatorial team also sought the expertise of scholars who have worked with Dena'ina materials to advise us and to contribute to the exhibition catalog. We are grateful for the assistance of Alan Boraas, Douglas Reger, Judy Thompson, Kate Duncan, Joan Tenenbaum, James Kari, Peter Bolz, Viola König, Sergei Korsun, Heli Laudentausta, Jonathan King, Adrienne Kaeppler, Janet Klein,

Priscilla Russell, Karen and Bill Workman, Sven Haakanson Jr., Holly Cusack-McVeigh, Ann Fienup-Riordan, Molly Lee, Katherine McNamara, and Marcus Lepola. Aron Crowell and Dawn Biddison of the Smithsonian's Arctic Studies Center (Alaska Office) have provided ongoing advice and resources, including the recent Dena'ina Language Institute film that the center produced. In addition, Arctic Studies Center summer 2010 intern Lena Hollender translated catalog cards from German.

Most of the beautiful object photography in the exhibition catalog is the work of Chris Arend, who traveled with us from Seattle to St. Petersburg, from Lime Village to New Haven, and beyond. Working with Chris is a curator's dream. Not only does he produce beautiful images, he is flexible and gracious in all circumstances and works meticulously and inventively to capture just the right image.

Filmmaker Brandon McElroy produced the wonderful Dena'ina dining experience video for the installation, as well as the video segments for the timeline of Dena'ina history after the arrival of the "underwater people." Videographer and educator Alan Dick created both a short video documentary and a longer instructional video as part of the Dena'ina Whitefish Trap Project.

Professional exhibition evaluator Bevery Serrell of Serrell and Associates, Chicago, has worked with us from the beginning of the project, designing and carrying out audience research, formative evaluation and prototype testing, and critical review and summative evaluation—all tools used by exhibition developers nowadays to ensure that an exhibition will engage its audience and achieve its goals.

We are honored to have the University of Alaska Press as the publisher of the exhibition catalog and are grateful for the opportunity to work with such fine colleagues at the press as Joan Braddock, James Engelhardt, and Sue Mitchell.

A project of this scope requires many hands—and heads and hearts. Many of the Anchorage Museum staff have been involved in the project. Always open to new ideas, former director Patricia Wolf was instrumental in the museum's initial involvement in the exhibition. James Pepper Henry,

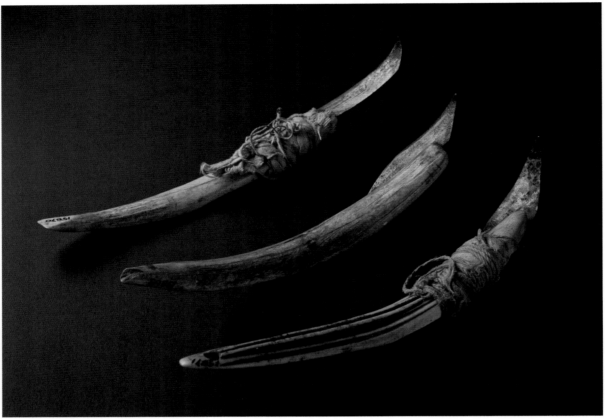

A.8 *Ghelghet'i*, Crooked Knives, Iliamna, 1931–1932. Metal, wood, cotton, fabric, twine. Photograph © Peabody Museum of Natural History, Yale University, ANT.015866. Photograph by Chris Arend.

FIG A.8

who became director in 2007, kept this project moving forward with his strong leadership and continuing support.

Former collections department heads Walter Van Horn and Marilyn Knapp assisted us in identifying all things Dena'ina in our collections, and Monica Shah, current head of collections and the museum's conservator, has been exceedingly helpful as we selected, requested, and planned for the installation of artifacts. Through Monica's efforts and with support from an Alaska State Museum grant-in-aid, the museum was able to have a conservation intern from the Getty Institute, Madeline Neiman, on-site during the summer of 2012 to work on a fragile Dena'ina fish trap, making it possible to include it in the exhibition. Collections staff Julie Farnham, Darian LaTocha, and Christine Smith have been responsive to our continual requests as

we researched and photographed Dena'ina objects in our own collections, as have Atwood Resource Center staff Teressa Williams and Sara Piasecki, who fulfilled our frequent requests for books and archival photographs.

The museum's registrar, Ryan Kenny, with the assistance of Carolyn Kozak, has overseen all the complexities of the loan process of an international exhibition with consummate professionalism and goodwill. Exhibition designer Dave Nicholls has worked closely with the exhibition's curators to realize their visions and create a memorable experience for our visitors. His highly skilled— and good-natured—crew of exhibit techs, Ted Gardeline, Rex Schloeman, and Nate Chambers, planned, prototyped, and built the show. Justin Osvak recorded and produced the audio elements, and Jane Rabadi designed the exhibition graphics.

Exhibitions department administrator and chief curator Julie Decker provided ongoing guidance, great ideas, and much appreciated moral support. IT director Doug Adams and Imaginarium Discovery Center manager Greg Danner have provided invaluable advice on the development of software elements for the exhibition.

Museum educators Jenya Anichenko, Monica Garcia-Itchoak, and Kelly Gwynn have worked with Alaska Native Heritage Center educator Ethan Petticrew and anthropologist Patricia Partnow to develop engaging and effective curriculum materials, educational programs, and family activities in conjunction with the exhibition. Special thanks go to Jenya for serving as our Russian translator during museum visits in St. Petersburg, her hometown.

One decidedly essential element of this project, fundraising, has been successfully directed through the leadership of Advancement director Ann Hale; before her, Joy Atrops-Kimura; and annual giving manager Arby Williams. I would like especially to thank Greg Smith, the museum's acting CFO, for managing the many grants entailed in this project, each with its own schedule and unique requirements. Sandra Narva and Steve Shwartzman at the Institute of Museum and Library Services and Susan Anderson patiently helped us traverse the terrain of grant extensions when we needed them. Special thanks also go to Janet Asaro and Sarah Henning for their marketing and public relations work on behalf of the exhibition.

Right before our catalog deadline, when we were beginning to feel swamped, Hannah Moderow came on board to assist with photo permissions and handle all the bibliographic details for the publication. The process of planning, developing, and producing the Dena'ina exhibition, with its numerous associated publications and programs, has been long and intensive. One individual who has been with the process from the beginning and who deserves the utmost thanks is special assistant Sharon Ennis. No words can express my gratitude for her innumerable contributions—her incredibly hard work, day in and day out, including evenings and weekends; her skills in managing a monstrous amount of data and complex image files; and her talent, creativity, and problem-solving coupled with an equanimity that defies chaos and frustration. She is a gem.

Many colleagues in other museums and cultural organizations assisted with our collections research and deserve our gratitude. An incomplete list includes Angie Demma; Jeanne Schaaf, Katie Myers, and John Branson, National Park Service; Roger Colten, Peabody Museum of Natural History, Yale University; Laila Williamson, Kristin Mable, and Jan Riley, American Museum of Natural History; Robin Wright and Rebecca Andrews, Burke Museum of Natural History; Kelly McHugh and Sharla Blanche, National Museum of the American Indian; Steve Henrikson and Bob Banghart, Alaska State Museum; Ian Taylor, British Museum; Helen Tello and Lars Malareck, Ethnologisches Museum Berlin; Savanna Bradley, Pratt Museum; Yuri Chistov, Julia Kupina, and Yuri Berezkin, Kunstkamera; Vladimir Grusman, Valentina Gorbacheva, and Irina Karapetova, Russian Museum of Ethnography; Russell Hartman, California Academy of Sciences; and Mari Lyn Salvador and Alicja Egbert, Phoebe Hearst Museum, University of California, Berkeley.

Finally, I would like to thank the many museums and individuals that generously agreed to lend objects to the exhibition. The institutions are listed in the section immediately preceding this introduction. Unfortunately, we were unable to complete our anticipated loans from the Peter the Great Museum of Anthropology and Ethnography (Kunstkamera) and the Russian Ethnographic Museum at this time because of a Russian government ruling in 2012, the result of a dispute over the disposition of an archival and library collection, that prohibits all loans from Russian museums to museums in the United States. We had worked for many years with our colleagues at the Kunstkamera and the Russian Ethnographic Museum, and we are grateful to them for allowing us to proceed with the publication of their Dena'ina materials under these circumstances.

—Suzi Jones
Deputy Director, Anchorage Museum

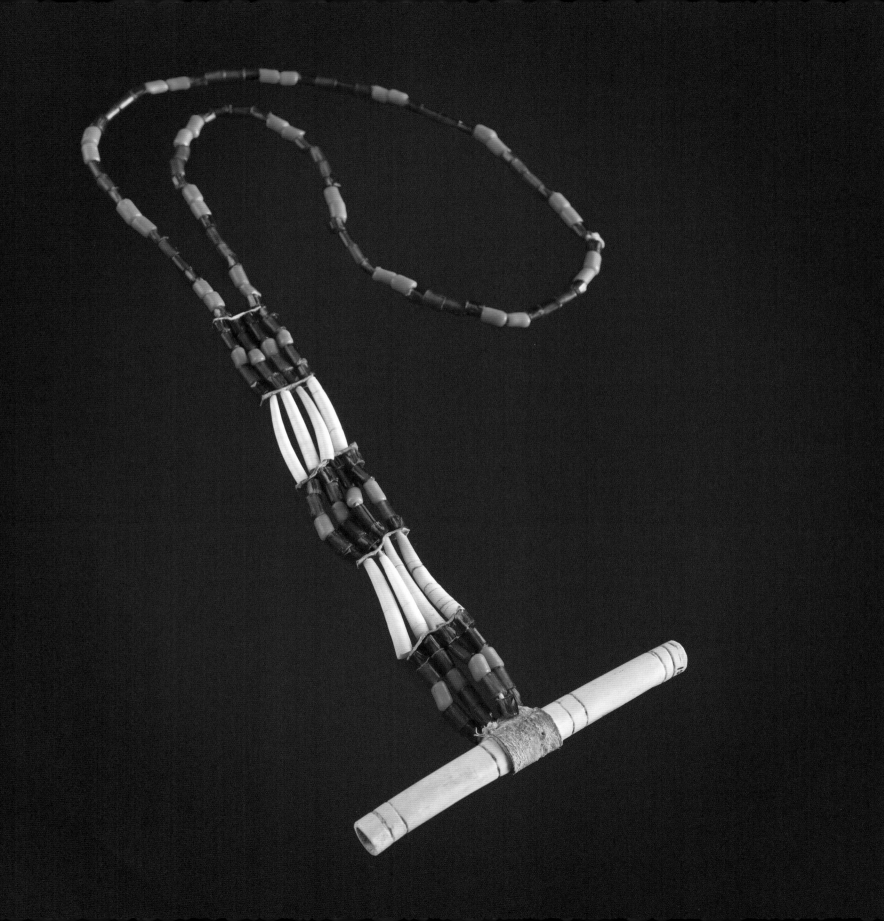

1

Introduction to Dena'ina Culture and History

James A. Fall

ena'ina Ełnena, the Dena'ina homeland, encompasses about 41,000 square miles of Southcentral Alaska. As the only Northern Athabascan people whose traditional territory bordered on salt water, most Dena'ina had access to the natural resources of marine waters and tidelands, as well as rivers, lakes, forests, and mountains. Their diverse subarctic environment provided seasonal abundance, followed by periods of scarcity. The Dena'ina were probably the most numerous of all Alaska Athabascan peoples, with an aboriginal population of perhaps four thousand to five thousand (Townsend 1981:637).

The Dena'ina are one people traditionally speaking a single language, which can be divided into four mutually intelligible dialects. The most divergent dialect is the Upper Cook Inlet dialect, spoken in the Tyonek area, in the lower and middle Susitna River drainage, along Knik Arm and the Matanuska River as far upriver as Chickaloon, and at Point Possession on the northernmost tip of the Kenai Peninsula. The other three dialects are more similar to each other. The Outer Inlet dialect was spoken on the Kenai Peninsula as far south as Seldovia and along a portion of western Cook Inlet around Kustatan and Polly Creek. Speakers of the Iliamna dialect lived along the eastern shores of Iliamna Lake. The Inland dialect was spoken in the drainages of Six Mile Lake and Lake Clark, the upper Mulchatna River, and the Stony River.

Anthropologist Cornelius Osgood noted differences between the Athabascans of the Mackenzie River drainage of northern Canada and those of the Pacific drainages of northwestern Canada and Alaska. The former groups lacked salmon, were generally egalitarian in social organization, were very mobile, and lacked clans and matrilineal organization. In contrast, the richer and more varied ecological setting of the Athabascans of the Pacific drainages appears to have supported more complex cultures, with semisedentary villages, matrilineal kinship and clan organization, formal leadership positions based on an interest in wealth and prestige, and large-scale ceremonial potlatching (Osgood 1936; VanStone 1974:49).

In their rich and diverse but variable natural environment, the Dena'ina built on this northwest Athabascan pattern, developing a "ranked" society based on the accumulation and redistribution of food, furs, and wealth items such as dentalium. Nevertheless, Dena'ina culture also exhibited other key features of the general Northern Athabascan way of life, such as flexibility, individualism, and a worldview that stressed respectful interactions with the nonhuman world (VanStone 1974:23, 59; Townsend 1980; Fall 1987). Unless otherwise noted, this chapter describes the "traditional" Dena'ina way of life at the time of the first interactions with Russian, British, and other European explorers and traders in the mid- to late eighteenth century.

1.0 *Ts'en zitl'i*, drinking tube with beaded strap, Iliamna, 1931–1932. L 47.5 cm. Bone, dentalium shells, glass beads, caribou bone (?). Photograph © Peabody Museum of Natural History, Yale University, ANT.015852. Photograph by Chris Arend.

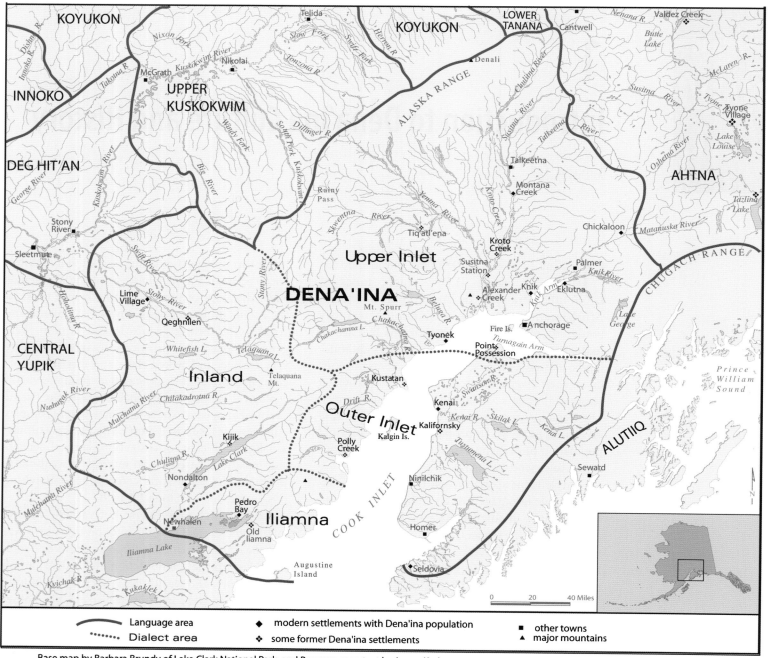

Map 1.1 Dena'ina Ełnena, the Dena'ina homeland.
The Dena'ina homeland consists of four dialect areas and comprises about 41,000 square miles in Southcentral Alaska. Map courtesy of the National Park Service.

Base map by Barbara Brundy of Lake Clark National Park and Preserve; map text by James Kari.

Names

Dena'ina means "the people" and is today the preferred self-designation among all Dena'ina. Based on the Russian spelling "Tnaina" (Wrangell 1980 [1839]:52), Osgood rendered the name as "Tanaina" (1933), and that spelling was standard in English into the 1980s, when the Alaska Native Language Center switched to the now favored "Dena'ina."

The Alutiit of Kodiak Island called the Dena'ina Kenaiyut, from which the Russians derived Kinaiuts (Wrangell 1980 [1839]:52) or "Kenaitze," their name for the Dena'ina (Townsend 1981:638). This name survives in the official name of the Kenaitze Tribe of the Kenai Peninsula, but it is not used by other Dena'ina For the Ahtna, Athabascan neighbors of the Dena'ina to the northeast, the Dena'ina are the Dastnaey, "the people out ahead."

Origins

Although the Dena'ina were firmly established along the shores of Cook Inlet when Euro-American explorers arrived in the late eighteenth century, the origins of the Dena'ina and the approximate date of their arrival in the Cook Inlet area have long been of scholarly interest. The Dena'ina are the only Northern Athabascans whose territory borders salt water; all other Northern Athabascans live inland along rivers and in mountainous terrain. Ethnographic and linguistic evidence thus points to an interior origin for the Dena'ina. For example, writing in the 1830s, Ferdinand Wrangell suggested that

> It is probable that the Kenay [Dena'ina] came to the place they now occupy from across the mountains. These migrant mountain people ultimately became coastal and semisettled; they formerly used birch bark canoes on lakes and rivers, and these have remained with them even now, but they also use baidarkas and baidaras covered with laftak (the tanned hides of sea mammals), probably adopted from the Kadyaks or Chugach. They cannot

> compete with the latter in skill and courage of navigation. Their favorite occupation remains the hunting of animals in the forests beyond the mountains. (1970 [1839]:12)

Likewise, applying linguistic and ethnographic evidence, James Kari concluded that

> The ancient Dena'ina were a mountain people. The area west of the Alaska Range in the Inland dialect area is probably the oldest Dena'ina homeland. Some bands of Dena'ina may have been participating in coastal activities on Cook Inlet for as long as 1,500 years. In the middle and upper Cook Inlet, the Dena'ina developed well-established routes for sharing in the labor and the products of both upland and coastal areas. By maintaining control of the key passes and transportation corridors in the Alaska Range and an aggressive posture, Dena'ina bands gradually annexed areas east and south—Lake Clark and Iliamna Lake and Cook Inlet basin—some of the finest resource areas in Alaska. (1988:336)

Kari suggested that the Dena'ina reached Cook Inlet in two migrations. The first, through either Rainy Pass or Ptarmigan Pass, brought the Upper Inlet people into the Susitna River country, from where they occupied the coastal area around Tyonek as well as Knik Arm and its tributaries. In a second, later movement, the Dena'ina reached the middle inlet from Iliamna Lake, establishing the Outer Inlet dialect on the Kenai Peninsula (1996b; see also Boraas 2007). Because of the large differences between the Upper Inlet dialect and the other three dialects, the Upper Inlet regional bands likely had been separated from the others for a substantial period of time. Additional evidence of the considerable length of Dena'ina occupation of the upper inlet is the diffusion of linguistic and cultural traits, including those of several matrilineal clans, to the

Upper Inlet people from the Ahtna Athabascans of the Copper River drainage to the northeast (Kari 1977).

The Dena'ina themselves acknowledge an origin outside the Cook Inlet country. Their oral traditions tell of battles with the Alutiit (Ułchena), perhaps for control of the Cook Inlet basin. One Dena'ina tradition of their arrival in Cook Inlet is provided by Alberta Stephan of Eklutna:

> Many years before the influx of the Russian fur traders and Russian settlements in Cook Inlet, there were wars with other Natives that had settled along the coastal regions of Alaska. The Athabascan Natives lived in the central mountain regions. They had winter homes where there was drinking water, meat and fur-bearing animals. Every spring there was a migration to their summer fish camps. Each family had their own fish camp along the coast of Knik Arm and Cook Inlet. You will note that the Athabascan place names are a description of the area. We don't know how long after the last war with the other Natives that the Athabascans started settling along Knik Arm and Cook Inlet. (1994:85; see also Stephan 1996a:147)

Also of note is that the Dena'ina name for the upper Stony River/Mulchatna River plateau, Htsaynenq', may be translated as "First Land," thus suggesting this area as the original homeland of all Dena'ina groups (Kari 1996a).

Social Organization: Clans and Moieties

In addition to age and gender, three organizational principles grounded a person in Dena'ina society: kinship, residence, and rank.

Every Dena'ina person was a member of one of about fifteen matrilineal clans, which were organized into two "sides" or "moieties" (table 1.1). In matrilineal clans, descent is traced through the female line, with the children belonging to their mother's clan. Dena'ina clans and moieties were exogamous, meaning that people had to marry someone outside their own descent group and in a clan of the opposite side, or moiety. For example, not only could a Nulchina man not marry a Nulchina woman, he also could not marry a Tulchina woman, because Nulchina and Tulchina were in the same moiety. Rather, he had to marry a woman of the K'kalayi, Chishyi, Ggahyi, or other clan of the opposite side. Hence, while children were of the same clan as their mother and siblings, their father belonged to an opposite clan. Most Dena'ina clans have equivalents among other Athabascan groups. Thus, clan membership extended the web of an individual's kin to other villages and other territories, although not every Dena'ina clan had members in all parts of Dena'ina territory (Fall 1981:409–427, 1987:39–40; de Laguna 1975).

Traditional stories explain the origins of clans (e.g., Kalifornsky 1991:205). Shem Pete's Nulchina clan origin story (see p. 99) tells how his Nulchina clan descended from the sky during a conflict between the allied Tulchina clan and the clans of the opposite moiety. Upper Inlet traditions trace the origins of the Chishyi, K'kalayi, and Ggahyi clans to three sisters who traveled down the Matanuska River and took their names from objects they found along the way. Katherine Nicolie explained the origin of her Tulchina clan as follows:

> Those Tulchina girls were pretty and they came out of the water, naked. They lived in the water. A K'kalayi man saw them every day, playing, and at sunset they disappeared. Once he crept up to them but they smelled him and they took off. He figured out a way to get one of them. He dug a hole in the ground to where they come out of the water. The next morning a bunch of Tulchina women from the bottom of the water came out. He snuck up and when one girl got close, he jumped up and grabbed her. He was really chewed up but he held her until the sun went down. She bit and scratched and it was

Table 1.1 Dena'ina Clans

Moiety (Side) A		Moiety (Side) B	
Chishyi[1]	Red Paint Clan	Tulchina	Water Clan
K'kalayi	Fish Tail Clan	Nulchina	Sky Clan
Ggahyi	Raven Clan	Diq'agiyi	Fireweed Clan
Nichishyi	Second Paint Clan	Dusdi Ghelchina[2]	Point Clan
Nuhzhi[4]	Clean or Neat Clan	Ułch'e Dnay[3]	One-Way Clan
		Q'atl'anht'an	Head of Lake Clan
		Qeghkuht'an	Downriver Clan

The following clans are recorded in older sources. They have no members among the Dena'ina today and are not recognized by today's Dena'ina speakers.

Dzeł Ht'ana	Mountain Clan (Moiety B)
Yuyqushq' Nughełchina	Northern Lights Clan (Moiety B)
Shdolaxdana	A Raven Clan
Tikenq'atl'uh Ht'ana	Corner Clan (Moiety A)
Bent'uh Ht'ana	Below the Wall Clan (Moiety A)
Tl'egh Ht'ana	Sedge Clan (Moiety A)
Tsaghelchina	Made at Rock People
Chinshla Ht'ana	possible clan
Katluchna	"Lovers of beads"

Notes

1. Chishyi is called "Chixlaht'an" at Nondalton and placed in Moiety B.
2. Dusdi Ghelchina is called "Yusdi Ghulchina" at Nondalton and is placed in Moiety A.
3. Ułch'e Dnay is found mostly among the Ahtna.
4. Ellanna and Balluta (1992:107) translate Nuhzhi as "Clean or Neat Clan." Kalifornsky (1991:2040) translates Nuhzhi as "Overland Clan."
 Sources: Kari 2007:66–67; Fall 1981:220–233; Osgood 1937:128–131.

getting cold as the sun went down. She said, 'Won't you let me go?' 'No. I want you for my wife.' 'Alright,' she said. 'Spit in my mouth.' He did. She turned around with her back towards him and said, 'Pee on my back all over.' He did. And finally she turned into human. That's how Tulchina come from, from the bottom of the water. (Fall 1981:419)

Clan membership was expressed through colors, for example, white or blue for Nulchina, blue for Tulchina, and red for Chishyi. Osgood (1937:131) described distinctive patterns of face painting linked to clan membership.

Social Organization: Regional Bands and Villages

The second principle of Dena'ina social organization is residence. Every Dena'ina person was affiliated with a named regional band. Regional band names generally consisted of the name of a place or area and the suffix *ht'ana*, which means "people of

[a place or area]." Each regional band had its own territory where its members followed their seasonal round of subsistence activities. Kari (2007:73–76) lists twenty Dena'ina regional bands. Examples for upper Cook Inlet include the Tubughna (Beach People) of the Tyonek area on the northwest shore of Cook Inlet, the Susitnuht'ana (Sand River People) of the lower and middle Susitna River drainage, and the K'enaht'ana (exact meaning unknown) of the Knik Arm and Matanuska River drainage. Examples for the outer inlet area include the Kahtnuht'ana of the Kenai River, the Tsaht'ana of the Kenai Mountains, and the She'unh Ht'ana or Kachemak Bay Dena'ina. The Dena'ina of Iliamna Lake were the Nila Vena Ht'ana. Inland Dena'ina regional bands included, among others, the Htsaynenht'ana of the upper Stony River and Telaquana Lake, the Vałts'atnaht'an of the Mulchatna River, and the Qizhjeht'an of Lake Clark.

With population losses following outbreaks of epidemic diseases in the nineteenth century and early twentieth century, the number of regional bands likely diminished as people aggregated at fewer winter villages (Fall 1987:29–31). For example, before population decline, the people of the lower Susitna River, concentrated around the village of Tuqenkaq' (at the mouth of Alexander Creek), were probably distinct from the middle Susitna and Yentna River regional bands.

Within each regional band were named villages (qayeh), the sites of one or more multifamily dwellings called nichił, made of logs and birch bark (Figure 5.1a b c). Occupying each village and house were extended families related through matrilineal kinship. The village is the Dena'ina equivalent to the "local band" among less sedentary Athabascan groups.

The Dena'ina settlement pattern can be described as one with a "complex of seasonal settlements with permanent bases" (Fall 1987:28–29). The permanent, or perhaps more precisely semipermanent, bases were the villages that were occupied in late fall, winter, and into early spring. Here, supplies of dried fish, meat, oil, and other staples were stored for winter subsistence, trade,

and potlatching. Villages also served as bases for hunting, trapping, and fishing activities of relatively short duration. Dena'ina elders stated that in precontact times, they were "village people, not nomads." By this they mean that while the Dena'ina moved extensively within their territories, and often established seasonal fishing, hunting, and trapping camps, they were based out of, and identified with, particular villages to which they returned year after year. It should also be noted that the most important Dena'ina ceremony, the memorial potlatch, took place in winter at villages (Osgood 1937:149–160; Fall 1987:63–65).

Dena'ina tradition bearers stress that both environmental and sociopolitical criteria figured in the choice of winter village sites. Of particular importance was proximity to good fishing locations. An adequate supply of wood for building, crafts, fuel, and preparing smoked fish and meat was essential, as was a good water supply. Elders state that all villages were eventually abandoned when wood supplies were exhausted. People then moved to other appropriate, familiar places. New villages also were founded when individuals achieved qeshqa status, built a new nichił, and attracted follower kin from other locations (Fall 1987). In this sense, village sites were "recycled," probably over the course of several decades.

Another important factor in the selection of village sites was ease of defense. Along Cook Inlet, for example, villages were usually situated on high bluffs or near hills or "knobs" so that water routes could be carefully surveyed for the approach of enemy war parties. In addition, each village usually had one or more hidden camps to which its inhabitants could retreat when under attack (Fall 1987:29).

Social Organization: Leaders and Followers

The third principle of Dena'ina social organization is rank. Osgood (1937:131–133) reported that Dena'ina society was composed of three "social classes" based on wealth: the "aristocracy," "commoners," and "slaves." However, because virtually all individuals had access to basic resources and had

choices about where to live, it is more instructive to view the Dena'ina social system as one based on ranked kinship and the culturally prescribed utilization of wealth, rather than on socioeconomic classes. Essentially, Dena'ina communities were composed of highly ranked leaders and their followers (Townsend 1980; Fall 1987:40).

Traditional leaders, called *qeshqa* (rich men), were responsible for organizing the economic, political, and social activities of Dena'ina villages (Fall 1987:3–6; Kari and Fall 2003:25–26; Ellanna and Balluta 1992:268). *Qeshqa* directed the hunting and fishing of their extended family members, who lived in one or more *nichił* within a village; managed the storage and distribution of food; organized trade; and settled disputes. As far as we know, all *qeshqa* were men. Their wives, traditionally up to eight, were *qiy'u*, "rich women," and their children (boys and girls) were called *jiggi*. Billy Pete translated "*jiggi*" as "prince and princess."

Most individuals who were not *qeshqa* or their immediate relatives were classified as *ghelchiłna*, which Dena'ina speakers translate as "clanspeople," "working people," or "helpers." Individuals, usually young men, who lived with a *qeshqa* and supported him through hunting and fishing in return for instruction were called *ukilaqa*, "his clan helpers."

Joan Townsend suggested that "slaves" (Dena'ina *elnu*) constituted a social class and were the personal property of *qeshqa*. They were not a significant source of labor, but their presence in a *qeshqa*'s household enhanced his prestige. Most slaves were war captives and were held for ransom or bartered with other groups (1979; see Osgood 1937:31).

Knowledgeable Upper Inlet Dena'ina elders deny that the Dena'ina traditionally held slaves. Instead, they assert that war captives eventually became voluntary "working people." Billy and Shem Pete explained,

> There was no such thing as slaves up here, unless they caught Aleuts [meaning Ułchena, the Alutiiq people], and if they behaved well, they treated them good. They weren't slaves then. They

never wanted to go home, and they wanted to be Dena'ina. One Aleut was staying at Susitna, spearing fish. A bunch of Aleuts came up and recognized him. He grabbed two fish and went home to the Indian village, pretending not to see the Aleuts. He warned his people. 'Bunch of Aleuts out there,' he said. They cleaned out [killed] most of them. Then he got married to one of the Indian women.

Shem and Billy Pete translated "*elnu*" not as "slave" but as "poor people, people who can't support themselves," or "lazy person." They explained,

> If someone came to someone's house, and if he worked, they fed him good, but if he was lazy, they gave him nothing. They didn't want a lazy man. Even if he died, they didn't care.

Social Roles

In addition to kinship, residence, and rank, age and gender were other principles of Dena'ina social organization. For example, most big-game hunting was done by men, and they did much of the fishing as well. Men were responsible for training adolescent boys of their clan. Dena'ina women fished, snared small game (such as ground squirrels), and harvested plants. They were the primary processors of foods for winter use. Women were responsible for the care of young children of both sexes, and trained girls as they transitioned to womanhood. In addition, they tanned hides, made clothing, and manufactured many key items of technology.

Life Cycle

Dena'ina babies spent much of their time strapped in *ts'utl'*, cradles made of birch bark. Young children were cared for primarily by their mothers and other female relatives. Children learned through play and by performing limited support roles in villages and in camps.

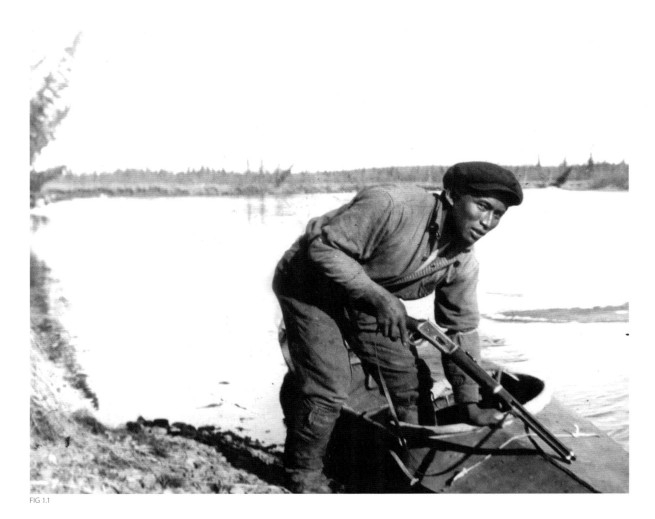

FIG 1.1

1.1 Anton Balluta climbing into a kayak to go hunting, Chulitna River, 1928. Dena'ina men were responsible for most hunting of big game, including moose, caribou, sheep, goats, and bears. Dena'ina boys learned hunting skills at an early age. Ida Carlson Collection, courtesy of Marilyn Balluta and the National Park Service, NPS H93.

Beginning at around age two years, Dena'ina boys were raised to be "tough," according to Shem and Billy Pete (Fall 1987:52–53). Under the guidance of elders, they swam in cold water and ran every morning. Boys learned to jump high in the air, thus enabling them to dodge the swinging forelegs of bears and other dangerous animals. Billy Pete described how boys "wrestled with trees." Every morning, the boy grabbed a small tree and tried to pull it from the ground. When he succeeded, he moved on to a larger tree, thus developing strong arms and shoulders. Boys practiced hunting and fishing with miniature versions of adult gear. (See also the interview with Antone Evan titled "Calisthenics, Games, and Training," "An Inland Dena'ina Material Culture Anthology, p. 155.")

When boys were ready to learn seriously, they were supervised by their maternal uncles (senior men of their own clan). Boys traveled to other villages to serve as one of their uncles' *ukilaqa* (e.g., Kalifornsky 1991:261, 357). Nickafor Alexan described the process in "Stories about How to Raise Children":

Just as soon as [the boy] came in [the house] this uncle said, 'Nephew you visit me?' He answer 'Yes.' And just as soon as he sit one of log from fire roll down. 'Nephew

1.2 Nora Alexie with porcupine and drying fish, Lime Village, late 1970s. Dena'ina women processed most fish and wildlife harvests, preserving them through drying and smoking for use throughout the year. In addition, they trapped small game, such as porcupines, hares, ground squirrels, and birds, fished, and picked berries and other plants. Photograph courtesy of Priscilla Russell.

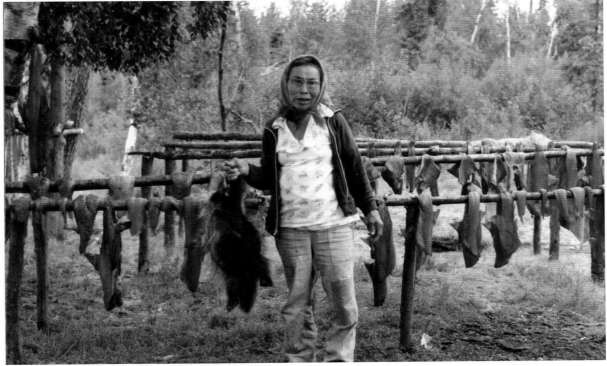

FIG 1.2

fix that.' He jump up and put the log back on the fire. And uncle ask if he could pack fresh water for him? He pack water. Every little thing nephew do that. (1965b)

Young Dena'ina women and men observed rigorous puberty rites as a key step toward learning, and transitioning into, adult roles. An individual undergoing puberty seclusion was called *hultsanen*, which Billy Pete translated as "in training." This term also refers to anyone who is fasting or "taking care of oneself" (Kari 2007:82).

For girls, puberty seclusion involved isolation for thirty days in a special shelter outside the village. The girl wore a hood or "cap" of caribou or moose hide. She used a bone tube for drinking, which hung at the end of a bead necklace (Osgood 1937:162). Katherine Nicolie (in Fall 1987:53) explained that the girl used a stick to scratch her body, worn around her neck on a moose hide string. Each morning she put a knot in the string, and her seclusion ended when the string had thirty knots. While isolated, girls were instructed in sewing by female relatives. They also learned to deal with spiritual power and learned about those dangerous actions that were *enge*—forbidden or taboo. After the thirty days, the young woman was ready for marriage (Fall 1987:53). Monthly seclusion continued for women until menopause.

Dena'ina boys observed puberty rituals at about age fifteen (Osgood 1937:162–163; Alexan 1965a). They were secluded in the forest for five days, observed dietary restrictions, and used scratchers like those used by girls. When the seclusion ended, very focused training began. "They truly jammed knowledge into them," Billy Pete said. Young men visited their kin in other villages as *ukilaqa*, learning skills and listening to stories. Bailey Theodore (in Fall 1987:54; see also Balluta 2008:33–37) recalled:

My Old Man told me to go around with the older people. He said, 'You

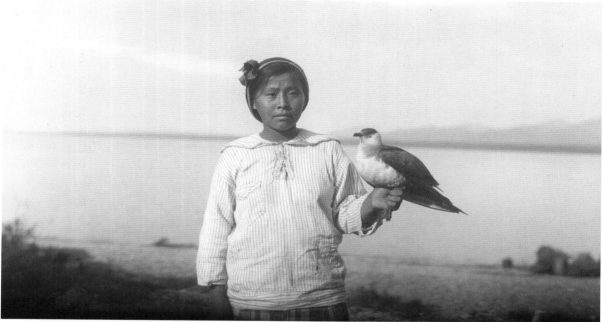

FIG 1.3

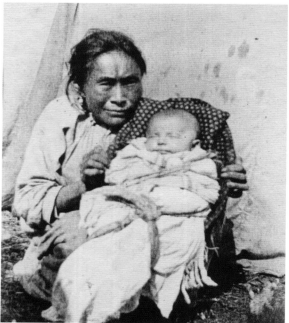

FIG 1.4

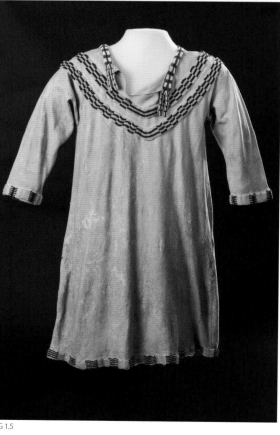

FIG 1.5

1.3 Agafia Trefon with a parasitic jaeger, Tanalian Point, near Port Alsworth, 1921. Young women observed an elaborate set of traditions at puberty, and the completion of these signaled the passage into adulthood. Trefon (1908–1928) is shown here as a young woman, before her marriage to Brown Carlson a year later. Photograph by Robert Vreeland. Robert Vreeland Collection, courtesy of Robert Vreeland Jr. and the National Park Service, NPS H216.

1.4 Annie Patchell with baby in carrier, Knik, 1906–1910. Dena'ina infants spent much of their time in birch bark baby carriers called *ts'utl'*, which were lined with moss. Robert Wheatley Collection, Anchorage Museum, B1982.052.257.

1.5 *K'isen ggwa dghak'a*, girl's dress, c. 1880. L 83.8 cm, W 62.2 cm; caribou hide, beads, sinew. Alaska State Museum 2009.010.001. Photograph by Chris Arend.

1.6 *Ts'en yił*, drinking tube, Susitna Station, nineteenth century. L 16 cm. Swan (?) bone, rawhide, glass beads, sinew. Anchorage Museum, 1997.048.004. Photograph by Chris Arend.

1.7 *Ts'en yił*, drinking tube, Tyonek, 1883. L 36.5 cm. Bone, beads, dentalium shells, sinew, ochre, skin (caribou?). Ethnological Museum Berlin, IVA 6125. Photograph courtesy of Staatliche Museen zu Berlin, Ethnologisches Museum. Photograph by Chris Arend.

At puberty, girls were secluded for thirty days, undergoing training. During these times, they used a bone tube for drinking, which hung around their neck from a bead necklace. The tube was sometimes decorated with incised lines. The use of dentalium shells (*k'enq'ena*) suggests that this tube was used by a *jiggi*, the daughter of a *qeshqa* (rich man).

1.8 *Ts'en zitl'i eł chizhigi*, drinking tube with comb, interior Alaska, c. 1930. L 41.6cm. Swan wing bone, rawhide, sinew, beads. Alaska State Museum, II-C-119. Photograph by Chris Arend.

In this example, a bone comb is also attached to the bead necklace along with the drinking tube. A girl's mother dressed her hair, the girl being prohibited from doing so while in puberty seclusion.

1.9 *Ułkesa*, sewing bag, Eklutna, c. 1950. L 24 cm. Wool and cotton cloth, woolen yarn, commercial thread. Anchorage Museum, 1985.047.002. Photograph by Chris Arend.

While isolated at puberty, girls received instructions in sewing from their female relatives. They stored their bone needles and sinew thread in a sewing bag called an *ułkesa*.

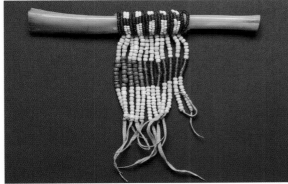

FIG 1.6

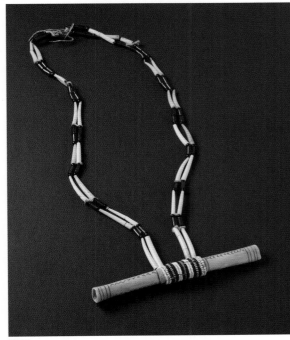

FIG 1.7

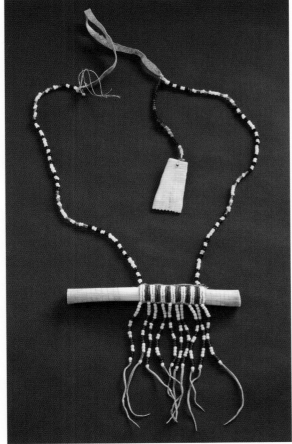

FIG 1.8

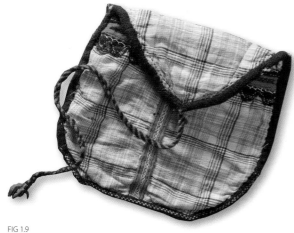

FIG 1.9

can get something in your mind. Go around with different ones and there's always something there.' I ran into stories from my Old Man and I found out that he knew what he was saying. He told me, 'Go around and see if you can hear the story again.'

A young man's first marriage required that he perform bride service for the woman's parents (Osgood 1937:164). Katharine Nicolie (in Fall 1987:63) explained,

> Long ago if a man wanted to be married to a family he had to move in with them and work for them. To see if he was dumb or lazy. That's why they move in with them.

Parents insisted that the young man prove his ability to support their daughter by demonstrating his hunting skills. Accumulated wealth was necessary as proof of a man's competence. Billy Pete (in Fall 1987:63) said,

> Young men had to collect fur blankets, fur dresses, and beads. Enough to support themselves and then they could get married. This was when they were maybe 30 years old.

Following bride service, the married couple might build their own *nichił*. If the man established a reputation as a good hunter, skilled organizer, and generous provider, he would attract his relatives to his house and could achieve *qeshqa* status. Such "rich men" could forgo bride service through the payment of wealth to obtain additional wives.

Dena'ina elders were honored for their wisdom and skills. They provided advice and guidance to younger people.

When an individual died, members of the opposite moiety were responsible for cleaning and dressing the remains. Traditionally, the dead were cremated, again by people from the opposite moiety. Sometime later the deceased's clan relatives would hold a potlatch to compensate the "opposites" for these services.

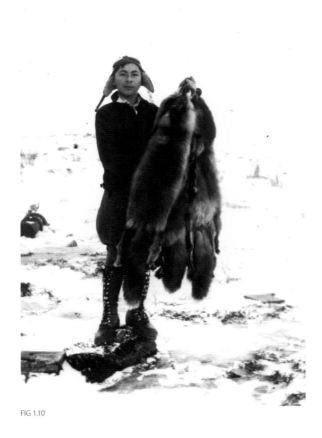

FIG 1.10

1.10 Charley Roehl at Seversen's roadhouse, Lake Iliamna, early 1930s. Trapping was a traditional source of wealth for young men, who could trade furs for food and other valued items such as dentalium shells (*k'enq'ena*). Traditionally, young men were instructed by older male relatives in how to become successful trappers. Success usually indicated that a young man was ready for marriage. Helena Seversen Moses Collection, courtesy of the National Park Service, NPS H609.

The Seasonal Round of Subsistence Activities

Table 1.2 depicts the seasonal round of subsistence activities for the Dena'ina regional bands of Cook Inlet, as it was followed in the late eighteenth and early nineteenth centuries before severe population losses resulted in significant changes to Dena'ina settlement patterns. Table 1.3 shows the corresponding seasonal round for the Iliamna and Inland dialect area villages. (For a more detailed discussion of the Upper Inlet Dena'ina seasonal round, see Fall (1987:31–38); for the Inland Dena'ina, see Gaul (2007:85–110) and Evanoff (2010:59–81, 167–189).

More than ninety names for the months of the year have been recorded in the four Dena'ina dialects. Table 1.4 provides a sample for the Cook Inlet and Inland Dena'ina areas (Kari 2007:161–163).

Table 1.2 Seasonal Round of Activities, Cook Inlet Dena'ina Regional Bands

Season		Months	Primary Activities
Spring	**Łitl'en**	**April** Nut'aq'i N'u "Geese Month"	Beluga & seal hunting Trout fishing Beaver hunting and trapping
		May K'gguya N'u "Baby Month"	Bird hunting Egg gathering Collecting clams and other shellfish Eulachon fishing
Summer	**Shani**	**June** Łiq'aka'a N'u "King Salmon Month"	King salmon fishing
		July Chiluq'a Ni'u "Fish Run Month"	Sockeye salmon fishing
		August Benen K'enedlidi "Month of Ripe Berries"	Berry picking
Fall	**Nuqeli**	**September** Benen Hdidechiqi "Month It Turns Yellow"	Snaring ground squirrels Silver salmon fishing Hunting & snaring caribou, moose, and other big game
		October Benen Nuk'nedełi "Month Birds Fly Back"	
		November Benen Qatgge Ntdałna "Month Going House to House"	Trapping Visting and trading
Winter	**Heyi**	**December** Benen Yach' Naqank'delyashi "Month Bear Turns over on Other Side"	Potlatching
		January Benen Q'ank'elich'deldiłi "Month for Going about Singing"	Ice fishing
		February Benen Tunteyashi "Month Water Increases"	Trapping and hunting
		March Benen Tich'enashi "Month We Go out"	Hunting bears in their dens

Note: Common names frequently used in Alaska for salmon species are king (chinook), silver (coho), red (sockeye), pink (humpy), and dog (chum).

Note: The chart highlights some key activities within each month. Activities may occur in multiple months.

Note: The Dena'ina equivalents for English-language names of months are approximate. Rather than being lunar months, the Dena'ina names are based on events within the annual cycle (Kari 2007:161).

Table 1.3 Seasonal Round of Activities, Inland Dena'ina Regional Bands

Season		Months	Primary Activities
Spring	**Łitl'en**	**April** Venen Nuk'net'ehi "Month They Fly Back"	Migratory bird hunting Fishing for pike and whitefish Beaver hunting and trapping
		May Venen Dghazhi "Egg Month"	Egg gathering Spring camp fishing and hunting continue
Summer	**Shani**	**June** Ts'ek'dzelghaxi N'u "Month We Put Up Fish"	Sockeye salmon fishing
		July Ch'ishanich "Midsummer"	Sockeye salmon fishing continues
		August Venen K'enijuni "Month of Ripe Berries"	Berry picking
Fall	**Nuqeli**	**September** Venen Niłtuk'el'eshi "Rutting Month"	Snaring ground squirrels Hunting & snaring caribou, moose, and other big game
		October Venen Nuk't'unłqasi "Month the Leaves Fall"	Hunting continues throughout winter Harvest of spawned sockeye salmon ("red fish")
		November Shagela N'u "Trout Month"	Ice fishing for trout, grayling, and other fish Trapping
Winter	**Heyi**	**December** Venen Nunqelts'edi "Month Sun Descends"	Trading, visiting, and potlatching
		January Venen Nuyilqu'i "Month Getting Light Again"	Ice fishing
		February Venen Nutchiłi "Month of Snow"	Trapping and hunting continue
		March Ndałika'a N'u "Bald Eagle Month"	Hunting bears in their dens Beaver trapping

Note: Common names frequently used in Alaska for salmon species are king (chinook), silver (coho), red (sockeye), pink (humpy), and dog (chum).

Note: The chart highlights some key activities within each month. Activities may occur in multiple months.

Note: The Dena'ina equivalents for English-language names of months are approximate. Rather than being lunar months, the Dena'ina names are based on events within the annual cycle (Kari 2007:161).

Table 1.4 Selected Dena'ina Names of the Months

	Cook Inlet (Outer and Upper Inlet Dialects)		Inland (Inland and Iliamna Dialects)	
April	Nut'aq'i n'u	"Geese Month"	Venen nuk'net'ehi	"Month They Fly Back"
May	K'gguya n'u	"Baby Month"	Venen dghazhi	"Egg Month"
June	Łiq'aka'a n'u	"King Salmon Month"	Ts'ek'dzelghaxi n'u	"Month We Put Up Fish"
July	Chiluqa'ni'u	"Fish Run Month"	Ch'ishanich	"Midsummer"
August	Benen k'enedlidi	"Month of Ripe Berries"	Venen k'enijuni	"Month of Ripe Berries"
September	Benen hdidechigi	"Month It Turns Yellow"	Venen niłtuk'el'eshi	"Rutting Month"
October	Benen nuk'nedełi	"Month Birds Fly Back"	Venen nuk't'unłqasi	"Month the Leaves Fall"
November	Benen qatgge ntdałna	"Month Going House to House"	Shagela n'u	"Trout Month"
December	Benen yach' naqank'delyashi	"Month Bear Turns Over"	Venen nunqelts'edi	"Month Sun Descends"
January	Benen q'ank'elich'deldiłi	"Month for Going About Singing"	Venen nuyilqu'i	"Month Getting Light Again"
February	Benen tunteyashi	"Month Water Increases"	Venen nutchiłi	"Month of Snow"
March	Benen tich'enashi	"Month We Go Out"	Ndałika'a n'u	"Bald Eagle Month"

Source: Kari 2007:161–163.

Łitl'en: *Spring*

For all Dena'ina, a new round of resource harvests began in spring. Small family groups left winter villages for spring camps. Early spring could be a period of hardship if winter food supplies had run short, and traditional stories indicate that starvation was not unknown. Trade with other villages took place if food was scarce.

Some spring camps were located at lake outlets, such as Dach'qelqiht ("Where We Spend the Spring"—the outlet of Whiskey Lake in the Yentna River drainage), where people built weirs to trap trout migrating from the lakes to the outlet streams. Places where resources such as bears or porcupines could be reliably found were appropriately named, such as Sheshjesh ("Saved"; Porcupine Butte in the Skwentna River drainage). Shem Pete explained, "There's lots of bears and porcupines on that hill, so when people get hungry, they go there." Porcupines were clubbed, while bears emerging from their dens were taken with spears, snares, deadfalls, and pitfalls. Other small game, harvested with snares or bows and arrows, included hares, ptarmigan, and spruce grouse.

A key early spring location for the Kenaht'ana of Knik Arm was Dgheyaytnu ("Stickleback Creek"), now called Ship Creek, in downtown Anchorage. Shem Pete explained that in early spring, people could survive on this run of needlefish until the arrival of other resources such as eulachon (smelt), king salmon, or migratory waterfowl.

Migratory birds, including ducks, geese, swans, and cranes, were key spring subsistence resources throughout Dena'ina country. For example, at Lime Village, hunting migratory birds resumed in late March. Harvest technologies included snares set in brush fences or on rafts in lakes, nets, deadfalls, bows with sharp-pointed or blunt arrows, throwing sticks, and sling rock-throwers (Russell and West 2003:12–20). In spring, the Dena'ina also harvested the eggs of waterfowl and gulls.

Spring trapping, especially for beavers, was an important source of fur and food. Animals were harpooned, clubbed, or taken in deadfalls (Osgood 1937:35; Johnson 2004:40–47).

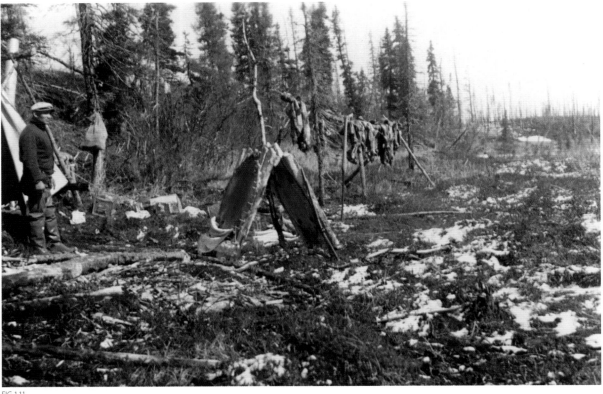

FIG 1.11

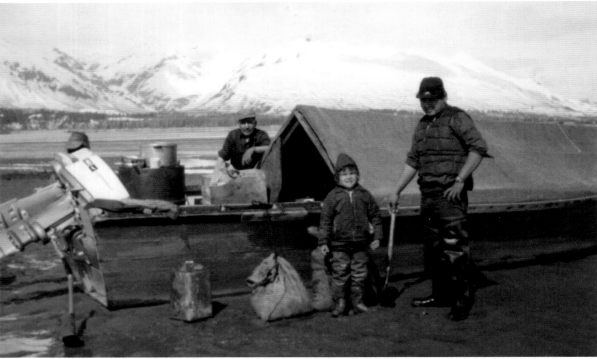

FIG 1.12

1.11 Pete Trefon's beaver camp, perhaps in the Tazimina Lakes or Mulchatna area, late 1930s. In spring, small family groups set up camps to hunt and trap beavers and other furbearers and small game. Often, two nuclear families shared a camp. Helena Seversen Moses Collection, courtesy of the National Park Service NPS H288.

1.12 A clam harvest. Left to right, Max Chickalusion Sr., Daniel Standifer Jr., Daniel Standifer Sr. at Polly Creek, c. 1974. In spring, Dena'ina harvested marine invertebrates such as razor clams, butter clams, and cockles in the mudflats of lower Cook Inlet. Tyonek residents continue to travel by skiff in the spring to lower Redoubt Bay, Harriet Point, and Polly Creek to harvest clams. Harvests of clams are widely distributed in the village. Chickalusion Collection, Tyonek 045. Courtesy of the Alaska Department of Fish and Game.

1.13 *Beyaga*, trigger for deadfall for porcupine, Fort Kenai, 1883. L (a) 72 cm, (b) 37 cm, (c) 19 cm, (d) 22.5 cm. Wood, bird quill sinew, ochre. Ethnological Museum Berlin, IVA 6158 ad. Photograph courtesy of Staatliche Museen zu Berlin, Ethnologisches Museum. Photograph by Chris Arend.
These pieces, once assembled, were used to create a deadfall, which in this case was used for porcupines.

1.14 *Telqeshi*, sea otter arrows (detail of figure 1.18). Ethnological Museum of Berlin IVA 6160. Photograph courtesy of Staatliche Museen zu Berlin, Ethnologisches Museum. Photograph by Chris Arend.

1.15 *Estl'eni*, bone spear points, Iliamna, 1931– 1932. L (small) 17 cm; L (large) 20 cm. Moose or caribou bone, moose hide thong. Photograph © Peabody Museum of Natural History, Yale University, ANT.015867. Photograph by Chris Arend.
Barbed points carved from bone were attached by a line to the harpoon used to hunt marine mammals such as seals, sea otters, and belugas. Cornelius Osgood acquired these points from "Nicolai."

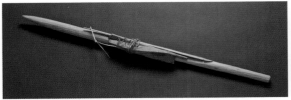
FIG 1.13

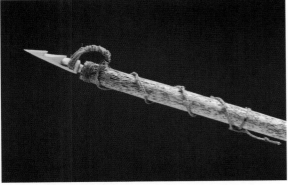
FIG 1.14

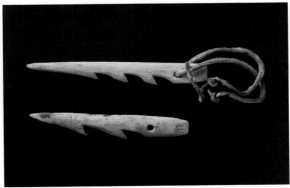
FIG 1.15

For the Cook Inlet Dena'ina, spring also brought the opportunity to hunt marine mammals. Osgood emphasized the importance of marine mammals, especially for the Dena'ina of Kachemak Bay (1937:37).

A unique beluga hunting technology of particular importance to the Cook Inlet Dena'ina was the *yuyqul*, the beluga-spearing platform, which they likely developed based on hunting strategies using elevated game lookouts called *dehq'a* along streams within the boreal forest (Fall 1981:192; Kari and Fall 2003:75–77). The *yuyqul* was a single large spruce tree embedded upside down in the mudflats at ebb tide and secured with lines of moose hide (and likely sometimes caribou hide) smeared with pitch. A hunter armed with a harpoon stationed himself in the "nest" formed by the upturned tree's roots and waited for belugas to approach with the flood tide in pursuit of salmon. After harpooning a whale, the hunter signaled to his partners waiting on shore with kayaks (*baydalgi*). They chased the wounded animal until it died and then hauled it back to their village. There it was butchered, and oil was rendered from the fat

Ferdinand Wrangell wrote an early account of Dena'ina beluga-spearing platforms (1980 [1839]:57). On June 10, 1883, the ethnographic collector Johan Adrian Jacobsen recorded an observation of a beluga-spearing platform at a west Cook Inlet Dena'ina village he called "Kastarnak," most likely Kustatan (Jacobsen, Papers). Shem Pete narrated a detailed description of the *yuyqul* based on oral traditions he learned in the early twentieth century from Bidyaka'a of Tyonek, the last person to hunt beluga from a *yuyqul*, in about 1880. (Shem Pete's description of hunting from a *yuyqul* follows this essay.)

Nickafor Alexan wrote that in the nineteenth century, Chief Pete (Benila Ch'ulyalen) of Tyonek hunted belugas with harpoons from a *baydalgi* near the McArthur River and that he also "used to have long logs sticking out of Beluga River close to the hills, and when the beluga's came in there at high tide to go up the river, he would spear the beluga" (1981:16, 18; 1965a).

On the importance of beluga harvests to the Cook Inlet Dena'ina, Nickafor Alexan wrote:

The Indians those days used to use the beluga's oil and eat the meat of the belugas they kill. Also they used to eat the blubber, boil all the fat into oil, put all the meat up to dry for the winter and take all the sinew string for bow. (1981:18)

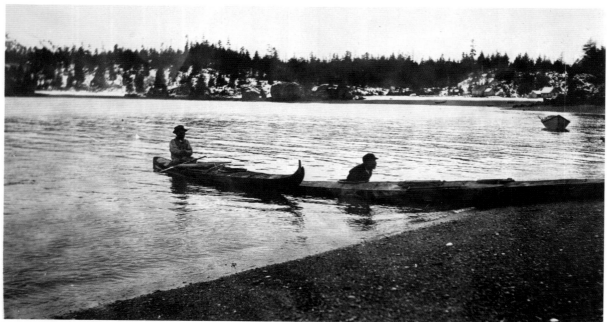

FIG 1.16

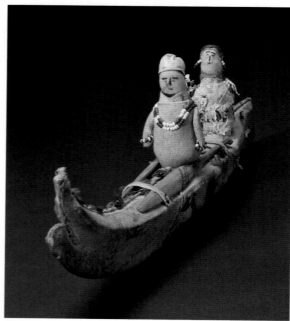

FIG 1.17

1.16 Two men in kayaks in Seldovia, 1916. The Dena'ina of Kachemak Bay, centered at Seldovia, were expert hunters of marine mammals. Simonson Collection, Anchorage Museum, B1991.009.143.

1.17 *Biqidin gga*, model kayak with two figures, Susitna Station, 20th century. L 32.2 cm. Moose hide (?), glass beads, wool and cotton cloth, wood, pigment. Anchorage Museum, 1997.048.003. Photograph by Chris Arend.
 The Dena'ina constructed one-, two-, or three-hole kayaks (*baidarka* [Russian], *baydalgi*, or *biqidin*) using a birch frame covered in sealskins, patterned after the watercraft of the Alutiit of lower Cook Inlet. These were used for travel and for hunting sea mammals on Cook Inlet and the lower portions of major rivers.

Harbor seals and, to a lesser extent, sea lions and porpoises were other marine mammals harvested for meat, oil, and raw materials by the Cook Inlet Dena'ina. Seals that hauled up on the beach were stalked and clubbed, or they were pursued in kayaks in open water and killed with bows and arrows or harpoons (Osgood 1937:37). The Iliamna Dena'ina hunted the freshwater seals of Iliamna Lake (Johnson 2004:33–35). Iliamna Dena'ina also crossed to Cook Inlet to hunt seals and beluga. Sea otters were taken in the lower and middle inlet from kayaks during well-organized hunts; they were not eaten but were valued for their fur (Osgood 1937:37–38).

The Dena'ina name for Point MacKenzie, Dilhi Tunch'del'usht Beydegh, provides further clues to the Cook Inlet Dena'ina seasonal round. The name means "Point Where We Transport Eulachon." It was here in spring that Susitna River Dena'ina brought large quantities of eulachon, which they harvested with dip nets, to trade with the K'enaht'ana for dried meat. Eulachon were rendered into oil for food and fuel.

1.18 *Telqeshi,* arrows for sea otter, Fort Kenai, 1883.
L 87–89 cm. Wood, bone, sinew, feathers, ochre. Ethnological Museum Berlin, *from top:* IVA 6161, 6162, 6160, and 6159. Photograph courtesy of Staatliche Museen zu Berlin, Ethnologisches Museum. Photograph by Chris Arend.
Arrows with detachable bone points were used for hunting sea otters in Cook Inlet.

1.19 Harvesting belugas.
Tommy Allowan, Herman Standifer, Theodore "Chad" Chickalusion, and Maxim Chickalusion Sr. harvesting belugas in Cook Inlet, 1957. Belugas were an important spring resource for the Cook Inlet Dena'ina villages. In the twentieth century, Dena'ina hunters pursued belugas using skiffs with high-powered outboard motors, shooting the belugas with rifles and securing them with a gaff and a rope through the lower jaw and upper lip. Pauline Allowan Collection, Tyonek 93. Courtesy of Pauline Allowan and the Alaska Department of Fish and Game.

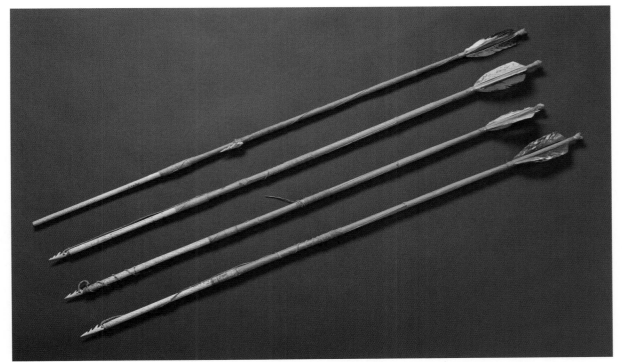

FIG 1.18

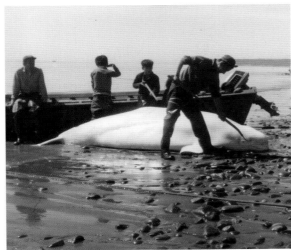

FIG 1.19

Intertidal resources were significant for the Cook Inlet groups and for the Iliamna Dena'ina who crossed to Cook Inlet, especially in spring. Peter Kalifornsky described spring activities focused on Cook Inlet beaches:

> When they stayed at Kustatan, they made oil from beluga, seal, and other things. Then they went after clams. They cooked the clams. Then they put them in a beluga stomach and poured in oil to preserve it for winter. When they opened it up, they washed the clams in hot water. They cooked clam soup whenever they wanted to make it. (1991:213)

Throughout Dena'ina country, an important spring vegetable resource, also harvested in the fall, was "Indian potatoes," or *k'tl'ila*. The roots were dug with pointed sticks, a moose leg bone or horn, or by hand. They were eaten raw, boiled, baked, or fried,

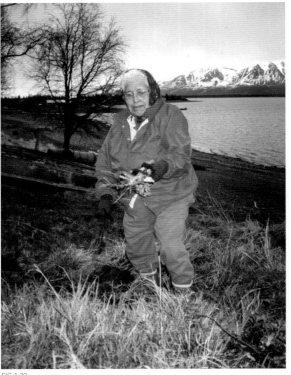

FIG 1.20

FIG 1.21

and often dipped in oil. In fall, *k'tl'ila* were stored in large quantities in underground caches. The Upper Inlet people traded bundles of these roots with Outer Inlet Dena'ina in exchange for furs or dried fish (Kari 1987:126–127).

Shani: *Summer*

Summer brought an abundance of salmon, the most important staple for virtually all Dena'ina communities. For the Cook Inlet villages, chinook (king) salmon were the first to arrive and perhaps the most prized. In the upper inlet, June was "Łiq'aka'a N'u," "King Salmon Month." The king salmon were followed by sockeye (red) salmon (likely taken in the largest quantities), chum salmon, pink salmon, and coho salmon.

Peter Kalifornsky wrote that the Kenai Peninsula Dena'ina constructed weirs of driftwood and willow laced with spruce roots "where the current in the river made eddies at low tide" (1991:209). They

placed traps in streams and fished with dip nets made of spruce roots. Such traps were also used by the upper inlet regional bands in numerous creeks and lake outlets. Kalifornsky also described snares for catching salmon:

> They also used to make a snare out of line made of spruce root with a slip-knot noose tied with grass to a forked stick; they looped that over the fish and strangled them. They didn't slip out. The forked stick held them. (1991:209)

A salmon harvest technology of particular importance for the Cook Inlet regional groups was the *tanik'edi* or dip net platforms. As described by Nickafor Alexan (1965a) and illustrated by Henry Wood Elliott in the early 1880s (Bean 1887), the *tanik'edi* consisted of poles lashed together and placed over the mudflats of Cook Inlet at low tide. Fishers stood on the poles and harvested salmon

1.20 Agnes Cusma gathering Indian potatoes in the spring at Nondalton, c. 1990. Photograph courtesy of Priscilla Russell.

1.21 Harvesting king salmon. A Dena'ina family picking king salmon from their net in Cook Inlet waters near Tyonek. At Tyonek, families set gill nets from the beaches near the village and south along Beshta Bay to harvest king (chinook) salmon beginning in May. Some families pick the nets from skiffs. Photograph courtesy of the Alaska Department of Fish and Game, Tyonek 572.

1.22 *Tach'enił'iyi*, dip net (fish net), Kenai Peninsula, 1842. L 110 cm. Wood (alder?), spruce root? Peter the Great Museum of Anthropology and Ethnography (Kunstkamera), 2667-26. Photograph by Chris Arend.

1.23 *Tach'enił'iyi*, dip net (fish net) (detail of figure 1.22). Peter the Great Museum of Anthropology and Ethnography (Kunstkamera), 2667-26. Photograph by Chris Arend.

1.24 *Tach'enił'iyi ggwa ch'u tsik'eneghełi ggwa*, model dip net and club for salmon, Kenai, 1883. L 78 cm. Wood, spruce roots, ochre. Ethnological Museum Berlin, IVA 6129. Photograph courtesy of Staatliche Museen zu Berlin, Ethnologisches Museum. Photograph by Chris Arend.
 Before the introduction of cotton and nylon gill nets, dip nets woven from spruce roots were a primary tool for harvesting salmon. Men and women fished with the dip nets while standing on pole platforms called *tanik'edi*, constructed over Cook Inlet's mudflats.

1.25 Mending nets. Eddie Kroto and Martha Alexan prepare nets for fishing. By the twentieth century, most Dena'ina harvested salmon with gill nets. An important chore in early spring is repairing the nets in anticipation of the arrival of salmon, beginning in May for Cook Inlet villages and in June for the Inland Dena'ina villages. Native Village of Tyonek Collection, Tyonek 160. Courtesy of the Native Village of Tyonek and the Alaska Department of Fish and Game.

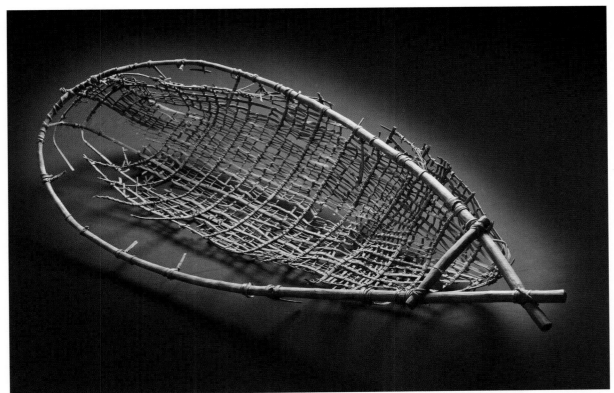

FIG 1.22

FIG 1.23

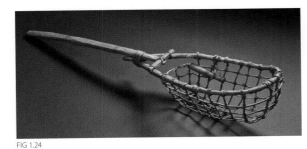

FIG 1.24

FIG 1.25

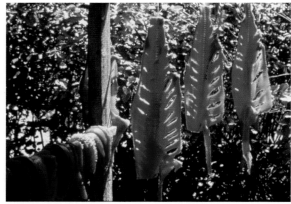

FIG 1.26

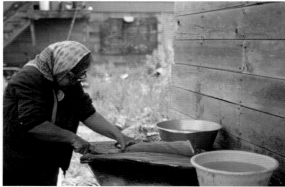

FIG 1.27

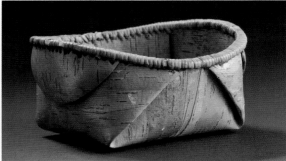

FIG 1.28

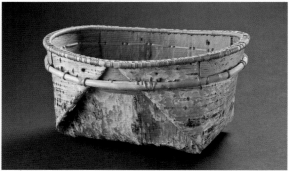

FIG 1.29

1.26 Salmon backbones drying at Fedora Constantine's smokehouse, Tyonek, 1981. King salmon backbones, called *k'iytin*, after soaking in a salt brine, are dried in the sun before being placed in the smokehouse. Backbones are used in soups. Also pictured is salmon roe, which is also smoked (*q'in nalggeni*). Photograph courtesy of the Alaska Department of Fish and Game, Tyonek 429. Photograph by Dan Foster.

1.27 Nellie Chickalusion, Tyonek, filets a king salmon, summer 1981. At fish camps and in Tyonek itself, king salmon are processed into a variety of products to be used through the summer and into the fall and winter. Here, Tyonek elder Nellie Chickalusion cuts a king salmon along both sides of the backbone. Photograph courtesy of the Alaska Department of Fish and Game, Tyonek 368. Photograph by James A. Fall.

1.28 *Q'ey hagi*, birch bark container. Susitna Station, 20th century. L 18 cm. Birch bark, willow root, wood. Anchorage Museum, 1997.048.001. Photograph by Chris Arend.

Birch bark containers (*ghelch'ehi* in Outer and Inland dialects, *q'ey hagi* in the Upper Inlet dialect) were ubiquitous in Dena'ina villages and camps into the early twentieth century. They served a variety of purposes, including collection of berries and other plants and storage of food. For cooking, the baskets were filled with water and hot rocks. Woven spruce-root baskets were also used for cooking. Today, birch bark baskets are largely made for sale as a craft item.

1.29 *Ghelch'ehi*, birch bark container, Stony River, c. 1940. L 34 cm. Birch bark, root, grass. Courtesy of the Burke Museum of Natural History and Culture, catalog no, 1.2E1179. Photograph by Chris Arend.

with dip nets when the tide came in. Among other locations, *tanik'edi* were used at Tak'at and Nuch'ishtunt (Point Woronzof) in the present-day Anchorage area, on Fire Island, at Kenai, and on the beaches along western Cook Inlet near Tyonek.

The Inland and Iliamna Dena'ina had access only to sockeye (red) salmon, but the run into Iliamna Lake is one of the largest in the world. These salmon become available for harvest in July and were caught into September and October (in their spawning and spawned-out phases). Diverse technologies were traditionally used by the Inland Dena'ina to harvest the salmon, including traps and weirs. Only as many salmon as could be processed in a day were removed from a trap and kept. The rest were released to spawn (Balluta 2008:108–116).

Large quantities of salmon were processed, primarily by women, for use over the winter.

Preservation methods included drying in smoke-houses (*baba*) and fermenting (*chuqilin*), and storage in underground caches called *ełnen t'uh*. Supplies were transported from the camps to the winter villages. In the fall, silver salmon, in the Cook Inlet drainage, and spawning sockeyes, in Iliamna Lake and Lake Clark, were dried without smoke to make *nudelvay* (Balluta 2008:117–121). Balluta notes that only male spawning salmon were harvested for *nudelvay*, as a conservation measure to preserve the runs. He comments,

> They knew what they were doing long ago. They didn't kill everything they see. They don't touch the fish once they go up to the spawning areas. This is taking care of our resources. (2008:116)

Late summer and early fall were the primary seasons for harvesting berries. About twenty kinds were used, mostly as food or for medicinal purposes. Raw or cooked berries were mixed with oil

1.30 Emma Alexie harvesting blueberries, summer, Lime Village, early 1980s. Blueberries and low bush cranberries are the most harvested berries throughout the Dena'ina area. Blueberries are picked during the summer, and care must be taken to preserve them since they rot quickly. Cranberries, collected in the late fall and into the winter, store better. Photograph courtesy of Priscilla Russell.

FIG 1.30

to preserve them for later use. A popular food was *k'enkash*, prepared by mixing cooked berries with dried, mashed fish eggs and storing the *k'enkash* in a birch bark or animal stomach container in a cool place. A confection of berries mixed with oil or fat and dried fish or meat was called *nivagi*, "Indian ice cream." A variety of plants were harvested over the course of a year for medicinal purposes. A good example is wormwood (*Artemesia tilesii, ts'elbeni*). The plant was boiled or soaked in hot water, and the resulting tea was applied to skin rashes, cuts, and any infection. The boiled or soaked leaves could

also be placed directly on the injured area (Kari 1987:60–151 passim).

Nuqeli: *Autumn*

Late summer and early fall brought a transition from fishing and gathering plants to hunting big game. Extended families traveled upriver and into the mountains and established hunting camps. Caribou were of particular importance. Dena'ina bands maintained caribou surrounds (*ses* in Upper Inlet dialect, *sex* in the Inland dialect) in which caribou were snared or trapped and shot with bows and arrows or speared. Some locations of surrounds included Rainy Pass and the Talkeetna Mountains. Caribou meat was dried and transported back to the winter villages in skin boats. Some meat was cached along trails and retrieved as needed in the winter (Osgood 1937:33; Ellanna and Balluta 1992:158–159).

Moose were also hunted in the fall and throughout the winter. They were tracked and killed with bows and arrows, or snared (Osgood 1937:33–35). According to oral traditions, moose were scarce within most Dena'ina territory until the early twentieth century (e.g., Fall 1987:25–26; Ellanna and Balluta 1992:29). But other traditions viewed moose populations as cyclical. Elder Johnny Shaginoff, who was born near Knik in the early twentieth century, observed, "Seems to me moose are just like rabbit. Come thick and then no more" (in Fall 1987:26).

Dall sheep were hunted throughout Dena'ina country with snares and bows and arrows. Dogs assisted in these hunts (Osgood 1937:35). The Dena'ina developed effective strategies for hunting sheep. For example, a mountain in the Matanuska River valley east of Chickaloon was called Chun eł Duk'eldesht, "Where Arrows with Excrement Are Shot Down," because, as Shem Pete explained,

> They hunt for sheep on that mountain. The sheep keep away from them so they move up above them and defecate, and then they shoot that arrow rubbed with excrement, and it

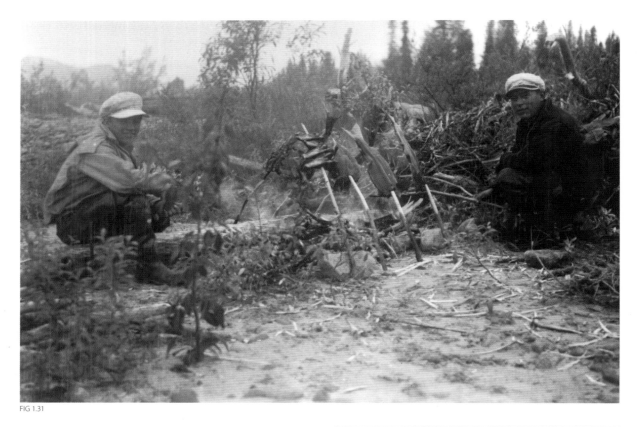

FIG 1.31

1.31 Men cooking beaver feet and salmon tails near Iliamna, 1930s. Helena Seversen Moses Collection, courtesy National Park Service, NPS H460.

1.32 Fall harvest: Antone Evan butchering a caribou as three young men watch, Nondalton, fall 1973. Joan Tenenbaum Collection, Anchorage Museum, TD08.1.18.2. Photograph © Joan Tenenbaum.

causes the sheep to move. (Kari and Fall 2003:302)

Johnny Shaginoff added,

> That's where they shoot arrow to scare game that they can't get to. And when they do that, the animal gets the scent you know. Smell it and run off, down where they can get them. Somebody else be waiting. That's what that means. (Kari and Fall 2003:302)

Mountain goats were found in only a portion of Dena'ina country, in Kenai Peninsula and the Chugach Mountains. The people of Knik Arm were particularly skilled hunters of goats.

The Dena'ina hunted both black and brown bears for food, fat, and skins, with late fall, when bears are fat, being a particularly important time.

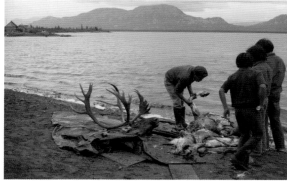

FIG 1.32

Bears were taken with deadfalls, pitfalls, and snares. On moonlit nights, hunters waited near streams on elevated platforms (*dehq'a*), from which they could shoot bears. Particularly prestigious was killing a brown bear with a spear (Osgood 1937:32–33; Balluta 2008:129–133).

1.33 Emma Alexie peeling birch bark in early summer. Birch bark was a versatile material that the Dena'ina used for variety of purposes. The Dena'ina highly valued birch bark because it is flexible, waterproof, and does not rot easily. Some of its uses included roofing material, coverings for canoes, and a variety of containers. Also, birch bark is one of the best fire-starters found in nature, as it will burn easily even if it is completely wet. This photograph was taken near Lime Village in the early 1980s. Photograph courtesy of Priscilla Russell.

1.34 Nora Alexie working on baskets in a tent near Lime Village. Photograph courtesy of Priscilla Russell.

FIG 1.33

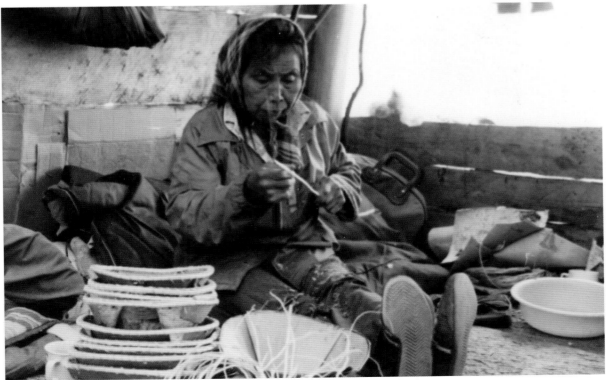

FIG 1.34

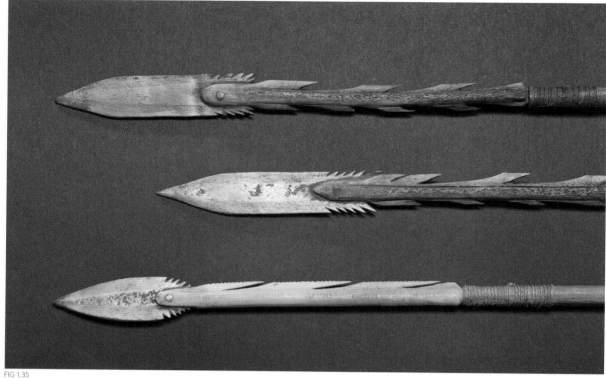

FIG 1.35

1.35 *Izin,* **arrows, Tyonek, 1883.** L 66 cm. Wood, metal, feathers, sinew, bone, ochre, blue pigment. Ethnological Museum Berlin, IVA 6082, 6083, and 6086. Photograph courtesy of Staatliche Museen zu Berlin, Ethnologisches Museum. Photograph by Chris Arend.

Arrows for shooting large game were constructed of spruce and had detachable bone foreshafts.

1.36 *Dayin q'aditin,* **bear spear point, Southcentral Alaska, 19th century.** L 38.5 cm. Iron. Anchorage Museum, 1969.062.001. Photograph by Chris Arend.

The Dena'ina manufactured several types of spear points. The largest was used for spearing bears. The lance to which the point was attached was up to eight feet long. Only the bravest and strongest individuals killed bears with these spears.

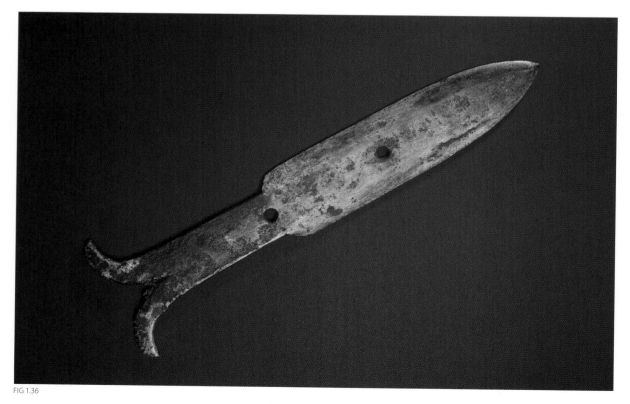

FIG 1.36

1.37 Winter cabin scene, c. 1980, upper White Fish Lake, located about 25 miles west of Lime Village. Photograph courtesy of Priscilla Russell.

FIG 1.37

An important fall subsistence activity described frequently in oral traditions was the trapping of ground squirrels, especially by women and girls, in the mountains. The dome-shaped shelter used in the fall camps was called a *qunsha qeneh* (e.g., Johnson 2004:25–27; Balluta 2008:75–77). Hoary marmots were taken at the same time with deadfalls. Both animals were an important source of food and fur.

Fall and winter were the primary periods for taking a variety of furbearers, including wolf, wolverine, lynx, red fox, river otter, marten, mink, and weasel. With the exception of lynx, these animals were not eaten and were taken only for their fur. Harvest methods included snares and deadfalls. Some furbearers, such as marten, were esteemed for making coats worn by *qeshqa* and their families. Mink, on the other land, were generally reviled:

"even the fur the Tanaina regard with contempt and only the very poor will use it" (Osgood 1937:36).

Heyi: *Winter*

Early winter, from November to January or later, was usually a period of rest in villages. Although local hunting, trapping, and ice fishing occurred, people survived on supplies of dry fish and meat. They visited other communities, traded, told stories, and held memorial potlatches. Peter Kalifornsky wrote, "Then, wherever they stayed, they settled in for winter. And they celebrated—they ate and told stories" (1991:211).

In late winter, especially if supplies were running low, but also to obtain fresh foods, small groups of kin scattered to local lakes and hunting grounds

FIG 1.38

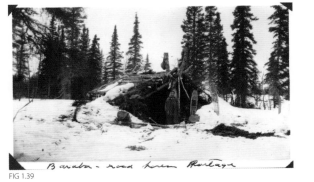

FIG 1.39

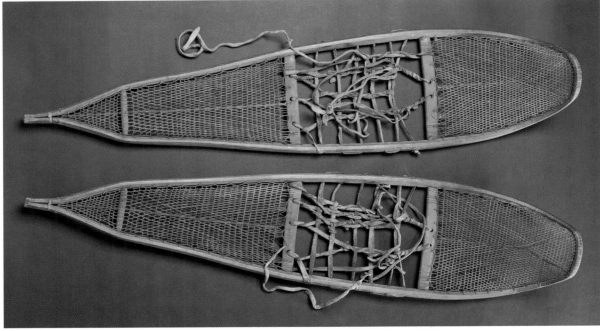

FIG 1.40

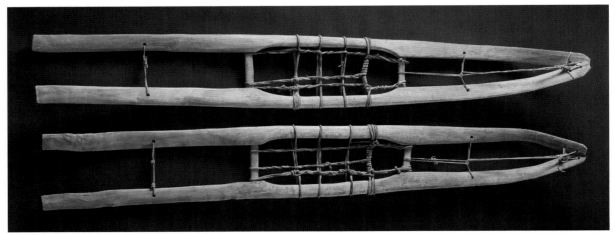

FIG 1.41

1.38 Starring. Nick Bobby and Seraphim Alexie are shown here starring during Russian Christmas, Lime Village, 1943. During Russian Christmas, starring takes place in many Dena'ina villages. A Ukrainian custom introduced by Russian Orthodox missionaries, in this tradition a decorated star is taken from the church into the homes, where people sing Nativity hymns and petition God to "grant many years" to the hosts, who in turn offer food and gifts to the star bearers. Matrona and Vonga Bobby Collection, courtesy of the National Park Service, NPS 70H.

1.39 Woman in front of house with snowshoes, c. 1908, along Newhalen portage. Photograph by prospector Arthur S. Tulloch. Photograph courtesy of the Alaska State Library, Arthur Stanley Tulloch Photograph Collection, P148-29.

1.40 *Ush*, snowshoes, Kenai, made by Z (?) Mishikoff, 1894. L 125 cm. Wood, babiche, moose hide thongs, ochre. Courtesy of the Burke Museum of Natural History and Culture, catalog no. 860. Photograph by Chris Arend.
 The Dena'ina manufactured a variety of snowshoes (*ush*) designed for use for particular trail and travel conditions. Frames were of birch and were made by men. The webbing of babiche (stretched, semitanned skin line) was woven onto the frames by women.

1.41 *Q'ishqa*, ski snowshoes, by Shem Pete, Willow, Alaska. Wood, hide. Anchorage Museum, 1965.011.004ab. Photograph by Chris Arend.

(e.g., Balluta 2008:64–69). Fish were harvested with hooks through the ice. With the aid of dogs, black and brown bears were located in their dens and killed with spears (Pete 1989). These dispersed groups sent food back to their villages. If food supplies were particularly low, the *qeshqa* sent men to other villages to trade fur or *k'enq'ena*—the shells of dentalium, a group of small tubular mollusks—for fish, meat, and grease.

Transportation Technology

The Dena'ina developed an extensive trail system to guide them through their territories, in addition to using the network of rivers and lakes. Different kinds of craft could be used to cross or travel down open water, including birch bark canoes (*baqay*), open boats with a wood frame covered with moose or caribou hide (*elgheji*), and log rafts (*hnes*). On both salt water and rivers, the Dena'ina used kayaks (*biqidin, baydalgi*) covered with sealskin and open sealskin boats called *badi* (Kari 2003c; in Kari and Fall 2003:102–104).

In winter, travel was facilitated by several kinds of snowshoes (Osgood 1937:79–83). Wooden sleds were made to transport supplies and were pulled by people, often women (Kalifornsky 1991:265), but also men (Osgood 1937:72). Dogs did not pull sleds until perhaps the late nineteenth century. By the early twentieth century, dogsleds for winter travel, such as checking traplines and hauling supplies, had been integrated into Dena'ina life, and a key task in summer became preparing an adequate supply of dry salmon to feed the dog team in winter (e.g., Johnson 2004:22–23; Balluta 2008:122–125).

Trade

Trade between Dena'ina villages, both within and between regional bands, was common, and reflected local and regional differences in the availability of natural resources. *Qeshqa* organized this intervillage trade through partnerships with each other (Alexan 1965b; Ellanna and Balluta 1992:269).

Shem and Billy Pete described the trade fairs that occurred near Susnikaq', the mouth of the Susitna River, in spring:

> The Susitna Dena'ina brought all kinds of parka squirrel coats and blankets. They brought lots of fur clothes and blankets to *Susnikaq'* and traded for lots of oil, two or three boat loads full. After one or two weeks they went back home. And they got a whole bunch of dry fish; king salmon was good and rich down there and they traded for them. They got good rich fish to take home, real fish from salt water. And a whole bunch of dry hooligans to take home. They brought home five or six *badi* of seal skins; they bought them too. From all over they came, to *Susnikaq'* in springtime. It was a regular meeting place. They traded for grease, and the Tyonek people wanted fur, so they went there [to trade] too. (Fall 1987:34–35)

Trade in winter between Dena'ina villages was important for survival. Shem and Billy Pete explained,

> The Tyonek people put up lots of food. They never went hungry because there was lots of seals and belugas. They put up so much oil they were really overloaded each summer. They put up lots of grease for everybody in the villages of the Susitna River and Knik Arm. They all came down to Tyonek in winter to trade for oil. They kept coming and coming, getting this oil. They brought all kinds of fur blankets: parka squirrel, whistler, lynx, marten. And *k'enq'ena* [dentalium shells] and lots of caribou and black bear meat and beaver meat so they could buy all this oil. And the Tyonek people were rich from oil, and from dry fish

[salmon] too. They bought lots of dry fish too. And in winter it used to be like that. They had a regular road down to Tyonek, a regular road for grease, seal meat, and fish. And this story is from long before the Russians come to this country, from a long time ago. (in Fall 1987:35)

These oral traditions highlight the direct access people of Tyonek had to saltwater resources, in contrast to the Dena'ina who lived up the Susitna River, who had better access to land resources. Shem Pete explained that the Upper Inlet people called Tyonek Ełnen Bunkda, "the Mother of the Earth," because of its rich sea products, while the Susitna River was Ełnen Tukda, "the Father of the Earth," for its land resources of meat and fur (Fall 1987:33).

Expressive Culture: Oral Traditions, Songs, and Dances

Traditional Dena'ina stories are called *sukdu*. Many were told for entertainment, but others were "told for a reason," as Max Chickalusion Sr. said, as forms of instruction and sources of knowledge (Fall 1990a; see also Balluta 2008:46–50). The Dena'ina valued narrative skills very highly.

The Dena'ina tell many stories of the trickster Raven (Upper Inlet *delgga*, Outer Inlet *ggugguyni*, Inland *chulyin*). These include such familiar tales as how Raven brought daylight and created land and many others in which he is a buffoon—stories told for humor.

The Upper Inlet Dena'ina told an eight-day cycle of stories about the culture hero Yubugh Tayqan ("One Who Paddles around the World"). Among other things, this hero invented snowshoes and transformed various animals from human-eaters to their current forms, establishing rules for human-animal interactions. As a teenager, Shem Pete heard K'eł Nuts'ehen—"Red Shirt" of Tanłtunt—tell the Yubugh Tayqan cycle over the course of eight evenings, but each night Shem fell asleep, so that years later he could remember only some of the

FIG 1.42

1.42 Antone Evan plays a plank drum, Tyonek Potlatch, January 13, 1982. Left to right, Peter Kalifornsky, Nickolai (Harry) Balluta, Albert Wassillie, Antone Evan, Pete Trefon, Sava Stephan. Prior to contact, the only percussion instrument that the Dena'ina used was the plank drum, *delgheli*. Although not as common as it once was, the plank drum is still used at Dena'ina gatherings. Photograph courtesy of Priscilla Russell.

stories. Versions of this hero cycle are told by other northwestern Athabascans, such as the Southern Tutchone (McClellan 1975:73), the Upper Tanana (McKennan 1959), and the Koyukon (Attla 1990).

Songs figured prominently in both public and private spheres. For example, mourning songs were composed for potlatches, while dancing songs were also performed, generally to the accompaniment of a plank drum. (Coray 2007 includes a collection of Dena'ina songs recorded in Nondalton in 1954, along with commentary.) Individuals also knew private songs that brought hunting luck (e.g., Balluta 2008:38–44).

Worldview

Worldview refers to "a people's basic assumptions about what kind of world they live in, what forces or entities control it, and what the place of humans is" (Keesing 1976:520). It is the aspect of a people's religious system that addresses questions of origins, validates moral and political principles, and provides meanings or a "grounding" for individuals within the natural and social environment. Belief systems are expressed through actions, such as ritual or magic, that attempt to shape, direct, or manipulate the course of events, such as hunting

success, a favorable change in the weather, or recovery of the sick.

James VanStone identified two major features of Northern Athabascan religion: a reciprocal relationship between humans and animals and individualism in the belief system. He wrote,

> Each individual tended to select from the belief systems of the culture those concepts that seemed particularly suitable to his own needs. Since so many beliefs were associated with game animals and with hunting, it is to be expected that the beliefs and practices of a skilled hunter were likely to be accepted by a good many others. (1974:59–60)

VanStone cautioned, therefore, against oversystematizing a description of the belief system of any Athabascan group based on the beliefs held by particular individuals.

For the Dena'ina, as for all Northern Athabascans, success in subsistence activities was not solely a result of practical skills and knowledge. Individuals also needed the aid, or at least the goodwill, of powerful "persons"—manifestations of the spiritual power that animates the environment, including the creatures that people depend on for survival (Osgood 1937:169; Fall 1987:56–61). Further, animals and other beings are sentient or aware of human actions toward them and demand respect. As Richard Nelson put it for the Koyukon Athabascans, it was "a watchful world" (1983). It was also a dangerous world, governed by *enge*, an elaborate system of rules and taboos. To ignore these rules was to court misfortune or disaster; to observe and respect them brought success or "luck" (de Laguna 1969–1970; McClellan 1975).

In "How Tyonek People Used to Eat," Nickafor Alexan explains the necessity of human respect for animal life and spirit:

> Salmon, they have story behind it and old people have to take care according to that. Animals they have story behind it, and they have to take care according to that. For example, fish story would go like this. Fish have people of their own, but we can't see them. It's just like we have spirit or soul we cannot see but we know we have some. (1965a:38)

The rules governing the respectful handling of animals were established by the animals themselves. Again, Nickafor Alexan:

> Once upon a time all the animal was talking like us and have masters like fish. One time they had a meeting and each animals decide how human should take care of them if they got killed for food. For example, beaver say if anybody got him for food, they should take care of his bone, put in fire so dogs won't chew it fresh. And if they have to club them to kill, they shouldn't use other kind of stick or wood except what beaver eat. (1965a:38)

The story of Beł Dink'udlaghen as told by Shem Pete explains the origin of the rituals involved in the Dena'ina First Salmon Ceremony, which are designed to show respect to the first king salmon harvested each spring and ensure their return in future years.

> Synopsis: In the beginning the people had no salmon. A boy turns into a fish. Then the salmon come to them for the first time. So the boy swims back out to the ocean with the salmon. After staying with the salmon, he flies back with the geese to the Kroto Creek area. He turns into a salmon and goes back out a second time. When he returns he leads the salmon to Kroto Creek and the Dena'ina develop their salmon fishery there at their specific places. Then the salmon boy turns into a human and gives them instructions on how to place him up by the bank to ritualize the catch of a small king

salmon. While on the bank the salmon boy begins to transform himself into different types of animals. Also he shows them how to do a winter solstice ceremony in the steambath, which then brings the arrival of the migrating fowl, the land animals, and the sea animals. (Kari and Fall 2003:184)

Dena'ina individuals could channel spiritual power through the private use of songs and spells. The goodwill of spiritual power might also be obtained through amulets. In addition, offerings were made to objects, such as K'uzhaghałen Qanłnik'a, the "Giant's Rock" at the summit of Iliamna Portage (Johnson 2004:49–54).

Within the Dena'ina community there were specialists who publicly displayed their relationships with spiritual power, usually for a practical end. Among these specialists were *el'egen* (shamans), men or women who could cure or cause illnesses and locate game. Shamanistic power was obtained through dreaming. Shamans used songs, canes (*janja tets'*), masks (*k'enan*), rattles (*delchezhi*), and medicine dolls (*k'enin'a* or *hnina*) to assist them (Osgood 1937:177–182).

The Dena'ina world included an array of non-empirical creatures. Particularly dangerous were *nant'ina*, human-like creatures who kidnapped children. Several lakes in Dena'ina country were inhabited by large fishlike monsters, such as the creature living in Ht'u Bena (Chelatna Lake) that could swallow a swimming caribou whole (Kari and Fall 2003:161). A class of beings called *k'enu qubideł'ishi* (good luck signs, sources of good luck) could bring luck and wealth to individuals if the appropriate ritual behaviors were observed (Fall 1987:58–61; Kari 2007:309–310; Osgood 1937:170–173).

Ceremonies

Although held for a number of reasons, the most elaborate Dena'ina potlatches (*qetitl'*) were memorial feasts for the dead, during which the matrilineal relatives of the deceased honored those of the opposite moiety who had assisted with the funeral

FIG 1.43

1.43 Shem Pete dancing with rattles. In 1985, during Shem Pete Day at the Anchorage Museum, Shem Pete performed and demonstrated how the puffin beak rattles and feather headdress (fig. B.3) were used during performances by the Dena'ina. Photograph reprinted with permission of the Cook Inlet Region, Inc.

with gifts and feasting. Memorial potlatches attracted guests from many other villages. They were a matter of honor and prestige for the host family. Individuals acquired prestige by hosting large potlatches, and potlatches figured prominently in a man's achievement of *qeshqa* status.

The Dena'ina First Salmon Ceremony, primarily observed in the Upper Inlet area, was a particularly important event held to honor the first king salmon harvested each spring. The fish were spread on fresh grass. People took a sweat bath, dressed in their best clothes, painted their faces, and decorated their hair. They then cleaned and cooked the salmon without breaking the backbones and returned the entrails to the water (Osgood 1937:148–149).

Warfare

Early sources (e.g., Wrangell 1980 [1839]:56) remarked on Dena'ina skill in warfare; the Dena'ina themselves stress their former warlike character

1.44 *Chijeł,* feather headdress, Willow, Alaska, late 19th century. Diam. 31 cm. Eagle and goose (?) feathers, red wool, sinew. Anchorage Museum, 1978.035.005. Photograph by Chris Arend.

This feather headdress, part of the Shem Pete Collection at the Anchorage Museum, was said to have been used only by Dena'ina shamans. It is believed to be made from golden eagle and goose feathers and is attached to red wool cloth. The earliest known owner was Big Chilligan. In 1931, it was potlatched to Simeon Chickalusion, and after his death in 1957 to Shem Pete. A gifted storyteller and the last lead singer of the Upper Inlet Dena'ina, Shem Pete (c. 1900–1989) was known for his lifelong dedication to the preservation of Dena'ina history.

1.45 *Chik'ish,* dance cap for potlatch, Seldovia, 1931–1932. L 26 cm. Ground squirrel, red wool, black fabric, long hairs (caribou?). Photograph © Peabody Museum of Natural History, Yale University, ANT.015839. Photograph by Chris Arend.

This is the only known example among the Dena'ina of this style of hat, which is similar to hats made by the Alutiit and Yupiit.

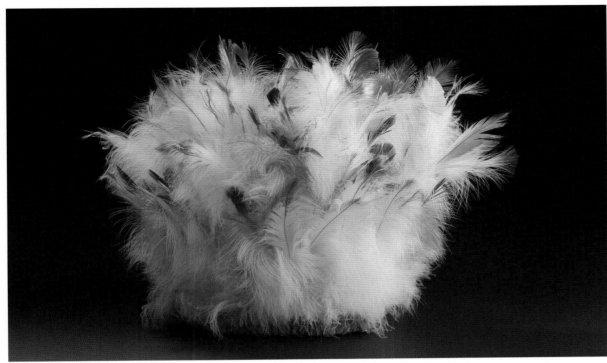

FIG 1.44

FIG 1.45

FIG 1.46

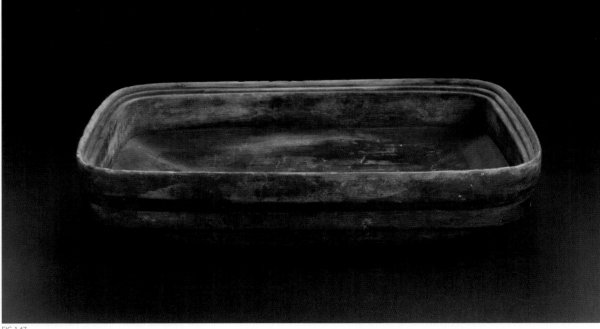

FIG 1.47

1.46 *Kendu shquł,* **feast ladle, Tyonek, 1883.** L 38.5 cm. Wood, ochre. Ethnological Museum Berlin, IVA 6143. Photograph courtesy of Staatliche Museen zu Berlin, Ethnologisches Museum. Photograph by Chris Arend.

1.47 *Ts'ideq daztuni,* **large food dish with bentwood rim, Iliamna, 1931–1932.** L 52 cm. White spruce, ochre, pegs (root/wood?). Photograph © Peabody Museum of Natural History, Yale University, ANT.015849. Photograph by Chris Arend.

Large food dishes like this would have been used during potlatches to serve a large number of people. This is one of four wood food dishes collected by Cornelius Osgood at Iliamna.

1.48 *Naneq*, stone lamps, Kenai. L 13–14.8 cm. Alaska State Museum, II-A-2608-2609. Photograph by Chris Arend.

Osgood (1937:108) reported that the Dena'ina of Kachemak Bay, Kenai, and Iliamna shaped lamps of stone by abrasion, taking up to half a year to produce a single lamp. Lamps were not manufactured in the upper inlet area. It is likely that the Dena'ina also obtained lamps through trade and warfare with the Alutiit (Ułchena) of lower Cook Inlet. Also, the Dena'ina term for this object is borrowed from Alutiiq/Yupik.

1.49 *K'duheł*, war club and arrowhead, Kenai, 1853. L 60 cm. Caribou antler, stone, caribou hide. The National Museum of Denmark, Ethnographic Collection, Hb106a and H840. Photograph © The National Museum of Denmark. Photograph by Arnold Mikkelsen.

Dena'ina war parties were led by particularly skillful and powerful warriors known as *ezhge'en* (*edzege'en* in the Upper Inlet dialect), which Billy Pete translated as "heroes" or "champions." They wielded clubs of caribou antler called *k'duheł*, which were soaked in oil to add strength and weight.

FIG 1.48

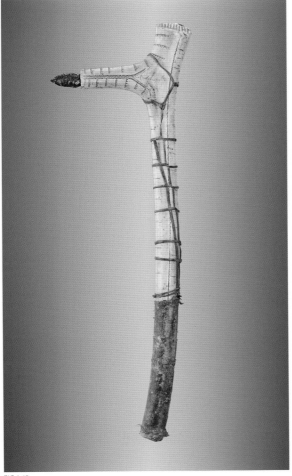

FIG 1.49

(Osgood 1933:704, 1937:110). Evidence of some intra-Dena'ina conflicts, primarily motivated by revenge, exist (e.g., Alexan 1965a; Wrangell 1980 [1839]), but most conflicts occurred with the Alutiit of Prince William Sound, the lower Cook Inlet, and Kodiak, and with the Central Yupiit of Iliamna Lake and Bristol Bay.

These conflicts generally consisted of raids back and forth between Alutiiq and Dena'ina villages, a goal being the capture of slaves and other valuables (Fall 1987:62; Osgood 1937:109–113). In the upper inlet area, the final battle ended with the defeat of the Alutiit by the Knik Arm Dena'ina at Point Campbell in present-day Anchorage. The Dena'ina named this site Ułchena Bada Huch'ilyut ("Where We Pulled Up the Alutiitqs' Umiak"). Soon after this incident, according to Dena'ina oral traditions, the Russians arrived in Cook Inlet. This places the events of the story in the mid-eighteenth century (Kari and Fall 2003:338).

An important cycle of stories about the Dena'ina hero Ts'enhdghulyał describes a series of battles for control of portions of the Iliamna Lake area between the Dena'ina and the Eskimo people of the Alaska Peninsula (Tenenbaum 1984; Kari forthcoming).

Especially skillful Dena'ina warriors were called *edzege'en* in the Upper Inlet dialect, translated by Billy Pete as "heroes" or "champions." Shem Pete explained that such men "were trained for the wars" and had huge hands and great strength with

which they wielded clubs of caribou antler soaked in grease called *k'duheł*. Other weapons of war included spears (*q'aditin*) and bows and arrows. In the Inland area, special arrows for war called *qut'an niłtu k'ghadiliy* ("arrows for people") were made wide so they could not be easily dislodged (Kari 2007:204).

Dena'ina warriors wore armor made of birch rods lashed together vertically with babiche or mountain spruce. A second type of armor was made of brown bear skin coated with a mixture of spruce gum and sand (Osgood 1937:111).

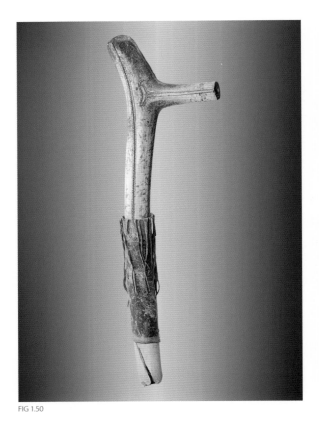

FIG 1.50

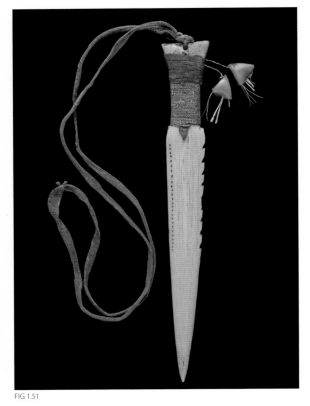

FIG 1.51

1.50 *K'duheł,* **war club, Kenai, 1853.** Caribou antler, caribou hide. National Museum of Denmark, Ethnographic Collection Hb106B. Photograph © The National Museum of Denmark. Photograph by Arnold Mikkelsen.

1.51 *Tl'usts'eghi,* **bone dagger, 1778.** L 33 cm. Bone, quill. British Museum, AM1972.q.46. Photograph © The Trustees of the British Museum. Knives were often made of caribou (?) bone before iron was widely available.

History: The Russian Period

Table 1.5 provides a chronology of some significant events in Dena'ina history. The Russians learned of the Dena'ina from the Koniag of Kodiak Island. The first recorded interaction between the Dena'ina and European explorers occurred during Captain James Cook's voyage up Tikahtnu (Cook Inlet) in 1778 in his unsuccessful search for a northwest passage. Near North Foreland, the English and Dena'ina engaged in trade. Cook's crew disembarked at Tuyqun ("Calm Water"), which they renamed Point Possession, and buried a box of coins to claim the area for Great Britain. Fedosia Sacaloff's "*Unhsah Tahna'ina*: The First Underwater People" preserves Dena'ina oral traditions about these interactions with Cook's crew (in Kari and Fall 2003:356).

Russian trading companies established their first posts on the Kenai Peninsula at Kasilof (Fort St. George) in 1787 and at Kenai (Fort St. Nicholas) in 1791. The Dena'ina became involved in the fur trade. Most trade was funneled through Dena'ina middlemen, usually *qeshqa*, enabling most Dena'ina communities to remain largely independent of direct Russian control until at least the 1840s (Fall 1987:48–52; Ellanna and Balluta 1992:61).

In the 1790s, the Lebedev-Lastochkin Company established posts at Tyonek and Old Iliamna. The English Navy captain George Vancouver observed the post at Tyonek in 1794, shown as "Russian Factory" on his map. In the late 1790s, the Tubughna, under the leadership of Quq'ey, destroyed this post and killed the Russians (Alexan 1981; Fall 1987:17). The Lake Iliamna post too was destroyed by Dena'ina in the late 1790s. Also in 1797, the Dena'ina attacked the Lebedev-Lastochkin post at Kenai (Boraas and Leggett 2010). Mistreatment of the Dena'ina by the Russians was one cause of these

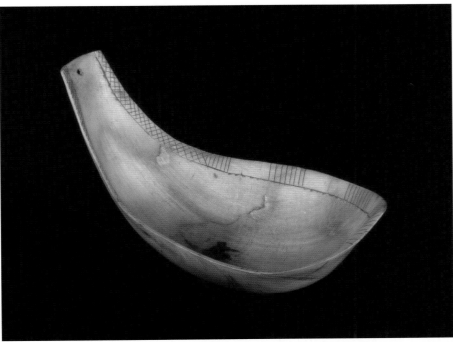

FIG 1.52

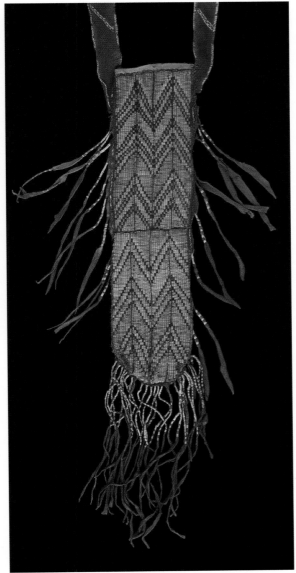

FIG 1.53

1.52 *Dalch'ehi*, horn bowl, Cook Inlet, 1778. L 24.3 cm, W 11.4 cm. Dall sheep horn. British Museum, NWC33. Photograph © The Trustees of the British Museum.
 This bowl was collected during the 1778 voyage of Captain James Cook. Dena'ina artifacts from the Cook expedition are the oldest known artifacts collected from the Dena'ina. To make a sheep horn bowl, the Dena'ina placed the horns in hot water for several minutes to soften them before carving them into spoons and bowls.

1.53 *K'izhagi yes*, knife sheath, c. 1790. L 31.7 cm. Caribou hide, porcupine quills, sinew, ochre. British Museum, VAN99. Photograph © The Trustees of the British Museum.
 This knife sheath, collected by Captain George Vancouver in 1794, is among the oldest known examples of Dena'ina quillwork.

attacks. The disruption of traditional trading relationships between Dena'ina villages and regional bands was likely another cause. Oral accounts speak of retaliations later by the Russians that resulted in Dena'ina deaths around Kenai.

Because of Dena'ina resistance, Russian penetration into most Dena'ina territory, including the Upper Inlet and Inland areas and most of the Kenai Peninsula, was minimal for most of the early nineteenth century (Kari and Fall 2003:17–21; Ellanna and Balluta 1992:61). Shem Pete reported,

They [the Russians] had their headquarters in Kenai. They killed lots of people, and they took their women. They didn't move into the [Dena'ina] villages. They [were] scared the Dena'ina would kill them. They didn't trap much [on the Kenai Peninsula]. [The Dena'ina] never let the Russians up there [up the Susitna River]. They [the Russians] were too

cheap [in trading]. They [the Dena'ina] don't allow them. They kill them. Not even ten or twenty in a group go there because too many natives. (Kari and Fall 2003:17)

Of particular importance was the devastating decline, of 50 percent or more, in the Dena'ina population as a result of a smallpox epidemic in the

FIG 1.54

FIG 1.55

FIG 1.56

1.54 *Degh'kisen Sez*, beaded woman's belt (detail of figure 9.0) Ethnological Museum Berlin, IVA 6110. Photograph courtesy of Staatliche Museen zu Berlin, Ethnologisches Museum. Photograph by Chris Arend.

This coin, which depicts King Louis XVI of France, is one of three decorating the belt. This coin is similar to a type of gaming token that was used in Europe during the late eighteenth century.

1.55 Church interior, Tyonek, 1967. Steve McCutcheon, Steve McCutcheon Collection, Anchorage Museum, B1990.13.5.AKNative.40.70.43B.

1.56 St. Nicholas Church, Eklutna, c. 1920. Starting in the 1840s, the Dena'ina began to adopt orthodoxy into their traditional belief system. Orthodoxy continues to play a role in the lives of many Dena'ina, and Russian Orthodox churches can be found today in five Dena'ina communities. Alaska Railroad Collection, Alaska State Library, p. 108-071.

replacing the traditional belief system, however, a syncretism of Christian and Athabascan traditions developed.

History: The American Period

With the sale of Alaska by the Russian government to the United States in 1867, the holdings of the Russian-America Company passed to the Alaska Commercial Company. Permanent trading posts were established in the Knik Arm area and on the Susitna River, and continued to be maintained on the Kenai Peninsula, at Tyonek, and on Iliamna Lake. In the American period, the trend toward fewer Dena'ina villages, concentrated around trading posts and churches, continued, although the seasonal round of fishing, hunting, and gathering activities and the dependence on subsistence resources persisted as well.

Rivalries between fur-trading companies brought relatively high fur prices and prosperity for Dena'ina communities into the 1890s. Fur prices dropped in 1897, however, and never recovered, creating hardships for the Dena'ina, who faced lower incomes and reduced access to trade goods (Townsend 1981:636).

Commercial salmon fishing in Cook Inlet began in the early 1880s, with the first salmon cannery built at Kasilof in 1882. Cannery ships began trading for fur with the Dena'ina, purchased salmon, and began fishing at traditional Dena'ina locations.

late 1830s (Townsend 1981:636). Abandonment of villages and the aggregation of people at fewer sites were among the permanent results of this loss of population (Fall 1987:29–31).

Another consequence of population loss appears to have been more openness on the part of the Dena'ina to conversion to Christianity by Russian Orthodox priests based in Kenai (Fall 1987:18–19). The first Russian Orthodox mission was founded there in 1845 by Hegumen Nikolai (Znamenski 2003:15). Over the next several decades, Orthodox priests traveled to Dena'ina villages, and gradually most Dena'ina became adherents of Orthodox Christianity. Rather than Christianity completely

FIG 1.57

By the late 1890s, overfishing was harming Cook Inlet Dena'ina subsistence fishing. The Russian Orthodox priest Bortnovsky observed:

> The quantity of fish grows smaller each year. And no wonder each cannery annually ships out 30,000 to 40,000 cases of fish. During the summer all the fishing groups are jammed with American fishermen and of course the poor Indian is forced to keep away in order to avoid unpleasant meetings with the representatives of the American Civilization. (Documents Relative to the History of Alaska, n.d. Vol. 2: 82)

The first commercial salmon cannery in Bristol Bay opened in 1883. As in Cook Inlet, unregulated commercial fishing, including operation of traps that blocked entire rivers, resulted in the depletion of salmon runs, including that of the Kvichak River, a major food source for the Iliamna and Inland Dena'ina. Not until 1907 did federal legislation

FIG 1.58

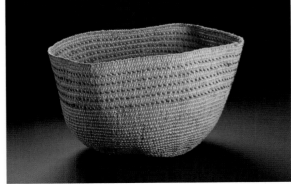

FIG 1.59

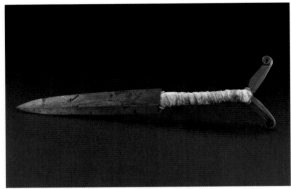

FIG 1.60

FIG 1.61

FIG 1.62

1.60 *Tl'usts'eghi*, **copper knife.** L 26 cm. Copper, hide. Photograph © Peabody Museum of Natural History, Yale University, ANT.015908. Photograph by Chris Arend.

Before the arrival of Europeans and Americans, the Dena'ina obtained native copper from the Ahtna Athabascans. Items such as knives hammered from this material were highly prized and generally only owned by rich men (*qeshqa*).

1.61 *Dabatnulgi*, **snuff container, Dena'ina, 1980–1990.** Birch bark and metal hook. James Kari Collection. Photograph by Chris Arend.

Peter Kalifornsky made this snuff container out of birch bark. Tobacco has been a popular trade item among the Dena'ina since the early nineteenth century. This container is nearly identical to one made 100 years earlier that is in the Ethnological Museum in Berlin (see figure 16.12).

1.62 *Viqizdluyi sez*, **beaded hunting belt with powder horn, measure, and ammunition bag, Cook Inlet, c. 1880.** Glass beads, wool, wood, caribou (?) hide, thread. (E90454-0) Department of Anthropology, Smithsonian Institution.

This highly decorated hunting belt with all the accessories one needs for muzzle loading was likely worn more as a sign of wealth through trade rather than used for hunting.

begin to address this problem (Ellanna and Balluta 1992:238).

American prospectors searching for gold ventured up the Susitna and Yentna Rivers in the 1870s and 1880s, but the first consequential discoveries occurred along Turnagain Arm at Resurrection Creek in 1888 and at Bear and Palmer Creeks in 1894, as well as on Willow Creek in the Susitna River drainage in 1897. An influx of several thousand people, mostly men of Euro-American origin, flooded the area. Tyonek became a major disembarking point for miners and prospectors, as well as for the military and scientific expeditions that followed in the late 1890s and early 1900s. In support of mining, Knik developed as a commercial center, and the first phase of homesteading in upper Cook Inlet occurred.

With the development of commercial fishing and processing, mining, and homesteading, a permanent non-Native population became established on the Kenai Peninsula and portions of the upper Cook Inlet area by the early twentieth century. Events of particular note were the founding of Anchorage as a base for the construction of the Alaska Railroad, the construction of the railroad itself, and a devastating influenza epidemic in 1918, which killed hundreds of Dena'ina and severely disrupted the traditional culture and economy.

Overall, the Dena'ina population declined in the late nineteenth century and early twentieth century. Disease, loss of access to important traditional foods such as salmon, and intermarriage with Euro-Americans all contributed to reducing the size of Dena'ina communities.

Shem Pete's *Susitnu Htsukdu'a* relates an oral tradition of predictions by his father's brother, a powerful shaman, of the depopulation of Susitna Station as a result of epidemic disease and the arrival of non-Natives in large numbers with their trains and planes: "So that Susitna Station gonna be nothing left like it is today. You'll be all gone, not even one." However, the shaman also predicted that eventually, all non-Natives would leave Alaska, and he admonished the Dena'ina to "put up lots of fish. And put the matches away. Put the ammunition away. Put up a file and an axe. Pretty soon no more white man in this Alaska" (in Kari and Fall 2003:97).

In the early twentieth century, Cook Inlet and Inland Dena'ina found employment in salmon

1.63 Salmon cannery at Kenai, built in 1888 by the Northern Packing Company. Starting in the late nineteenth century, canneries appeared in the Dena'ina homeland. These canneries were a source of income for the Dena'ina; however, the nonsustainable practices of the day had a devastating impact on Dena'ina subsistence fishing. H. M. Wetherbee Collection, Archives, University of Alaska Fairbanks, Album no. 1, 1959-866-35.

1.64 Mouth of Ship Creek in Anchorage, 1915. The mouth of Ship Creek, located in what is today downtown Anchorage, was a traditional spring fishing site for Knik Arm Dena'ina. After 1914, this location could no longer be used by the Dena'ina as it was selected by the federal government to be the unloading area for the Alaska Railroad. Marie Silverman Collection, Anchorage Museum, B1963.16.15.

1.65 Knik, Front Street. The discovery of gold in upper Cook Inlet brought an influx of people into the Dena'ina homeland hoping to strike it rich. Shown here is Front Street in Knik, with several Dena'ina and their dogs in the background. Anchorage Museum, B1967.001.125.

FIG 1.63

FIG 1.64

FIG 1.65

canneries. Later, the Dena'ina became more directly involved in commercial salmon fishing, adding this activity to their spring and summer subsistence fishing at such traditional sites along Cook Inlet as Fire Island, Point Woronzof, Point Possession, and Kenai. In the 1930s, Iliamna and Inland Dena'ina began participating in the commercial salmon fishery in Bristol Bay (Ellanna and Balluta 1992:239; Johnson 2004:19).

An additional effect of the demographic, sociocultural, and economic changes of the early and mid-twentieth century in the Cook Inlet area was a decline in the use of the Dena'ina language. Policies of the U.S. Bureau of Education discouraged the use of Alaska Native languages, and children were physically punished for speaking their languages. In

1.66 Dena'ina people with beaver pelts at Seversen's Roadhouse, Iliamna, 1930. Until World War II, many Dena'ina trapped to supplement part of their income. As the population increased, territorial game restrictions made it more and more difficult to make a living from trapping. Alaska Aviation Heritage Museum Collection.

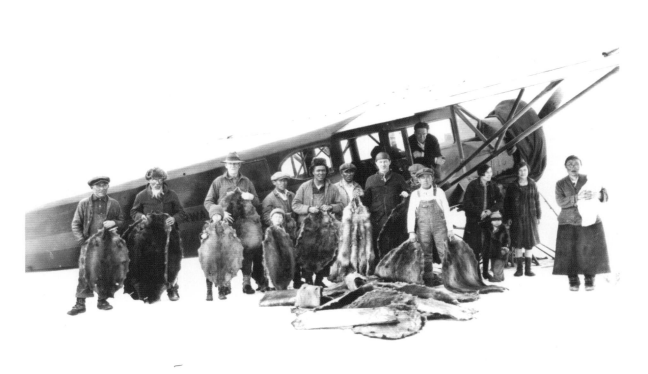

Beaver Pelts — Severson's — Lake Illiamna.

FIG 1.66

the early 2000s, only about fifty people were fluent speakers of Dena'ina (Kari and Fall 2003:10). Elders recalled the fear and shame they associated with speaking Dena'ina as children as a result of their experiences in school. These elders explained that linked to this suppression of the language by the school system was a dismissal of the Dena'ina way of life and identity. An important consequence of this loss of the Dena'ina language has been a disruption in the passing on of Dena'ina oral traditions as expressed in *sukdu*, the traditional stories. Evidently, the most knowledgeable elders of past generations were unwilling, and likely also unable, to teach these stories to their children and grandchildren in English. However, such traditions will live on as oral

and written English texts as the Dena'ina originals are preserved, especially if they are incorporated into school curricula and the stories are considered relevant by present and future generations.

An important development in the twentieth century was the enforcement of game laws that restricted traditional Dena'ina subsistence hunting, most significantly in the more populous areas along the road system on the Kenai Peninsula, Anchorage, and the Matanuska-Susitna valleys. Alberta Stephan of Niteh and Eklutna recalled the difficulties her grandparents' family faced:

> The year 1913 also saw new territorial laws, hunting and fishing regulations. The natives could not hunt

1.67 Tyonek Oil and Gas.
In 1964, the Native Village of Tyonek sued the federal government for the money from oil lease sales on the reservation. Eventually they won in court and used their money to help rebuild the village and support early Native land claims efforts. Although oil and gas were never found on the reserve itself, significant amounts were found below Cook Inlet in front of the village. Ward Wells, Ward Wells Collection, Anchorage Museum, B1983.091.S4560.10.

FIG 1.67

for traditional foods anymore. They were not allowed to fill their caches for winter. The native people were not allowed to hunt or fish for their food even though that was the only way they always survived. No one told them how they were supposed to live.... The Esi family at Matanuska were watched closely by the Game Warden. They came unexpectedly always trying to catch them with fresh moose meat. (2001:23–24)

World War II brought increased development and population growth to Southcentral Alaska. The Seward and Sterling Highways connected the Kenai Peninsula to Anchorage, and the Glenn Highway linked Anchorage to the Alaska Highway, Canada, and the rest of the United States. Further economic and population growth followed the discovery of oil and gas reserves under Cook Inlet and the Kenai Peninsula in the 1950s. The consequences of such growth and natural resource exploitation included the destruction of wildlife habitat and increasing competition for depleted populations of fish and wildlife.

In 1964, Tyonek won the right to directly receive $12.9 million from the sale of oil and gas leases on lands within the Tyonek Reserve, which had been established by Congress in 1915. The village invested the money in new homes, community infrastructure, and Anchorage real estate. However, these leases did not result in the development of oil or gas on Tyonek lands (Stanek et al. 2006:86).

Congress passed the Alaska Native Claims Settlement Act (ANCSA) in 1971. The act split Dena'ina communities into three regional corporations: Cook Inlet Region Incorporated (including the village corporations of Knik, Eklutna, Tyonek, Seldovia, Kenai, and Salamatof), Bristol Bay Native Corporation (Nondalton and Pedro Bay), and Calista Corporation (Lime Village). It also extinguished aboriginal hunting and fishing rights but left unresolved issues regarding subsistence hunting and fishing opportunities. The Alaska legislature passed a subsistence statute in 1978 that defined subsistence as "customary and traditional uses" and established subsistence as the priority use of fish and wildlife. An early test of the state's law occurred in 1979 and 1980, when Tyonek approached the Alaska Board of Fisheries to reopen subsistence fishing for king salmon along the village's beaches, which had been closed since 1964 because of overfishing by the commercial fishery. The board denied Tyonek's proposal on the grounds that the subsistence fishery should target the more abundant sockeye salmon, preferring to allocate the highly prized king salmon to the sport fishery. Tyonek sued in state court and won, arguing that the early king run was historically critical to Tyonek's economy and way of life and that state law required the board to provide subsistence fishing opportunities on fish stocks that were customarily and traditionally used. This case set an important precedent for the state's management of subsistence fisheries (Fall 1989; Stanek, Fall, and Holen 2006:93–95).

In 1980, Congress passed the Alaska National Interest Lands Conservation Act (ANILCA). Title VIII of ANILCA established a priority for

subsistence hunting and fishing on federal lands for "rural Alaska residents." This provision benefited Dena'ina communities off the road system and near federal lands, such as Pedro Bay, Nondalton, and Lime Village. But the Federal Subsistence Board determined that communities along the road system, such as Knik, Eklutna, and Kenai (home to most Kenaitze), were "nonrural" and therefore ineligible for the protections of subsistence fishing and hunting under ANILCA. State management also classified most of the Cook Inlet watershed (except the beaches around Tyonek) as "nonsubsistence areas" where subsistence fishing was not permitted. Instead, beginning in 1989, the Dena'ina communities of Knik, Eklutna, and Kenai have had to obtain "educational fishery permits" from the Alaska Department of Fish and Game, which provide their members with a limited access to Cook Inlet salmon for customary and traditional uses, including food, sharing, and educating young people.

ANILCA also established Lake Clark National Park and Preserve, all of which is in Dena'ina territory. The park has supported Dena'ina subsistence activities and has had an active program to document and preserve Dena'ina history and culture. In 1983, Andrew Balluta became the first Dena'ina ranger for the park. In 1992, he collaborated with the anthropologist Linda Ellanna to produce a major ethnography of the Nondalton Dena'ina, and he continued, with National Park Service support, to record and preserve Dena'ina traditions (e.g., Balluta 2008). Lake Clark National Park has produced a number of other publications that document Dena'ina history and culture (e.g., Ellanna 1986; Stickman et al. 2003; Stanek, Fall, and Holen 2006; Gaul 2007; Evanoff 2010).

In 1972, the Alaska legislature created the Alaska Native Language Center at the University of Alaska Fairbanks. Soon, ANLC linguists, including Michael Krauss and James Kari, had developed a practical orthography for the Dena'ina language. Language workshops followed, and several Dena'ina, most notably Albert Wassillie and Peter Kalifornsky, became literate in their Native language. Kalifornsky's collection of his Dena'ina writings, *A Dena'ina Legacy: K'tl'egh'i Sukdu* (1991), won an American Book Award in 1992.

In 1993, Bureau of Indian Affairs director Ada Deer issued, for the first time, a list of federally recognized tribes in Alaska. On the list, were seven Dena'ina tribes, including Eklutna, Knik, Kenaitze, Tyonek, Pedro Bay, Nondalton, and Lime Village. Three other tribes in Dena'ina territory but with primarily non-Dena'ina membership are Chickaloon (primarily Ahtna), Ninilchik (primarily Alutiiq), and Seldovia (primarily Alutiiq).

History: The Twenty-First Century

In the early twenty-first century, the Dena'ina were a minority within a minority within their own homeland: in 2010, 61 percent of Alaska's population lived on traditional Dena'ina lands, including about 52,000 Alaska Native people from all over the state. At around that time, according to the Alaska Native Language Center, people of Dena'ina heritage numbered perhaps one thousand, constituting just 0.2 percent of the population of Southcentral Alaska and about 2 percent of the area's Native population.[1]

Efforts to support learners of the Dena'ina language were strong in the early 2000s. In 2003, the Kenaitze Tribe hosted the first Dena'ina Festival, followed by a three-week Dena'ina language course at Kenai Peninsula College (Gaul and Holton 2005). The Dena'ina Language Institute occurred annually from that beginning through 2011. In 2005, the Dena'ina language website, Qenaga.org, was established through the Dena'ina Archiving, Training, and Access project of Eastern Michigan University and the Alaska Native Language Center, with funding from the National Science Foundation. The website offers a guide to learning the language and a digital archive of more than five hundred documents and recordings relating to the Dena'ina language.

At the outset of the twenty-first century, little public acknowledgment of the Dena'ina heritage of Anchorage, Alaska's largest city, existed. Through the efforts of the Dena'ina community and others, this situation began to change (Fall 2009; Langdon

FIG 1.68

FIG 1.69

1.68 Kenaitze educational fishery net. Throughout most of the 1980s, the Kenaitze Indian Tribe fought in the courts for the right to harvest subsistence salmon. In 1989, a compromise with the State of Alaska was reached. The tribe is now allowed to harvest a limited number of fish and pass on traditions handed down to them by their ancestors. Photograph courtesy Kenaitze Indian Tribe.

1.69 Dena'ina festival, 2004, at the Kenaitze Indian Tribe's fishing site. The Kenaitze Indian Tribe has hosted several gatherings of Dena'ina at their fishing site to bring together people who want to learn about and share Dena'ina culture. Here Agnes Alexie, Michelle Ravenmoon, Andrew Balluta, Pauline Hobson, and Donita Slawson sing in Dena'ina. Photograph courtesy Alaska Department of Fish and Game, Tyonek 116.

and Leggett 2009). In 2006, a citizen's panel recommended that a new convention center in downtown Anchorage be named the Dena'ina Civic and Convention Center, a recommendation that was unanimously adopted by the Anchorage Assembly. The center opened in 2008. Additionally, several interpretive signs about Dena'ina place-names, history, and culture were designed and placed in the city's parks and along its trails, including one at Chansh Kaq' Bena (Westchester Lagoon at the mouth of Chanshtnu, or "Chester Creek") on the popular Tony Knowles Coastal Trail. A sign in downtown Anchorage featuring Captain Cook peering over a nameless group of Dena'ina that the Dena'ina community found offensive was removed in September 2008.

On the Kenai Peninsula, the Kenaitze Tribe conducted several programs to preserve and promote Dena'ina cultural traditions. The tribe has administered a cultural and educational salmon fishery in the Kenai River since 1989. In partnership with the U.S. Forest Service, the tribe hosts the K'beq' interpretive archaeological site at Cooper Landing at the location of a former Dena'ina village. At its headquarters in Kenai, the tribe has developed the Ts'itsatna Tribal Archives Collection, including books, audio and video recordings, and photographs. In partnership with Kenai Peninsula

College, the tribe created the Kahtnuht'ana Qenaga website about the Dena'ina language.

Responding to Change, Conserving Traditions

For centuries, the Dena'ina way of life thrived within a rich but challenging homeland. Material items, sociocultural traditions, stories and songs, and cultural and spiritual values all attest to effective and sustained adaptations to the natural and social environments of Southcentral Alaska. Beginning in the eighteenth century and continuing at an accelerating pace up to the present, Dena'ina communities have also faced the challenges brought by waves of newcomers, including depleted resources, epidemic disease, and socioeconomic and political changes and opportunities. In the twenty-first century, the Dena'ina continue to play an important and ever more visible role within the diverse lifeways of modern Alaska while nourishing links to their history and distinctive culture. It is the goal of *Dena'inaq' Huch'ulyeshi: The Dena'ina Way of Living* to enhance an understanding and appreciation of this history and culture and thereby enrich the lives of all who live in or visit Dena'ina Ełnena, Dena'ina country.

Notes

1. Data from Alaska Native Language Center, www.uaf.edu/anlc/languages/stats (accessed November 2012).

Table 1.5 A Dena'ina Chronology

12,000 BP	Glaciers begin to recede from upper Cook Inlet Basin, creating places for people to live.
10,000–7,500 BP	Earliest Alaska Native habitation of Cook Inlet basin occurs.
3,600 BP–AD 1300	Kachemak traditions are present in the Cook Inlet basin.
500–1000	Migrations of Dena'ina from areas west of Cook Inlet to Cook Inlet basin occur.
1000	Development of cold storage pits enables preservation of large supplies of salmon and supports semisedentary villages and the elaboration of social and political organization.
1741	The Danish navigator Vitus Jonassen Bering and Russian explorer Aleksei Ilich Chirikov, sailing for Russia, explore portions of Alaska but do not enter Cook Inlet.
1763	The Russian fur trader Stephan Glotov, on Kodiak Island, learns of the "Tnaiana" from the Koniag (Alutiit).
1778	Captain James Cook, sailing for Great Britain, explores Cook Inlet, meeting Dena'ina near West Foreland and Point Possession.
1784	Grigorii Ivanovich Shelikov establishes a trading settlement at Three Saints Bay, Kodiak, predecessor to the Russian-America Company and a base for Russian expansion into Dena'ina territory.
1786	British seafarers George Dixon and Nathaniel Portlock, sailing for Great Britain, explore Cook Inlet.
1787	Lebedev-Lastochkin Company founds post at Kasilof (Georgievsky Redoubt, Fort St. George).
1791	Lebedev-Lastochkin Company founds post at Kenai (Nikolaevsky Redoubt, Fort St. Nicholas).
1794	British captain George Vancouver, sailing for Great Britain, visits North Foreland (Tyonek) and describes the Russian post.
1797	Tyonek Dena'ina under Quq'ey destroy the Russian post at North Foreland; the Russian post at Iliamna is also destroyed. Dena'ina attack the Russian fort in the Battle of Kenai.
1799	Russian-American Company is formed.
1837–1840	A smallpox epidemic kills at least half of the Dena'ina population.
1845	Russian Orthodox mission at Kenai is founded.
1867	Russia sells Alaska to the United States.
1860s–1880s	Alaska Commercial Company establishes trading stations along Cook Inlet, including Tyonek and Knik; competitors also arrive.
1882	First commercial salmon cannery is established at Kasilof, Kenai Peninsula.
1883	First commercial salmon cannery is established in Bristol Bay.
1883	Johan Adrian Jacobsen visits Kenai and Tyonek to collect ethnographic items for the Ethnological Museum of Berlin.
1880s–1890s	American gold-seekers and explorers arrive.
1888	Gold is discovered in Resurrection Creek on Turnagain Arm.
1890s–early 1900s	The town of Knik grows substantially.
1894	Bear and Palmer Creeks (Kenai Peninsula) experience gold "stampedes."
1896	A drop in fur prices leads to collapse of the fur trade around Cook Inlet.
1897	Knik Arm Dena'ina move the Russian Orthodox chapel from Knik to Eklutna.
1898	Captain Edward Glenn undertakes a military exploration of upper Cook Inlet. This tour is followed by other military and government-sponsored explorations in the early twentieth century.
1908	A school is established at Susitna Station by the U.S. Bureau of Education.
1914	A survey team arrives at Ship Creek. Anchorage is founded as a home base for the construction of the Alaska Railroad.

1915	"Moquawkie" (Tyonek) Indian Reserve is established.
1918	An influenza epidemic sweeps through Native populations.
1930	Modern Nondalton is founded.
1931–1932	Anthropologist Cornelius Osgood conducts fieldwork in Seldovia, Kenai, Eklutna, Susitna, Tyonek, and Iliamna (now Old Iliamna).
1934	Susitina Station is abandoned; most inhabitants move to Tyonek.
1930s	Kustatan is abandoned; inhabitants move to Tyonek or Kenai.
1937	Osgood's *The Ethnography of the Tanaina* is published.
1939	The last Dena'ina leave Dasq'e at the mouth of the Deshka River, the last Dena'ina village in the Susitna basin.
1939	The Native Village of Tyonek ratifies the Indian Reorganization Act Constitution and by-laws.
1940s	World War II. The Cook Inlet area experiences a significant military presence. War efforts entail construction and enhancement of highways and other infrastructure. The non-Native population growth accelerates.
1950s	Oil and gas development occurs on Kenai Peninsula and in Cook Inlet.
1957	Nikafor Alexan of Tyonek writes his stories while hospitalized.
1959	Alaska achieves statehood.
1961	The Native Village of Eklutna organizes in response to encroachment on traditional lands.
1962	The Kenaitze Indian Tribe organizes.
1964	Tyonek wins a precedential lawsuit regarding oil and gas exploration on reserve lands.
1964	The Cook Inlet Native Association is founded.
1971	The Alaska Native Claims Settlement Act is adopted by Congress.
1972	The Alaska Native Language Center is established by the Alaska Legislature; a Dena'ina practical orthography is developed.
1970s	The first Dena'ina language workshops take place; early work by Dena'ina writers appears.
1980	Tyonek wins a subsistence lawsuit and the right to continue its traditional king salmon fishery.
1980	Lake Clark National Park and Preserve established by Alaska National Interest Lands Conservation Act (ANILCA)
1980s	Educational fisheries are established by the Alaska Department of Fish and Game for the Kenaitze, Knik, and Eklutna Dena'ina Tribes of Cook Inlet.
1987	*Shem Pete's Alaska* is published; a second edition follows in 2003.
1991	Peter Kalifornsky's *A Dena'ina Legacy: K'tl'egh'I Sukdu*, is published, subsequently winning the American Book Award in 1992.
1993	The Bureau of Indian Affairs recognizes Alaska tribes, including seven tribes with primarily Dena'ina membership.
2003	The First Dena'ina Language Institute is held in Kenai; annual language learning workshops follow.
2004	Groundbreaking takes place for for Nat'uh ("Our Special Place"), the Cook Inlet Tribal Council building in Anchorage.
2005	Qenaga.org, the Dena'ina language website, is launched.
2008	The Dena'ina Civic and Convention Center opens in Anchorage.
2013	The *Dena'inaq' Huch'ulyeshi* exhibition opens in Anchorage.

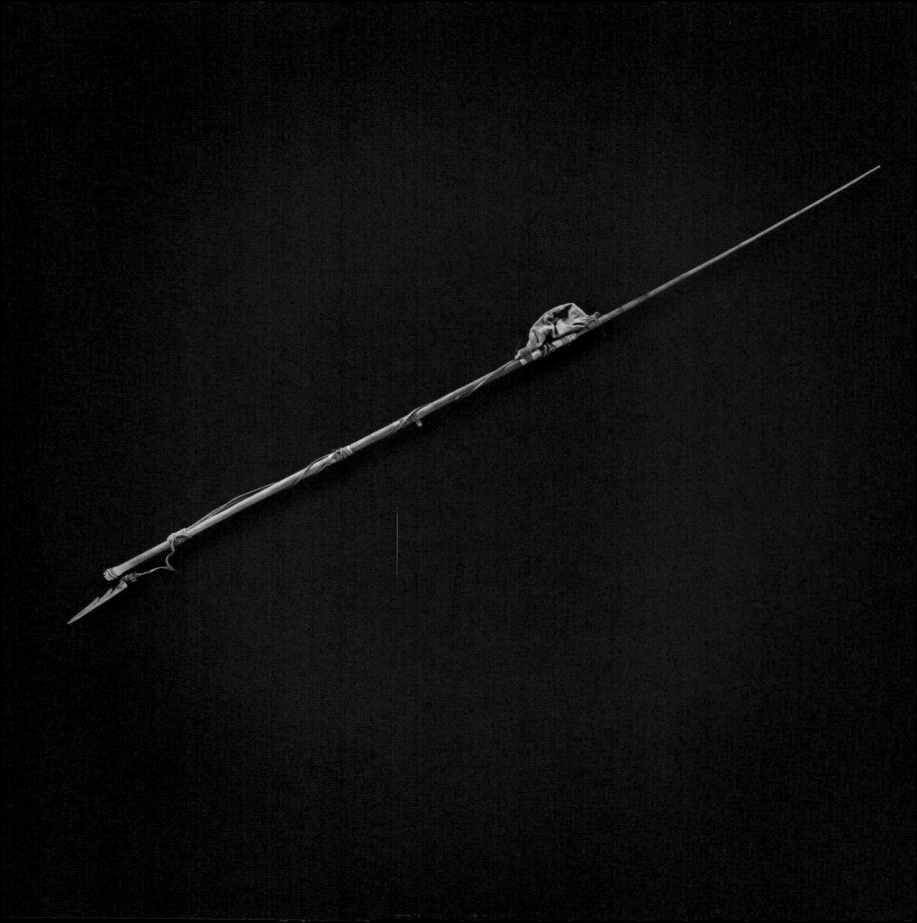

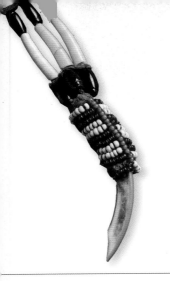

2

Quyushi Uqu Che'el'ani: Beluga Hunting

Shem Pete

The Dena'ina hunters' use of a stationary spearing tree (*yuyqul*) for harpooning beluga whales in Cook Inlet seems to be unique in North America. The earliest recorded source on this hunting method is Ferdinand Petrovich von Wrangell's eyewitness account from the 1830s. The *yuyqul* is also briefly described by H. P. Steensby in his 1917 survey of Eskimo whaling techniques. There are no known photographs or other period images of a *yuyqul*. In commentary from Nickafor Alexan, a Dena'ina from Tyonek, it is noted that Chief Pete of Tyonek was among the last to have hunted from a *yuyqul*.

Shem Pete, a contemporary of Nickafor Alexan, has provided the most complete description of beluga hunting from a *yuyqul*. Shem Pete's richly detailed description is based on the eyewitness accounts he heard from Chief Pete and Bidyaka'a when Shem was a young man. This masterful description is an exemplary work of oral history and precise ethnographic description.

Nacheyakda'ina quyushi uhu qul'ih.
Our grandfathers used to hunt beluga.

Ch'ubetnu Tubughnenq' qech' tabagh quy-ushi qughidił.
Beluga come near the beach between Chuitna [Chuitt] River and Old Tyonek.

Ch'bala beggats'a dnagheIt'ayi sht'a qunuhggats'hghighi'uk ch'q'u
They used to dig up a spruce tree with a big root structure and

beggats'a ghini badahdaIqeyh t'qeyeghiłik.
they hewed out the root structure (into a perch).

Tsenqeydghiltuk' ch'u belutuna ghinhdi łuq'u qeyech'anqeyedghigits'.
They carried it down to the water, and they tore off all the inner bark.

Qeydełt'ich' ch'q'u yethdi heyetnełggush.
They peeled it and then they dried it.

Łduntutset gheli hdi yuse gheli nintutset sht'a quhqelash ch'u hq'aqeydeyeł.
At low tide, when the tide had gone quite far out, they would dig a hole and put it [the tree] in.

Ch'bala lu hniqeyduyeł hq'aqeydełchet.
They stuck the top end of the spruce in a hole, and they stood it up.

2.0 *Dineh*, harpoon, Tyonek, 1883.
L 278 cm, W 12 cm. Wood, bone, skin (seal?), braided sinew with red yarn, faded pigment, either red or black. Ethnological Museum Berlin, IVA 6136. Photograph courtesy of Staatliche Museen zu Berlin, Ethnologisches Museum; photograph by Chris Arend.
 This harpoon is the only known example of a Dena'ina beluga spear.

Dnigi deyes k'qałen ghini tuq'i nilanh
qeyełtl'ił ch'q'u jahtl'in eł naltlah t'qeyeł'ish.
They braided three strips of moose skin and
smeared it with pitch.

Ch'q'u ch'bala lu ghu hniqeydghitseyi ghu
tl'ił ghini yutgge sht'a benyestkeyh ghu
t'qeyeghił'ik.
They tied ropes onto the spruce that was
standing there.

Ch'u tl'ił ghini dnaghelt'ayi sht'a
bech'annayk'et'h t'qeyeghił'ik.
They had many ropes extending out in differ-
ent directions.

Ch'qiluna k'uych'ena hyighitih, ts'iłq'i tl'ił.
Five or six people held one rope.

Yethdi ggaqeydełnesh dghu tl'ił ghini łuq'u
hyitih ch'u qeyenenish ch'u ggaqeydełchet.
Then they stood it [the tree] up when they
pulled on all the ropes and they held on to it.

Ch'q'u tl'ił ghini łuq'u hyitih.
They held on to those ropes.

Ch'q'u yethdi ts'i'un hnidi'ush hnuq'u tl'ił
ghini benułtu hnitsanaltsadi yi'enhyeyish
tl'ił ghin.
And then when it [the tree] was sticking
straight up, they tied the ropes to stakes.

Yach'en elugh yin k'a qenhyuyish hyitih
ch'q'u yina kiq'u ts'ilt'an ghunen qeyuyish.
They held on [to the ropes] on the other
side while one man tied up those that were
still untied.

Dach' ghunen diq'u qeyuyish qughesht'a
qiłket hnuq'u yethdi yina kiq'u qenhyiłkis.
Thus he tied them to stakes very well, and it
was secure when they tied it over and over.

Yuyqul k'atnili qeynułtu dghiłchik.
They made a pole ladder for the spearing tree.

Q'uyethdi bantadusht hnuq'u yuyqul deduh-
na ghuna nik'uhdel'ush.
When the tide came in, they took out [in
a canoe] the ones who would sit in the
spearing tree.

Qeyeqadghilggesh ch'u yuyqul ghini qeyal-
ggesh beggats'a badahdalqeyi ghini.
They climbed up the spearing tree and got into
the hewed-out roots of the spruce tree.

Tiqeshi ghin łuq'u qeyeduqeyedełdeł tiqeshi
k'ghenidi ghini k'elises bedinghilin tl'ił
benaltl'inh łu.
They passed up to them spears with blad-
der drags tied onto them with braided
sinew ropes.

Qutsaghił'i k'deyes bighejetl'i k'eghenidi
t'ghit'a łu.
It is said that the drag was an inflat-
ed sealskin.

Bedinghilin tl' ila yaghelisht' a
quhnaghits'egh t' qeył'ish.
They coiled the braided rope neatly.

Ts'iłghetna ch'qilu beq'edi betetneshi łu
betl'ila k'ghila łu.
The rope was said to be twenty-five fathoms
long [measured by outstretched arms].

Nishhqugh nintudushi dghu quyushi łiq'a
tl'uyeh ch'adeł.
At half-tide, the belugas come after
the salmon.

Quyushi qeye'idelqay łu.
Then they speared a beluga.

K'ghenidi tuhyiłdeł hch'abesyiłchesh.
They threw the drag into the water and it [the
beluga] pulled it away.

Hnuq'u ki dahdi qughena qudeł yiki q'u k'a
qeydelqay,
*Whenever it swam up by them, they speared it
another time.*

Yeqech' ghu t'qet'ih ch'u dahdik'a
aqeydelqay.
*They did that and they would spear it sev-
eral times.*

Yungget dghu baydalgi at hdalts'ina
dendałteyna quyushi ghin qeyeł k'uhnedeł.
*Up there on shore, strong men who sat in
bidarkas went out together in their boats after
the beluga.*

Kiq'u qeye'idelqay yi kiq'u hk'uhnedeł.
They speared the beluga too as they went out.

Yethdi quyushi ghini qeyetl'uyeh neqash ch'u
Then they caught up with it in the chase and

k'ghenidi ghini hyiłket yethdi
hch'abesqubełchesh.
*they grabbed the drag and it [beluga] pulled
them behind it.*

Tahyelneh gheli.
They really tired it out.

Nilghenaq'u qunudleh qadelchet k'eldunahdi
tl'ił hyitih qeyenenish.
*Now and then it swam back up and surfaced,
and some of them would hold on to the rope
and pull on it.*

Tahyełneh ch'q'u q'aditin eł nuhyiggat ch'u
qubelaq'aydelyesh.
*They tired it out, and they stabbed it with the
spear and they caught it.*

Qeyats'ena qeyk'eneggesh.
They strung a rope through its jaw.

Daha tabagh hech' daghiłggech'
besqeytelish.
*They started to drag it to whatever beach
was close by.*

Niqahyiłtash.
They brought it ashore [above the tide line].

Nił'unihyiłtash.
They butchered it.

Nughelkidi hyighush.
They cut the blubber into blocks.

Yethdi baydalgi q'eduhyilash yethdi
nuhqitdel'ush.
*Then they loaded it onto bidarkas and trans-
ported it back.*

Qayeht'ana niłtehyel'ih.
They divided it among the villagers.

Paul Chuitt betukda, Bidyaka'a qeyełnihen,
quyushi chich'eł'ishi qeshqa ghila.
*They said that Paul Chuitt's father, whom
they called Bidyaka'a, was the one who was
the chief of beluga killing.*

Yen undaden yuyqul beq'e dghiduhen ghila.
*He was the last one who sat on a beluga-
spearing tree [in about 1880].*

———————————

3

An Overview of Research on Dena'ina Culture, History, and Language

James A. Fall

3.0 Ułkesa, Sewing Kit, Alaska, c. 1850.
L 150 cm, W 16 cm; caribou hide, porcupine quills, sinew; contents include sinew, awl, babiche. Russian Museum of Ethnography, 8762-17220/1-3. Photograph © Russian Museum of Ethnography. Photograph by Chris Arend.

The first eyewitness accounts of the Dena'ina appear in the journals of Captain James Cook of the British Navy for the year 1778 (Cook and King 1785). Although Cook saw no difference between the people he met at West and North Foreland in May 1778 and the Native people of "Sandwich Sound" (the Alutiit of Prince William Sound), an eleven-item word list collected by William Anderson, the surgeon on Cook's expedition, during encounters with Natives in Cook Inlet, perhaps at Trading Bay or Point Possession, is clearly Dena'ina (Kari and Fall 2003:346–347).

The most important early source on Dena'ina ethnography is the essay by Rear Admiral Ferdinand Petrovich von Wrangell, chief manager of the Russian-American Company from 1831 to 1836. This account, published in German in 1839 and available in English translations published in 1970 and 1980, is based on information collected by employees of the Russian-American Company and other observers, including an early nineteenth-century account by the Russian naval officer Gavriil Ivanovich Davydov (1977 [1810–1812]). Wrangell's compilation includes the first known descriptions of the beluga-spearing platform (*yuyqul*), as well as details on the Dena'ina clans and the seasonal round of subsistence activities. Wrangell was likely the first observer to describe the Dena'ina as a "mountain people" who had adapted their way of life to a marine environment.

Probably the first systematic description of the Dena'ina following the sale of Alaska to the United States appears in Ivan Petroff's 1884 "Report of the Population, Industries, and Resources of Alaska," prepared as part of the tenth U.S. Census of 1880. Although Petroff's credibility as a scholar has been questioned (Pierce 1968; Black 1981), his account of the Dena'ina is based in part on observations he made while stationed in Kenai in 1869–1870 and while conducting research for the census in the Cook Inlet area in 1881, and it offers interesting details on Dena'ina material culture, subsistence activities, and other customs.

In 1883, Johan Adrian Jacobsen, sent on an expedition to the Northwest Coast of America to collect ethnological materials for the Ethnological Museum of Berlin, visited Tyonek ("Tagunak"), Kenai, and Seldovia to collect items of Dena'ina material culture. Jacobsen's expedition is chronicled in Adrian Woldt's book, *Alaskan Voyage, 1881–1883: An Expedition to the Northwest Coast of America 1881–1883*, which is available in an English translation by Erna Gunther (Jacobsen and Woldt 1977).

A brief description of Dena'ina culture appeared in the original *Handbook of North American Indians*, published by the Smithsonian Institution's Bureau of American Ethnology, under the title "Knaiakhotana" (Hodge 1907). The article was based on Russian sources and accounts of late nineteenth-century American explorers. The journals

FIG 3.1

[column headings from manuscript]

English	Oonalaska	Sandwich Sound [Cook Inlet]	Norton Sound	Greenland from Emnik	Esquimaux
No	Net		Ina	Nag	
Yes, or Aye	ūh	āā	Eh	Ilisve	
What call you that		a hā'shou	-	Nina	
1	Turadae	Chilki	Adwrjac	Attousek	Attouset
2	Alac	Taiha	Aiba	Virlak	Mardluk
3	Canoogin	Toh ke	Pinjashooc	Pingajuak	Pingasut
4	Seeh'n	Chetkels	Thotamee	Sisamat	Sisamat
5	Chang	Hocheene	Dullemec	Tellimat	Tellimat
6	Aloo	Takulai	In counting more		Arbrngot
7	Ooloo	Keichilho	than they re-		{Arbangot, {attousek
8	Hanchug	Kliew	peat the same		Arbangot mun slik
9	Seching		words over again		Kollin illoet
10	Hasc				Kollit

3.1 Dena'ina word list, 1778. This eleven-word Dena'ina vocabulary list comes from a clerk's copy of William Anderson's journals written during the 1778 voyage with Captain Cook to Alaska. It is under the heading "Sandwich Sound." This is the earliest known documentation of the Dena'ina language and offers conclusive evidence that Captain Cook and his crew came in contact with Dena'ina people. National Archives of the United Kingdom, PRO ADM55/113.

of clergy of the Russian Orthodox Church are another key source of ethnographic and historical information about the Dena'ina of the nineteenth and early twentieth centuries (Townsend 1974; Znamenski 2003).

The first professional anthropologist to conduct research with Dena'ina respondents was Frederica de Laguna (1906–2004). In 1930 and 1931, while a graduate student at Columbia University, she conducted two summers of archaeological fieldwork, primarily along Kachemak Bay, but at several other sites along Cook Inlet as well. De Laguna's research was designed to explore the question of whether an "Eskimo" (i.e., Alutiiq) occupation of Cook Inlet had preceded the arrival of the Dena'ina Athabascans. Although her work was primarily archaeological, de Laguna interviewed several Dena'ina about sites, artifacts, and history (de Laguna 1934, 1996).

Cornelius Osgood (1905–1985) was the first anthropologist to conduct focused research on Dena'ina ethnography. At Yale University, Osgood had begun "a series of descriptive studies of Athapaskan groups to serve as the basis for a general cultural analysis involving the whole of the extensive Northern Athapaskan area and adjacent regions" (1937:5; see also Osgood 1933, 1936). He arrived in Seldovia in June 1931 and stayed a month, then visited, in turn, Iliamna[1], Eklutna, Tyonek, Susitna Station, and Kenai "for one or two weeks [each]" until September. Osgood returned at the end of the summer of 1932 "for several weeks" to Kenai and Seldovia. His seminal *The Ethnography of the Tanaina* was published in 1937 as part of Yale University's Publications in Anthropology series. It was reprinted, without changes, by the Human Relations Area Files Press in 1976.

The purpose of Osgood's ethnography was to describe the Dena'ina way of life as it existed before the changes brought about by contacts with Europeans and Americans. As he put it, his goal was to "present descriptively the manifest culture of the Tanaina as it would have appeared just previous to historic contact, or in the third quarter of the eighteenth century" (Osgood 1937:24). Of his nine paid respondents, Osgood learned the most from Fitka Balishoff of Seldovia, and his ethnography is

3.2 Cornelius Osgood.
Osgood, left, was the first anthropologist to do a detailed study of the Dena'ina. In 1931 and 1932, he spent part of the summer in Kachemak Bay, Iliamna, Eklutna, Tyonek, Susitna, and Kenai. The result of his work was *The Ethnography of the Tanaina*, which laid the groundwork for all subsequent research among the Dena'ina and is still referenced today. Photograph courtesy of the Charles E. Bunnell Collection, Archives, University of Alaska Fairbanks, UAF-1958-1026-965.

3.3 *Vadahdalqeyi*, bowl, Iliamna, 1931–1932. L 33 cm. White spruce, pigment, babiche stitch repair. Photograph © Peabody Museum of Natural History, Yale University, ANT.015864. Photograph by Chris Arend. This wood bowl has a black design painted on the inside and a red three-toed raven's foot design painted on the bottom.

FIG 3.2

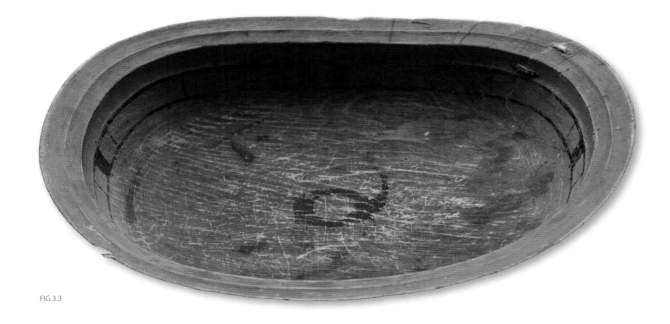

FIG 3.3

FIG 3.4

FIG 3.5

3.4 Fitka Balishoff. Balishoff of Seldovia was one of Osgood's main informants in 1931. He provided important details on the Kachemak Bay Dena'ina, who were few in number by this time. Photograph by Cornelius Osgood. Cornelius Osgood Papers, Archives, University of Alaska Fairbanks, Series 2: The Tanaina 1931–1937.

3.5 Nickafor Alexan and Charlie Kroto, Tyonek, 1920s. Alexan was the first Dena'ina writer to document the history of Tyonek through a series of traditional Dena'ina stories and historical narratives in the early 1960s. Photograph courtesy Nora McCord, Alaska Department of Fish and Game, Tyonek 130.

perhaps therefore somewhat weighted toward the Kachemak Bay Dena'ina, although he had particularly knowledgeable respondents at Kenai (Feodore Sasha), Eklutna (Jim Nikita, or "Eklutna Jim"), and Tyonek (Simeon Chickalusion). He was less successful at Susitna and Iliamna and did not visit any Inland Dena'ina communities. Notably, Osgood's map of Dena'ina territory excludes the Stony River (Osgood 1937:14).

Nickafor Alexan of Tyonek (1900–c. 1970) was the first Dena'ina person to write ethnographic descriptions about his own people. Therefore, although he wrote in English, Alexan was the first Dena'ina writer. He composed approximately nine essays in the late 1950s or early 1960s, consisting of biographies, traditional stories, history, and thematic essays (Alexan n.d.), now archived at the library of the University of Alaska Anchorage. Some of these essays were later published in the *Alaska Sportsman* (Alexan 1965a, 1965b), in the Native Village of Tyonek newsletter in 1967, and by the

Kenai Peninsula Borough School District (1981). In the essay "How Tyonek People Used to Eat," Alexan explained his motivation:

> I want to tell this [story] because some time if our food supplies are cut off from outside and this country become famine, then some young generation might think about how did old people use to make a living. This story of old time might help some one if they read it and understand. (Alexan 1956a:60)

Alexan's interest in recording Dena'ina traditions that young people might find useful, especially if facing a future crisis, recalls Dena'ina elder Shem Pete's admonitions in "The Susitna Story" that the

FIG 3.6

FIG 3.7

3.6 Albert Wassillie at the Nondalton Winter Carnival in 1974. Albert Wassillie, left, of Nondalton, along with Peter Kalifornsky of Kenai, made significant literary contributions to the Dena'ina language. Among Albert's achievements were the *Dena'ina Junior Dictionary and Nondalton People's Stories.* Joan Tenenbaum Collection, Anchorage Museum, TD 08.1.6.1.16. Photograph © Joan Tenenbaum.

3.7 Peter Kalifornsky, Kenai, 1978. Kalifornsky is shown in this 1978 photograph after he published his first book, *Kahtnuht'ana Qenaga: Kenai People's Language.* Kalifornsky was among the last speakers of the Outer Inlet dialect of Dena'ina. He devoted more than fifteen years to writing in his language so that it would be preserved. Photograph courtesy of the Ukpeagvik Inupiat Corporation and Tuzzy Consortium Library of Barrow, Alaska, TT.02766a.

Dena'ina maintain their fishing and hunting skills, and his hope that those who heard his stories might "save their lives" with what they learned (Kari and Fall 2003:5, 96–97).

Nickafor Alexan was the first of a number of prominent and skilled Dena'ina authors. Some, such as Albert Wassillie of Nondalton (1922–1989), focused on linguistic materials and traditional stories (e.g., Wassillie 1979, 1980a, 1980b), while others, such as Alberta Stephan of Eklutna, who writes in English, have focused on history (Stephan 1996, 2001). The most prolific of these writers was Peter Kalifornsky of Kenai (1911–1993), whose numerous Dena'ina writings were compiled in *A Dena'ina Legacy: K'tl'egh'i Sukdu* (Kalifornsky 1991). In addition to preserving oral traditions, Kalifornsky composed original essays in Dena'ina on a range of ethnographic, historical, and philosophical topics. In 1992, this work won the American Book Award from the Before Columbus Foundation.

Joan Townsend (1933–2006), a cultural anthropologist who spent most of her career at the University of Manitoba, conducted archaeological research at Pedro Bay in 1960, followed by ethnographic fieldwork, primarily at Pedro Bay but also briefly at Nondalton, in 1962 (Townsend 1965). Townsend wrote a number of important scholarly articles on Dena'ina ethnohistory and culture, including the article "Tanaina" for the Smithsonian Institution's *Handbook of North American Indians* (Townsend 1981; see also Townsend 1970, 1980). She explained that the purposes of her research were "to present a descriptive study of the changes in the various aspects of Tanaina culture which have occurred since contact with Western civilization… [and] to determine what elements of Tanaina culture have persisted and what forces have brought about some of the specific changes or persistences" (Townsend 1965:2).

In July 1966, the Swedish folklorist Anna Birgitta Rooth (1919–2000) visited Nondalton while she was investigating North American Indian creation myths. Her report, *The Alaska Expedition 1966: Myths, Customs, and Beliefs among the Athabascan Indians and the Eskimos of Northern Alaska* (1971),

FIG 3.8

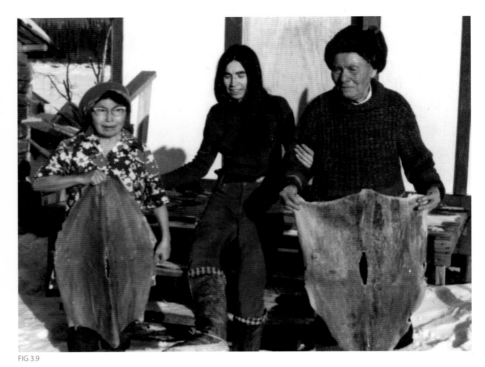

FIG 3.9

includes transcripts, in English, of the traditional stories and other ethnographic information she collected in the village.

Nancy Yaw Davis, then a graduate student at the University of Chicago, conducted ethnographic fieldwork in Eklutna in the 1960s (Davis 1965). Unlike most prior Dena'ina research by anthropologists, Davis's work described a contemporary community. In the 1990s and 2000s she was active in renewing interest in documenting the Dena'ina heritage in the Anchorage area and organizing the "Dena'ina Team" of Eklutna and Knik Dena'ina to investigate traditional sites (see also Davis and Davis 1996).

A practical orthography for the Dena'ina language was developed by the Alaska Native Language Center of the University of Alaska Fairbanks under the direction of Michael Krauss, soon after the center's founding in 1972 (Krauss 1980). Linguist Joan Tenenbaum conducted research on the Dena'ina language, primarily in Nondalton, beginning in the early 1970s. In 1984 she published an important collection of Dena'ina *sukdu,* or traditional stories. In the 2000s, Tenenbaum assisted Dena'ina language revival efforts, including conducting workshops and preparing a pronunciation guide.

James Kari, of the Alaska Native Language Center, began linguistic fieldwork on the Dena'ina language in Kenai in 1972 and has subsequently worked in all Dena'ina communities with speakers of each of the four dialects (Kari 2005). In addition to documenting the language (e.g., Kari 2007), Kari has recorded place-names and their stories throughout Dena'ina country (Kari and Kari 1982; Kari and Fall 2003) and made many important collections of traditional stories, biographies, and history (e.g., Johnson 2004; Balluta 2008). He has worked with most of the expert Dena'ina speakers of the late twentieth century.

Beginning in 1972, Priscilla Russell (Kari) conducted ethnographic research in all Dena'ina communities, with a particular focus on the way of life in Lime Village in the late twentieth century (Kari and Kari 1982; Kari [Russell] 1983, 1987; Russell and West 2003).

Alan Boraas, an anthropologist at Kenai Peninsula College in Soldotna, has conducted archaeological, ethnographic, and linguistic research with Kenai Peninsula Dena'ina since 1974 (e.g.,

3.8 Joan Townsend in the field. Townsend conducted archaeological and ethnohistorical research among the Den'aina in the Iliamina and Inland Den'aina regions during the 1960s. Photograph courtesy of the University of Manitoba Archives and Special Collections, PC 218, A.07-50, Box 1, Folder 4, Item 1.

3.9 Left to right, Emma Alexie, Priscilla Russell, and Shem Pete. Russell, an ethnographer and botanist, spent more than fifteen years among the Dena'ina, collecting information for her books, *Tanaina Plantlore* and *Bird Traditions of the Lime Village Area Dena'ina.* Photograph courtesy of Priscilla Russell.

Boraas and Peter 1996, 2009). He has also worked closely with the Dena'ina writer Peter Kalifornsky and collaborated with the Kenaitze Tribe on cultural heritage and language programs.

In 1978, while a graduate student in anthropology at the University of Wisconsin–Madison, I began systematic fieldwork that focused on the precontact sociopolitical organization and economy of the Upper Inlet Dena'ina communities and how these changed from the late eighteenth century into the early twentieth century (Fall 1981, 1987). I have continued working with Upper Inlet Dena'ina elders, most notably Shem Pete, Billy Pete, and Katherine Nicolie, recording traditional stories and ethnographic and ethnohistorical information (e.g., Fall 1990; Kari and Fall 2003). As an employee of the Alaska Department of Fish and Game's Division of Subsistence, I have also contributed to studies of contemporary subsistence hunting and fishing in Tyonek (Fall, Stanek, and Foster 1984; Stanek, Fall, and Holen 2006) and Nondalton (Fall et al. 2010). Beginning in the early 1980s, the Alaska Department of Fish and Game, generally with funds from the National Park Service or the U.S. Fish and Wildlife Service, conducted a number of other studies of the role of hunting, fishing, and gathering wild resources in late twentieth-century and early twenty-first-century Dena'ina communities that demonstrated the continuing economic, social, and cultural significance of these activities and marked a growing interest in documenting the contemporary Dena'ina way of life (e.g., Behnke 1982; Morris 1986; Fall et al. 2006, 2010). This interest on the part of state and federal government agencies in part resulted from the passage of state (in 1978) and federal (in 1980) laws that required documentation of subsistence hunting and fishing in Alaska (e.g., Fall 1990b; Norris 2002).

Section 14(h)(1) of the Alaska Native Claims Settlement Act (ANCSA) (1971) required documentation of Alaska Native historic and cemetery sites. The Cook Inlet Historic Sites Project (1975) was an early effort to document oral traditions about sites in traditional Dena'ina territory. Beginning in the 1970s, the Bureau of Indian Affairs' ANCSA program conducted archaeological and oral history research related to Dena'ina places, primarily on the Kenai Peninsula and in the Lake Clark area (Pratt 2009).

In the late 1980s and early 1990s, anthropologist Linda Ellanna (1940–1997), then at the University of Alaska Fairbanks, and Andrew Balluta of Nondalton, then working as a ranger for Lake Clark National Park and Preserve, conducted detailed research on the traditional and contemporary Dena'ina culture and way of life of Nondalton and other former Dena'ina communities of the Lake Clark area (Ellanna 1986; Ellanna and Balluta 1992). Ellanna's work traces both changes and continuities in the Dena'ina way of life through most of the twentieth century based largely on the accounts of Dena'ina elders.

Lake Clark National Park has continued to support research and publications about the Dena'ina through studies of contemporary communities as well as of historical ethnography and ethnohistory (e.g., Stickman et al. 2003; Gaul 2007; Stanek, Fall, and Holen 2006; Evanoff 2010). Park historian John Branson has researched and compiled historical photographs and other documentation of Dena'ina communities, history, people, and culture (Branson 1998). As National Park Service employees, Karen Evanoff and Michelle Ravenmoon, both members of Inland Dena'ina families, have conducted systematic research on historical and contemporary Dena'ina communities and ways of life through interviews, recordings of oral traditions and placenames, photography, and films (e.g., Ravenmoon and Webb 2007). Working with the Oral History Office of the University of Alaska Fairbanks Rasmuson Library, the park produced "Lake Clark National Park Project Jukebox," an online compilation of five indexed interviews with Dena'ina elders and fourteen photograph albums on such topics as education, subsistence, trails, and old villages (http://jukebox.uaf.edu). The park also contributed to the publication of a collection of Dena'ina songs recorded by John Coray in Nondalton in 1954 (Coray 2007).

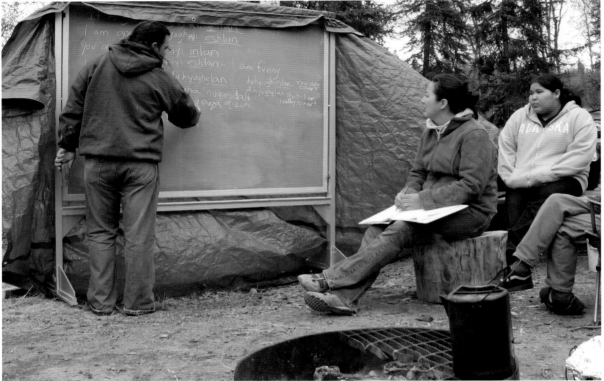

FIG 3.10

3.10 Dena'ina Language Institutes. From 2003 through 2010, the Dena'ina Language Institute was held annually to bring together Dena'ina speakers and learners to help reinvigorate the language. In this photograph, taken at the 2006 institute, which was held that year at Spirit Lake near Kenai, Jon Ross presents a Dena'ina verb paradigm. Photograph courtesy Aaron Leggett.

In the late 1990s and early 2000s, the historian Andrei Znamenski (2003) translated and annotated the journals of Russian Orthodox missionaries to the Dena'ina from the 1840s to the 1930s. Znamenski also conducted interviews with Dena'ina about the role of orthodoxy in Dena'ina life.

Aaron Leggett of Eklutna has been working on Dena'ina revitalization since 2002, when he was hired as an assistant to the historian for Cook Inlet Region, Inc. (CIRI), A. J. McClanahan. McClanahan had previously produced *Our Stories, Our Lives* (1986), a collection of biographies of Alaska Native people from the Cook Inlet area, including many Dena'ina. While at CIRI, Leggett prepared a series of articles on Dena'ina topics that ran in the monthly newsletter from 2003 to 2006. He also helped create interpretive materials for the Cook Inlet Tribal Council's new headquarters, called Nat'uh ("Our Special Place"), the first building in Anchorage to have a Dena'ina name. In 2006, he became the Dena'ina cultural historian at the Alaska Native Heritage Center, where he served as a community resource on a variety of projects aimed at increasing the public's awareness of the Dena'ina people and their history and culture. From March 2011, he has continued his work as Dena'ina cultural historian and the Dena'ina exhibition co-curator at the Anchorage Museum.

Finally, a major contribution to Dena'ina scholarship was the *Bibliography of Sources on Dena'ina and Cook Inlet Anthropology,* published in 2005 and updated in 2012 (Dixon, Kari, and Boraas 2005; Kari et al. 2012). Listing approximately two thousand sources, ranging from archival materials and government reports to popular and scholarly articles and books, the bibliography demonstrates the breadth and depth of Dena'ina scholarship. The bibliography is available on the Kenai Peninsula

College website. Through its Ts'itsatna Tribal Archives, the Kenaitze Indian Tribe played an important role in distributing the bibliography.

Several themes are evident from this brief overview of Dena'ina research. Early observers recorded what they saw and heard of Dena'ina culture, providing important but incomplete accounts, generally conditioned by a point of view that the Dena'ina were rapidly changing if not disappearing. After more than a century of profound changes, research by anthropologists, as well as writings by Dena'ina themselves, often focused on salvaging information about past Dena'ina ways of life and on understanding the conditions that led to such changes. With a few exceptions, not until the 1970s did anthropologists turn their attention to how contemporary Dena'ina communities functioned, noting the tenacity with which these communities have survived. The key role played by many Dena'ina people themselves in documenting Dena'ina history, culture, and contemporary life is particularly noteworthy. Finally, systematic and comprehensive research in collaboration with Dena'ina language experts since the 1970s has provided not only linguistic data but a wealth of narratives covering virtually every aspect of Dena'ina ethnography and history.

Note

1. The Iliamna village visited by Osgood is now known as "Old Iliamna," to distinguish it from the newer settlement on the opposite shore of Iliamna Lake called Iliamna.

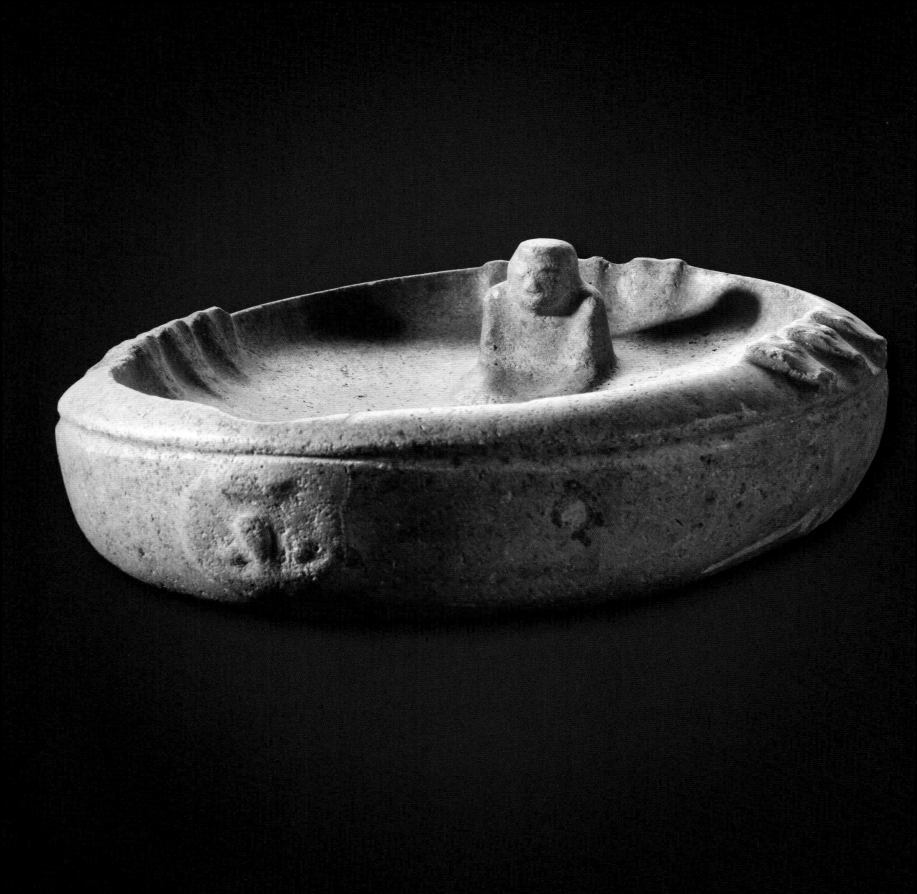

4
Dena'ina Archaeology

Douglas Reger

Studies of Dena'ina archaeological sites provide information about origins and life before European influence in their territory and give historical perspective to descriptions of Dena'ina culture by elders and ethnographers. Prior to the arrival of European explorers and traders with trade goods of metal, glass, and ceramics, the Dena'ina made most tools and other items from wood, antler, or bone, materials that do not long survive burial in acidic northern soils. Archaeologists often note the scarcity of artifacts or animal remains in Dena'ina sites and attribute the absence to soil conditions or to Dena'ina methods of disposing of animal remains, which were aimed at avoiding displeasing the animals' spirits. The consistent lack of remains discouraged excavation of Dena'ina sites for many years, and most research has remained unpublished. During the past several decades, excavations of prehistoric Dena'ina sites have occurred more frequently, and new insights into Dena'ina culture prior to the arrival of European influences have begun to emerge.

Studies of the Dena'ina language and recordings of oral histories and myths show that Dena'ina people moved to their historic territory around the Cook Inlet basin from an uncertain interior Alaska region (Kari 2003b). The presence of speakers of the Dena'ina language in the Lake Clark and Stony River areas suggests those waterways as possible routes from a more interior origin. The Dena'ina lifestyle and practices reflected that origin, and analysis of their language supports that assumption. The archaeological story could provide physical evidence in support of recorded accounts but has not developed enough to support or argue against that reconstruction. Archaeological studies have, however, provided some idea about the prehistoric culture of the Dena'ina and about when they arrived in the Cook Inlet area.

The human history of the Cook Inlet basin began when glacial ice melted after the last major ice age. The earliest cultural remains are estimated to be at least 10,000 years old, dating from the end of the last ice age. Since then, numerous cultures have occupied the Cook Inlet area (Reger 1998; Workman 1998). After the first entry of people into the area, many of the succeeding cultures around Cook Inlet traced their closest connections to the Eskimo and Alutiiq people of the North Pacific rim. Approximately 4,500 years ago people of the late Ocean Bay culture, best known from Kodiak Island, lived in the Kachemak Bay area, and traces of their activities have been found in the upper Cook Inlet area. The following Kachemak culture was equally widespread, and the Kachemak occupation extended inland along major river drainages. The Kachemak people intensively harvested salmon along the inland rivers, and their culture

survived from 3,000 years ago to about 1,200 years ago. They were the last group in the area prior to the arrival of the Dena'ina people. The culture history around Iliamna Lake and likely also Lake Clark was much the same except that a southwestern Alaska Eskimo culture, the Norton culture, occupied the area until about 1,300 years ago. Very few details of life and culture prior to the coming of Euro-American explorers are known for most of the Inland Dena'ina area.

At the time of the arrival of European explorers, Dena'ina Athabascan speakers were the dominant population on the shores of Cook Inlet. A new style of house, accompanied by a sharp decrease in artifacts and debris in the houses, signaled the change from earlier groups. Much of the archaeological information about the prehistoric Dena'ina comes from excavations on the Kenai Peninsula because more intensive investigation has occurred there than in other Dena'ina locations. Excavations at two prehistoric sites in Kachemak Bay have uncovered bone artifacts that help define traditional Dena'ina tool use (Workman 1996). More recent excavations in the upper Cook Inlet area have generally focused on historic period sites. One site at an inland lake, Hewitt Lake, exhibited a pattern of Dena'ina cultural artifacts overlying earlier Kachemak levels, but the complex layering in the soil made separation difficult (Dixon 1996). Collections from the various sites when examined as a whole, however, provide some insight into the prehistoric Dena'ina people.

Prehistoric Dena'ina artifacts from sites well within the boundaries of their historic territory have been dated to the time just prior to the arrival of European explorers. Extending those findings back in time is the method of interpretation known as the "direct historic approach." The technique gives confidence that the artifacts are indeed Dena'ina, with the expectation that similar remains can be confidently traced further back in time and outward to the territorial margins. By this means, early dated collections can be compared with still earlier or distant site remains and an age estimated for Dena'ina movements through time and across the landscape.

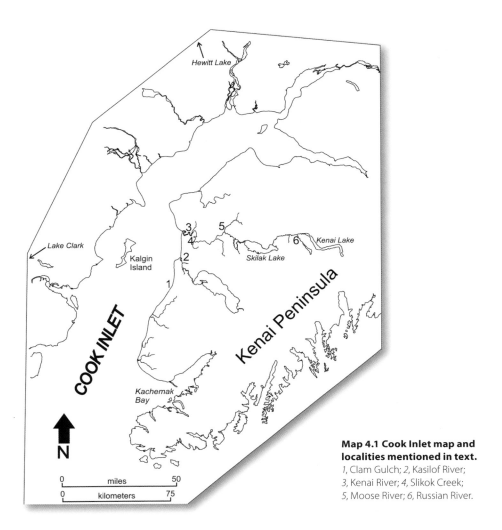

Map 4.1 Cook Inlet map and localities mentioned in text.
1, Clam Gulch; *2*, Kasilof River; *3*, Kenai River; *4*, Slikok Creek; *5*, Moose River; *6*, Russian River.

Houses

Dena'ina house pits occur singly and in scattered groups of two or three. They tend to be on high bluffs above major streams or along the banks of tributaries. House pits with raised walls of late prehistoric age are also frequently found near lakes in the hinterlands. When found in groups, Dena'ina houses often face nearby water and more frequently are oriented toward the south or west than toward the north or east, but rarely do all face in the same direction. Where located in the same area as earlier Riverine Kachemak house pits, the Kenai Dena'ina often reused the older pits. The

4.1 Dena'ina house remains on the Kenai River downstream from Skilak Lake. Raised wall berms are seen, with an entry passage behind the tree. The house is estimated to be from the late prehistoric or early historic period. Photograph by Douglas Reger.

FIG 4.1

Dena'ina excavated storage pits near their houses and on top of high bluffs overlooking good fishing locations. Large concentrations of cache pits occur along major salmon streams in upper Cook Inlet, such as Kroto Creek and Alexander Creek, and are reported north of Tyonek on the west side of Cook Inlet. Large numbers of pits also occur at Kijik near Lake Clark.

The sites along the lower Kenai River that yielded the most information about Dena'ina archaeology are at the confluence of Moose River, a clear water tributary, and the Kenai River. A smokehouse at one site there had multiple interior smudge pits. No aboveground structure survives, but important artifacts were recovered, particularly from the smudge pit fills. One smudge pit was filled with fire-cracked rocks, charcoal, and fragments of burned bone that fit together to form a barbed dart head with barbs carved into one edge. A line hole suitable for attaching a line was drilled into the base of the dart. Beside the largest smudge pit were a stone-splitting adze and three copper artifacts. The copper in a bipointed pin and an ulu blade was chemically traced to a copper deposit in the southeast Copper River basin.

Excavations at the Moose River Site provided details about an aboriginal Dena'ina house. The hearth and some roof logs were found partially covered by fragmentary sheets of birch bark. Bones of food animals and a Washington clam shell (*Saxidomus giganteus*) were scattered in and around the hearth.

House pits more complex in layout than earlier pits with additional rooms began to appear about A.D. 1000. Most houses of the period had a smaller second room behind the main room. Many had entry rooms or tunnels and occasionally other rooms appended to the main room's side or back walls and accessed by connecting passageways. The floors of the houses typically were only slightly excavated into the surrounding terrain, and earthen walls now remain standing several feet above the surrounding land surface. The hearths in Dena'ina house pits are identified by scatters of wood ash and fine bone fragments at the center of the largest room, usually the front room. The hearth was not encircled with hearth stones; rather, according to knowledgeable present-day elders and historic period accounts, the hearths were built within a log crib, which was partially filled with sand. Trash piles of fire-cracked rock and bone were placed outside the house, off to one or both sides of the entry. Few artifacts are normally found within the houses, and few structural details have survived through time.

Good fishing locations were often marked by the presence of smokehouses. A smokehouse near the confluence of the Kenai River and Moose River appears as a roughly square, flattened area partially dug into an irregular surface. Another site beside the upper river revealed reuse of an earlier house depression as a smokehouse. The old depression was filled with fire-cracked rock rubble that contained artifacts, bones, and post molds, indicating that racks or similar structures were erected for preserving fish. The accumulations of rock rubble are thought to be debris from fires used to smoke and dry fish during damp weather. The rocks used to hold the heat of smudge fires often cracked from firing, creating large amounts of fire-cracked rocks. Deposits of fire-cracked rock rubble and charcoal containing artifacts and bone fragments but no aboveground structures were also found at good fishing locations along the middle Kenai River. Smokehouse sites yield no evidence of habitation structures, but midden deposits indicate the locations were probably summer fish camps, where the Dena'ina lived in tents or temporary shelters.

Artifacts

Stone artifacts were used by the prehistoric Dena'ina but are much less common and usually less carefully made than those found at earlier, non-Dena'ina sites. Copper tools were made of copper acquired in trade from the Ahtna of the Copper River country north and east of Dena'ina territory. The copper tools were cold hammered from copper nuggets. Bone, antler, and wood were the usual materials from which artifacts were fashioned by the early Dena'ina, but those materials did not survive natural decay, and organic artifacts are rarely recovered.

Stone Tools

Ground slate points from Dena'ina sites usually have stems, slight shoulders that expand to the wider blade, and relatively long blades. The shoulders were formed at a 90-degree angle or were slightly barbed. Slate points were bifacially ground and have a biconvex cross section or a slight central ridge along the length of the blade. The stem edges were rounded and the butt was ground straight across. Slate points with barbing and a slight medial ridge appear to occur early in the Dena'ina occupation.

Slate ulus or *vashla* were mostly fashioned on an unmodified, flat piece of slate by grinding a straight or slightly curved cutting edge. No special modification was made to attach a handle. Coarse-grained stone and scoria or pumice, found in some sites, were presumably used to smooth the ulus and points.

Boulder chip scrapers and knives are commonly found in Dena'ina sites along the Kenai River. The chips were struck from river cobbles and probably were tools of convenience, made on the spot to process salmon. The tools show little wear beyond a slight blunting of the edge.

The stone splitting adze with a groove for hafting is a hallmark of late prehistoric archaeology around the North Pacific Rim, not only in Dena'ina sites. They are heavy, nicely smoothed adzes with a groove pecked into the top and occasionally both sides of the tool. The adzes have a working edge at one end with a rounded, blunt opposite end. Some grooved

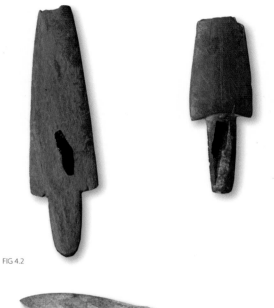

FIG 4.2

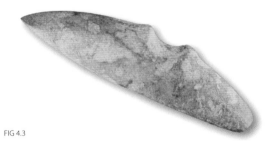

FIG 4.3

4.2 Ground slate points (9 cm, 6.5 cm) from the Slikok Creek Site, KEN-063. Photograph by Douglas Reger.

4.3 Ground splitting adze from the SEW-216 site, near the confluence of the Russian River and the Kenai River. The adze (25 cm) was found adjacent to a historic period cremation burial. Photograph by Douglas Reger.

splitting adzes were sharpened at both ends. Many smaller adzes were formed of a green stone or a variety of serpentine that occurred in local gravels or in the Prince William Sound region. Gray metamorphic river cobbles were also pecked and smoothed into splitting adzes. Splitting adzes may have been used by simply grasping the adze and chopping, but historic period accounts describe lashing the stone adzes to wood and antler handles. The one-piece handles typically have a T-shaped form, with the adzes lashed to the top crosspiece. Historic period sources suggest the heavy splitting adzes were used in splitting and shaping wood. Highly polished small adze bits suitable for inserting into a bone socket, which would then be lashed to a wooden handle, have been recovered from several Dena'ina sites on the Kenai Peninsula coast.

One early historic period site along the upper Kenai River yielded narrow stone chisels with finely ground cutting edges at one end. No modification of the narrow stone pieces had been made beyond the cutting edge. Functionally, the chisels would have worked similarly to grooved splitting adzes but probably were used less as chopping tools. Such chisels occur elsewhere in undated contexts but were probably part of a Dena'ina toolkit.

Copper tools

Copper pins with a square cross section and tapered points at both ends occur widely in Dena'ina sites, although not in great numbers. The copper came from a source in the Copper River area. A pin from a Kenai River site has an unidentifiable fiber wrapped around its middle. A similar pin found near Knik was inserted into a wood handle (Dumond and Mace 1968). A fragment of a thinly hammered

copper ulu blade was recovered in Dena'ina levels of one site along the Kenai River (Reger 1998). A large copper spear point with a long narrow tang for attaching to a shaft was found at the same site and was fashioned from a very thick piece of copper alloy of Western origin. The point, which has been radiocarbon dated to the early nineteenth century, was no doubt a trade item.

Organic artifacts

Artifacts fashioned from organic materials such as bone or antler are rarely found, probably because of the acidic soils common in the area. Organic artifacts do survive but are usually of recent age, postdating the arrival of Euro-American explorers, or else they survived because they were burned in a hearth or other unique environment.

Quite unlike people of the preceding Kachemak culture, the prehistoric Dena'ina of Kachemak Bay fashioned bone tools from the leg bones of land mammals (Workman 1996). The earlier people usually made their bone tools from the bones of sea mammals.

A unilaterally barbed dart head with a line hole drilled in the base was reconstructed from burned fragments recovered from a smudge pit near Moose River. The dart head was carved from antler and has a pointed tip. The dart is of the type historically used on the tip of a wooden shaft to make a harpoon for taking salmon or large sea mammals. Similar dart heads have been found in sites around Kachemak Bay, at Clam Gulch, and recently in historic period contexts near Kenai.

A single toggling harpoon head was recovered from an early historic period site beside the upper Kenai River. The bone harpoon head has a closed socket at the base in which a bone foreshaft or pointed handle would have been inserted. A hole for attaching a line to the harpoon head was drilled in the middle of the tool. The toggling spur was carved into two separate points. A blade slot was carved perpendicular to the plane of the line hole and the flat face of the spur. Toggling harpoons were used historically by the Dena'ina to harpoon salmon, seals, and belugas (Osgood 1937).

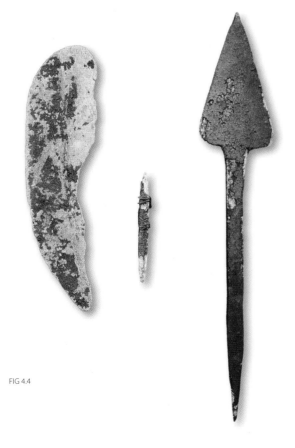

4.4 Copper artifacts from the Nilnunqa Site, KEN-066, near the confluence of the Moose River and the Kenai River. The ulu blade (7.5 cm) and pin (3 cm) are of native copper from the Copper River area and the point (11.25 cm) is of European copper. Photograph by Douglas Reger.

FIG 4.4

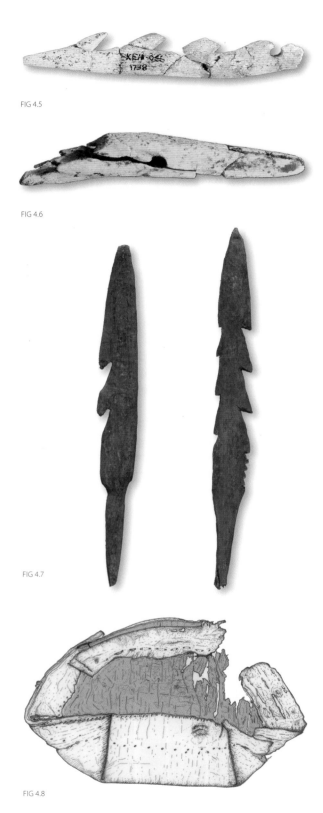

FIG 4.5

FIG 4.6

FIG 4.7

FIG 4.8

One historic period site on the upper Kenai River yielded two antler arrow points, one barbed along a single edge and the other barbed on both edges. The points are pointed at the tip and have conical bases. A long bone rod, pointed at both ends and round in cross section, may be a foreshaft for attaching a socketed harpoon tip. Such pointed bones often occur in Athabascan sites in Interior Alaska. A spoon carved from bone, a pointed antler foreshaft, and various fragments of mammal leg bones for making artifacts were recovered from a cache in the wall of a Dena'ina house pit near Kasilof that was radiocarbon dated to about four hundred or five hundred years ago.

Birch bark was frequently used to line cache pits, although grass also was commonly used to protect stored fish from the surrounding soil. Birch bark also survives in some house pits, where it formed a cover for the roof. A small birch bark basket with folded corners was uncovered near the bottom of a midden at the Clam Gulch Site.

Marine shells have been found in many lower and middle Cook Inlet Dena'ina sites (Reger and Mobley 2008). The shells are most frequently from the Alaska surf clam (*Spisula alaskana*) and the Washington clam (*Saxidomus giganteus*). Other shells recovered include dogwinkle (*Nucella lima*), Pacific razor clams (*Siliqua patula*), blue mussel (*Mytilus edulis*), various cockles, and other hard shell clams. Shellfish acount for only a very small proportion of faunal remains and probably were obtained to fashion such artifacts as beads and labrets, as well as for consumption. A shell labret—an ornament to be worn in the lip—manufactured from a very thick clamshell was found in a late prehistoric period house near the Russian River on the Kenai Peninsula. A cache in a house wall near Kasilof contained tools and materials for making shell artifacts.

Art Objects

Beads recovered from two Kenai River sites were made from stone, bone, and amber. Single stone beads have been recovered from two other sites.

4.5 Barbed antler dart (7 cm) reconstructed from fragments found in a smudge pit at the Nilnunqa Site, KEN-066, near the confluence of the Moose River and the Kenai River. Photograph by Douglas Reger.

4.6 Closed-socket, toggling harpoon head (7.5 cm) carved from sea mammal bone found at the SEW-214 site near the Russian River. A slit in the tip was cut to receive a stone blade. Photograph by Douglas Reger.

4.7 Barbed antler arrowheads found at the New Village Site, SEW-298, on the upper Kenai River below Kenai Lake. The arrowhead on the right is 10.5 cm long. These arrowheads are estimated to be from the early historic period, that is, after contact with Europeans in the late 1700s. Photograph by Douglas Reger.

4.8 Birch bark basket recovered from the Clam Gulch Site, KEN-045. The sewing holes are visible, and there is a double lining on the rim. The basket is 21 cm long and estimated to be 350–400 years old. Drawing by Susan Fair.

4.9 Bone and shell decoration objects from the Clam Gulch Site, KEN-045.
The bone earring (2 cm) on the left has a line hole at the top. The shell pendant piece (3 cm) is ground on all surfaces. Photograph by Douglas Reger.

FIG 4.9

Rectangular shell pieces were found at the Clam Gulch Site, presumably cut and polished for preparation of a pendant or other decorative piece (Reger 1987). Bone objects from one historic period Dena'ina site on the upper river are incised with a circle-and dot-motif, parallel lines, and cross-hatching. Small T-shaped bone earrings and other dangling jewelry items have been found at several Dena'ina sites.

Treatment of the Dead

Evidence of the treatment given the dead by the Dena'ina has been found in just a few sites along the Kenai River. At the time European explorers arrived in the Cook Inlet area, in the late 1700s, the Dena'ina reportedly cremated their dead. Three sites along the upper Kenai River and a single site along the lower river have yielded burned human remains thought to be from cremations. Two of the upper river sites were located on high bluffs overlooking the river. Coincidentally, both were located on top of much older Riverine Kachemak burials. One of the cremations was associated with glass trade beads, some of which were partially melted. The beads were recovered both as single beads and as glass lumps with identifiable individual beads. One historic period cremation also had a grooved splitting adze recovered from beside the burned remains.

Subsistence

Faunal remains from Dena'ina sites document the importance for late prehistoric people of hunting small mammals. The snowshoe hare (*Lepus americanus*) is the most common land animal found at sites along the Kenai River. All parts of the snowshoe hare have been found, indicating that processing of hares at the sites and within houses was common. Hare bones are very commonly found in the central fire hearths of Dena'ina houses. Marmot, red squirrel, porcupine, beaver, Arctic ground squirrel, muskrat, weasel, and river otter bones have also been found in excavated sites. Trapping for furs may account for the presence of some species, but most available small mammals were taken, and many were probably eaten.

Larger land mammals represented in site remains include brown and black bears, wolverine, mountain sheep, moose, and caribou. Caribou were identified at one site in the upper Kenai River drainage but not at any other site north of Kachemak Bay. Caribou bones are very common in Dena'ina sites around Pedro Bay at the east end of Iliamna Lake. Moose bones have been found at some sites but are not common.

Bird bones are not common at most sites but were common at one coastal site, Clam Gulch. Some bones from cormorants, not usually an inland species, have been found in sites along the Kenai River, as have bones from more familiar birds such as eagle, large owl, duck, ptarmigan, and grouse.

The frequency of fish bones sometimes rivals the frequency of hare bones in Dena'ina sites. Salmon and trout are by far the most common fish found, with a few marine species and possibly whitefish occasionally recovered. Vertebrae and rib bones are usually found in cache pits and in refuse middens outside the entrance of houses. The larger salmon vertebrae identified to date do not include the very large vertebrae of the king salmon. This may reflect the extreme importance of the king salmon as the first returning salmon in the spring. Special ritual disposal of king salmon bones would be expected because of that importance. Excavations at three sites in Kenai and Kasilof areas have shown the importance of small cod to the prehistoric Dena'ina.

Marine mammal bones and shells found in lower Cook Inlet sites attest to the adaptation by

the Dena'ina to the marine environment there. Seal, porpoise, and other marine mammals were critically important foods for the Dena'ina of Kachemak Bay.

Dating

Thirty-seven radiocarbon dates from sixteen sites along the Kenai River show that the first significant occupation of the area by Dena'ina speakers occurred between A.D. 1000 and A.D. 1200. The Dena'ina are the primary Native people along the Kenai River to this day. The dates obtained for Dena'ina sites in other parts of their territory generally reflect habitation in the several centuries prior to the appearance of the European explorers.

Settlement Patterns

Mapping the distribution of house pits and clusters of pits through archaeological survey and testing reveals important information about subsistence patterns and social groupings. The pattern of Dena'ina settlement along the Kenai River before the arrival of European explorers in 1778 was considerably different from that of the preceding Kachemak population. While the Riverine Kachemak people clustered their dwellings tightly together in easily identifiable villages, Dena'ina houses were more widely scattered. Houses frequently were built well away from the riverbank (but not always), and faced away from the river as often as not. Houses in a loose group could be as much as 100 meters apart. Sometimes only a few meters separated houses, but that closeness was probably a result of rebuilding on older locations rather than a deliberate clustering of houses occupied at the same time. We know from ethnographic accounts that dwellings were frequently abandoned for a time and the occupants moved to a new location. The reasons for moving could be as simple as depleted local firewood sources. Many Dena'ina house pit sites consist of single house pits found with several cache pits. Unlike the earlier Kachemak sites, Dena'ina sites usually include a cache pit or two.

Dena'ina house pits are most often located on high bluffs or scattered along tributary streams away from the main river. A few house pit sites occur well away from streams, seemingly placed in hidden locations without concern for ease of access to the river. Fish camp sites are identifiable by the presence of middens at good fishing locations without nearby house pit depressions. Various cache pits can also be found singly and in clusters well separated from house pits. Not all cache pits are associated with presently known good fishing locations. They frequently occur on high bluffs above sections of fast-flowing rivers with no nearby eddies or tributaries, in the most unexpected settings.

Although Dena'ina house pit sites along the Kenai River are widely scattered, most are clustered in several areas. One large grouping is near the mouth of the Kenai River and extends several miles upstream. That concentration includes the historic period village of Skittok and the location that became modern Kenai. A second grouping that may relate to the Kenai group is at Slikok Creek and along various officially un-named drainages downstream to the mouth of the Kenai River. Another large concentration of sites is below Skilak Lake in the area known by modern Dena'ina as Stepanka. The concentration extends from the outlet of Skilak Lake down to the mouth of Killey River. The third large area of concentrated sites is around the confluence of Russian River and the Kenai River. House pit sites occur with great regularity between the outlet of Kenai Lake to just below the mouth of the Russian River.

Historic era census information tells us the population size of the villages at Kenai and Skilak Lake (Mishler 2007). Caution is necessary, though, in projecting those estimates back into prehistory, because the traditional Dena'ina manner of living in widely spaced dwellings apparently changed in response to Russian influences. The Dena'ina began constructing houses in tighter clusters, often after moving to Kenai to be near the trading post, priests, and, later, schools. That said, the early (1800s) reports are useful for making rough aboriginal population estimates for the Kenai River drainage. The

Russian Orthodox churchman, Abbott Nicholas, reported that his song leader traveled to Skilak Village during 1862 and vaccinated 100 villagers. That provides an estimate of the number of Dena'ina on the middle range of the Kenai River. In the 1880 Census, population figures are given for Kenai, Skittok, and Chernila, a settlement less than a mile from Kenai along the coast. Combined, those settlement counts give a population of 102 for the lower river during 1880. The count for Skilak in the 1880 Census is 44, indicating the Dena'ina there had already begun to abandon the middle river village. No information is available for population numbers of the upriver or mountain people's village at Russian River. Projecting the numbers from the other two areas, a population count of about 100 individuals in the Russian River area might be expected. Based on these estimates a total population of Dena'ina along the Kenai River prior to European arrival may have been about 300 individuals but could easily have been twice that many.

Dena'ina households were so dispersed within the suggested village groupings that calculations of prehistoric occupant numbers and numbers of houses are uncertain for estimating village size. Even the estimated number of individuals per household is questionable despite ethnographic researches. Captain George Vancouver's subordinate, Lieutenant Whidbey, reported visiting two Native houses near what today is called Moose Point, north of Kenai along the coast. Whidbey noted that each structure housed fifteen people of varying age and sex but did not describe the houses. Such a large number would be very crowded in a two-room house and may represent the practice among Upper Cook Inlet Dena'ina of building larger houses and living in greater numbers per house than at Kenai. Cornelius Osgood recorded that the Kenai people attached extra rooms to the basic two-room structure, one extra room for each additional family in the household. Thus the basic two-room house probably sheltered around seven to ten people. Such would probably be a nuclear family or a minimally extended family. Early historic period estimates of house groups in the upper Cook Inlet area were larger than suggested by the archaeological evidence in the Kenai area and may have reflected the cohabitation of extended, kin-related groups (Fall 1987).

The dispersed distribution of Dena'ina houses suggests the unit of primary importance was at the house group level. Interaction between house groups was probably much less important. This hypothesis about the archaeological record needs to be researched through further excavation and ethnohistoric investigation.

Archaeological investigation of Dena'ina sites has provided hard evidence that Dena'ina occupied the shores of Cook Inlet for at least the last five hundred years, and perhaps two hundred fifty years before that. Excavations show that the Dena'ina quickly adapted to the marine environment and expanded their knowledge about the subsistence resources. In that way, archaeology has supported historic period descriptions of the Dena'ina lifeway, emphasizing the great adaptability of the people to new opportunities.

Archaeological investigations in the upper Cook Inlet basin provide evidence for historic era and late prehistoric ties to the Ahtna Athabascans in the Copper River area to the east of Cook Inlet. Patterns of complex cache pit construction with multiple storage cells in a cache point to influence from the Copper River area. The trade of artifacts made from copper from the Kennicott River region also demonstrates contact between the prehistoric populations. Thus, archaeological data support the interpretations offered in linguistic studies and expressed in traditional stories.

Additional excavation of Dena'ina sites could further expand the picture of tools and physical remains known from ethnographic accounts. The insights gained about Native life from linguistic studies and from examining social groupings can often be confirmed archaeologically. Further archaeological investigation of as yet unexplored Dena'ina territories should yield more information on past migrations, origins, and lifeways.

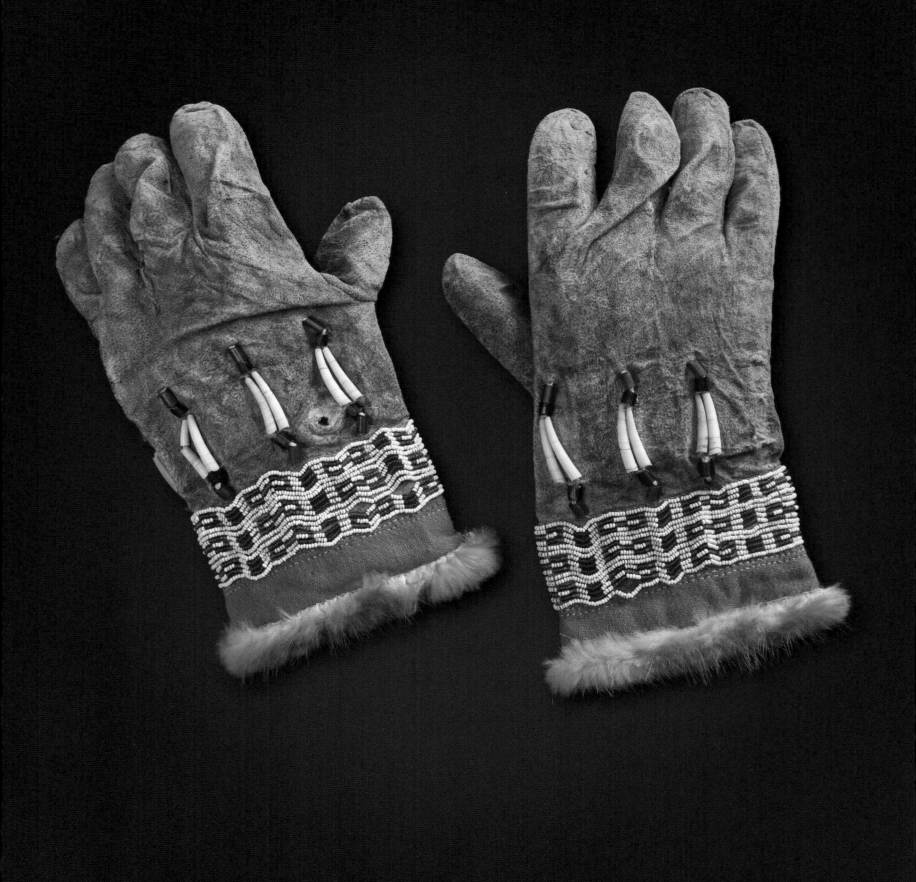

5

Dena'ina Qeshqa: Leaders and Political Organization

James A. Fall

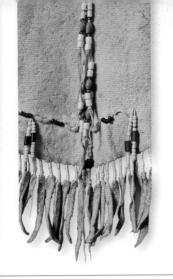

5.0 *Lugech'*, gloves, Nondalton, early 20th c. L 26 cm. Caribou hide, dentalium shells, beads, wool, beaver fur, sinew, thread. Private collection. Photograph by Chris Arend.

These gloves, decorated with dentalium shells to signify rank, were once owned by Gabriel Trefon, a *qeshqa* in Nondalton.

Dena'ina oral traditions, including many *sukdu*, highlight the key role of the *qeshqa*, or "rich man," as leaders in Dena'ina communities.[1] These traditions also describe the goal of young men to become "rich" and achieve *qeshqa* status through vigorous training, hard work, displays of generosity, and obtaining "luck," the goodwill of the spiritual power that animates living things. The role of the *qeshqa* offers a useful starting point for exploring Dena'ina adaptations to their productive but demanding homeland and for understanding key Dena'ina values, such as diligence, generosity, wealth, and the respectful treatment of the natural world.

Leadership may be understood as "setting a course of action followed by others" and is an aspect of the political organization of all societies. "Political organization" may be understood as the rules and social roles that shape a group's policies, maintain its internal order, and protect its territorial boundaries (Fried 1967:82). In some societies, leadership roles arise within specific economic or social contexts and are short-lived, while in other societies leaders have broad responsibilities and occupy permanent positions. Sometimes individuals become leaders solely through their personal qualities and abilities, but individuals might inherit political positions, or at least an advantage in attaining such positions, by virtue of their kinship with other leaders. "Rank" is the ordering of social statuses, including leadership roles, in a hierarchy; some statuses have more authority and prestige than others and bring with them culturally sanctioned privileges.

In traditional Dena'ina society, men called *qeshqa* occupied highly ranked leadership positions that were achieved through the accumulation and redistribution of wealth. They had authority to lead in that they wielded political power that was legitimized by their display of skill, knowledge, and generosity. It is likely that these Dena'ina patterns of leadership sprang from a traditional Northern Athabascan interest in wealth and prestige (Osgood 1937; VanStone 1974), an interest the Dena'ina shared with the Eyak, Tlingit, and other Native peoples of northwestern North America, which was elaborated in the relatively rich and diverse but highly variable natural environment of the Dena'ina homeland. Each *qeshqa* was the manager of the economic activities of a group of his follower-kin. He stimulated economic production, redistributed food and raw materials, and directed trade with other communities.

Individuals achieved *qeshq*a status through their skills in hunting, trapping, and trading and their use of material goods to create groups of economic and political supporters. Each man's position in the matrilineal kinship system, as well as his reputed relationships with manifestations of spiritual power, enhanced the likelihood that he could attain high rank.

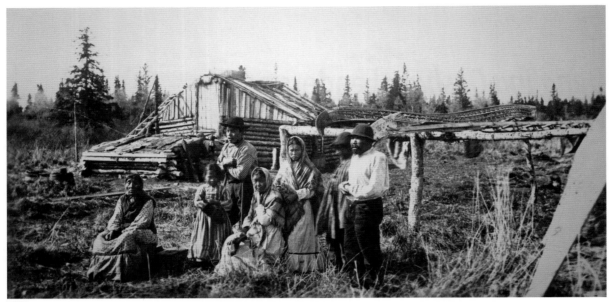

FIG 5.1a

The *Qeshqa* and the *Duyeq* in Dena'ina Social Organization

Every Dena'ina person was born into a matrilineal clan, and each person was also affiliated with a regional band. Although Cornelius Osgood wrote that Dena'ina society was composed of two "classes," an "aristocracy" and "commoners" (as well as slaves) (1937:131), there was some mobility between these social categories. It is more informative to view traditional Dena'ina social organization as composed of a set of ranked statuses that can be grouped as leaders or followers. Men and women classified as *qeshqa* and *qiy'u*, respectively, were leaders, and their children, *jiggi*, shared the high rank and privileges of their parents. Women were not *qeshqa*, but the term *qiy'u,* or "rich woman," indicates that women's roles were stratified or ranked, just like men's (Ellanna and Balluta 1992:269–270). Other members of the clan, household, village, and regional band were the followers of the *qeshqa*, called *ghelchiłna*, "members of a clan" or "working people," or *ukilaqa,* "his clan helpers."

Upper Inlet Dena'ina elders asserted that the *qeshqa* "owned" the *nichił*, the multifamily dwelling whose inhabitants worked together to harvest fish, wildlife, and wild plants. As Shem Pete explained, "Whoever had this big *nichił*, he was the boss." The *qeshqa* built the *nichił* in a location associated with his clan, and people living in the house were related to the *qeshqa* by clan membership or through marriage. As an example, when discussing Wasihdi Tukda, a nineteenth-century *qeshqa* at Alexander Creek, Dena'ina elder Shem Pete explained, "All the relations [*ghelchiłna*] of a rich man were his people. He was the captain, the boss."[2] His son, Billy Pete, added, "They had one main boss, like at the mouth of Red Shirt Lake, [the village named] *Tanłtunt*. He was the main boss. Whatever he said, that got to go."

Dena'ina elders translated *qeshqa* as "rich man" but often also glossed it as "boss," "captain," or "chief." Nevertheless, elders also explained that before contact with Europeans and Americans, the Dena'ina did not have "chiefs," referring to the formal office of chief called in Dena'ina *duyeq*, which is derived from "toyen," a term introduced by the Russians. Russian Orthodox missionaries supervised the election and installation of *duyeq* in villages; as Alexandra Allowan said in explaining the term, "Priest make that." The *duyeq* were

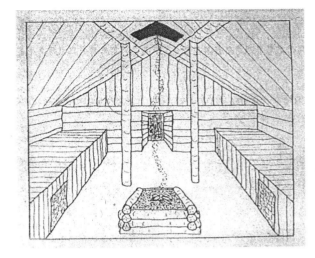

FIG 5.1b

FIG 5.1c

expected to assist agents of the Russian-American Company in the fur trade. *Qeshqa* generally exerted leadership over their kin. In contrast, *duyeq* were expected to be "village chiefs" who had authority over all persons living in a community. As the Dena'ina population dropped and people of various clans consolidated in fewer, centralized communities, such a formal leadership position was desirable. However, observers of Dena'ina communities of the late nineteenth century, such as the Russian Orthodox priest Nikita (in Townsend 1974) and U.S. Army Lieutenant Joseph Castner (1899), noted the general lack of village-wide authority of Dena'ina *duyeq*—not surprising, insofar as there was no precedent in Dena'ina communities to follow an appointed officeholder who was not one's kin. It was the *qeshqa* who remained influential and productive leaders into the early twentieth century, and the most effective *duyeq* were also *qeshqa*.

The Economic Role of the *Qeshqa*: "Master of the Cache"

According to Dena'ina oral traditions, the *qeshqa* played major economic roles in the precontact and early postcontact economy. The *qeshqa* organized cooperative hunting and fishing groups of his follower-kin, stimulated production, and directed the processing and preservation of foods. As Shem and Billy Pete said, "They had the chief, the captain, to tell them what to do" (see also Ellanna and Balluta 1992:268 and Evanoff 2010:24 for similar traditions of the Inland Dena'ina).

Fishing sites near Dena'ina villages were owned by clans. During the productive but brief salmon runs, the kin-based organization under the direction of the *qeshqa* focused available labor on maximizing the use of an abundant but temporary resource. A good example is Baytnidahen, a nineteenth-century *qeshqa* at Tanłtunt (Red Shirt Lake Village). As Shem Pete explained,

> Baytnidahen was the boss at Tanłtunt. In summer he told his *ukilaqa* to put a fish trap across the lake outlet. When they got enough fish, he told them to pull the trap out and let the fish go up to the creek. They put up lots of fish. They used that place real good. That's why there was lots of people staying there.

Shem Pete explained how *qeshqa* stimulated production by admonishing their followers to work hard if their energy slackened:

> When his helpers got tired, the *qeshqa* told them, 'You boys put up more fish in the cache.' That's why they had their own nations [clans]. The chief was the one who told people what to do. He thought it all out. How many people

and where to go. He'd tell experts to make skin boats or expert sewers to sew skins together. That was their job for that time.

The hunting of large game was also a communal effort throughout Dena'ina territory. Large caribou surrounds were constructed and maintained by kin under the direction of a *qeshqa* (Ellanna and Balluta 1992:268). He also directed the hunts. *Qeshqa* coordinated the hunting of land mammals, birds, and marine mammals by the young hunters who were his *ukilaqa*. "That way they were well organized," Billy Pete said.

In addition to organizing harvests of wild foods, the *qeshqa* amassed these harvests and then served, in Billy Pete's phrase, as "master of the cache," regulating the use of the goods produced by members of his household (his *ghelchiłna*). He periodically redistributed fish and game, managing supplies so that they would last the winter. Osgood (1937:132) wrote that the chief "shares in the success of all hunts" and distributed the food "to the needy" (see also Ellanna and Balluta 1992:269). Shem Pete said:

> The *qeshqa* was the boss, the captain, so his *ukilaqa* gave him half of it. When they killed caribou, they gave him half of everything they caught, meat and skin. That's the way they did it a long time ago. Chief, they gave him half of everything they caught. They dried the meat up real good and he save it. Maybe once a week that chief put up lots of grub and he told his wives to cook for their people. He save that, in the winter time, that dry meat, he save it, and they packed it all home for the winter when they needed it.
>
> Each family had different places. When they came back they just put the meat and stuff in with the chief's grub. The captain knew how much grub each man had and he'd tell one man in the morning, "You get this much grub and feed everybody. You get bear meat and

two bundles of fish and feed everybody in the house." The next day he'd tell another man to do that. That chief was really smart. He'd tell everybody what to do before they got up in the morning. He'd tell them what to eat. If food was low, they'd put it all in one pile and ration it out.

> Each day was somebody's turn to provide grub for the whole *nichił*. Every week or so it was the chief's turn and he put up lots of grub. They packed home everything and gave it to the chief. He gave them everything. Every week they had a real good meal from the chief.

Peter Kalifornsky (1991:209) described the *qeshqa*'s management of salmon supplies among Kenai Peninsula Dena'ina:

> Their chief would estimate how long the food supply they had put up would last. It was the rule that one day's allowance of food was a piece of dry fish as big as from the meaty part of your palm at the base of your thumb to the tip of your middle finger.

The *qeshqa*'s followers viewed this redistribution of food as generous behavior, and consequently the *qeshqa*'s reputation as a provider grew. The size of his group of followers often increased as a result as well.

The *qeshqa* was also the organizer and central figure in intervillage trade (Ellanna and Balluta 1992:269), as the following story by Tyonek elder Nickafor Alexan illustrates:

> At one time the old Chief of Tyonek was a friend with the Chief of Knik. The two chiefs had made an agreement to sell food between each tribe. The agreement was for the Tyonek Chief to sell the Knik Chief dried and smoked fish, because the Knik people couldn't catch enough. As for the Tyonek Chief,

he could trade fish for caribou hide, moose hide, and dried meat and sinew, because the Knik people lived a lot closer to the mountains where there is a lot of meat to hunt.

The two Chiefs call each other *Shluchin*, which means be friends always, no matter what came between them. Both of the chiefs had been good friends and had traded for a long time. (1981:1)

Dena'ina oral traditions reveal that wealth items, called *ghuliy*, also played a role in this intervillage trade. The following account, told by Shem and Billy Pete, is one example.

That's what they use *qeshqa* for, to tell people when to work and what to do. They knew everything. The *qeshqa* tell his *ukilaqa*, after they put up fish, "Go down to Tyonek and get oil." He gave them fur blankets and beads to pay for it. If he figured they didn't put up enough oil. They bought seal and beluga meat too. They paid for it, loaded it up, and went back to where they stayed [their winter village]. That *qeshqa* look after everything.

Through skillful trading and potlatching—through the distribution of wealth—a *qeshqa* could increase his prestige and attract more follower-kin. Not surprisingly, some of the most powerful *qeshqa* lived in villages in highly productive areas, such as Tyonek and Alexander Creek.

The Role of the *Qeshqa* in Community Life: "Paternal Guardian"

As prestigious senior clan members, *qeshqa* were agents of social control in their communities. They concerned themselves with the orderly flow of daily life and the general welfare of their followers. Osgood called this role "paternal guardian" (1937:132). A Dena'ina elder said that the *qeshqa*

served as a "general superintendent" for "the people he was taking care of." Billy Pete explained that *qeshqa* inspected the village and observed individuals as they performed their daily tasks. If he noticed someone, for example, chopping wood in a dangerous manner or carrying too heavy a load, he corrected them or instructed them to get help, because "he didn't want his people to get hurt." The *qeshqa* also assumed responsibility for training the younger members of his household, especially young men of his clan, who served as his *ukilaqa*.

Also, as the most authoritative member of his local descent group, the *qeshqa* helped settle disputes between clans. He could banish any individual who became a liability to his kin through antisocial or indolent behavior. *Qeshqa* also organized war parties (Ellanna and Balluta 1992:271), although actual leadership in battle might be assigned to skilled warriors called *edzege'en*, which Billy Pete translated as "champions."

Some, but not all, *qeshqa* were shamans and performed public curing displays. Behenatsili Tukda, a late nineteenth- and early twentieth-century *qeshqa* at Tyonek, is an example. A reputed or demonstrated connection with spiritual power enhanced the *qeshqa*'s effectiveness as an agent of social control.

Personal Characteristics of Dena'ina Leaders

Several personal qualities typified a Dena'ina *qeshqa*. First, such individuals had to be "rich" and generous: they validated their rank by distributing wealth and thereby gained prestige. For the Dena'ina, being rich did not mean simply accumulating and displaying wealth for one's own benefit. Rather, it meant managing production for the welfare of all (Ellanna and Balluta 1992:268).

A leader was also "smart." Mental agility was manifested in success in hunting, trapping, and fishing, and in a leader's knowledge of many traditional stories.

Verbal eloquence was another important quality. For example, Johnny Shaginoff, in recalling Afanasi, a nineteenth-century *qeshqa* at Knik, said,

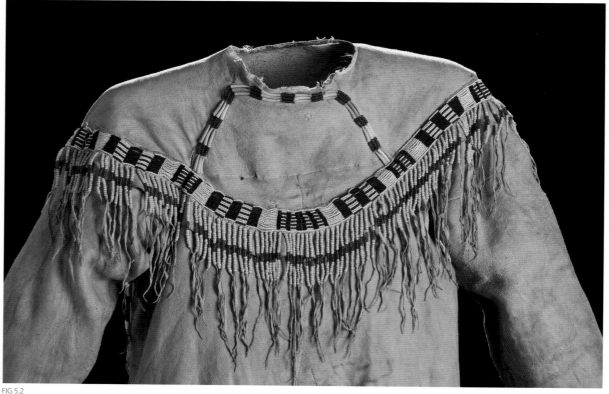

FIG 5.2

5.2 *Ukaych'uk'a*, **man's tunic, Tyonek, 1883.**
L 124 cm, W 54 cm. Caribou hide, beads, sinew, down (eagle?), ochre, fur on cuffs (otter, beaver, or muskrat?). Ethnological Museum Berlin, IVA 6147. Photograph courtesy of Staatliche Museen zu Berlin, Ethnologisches Museum. Photograph by Chris Arend.
 The extensive use of dentalium shells on this outfit suggests that it was owned by a man of high status, a *qeshqa*. This outfit is an excellent example of Dena'ina craftsmanship, with beaded designs that evoke the earlier patterns found on quilled garments. See also figure 13.15.

5.3 *Tsit'egha*, **hood, Knik River, Cook Inlet, 1883.**
L 59 cm, W 41 cm. Caribou hide, ochre, sinew, beads, dentalium shells, porcupine quills. Ethnological Museum Berlin, IVA 6150. Photograph courtesy of Staatliche Museen zu Berlin, Ethnologisches Museum. Photograph by Chris Arend.

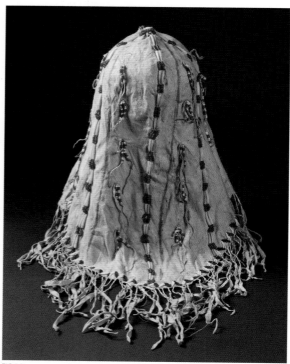

FIG 5.3

"He preached to the younger people about how to make a living. He made them get up and go."

Many *qeshqa* also had a reputation for bravery in war, and had a relationship with manifestations of spiritual power. They were "lucky" men, and their followers believed that as a consequence, they had unusually acute hunting and trapping abilities.

Insignia of Rank

Highly ranked Dena'ina individuals controlled wealth, called *ghuliy*, which they displayed as insignia of rank and also gave away on formal occasions such as potlatches as evidence of their generosity. Traditionally, wealth consisted of strings of *k'enq'ena* (dentalium shells), stored in caches or displayed on clothing or as necklaces and bracelets. Wealthy individuals also wore nose ornaments of *k'enq'ena*. "Rich clothes" made of especially valued

FIG 5.4

FIG 5.5

5.4 *Nk'itl'iɫ*, wristlets, made by Mrs. Ely Stephan, Tyonek, c. 1900–1910. L 26 cm. Wool, dentalium shells, beads, leather, shell buttons, sinew and cotton thread. Anchorage Museum, 1978.035.003ab. Photograph by Chris Arend.

These wristlets were part of the potlatch regalia that was transferred to the Anchorage Museum by Shem Pete in 1978.

5.5 *Sukna dghak*, potlatch shirt, Susitna Station, c. 1902. L 75 cm, W 48 cm. Wool, thread, shell buttons, dentalium shells. Anchorage Museum, 1978.035.001. Photograph by Chris Arend.

This decorated shirt was used in Dena'ina potlatches during much of the twentieth century. Made at Susitna Station around 1900 for Chief Evan (fig. 5.17), it was then passed down to Big Chilligan (seen wearing it in fig. 5.23). In 1930, it was potlatched to Simeon Chickalusion (seen wearing it in fig. 5.19).

furs such as marten or lynx were also signs of high status.

Privileges of Rank

In addition to the right to display insignia of rank, such as wearing *k'enq'ena* necklaces, another privilege of status as a *qeshqa* was exemption from performing routine tasks, such as chopping wood or hauling water. Another prerogative of a wealthy man was polygyny. *Qeshqa* were said to have had up to eight wives (Alexan 1965a).

Privileges of rank extended to close relatives of a *qeshqa*. A *qeshqa*'s wife was a *qiy'u*, a rich woman, who wore *k'enq'ena* and highly valued furs and sometimes assumed some of her husband's responsibilities upon his death.

Children of a *qeshqa*, both boys and girls, were called *jiggi*, a term Billy Pete translated as "prince and princess." They were "raised rich." Girls especially were pampered with special foods and were attended by several lower-ranking women, whom Billy Pete called "nurses." Male *jiggi* were primary candidates for leadership positions because they had access to training and the stories of their highly ranked kin. However, oral traditions also depict the children of *qeshqa* as "spoiled" (e.g., Chickalusion 1980) and describe the rise of orphans to "rich man" status through hard work (Alexan 1965b).

Becoming a Leader

Young Dena'ina boys were trained and toughened by their fathers and later by their maternal uncles. Following puberty seclusion, training intensified as boys learned the skills and knowledge necessary to

become successful hunters, fishers, and trappers. Young men traveled from village to village to learn from their relatives. If the *qeshqa* was impressed, he invited the boy back. Billy and Shem Pete said,

In September a rich man would take the hardworking young man to the mountains. The rich man showed him the country. 'Come back in September month and I'll show you my country,' he said. The *qeshqa* was looking for another man in case he died, to take his place. He didn't want his knowledge to go to waste.

Stories and Private Knowledge: "Picking Up Something Good"

One reward *qeshqa* offered to his young helpers was stories, as a way to "get educated." Shem Pete described this travel from village to village to learn stories as "picking up something good."

You have to hustle for everything when you are young and strong. You must go

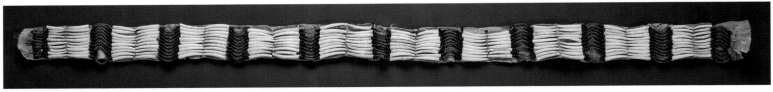

FIG 5.6

around and get rich from stories. Go from *nichił* to *nichił* and pretty soon you'll know everything. You'll become head man. But you can't learn by yourself. You can't get any place by just sitting at home.

Young men got educated by listening to stories. They made a circle to Tyonek, Kroto, Whiskey Lake, Tanłtunt, Kenai, Kustatan, Alexander Creek. For the stories, in winter they made a circle. In summer they helped put up fish. When they learned all the stories, they ran to the next place and listened until late at night. That's the way they got rich; gathered up all the stories in their heads. Going around year after year for five or six years and they get really smart.

Stories included examples of "how to get by," describing techniques for harvesting wildlife or locating resources. Key values were also imparted in stories.

But stories were not told to just anyone. Nickafor Alexan wrote,

> [In] those days people were selfish with their story. They wouldn't tell good story when someone who is not relative is around. They only tell good parables to their relations and close relation and their own family so other people wouldn't get smart from it. (1965b)

As Nondalton elder Hamushga Zackar explained to the folklorist Anna Birgitta Rooth in 1966,

That building, this birch bark house, when they built: that's rich people's. They call them rich peoples because they got everything. They got skin, moose skin, caribou skin, everything what they talked about from Alaska.... Then evening time, after supper, that rich man he got lot of workers for him. Lot of [people] work for him and he paid them. And now in the evening time after supper...then they tell stories. That's not stories, but what they gonna be, what is good, what is no good. They have to tell them what to do. (1971:85–86; for a similar story, see Alexan 1965b)

As the story continues, a poor young man lived with his grandmother in a separate house.

Then soon as he [the rich man] preached [to] those peoples, [the young man] sneak over there and remember it, and he just lay down [outside the house] and remember it, and he just listen and he wants to pick that up what he [the rich man] was telling those other peoples. To listen to these peoples so he can take it up and he can use that word.

After that, that kid was listening...and he [taught] himself what is no good. What he [the rich man] used to [tell] those other peoples, he [the boy] do that. He do what is good and he try to be [and] work like that and then, after he really was big, then he got *rich* and got a big birch-bark house. And

5.7 *T'uyedi*, dentalium shell necklace, Nondalton, early twentieth century. Dentalium shells, beads, sinew, leather. Private collection. Photograph by Chris Arend.

This is another fine example of a dentalium shell necklace. This necklace was owned by Gabriel Trefon of Nondalton and is most likely the one he is wearing in figure 5.18.

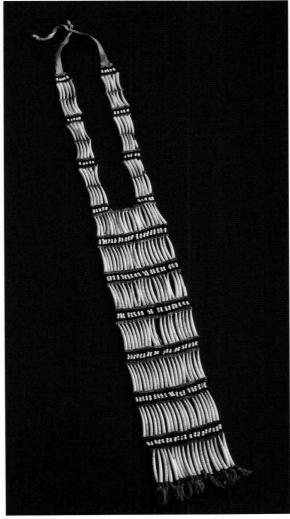

FIG 5.7

he got everything what he use, just like that man [who] was telling stories. He really [was] just like … [the rich man]. He got lots of things. And somebody work for him and he preached to those people every evening.

Wealth-bringing Beings

Traditional stories told by *qeshqa, qiy'u,* and other elders also instructed their young relatives about

spiritual power and proper ways to interact with wildlife and fish so as not to offend them and lose one's luck. Stories and other oral traditions also included information that could make one "lucky" or "rich" by obtaining the goodwill of powerful, wealth-bringing beings called *k'enu qubideł'ishi*, "sources of good luck," or, as Billy Pete translated it, "lucky charms." Nickafor Alexan wrote:

Olden days, they didn't know anything about God. But they know some body in the sky who watch all the good boys and girls and bad boys and girls. If he see any boys or girls ran out of the house very early in the morning he throw them some good thing they are going to use in their future. That mean if boys and girls working all the time and early bird they have a good future a head of them. And if he see some boys and girls come out late and slow, he throw them some raggedy clothes. These children has always bad luck in the future.

This uncle see that his nephew have good fortune ahead of him. So he told his nephew to look on top of the house when he go or ran out in the morning. Well this young man want to know why his uncle told him to look on top of the house. So he always wake up more early, ran out always look on top. One morning early he ran out and look on top of house, he saw something like snow man. Then he know what this uncle mean. He sneak up and grab it. And this thing try to get away but he held it tight. His uncle heard the commotion and said to him, "Nephew hold him, hold him." Well his holding it. Pretty soon this object just disappear into him. Then his uncle come out and took him in the woods just short distance and told him to take a bath with snow. Which he did. And put him away for one hundred days, first five

days without water, ten days without eat. He didn't let him work or walk around for hundred days.

I learned this young man became richest man when growing up. (1965b: 13–14)

This "snow man" is probably the being that Peter Kalifornsky called Neli Qelch'eha, the "Steambath Spirit":

> The steambath spirit, that too brings them good luck, they say. People who will have fortunate lives are the only ones who see it, they say. In the steambath house, where the rock pile is, there it would come up, and they would grab it and hang onto it. And it was absorbed into them.
>
> Its flesh is like jelly, it seems, and it doesn't have arms or legs, it seems. It has no bones, either. And it is gray. (1991:53)

As explained by Maxim Chickalusion Sr., senior relatives could assist young people in obtaining luck:

> Some people got rich from seeing things and others got rich from others doing it [performing ritual observances] for them. One little boy was sitting on the beach with his mother. They were poor. A beetle, *naqedalyasi*, crawled up from the water and crawled on the baby. She killed it on his chest, dried it, put it in a sack, and put it away for him. When he grew up it was like wearing a cross. After his mother died he got rich and made a potlatch. He then showed it to the people and he said, 'This is what made me rich. My mother did this for me when I was a child.'

Katherine Nicolie told a similar story:

> Somewhere along Turnagain Arm, a middle-aged woman with a baby boy

He sneak up and grab it.

FIG 5.8

5.8 "He sneak up and grab it." An illustration by Diane L. Theide from Nickafor Alexan's story showing the rich man's nephew grabbing a wealth-bringing being that resembled a "snow man." This may be the Neli Qelch'eha, or "Steambath Spirit," which brings good luck (Alexan 1965b:13).

was walking on the beach. She heard a *tuyushi* [a muskrat-like creature] humming. It was getting close. She knew she couldn't take it for herself, for she was too old. So she took it for her baby. There were pools of water left along the beach after the tide went out. She put some water on the baby and lay it there and got a strong stick. The *tuyushi* made a noise and came out of the water, ran around the baby from the head to the other end, and peed on the baby. It ran back towards the water but she clubbed it and skinned it. She put the guts on a rock and dried the meat and skin real nice. She took care of herself [fasted] for 30 days and the little baby grew up to be really *qeshqa*. She fixed the skin and put bead work on it and when he made a potlatch for his dad, he wore that skin.

The naturalist Wilfred Osgood caught a least weasel when he visited Tyonek in 1900. He wrote:

The natives regard the capture of one of these rare animals as a piece of great good fortune. One old Indian who frequently visited our cabin told us that his brother who had caught one when a small boy had in consequence become a "big chief" and he assured me that since I had caught one I must surely be destined to become a man of great wealth and power. (1901:70)

Validating Rank

As a result of training and instruction, each young Dena'ina man ideally developed the skills, knowledge, and values to become a successful fisher, hunter, and trapper. Young men also needed to accumulate visible wealth in the form of food, furs, tanned skins, and prestige items. Even before the advent of the fur trade with Europeans and Americans, fur trapping was a means to acquire wealth. Shem Pete said,

> They used marten skins for blankets. They were pretty expensive. After freeze up young people went where there were lots of marten. They'd stay until March and then come back to their women relatives with their skins on their sleds, to make coats. That was before they started trapping for profit, before the Russians came.

If a young man was especially successful in accumulating wealth, he began his potlatching career and displayed his generosity through feasting. His prestige and reputation grew. He could marry well, establish his own *nichił*, attract followers, and become a *qeshqa*. Nickafor Alexan wrote:

> He working hard and do what he hear and make living. And then he got married to good girl. Go out hunting and get all kind of animal and fur. And making potlatch. That's what people like in those days. (1965b:14)

In the 1830s, the governor of Russian America, Ferdinand von Wrangell, wrote of the Dena'ina:

> A person who distributes his fortune to his countrymen most extravagantly during a festival receives the greatest esteem in his village and in the entire moiety; others take his advice and never contradict him. Thus originates a toyen [i.e., a *qeshqa*]; or better to say, the esteem of him. (Wrangell 1970 [1839]:11)

Several Dena'ina elders explained the formal recognition that a young man had become *qeshqa* came with marriage to a *jiggi* and, following bride service, establishment of a separate household near his father-in-law. For example, Billy Pete added the following postscript to Shem Pete's "Half a Man" story. The young man, who is the central character in the *sukdu*, had just married a *qeshqa*'s daughter.

> That boy went to work and started trapping and everything. He got rich and he made potlatch year after year. They put up lots of fish. He took the place of that *qeshqa* after he got old enough. And they had lots of kids. And they just kept carrying on and carrying on.
> *Qeshqa* liked people who worked really hard. When that young man was thirty, it was time to get married. He married *qeshqa*'s daughter and the *ukilaqa* [of his wife's father] made *nichił* for him and he was on his way to be a millionaire. The *qeshqa* wanted another good man to be *qeshqa* to carry out the tribe [clan] along for betterment, to watch out for his people.

Additional evidence of succession to Dena'ina leadership positions are *ijinen*, inherited leaders' titles that are associated with particular locations. Examples include Bentehen ("the one at Benteh"), Nitehen ("the one at Niteh"), and T'suk Qayeh Iden ("the one at Tsuk Qayeh").

Loss of Wealth: "Going Broke"

Dena'ina oral traditions about *qeshqa* reveal that their material wealth was a consequence of their hunting and fishing skills, the support of their kin, their trading abilities, their wisdom, and their generosity. But inevitably, a few rich men broke the rules and became "stingy." They are remembered as "bad men," in contrast to most leaders, who were "good men." These stingy *qeshqa* "went broke," as Shem Pete put it, as a consequence of their greed. Indeed, the perils of greed are often a theme in Dena'ina *sukdu*, such as Peter Kalifornsky's "Ch'enlahi Sukdu" ("Gambling Story") (Kalifornsky 1991:62–67).

An instructive example of a "bad" *qeshqa* is Dusgeda Tukda of Knik, whose career as a trader stretched from Russian times until about 1910. Dusgeda Tukda was a middleman between the Knik and Susitna Dena'ina and the Euro-American stores at Kenai and later at Knik. His reputation as a "bad man" resulted from his hoarding of large amounts of wealth and his abuse of his followers. Because of his reputed spiritual powers, however, people were afraid of him. But finally, his followers left him. Shem Pete attributed his fall from power to the actions of rival shamans. Almost overnight, his caches were empty. He then lived alone with his wife, with no clan helpers, and died a poor man.

The Dena'ina *Qeshqa* and the Fur Trade[3]

Trading networks, trading traditions, and an interest in wealth and prestige were well established throughout Dena'ina country when the Euro-American fur trade began in the Cook Inlet area in the late eighteenth century. As discussed, Russian trading companies established posts at Kasilof, Kenai, and, for a brief time, Old Iliamna and Tyonek. Armed resistance to Russian penetration into their territory enabled most Dena'ina to remain largely independent of direct Russian control, and they participated in the early fur trade through their *qeshqa* as middlemen. Although the Russians attempted to formalize and control these trading relationships through the appointment of "toyens" or "chiefs" (*duyeq*), the successful *duyeq* were already recognized as *qeshqa* by their kinsmen.

The role of the *qeshqa* in this trade is best illustrated through the biographies of several leaders of the mid- to late nineteenth century, as preserved in oral traditions and written records. One such *qeshqa* was Diqelas Tukda (Alexander) of Alexander Creek, who lived from about 1830 until about 1906. Diqelas Tukda was a middleman between the Russians on Cook Inlet and the Upper Kuskokwim Athabascans, the Gheltsana. Diqelas Tukda, his maternal uncle, and their clan helpers regularly crossed the Alaska Range to trade with the Gheltsana. Following is a translation of Shem Pete's account of this trade:

> Long ago, when the Russians came, Diqelas Tukda would carry around a Russian gun. With his maternal uncle, he would go to the interior Athabascans and trade with them, selling them tobacco, tea, and matches in exchange for furs. From this Diqelas Tukda became a rich man.
>
> Once Diqelas Tukda and his uncle went back to the inland Athabascans again. He carried a gun inside his shirt too. They left from Susitna and went back to those people. They went back up the Yentna River and returned to the upper Kuskokwim people. Those inland people looked really mean. 'He took too much from us,' they said. 'Let's throw him in the river.' But Diqelas Tukda found out what they meant to do. His uncle knew the inland people meant to throw him in the water too.
>
> For two nights he walked around the fire, scowling and poking up the fire with a stick. Thus he kept walking around the fire. When they got really mean he took out the gun he had inside his shirt and shot through the smoke hole. Then the people would cry, "The sky is breaking! The sky is breaking!"

Then they would hide behind the partition in the birch bark house. They became real good again. They were scared. Diqelas Tukda's uncle walked around the fire and put powder in the gun. He covered up the firing pin cap. He loaded it and pulled the hammer back. Then he put it back in his shirt and kept on walking around the fire.

After two nights of this his uncle told him, "You go back. I'll stay right here. You go back." His helpers picked up everything and went back. When afternoon came he told the inland people, "That's enough. Now I too will go back."

"Good," they said.

Until he got out of arrow range he was afraid of them; his back felt hot, as he used to say.

Then he felt good again. He ran back out and kept running and running, and when it got dark he caught up with them. They traveled at night, and when they got far away they stopped at a good lookout point and spent the night. Then they knew they had escaped. When they traveled back for three days, and they had slept well, and then they got back home. When they returned, the one they call Diqelas Tukda was given the name, "The man who introduced guns to the country." (1977)

The Russian explorer Zagoskin traveled along the Kuskokwim River in 1844. His journal records examples of Dena'ina "chiefs" crossing the mountains from Cook Inlet with European goods in order to acquire beaver skins to trade at the Russian post at Kenai (1967:254, 269). As in Shem Pete's account, Zagoskin reported, too, that the Dena'ina took advantage of the Kuskokwim Athabascans. Dena'ina participation in this trade persisted until the close of the nineteenth century. For example, in 1896,

the Russian Orthodox priest Bortnovsky reported of the Tyonek Dena'ina:

> They have a good aptitude for trading and exercise their trading abilities with the multitudes of miners passing through this region. They also trade with the Iliamna Indians; in this case instead of money, they use dentalium, formerly supplied by the Russian American Company. (Townsend 1974)

The Tyonek Dena'ina, like the Susitnuht'ana, traveled over the Alaska Range to trade with the Gheltsana. The following is extracted from an Alaska Commercial Company (ACC) log entry for August 16, 1877:

> Today, the last of the Indians left here. Six men and four women going to the Colchans [the Upper Kuskokwim Athabascans]. They will trap on their way and trade with that tribe on their arrival there. They will return about the first of March. (Fall 1987:37)

Diqelas Tukda, along with other nineteenth-century Dena'ina *qeshqa*, continued also to trade directly with Dena'ina groups themselves. He traded with the *qeshqa* of Tyonek, bringing furs he acquired from inland people to exchange for European goods.

Shem Pete provided the following biographical account of Dusgeda Tukda of Knik and his middleman role in the fur trade during the mid-nineteenth century, before the sale of Alaska to the United States:

> When Dusgeda Tukda was a rich man at Knik, he bought all the fur people could trap, from Alexander Creek, Kroto, Susitna Station, Knik. In spring time he took all the fur to Kenai. He took two *badi* [open skin boat]. Those rich Russian people came aboard and packed him up. They gave him a bath and nice suit of new clothes

and everything. They set him by the table and put vodka on each side of him. He told those Russian storekeepers, 'Take bunch of grub to my people. They're waiting down at the beach.' They brought crackers, tea. His people started cooking down the beach. He stayed with the richest Russian people two days. His people packed the fur. The Russians graded them and stacked them on the floor and every place else. Two of the richest Russians, one on each side of him, held his arms. They walked around the fur. The Russians left notes on top of each pile [to indicate value]. They told him how much money he had coming. He said, 'OK, OK, OK, OK. Put it in canvas sacks and bring it to the *badi*.' He brought enough grub for two big *badis* and took it back to Knik. Flour, sugar, lard, tea, crackers, salt, rice, beans. During the winter he traded with the grub for the fur. He made millions of dollars on the fur the other poor people trapped. They came for tobacco too. He brought tobacco from the Russians and bought fur from the Indians with it. From Cantwell, Copper Center, all the way from Northway, Valdez Creek, the fur came in. For all the fur they had, he gave them grub.

During the last three decades of the nineteenth century, the ACC and other American trading firms established several posts within Dena'ina territory. The *qeshqa* responded to this challenge to their middleman role by sometimes accepting employment as "storekeepers" and agents for the traders. A good example of this is Beniła Ch'ulyałen of Tyonek, whose Dena'ina name means "the one who gathers things together," and who was known in English as Chief Pete. He was active during the second half of the nineteenth century and probably died between 1910 and 1920.

Early in his life, Chief Pete was an especially successful beaver hunter, working the areas around Beluga Lake. He had the aid of a group of clan helpers, who provided him with their catches. This *qeshqa* excelled as a trader, using most of the beaver skins and other furs his followers obtained to further his trading ventures. Elders report that his earliest dealings were with the Russians at Kenai. From them he obtained copper implements, clothing, and tea, which he brought to the Susitna Dena'ina to exchange for furs. He also exchanged subsistence products, such as beluga oil and seal oil, for furs. For the late nineteenth century, an excellent record of Chief Pete's activities is contained in the journals of the ACC agents. In fact, the priest Bortnovsky commented on this man's close relationship with the traders. On June 16, 1896, he wrote,

> The chief of the village of Tyonek, Peter Inyhliachuliahlan, is a milk-livered man and is ready to dance to the storekeeper's pipes, especially when he sees some profit to himself. (Townsend 1974)

However, a careful reading of the ACC journals reveals that Beniła Ch'ulyałen was not controlled by any trading company. In fact, he shifted his allegiance from competitor to competitor in order to gain higher prices for his furs. A brief review of his career illustrates this quite well.

In 1885, George Holt, the ACC trader at Knik, was killed by a Copper River Indian. The ACC agent at Tyonek sent Peter to Knik to temporarily look after the store and to trade. The agent later recorded that all was going well at Knik. In the fall of 1886, the new agent at Knik attempted to hire this *qeshqa* as an interpreter, but Peter soon left to trade for beaver furs along the Susitna River for an ACC rival. In December 1886, Peter acted as an agent for a third trading firm.

In 1889, the ACC agent at Tyonek finally managed to acquire the services of Beniła Ch'ulyałen, who ran the post while the agent was ill. Later that year, he declined an offer from the ACC to trade for them with the Susitna Dena'ina, who at this time

were the major suppliers of furs to the Tyonek post. Instead, Chief Peter became an agent for yet another ACC rival. The following fall, September 1889, the Tyonek ACC agent again obtained the services of "Chief Peter" for himself. He outfitted him with trading goods and sent him up the Susitna River, where the *qeshqa* built a store, becoming the manager at this new outpost. He performed this role well for about one year. Thus, as a free agent, Beniła Ch'ulyałen throughout his career took advantage of commercial rivalries, and his talent in trading enabled him to remain a "rich man."

Beniła Ch'ulyałen used the wealth he obtained in his trading ventures to enhance his prestige. According to oral traditions, he distributed wealth to "poor people" in Tyonek. He is also remembered in oral traditions as an excellent organizer of subsistence activities and a concerned provider. For example, in the 1890s the early salmon runs around Tyonek were poor. Chief Pete and his assistants acquired fish heads from a commercial fish processor. He instructed his followers to dry them for winter.

Some Twentieth-Century Dena'ina Leaders

The formal role of the Dena'ina *qeshqa* weakened in the early twentieth century (Fall 1987:52). Diminished fish and wildlife populations, a declining fur trade, and the severely reduced Dena'ina population undermined opportunities to accumulate and distribute the wealth needed to acquire the prestige that the achievement of *qeshqa* status demanded. Additionally, new political institutions arose as the non-Dena'ina population throughout much of the Dena'ina homeland grew. Nevertheless, leadership roles persisted in Dena'ina communities, based to a large degree on the values and abilities that *qeshqa* and *qiy'u* represented. Following are a few examples of well-known and effective Dena'ina leaders of the twentieth century.

Gabriel Trefon

Ellanna and Balluta provide a biography of Gabriel Trefon (1897–1964), one of the last traditional chiefs of Nondalton (see figure 5.18). He is remembered as a man "who could see into the future" (i.e., he had foresight), but he also had considerable knowledge about traditional Dena'ina ways of living. Nondalton people recall that it was the responsibility of the chief "to make sure that everyone had enough and that people would help one another. It was the chiefs, they say, who solved problems in the community." Gabriel Trefon was a skilled hunter and trapper, a commercial fisherman, and an innovator—he was the first Inland Dena'ina to own an outboard motor, a Coleman lamp, and a snowmachine. When "first chief" Zachar Evanoff passed his leadership role to Alexie Balluta in 1930, Gabriel Trefon became "second chief" of Nondalton. He succeeded to the position of "first chief" in 1947. Soon after his death, the leadership of the community was turned over to a council and a mayor (1992:277–283).

Simeon Ezi

Simeon "Basdut" Ezi (1870–1935) was the *qeshqa* at the former village of Niteh, at the mouth of the Knik River (see figure 5.15). According to Shem Pete, Ezi succeeded to this leadership position after the "rich man" at Niteh, Nitehen, died (Kari and Fall 2003:293). In 1920, Ezi was recognized as first chief at Eklutna after the death of Chief Nicholai (*Anchorage Daily Times,* January 22, 1935). He was known as an excellent hunter and fished for many years at Nuch'istunt (Point Woronzof). According to his granddaughter, Alberta Stephan (in Kari and Fall 2003:295), Simeon Ezi "was the last recognized chief of Upper Cook Inlet. He was the chief of the Natives. Simeon Ezi inherited a document that was given by the dominating foreign people stating that he was in charge of the Natives of Upper Cook Inlet." Simeon Ezi was buried in the Anchorage Cemetery when he passed away in January 1935.

Mike Alex

Mike Alex (1908–1977) was the last traditional chief at Eklutna (see figure 5.27). He was known as a hard worker, a skilled fisherman and hunter, a fine storyteller, and an excellent teacher. In the 1950s, Mike

Qeshqa

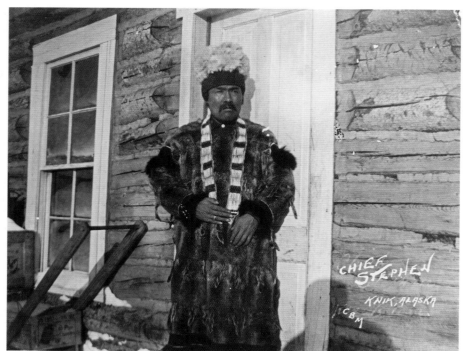

FIG 5.9

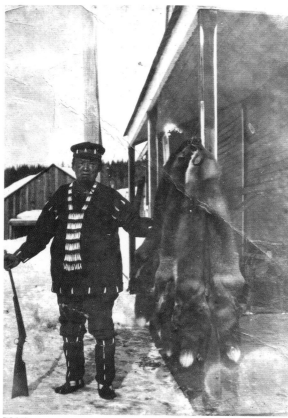

FIG 5.10

FIG 5.11

5.9 Chief Vonga Bobby of Lime Village cutting fish in the Stony River across from Lime Village in the late 1970s. Photograph courtesy of Priscilla Russell.

5.10 Chief Affansi of Sunrise, Alaska. This photograph was taken in the early twentieth century and shows the leader of small band of Dena'ina that utilized the Turnagain Arm area. In addition, this photograph is the only known visual record of Dena'ina clan face painting. Debbie Fullenwider Collection, Cook Inlet Tribal Council. Photograph reprinted by permission of Cook Inlet Tribal Council, Inc.

5.11 Chief Stephan of Knik. Chief Stephan is shown wearing a ground squirrel parka, headdress, and dentalium shell (k'enq'ena) bandolier in this late nineteenth-century photograph. Louis Weeks Collection, Anchorage Museum, B2003.019.149.

FIG 5.12

5.12 Chief Wasilla of the Wasilla area. The town of Wasilla takes its name from this man. "Wasilla" is a corruption of the Russian name Vasili. Chief Wasilla died in August 1907. Robert Wheatley Collection, Anchorage Museum, B1982.052.273.

5.13 Chief Ephim of Susitna Station. Chief Ephim was the last Dena'ina *qeshqa* from Susitna Station, serving from 1911 to 1915. Mike Alex Collection, Anchorage Museum, B1980.098.52.

5.14 Chief Talkeetna Nicolie of the Talkeetna area. Chief Nicolie is shown wearing a fur coat in this 1916 photograph, taken by Sydney Laurence. Based on two photographs taken at the same time, the men in the background are either building Chief Nicolie a new house or dismantling his old one, which had to be torn down to make way for the Alaska Railroad. Pyatt-Laurence Collection, Anchorage Museum, B1983.146.104.

FIG 5.14

FIG 5.13

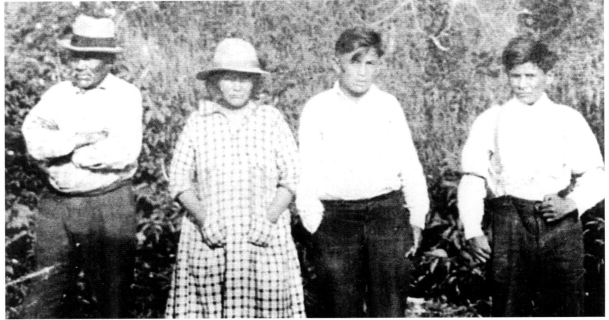

FIG 5.15

FIG 5.16

FIG 5.17

5.15 Chief Simeon Ezi. Chief Ezi (left, wearing hat) was the Dena'ina leader from Niteh (a village on an island near the mouth of the Matanuska River) and later moved his family to Eklutna. Chief Ezi was known to many of the early Anchorage settlers, and his death in 1935 was covered in the local newspaper. Chief Ezi is buried in the Anchorage Cemetery, where a gravestone was recently erected in his honor. Photograph courtesy of Alberta Stephan.

5.16 Chief Evan of Susitna Station. Chief Evan was both Shem Pete's and Chief Ephim's older brother and served as a cultural broker during the early twentieth century. Photograph from Frederick A. Cook, *To the Top of the Continent* (1908), p. 30.

5.17 Chief Eklutna Alex. Chief Alex was baptized Alec Vasily, acquiring the name "Eklutna Alex" later from railroad workers. He was the last shaman in Eklutna and father of the last chief of Eklutna, Mike Alex. Debbie Fullenwider Collection, Cook Inlet Tribal Council. Photograph reprinted by permission of Cook Inlet Tribal Council, Inc.

5.18 Chief Gabriel Trefon. In 1947, Gabriel Trefon moved up from second chief to first chief when Chief Balluta became old and blind. Chief Trefon is shown with a headdress, dentalium shell necklace, and puffin beak rattles in this photograph, probably taken by Harlan Williams in March 1960. Agnes Cusma Collection, courtesy of the National Park Service, NPS H-988.

5.19 Chief Simeon Chickalusion. Chief Chickalusion was born in Tyonek, grew up in his father's village, Kustatan, and later moved back up Cook Inlet to Tyonek. He became chief following the death of Chief Chilligan and inherited the shirt and dentalium necklace that had previously belonged Chief Chilligan (shown in figure 5.5). Chickalusion Collection, Tyonek Image 40. Courtesy of the Alaska Department of Fish and Game.

FIG 5.18

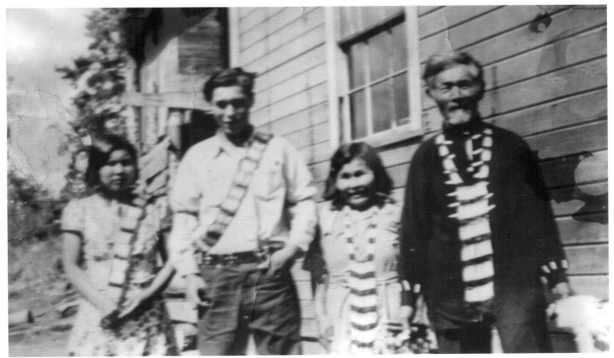

FIG 5.19

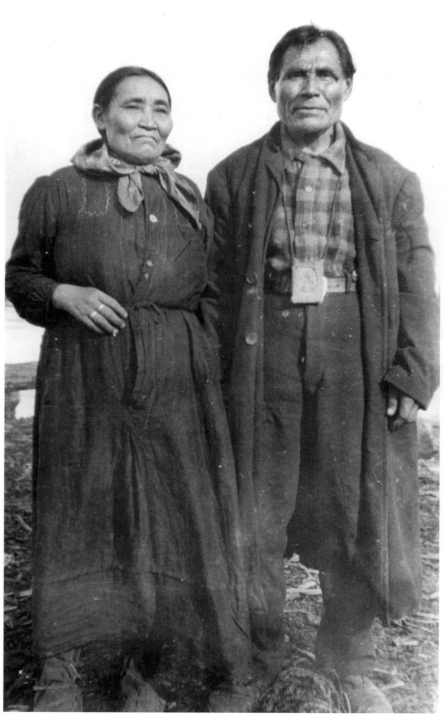

FIG 5.20

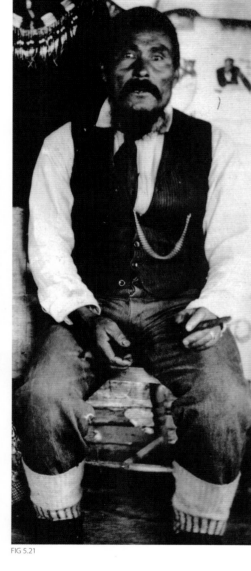

FIG 5.21

5.20 Chief Evon Constantine. Chief Constantine, the leader for the Lime Village/Qeghnilen Dena'ina during the 1930s, is shown in a photograph taken by Anton Balluta in 1930. Sophie Balluta Austin Collection, courtesy of the National Park Service, NPS H-447.

5.21 Chief Zackar Evanoff. Chief Evanoff was the leader of the Kijik Dena'ina from the 1890s to the 1930s. He oversaw the move of his people from Kijik, which was devastated by the 1900 flu epidemic, to Old Nondalton, and was the last resident to leave Kijik in 1909. Arthur Stanley Tulloch Photograph Collection, Alaska State Library, P148-76.

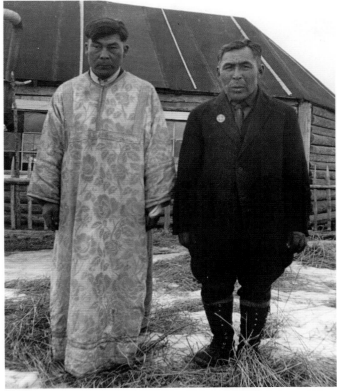

FIG 5.22

5.22 Chief Alexie Balluta. In 1930, Chief Balluta (right) moved up from second chief to first chief of the Kijik Dena'ina at the urging of the Russian Orthodox priest, who was concerned since Chief Evanoff had become very old and blind. The Dena'ina chief served as the main liaison with the priest concerning religious matters in the village. John Lee Collection, courtesy of the National Park Service, NPS H-500.

5.23 Chief Chilligan. Also known as Chilligan Phillip or "Big Chilligan," Chief Chilligan was from Susitna Station and became the chief of Tyonek in the 1920s. In this photograph he is, wearing the potlatch shirt shown in figure 5.5. Photograph courtesy Alexandra Allowan Collection.

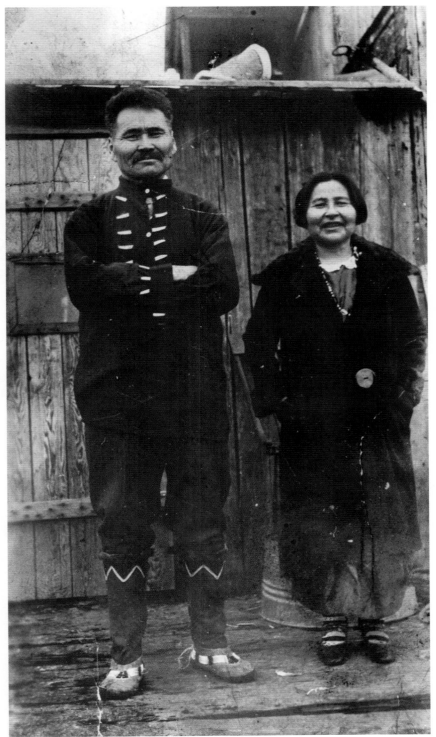

FIG 5.23

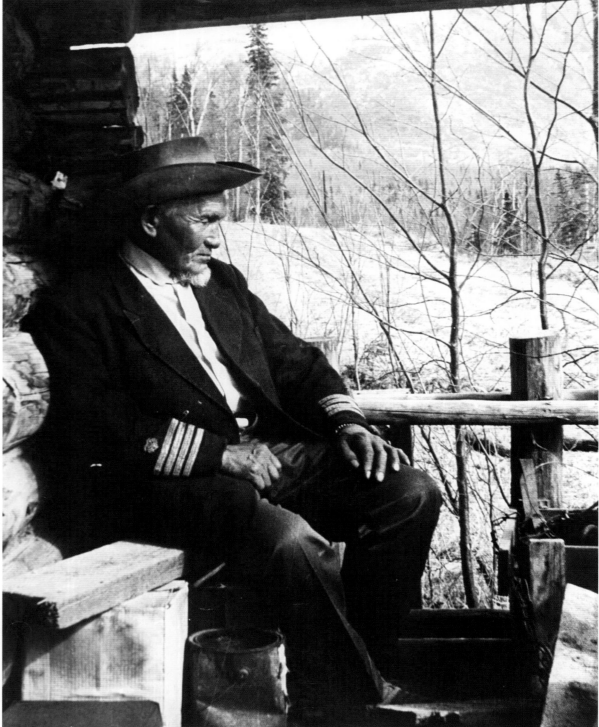

5.24 Chief Billy Ezi. Chief Billy Ezi was the last chief of the Niteh band of Dena'ina. In 1951, he filed a claim with the U.S. Indian Claims Commission in an attempt to gain land for his people. Photograph courtesy of Alberta Stephan.

FIG 5.24

5.25 Chief Chijuk. Chief Chijuk (Curly Hair), center, was the Dena'ina chief for the Kroto Creek Dena'ina. Chijuk and his family were the last residents of Kroto Creek. After his death in the late 1930s, the rest of his family moved to Point Possession. Photograph courtesy of the Alexandra Allowan Collection.

5.26 Chief Theodore Chickalusion. Theodore Chickalusion was the last chief of Kustatan and the older brother of Simeon Chickalusion. Chickalusion Collection, Tyonek 37, courtesy of the Alaska Department of Fish and Game.

5.27 Chief Mike Alex. Chief Mike Alex became the last chief of Eklutna after the death of his father, Eklutna Alex, in 1953. For many years, he was well known as the caretaker of the Eklutna St. Nicholas Church and cemetery. Photograph courtesy of Marie Rosenberg.

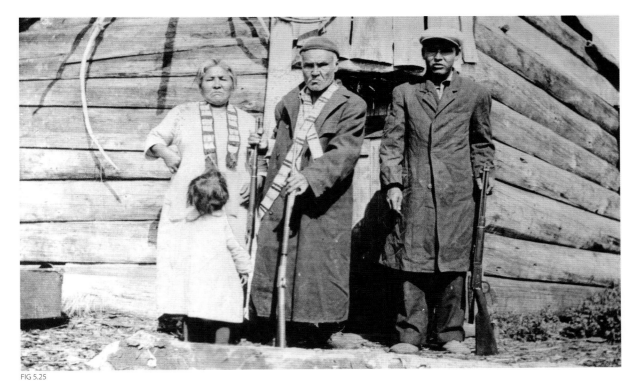

FIG 5.25

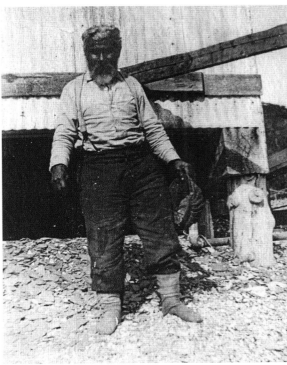

FIG 5.26

FIG 5.27

Alex and his sons built a new church in Eklutna and restored the cemetery. In addition,

> Mike had a chief's concern for the future of the Dena'ina people. He would advise the young Dena'ina about their personal affairs. He would call and visit the sick and elderly, telling them of church activities and other news. (Kari 1978:6)

As he had in 1959 for Simeon Chickalusion's memorial potlatch (see below), Shem Pete composed and performed a mourning song in honor of Mike Alex, his "big younger brother" (*shkelaka'a*), at his funeral (Kari 1978).

Simeon Chickalusion

Perhaps the best-known Dena'ina leader of the twentieth century was Simeon Chickalusion of Tyonek (1880–1957) (see figure 5.19). He was born in Tyonek in 1880 but lived in Kustatan, where his father was chief, into the 1920s. Nickafor Alexan wrote of Chickalusion's leadership qualities,

> I would say he was a very good rustler and hard working man. In 1931 our chief Chilligan Phillip died. Chickalusion became our Sixth Chief of Tyonek. To me he is best man for Chief because he understand everything. He talk English, he talk Russian good and he talk very good in our native language. (Alexan, n.d.)

In 1930, Chickalusion organized the relocation of Tyonek to its present site to avoid flooding. Nickafor Alexan recalled,

> After the village was complete we elect Chief Chickalusion for our Governor. He organize Constitution and by law and charter for the village. With that we borrow eighteen thousand dollars from Government to buy stockholder store for the community store. With Chickalusion advice we bought

> caterpillar tractor, sawmill, projector show, wood saw. (Alexan n.d.)

In 1934, Chickalusion invited the last Susitna Station Dena'ina to move to Tyonek. Both villages had lost many people in the 1918 influenza epidemic, and Chickalusion believed the communities would be stronger if they joined together. Simeon Chickalusion also served as one of Cornelius Osgood's major respondents for his *Ethnography of the Tanaina* (1937).

Billy Pete recalled Chickalusion's "paternal guardian" role as Tyonek's chief:

> Chickalusion was chief down here. Don't matter what it was—if you wanted cup of tea, or if you needed a hand, for anything at all, he'll get right out there and help you. Don't matter what it was. He'll get right out there and help you. He'll boss the whole thing—how to build a house. He'll just walk around and tell everybody how to do things. If somebody didn't know anything about how to do a certain job, why he'd go and tell them how to do it. And they did it that way. (in Kari and Fall 2003:59)

Simeon Chickalusion died in 1957. In 1959, Shem Pete hosted Simeon Chickalusion's memorial potlatch in Tyonek and performed a mourning song he had composed in Chickalusion's memory. Shem Pete inherited the *ghuliy* (wealth) that had signified Chickalusion's role as a *qeshqa*: a beaded wool shirt (*sukna dghak*), a dentalium shell necklace (*t'uyedi*), dentalium shell wristlets (*nk'itl'ił*), puffin beak rattles (*ch'dulałi*), and an eagle feather headdress (*chijeł*) (Kari and Fall 2003:60, 115–117).

Dena'ina Leaders in the Twenty-First Century

Dena'ina leadership in the twenty-first century takes many forms. Some leaders hold offices in the regional and village corporations established by ANCSA (Ellanna and Balluta 1992:273–275). Leaders are

also members of the tribal councils that govern each Dena'ina community, although none of the Dena'ina tribes any longer has the formal office of "chief."

Elders who are traditional culture bearers are also important leaders in twenty-first-century Dena'ina communities. In some ways, they most resemble the Dena'ina leaders in the past in sharing their knowledge and wisdom in the form of traditional stories and survival skills with new generations.

Notes

1. This essay is based primarily on Fall (1987). Other sources are noted where appropriate.
2. Unless otherwise indicated, quotations from Shem Pete, Billy Pete, Maxim Chickalusion, and Katherine Nicolie are from interviews conducted by James A. Fall in 1978 and 1979.
3. This section is based on a lecture presented at the annual meeting of the Alaska Anthropological Association, March 2, 1985, Anchorage.

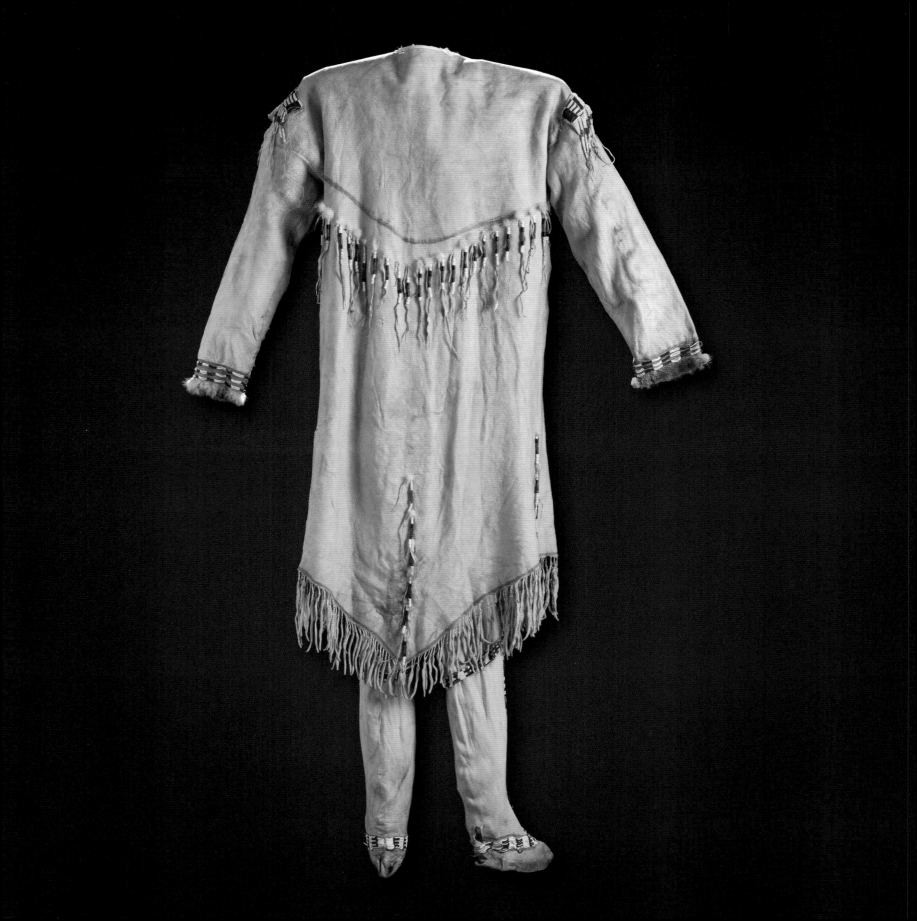

6

The Nulchina Clan Origin Story of the Upper Inlet Dena'ina

Told by Shem Pete, with assistance from Billy Pete
Transcription and commentary by James A. Fall

This conversation and the story that followed occurred during one of my first visits to Shem and Billy's home at Nancy Lake, Alaska, on September 28, 1978. We were still getting acquainted. I brought up the topic of clan membership because I thought it would provide a good background for our discussions of leadership, social organization, and subsistence. Most of the discussion took place in English.

Traditionally, every Dena'ina person was born into one of about fifteen exogamous, matrilineal clans. *Matrilineal* means descent through the female line: each child belonged to his or her mother's clan. Every clan was named, and the origin of most was explained by a story. The clans themselves were grouped into two "sides" or moieties that were also exogamous; people belonging to different clans within the same side could not marry each other. The moieties themselves did not have Dena'ina names, although the Ahtna, the Athabascan neighbors of the Dena'ina in the Copper River basin, call the moieties "Seagull" and "Crow" (i.e., raven) (de Laguna 1975:89). Besides regulating marriage, Dena'ina clans held rights to the use of certain fishing sites, hunting areas, village locations, inheritance of leadership positions, and features of personal adornment (see Fall 1987:39). The conversation is transcribed from Alaska Native Language Center tape 1A: 282–330 (ANLC Ti 4[4[), which is housed at the Alaska Native Language Center.

The Origin of the Nulchina Clan

JF = Jim Fall *SP = Shem Pete* *BP = Billy Pete, Shem's son*

JF [To Shem] You're Nulchina, right?
SP Nulchina, yeah.
JF Then your mom was Nulchina?
SP Nulchina, yeah.
JF How about your dad, then. What was he?
SP K'kalyi nation [i.e., clan].
JF [To Billy] You're K'kalyi too?
BP Yeah.
SP I'm Nulchina. Come down from the sky.

BP All over, [from] Copper Center, probably around half of the Yukon River, and Stony River and Iliamna Lake, you go around and you'll find bunch of K'kalayi [and] Chishyi. They're all related to me somehow or other.
SP My relation's Tulchina. Tulchi, out of the water. They get them from the water, all of us.
BP There's two tribes belong to each other— Nulchina and Tulchina.

FIG 6.1

6.1 Shem Pete, a member of the Nulchina clan, at his cabin in Willow in the late 1960s. Photograph courtesy of Knik Tribal Council.

JF Tulchina and Nulchina belong to each other?

SP Yeah, they're two brothers. Just like brothers.

BP On my side, I don't know how many of them.

SP Ggahyi, Chishyi, K'kalyi. I don't know how many more.

JF There's two sides, then?

SP Right. Oh, they were trying to go make a war with us, because, K'kalyi, Chishyi, they got more people than we are. So we, Tulchina, first they get 'em. Then, their relation up in the air—they called them up. They told them to come down and help us. They coming down, just like an airplane. "Bzzzzzzz"— they're coming down. Big bunch of them Nulchina. That's we. We're going to help the Tulchina. That's my part too. So we help each other; pretty soon we are more people than them people. They said, "We can't get along

that way," because they're ready to fight, you know. "Let's go get married to each [other's] sisters." So, [they became] brothers-in-law, *shtlen* ["my brother-in-law," man speaking]. They tell each other [that]. They say, "OK." They did that. They got married to the sisters. They're brothers-in-law, just like brothers then. So they don't fight. [to Billy] That's why you people are alive yet. They were going to clean the whole nation out. They didn't. They married to their sisters. [They were] brothers-in-law, just like brothers then. They came together, mixed all pretty good, you know. [Then] they lived just like one people, you know.

Some Related Traditions

In his *Ethnography of the Tanaina,* Cornelius Osgood (1937:130) related a similar Dena'ina story about the origins of the Nulchina as the "north star people." Osgood heard the story at Eklutna. The daughter of a Chishyi rich man (*qeshqa*) was kidnapped by a man from the North Star. A war ensued, which ended when the Nulchina and Chishyi leaders agreed to marry each other's sister.

Peter Kalifornsky (1991:204–205), a Dena'ina writer from Kenai, in his story *"Dena'ina Qulchilch"* ("The Dena'ina Clans") recorded that the Nulchina, the Sky Clan, lived on a frozen cloud that drifted over Susitna Mountain (Dghelishla), where they landed after the frost melted away from under them. The clan members then traveled down Cook Inlet, where they met and named the other clans.

Frederica de Laguna (1975:95–96) related the Ahtna story of the origin of the Naltsina clan, which came down from the sky at either Taral or Tazlina Lake and engaged in a war with the Tcicyu (Dena'ina Chishyi) on behalf of their relatives, a clan called the Dits'i'iltsiine.

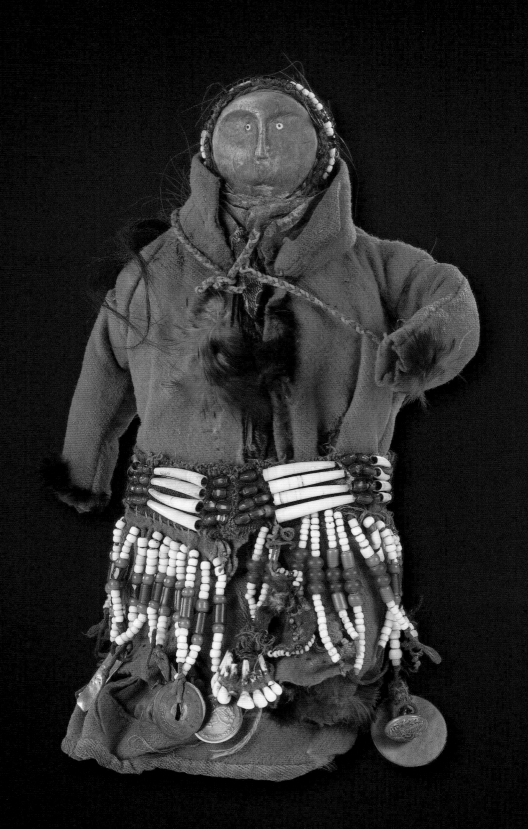

7

"What Is Good, What Is No Good": The Traditional Dena'ina Worldview

Alan Boraas

Introduction to the Dena'ina Worldview

The traditional Dena'ina worldview, like the worldview of any culture, is a lens through which people interpreted the world around them, gave meaning to life, prioritized activities, defined order, and interacted with the supernatural. Describing any culture's worldview is complicated; differences in gender and age and the ongoing negotiated meaning of life are among the complex factors that structured and restructured worldview. In this essay, I give a general overview of traditional Dena'ina worldview based primarily on mythology or *sukdu* (traditional stories) to provide a glimpse into the past that is vital to understanding the cultural history of this place. The stories are invaluable for their insight because that is how the Dena'ina traditionally expressed and passed on their worldview. In 1966, Hamushga Zackar, then about eighty years old, told Anna Birgitta Rooth,

> In the evening time, after supper ... then they tell stories ... what they gonna be, what is good, what is no good.... This is what old peoples told us. This is the [gift] of the stories.... A story [that tells] what we supposed to do, we always do ... after we get old, then we have to try to tell stories to young people.... We have to learn to listen to stories all the time. (1971:85–87)

We should be cautious, however, since the stories are not a simple blueprint of life easily translated into Western thought. Dena'ina scholar Peter Kalifornsky wrote of traditional Dena'ina,

> They feared evil and they were energetic, and they always had hope. They had belief. In the stories there are things beyond explanation that cannot be understood. (1991:73)

Through recordings, writing, and translation, we too can "learn to listen to stories," although not in as meaningful a setting as in the evening in the cabins of the ancestors, and we should not pretend to understand it all.

The world as construed by the Dena'ina can be thought of as having multiple dimensions, some similar to those of Western culture and some quite different. These dimensions consisted of the human body and the animating force of the human spirit or soul, ancestor spirits, animals and plants and their spirits, spirits of place and power, and Naq'eltani, a named universal essence. Souls and spirits form the basis of the Dena'ina worldview in all dimensions. Kalifornsky describes the spirit- or soul-like essence of existence when he writes, "Whatever is on this earth is a person [has a spirit] they used to say" (Kalifornsky 1991:13). The various types of spirits and souls emerged during different time periods, which to the Dena'ina are "the time when the

animals could talk," "the coming of the campfire people," and "after the whites came" (Boraas and Peter 1996:191).

Animals and Plants

"The time when the animals could talk" refers to a time before human time when animals formed societies and communicated with one another (Rooth 1971:47). The Dena'ina organized the biological world into four categories, each named for the dominant species in that category (Russell and West 2003:49–51). Warm-blooded animals are termed *ggagga*, which is also the name for brown bear. The two subcategories of warm-blooded animals are mammals, also called *ggagga* (brown bear), and birds, called *ch'ggaggashla*, "someone's little creature," which was also the name for chickadee. Birds are further divided into winter birds, *hey ch'ggaggashla*, the birds that stay year-round, and summer birds, *shan ch'ggaggashla*, the migratory birds, some of which nest in Dena'ina territory during the summer, like ducks, and some of which pass through to nesting grounds elsewhere in the north, like snow geese. Fish are another primary category and are called by the generic name for salmon, *łuq'a*, the primary subsistence food throughout the region. Insects are called *ggih*. Last, plants are named for the most important tree, *ch'wala*, or spruce.

Animals and plants formed partnerships as described in the origin story, "When the Animals Divided into Pairs" (Kalifornsky 1991:78–79). Other stories expand on this idea, with animal partners interacting in scenarios meant to convey a message; some examples are "Porcupine and Beaver" (Kalifornsky 1991:110–111) and "Lynx and Wolverine" (Tenenbaum 1984:34–47). Animal and plant partners interacting during the time when the animals could talk foreshadowed the reciprocal alliances that later formed the basis of Dena'ina society (see Osgood 1937:138–139).

Many Dena'ina stories involve Raven, usually in consort with other animals. Raven has several names in Dena'ina. The more formal Ggugguyni,

"the creature," and Delgga, an onomatopoeic rendition of one of Raven's calls (Kari 2007:35), are sometimes referred to with grammatical structures that are reserved for humans, testimony to the importance of Raven, who appears as a dreamer (*qatsitsexen*) in stories related to cultural charter (see Rooth 1971:87–88; Kalifornsky and Boraas tapes, February 3, 1990). Human dreamers initiated cultural practices (Boraas and Peter 1996:186), and Raven as a dreamer also originated many cultural practices that seem to be derived from some other powerful spiritual source: in other words, Raven is the translator of the practice, not the creator. In the "Raven Story," the narrator states, "And they told stories about Raven, how smart he is, and how foolish too" (Kalifornsky 1991:87). Another word for Raven, Chulyin, translates as "Shit Eater" and bespeaks of the foolish trickster component of Raven. In many stories, Raven as Chulyin appears as the paradoxical reverse of what is expected: he's bad when he should be good, mean when he should be nice, and stupid when he should be smart. For example, in one story Raven is supposed to be hunting but instead steals from a food cache and gorges himself. The people find him and cut his head off, but he comes back to life (Rooth 1971:44, 58). Traditional Dena'ina usually chuckle after the telling of such a raven story, indicating the events are to be taken as the opposite of what they appear and are an instance of all things, Raven included, having a good and a bad element.

Plants also formed a society. *Ch'wala*, the spruce, was the primary nonfood plant used for buildings, tools, and firewood for heat and cooking, but all the trees were used one way or another. More than eighty edible and medicinal plants were harvested by the Dena'ina, and these formed an important part of nutrition and health (Russell 1987). Russell (1987:22–23) indicates that partner plants had similar characteristics, such as the rose and devil's club, partnered because each is thorny.

The tangible component of the natural world was characterized by cause-and-effect relationships between phenomena that were intimately known to the Dena'ina, who were keen observers of nature.

7.1 Pete Bobby with his hunting dog searching for caribou thirty miles upriver from Lime Village, early 1980s. In the traditional Dena'ina worldview, humans and dogs are partners. Photograph courtesy of Priscilla Russell.

FIG 7.1

And, like other Athabascans, the Dena'ina believed that animals were aware of human thoughts, words, and actions. Animals could sense human events that left a "scent" (*beggesh* or *beggesha*) at a place or on an artifact (Boraas and Peter 2009:215, 217). Moreover, animals were willful both individually and collectively and could choose to offer themselves to hunters who held the proper attitude, spoke correctly, and practiced the proper hunting and butchering practices. But if humans sent the wrong message by being sloppy in butchering practices or arrogant in the hunt, animals could choose to withdraw and not allow themselves to be killed for food (Kalifornsky 1991:120–121). Humans ultimately had a controlling agency in their own survival if they were circumspect in their thoughts, words, or actions. Animal society was considered co-equal to human society, and the interaction between humans and animals was a continual negotiation that gave stability to the ecological order.

The bones and carcasses (if there was anything left, since most of the animal was used) of animals killed and eaten were ritually disposed of. The bones of water animals, such as fish, were disposed of in a stream, and land animal bones were burned in a hearth (Boraas and Peter 2009:220–221). This sent the animal's spirit to a reincarnation place presided over by K'unkda Jelen, the "Mother of Everything Over and Over," where the properly treated animal "put on its clothes again" (Kalifornsky 1991:45), that is, became an animal again and returned to the human land. The practice ritualized ecology and, in effect, returned important ocean-derived nutrients from anadromous fish back into the stream ecosystem. Salmon, the most important subsistence food, was recognized in the First Salmon Ceremony (Osgood 1976:148–149), a world renewal event that was accompanied by special songs described as a type of love song (Rooth 1971:61).

Attitudes toward bears typified attitude toward animals. In "Three People in Search of Truth" (Kalifornsky 1991:164–167), three brothers hunt a brown bear, the most feared and respected animal. The first fails because he is poorly skilled, the second

fails because he is impetuous, and the third succeeds because he is skilled, controlled, and speaks the correct words to the bear, which then respects him and does not resist being killed. In Kenai, a successful hunter used the phrase *"Chadaka, k'usht'a nhu'izdeyeshdle,"* which translates as "Great Old Man, I am not equal to you," to communicate humility toward the bear he was hunting (Kalifornsky 1991:167). In 1966, Mrs. Mike Delkettie, a Nondalton Dena'ina, reported that a similar saying was used in that area; moreover, the eyes of the bear were buried near the spot where it was killed as an offering showing proper respect (Rooth 1971:62). Francis Wilson, also from Nondalton, told Rooth that after a bear was killed they had to follow prescribed procedures, particularly in the treatment of the head, lest they never kill another bear, because "the bear still knows what is happening, so they have to be very careful with what they are doing" (Rooth 1971:50). Hunting rituals and prayers were meant to thank an animal for allowing itself to be killed, and sometimes they also involved giving an offering as a measure of the importance of proper attitude (Rooth 1971:50).

Animals had great power, and that power could be made available to a human through a personal spirit animal (animal familiar). Common spirit animals were the wolf and eagle, but any animal could become one's helper spirit (Mamaloff 1993:2–3). These powerful spirits were sought through vision quests and could be called on for psychological strength in confronting a difficult task or to overcome a physical or mental condition. In some cases, animal helper spirits provided assistance that could not be explained by other means, similar to the modern Christian concept of aid from a guardian angel. But unlike a guardian angel, animal helpers were also feared because they were powerful and a misstep could have negative consequences.

Dogs, *lik'aha*, formed another realm distinct from humans and wild animals and emerged with the coming of the campfire people. Dogs had animal characteristics but lived with humans and aided in hunting, and so were unlike any other animal. "The Dog Story" (Kalifornsky 1991:132–139) is an important story depicting the origin of dogs and how they must be treated and fed well in return for their service in hunting.

Plants were also perceived to be sensate. Kalifornsky writes, "They always prayed to plants and to all living things" (Kalifornsky 1991:13). It was common to offer a small prayer of thanks and leave an offering when harvesting a plant. If this was not done, the sentient plant might perceive disrespect and could choose not to grow in that spot again, a potentially serious situation for a people relying on medicinal plants with curative powers (Rooth 1971:44, 46; Russell 1987:19). Certain mountain plants, such as false hellebore, were thought to have greater healing efficacy than their lowland counterparts, and pilgrimages to the mountains were undertaken to collect them and other medicinal plants (Rooth 1971:46, 60).

Humans and the Coming of the Campfire People

"The coming of the Campfire People" refers to the appearance of the Dena'ina. Animal society did not dissolve with the advent of humans, but together they formed parallel societies differentiating into

FIG 7.2

7.2 *Nunk'yulyuyi*, hunter's talismanic pouch, Tyonek, early 20th century. L 25 cm. Swan's foot bag, leather strap, nine wolverine claws, two wolverine noses, one brown bear tooth, one marten bone (?). Tebughna Foundation. Photograph by Chris Arend.

Materials used as talismans were believed to confer on their bearers the quality of the animals from which they came—for example, the bravery of the wolverine, the wolverine's keen sense of smell and ability to locate food, and the power of the brown bear. Dena'ina hunters are said to have carried talismans such as these.

separate realms, what Osgood called the "semi-visible world" of animal, plants, and places (1937:169). With the coming of the Campfire People, precontact culture emerged, as envisioned by the Dreamer, Qatsitsexen. Once the Dreamer, in the form of Raven or some other entity, had established cultural practices, this era was historically static, and change was suppressed rather than encouraged, as would be expected for an ecologically sustainable culture.

Origin stories and linguistic information indicate the Dena'ina migrated into Southcentral Alaska at different times and from several places (Kari 2003a:144–147; Boraas 2007:32–33). Among the earliest migrations was movement from the upper Kuskokwim area into the upper Cook Inlet via Rainy Pass (Kari 2003b:144), and the introduction of three clans into the upper Cook Inlet from the east via Chickaloon Pass from the Copper River area (Kari 2003b:14). Dena'ina elder Shem Pete stated that the upper inlet occupation was of long duration and that Dena'ina never jointly occupied the Susitna Valley with anyone (Kari 1988:333; Kari and Fall 2003:14). Another migration, perhaps at the same time as the Rainy Pass movement, also originated in the upper Kuskokwim area but moved further south into the Stony River area. The Stony River/Telaquana band of Dena'ina are known as Htsaht'ana, meaning "First People" (Kari 1996a:60), and a story recorded by Pete Bobby of Lime Village opens with the phrase, "*K'qizaghetnu qeł hdghinih natuda naguna,*" "They say our ancestors were from K'qizaghetnu [Stony River]" (Bobby 1978:1). Kari points out the people call the piedmont west of this area Htsaynenq', "First Land," an area perceived to be the Inland Dena'ina original homeland (1988:328).

An important origin story related to movement from the Kuskokwim piedmont occurs in three known versions: one told by Alexie Evan to Anna Rooth (1971:68–70) and later in greater detail to Joan Tenenbaum (2006 [1976; 1984], 164ff.); a second titled "Imagination," written by Peter Kalifornsky (1991:72); and the third titled "*Ch'iduchuq'a,* Game Enters Mountain," told by Ruth Koktelash (in Evanoff 2010:18–19). In the story, starving Dena'ina

from the Kuskokwim piedmont move southeast to the mountains, where a spiritually powerful person, perhaps a *dghili dnayi,* or mountain spirit, which takes the form of an old man in one of the stories and of a kingfisher or a northern shrike in another, opens a mountain using a magical stick, called *janju tets'* (Kari 2007:306), allowing the people to enter what is now Dena'ina territory. At first, they confront threatening monsters, which they overcome with the help of the *dghili dnayi* and his magic songs. The Dena'ina then encounter great quantities of game animals and become prosperous from that time on. The mountain is Telaquana Mountain, or Nduk'eyux Dghil'u, "Animal Goes in Mountain" (Evanoff 2010:110), east of Lime Village at the headwaters of the Stony River.

The traditional Dena'ina perceived of self as consisting of three entities: body, breath, and shadow spirit (Osgood 1937:169). Body or *benest'a* (his or her body) was the corporal physical body, with at least one difference from how it is viewed in Western culture (Kari 2007:86). This life force existed just below the skin and created a kind of permeable envelope within which was the self and through which the individual intersected with the physical realms outside the body.

The second part of self was breath, *niłq'ech'* (Kalifornsky 1991:203). The phrase *deshishch'-idnulk'et'i niłtu qghich'ex* translates as "they lived for good health," which literally means "they lived for durable breath" (Kalifornsky 1991:203; Kari n.d.:538). Breath equates with health, and living for durable breath reflects the physically demanding lifestyle requiring what by today's standards is intense, sustained physical activity year in and year out. Being in poor physical condition jeopardized one's own and one's village's survival, and hence fitness and knowledge healing through the use of medicinal plants and herbs was of paramount importance. Games included endurance and strength events, such as running, snowshoeing, or wrestling (Osgood 1937:124), and stories speak approvingly of those with endurance or strength (Kalifornsky 1991:238–239). When a person died, breathing stopped (*nishich'k'dani'un,* "he stopped breathing";

In this dramatic excerpt from "Ch'iduchuq'a," the animals that people hunt and trap have been disappearing and people are starving. The people search out a medicine man, Ch'iduchuq'a, who, with his partner, a pika (rock rabbit), leads the starving people up into the mountains. There they reach a rocky bluff, and Ch'iduchuq'a, with special songs and a cane, creates an opening in the mountain. They all enter and discover the missing animals trapped inside the mountain. Ch'iduchuq'a and the pika start dancing and drive the animals and the people out of this mountain enclosure and to the other side, into a Dena'ina homeland of plenty.

Ch'iduchuq'a

Ch'iduchuq'a gun
detets'a tsayan qilan ghu qeydenł'eq.
Hendi eła tsayan qighila ghu łu
tsayan ghin yudeq qech' q'u dnazdlet.
Niłk'uch' t'qunił,
niłk'uch' t'qunił.
Dakaq' ghu nilk'uch' t'qidyuq.
Hnuyu yuyeh nduhniyu Ch'iduchuq'a gun
 q'ich'idya eła.
Ghuna k'adelyaxna ghuna dakaq' ghu qech' q'u
 ndusaqenghat'ech.'
Da'u yuyeh qehnił'an qut'an dnaghelt'a.
Idi eła yuyeh gu ki łu
tayanq' gu nuquq' cheh dełken yi hghi'u.
Vejex ggagga yeghdishla qunsha shq'uła nudyi
t'anch'gheli łu yuyeh hdalts'i.
Hdichin.

Q'uyehdi hyegh nehch'en k'taljich q'ich'idya
 Ch'iduchuq'a gun eła.
Niłegh k'uch'en łu yunih htazyu.
Yunih niqaqidghazyu q'uyehdi neshech'
 dakaq' qech' hdi
qeynazyet'.
Qeynazyet hnuyu ghini łu ye'un tikahdałen.
Ch'iduchuq'a detets' a qilan
yi ghini niqaydult'eh ch'łuq'u gun łu ye'un
titl' ił' iłk' at'.

English Translation

Ch'iduchuq'a
struck at the rocky bluff with his cane.
All of a sudden, where the rock had been,
it split upward.
The rock moved apart,
the rock moved apart like this.
A doorway opened then.
Then they went inside, Ch'iduchuq'a and the pika.
The ones who were singing stuck their heads into
 the doorway.
They looked inside, all those people.
And there inside,
in the middle of an open space, was a big sandbar run-
 ning off into high mountains.
Caribou, brown bears, black bears, ground squirrels,
 marmots, mountain sheep,
all of them were staying inside there.
They were hungry.

And then they started dancing behind them, the pika
 and Ch'iduchuq'a.
They circled around them, one to each side.
They circled around behind them and then out toward
 the door they started driving them.
As they started driving them, the animals began
 to move out.
Ch'iduchuq'a had his cane
and was waving it around, and as he did that,
they went out in single file.

Excerpt from "Ch'iduchuq'a," told by Alexie Evan. In Dena'ina Sukdu'a: Traditional Stories of the Tanaina Athabaskans, *compiled and edited by Joan M. Tenenbaum (Fairbanks: Alaska Native Language Center, 2006), 171–174.*

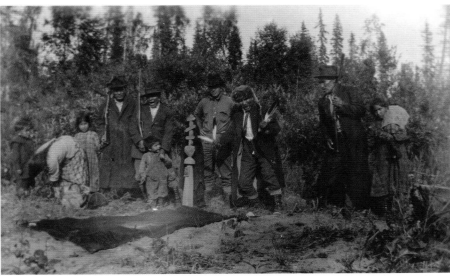

FIG 7.3

FIG 7.4

7.3 A shaman performing at a burial, c. 1920–1930 (?), upper Cook Inlet. This image is the only known image of a Dena'ina shaman performing at a funeral. The blanket covers the grave, and a Russian Orthodox cross with an icon is attached at the foot of the grave. Anchorage Museum B1987.56.38.

7.4 Spirit houses, Eklutna Cemetery, 1950. Prior to contact, Dena'ina people cremated their dead along with some of their deceased's possessions. After the adoption of Russian Orthodoxy, this practice was no longer allowed. Since Dena'ina people were unable to cremate their dead, they believed that a person's spirit might become confused and would need a place to stay before making the final journey to *yuyan* (heaven). Thus they constructed spirit houses to contain provisions for the departed. Maynard C. Dahlstrom Collection, Alaska State Library, ASL-P414-3960.

Kari n.d.:438), and the life force gradually ebbed from the body, the breath dissipating to "go into the sky" (Osgood 1937:170).

The third component of self was *k'eyiga,* "one's shadow spirit" (Kari 2007:307) or soul, and was permanent, transcending death. The shadow spirit left the body when one dreamed, and shamans could willfully cause their shadow spirit to leave their body through trances. Seeing a person's shadow spirit meant that person was going to die (Osgood 1937:169–170). Upon death, one's shadow spirit, unlike the body that decayed and the breath that dissipated, became an ancestor spirit or *nusdalt'na* (Kari 2007:309), the extension of self after death.

Ancestor Spirits

Ancestor spirits occupied the same "semi-visible" space as other spirits. With death, passage into that dimension was actuated by cremation, and the shadow spirit was then described by the term *q'egh nutnughel'an,* "spirit of the recent dead" (literally: "the one seeing his tracks again") (Kari n.d.:789; see also Kari 2007:310). An unusual noise might be a signal that an ancestor spirit was present, and the crackling of a spruce fire was interpreted

as demands by ancestor spirits to be fed, resulting in the custom of offering a bit of food to the fire (Osgood 1937:166, 170). Ancestor spirits were revered but also feared because of the belief that, upon death, the ancestor knew one's thoughts and memories (Boraas and Peter 2009:215) and might revenge an unresolved conflict (Osgood 1937:170).

In traditional society, part of the function of the cremation and subsequent memorial potlatch ceremonies was to settle interpersonal conflicts that had not been resolved in life and restore harmony. After death, the deceased's shadow spirit lingered nearby, and the body was attended by relatives in a twenty-four-hour watch. During that time, forgiveness for unresolved issues was asked in the form of prayers, songs, or one's personal thoughts to the deceased. Sometimes the intensity of the relationship was so great that the apology took the form of hysterical grief involving uncontrolled crying or self-torture and occasionally escalating to the griever's becoming insane or committing suicide (Osgood 1937:168). The "dead that holler from the grave" (*nuqnujełen*) are distraught ancestor spirits potentially harmful to humans (Kari 2007:309). As a measure of protection from ancestor spirits (and other spirits as well), Osgood (1937:170) reported, Dena'ina would leave a container of water at the doorstep to prevent the passage of an ancestor spirit into their house.

The memorial potlatch, or "big potlatch," ritually commemorated the atonement of bad feelings

FIG 7.5

FIG 7.6

7.5 Martha Alexan singing with Shem Pete at a potlatch, Tyonek, 1982. Photograph courtesy of Priscilla Russell.

7.6 Playing *ch'enlahi* at a Tyonek potlatch, January 13, 1982. Players in front, left to right: Albert Wassillie, Nicolai (Henry) Balluta, Max Chickalusion Sr. Players in back, left to right: Pete Trefon, Jim Kari, Shem Pete. Photograph courtesy of Priscilla Russell.

between the deceased and the living. The big potlatch was a powerful, liminal state of renewal, reestablishing harmony in the social order. Details of the ceremony varied (Osgood 1937:149–160), though all involved memorial songs, adulatory speeches, feasting, games, and gifts to the opposite moiety that were imbued with love (*beggesha*). Eventually, an ancestor spirit was reincarnated.

Celebratory potlatches, called "little potlatches," were given for other reasons, such as for the first animal killed or another noteworthy event (Osgood 1937:154). Giving a potlatch was a major event and, in the case of a memorial potlatch, involved years of preparation. Individuals created string calendars (*niłnuk'qełkishi*, Kari 2007:307), knotted sinew as time markers with bits of fur or other representations to indicate successful potlatches, puberty events, first moose kill, or other important life events (Osgood 1937:154, 157).

Spirits

The traditional Dena'ina world was populated by a diverse array of spirits that could take a form or simply be a presence. Some were powerful and feared, others were friendly but mischievous. Spirits could be encountered anywhere, so one was never truly alone, no matter how far from a village one might be. Spirits reflected the primary concerns of Dena'ina life, such as interacting with a willful nature, the character of good and bad, the cause of mysterious events, or an unexpected death that could not be attributed to any obvious cause. More than twenty spirits are known.

One of the most significant spirits was Gujun, a powerful mountain spirit (*dghili dnayi*) who is portrayed in several stories as the "Father of the Animals." He and his wife, K'unkda Jelen, appear in "The Mouse Story" (Kalifornsky 1991:154–159), a seminal Dena'ina story depicting interaction with nature. In the story, a lazy man helps a little mouse over a windfall. Winter comes, and starvation afflicts his village. The man then undertakes spiritual walking toward the mountains. "Spiritual walking" is a term used by Rooth to mean walking to enter a spiritual state or resolve a conflict (1971:55). In "The Mouse Story," the phrase *gheyuł, gheyuł, gheyuł,* "he walked and walked and walked," indicates spiritual walking. In the foothills, he comes to the house of Gujun and K'unkda Jelen, where, because of his proper attitude toward the mouse, the giant spirits help him help his people by transforming down feathers into food. The villagers become strong and are again able to hunt and survive. K'unkda Jelen,

7.7 *Qamga*, gaming discs, Alaska, 1931. Diam. 6.4 cm. Wood (spruce), pigment. Photograph © Peabody Museum of Natural History, Yale University, ANT.015920. Photograph by Chris Arend.

According to Cornelius Osgood, who collected these discs in 1932, Dena'ina used them to play a game of quoits. Two pairs of spruce discs, soaked in oil for four days to make them heavier and prevent splitting, were thrown by the players at targets on a caribou skin game board.

7.8 *Ch'enlahi k'enut'a*, game sticks, made by Fitka Balishoff, Seldovia, 1931–1932. L 6.5 cm. Wood. Photograph © Peabody Museum of Natural History, Yale University, ANT.015921. Photograph by Chris Arend.

These sticks were used to play a two-man stick game described by Cornelius Osgood in *Ethnography of the Tanaina*, p. 126.

7.9 *Ch'enlahi k'enut'a*, gambling sticks with case, Kenai Peninsula, 1848–1853. L 8.5 cm. Bone, sinew, hide. Peter the Great Museum of Anthropology and Ethnography (Kunstkamera), 337-15/1 and 337-15/2. Photograph by Chris Arend.

The stick game (*ch'enlahi*) was a popular gambling game in which two teams attempted to guess the location of the sticks in the hands of their opponents. Each team alternated singing gambling songs (Osgood 1937:126; Kalifornsky 1991:62–69).

FIG 7.7

FIG 7.8

FIG 7.9

the "Mother of Everything Over and Over," appears in other stories as a beautiful woman presiding over the reincarnation of animals (Kalifornsky 1991:43, Rooth 1971:70–73). Curiously, in one story, Gujun appears as a revengeful murderer, though it is likely in that story he is a reversal of what is good (Kalifornsky 1991:244–247).

Another powerful spirit was K'eluyesh, one of the giant spirits. K'eluyesh appears in the "Gambling Story" as a powerful entity that restores normalcy to the life of a "true believer" (*k'ech'eltanen*, one who has developed a high level of spiritual awareness) who has lost everything to a shaman through gambling (Kalifornsky 1991:62–67). Doroshin (quoted in Radloff and Schiefner 1874) states that out of respect to K'eluyesh, food taboos and a special mountain language were used by the Kenai people (Kari n.d.:1099).

Nant'ina were one of several evil spirits. Osgood describes *nant'ina* as a version of the Nakani belief that is universal among Northern Athabascans and appears among Algonquin speakers as Windigo, the epitome of evil. Among Dena'ina, a *nant'ina* is described as "the one who steals us" (Osgood 1937:171–172; Kalifornsky 1991:57), in apparent reference to individuals who die while hunting or traveling alone. Gilyaq (Kalifornsky 1991:59) was another evil spirit who, in this case, had the power to sense people's thoughts. If someone's heart ached, longing for a loved one, he could sense that and become that person and come to you. But it wasn't your loved one, it was Gilyaq, and thus a cruel form of deceit, turning hope into despair.

The barking dog (Sus Łik'a) was a spirit related to an apparent form of culture-bound psychosis involving subconscious psychodrama (see Osgood 1937:171). If one violated taboos regarding animals,

K'eła Sukdu

Peter Kalifornsky

Sukgheli łuq'u Dena'ina qghelach'. Tak'hnelt'eh ch'u tan'i qełchin ch'u łuq'a uquqel'an tach'enił'i eł. Yeh łuq'a nagaqel'an tach'enił'i eł. Heyi niłtu k'qezdelgha.

Ts'ełt'an quht'ana yeh qheyuł ch'u ch'qidetnik'. Heyi niłtu k'usht'a q'u ninik'eset'. Yethdi k'ełagga gheni q'ileshteh gheyuł ch'u q'inggwa iditnal'un. Yigheni yeghetneq ch'u dan'i jen'ey ghełghel.

Yegheni shughu hey qwa qizdlan ch'u chik'enaq qbetu dnzet. Na'uni qizdlan ch'u yadi ninya qbek'uhdi'u ch'u. Heyi niłtu niqeydalkidi qwa k'qusil. Qdichin. Chik'enaq qwa dinzet.

Yin kił ghunen k'ełaggwa dani jen'ey ghełghelen ghun qil'i niłtu tiniyu. Dghiliqenh tazu. Yehghu gheyuł, gheyuł, gheyuł, ch'u nichiłka aniyu. Ch'u dasgedi qughe'u. Yeh dukaq'di qul hq'u yuqech'hdi, "Aa, hunch'dal'an. K'tu'ushch' naqanlgheł ch'u ginldush," yełni. K'tu'ushch' naqalghel ch'u yethdi naqandalghel yethdi dakaq' ch'ak'tnintun. Qighel'ets. Qichika yuyuh ezdu. Tuyanq' detsen dazdlu. "Shqen nutujuł. Gu zidu. Hunch'dal'an," yełni. Yeghuk'eniłkit. Ch'aduch' hghuda t'ent'an qit'anideshni. Qit'anch'itni," yełni. "Shqen nutujułda yetda'hdi neł nuqtulnek," yelni.

K'usht'a k'dit'al k'enli t'et'an. Ełnen ghenu. "Aa shqen dunghejuł," yełni. Uch'enqech' k'kegh'i qt'ingheju.

"Yaghali," yelni. "Qit'anideshni ch'aduch' qghuda t'ent'an. Nełch'indaqna łuq'u qdichin. Chik'enaq qutudinzet. Ndesnaqa beł itigheł yeshi uqu nughenyuł. "Yaghali, nuntheshtuh," yelni. "Nenk'u shnunintun."

Łuq'u qughesht'a q'inggwa dahdi k'tsenggwa dahdi ghenalggeni łuq'a denłts'eq'ggwah k'eyesggwa yiyełdeł. Ts'anesdets'eq'ggwah diyełdeł ch'u. Łuq'u ya k'ighałchet. Hał k'u k'ushu k'usht'a iłagh. Ditushi yeł didghełdatl'.

"Ginhdi nqayeh quht'ana nach'u haztunh gin'eł nininjuda q'u niditi ghecheł ch'u ditushi gini beyditi ghełtesh. K'tu'ushch' naqantghelghełda ba dinlchetda ndahkugh ni'ilyuh tut'ał. Yethdi nutghejuł ch'u nełch'indaqna un detghenił ch'u. Yinahdi nen'eł snuqiditulyash. Nełch'indaqna beł itighełyesh yina ghutghełket yigheni nagh htusegh qech q'u łuq'u nunqiditultesh. Łuq'u tik'u nuqtudedeł ch'u chik'htuł'ish. Itighedyesh," yedgheni.

Yeqech'a besukt'a qdilanch'a, "K'eła yethdi łuq'u k'qezdelgha łuq'u gin ninya en'ishla k'usht'a shqidinil," yełni. "Nenhdi ch'qidghendnik'. Nughenyuł. Sha ninyu ch'u shighendneq ch'u dan'i q'in'el dan'i desh gheł ghel. Yethdi yeqech' shnunintun. Yeqech' hguda yech' nen'eł niqdalnen," yełni. "Shish'izhi k'eła dnavi shighelihdi sh'izhi qdilanch'a Gujun. Gujun dnayi shina'i łuq'u yadi ninya qilan."

The Dena'ina text of the mouse story and its English translation are from the collected writings of Peter Kalifornsky, published in 1991 as A Dena'ina Legacy, K'tlegh'i Sukdu (154–159).

The Mouse Story

Peter Kalifornsky

Long ago this is the way the Dena'ina lived. They drove poles for a fish weir where they fished with a dip net. They brought in fish with a dip net and they made ready for winter.

One man only walked around, and he was lazy. He wasn't preparing for winter at all. Then a little mouse was going in the brush with a fish egg in its mouth, but it couldn't get over a windfall. The man lifted the little mouse over the windfall.

Then winter came to them and sickness struck. Bad weather came and they couldn't find any animals to hunt and what they had stored for winter was gone. They were hungry. Sickness struck them.

The young man who had helped the little mouse over the windfall went out walking without hope. He went to the foothills. There he walked, and walked, and walked, and came to a big brush shelter. Smoke was coming out. There was no door, but from inside he heard a voice, "Yes, we were expecting you. Turn around the way the sun goes [clockwise] and come in," someone said. He turned around the way the sun goes and, as he turned, a door opened. He went in. A big old lady was sitting inside. A fire was burning in the center of the room. "My husband is coming back. Sit here. We [were] expecting you," she said to him. She fed him. "I know why you are here. We know you," she said. "When my husband returns he'll explain it to you," she said.

Not long after it hailed. The earth shook. "Yes, my husband is coming back," she said. From outside, a giant came in.

"Hello," he said. "I know why you are here. Your relatives are all hungry. Sickness has struck them. You are going about to try to save your relatives. Good, I'll help you," he said, "because you have helped me."

The giant put all kinds of small little fish eggs and little meats and dry fish into a little skin a pinch at a time. Pinch after pinch he put in and then he wrapped it up. It didn't come to much of a pack. He put down feathers in the pack.

The giant said, "Take this to your village. Before you arrive put down the pack and spread out the food. Then sprinkle the down feathers over it. Turn around the way the sun goes and, when you touch it, it will turn into a large pile of food. Then go to your village and tell your relatives to come with you. They will help you bring the food the rest of the way to your village. With this food you will save your relatives. You will feed them and before it is all gone, they will regain their strength. They will go to the woods and they will kill game. You will be saved," the giant said.

"The mouse you saved was getting ready for winter like everything else. But no one took pity on it when it needed help," the giant said. "You were lazy. You were walking about when you should have been helping. But you lifted me over that windfall when I had that fish egg. You helped me. That is why it has turned out this way," he said. "My name is mouse's relative, but really my name is Gujun.

Gujun is related to all of the animals."

for example, the animals were perceived to withdraw, which would affect the subsistence community as a whole. The consequent guilt would manifest itself as a dog barking in the distance in a mentally tormented individual. The person was said to follow the sound into the woods and not return unless people saw the individual and brought him or her home.

Sometimes events happened in which the present world encountered the spirit world in an uncomfortable or frightening way. One such episode was seeing a detached hand, *qujeha* (Kari 2007:309). In a story from the historic period, "The Other Half of the Kustatan Bear," a bear paw emerges from under a man's bed at Kalifornsky Village after a series of intense spiritual experiences. The man drives it away with holy water and a cross (Kalifornsky 1991:307).

Steambath spirits, *neli qelch'eha*, were powerful and were implicated in potlatch, cremation, and vision quest ceremonies (Kalifornsky 1991:49, 51). Household spirits, *yuh ht'ana*, were generally friendly and often annoyingly playful (Kalifornsky 1991:55, 372).

Spirits of place are important in Dena'ina mythology, and of these, the mountain spirits figured prominently. These existed as both little people and giants mentioned above. They could be helpful to a traveler or hunter but were dangerous to one with improper beliefs. They formed their own society and could occasionally be heard in the mountains talking, but were rarely seen. Other spirits of place were also associated with a particular habitat and could be good, ominous, or sometimes evil. Good tree spirits, for example, would exist at a place that was associated with a good event, and one got a good feeling when visiting there; evil tree spirits might exist at a place where an aggressive or hostile act occurred, and an ominous feeling would be felt by someone who passed there.

Specific places also had, and have, a spiritual aspect. Sentry stones guarded the eastern end of Dena'ina territory at the Russian River in the Kenai Mountains and were said to warn the Dena'ina of Alutiiq incursions, presumably from Resurrection Bay (Osgood 1937:112). Giant's Rock, along what became the Pile Bay Road between Old Iliamna and Kamishak Bay, one of the major trails connecting eastern and western Dena'ina territory, was the site of a mythological story and was a spiritual place (Johnson 2004). Though the rock was dynamited in 1955 during Territory of Alaska road-building activities, Dena'ina still regularly leave votive gifts at the site of the dynamited rock in homage to the place and the mythological event that happened there. Other sacred rocks are said to exist in Dena'ina territory, but at present, their location is privileged cultural information.

While some villages were known for their goodness, other villages became known as bad places because of events that happened there, and they continue to have an evil essence. Two such villages are known on the Kenai Peninsula, Tiduqilts'ett, "Disaster Place," a village on the bluff just south of the Swanson River mouth, and Tuqeyankdat, "Bad Clearing," on the bluff north of Kenai (Kalifornsky 1991:270, 322). Well into the twentieth century many Dena'ina refused to go near Tuqeyankdat because of the evil forces that lingered there.[1] The now abandoned village of Kijik figures prominently as the origin of two powerful shamans in the shaman battle described in "The Kustatan Bear Story" and "The Other Half of the Kustatan Bear Story" although it is not necessarily an evil place (Kalifornsky 1991:290–309). Evil Creek near Kijik is the location of actions by a Russian Orthodox priest around 1900 who violated traditional spiritual practices (Lynch 1982).

Naq'eltani

The final dimension is that of Naq'eltani, first reported to the Western world by Sheldon who wrote of the Dena'ina:

> In the spirit world they place one supreme being named Nah-cri-tah-ny, who is regarded as the maker and creator of all things. There are many lesser spirits under the direction of the great

Hutał Hnidenghi'iy
'Flat Rock That Is Embedded'

Told by Gabriel Trefon, Nondalton

[Nanutset] q'et'q'u qut'ana qeyghudighiłt'a'i sukdu q'u q'ent'a ha.
/Before our times long ago they had stories that they would be able to use, so it seems.

Ha'it q'uhdi hudulyi eł qeyeghudighiłt'a.
/They used these (stories) as medicine.

Nghu Hutał Hnidenghi'iy.
/There is 'flat rock that is embedded.'

Nghu Hutał Hnidenghi'iy łitl'en ha ha'it ghini yudeq gheli nitnatni'u.
/There that 'flat rock that is embedded' in springtime it stands up really high.

Q'uyehdi venutnu'ididlix.
/So then the current passes by it.

K'etnu ghu tayanq' ghelishla hnidenghi'u.
/It is embedded there just right in the middle of the (Newhalen) river.

Venutnu'ididlix ha ha'it q'uyehdi venutnuk'ididlih.
/The current flows past it and then they (fish) swim around it.

Venutnuk'ididlih ha'it q'uyehdi,
/They (fish) swim around it and then,

n'uyi ghini vayi'ux ha ha'it ghu
/that sun shines on it and there

"Shnushutnuł'uł," nih.
/"The sun passes all around me," it (the rock) says.

"Yada nunujehi qilan ha ha'it ch'q'uhdi shq' dunuk'enjeh
/"The various birds there land upon me

"ha' q'uda chi'ul shk'tnit'an."
/"and they just use me for recreation."

Dach' hdi qeyeł dghini.
/That's how they would say.

"Shnutnu'ididlix q'u yedahdi tushdenghazhq'uch'," dghinih.
/"The current wraps around me and thus the water has shaped me," it (rock) said.

"Tushdenghazhq'uch' q'uyehdi shdnunuk'ididlih.
/"I have been shaped by the water and then they (fish) swim past me.

"Shnutnuk'idasdlagh.
/"They (fish) repeatedly swam past me.

"Shch'enaqa sheghkuh niqatatnułdes.
/"My children (as small rocks) roll ashore downstream of me.

"Nch'u shk'dghalgget.
/"I am inaccessible.

"Shnushutnułt'uł.
/"The sun passes all around me.

"Shnenqiłt'a.
/"They depend on me.

"Chi'ul shk'tnit'an."
/"They use me for recreation."

Dach' qeyeł dghinihi.
/That is what they used to say.

Hudulyi tqeyghet'an nanutset q'u q'et'q'u.
/They had that as medicine long ago before our time.

Yi shughu q'udi guhdi nak'uch' qenadelgheshna
/Now here because the ones (white people) who talk differently from us

ha naguna qit'ach'idunih hyitni,
/want to know about our local people,

ghudahdi, q'udi guhdi qughesht'a nuqghelnek.
/here at this time I have told this carefully.

/Galeq teh duqeytidulił.
/They will put it in a book.

That's all.

Immediately concluding the narration of the story, Gabriel Trefon begins singing the song of the "flat rock that is embedded."

Hnidenghi'esh'u
/I am embedded in the ground.

Shnutnuyu'ididlix.
/The current wraps around me.

Tughushdenghiłq'uch'.
/I have been shaped by the water.

Shenuyuk'ididlih.
/Fish swim past me.

Shnushutnuł'uł.
/The sun passes all the way around me.

Chi'ul hyu shek'tnit'an.
/They use me for their recreation.

Shnutnuyuk'ididlix.
/The current flows around me.

Shch'enaqa sheghkuh niqatatnułdis.
/My children roll ashore downstream from me.

"Hutał Hnidengh'iy," "Flat Rock That Is Embedded" story, told by Gabriel Trefon, Nondalton. Recorded by Clark Davis in Nondalton in 1961 on Ti1262. First transcribed by Jim Kari, and translated by Andrew Balluta and Jim Kari in April 1985. Published in Balluta (2008:23-44), with an audio recording of the Trafon narrative.

FIG 7.10

spirit. Among these is the god of the lakes, and the god of the mountains. The lake god assumes the form of a big fish and he is supposed to be destructive, inflicting punishment upon evil-doers and destroying those who disturb him in his haunts. The mountain god is regarded as a protector, helping the Indian in his troubles and guiding him to good hunting and fishing grounds. If an Indian ventures into the high mountains and appeals to the spirit, he is supposed to be received cordially and is given direct advice for his future conduct. (1908:277)

The "mountain god" is likely Gujun, the "lake god" is one of the spirits of place, and Naq'eltani is the creator. The word "Naq'eltani" means the air or breath that passes over and through us—in other words, a universal omnipresent essence that some Dena'ina have likened to "pure love" or "pure truth" (Boraas and Peter 2009:215), not unlike the Navaho Dené concept of *hozhǫ* (see Wyman 1983:537). Naq'eltani as creator is probably the force that empowered Raven in the form of a dreamer to envision Dena'ina society. Traditional Dena'ina told Donita Peter that shadow spirits cease to be reincarnated once they have achieved their purpose and at that point merge into the state of Naq'eltani, which, like gravity, is unseen but is everywhere.

After the Whites Came

The third time period in the traditional Dena'ina worldview is called "after the whites came." Russians began occupying Dena'ina territory in 1786, building Georgievsky Redoubt (Fort St. George) at the

FIG 7.11

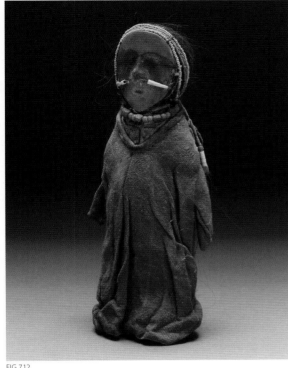

FIG 7.12

7.11 Museum ledger entry for doll shown in figure 7.12, 1894. Image courtesy American Museum of Natural History.

7.12 *Chik'a qenin'a*, shaman's doll, Kenai, 1894–1915. L 26 cm, W 8.5 cm. Wood, wool, dentalium shells, beads, thread, sinew. American Museum of Natural History, E/2680. Photograph © American Museum of Natural History.

mouth of the Kasilof River. Other redoubts (fortified posts) and artels (unfortified trading posts) were built, and by the late 1700s, about two hundred Russians occupied the Cook Inlet basin. Most left after a series of battles in 1797, and for the duration of Russian America, only a handful of traders and priests remained. After the 1867 purchase of Alaska by the United States, mostly white Americans, many first-generation Swedish-speaking Finns associated with commercial salmon canning, began to settle in Dena'ina territory. By 1920 the non-Dena'ina population exceeded the Dena'ina population, and after World War II, the accelerating relocation of mostly white migrants to the north left the Dena'ina a small minority in their homeland.

The two Western institutions that had the most effect on the traditional Dena'ina worldview were organized religion and public education. By the mid-twentieth century most Dena'ina were baptized as Russian Orthodox. After initial conflicts between missionary priests and Dena'ina, Russian Orthodoxy became a highly indigenized religion, with many of the key concepts of Christianity understood in terms of the traditional Dena'ina worldview (see Znamenski 2003). The degree of syncretism of the worldviews is reflected in the fact that the last Dena'ina shaman in the Kenai area, Annie Unishev, was married to a Dena'ina lay reader in the Orthodox Church, Simeon Unishev. Presumably as with their marriage, much of the spirituality of traditional beliefs was compatible with the theology and practice of Russian Orthodoxy, at least as it was contextualized by the Dena'ina.

The introduction of public education through the territorial school system begun in the early twentieth century in Dena'ina villages was a powerful agent of change that did more to affect worldview than religion, for two reasons. First, the policy of the territorial schools to extinguish Native languages was carried out through corporal punishment. Administering beatings for speaking Dena'ina was variable, but it seems to have been particularly harsh in the Kenai Territorial School. Language extinction was generally successful in the Cook Inlet area, less so in the Lake Clark area, and had the effects of making a generation ashamed of its heritage and removing the language of Dena'ina worldview from active use. Because of the complexity of the Athabascan verb and its ability to precisely reflect traditional thought, the latter was particularly harmful. Second, the public school system

The Shaman and the Priest

Shamanism continued in several Dena'ina communities well into the twentieth century, despite Russian Orthodox clergy's attempts to eradicate it. In his daily journal, Hieromonk Nikita recounts his experience admonishing a shaman.

August 11, [1881] Thursday. . . . In the house of my interpreter John Kirilov, I found the chief and other people, among whom was the local shaman, a clever fellow, either a Creole or one of the cunning Indians. He spoke Russian well and bore himself smartly. I utilized his presence to denounce him. I disclosed his deceit of his simple-minded and trusting fellow-men, I accused him of laziness and cowardice because of his refusal to partake of holy communion, I advised him to repent and in token of his repentance to surrender voluntarily the objects which he used during his shamanistic performances. He replied evasively, refusing my request. It could be seen that he wished to hide or go away and undoubtedly would have done so if he had not been afraid of impairing his reputation among his followers. Then, not wishing to leave the scoundrel with even the shadow of a triumph and the listeners (including my churchman) in doubt, I, knowing the obedience of Aleuts and Kenai Indians to a priest's advice and to the church prohibitions, threatened the shaman with complete excommunication, i.e., expulsion not only from the church and holy communion, from which he excluded himself as being an unworthy member, but from the community as well in the full sense of this word. Consequently, I, through my interpreter, forbid all the people of Toyonek and neighboring villages from receiving him in their houses, greeting him and speaking to him, taking him on hunting and fishing parties, giving him presents, visiting him, eating with him from the same kettle or drinking from the same cup and having any kind of contact with him. I threatened those who refused to do so with church punishment.

It became very quiet in the house. All sat with downcast eyes. The shaman also remained silent with his head down, thinking for a minute or longer, then, without a word he left the house. In a few minutes, he returned with a dirty, greasy sack and shook from it the objects of his profession, namely wooden rattles used in dancing, colored sticks, strips of wood, feathers, a doll with hair and queue, and other trinkets which were so dirty that one could not handle them without repulsion. Then one or two similar dolls were brought in by some women: All these things I burned in their presence on the street. It was amusing to see the indignation of one old woman when she saw my churchman spitting on a doll brought by her.

I doubt that the shaman surrendered everything. Anyway, this case impressed my audience tremendously. Immediately after this the chief was the first to remove the various objects from the grave of his father: the others have promised to follow his example. Giving the proper instructions to the shaman, I blessed him and promised to give him communion on my next visit if he proved by his deeds that he had relinquished his occupation entirely.

Excerpt from the "Travel Journal of Hieromonk Nikita," Kenai (1881–1882). Original in Alaska Church Collection, Box 490. Translated version in Documents Relative to the History of Alaska, *vol. 1, pp. 60–67.*

7.13 *Unlas*, **pocket icon, Eklutna, c. 1900.** L 5.1 cm, W 4.5 cm. Embossed brass, birch bark. Debbie Fullenwider Collection, Cook Inlet Tribal Council, 44. Photograph reprinted by permission of Cook Inlet Tribal Council, Inc. Photograph by Chris Arend.
This icon of St. Nicholas belonged to Eklutna Alex. It is backed with a piece of birch bark.

7.14 Elementary school classroom at the E. L. Bartlett School in Tyonek, 1968. Steve McCutcheon. Steve McCutcheon Collection, Anchorage Museum, B1990.014.5AK Natives, 40.70.36B.

introduced the Western concept of historicism (explanation through hermeneutics), in which history is explained as an evolving and unfolding text, an approach quite different from the historically static explanation of the coming of the Campfire People, for whom the Dreamer set culture in motion and change was suppressed rather than encouraged.

During the latter part of the twentieth century and the early twenty-first century, the Dena'ina experienced significant changes. With the passage of the Alaska Native Claims Settlement Act in 1971, regional and village corporations became significant players in the Alaskan economy, necessitating a shift in values toward materialism. Second, starting with the Native Village of Tyonek in 1939, modern tribal entities have merged that provide educational, health, and elder services for tribal members. In terms of worldview, the tribes are engaging the question of how to be a tribal person in the modern world. Most consider language revitalization key to answering this question.

FIG 7.13

FIG 7.14

Notes

1. Peter Kalifornsky, personal communication, 1990.

"No one was allowed to speak the language—the Dena'ina language. They [the American government] didn't allow it in the schools, and a lot of the women had married nonnative men, and the men said, 'You're American now so you can't speak the language.' So, we became invisible in the community. Invisible to each other. And, then, because we couldn't speak the language—what happens when you can't speak your own language is you have to think with someone else's words, and that's a dreadful kind of isolation."

—Clare Swan
Kenai, Alaska

From an interview with Dena'ina elder Clare Swan in the film, Alaska, the Last Frontier? Producer, Eleanor Morris, academic consultant, Philip Sarre, 1995. London: BBC for the Open University in association with the Annenberg Project; quote from transcript in De Blij, Harm J., Alexander B. Murphy, and Erin Hogan Fouberg. 2007. Human Geography: People, Place, and Culture. *New York: J. Wiley, p. 177.*

8

Ye'uh Qach'dalts'iyi:
"What We Live On from the Outdoors"

Karen Evanoff and Michelle Ravenmoon

Fish Camp
Michelle Ravenmoon

The water is lapping at my boots as I put a freshly caught sockeye salmon on my cutting table. The many sounds around me are comforting: the children talking to each other, some touching the salmon in the container close to me, some standing in the water with their pants rolled up, coffee can in their hands, attempting to catch sticklebacks. Some have already caught sticklebacks and are attempting to dissect them. I assume they are imitating their mother and aunties, who are cutting the salmon nearby. I can hear the seagulls squawking as they swim closer and closer in hopes of some scraps thrown their way. I hear my brother-in-law, who is filming the process for me. He is asking questions about putting up salmon; he is new to the process. He asks the child who is washing the slime off the salmon, "What are you doing? What will you do next? Why are you washing it?" The girl, about nine years old, answers simply, "I am washing the slime off so we can eat it." I am busy discussing the plans for our catch of the day with my

niece. Close in age, we grew up together and are more like sisters. We both want the children to have a role in helping with our age-old tradition of putting up salmon so they too will know how and they will understand the importance of harvesting our own food from the land. We have all returned home to help put up salmon for winter.

Fish Camp
Karen Evanoff

Early this spring, I was at fish camp, and my aunt was there at her camp. During my visit, she talked about the fish that would be coming and when everyone else would be moving down. She brought out her small hand Swede saw and said she needed a new blade. I told her I would pick one up in Anchorage, but she had to give me the measurement. She pulled out a piece of yarn from her knitting pile and measured the saw blade with it. She spoke of the weather, too: "It's a little colder than usual this spring, but there are a lot more birds going downriver." I value her traditional knowledge and insights. In the distance, I could hear

8.0 The sounds of fish camp. Seagulls fighting and squawking over fish scraps are a familiar sight at Dena'ina fish camps. Photograph by Aaron Leggett, Anchorage Museum.

FIG 8.1

8.1 Drying the salmon. After the fish have been split and soaked in a brine solution, they are left outdoors on fish racks to dry. Once they are dry, they are stripped out and hung in the smokehouse. Photograph by Dave Nicholls, Anchorage Museum.

8.2 Yuzhun Evanoff stripping out the salmon. Photograph by Dave Nicholls, Anchorage Museum.

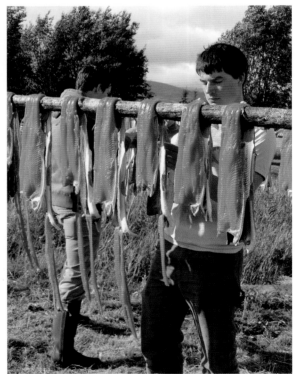

FIG 8.2

my sister pounding nails in our smoke-house, preparing for the summer. There have been a lot of changes, but we still process salmon the same way, splitting it thin enough so it dries and doesn't sour; keeping the fire in the smokehouse stoked, especially on the rainy days; and sharing our abundance with others.

My earliest fish camp memory is of my grandmother, who was blind, pulling grass and short brush by hand to clear the path and the area around the dock, or sitting near a pile of fish bones, pulling threads from a gunny sack and tying together the bones that had been split from the salmon. Now we're preparing for another summer at fish camp. A familiar excitement is in the air.

Ye'uh qach'dalts'iyi means "what we live on from the outdoors." Over many generations, by

understanding and practicing the ancient beliefs and values of our ancestors, we continue to sustain our culture and live a fulfilling life.

Looking beyond earthly forms has been a large part of this guidance. Elder Ruth Koktelash shared a part of this spiritual knowledge of the Dena'ina people in her description of preserving salmon underground. First a hole is dug, and the salmon is placed in it, carefully layered with leaves and moss. In a 1986 interview, Ruth described this process and the ancient beliefs of the Dena'ina people:

> And then they put the white moss
> on top real thick
> and then they bury it
> and before they bury it,
> they look up in the sky for the clouds.
> If there's a cloud in the sky over the hole,
> that's when they bury the place.
> When they see that cloud
> and bury the fish, they say,
> "Right under this cloud is where we bury
> the fish so we won't lose that place."
>
> That was long, long time ago they used
> to do that.
> Not these days.
>
> Then they watch that cloud
> and then they bury the pit real good
> so that nothing can ever find it.
> While they are still working on it yet
> and fixing it up real good,
> the cloud would be blown away already.
>
> Well, that's the Dena'ina (from an interview with Andrew Balluta, Linda Ellanna, and George Sherrod (LACL2182/007.06.01) in Evanoff 2010:77–78).

Ruth refers to the fish pit being placed beneath a cloud, with the cloud later blown away. The appearance of the cloud is guidance from the Dena'ina ancestors on where to dig the pit. As Ruth says, "Well, that's the Dena'ina." It is through these beliefs and practices that Native cultures have not only survived but thrived. The closest the Native people

come to describing the deep spiritual connection to living from the land is by retelling the stories from the past, learning from and practicing these values, and passing them on to our children.

We have come to know the practice of harvesting food from the land as *subsistence*. Regardless of how subsistence is defined, depending on the land for food is far more than taking what the land has to offer. Subsistence encompasses the entirety of the Native culture, and Alaska Native people have depended on the land from time immemorial. To live from the land is not an easy task, and starvation was not a foreign word to our ancestors. Traditional knowledge about harvesting animals, plants, and fish, including techniques and beliefs, has been passed down from generation to generation. The Dena'ina language, spirituality, and identity all are embedded in living from the land. The knowledge of the traditional ways of living from the land is important. This knowledge needs to be passed on to younger generations. It is vital to the well-being of the Dena'ina people.

In the Dena'ina language, there is no word for subsistence. *Ye'uh qach'dalts'iyi,* "what we live on from the outdoors," is how and what we live from; it is the connection to all living things in the natural world—the outdoors. It is traditional values passed on through generations. Olga Balluta from Nondalton explains the important value of sharing and celebrating the first salmon:

> Long ago, the first fish they got, they would have a big potluck and invite mostly all the elderly people. Invite them to eat one little bit, even if they get just a little piece out of the fish they got. And they share that one fish with everybody, that is with the soups and all, pass it to everybody to have a drink out of the cup. That is how they used to do with their first salmon that they catch. (Lake Clark National Park, Subsistence Interviews, 2003)

The land and water continue to provide physical and spiritual sustenance for the Dena'ina people in

everyday life. In the Dena'ina traditions, all things are connected. Although our focus here is on *ye'uh qach'dalts'iyi*, many parts of the Dena'ina culture are reflected in this cycle of life that connects us to our food sources.

To grow up in rural Alaska and have the close relationship with the land is truly a gift. We now live in a time when food is premade and comes in a box; we are becoming further and further removed from the origins of our food and the processes our food goes through to make it to our dining room table. Before the Dena'ina had contact with the outside world, obtaining food was the focus of daily life. Harvesting food was a year-round job. Even now, the Dena'ina believe that the knowledge of living from the land has to be passed on to the younger generations. As Dena'ina elder Agnes Cusma from Nondalton said:

> Don't teach your kids to eat white people's food too much. You got to cook; anything you eat, you got to give to them. Let them eat that. Gotta know how to eat out of the country. (Lake Clark National Park, Subsistence Interviews, 2003)

According to Dena'ina prophecy, the time will come again when we will depend on our traditional knowledge for survival. Respected elder, the late Shem Pete, originally from Susitna Station, was told a prophecy of having to depend on traditional food again. His uncle was a medicine man in the 1880s who prophesized the coming of diseases, foreigners, airplanes, trains, and the dispersal and death of the Upper Inlet Dena'ina. The great medicine man also warned the Dena'ina, "Don't eat too much white man grub." He said to put up lots of fish and meat.

> Now remember, who got little money gonna buy some matches. Buy ax, buy file. Pretty soon gonna be something happen. Listen careful.... There gonna be white man gonna be like this sand.... You fellows not going to be living in one place. Few here, few there, all over just scattered along like

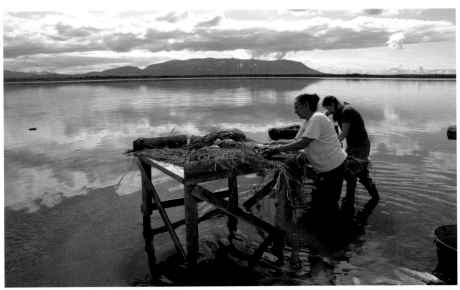

FIG 8.3

berries between white people.... And all the white people gonna see something happen. Grgrgrgrgr airplane gonna be like mosquitoes. So they all gonna get into the airplane. Then they gonna pick it up and take them all back to the States. (Kari and Fall 2003:97)

Shem's uncle urged the Dena'ina people not to take the world for granted. The Dena'ina have the memory through generations of living with very little and surviving. Although it is a material world today, this does not mean traditional knowledge should be forgotten. *Ye'uh qach'dalts'iyi* is a sacred part of the Dena'ina existence.

Living from the land is a relationship with nature. Many Alaska Native people used stories to describe the importance of this respectful relationship with nature. The ideals in some cases may be very different from those traditional to Western culture, but this relationship created a balance that worked for the Dena'ina people. This knowledge has become less recognized and practiced by the young people. In a system dominated by Western education, passing on Dena'ina traditional knowledge has been put on the back burner, seemingly not as

8.3 Cutting fish, 2008. Nancy Delkettie and Jessica Hay are shown here in 2008 cutting fish at a fish camp located below Nondalton. Layering grass on the cutting table is a traditional technology used by the Dena'ina to prevent the fish from sliding on the cutting surface. Photograph by Davin Holen, courtesy Alaska Department of Fish and Game.

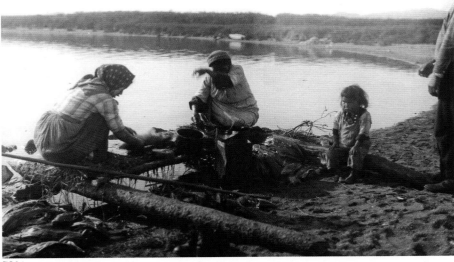

FIG 8.4

8.4 Cutting fish, 1921. Two women cut fish at Simeon Wassillie's fish camp on the east side of the Newhalen River, August 7, 1921. Photograph by Robert Vreeland. Robert Vreeland Collection. Photograph courtesy Robert Vreeland Jr. and the National Park Service, NPS H-214.

important. Native knowledge, especially living from the land, is threatened because it is not recognized as a vital part of our educational system. Our subsistence practices may be seen as killing animals to eat, when in reality, living from the land is a much bigger picture. *Ye'uh qach'dalts'iyi* encompasses spirituality, language, history, traditions, and the foundation of the Dena'ina people. Elders often say that young people are not learning the customs. This can be confusing to a young person. Many young people go through the actions of harvesting animals and helping with gathering food. What seems to be missing are the traditional Dena'ina *sukdu* (stories) that provide meaning. For example, there is a traditional story about the animals, who refer to the Dena'ina as the Campfire People. The significance of this story is how to care for animal bones, and it relates to the Dena'ina belief that everything has a spirit. Thus, it is respectful and proper to place animal bones in the water or to bury them. The story explains that animals are reincarnated, and if the bones are not cared for properly, then the animals remain disfigured and cannot come back to earth. When the bones are cared for properly, the animals put on their clothes again (the skins or hides of certain animals) and come back to earth.

Speaking in a language workshop in 2004, respected Dena'ina elder Andrew Balluta said, "If you 'kill' a bear for food, you don't really 'kill' the bear, he is just taking his coat off." The late Dena'ina elder Alec Balluta added, "We don't kill anything, their spirits still live. If we killed them, there would be no more animals around." The traditional Dena'ina stories are part of the context that connects us spiritually and distinguishes between simply killing an animal for food and our practice of living from the land.

Another Dena'ina *sukdu.* "The Mouse Story" is a popular *sukdu.* In this *sukdu,* there is a lazy young man who likes to take walks and sleep a lot. All summer long, his village busies itself putting away food for winter, but he doesn't help. His grandmother tells him he needs to stir a pot of soup and skim off the froth. He sees a little mouse run by, and in disgust, he tosses hot broth on the mouse. When winter comes, the weather is very harsh, and the village people are unable to get any food. The lazy young man goes out for a walk and hears a voice telling him to turn around three times in the direction that the sun moves across the sky. When he does, he finds himself in a room with a giant woman who offers him food. There is also a sick child there with burns on its back. She tells the young man that her husband will be back soon. When her husband—also a giant—returns, they tell him they are mice and show him their child, whom he burned during the summer. They explain to him that his village is now suffering because of the way he treated the little mouse. Seeing the burned mouse makes the young man feel sorry. They give him a bag of food and instructions to find caribou. He brings the food back to his village, and he is able to hunt caribou for his people. The young man is no longer lazy. There are several versions of this story, but the message is clear. All animals, including mice, must be respected. Anything alive, including plants, is not to be harmed for the sake of fun or for no reason. If respect is practiced in this way, reward will come; showing disrespect can bring punishment. This is a natural law that we live by.

Fish camp continues to be an important tradition of the Dena'ina people. The comparison often

FIG 8.5

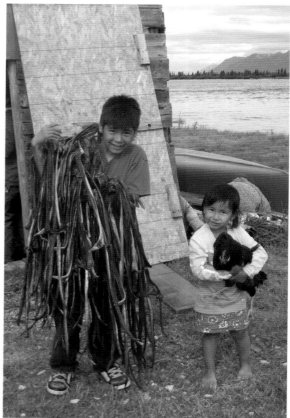

FIG 8.6

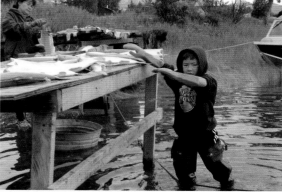

FIG 8.7

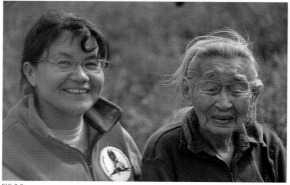

FIG 8.8

8.5 Using the *vashla*, or ulu. Elder Mary Jensen of Pedro Bay splits red salmon with a traditional Dena'ina knife. This particular *vashla* blade originally belonged to Mary's grandmother. Photograph by Aaron Leggett, Anchorage Museum.

8.6 Everyone helps out. Clyde Trefon's son helps carry dried fish strips out of the smokehouse. The fish strips are then cut into smaller pieces and placed in Ziploc bags. Photograph by Valerie Engbretson, courtesy Alaska Department of Fish and Game.

8.7 Starting early. Kela Stickman helps his mother by retrieving fish from the *k'usq'a* (fish bin) in the water and placing them on the cutting table. Photograph by Dave Nicholls, Anchorage Museum.

8.8 Karen Evanoff and Mary Hobson at fish camp. Family fish camps are occasions for visiting, sharing memories, and catching up on the news, as well as catching fish. Photograph by Dave Nicholls, Anchorage Museum.

used when one is asked what fish camp is like is, it's like Christmas, only better. We are not paying a price for gifts or experiencing a fleeting moment of joy and celebration. We are preparing all year long for our few months of celebration. We are coming together as family and community and sharing the gratitude of putting up fish—fulfilling our spirits, minds, emotions, and bodies from the same source and practices as our ancestors did. It's hard to put into words the feeling—the connection—that ignites the spirit when it comes time for fish camp.

It is an ingrained, unconscious movement that is felt when spring turns into summer. Fish camp is a communion with every aspect of putting up fish. It's a relationship that has been created from the time of birth, sensing when summer comes, it's time to go back to fish camp, it's the smell, the slime, it's nature—connecting back to the water, bringing relatives home. It's knowing that you have fish for

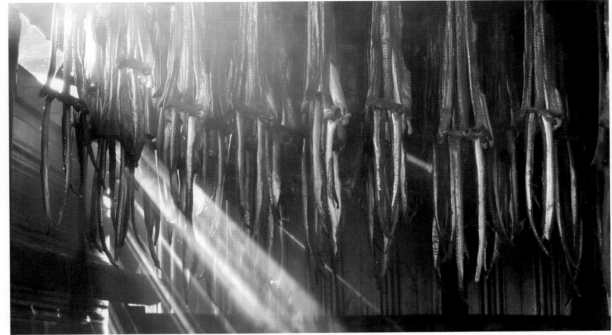

8.9 Evanoff smokehouse. In the smokehouse, with the sun shining and the smoke wafting, one feels the hands of time turn back and a connection to the Dena'ina ancestors. Photograph by Aaron Leggett, Anchorage Museum.

8.10 Gladys Evanoff, Evanoff family fish camp, 2011. Gladys Evanoff, originally from Pedro Bay, is shown at her fish camp on the Newhalen River. While in camp, she helps supervise the putting up of fish. Evanoff makes sure everything is done the way she was taught, so that this traditional knowledge is passed down to the next generation. Photograph by Suzi Jones, Anchorage Museum.

FIG 8.9

FIG 8.10

winter not only for your family but to share at potlucks and with relatives and friends. It's a spiritual igniter that restores this underlying excitement after a long winter. It's a part of life that is not questioned, whether we go to fish camp or not. It's done every summer. It's the contented labor of splitting fish, of stoking the smokehouse fire, of taking care and feeling pride in putting up fish the right way.

This deep-rooted way of life cannot be measured, it cannot be priced, but it can easily be overlooked by an outsider because it is beyond the visual and the spoken. This is the difference between being born into this way of life and learning about it later in life. Processing salmon—the Dena'ina call it "putting up salmon"—is what Dena'ina people do.

The connection, the familiarity, and the lifelong relationship with the camp, nature, fish, and food source are there from birth and over generations for those raised in the village. *Ye'uh qach'dalts'iyi,* "what we live on from the outdoors," defines the Dena'ina people, and this knowledge is vital to the continuance of our people. Today, as July rolls around the corner, word is spreading through the villages: The fish are coming. The Dena'ina are ready for the spiritual fulfillment of the summer season and connecting with the salmon once again.

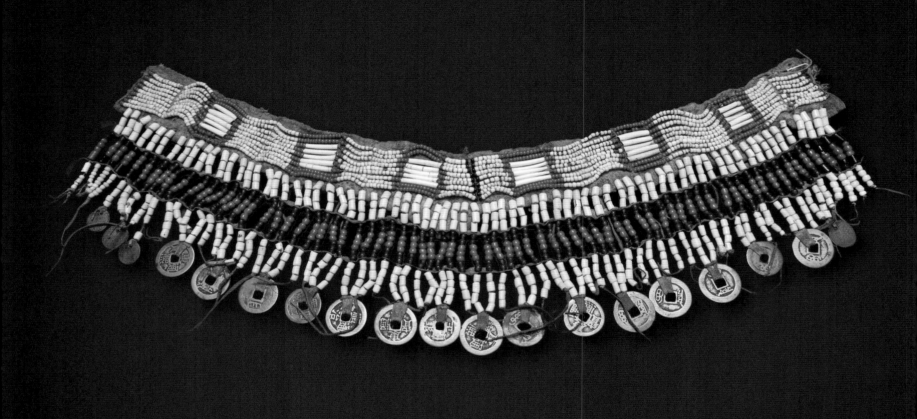

9

Dach' hdi łu t'qidyuq . . . "and that's the way it happened": The Tradition of Dena'ina Storytelling

Joan M. Tenenbaum

Dach' hdi łu t'qidyuq . . . "and that's the way it happened." Thus concludes another Dena'ina story in the customary and usual manner. Imagine yourself around a campfire in a fall time hunting camp, about five hundred years ago. The stars are bright overhead, the fire keeps the chill air at bay, your brothers and sisters are snuggled up next to you, your parents are nearby, and your uncle has just finished telling the story of the wolf who raises the young boy to be stronger than he is himself. Perhaps you hear a wolf howl in the distance, and you know, as surely as you know anything in life, that you are Dena'ina, and that wolf is your brother.

A rich and varied tradition of storytelling embellished Dena'ina life for thousands of years. In fact, one might regard Dena'ina storytelling as the equivalent of an educational system. The entire worldview of the Dena'ina people was encompassed in these oral narratives. In an environment in which whole families lived together in one room and often led an involuntary indoor life in winter, the telling of stories by elders night after night imparted an unbroken cultural history to each generation. In an era before Dena'ina was a written language, listening to stories was the way young people learned what it was to be Dena'ina: the stories conveyed pragmatic instructions about survival, guidelines for proper behavior, the way a person should behave toward other humans, animals, and powerful spiritual beings, the values and attitudes of the group, the characteristics of the animals in their surroundings, the names of the places in their region, how to acquire and use spiritual power, and the consequences of violating the ethical code.

The story of the poor boy in "The Old Lady's Grandson—Chitda Vekuya," told by Andrew Balluta, exemplifies the importance of the stories.

> There was a rich man who had a village of his own with many possessions and many workers. An old grandmother stayed near him, and only her grandson stayed with her. They were really poor. At night, they would tell stories in the rich man's house. The poor boy would go and stand just outside the door and listen.
>
> One time he heard the men in the rich man's house say they were going hunting as they had not seen game in a while. The poor boy asked to go with them. They said, 'You! You are a poor lady's grandson—you have no gear! How do you think you can kill anything?' And they threw him aside.
>
> The boy went back to his grandmother and said he would go hunting.

FIG 9.1

She, too, said, 'You poor boy, you say that again. People are not killing anything—how can you say you might get something for us?'

'Well, OK, I'll just go around near here.' And he took his bent up gun and went out hunting.

In the evening the rich man's workers were all returning and no one had gotten anything. After it got really dark, the poor old lady's grandson returned, carrying a pack! He went in to the old lady with a pack of meat! His grandmother said, 'Pack it to your uncle out there!' So the boy went in to the rich man's house and put that pack of meat by his uncle, and said, "I killed something."

Well, what could those workers say then? The one they had refused to bring along was the one who had killed something. The boy's uncle, the rich man, said to them, 'Here is the one we call Poor One. While they were telling stories to you at night, he was listening outside. He was barefoot and was cold and he had been listening. That's the reason he killed something.'

Well, the seasons changed, and that boy married the rich man's daughter, the one who had been so poor! (Balluta 2008:51; other versions told by Nickafor Alexan in Alexan 1965b:14; Hamushka Zachar in Rooth 1971:85; and Peter Kalifornsky in Kalifornsky 1991:179)

In 1973, as a young graduate student in anthropological linguistics, I went to live in Nondalton to document the Inland dialect of the Dena'ina language.[1] During the course of my linguistic work there, aided by my excellent Dena'ina-speaking assistants, I recorded, transcribed and translated twenty-four traditional Dena'ina stories told by Antone Evan, Alexie Evan, Gulia Delkittie, Katherine Trefon, and Mary V. Trefon. These were later published by the Alaska Native Language Center under the title *Dena'ina Sukdu'a: Traditional Stories of the Tanaina Athabaskans* (compiled and edited by Joan M. Tenenbaum 1976, 1984, 2006). As I worked with the stories, analyzing and taking apart each word in order to understand it, I realized that quite by accident, I had recorded four different genres of traditional story. Since that time, I have become aware of the other varieties of traditional Dena'ina narratives.

The numerous categories of Dena'ina narratives form a compelling body of northern literature. In all preliterate societies, cultural information has been passed down through the generations through oral narrative. Recounting and listening to legends, histories, and tales of humor and heroes formed a large part of traditional Dena'ina life until quite recently. Dena'ina became a written language in the 1970s

9.1 Andrew Balluta in a photograph taken in April 1975 by Joan Tenenbaum at the first all-Dena'ina language workshop. Photograph © Joan Tenenbaum.

9.2 Joan Tenenbaum in a photograph taken in the winter of 1974, after she had arrived in Nondalton to document the Inland dialect of Dena'ina. Photograph © Joan Tenenbaum.

with the work of linguists James Kari and myself and later others, including Peter Kalifornsky, who became literate in his own language in his sixties and during the rest of his lifetime amassed a large volume of essays, poems, songs, anecdotes, and traditional stories, all in his own hand in Dena'ina (Kalifornsky 1991).

The largest class of Dena'ina narratives includes stories called *sukdu,* stories set in a faraway past that tell of the way the world was before it became the way it is today. Among the *sukdu* are many animal stories and scores of stories about Raven, a familiar character in the traditional stories of many Native Americans. Other *sukdu* are *dghiliq' sukdu'a,* or "mountain stories," legends that take place in a slightly less distant past. The remaining types of Dena'ina stories consist of historical narratives, including accounts of wars waged; personal travel narratives; anecdotal ethnographic narratives; biographies; and stories of the origins of Dena'ina clans.

FIG 9.2

The *Sukdu*

The Dena'ina say that the *sukdu* take place in an ancient time when all animals were "people." Sometimes characters such as Raven, Lynx, and Wolverine act the way they would act in animal form, other times they do things only someone in human form could do. In those days, they had the ability to be either animals or humans, and they would transform back and forth at will. Although the stories were told for entertainment, they also impart Dena'ina beliefs about the origin of the world and its inhabitants. It is in the *sukdu* that we learn why Chickadee has a black cap, why Rabbit's feet are yellow, why Woodpecker eats only insects, why Brown Bear respects Porcupine.

But perhaps more important, the *sukdu* demonstrate through parables the Dena'ina behavioral code, which governs relationships between animals and humans—as well as between various sets of humans—and the consequences of breaking that code. In Dena'ina life, it was important to maintain

a proper spiritual balance between the human and the nonhuman world. This was a matter of direct daily concern. For example, brown bears were considered to be spiritually and physically more powerful than humans. Great care was always taken when speaking about, hunting, and disposing of them. Brown bears were never called by their name. Instead, they were referred to as "Grandfather" or by another respectful term. If proper respect was shown when approaching this animal, and if the hunter was sincere, the bear would give his coat (hide and flesh) to the man.

In the *sukdu,* we also learn the proper way to dispose of animal bones and other remains. The bones of water animals such as fish or beaver were to be placed back in the water; those of land animals, such as caribou, were to be placed on the land. If proper respect was shown in this way the animals would return and make themselves available again for harvesting.

9.3 A gathering of linguists at the University of Alaska Fairbanks. Left to right, Michael Krauss, Joan Tenenbaum, Jim Kari, and Peter Kalifornsky. With the exception of Albert Wassillie, this photograph shows all the Dena'ina writers of the 1970s. Photograph © Joan Tenenbaum.

FIG 9.3

Chulyin Sukdu'a: Raven Stories

There are hundreds of Raven stories. It was Raven as benefactor who created the present state of the world and many of the things in it. He is also the trickster who can produce anything he wants merely by wishing for it and who constantly outwits both strangers and friends for his own selfish and often gluttonous reasons. Here he is in his creator role in the *sukdu* "Raven and Caribou—Chulyin Vejex Sukdu'a," told by Antone Evan:

> Long ago Raven was flying around and flew over Caribou. He circled and landed nearby and then filled up all his pockets with lowbush cranberries. When Caribou saw him he attacked him. He bit him a few times, and then

he had no more teeth. In those days Caribou had fangs, like Brown Bear, but after Raven did that to him with the cranberries, he had no more teeth.

Then Raven said to him, 'How come you can't smell anything? People walk upwind of you and you don't even smell them.' Then Raven walked through the forest and tore off some pieces of birch bark and put them in his pockets. He went back to Caribou and rolled up the birch bark pieces and twisted them into Caribou's nose. Then they walked away from each other.

Raven walked out far away, and then he walked upwind of Caribou. Suddenly Caribou rose and started running away—he had smelled him!

9.4 Antone Evan and Joan Tenenbaum. Antone dictates and Joan writes, working together to transcribe stories, in Nondalton, December 1974. Photograph © Joan Tenenbaum.

FIG 9.4

Thus Caribou became able to smell. When any people walked upwind of him, he could smell.

And that's the way it happened, the story of Raven and Caribou. (Tenenbaum 2006:86)

Raven appears in his trickster role in many other *sukdu*. Here is one episode from "Raven Story—Chulyin Sukdu'a," told by Antone Evan:

Raven was walking and walking and then got lonesome and decided he wanted to travel by boat. He produced a canoe by drawing an outline of it in the sand and then kicking it. After a search for a companion, he settled on a nice fat seal. When they camped for the night, Raven told the seal, 'When it's this time of year, people never camp right on the beach. They camp very far up in the woods when conditions are like this.'

So Raven led the seal far inland where there was no water anywhere. With difficulty, the seal followed behind. Then the seal asked Raven what they would eat. Raven told him, 'Ah, yes, at times like this, when we're starving, it's our feet. We cut off one of our feet,' he told him. Raven made two roasting sticks. He cut off his own dried-up foot and stuck a roasting stick through it and stuck the stick into the ground. 'Go ahead, you next,' he told the seal. When the seal objected that it would hurt him, Raven made a powerful wish. He put the knife in the seal's hand. 'Go ahead, it never hurts,' he told the seal. The seal cut off his own foot and indeed, it didn't hurt. Raven then told him to wipe it with his spit and his foot would grow back, which it did. The seal put his foot on a skewer and stuck it in the ground near the fire.

Now the seal's foot was really fat. As soon as the heat hit it oil started dripping from it and it started sizzling. Then Raven said to the seal, 'Friend, when we are good friends like this, we never eat our own foot. We eat the other person's foot.' Raven's foot was hanging there, with the toes all curled up from the heat. When the seal wasn't looking, Raven took oil from the seal's foot and rubbed it on his own dried-up foot, and said, 'Look, friend, my foot is oily, too!'

When they were roasted, Raven poked the stick with his own foot in the ground by the seal, and the seal's foot by himself, and they began to eat. Raven got just sick on the oil from that foot, and, as for the seal, he tried to eat that raven foot, which was dried up like a hoof. (Tenenbaum 2006:110)

Dghiliq' Sukdu'a: Mountain Stories

A remarkable set of Dena'ina *sukdu* are the mountain stories. Unlike other traditional narratives, these stories were told only in the late summer and fall, when the Dena'ina went into the mountains to snare ground squirrels and hunt caribou and other game. Events in the mountain stories appear to take place in a more recent time period in which the Dena'ina are pursuing their customary subsistence activities; however in the worldview of the mountain stories—as in the other *sukdu*—the separation between the natural world of animals, plants and other spiritual entities and the world of human beings is very narrow. Humans and animals can communicate with each other, and the nonhuman world is responsive to songs and spells, as well as to violations of the proper ways to behave.

In listening to the mountain stories, there emerges a picture of what Dena'ina life was like before Europeans came to the area. Because these stories were memorized and may be hundreds of years old, or more, the content of the stories mirrors the beliefs of earlier generations of Dena'ina society. And they paint a vivid picture of traditional Dena'ina life. Recurring themes in the mountain stories are traditional hunting and gathering, starvation, famine, and being at the mercy of the weather. Through the retelling of these stories the Dena'ina beliefs, attitudes, and values were passed on to new generations. These stories explain many things, such as the relationship of humans to the land, animals, and nature, how one should treat animals, and the value of group survival over the desires of any individual.

The "Ground Squirrel Story—Qunsha Sukdu'a," told by Antone Evan, exemplifies the nature of the mountain stories, the interactions between humans and animals, and the Dena'ina value of respect for all creatures.

> Two women went up into the mountains. They built a brush shelter. In the morning they set their snares. The next morning each one looked at her snares. One woman brought home only really big ground squirrels. As for the other one, she brought back only small ones. They spent the summer there, and that one woman got only really small squirrels all summer.
>
> Once more in the morning it dawned a clear day. The women walked back along their snare lines. The woman who killed only small ground squirrels came to her snare. When she pulled it out of the hole, she once more saw a little squirrel's tail sticking out. She ripped out the snare and squirrel both and slung them down the hill into an alder thicket. She started off again.
>
> She hadn't gone far when it started getting foggy around her. Pretty soon she was fogged in and she lost her way completely. She became wet and cold. She kept walking around, and then she seemed to hear a sound nearby. It sounded like someone singing coming from down the hill. She listened, and started walking towards the sound. She walked and walked, and then suddenly she came upon a ground squirrel house, a big hummock of grass. Then she realized that the sound was coming from in the ground squirrel hole. She heard someone singing. A human was singing down there in the ground. She walked around the house.
>
> Then she heard someone say, 'Put your sleeve over your eyes and lean your head against the house.' She put her sleeve over her eyes and leaned her head against the house. And at that she tumbled inside with a jolt. She opened her eyes and saw that she was in a nice ground squirrel home. It was warm. A fire was burning in the center of the floor. It was really nice and warm in there. She sat down next to the fireplace, and saw a woman on the bed holding a child in her lap. She was

singing. As she warmed herself, she watched the baby in the woman's lap, and there was a string hanging down from him. She realized that it was a snare, her snare, tied around his waist. So she went over to him and loosened the snare, and when she pulled it away the child let out a deep breath.

Then the ground squirrel woman said, 'When you people are walking around this way, and come across any wild animals, don't think to be mean to them. Nowadays kids like these don't stay indoors, they keep running in and out. Why should they make you angry?' The woman said nothing.

'Go now, it's all right, you can go now. Put your sleeve over your eyes and lean your head against the wall.' The woman did as she was told, and at that, she tumbled back outside. She tumbled back outside, and the sun was shining; there was not a single cloud. She saw that it was a fine day.

She started walking back along her snare line, and there were big ground squirrels in her snares. She brought home big ground squirrels.

The next morning she went out along her snare line again, and once again, she brought back only big ground squirrels. From that time on, she began to kill only big ground squirrels.

And that's the way it happened, the Ground Squirrel Story. (Tenenbaum 2006:134–141; other version told by Alexei Evan in Rooth 1971:70)

The poignancy of life and the thin margin of culture separating the Dena'ina from starvation are themes that recur throughout the *sukdu*. Here are also found the origins of many of the songs the Dena'ina use for luck in hunting, to procure game in times of starvation, or to affect the weather.

"Fog Woman Story—Nunigi Deghk'isen Sukdu'a," told by Antone Evan is a heartrending tale of the position of the individual within the group, and the origin of the song used to drive away the fog.

Long ago it was summer time when the families were in the mountains. The parents had one son, their boy child. They climbed up and built a brush shelter. His mother went out after ground squirrels, and as for him, he and his father went hunting caribou. They hunted caribou and every kind of game. Then one day the young man encountered a young woman on the mountain. He asked her to go back home with him, but she refused.

All summer long he kept returning to that woman on the mountain. Then once more he asked her to come home with him, and when she said it was not right, he told her it would be all right. And so she started back with him, and it began to rain on them a little.

When they came to their camp, it began to rain harder on them. Day after day, it rained and it rained, and was foggy. The people could not hunt and their food started to run out. Everything they had hunted that summer was used up. The woman told the man that this was the reason she had refused, that unless she left it would never be good for his people.

So they wrapped their baby in a blanket, and started up the mountain. She told him when it was far enough, that he should sit there, and she continued up the mountain. The man watched her and as she walked up, the fog was lifting with her. He burst out crying. He watched her walk over the hill, out of sight, and the fog, too, went over the hill. He burst out singing. He watched her as she walked over the crest of the hill. It stopped raining; the sun started shining.

The man cried and cried, and then he wiped his eyes, turned around and looked out onto the flats. There were caribou—thousands of caribou. He wiped his eyes, ran down to his camp, grabbed his bow and arrows, and started hunting caribou. He packed a bunch of meat home. It was good for them again.

And that's the way it happened, Fog Woman Story. (Tenenbaum 2006:150; other version told by Alexei Evan in Rooth 1971:64)

For those who believe in traditional Dena'ina ways, the events described in the *sukdu* are still possible today. A seminal mountain story called "We Found Little Brother—Kela Nuch'iłtan," told by Antone Evan, tells of a wolf who joins a young Dena'ina family one summer and imparts his strength and skill to the family's baby. As the baby grows up, the wolf comes to his family each summer as they hunt in the mountains. The wolf helps the family and in turn is helped by them. In the story, the wolf howls when he has made a kill as a signal to the humans that he has left meat for them. When the boy becomes a man, his wolf-brother warns him that the other wolves will be jealous of him because he has a brother who is a wolf. In the end, the man becomes such a strong warrior that he is more powerful than even the wolf who raised him.

To this day, the Dena'ina regard wolves as their brothers, and the agreement between the wolves and the Dena'ina is still honored. The Dena'ina believe that in hard times the wolves will help them. If a person hears a wolf howl and he goes to where the sound is, he will find meat left by the wolves (Tenenbaum 2006:176; other version in Vaudrin 1969:66; and told by Andrew Balluta in Ellanna and Balluta 1992:44).

Historical Narratives

Besides the *sukdu,* the Dena'ina have other types of traditional narratives. These are accounts dating from the historical past. Examples of these are factual histories of wars waged with other Dena'ina groups and with the neighboring Yupiit, the Alutiit, and the Russians. These stories provide a perspective on the history of the region that was once the exclusive and vigorously defended homeland of Alaska's most populous group of Athabascans. There are many such stories. They recount battles, ambushes, hostage taking, and blood revenge, and the deeds of heroes, both Dena'ina heroes and enemy heroes. These are men who were raised with knives put beside them in their cradle; who were so quick and strong they could catch arrows in the air as they were shot at them; who could vault completely over enemy warriors with their spears raised and attack them from behind; who fastened brown bear fangs to the bottoms of their snowshoes so they could run on glare ice; who, when hungry, could eat an entire bundle of forty fish in one sitting; and who could spear a brown bear single-handedly, even in old age. These were the Dena'ina heroes. Their stories are lively and vivid, and the listener readily senses the pride with which they are regarded by the Dena'ina (Tenenbaum 2006:214; other versions told by Fitka Balishoff in Osgood 1937:183; told by Nick Kolyaha in Rooth 1971:101; told by Nickafor Alexan in Alexan 1981; told by Andrew Balluta in Ellanna and Balluta 1992:47 and in Balluta 2008).

Personal Travel Narratives

In traditional times the Dena'ina were great travelers. They traveled hundreds of miles up and down the many rivers in their territory, over mountain passes, from Cook Inlet inland and back to the ocean. Besides their regular seasonal travel for subsistence harvests of salmon, moose, caribou, berries, ground squirrels, and other game, they also traveled to visit relatives, attend ceremonies, or trade. The Dena'ina were impressive walkers, covering miles of territory on foot and hauling sleds behind them in wintertime. Before Europeans came to the area, the Dena'ina did not use dogs for hauling sleds but rather utilized some as pack animals and trained others specifically for hunting. The Dena'ina have a wealth of traditional narratives

describing notable trips. One such narrative told by Antone Evan describes a trip from Lake Clark to the village of Tyonek:

> About halfway through Lake Clark Pass is a glacier with many crevasses covered with snow, some of which can span up to five feet across. One man was hauling two sleds behind him and a child sat in his second sled. The first sled made it across but the second sled fell into a crevasse. The group was able to pull up the sled, but the child had fallen out. The Dena'ina gathered all the rawhide sled lashings and all the extra lines they had and spliced them into one rope. The child's father tied the rope around his waist and told the others to lower him down into the crevasse. They were nearly at the end of the line when finally he shook it, and they pulled him back out of the crevasse. He had the child with him. They went back down below the glacier towards Lake Clark and made camp. When the child was in the crevasse he had put his hand out of the coverings, and his hand was frozen. He lost that hand. The people came back to the village, and that child grew up and had children. Though handicapped with only one hand, he nevertheless lived to be an old man. (Ellanna and Balluta 1992:49; for other personal travel narratives, see Kalifornsky 1991:331; Kari and Fall 2003)

The Names, the Ancestors, the Land

For the Dena'ina, place-names were an essential component of their land and life. A set of names was vital for navigation and orientation through Dena'ina territory. These names were carefully passed on through the generations and were learned while traveling and from listening to stories. These oral place-names were not learned from maps or written records. The Dena'ina could recite detailed accounts of travel, enumerating sequences of place-names of known routes and highlighting camping spots at the end of each day of travel. Listening to the names in these travel narratives is like listening to poetry (Kari 2007):

Sand River	Susitnu
Among the Lakes	Benteh
Where We Slide Down	Shk'ituk't
One Burning Inside	K'idazq'eni
Soft Snow Mountain	Nakida Dghil'u
Down Feathers Lake	Keshch'a Bena
Black Stone Axe	Tsalt'eshi
Beaver's Sleep	Chu Nula
Bear Tree Mountain	K'denez Dghil'u
Blue Water Lake	Tutnutl'ech'a Vena
Carved Around It	Naqazhegi
Journey Rock	Tsayil
Mountain Base	Dzel Ken
The Ancient One	K'esugi

Ethnographic Narratives

The Dena'ina also enjoyed retelling stories relating factual descriptions of subsistence practices, including the construction and use of traditional implements. The events in these stories take place in the more immediate past, as in the travel narratives. Many of these are ethnographic descriptions of how the Dena'ina survived during difficult winters. They also illustrate important cultural values associated with subsistence, such as sharing, kinship, and respectful behavior toward all living things. Originally autobiographical accounts, these stories serve to instruct and explain to later generations ways of meeting difficulties in life.

The Dena'ina had specially trained hunting dogs that often saved lives by being able to locate bears in their dens in late winter when food supplies ran short. "The Hunting Dog Story," told by Shem Pete tells of such a dog in a group of Dena'ina living in a *nichil,* a large multifamily winter dwelling:

> Famine struck people living in a *nichil* late one winter. People were already

dying. Two brothers set out hoping to reach another village where there might be food for their people. They tightened their rope belts and they went out together. An old dog followed them. The older brother was going ahead of the younger brother. When they got too far ahead of the dog, the younger brother ran back for it. It was staggering along. It was starving, too. The younger brother gave the dog something to eat from out of his shirt. The brothers kept on, at times holding on to each other for support. Again, when they got too far from the dog, the younger brother ran back to it, and this time he put it under his arm and caught up with his older brother. "Throw that old dog away! We've got to make it to that other *nichił*," his older brother said.

Evening arrived. Again, they got too far from that dog, and the older brother said, "Throw that old dog away!" But the younger brother turned back. He found where that dog had dragged itself off the trail and he ran off the trail following it. The dog's tail was sticking out of the snow and it was wagging it back and forth. The dog had found a den!

He quickly caught up with his older brother and said, 'Older brother! That old dog you were bawling me out about found a den entrance!' The older brother turned and starting running behind his brother. They returned to that place. They tied up the dog, they put sticks across the hole, and they speared it. They dragged it out. The younger brother chopped lots of wood. His older brother shoveled snow away with his snowshoes. They got strong again when they saw that bear.

They butchered the bear up real well, and the younger brother built a big fire. They made camp. Cutting off good pieces of meat and fat the younger brother stuck them on sticks over the fire. When it was roasted, he put meat by his older brother real nicely. 'Older brother, eat!' For that old dog, he cut off a chunk and put it in his mouth. His older brother stared at him, stingy for that meat. The younger brother told his brother, 'I realized why that old dog followed us here, and that's why I went back for it. But you bawled me out over that. You are eating well due to that old dog.'

They ate and they just fell down. He put the dog by his feet real nicely. They fell down and they slept. In the morning they took as much as their strength would allow back to their *nichił*. That old dog got strong again. His tail was erect. He hobbled along right behind them.

When they returned home, everyone was collapsed inside the *nichił*. They made soup for them, and they kept doing that till they had given everybody soup. All the people slept, and the brothers kept a fire going for them. They had gotten a little strong already. In the morning they took whoever was strong enough and packed all the meat and fat back home. The rich man had them pack fat over to the neighboring *nichił*. They say that lots of people got saved from that bear. (Pete 1989; also in Fall 1990a; for other ethnographic narratives, see Alexan 1965a, 1965b, 1981; Kalifornsky 1991; Kari and Fall 2003)

The Dena'ina Storyteller

In the time before Europeans came to the area, Dena'ina narratives were told in every household, all winter, by parents and grandparents alike. Anyone who knew a story could tell it. In the summer and fall, the mountain stories were added

9.5 Shem Pete standing with a rifle near Delggematnu (Cache Creek) in 1977. Photograph courtesy of Priscilla Russell.

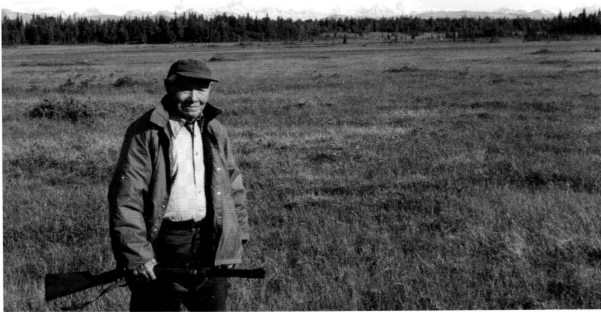

FIG 9.5

to the repertoire. Many of the *sukdu*—raven stories and other stories about animals—were never the exclusive property of individuals but rather resided in the collective memories of the entire cultural group. Repetition of traditional stories fostered a feeling of togetherness, and because everyone knew the stories, this strengthened family and group cohesiveness. In fact, because the stories were shared knowledge, adults could make reference to characters and events in them to admonish youngsters and gently steer them toward acceptable social behavior. Often, particular stories were chosen for telling because they related to situations at hand, and because the stories were told in the third person, this method of teaching was very effective for young people.

Habitually, *sukdu* were told in a distinct style of speech, in a slow rhythmic tone or a somniferous voice pitched lower than usual, heightening the dramatic impact. The language itself also differed from everyday speech, containing archaic and old forms of speech, dramatic pauses, purposeful repetitions, and changed voices for different characters.

When the stories were told in the darkness of a winter evening, children were expected to listen without interrupting, but adults were always free to interject details they felt were essential. During my fieldwork in Nondalton, after I had recorded and transcribed the stories, I took them to my main assistant (Pete Trefon Sr.) and read them to him from my notebooks. He then translated them for me word by word. During most of these sessions his wife was also present in the room, and the two of them acted as audience after the fact, commenting, correcting and even adding words they deemed necessary. There was never a story they had not heard many times before.

While animal stories could be told to anyone, biographical tales were passed down almost exclusively through family lines. Knowledge of traditional stories carried great prestige for the Dena'ina and was seen as a form of wealth. It was no coincidence that wealthy men among the Dena'ina were often the best storytellers. For within these stories was not only the practical knowledge essential to survival but, more important, esoteric and detailed instructions regarding spiritual songs, spells, and lucky signs that enhanced one's hunting success, spiritual power, and overall wealth.

As young men grew up, they were encouraged to travel and visit the houses of their wealthy matrilineal kinsmen, often wintering with them, for the purpose of augmenting and evaluating what they had learned at home. It was customary for a wealthy man, a *qeshqa*, to offer stories as a reward for work done by these young men. Thus the hardest-working youth and those who showed the most initiative and promise were rewarded with the most stories. Because of the secret nature of the knowledge of how to deal with the spiritual world, those individuals who through kinship ties received the best instruction and training had a great advantage over their rivals, as the story of the poor boy with few relations shows.

Tradition Is a Power in Itself

As we sit by the campfire, it grows late, but we ask for another story. What a rare privilege it is to have this wealth of knowledge, to learn the stories of our ancestors, to understand the terrain around us, and to know what it means to be Dena'ina in this place. We can laugh at the antics of Raven, marvel at the power of heroes, and admire the resourcefulness of our forefathers. But most of all we can be reassured by our connection to our community, and recognize that community includes humans, animals, and the land around us.

Note

1. The original research was supported by the National Institute of Education (grant no. NE-G-00-3-0180), the National Science Foundation (grant no. GS-38240), and the National Institute of Mental Health (grant no. 1 FO1 MH 58640-01).

K'ich'ighi: Dena'ina Riddles

Albert Wassillie

Following is a selection from the Dena'ina riddles (*k'ich'ighi*) collected by Albert Wassillie Sr. in Nondalton in the 1970s. In her introduction to this collection, Tupou Pulu, the former director of the University of Alaska's National Bilingual Development Center, noted

> The Dena'ina people…used to delight in telling each other riddles. Their riddles were derived mainly from careful observation of their natural environment. Sometimes the solutions to riddles took a month or more to be correctly reached. Night after night, answers would be put forth as the people sat around the fire. Whenever someone thought he had the correct answer, he would say "*Yihhey*," and then he would quickly give the answer.
>
> Riddles are of special interest as a form of creative expression, because they challenge the listener into active participation. They stimulate the brain to bring all its resources into the resolution of mysteries presented by their creators. (Wassillie 1980b:i)

Wait, there is someone coming to us but it is quiet again.
Ijanda ki shi'a…Nagh ch'niyu q'u nt'i.
It is a gust of wind blowing against us.
Łch'ivaya.

Wait, I see the place where someone dragged a spear.
Ijanda ki shi'a…Ten quq' tuqesi vesch'dghalkidi shugu.
The pressure crack on the ice.
Ten nanidlut'i.

Wait. I see a little stick someone stuck in charcoal.
Ijanda ki shi'a…Chik'a gguya t'ash ach'dghiyeli shugu.
The tip of the weasel's tail.
Kughuljena kajada kiyiq'

Wait, I see a track but it went this far and then stopped.
Ijanda ki shi'a…Ey gu hqugh yan nidnatqa'.
A snowball that rolled down hill and stopped.
Nzhah chench' ts'ilvits'i.

Wait, I see lots of pretty nests.
Ijanda ki shi'a…K'eghazhq'a qelzhin.
The little whirlpools made by a canoe paddle.
Tagh'i tl'egh niqatak'ułch'ex.

Wait, I see it is inflicting wounds upon its own body.
Ijanda ki shi'a…Udivet'.
It is a caribou that is shot with a caribou bone arrowhead.
Vejex udi veda k'qes eł ldexi.

Wait, I see someone threw dentalium in the mountain streams.
Ijanda ki shi'a…K'enq'ena dghili k'etnu gguya tuch'nghiłtl'idi
It is the mountain trout, the brook trout, the char, or the Dolly Varden with their bright white fins.
Qak'elay ts'elghuk'a.

Wait, I see little brothers chasing each other up into the air.
Ijanda ki shi'a…Niłkela'ina diqaniłdenghilggashna.
It is the sparks going up from the fire.
Tsidyan diqadel'ahi (Wassillie 1980b).

10

Gunhti Stsukdu'a: Ki Nch'uk'a "Tanaina" Ghayełe'
This Is My Story: "Tanaina" No More

Aaron Leggett

I was born October 4, 1981, in Anchorage, Alaska, at the old Alaska Native Service Hospital on Third Avenue. My grandmother, Marie (Ondola) Rosenberg, was a full-blooded Dena'ina from Idlughet (Eklutna), and as I sit down to write this article it occurs to me just how much change my family has witnessed in three generations.

When my grandmother was born, in 1933, the Anchorage area had a population of about 3,000 people. When my mother was born, in 1957, the area had a population of about 80,000, and Alaska was a territory. When I was born, the population was about 180,000; today, it is close to 300,000. By the time my grandma passed away, in 2003, she had seen the Anchorage population increase by 100 percent.

The world my grandmother grew up in no longer exists. She grew up fishing with the family at Fire Island and hunting Dall sheep in the Eklutna Mountains. She spoke Dena'ina with her mom, Olga (Alex) Ondola, and her maternal grandfather, Beł K'ighił'ishen (Eklutna Alex). Today Eklutna Lake is a state park, and although the fish camp still exists at Fire Island, the regulations are such that it is no longer feasible for us to fish there. Today, I am the only person in the village who is learning the language, a task made all the more difficult because I never got the chance to speak it with my grandma.

I grew up living what seemed to me to be a typical suburban lifestyle here in Anchorage, but I can

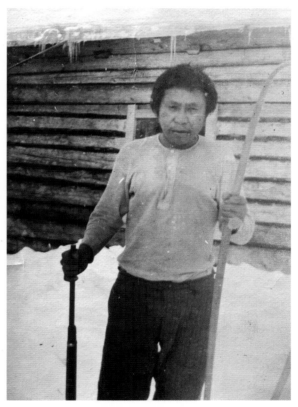

10.1 Beł K'ighił'ishen (1869–1953). Known as "Eklutna Alex," Alec Vasily is standing in front of a hand-hewn log cabin, holding a rifle barrel in his right hand and a snowshoe frame in his left. Eklutna Alex was one of the last chiefs of Eklutna village and thought to be its last shaman. Aaron Leggett is the great-great-grandson of Eklutna Alex. Debbie Fullenwider Collection, Cook Inlet Tribal Council. Photograph reprinted by permission of Cook Inlet Tribal Council, Inc.

10.0 *Niłnuqeyishi*, Eklutna Alex's counting cords, Eklutna, early 20th c. 25–54 cm. Moose hide, yarn, sinew, ochre. Debbie Fullenwider Collection, Cook Inlet Tribal Council, 17–22. Photograph reprinted by permission of Cook Inlet Tribal Council, Inc. Photograph by Chris Arend. These counting cords once belonged to Eklutna Alex. The cords were used as mnemonic devices to help record significant events in a person's life. They probably date from the early twentieth century through World War II.

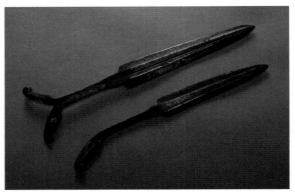

FIG 10.2

remember the day I learned that I was Dena'ina as if it were yesterday. It was November 22, 1984, a day or two after half my preschool class dressed up as Indians and the other half dressed up as Pilgrims. We knew we would then make cranberry sauce and put it in little Gerber baby jars. I remember being excited to give my grandma my Gerber jar for the Thanksgiving dinner. I remember giving it to her and saying, "Grandma, we dressed up as Indians in school." She replied, in her husky voice, "Aaron, you are Indian." That one sentence would completely redefine who I was. What do you mean, I was an Indian? Indians were something I only saw in Disney's Goofy cartoons or that existed here long before "civilization." They lived in teepees and wore feather bonnets.

As I got a little older, I gradually came to understand what she meant when she said that we were "Indians." She meant, of course, that we were Dena'ina. When I first came to understand that I was Dena'ina, it had little effect on my daily life. Never once as a child do I ever remember eating traditional foods like sheep meat at her house. In fact, when I think about my grandma and what we ate, I always think of Arby's, her favorite place to take us to eat. One time, I remember her telling me about the first time she tasted Coca-Cola. She was about six. Her dad took her to Anchorage, and they went to a soda fountain. She talked about what a treat it was. That seemed so bizarre to me, as we always had a twelve-pack of it in our refrigerator.

Whenever I think about that time in my life, I associate another person with my being Dena'ina. His name was Roy Alex, and he was my grandmother's uncle. He was born in 1917, just a few years after Anchorage was created as the headquarters for the Alaska Railroad. As a child, I was always intimidated by him. When I think of him, I always remember him being at my grandmother's house every year at Thanksgiving. He was always the first one to show up, and he would eat a quick dinner before heading into Anchorage to play bingo. Uncle Roy, as he was known, was the only one of my relatives that I ever knew who spoke Dena'ina as a first language. He passed away in 1996, and I regret never having had the opportunity to ask him questions about what this area used to be like.

When I was kid, there was not much talk about us as Dena'ina people. I remember when I was in the fourth grade we learned about Athabascan people. Even as a kid, I remember always being fascinated by the state I lived in. Given that I was Athabascan, I was excited to learn more about my grandma's people. Unfortunately, the curriculum and the way it was taught left a lot to be desired. I remember coming in from recess one day for story time. The teacher sat us down to hear a couple of Athabascan stories. The first story she read was called "The Chickadee Story." After she finished the story, which ends with the violent demise of the chickadee and the grandmother, I remember the disgust on her face. She stopped reading from the book, and we went on to our math lesson. What I didn't know at the time but learned ten years later was that the teacher was reading a poor rendition of a very complex story that, even to this day, I don't think I completely understand. As I reflect on this incident, what disturbs me the most about the whole thing was that the teacher never mentioned that the story came from the Dena'ina and that these people still lived in this area.

As I grew older, I began to struggle with my Native identity. The most obvious reason was the negative stereotype held by some in the dominant culture that all Natives were drunks living on the street. Of course, this is rather mild when compared

10.2 *Tl'uts'eghi* **Eklutna Alex's knives, Eklutna, c. 1900.** L 29 cm, L 26 cm. Steel. Debbie Fullenwider Collection, Cook Inlet Tribal Council, 9, 10. Photograph reprinted by permission of Cook Inlet Tribal Council, Inc.

10.3 Thanksgiving costume, 1984. Aaron proudly displays his Indian costume, which he had made that day at St. Mark's Pre-School in honor of Thanksgiving. Shortly thereafter, he found out he really was an "Indian." Photograph courtesy of Diane Buls.

to the experience of people of my grandmother's and great-grandmother's generation, who would come into Anchorage and see signs hanging in the restaurants, signs like those in the Anchorage Grill that said "No Natives, dogs or Filipinos" (Bryson 1988). Another reason why I struggled with my identity as an Alaska Native is that I didn't grow up in a rural village. My village was, in fact, Anchorage, my ancestors' homeland. Therefore, I never really had the option of going back to a village to see what life was like.

In addition, there was virtually nowhere in Anchorage I could learn about the "Tanaina Athapaskans." (The possible exception to this was the Anchorage Museum of History and Art's Alaska Gallery, which has the huge task of covering all of Alaska's history.) Outside anthropologists, Europeans, referred to us as "Tanaina Athapaskans," and as a kid it was a bit unsettling because I always knew myself, to be Dena'ina Athabascan.

Throughout my adolescence, I didn't really give much thought to being Dena'ina. Outside of my own family, I can think of only one person who ever told me that I should be proud to be Alaska Native. However, there are two events that do stick out from my teenage years. Both occurred around 1996. The first one is how I got my Dena'ina name, Chada. I have a cousin who is twelve years older than I am, and during this time, my family and I reconnected with her when she and her then husband moved to Alaska. I had not grown up with this cousin because she had been adopted out when she was a baby. She rediscovered her Dena'ina family only in the early 1990s. As a teenager, she and her husband did a lot for me and my younger brother and sister by spending time with us. She noticed that many of my mannerisms reminded her of an old man. So one day at one of our family gatherings she asked our grandma what the Dena'ina word for "grandpa" was. As it turned out, my grandmother knew the word quite well (Chada), since that is what she and her siblings and cousins all called their grandfather, Eklutna Alex.

The other event that I remember was going to Roy Alex's funeral on September 28, 1996. I had

FIG 10.3

been to the Eklutna Cemetery a few times as a child, but up to that point I had never been to a funeral. Before heading out to Eklutna for the burial, I attended the funeral services at St. Innocent Cathedral in Anchorage. I remember coming into the ornate Russian Orthodox church and standing, and all of a sudden the bells rang and the priest started singing in Slavonic. The altar attendants were swinging their censers in the air for what seemed like an absolute entirety as we stood there. I was mystified as to what was going on. Then we went out to the Eklutna church, St. Nicholas, where several people spoke in front of the grave. As people started talking about "Uncle Roy," I learned for the first time in my life that he was the brother of Mike Alex, the last chief of Eklutna, and that his father was the last shaman in Eklutna. I remember just standing there, thinking, "Why didn't anyone ever mention this to me?" As I

think about that question my fifteen-year-old mind had formed, I think I have some understanding of an answer. My family spent so much time trying to adapt to this constantly changing world that they didn't think Dena'ina traditions were going to be important to me later in life. My mother once told me that if she had spent a lot of time talking about being Dena'ina, I would have resented it. She said her main focus was to make sure her children got into college and were successful in life.

After I graduated from high school, I went on to attend the University of Alaska Anchorage. After my first year of college, I applied for a summer job at the Alaska Native Heritage Center. The reason I applied for a job at the center was that I already had a background in tourism, having been a tour guide on the Alaska Railroad. Also, I took a semester-long tourism class my senior year of high school. When I applied at the center, my thought was that I could transition the public speaking skills I already had, along with an intermediate level of knowledge about the history of Alaska. I figured it would be a fun summer job that would look good on my résumé. I also thought the job would complement the career I thought I would have after I had transferred to the University of Nevada, Las Vegas, to get a bachelor's degree in hospitality management. That summer, a wrench was thrown into my career plans. After attending the two weeks of training at the center before the season started, I was informed that I would have two jobs that summer. One would be as an emcee for the dance groups that performed during the summer, which was what I had imagined I would be doing. The other job was to serve as a village site host at the Athabascan cabin. The latter was not anything that I had ever imagined I would be doing.

When they told me this, I was really intimidated. What could I offer our visitors? I didn't grow up in a village, so in my mind I wasn't really an "Athabascan." I had to shift strategies and learn as much as I could so that I would have something to say and be able to answer questions. About a month into it, a funny thing happened. I realized that I enjoyed talking to people about Athabascans. In fact, I had

an insatiable desire to know more about my people. I would spend every free moment I had learning as much as I could. It was during this time that I read a book that first opened my eyes to what is possible in anthropology. The book is *Make Prayers to the Raven*, written by Richard Nelson, who worked and lived with the Koyukon Athabascans in the 1970s. A blending of ethnography, personal reflection, and natural history, this book is the one that showed me that from within this discipline of anthropology, Alaska Natives could have a voice.

The next event that helped steer the work that I do was a class I took in the spring of 2002 at UAA called "Athabascan Adaptations." Since (1) I was an Athabascan, (2) I needed a humanities credit, and (3) I knew a little something of Athabascans, I thought this would be an easy class to help me get through school. As luck would have it, the class was taught by Alan Boraas, a professor of anthropology at Kenai Peninsula College who has worked with Dena'ina people for the last forty years. There were about half a dozen of us in the class, and I was the only one who was not an anthropology major with several years of course work. (In fact, most of those students have gone on to get their master's and doctoral degrees in anthropology). It was during this class that I also met James Fall, who came and talked to us about a "nonsubsistence" designation for Southcentral Alaska.

When I think about that semester, several things come to mind. The first thing I learned was that I was able to digest anthropological theory and then apply it to Athabascans. I also remember the week that Alan decided to give the class a taste of Dena'ina linguistics. He explained to us the rules that govern the Athabascan verb, and we broke apart a short sentence. The next part of our lesson was to listen to the language being spoken. I remember sitting there and listening intently to a recording of Peter Kalifornsky telling "K'eła Sukdu" ("The Mouse Story"). What I remember vividly thinking at the time was that this was the only time in my entire life that I was going to be able to hear conversational Dena'ina spoken. As we finished the class, I also remember Alan telling us we had just conducted

FIG 10.4

10.4 Dena'ina language class at the Alaska Native Heritage Center, spring 2004. On this particular day, there were four fluent Dena'ina speakers present. From left, Nastasia Zackar, Sava Stephan, Helen Dick (with back to camera), and Mary Hobson, speaking into a recorder held by Aaron Leggett. Also seen are Dena'ina teachers (turned slightly away from camera) Donita Slawson and Pauline Hobson. Photograph courtesy of the Alaska Native Heritage Center.

published by The CIRI Foundation when I struck up a conversation with her. About six months later, I saw her again at the Alaska Federation of Natives Conference in Anchorage, and I thought I would stop by her table and say hi and reintroduce myself. Much to my surprise, she remembered me and asked what I was doing for work. I had just quit my job at the center because I needed to have a job that could accommodate my school schedule. A.J. informed me that she was looking for an assistant and asked if I would be interested. I jumped at the chance not only to work for my Native corporation but also to do history projects with somebody of her caliber. This was something I had only dreamed of.

When I started to work for CIRI, one of things that A.J. felt strongly about was that I should write articles about my Dena'ina heritage. A. J. herself had a long history with Dena'ina people, going back to the mid-1980s, when she did oral history interviews with prominent Dena'ina elders, Shem Pete, Billy Pete, Katherine Nicolie, Sava Stephan, and Peter Kalifornsky, along with several others. In her book, *Our Stories, Our Lives* (1986), she also captured an interview with a Dena'ina man whose story revealed somebody whose life had been destroyed by disease and alcohol. At the time she interviewed him, he was watching the world he was born into disappear as more and more people came to Southcentral Alaska. The man's name was Happy Nicoli. He was a street person who was born at K't'usq'atnu (Sunshine Creek) near Talkeetna. During the interview, he repeatedly mentioned his childhood, which had been filled with traditional subsistence activities carried on from generation to generation. I still think about that interview from time to time; it was the most powerful interview in the book. It gave a face to all those Dena'ina people who weren't able to cope with all the changes they experienced in their lives.

While I was at CIRI, I worked on a number of projects that have helped shape the work I do. The first project involved the Anchorage Memorial Park Cemetery and creating monuments for a series of unmarked Dena'ina graves. CIRI, along with a local historian named John Bagoy, whose

an exercise in the Dena'ina language, and that there was a strong possibility this language would cease to be spoken within a generation. As a Dena'ina person at that time, I remember feeling great sadness that he might be right. Fortunately, what neither Alan nor I could anticipate was the renewed interest in Dena'ina language and culture that began in 2004. It is an interest that only continues to grow stronger. Alan and I are both deeply committed to seeing that the language does not disappear. Finally, the last thing that I took away from that class, and by far the most important, was the opportunity to get to know Alan. Not only did I get to learn from him and see him as a mentor, I was later able to work with him as a colleague, and today I consider him a true friend.

While I was working at the Alaska Native Heritage Center in the winter of 2002, I met another person who has also shaped the career I have today. Her name is Alexandra J. McClanahan. At the time, she was the Cook Inlet Region, Inc. (CIRI) historian. I was familiar with A.J., having read her column, "A Look Back at History," each month in the CIRI newsletter. One weekend she was out at the center signing one of her books that had been

family was among the first Americans to come to Anchorage, contacted relatives of three of the men buried there. This project had been sitting dormant for a couple of years, and A.J. asked me if I would be interested in picking it up. I relished the chance to be able to contact the families and work out a design for monuments to replace the Dena'ina spirit houses, which had long since returned to the earth. By working with the families, I learned that all three families actually knew each other and that two of them had grown up near each other in Anchorage. They also knew where the Bagoy family had lived. In the summer of 2003, the monuments were erected. The local newspaper covered the event on its front page, including a color photograph that ran across the entire page. (Pesznecker 2003:A1)

The next event that shaped the work I do came in the winter of 2004, when A.J. received a phone call from Byron Mallott, who at the time was president of the First Alaskans Institute. Byron had been asked by then mayor Mark Begich to give the welcoming remarks to the World Winter Cities Association for Mayors, which was meeting in Anchorage. Byron, a Tlingit from Yakutat, knew that his speech should honor the Dena'ina people. A.J. and I worked with Byron and his staff to create a speech, along with two editorial pieces that ran in the *Anchorage Daily News* during the conference. After the pieces were published, there was a reaction by the public like nothing I had ever seen up to that point. For the first time, people started to realize there was a rich history to the area long before Captain Cook arrived. I will never forget the day the first article was published. I went to one of my anthropology classes and saw that the teacher had photocopied it for our class to read.[1]

The next big Dena'ina project that A.J. and I embarked on was telling the story of Cook Inlet inside a new building that would house most of CIRI's Native nonprofit organizations. The person who decided she wanted this new building to be for our people was Gloria O'Neill. I had known Gloria since I took my first job at age sixteen. She has always been a huge supporter of the work that I do. Much of the reason why I am able to do what

I do today is directly related to her support over the years. It was decided that this building should have a Dena'ina name, and we selected the name Nat'uh. "Nat'uh" literally means "our piece of land," but figuratively it expresses what Gloria wanted to create, which is "Our Special Place." What started as a relatively simple photomural project quickly developed into something much more meaningful that really tells the story of the Dena'ina people. Inside the building the history of Cook Inlet is presented through photomurals, a timeline, and quotations from Native people in the region. The building opened in December 2005, and I have personally observed many people who have told us what a great and welcoming building it is. More recently, it has been further enhanced with a display case that houses artifacts that were owned by my great-great-grandfather. We also created a book to make the historical information available to those who may want more information or who may not be able to see the building in person. It is *Dena'ina Nat'uh: Our Special Place*.

As I write this article, I am reminded of several artifacts displayed inside a case at Nat'uh, especially the several *Niłnuqeyishi* (Dena'ina string calendars) that were owned by Eklutna Alex. From what we know about these calendars, a person would tie a knot in the string or attach a piece of fur or cloth to mark a special occasion. This article is my *Niłnuqeyishi* because it marks important events in my own life. In some ways, I wish I had been keeping a string calendar to remind me of the things that have occurred in the last ten years, although I had no way of knowing how important some of these events would become or where they might lead.

In the spring of 2005, I was approached by one of my professors to help organize a class about Dena'ina heritage and representation in Anchorage. Professor Steve Langdon had attended a lecture given by James Fall and Nancy Yaw Davis as part of the Cook Inlet Historical Society programs in the fall of 2004. In their talk, they discussed how little public recognition had occurred with regard to Dena'ina people. I was in the audience, and, of course, to me this was nothing new, but I remember

10.5 *Niłnuqeyishi*, counting cord, Kenai, prior to 1907.
Gut, glass beads, feathers, hair. Alaska State Museum, II-C-316g. Photograph by Chris Arend.
 This counting cord is part of a set that was collected by Father Ioann Bortnosky, the Russian Orthodox priest at Kenai from 1896 to 1907. Father Bortnovsky collected it from the Kenaitze Dena'ina at the request of Judge James Wickersham, who was a district court judge for the Territory of Alaska at the time. A letter written by Bortnovsky provides rare insights into the meaning of the knots and beads on the counting cords in this collection.

FIG 10.5

when Professor Langdon asked me what I thought about it. I told him at that time that I found it deeply ironic that if someone were to walk through downtown Anchorage they would be hard-pressed to find any information about us as a people. And yet these visitors would find a statue of Captain Cook. So in the spring of 2006, Steve, James Fall, and I created a class at UAA titled "Dena'ina Heritage and Representation in Anchorage" with the aid of a community engagement grant (Langdon and Leggett 2009).

In the class, we asked the students to read a variety of Dena'ina literature and discover what (if any) information was available through public displays. We then had the students create signage they felt would be appropriate for places that were important to Dena'ina people. That first year we had requested that someone from local municipal government attend the class, but we were unsuccessful. At the end of the class, our students had created six signs they thought should be put up within the

municipality. The questions of who would fabricate and install them, and when, were left up in the air.

A couple of weeks after the class ended, I went to Kenai for three weeks to get university credit in Dena'ina, and the day I got back there was a message on my answering machine from Donita Slawson, the Dena'ina language project manager at the Alaska Native Heritage Center. She asked me to come to City Hall and testify on the naming of the new $110 million convention center in Anchorage. There was only one name I would be happy with, and that was "Dena'ina." We were also fortunate that Jon Ross, then the CEO of the Alaska Native Heritage Center, was on the naming committee. After some discussion, we were able to persuade the committee that by naming the building after the Dena'ina, we would be honoring the first people of Anchorage as opposed to one individual.

Nevertheless, there was still one more hurdle to get over. The Anchorage Assembly had to accept the committee's recommendation. Several people,

FIG 10.6

FIG 10.7

FIG 10.8

10.6 Locating the dip-netting rock. Wayne Dick and his son, Bryan, talk with Aaron Leggett at the dip-netting rock located below the village site at Qeghnilen (about thirty miles upriver from Lime Village). They visited this site in 2009 shortly after Bryan assisted his grandmother, Helen Dick, in making a traditional dip net. This site, extremely important to the Stony River Dena'ina, is ideally located in the river to harvest large quantities of salmon. Photograph by Chris Arend.

10.7 Talking about spruce roots. Helen Dick is explaining to Aaron Leggett in Dena'ina the variety of uses for spruce roots. Photograph by Chris Arend.

10.8 *Vak'izhegi*, Helen Dick with bear gut parka, Lime Village, 2009. L 91.4 cm. Bear gut, thread. Anchorage Museum, 2010.010.001. Photograph by Chris Arend.
 Helen Dick told Aaron Leggett that she had wanted to make a bear gut raincoat since she was a young girl and that she had promised her grandmother she would make one. Aaron encouraged Helen to make one, and, during one of his trips to Lime Village, even tried to harvest a bear for her. Helen made this parka in 2009, noting that it was made from the intestines of four different bears. She explained that the darker strips of intestine are from bears taken during berry season. Completing this parka gave Helen a great sense of accomplishment for having kept her promise to her grandmother and having this rare item preserved by the Anchorage Museum.

FIG 10.9

10.9 Documenting fish camp. In July 2011, Aaron Leggett and other Anchorage Museum staff traveled to Pedro Bay and Nondalton to document Dena'ina fish camps. Aaron is photographing Pedro Bay elder Mary Jensen as she cuts red salmon with her *vashla*, or knife, on the shore of Iliamna Lake. Photograph by Suzi Jones, Anchorage Museum.

including James Fall and Alan Boraas, wrote to the *Anchorage Daily News*, making the case for the name. On the day the issue was to be decided, those of us who supported naming the convention center the Dena'ina Center were prepared to make a strong case as to why this would be an appropriate name. After we all testified, the Assembly voted. I remember the sheer anxiety I felt as each of the fourteen Assembly members cast their votes. Then I saw it, something that I will take to my grave as one of the most beautiful things I have ever seen: fourteen green lights, a unanimous vote that "Dena'ina" would be the name of the convention center. I knew that from that day forward, the work I did would have a new significance.

In 1989, there had been a series of articles in the *Anchorage Daily News* about the fight that the Kenaitze (Kenaitze is the Russian name for the Dena'ina) Indian Tribe had been waging for ten long years to be able to put a fishnet in the Kenai River. The writer quoted Kenaitze tribal chairman Clare Swan as saying something that I feel encapsulates the twentieth century for the Dena'ina: "It never

occurred to people that Natives live here.... Even among ourselves, we were sort of invisible."[2] I came across this quotation while at I was working at CIRI. As soon as I read it I knew exactly what she was saying, and I knew that I had to do whatever it took to make sure this statement would no longer be true in the twenty-first century. On October 23, 2008, at the Dena'ina Civic and Convention Center, I represented the Native Village of Eklutna and Debbie Fullenwider represented Eklutna, Inc., as we welcomed the Alaska Federation of Natives to Anchorage and the new convention center. After I walked off the stage, I sat down in my chair and leaned over to Clare to say, "Well, we're no longer invisible, to outsiders or ourselves."

It is hard for me to imagine what the future holds for us as Dena'ina people. Many of the things I could only have dreamed of a few years ago—such as interpretive signage, proper recognition, and a museum exhibition and catalog—are already happening. Nevertheless, there is still much work to be done to reinvigorate *naqenaga* (our language). I dream that one day we will have our own museum so that we can continue to tell our story. I'm sure that one day a young Dena'ina person will read this and be amazed that there was a time when we were "invisible people." If it weren't for the elders and anthropologists who didn't want to see our knowledge disappear, and today's middle-aged Dena'ina, who have taken that information and run with it, none of what I do today would be possible.

The Dena'ina museum exhibition and the catalog you hold in front of you are our efforts at restoring our visibility. Starting in the fall of 2007 and continuing through the spring of 2008, I had the opportunity to travel around the world to see more than three hundred of my ancestors' objects. The oldest pieces were from the late eighteenth century and the most recent ones were from the early twentieth century. My journey took me to Juneau, Seattle, New York, New Haven, London, Edinburgh, Berlin, Helsinki, and St. Petersburg.

As I reflect on this journey, two events in particular still strongly resonate with me. The first one happened on our first day at the Kulttuurien

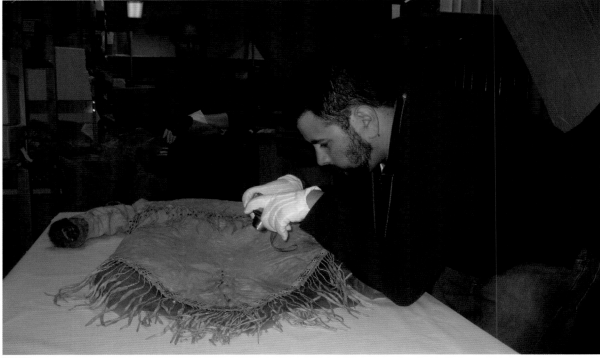

FIG 10.10

10.10 Surveying Dena'ina collections. During research for the Dena'ina exhibition, Aaron Leggett photographed details on a Dena'ina tunic at the Kulttuurien Museo (Museum of Cultures) in Helsinki, Finland, October 31, 2007. Photograph by Suzi Jones, Anchorage Museum.

10.11 *K'isen dghak'a*, woman's summer dress. Kenai Peninsula, 1846. L 140 cm. Caribou hide, sinew, porcupine quills, fur. Museum of Cultures, National Museum of Finland, VK177A. Photograph © Finland's National Board of Antiquities/Picture Collections. Photograph by István Bolgár.

10.12 *Tl'useł*, woman's summer moccasin-trousers, Kenai Peninsula, 1846. L 107 cm. Caribou hide, sinew, porcupine quills. Museum of Cultures, National Museum of Finland, VK177B. Photograph © Finland's National Board of Antiquities/Picture Collections. Photograph by István Bolgár.

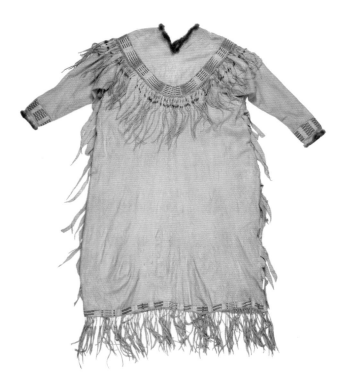

FIG 10.11

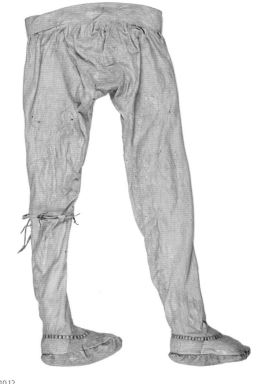

FIG 10.12

10.13 *Q'us*, quiver, Alaska, 1850s. Caribou hide, eagle feathers, porcupine quills, sinew, ochre. Furuhjelm Collection, Hämeenlinna High School (Hämeen Lyseon Lukio). Photograph by Marcus Lepola.

This stunning example of a painted Dena'ina quiver was collected in Russian America and donated by Finnish mining engineer Hjalmar Furuhjelm to the Hämeenlinna High School in Finland. Hjalmar was the younger brother of Johan H. Furuhjelm who was the governor of Russian America between 1859–1863. This collection has recently come to light thanks to the work of Finnish researcher Marcus Lepola. Lepola shares an interest in Dena'ina archery with Leggett, and during a 2012 summer visit to Alaska, Leggett assisted Lepola in a project to make a bow in the traditional Dena'ina style from Alaska birch.

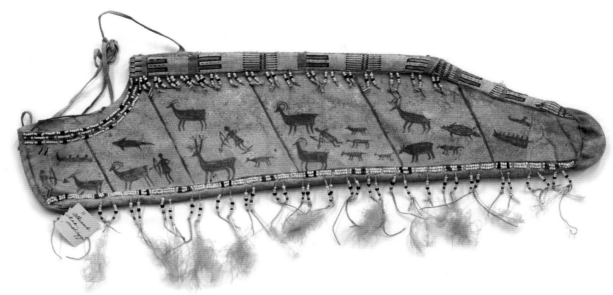

FIG 11.13

Museo (Museum of Cultures) in the Tennispalatsi in Helsinki. I will never forget when the collections staff opened that first box and pulled out the first Dena'ina tunic. I had heard about this object for many years but had never actually seen it with my own eyes. I remember my excitement and the smile that instantly came to my face as I finally got to see what Dena'ina quillwork looked like. The other event that stands out for me, and that speaks to the power these objects still hold, happened while we were in St. Petersburg. I was photographing a tunic, and suddenly felt that somebody besides myself, Suzi Jones, our translator Jenya Anichenko, and the two museum staff members had entered the room. I turned around and looked at the table with objects and saw a shaman's doll. I had read about these and knew they were used to house a Dena'ina shaman's spirit, but until that point I didn't really understand what that meant. I had an overwhelming urge not to handle this doll, as it was obviously something

that had a power to it that I will never completely understand. People have asked me what it was like, getting to see and handle all of these objects. When I answer, I always come back to the idea that for every question these objects answer about my people, I am left with twenty-five more questions that may or may not ever be answered.

Notes

1. The 2004 articles by Bryan Mallott are "Dena'ina Preceded Today's Metropolis," *Anchorage Daily News*, February 18, B6, and "Dena'ina Offer Knowledge, Wisdom," *Anchorage Daily News*, February 19, B6.
2. Clare Swan is quoted by reporter David Hulen in a 1989 article, "Kenai Tribe Is No Longer Invisible," *Anchorage Daily News*, May 28, A1.

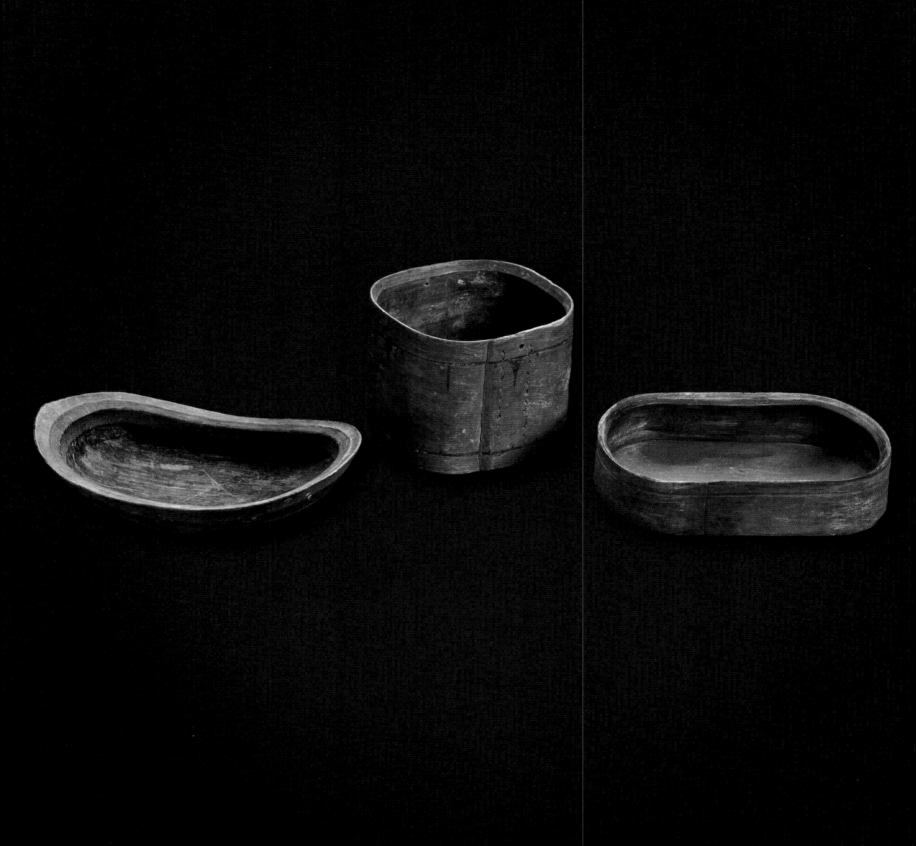

11

An Inland Dena'ina Material Culture Anthology

James Kari

The museum exhibition and book, *Dena'inaq' Huch'ulyeshi*, contribute to the ever-increasing public awareness of many truly distinctive features of the Dena'ina language of Cook Inlet basin. Dena'ina is a Dene (or Athabascan) language. The Dene language family had about fifty languages and dialects, including Navajo and Apache in the Southwest and Hupa and Tolowa in Northern California and Orgeon. Dene is the largest indigenous language family in territory in North America. Moreover, Dene languages have a complicated grammatical structure and are considered to be the premier verb-prefixing languages in the world. In 2010, Edward J. Vajda assembled some striking evidence that the Dene languages of North America have an ancient historical connection to a group of unusual verb-prefixing languages in Central Siberia, the Yeniseian language family. Vadja has proposed calling the combined group the Dene-Yeniseian language family.

Shaped like a westward-leaning horseshoe around Cook Inlet basin, the Dena'ina language area has a spectacular variety of geological, biogeographic, and climatic regions. There are four main dialect areas: Inland, Iliamna, Upper Inlet, and Outer Inlet. We can view the many special ecological niches and the prehistoric and historic influences through the vocabulary of the Dena'ina language and its regional dialects. The 2007 *Dena'ina Topical Dictionary* is a convenient and informative source on Dena'ina vocabulary, with thirty-one chapters and detailed lists of terms for biota (such as animals, birds, and plants), various material culture domains (tools, hunting and fishing equipment, and clothing), and cultural domains (foods, games and sports, numbers, spiritual concepts). There is exceptional diversity in lexical details for the Dena'ina dialects. For example, Dena'ina has more than eighty documented month names; this reflects the mixing of maritime and continental climates throughout Cook Inlet basin. The Dena'ina fish and marine fauna inventories reflect three zoogeographic provinces, and thus they vary greatly in the dialect areas. Almost all of the Dena'ina marine biota—beluga, seal, sea otter, and marine fishes and shellfish—are not found in other Dene languages. Dena'ina has 312 names for 132 native species of birds. Many names for birds are unique to one or two dialect areas (Russell and West 2003).

The Dena'ina have long occupied the Htsaynenq' plateau, the piedmont on the west side of the southern Alaska Range (the Stony River, upper Holitna River, and upper Mulchatna River; see map 1.1). From several kinds of evidence, including dialect distinctions, vocabulary patterns, certain placenames, analysis of narratives, and certain archaeological evidence, Dena'ina bands expanded in stages into Cook Inlet basin (Kari 1988, 1996a, 1996b,

1.0 *Ts'ideq daztuni*, **bowls, Old Iliamna, 1931–1932.** From left, L 16 cm; L 27 cm; 23.5 cm. Wood, ochre, paint. Photograph Peabody Museum of Natural History, Yale University, ANT.015863, ANT.015851, and ANT.015850. Photograph by Chris Arend. These three bowls suggest the variety of bowls and containers the Dena'ina fashioned out of wood.

2007:xix–xxi; Kari and Fall 2003:10–14, 144–146). The Dena'ina had long-term occupancy of the southern Alaska Range uplands before the first Eskimo groups occupied Southwest Alaska about 3,500–4,000 years ago. There are some hints in the Dena'ina vocabulary that the Dena'ina encountered some ancient unidentified languages.

In terms of cumulative linguistic, cultural, and folklore records, Dena'ina is the best-documented Alaska Dene language. There is an array of Dena'ina language publications that feature leading storytellers: Antone Evan and Alexie Evan (Tenenbaum 1984), Peter Kalifornsky (1991), Walter Johnson (2004), and Andrew Balluta (2008). There are two well-illustrated geographic books, James Kari and James A. Fall's *Shem Pete's Alaska: The Territory of the Upper Cook Inlet Dena'ina* (2nd ed., 2003) and Karen E. Evanoff's *Dena'ina Ełnena: A Celebration* (2010). A 165-page online document, "Bibliography of Sources on Dena'ina and Cook Inlet Anthropology," compiled by James Kari, Alan Boraas, Aaron Leggett, and R. Greg Dixon (2011), is updated periodically. In late 2012, more than 825 Dena'ina entries were listed in the Alaska Native Language Center (ANLC) Archive. This list is also actively updated. It is also important that the Kenaitze Indian Tribe is in the early stages of assembling a Dena'ina Archive in Kenai.

This article demonstrates the potential of an audio anthology. The Dena'ina Audio Collection has more than 470 recordings and is one of the best-organized audio collections for an Alaska Native language. For languages with rich audio records, a selection of recorded segments can be organized into compilations on specific topics.

This chapter features several highly detailed Nondalton Dena'ina narrative segments on material culture and traditional technologies. The selection was drawn from several recordings made in Nondalton with Antone Evan in June of 1981 by Priscilla Russell on the theme of Dena'ina material culture. Tape ANLC 1390 by Antone Evan, just over fifty-six minutes long, is a classic Dena'ina language recording, a brilliant, well-organized lecture. For thirty-six minutes, Evan discusses numerous implements that were in use in Lime Village and Nondalton when Evan was growing up. After thirty-six minutes, Evan shifts gears and tells two parables, then sings a medley of songs, then plays his harmonica. Several other recordings by Russell in 1981 with Antone Evan, his older brother Alexie Evan, and Ruth Koktelash (on ANLC tapes 1337, 1296, and 1302) also have good segments on material culture. In addition, I have included one segment about snares from an interview with Alexie Evan and Rose Hedlund that was recorded by Joan Townsend in 1973.

For this anthology, I first grouped Antone Evan's original segments into topics and then supplemented those topics from other recordings by Antone Evan, Alexie Evan, and Ruth Koktelash. The final selection demonstrates the value of the audio anthology at many levels: as narrative performance, for its technical descriptions, and as a source of rare vocabulary and verbal constructions. Thus, a Dena'ina material culture anthology is actually an open-ended proposition that can be continued in the future. Among the recordings in the Dena'ina Audio Collection are other classic Dena'ina material culture segments by Shem Pete, Pete Bobby, Vonga Bobby, Andrew Balluta, Ruth Koktelash, Sava Stephan, Peter Kalifornsky, Emma Alexie, Helen Dick, and others.

The 1981 recording, ANLC 1390, by Antone Evan on Dena'ina material culture is clearly one of the most significant Dena'ina audio recordings. Andrew Balluta confirmed this in 1985: "For me, I believe this is one of the most important stories I've heard from this project." The Dena'ina text was first transcribed by Albert Wassillie in 1985 as an eighteen-page handwritten draft. It was translated by Andrew Balluta in 1985 and published the following year by Linda Ellanna in her edited work, *Lake Clark Sociocultural Study* (1986:A109–117). The ANLC copy of this recording was missing for several years, but a copy of the tape was provided by Antone Evan's daughter, Laura Rice, in 2002. In 2004, this text was reviewed by Andrew Balluta. Andrew, who was an important and enthusiastic contributor to Dena'ina language, provided

the explanatory notes for many items discussed in the text.

With the audio CD for this anthology (available at the ANLC), one can listen to the text while reading the anthologized extracts in this chapter. The sixteen subsections and the audio files occur in the same order, and the audio file name is provided at the beginning of each subsection in the text. Thus the text with the audio files can function as a Dena'ina language-learning exercise. The reader can pause the audio track, practice repeating a phrase, or replay a portion of the track. I have also highlighted the first mention of important vocabulary items in **boldface type** so that some Dena'ina words can be connected with their English meanings. At the beginning of the seven main sections, I have provided references to related material in the 2007 *Dena'ina Topical Dictionary,* where these terms are presented, along with other items in this vocabulary domain.

Speakers Featured in the Interviews

Antone Evan (1919–1983) the principal narrator for this anthology, was born at Qeghnilen (Canyon village) on the upper Stony River, and lived in Nondalton from the early 1940s. Antone was an intensely proud teacher of Dena'ina language and traditions. He was a truly great storyteller, lead singer, and harmonica player. There are thirty-two recordings with Antone Evan in the Dena'ina Audio Collection, and fewer than half of these have been transcribed.

Alexie Evan (1902?–1986) was Antone Evan's older brother. He moved from the Stony River to Nondalton in about 1940. Alexie is fondly remembered as an expert storyteller and singer. A fine selection of Dena'ina narratives by Antone Evan and Alexie Evan was published in *Dena'ina Sukdu'a* (Tenenbaum 1984, repr. 2007).

Ruth Koktelash (1912–1987) was from Lime Village and was a member of the distinguished Bobby family. Her parents were Paul Constantine Bobby and Annie Bobby. Ruth was an expert storyteller and craftsperson. She made numerous types of items, such as caribou skin boots, gloves,

and various garments. She was married to Pete Koktelash (1902–2004) and lived in Nondalton from the 1930s.

Rose Hedlund (1917–2004) and her husband, Nels Hedlund, lived at their beautiful home at Chekok Point on Iliamna Lake. Nels was an expert speaker of Central Yupik. Rose worked closely with Joan Townsend in the 1960s and 1970s to record extensive information about the Dena'ina traditions and history of Iliamna Lake.

Typographical Conventions Used in the Narratives

/	English translation.
boldface	First mention of main terms, Dena'ina and English.
…	Ellipsis dots mark a *false start*, a word that the speaker begins but does not finish.

Commentary by Andrew Balluta and others appears in brackets following the section on which he (or they) commented.

1. Fishing Gear

Dena'ina Topical Dictionary: 18.7 (fishing gear); 2.2, 2.3 (fish, salmon)

1a. Antone Evan, Fishing Gear

Audio file name: 1a-1390-ae-fishing.wav; *length*: 3:58

Nanutset shanlaghi iqu qul'ih.
/Before our time they used to go for the summer fish run.

Tahvił k'i qighisen.
/There were no nets.

This is for salmon trap, fish trap.

Taz'in ghini qeytl'ix ha'it dghu
/They wove salmon traps and

FIG 11.1

11.1 *Hulehga taz'in,* **whitefish trap, Lime Village (?), c. 1970s.** L 251 cm, W 33.2 cm. Wood, spruce root, metal wire. Anchorage Museum, 1997.023.001a. Photograph by Chris Arend.

This fish trap is believed to have been made by Vonga Bobby of Lime Village and used at his Tishimna Lake fall camp. It was later acquired by Nixie Mellick of Sleetmute before being donated to the Anchorage Museum.

11.2 *Hulehga taz'in,* **whitefish trap, detail of figure 11.1.** Anchorage Museum, 1997.023.001a. Photograph by Chris Arend.

FIG 11.2

dghiłdit ha qeytl'ix ghu **shanlaghi taz'in**.
/they wove them in narrow mesh, the **summer run fish trap**.

…that's for salmon traps.

Shagela **shagela taz'in** ey hdi qich'a dghiłtsuz ha tqeyl'ix łu.
/The **trout fish trap** that one they made somewhat stouter.

Shanlaghi tahvila ghini hk'uch' hk'uch' t'ent'ah ha qeyghitl'ix.
/They wove that **summer run fish net** one differently as well.

Yi taz'in ghini, yi shagela taz'in.
/This type of trap was the trout trap

Huzhehi **huzhehi taz'in** ku'u hghitl'ix dghiłchek'i
/For the blackfish, the **blackfish fish trap** also they wove a trap, a smaller one.

11.3 *Hchił*, **fish weir, Knik, 1906–1910.** Dena'ina people used a variety of methods to harvest salmon and trout. This fish weir was used to funnel fish into a central location, from where the fish were scooped out with a small dip net. Robert Wheatley Collection, Anchorage Museum, B.82.52.260.

11.4 *Tanik'edi*, **rock dip-netting platform.** This rock located, in the Stony River at the base of Qeghnilen (Canyon village), has been used by Dena'ina people for centuries and continues to be a highly productive place to harvest fish with a dip net. Den'aina Huch'ulyeshi Collection, Anchorage Museum. Photograph by Chris Arend.

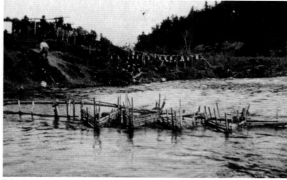

FIG 11.3

FIG 11.4

Yehdi ken ken at niha huzhehi qilan huzhehi taqeyghi'uk.
/The blackfish are there in the flats, where there are blackfish they set these fish traps there.

Dghiłchek'i taz'in.
/It was a small trap.

T'anch'q'u niłk'uch' qeyghitl'ix yi taz'in.
/They made all the fish traps many differently.

Shanteh naqeliteh ghu tuqesi **tuqesi** ghuhdghiłt'ah ghu shan laghi.
/In the summer and fall they used, spears **spears** during the summer fish run.

Tuqesi ghuhdghiłt'ah.
/They used spears.

Qishehi kiq'u shan laghi kiq'u qeyeł qeyiqu ghel'ih.
/Then they also used **gaff hooks** for the summer run.
[Andrew Balluta: What they call *qishehi*. It's a big hook on the end of a long pole.]

Dineh qeyeł dghinihi yi kiq'u yehdi łiq'a ka'a qeyeł qeyiqu ghel'ih, **dineh**.
They had another kind of spear they call *dineh*, and it is also used that for king salmon, the **toggle spear.**

Shanteh shagela qeyeł uqu ghel'ihi **k'entsa quggił**.
/In summer they would get trout with a **handheld fish snare.**

Yudi **yudi t'u** k'entsa quggił hdenghighuk ghu.
/They made the handheld fish snare with **golden eagle feathers**.

Shanteh shanteh k'i qeyghudghiłt'ah q'u k'entsa quggił ghini.
/In summer they would use the handheld fish snare in summer.

Dettix ha **tasaq'a** k'i qeyghudghiłt'ah ch'u yi k'entsa quggił ghini.
/As it freezes up they also used it at **open places in the ice**, that handheld fish snare.

Nch'equyi, nch'equyi qeyeł dghinihi yi kiq'u shagela qeyeł uqu ghel'ihi **nch'equyi**.
/They used to call dip net, which they also used for catching trout, the **small dip net**.

Yun'e yun'e Qenghilen hghila hdi,
/They were upstream at "current flows through" [Canyon village, on upper Stony River] and

yehdi **tach'nił'iy** ghuhdghiłt'ah shan laghi łu.
/there they used the **long-handled river dip net** in the summer run.

Tach'nił'iy veten daghiłnazi.
/This handle of this dip net is long.

Nanutset iy q'u q'et' gheli q'u.
/Before our time, really long ago.

pause

Q'udi gin t'anch'q'u shan laghi łiq'a nihdi
t'anch'q'u qeyeł qeyeł uqu ghel'ihi.
/Now here for salmon run the various salmon
everyone used that (long-handled dip net).

[Andrew Balluta: This dip-net basket is woven out
of spruce roots, that's made like a basket. They
used to put it underwater with a long pole on it
and leave it underwater until they can feel fish go
inside of it, and pull it up.]

1B. Alexie Evan, Fishing on Upper Stony River

Audio file name: 1b-1302-alxe-fishing.wav;
length: 1:10

Shan laghi dach' łiq'a ghu yi k'i yi k'i eqech'a.
/In the **summer fish run**, the salmon are there
like this.

Long time Qeghnilen Stony River hyach'
/Long ago in Qeghnilen, in Stony River over there

tahvił k'i nch'u eł k'uqu qul'il.
/they didn't catch them with **net**s.

Hyut'anch' **nch'quyi** yan eł k'iqu qul'an.
/They only had **dip nets** to catch them with.

Yihdi yik'i dnaghelt'ayi nuqenłchi dghiłt'a.
/There were many weir fences going across.

Ts'ił tets hnu *ten* [qeluzhun] **hał** k'i qeyeł
chidełt'ex qenghił'an t'an
/In one night they watched them harvest ten **pack
bundles** of [forty] fish with it.

[Andrew Balluta: The fish are counted as forty fish
to **hał**, a bundle, and that's the way they used to
count their fish when it's fresh.]

Nch'equyi eła t'qeyghił'an.
/They used to do that with that short-han-
dled dip net.

Q'u hech'u yuhdi hench'q'u daghiłteyi qeyeł
k'zełghax t'qeyeghił'ani yi ghini.
/In that way there quickly and strongly they used
to harvest with them (dip nets).

Q'udi guhdi **tahvił** eł yan k'iqu qel'an ch'et'ih.
/Now around here we only use **net**s to catch them.

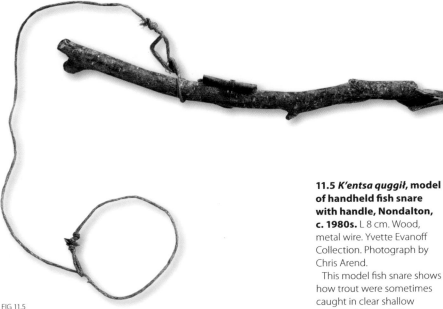

FIG 11.5

Nt'i gin nda'ich' shu qit'a dgheshnini qilan?
/Well, what else do I know about?

Yeah

1C. Ruth Koktelash, Fishing and Making Fish Nets

Audio file name: 1c-1337-rk-fishing.wav;
length: 0:56

The Silver Salmon Harvest
Nusdlaghi **nusdlaghi** Huch'altnu yeh
ch'dighelts'i.
/We stayed for **silver salmon** at Swift River.

Nusdlaghi yet veł chich'dełt'ex.
/We would harvest silver salmon there.

Nt'i na'eł yagheli gheli.
/That was so nice for us.

Nt'i chich'tul'il qich'a gheli na'eł yagheli ghila.
/We enjoyed that even more than playing, that
was fun for us.

Q'u.
/That's all.

**11.5 *K'entsa quggił*, model
of handheld fish snare
with handle, Nondalton,
c. 1980s.** L 8 cm. Wood,
metal wire. Yvette Evanoff
Collection. Photograph by
Chris Arend.
 This model fish snare shows
how trout were sometimes
caught in clear shallow
streams. Although the snare
was traditionally made
from golden eagle feathers,
during the twentieth century
metal wire was often used
instead.

Making Nets

Tahvił **tahvił tl'unqina** yi gin shughu.
/A net, a **net needle**, that one.

tahvił qeyłtl'ixi,
/as they weave the **nets**,

qeył k'etl'ix ha tqyeł'ih.
/they would weave with it.

veł k'eshtl'ila'i tahvił eł eshtl'i.
/I would weave nets with a mending needle.

Ch'eq' k'i **tahvił** qeyłtl'ix yi gini needle.
/They also wove a **willow bark net** with this needle.

Ts'ah tahvił qełchix ghu gini gini ghuhdiłt'a.
/They made these **sinew nets,** and they used these.

Qeynedets ch'u da hya hyinghazts'ah hya hyinghazts'ah ch'u
/They spin it [the sinew], and they would coil it up and coil it up, and

hya hyenghets'eh niłnes hnuyu,
/they coil it up, and when it's long enough,

qeytl'i qeytl'i ch'u qeyq'anahdetl'ix.
/they weave and weave until it [the net] is finished.

Ch'u q'u ku'u qeyki nuk'eneldesi ghu tqił'ix, tqił'ix.
/And then they start spinning some more onto the end of it; they fix it and they fix it.

Ch'u tahvił ghini t'iłnes gheli.
/And the net becomes real long.

Q'uyethdi **qeyetsik'teh** nik'nelax ch'u.
/And then they fix the **upper net line**.

Qałnigi qeydenghułyish ch'u yihdi yehdi **duyeh vets'esa** qeyłniyi.
/They tie on **rocks (weights)**, and these they call the **lower weight stones**.

Yudeh idahdi **chik'a gguya dazggeni** qeytsik'teh ghin tsik'teh heł nik'enlax,
/Then up above they put **small dry pieces of wood (as floats)** on the upper net line,

ch'u detahyełkes. ch'u detahqełkes.
/and they put it in the water, they put it in the water.

1D. Antone Evan, Harvesting Blackfish near Nondalton

Audio file name: 1d-1296-ae-blackfish.wav; *length:* 2:57

Antone Evan [*not recorded*]: There is a fish called *huzhehi*, it means "spit out of the water."

Yi **huzhehi** iy gu Nondalton gu,
/These **blackfish** here in Nondalton,

Old Village ghenehch'en tustighitun Qizhjeh Venach'.
/On the upland side of Old Village is a pass trail toward Lake Clark.

Ten at ten tinitun.
/The trail is **on the ice**.

Ten qilan hnuyu
/When there is ice

Qizhjeh Vena ch'en ghu nuhdenghatq'un.
/On the Lake Clark side there, there's a ridge going downward there.

Ten qilan ghu tayanq' ghu **tudani'u**.
/In middle of the ice, there is **open water** that extends out.

K'etnu gguya qilan.
/There are **little creeks** there.

Yet huzhehi qilani.
/There are blackfish streams there.

Yeh gudih q'u gheli yan huzhehi neł'ih, qilan qit'aqideshni.
/This is the only place around that I see blackfish, that I know of.

Iy gu Deggech' Vałts'anaq' qech' yeh k'i huzhehi nqilan k'etnu gguya.
/Above here in "the upper area" toward Mulchatna River there are little creeks that have blackfish.

Ven q'atl'a nqilan ha.
/There are places at the heads of lakes.

K'qizaghetnu, Qek'dichen Vena gheneh ch'en yeh
yeh kiqu k'etnu gguya nqilan.
/On Stony River, at Hek'dichen Lake (Trout Lake)
on the upland side, there are also small streams.

Yeh ku'u huzhehi qilan.
/Also, there are some more blackfish there.

Yeh nanutset qeyiqu ghel'ih, yeh huzhehi ghini.
/Long ago they used to fish for them, there, those
blackfish.

Q'udi gudihdi nch'u qeyiqu ghel'igh.
/Nowadays, they don't go for it around here.

Yi huzhehi nanutset heyiqu ghel'ih.
/Before our time, they used to go for blackfish.

Taz'in hnułtu hghiłchik dghiłchek'i.
/They used to make a **fish trap** for it, a small one.

K'etnuh k'ehnił'ih.
/They would look for the creeks.

K'etnu ndahqugh tqidaghiłkugh nt'i,
/At just the right size streams,

huzhehi nqilan ha'it dghu,
/wherever there are blackfish,

k'etnu gguya nch'u denqidiłkugh da,
/in the **smaller creeks**, that are not too large,

tundil'uh hnu ts'inun hdałt'ah yeh qugh **dakaq'**,
/where the waters come out, where it is straight
across from the **stream mouth,**

ghu qeytnełchix.
/they would make it.

[Andrew Balluta: They make the blackfish fish
trap so it just fits across the creek mouth.]

Qeyełchixi eł q'uyehdi k'etnu taqey'ux.
/They would make it, and then they put it in
the water.

Ts'ideq qenghi'uh ha.
/It stands **upright (vertically).**

FIG 11.6

Q'unch' taz'un k'i nch'u tqeyl'ik.
/They do not set it horizontally.

Ts'ideq hnighi'u ha'.
/It stands upright.

2. Snaring Ground Squirrels

Dena'ina Topical Dictionary: 18.6

2A. Antone Evan, Ground Squirrel Hunting

Audio file name: 2a-1390-ae-grndsqhunt.wav;
length 1:35

Shanteh ghuhdi dghiliq' tuqedeł ha qunsha
iqu qul'ih.
/During the summer, they used to go up on the
mountains and hunt ground squirrels.

Iy k'i yudi yudi t'u k'entsa quggił hdenghighuk.
/They used to make snares out of golden
eagle feathers.

11.7 Ruth Koktelash holding ground squirrel snares and a *vak'izheghi* (gut raincoat). Ruth Koktelash (1912–1987) was born at Qeghnilen on the Stony River near Lime Village. In 1928, she married Pete Koktelash, who was also born at Qeghnilen but who was by then living in Old Nondalton. She and her husband then moved with rest of the village to the current site of Nondalton. Ruth was well respected for her traditional knowledge. *Nuvendaltun Quht'ana: The People of Nondalton* (1990) is dedicated to Ruth and another respected elder, Albert Wassillie. Photograph courtesy of Priscilla Russell.

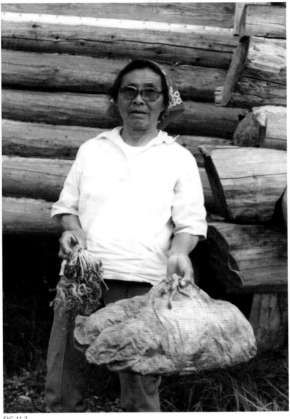

FIG 11.7

Ghu **qunsha quggił** quggił qeyeł dghinihi.
/There they called these **ground squirrel snares**.

Dghasdlin ey dishji hqugh dnaghelt'a hdi k'ishi qeyenghighuk ghu.
/They used to make a hundred snares and even up to a thousand snares perhaps.

[Andrew Balluta: These were made out of eagle feather stems.]

Quggił ghini vishuk yiqeynghiluh ghu.
/They used to keep their snares in a sack.

Quggił yes qeył dghinihi, quggił yinazdluyi.
/They used to call it a **snare sack** in which the snares are kept.

Dghiliq' **qunsha** iqu qul'ih.
/They went on the mountain for **ground squirrels.**

Deghk'isna ghuna **qunsha tets'** qevegh ghila ghu.
/Those **women** had a **ground squirrel staff** for them.

Yi quggił ghini ts'ełghedna ts'ełghedna nilan ha.
/They'd have twenty of those snares.

Yudeq ghu dehtets'a ghenih hyegh qeydenghichet.
/Up above there they put them on the ends of their staffs.

Q'uyehdi qunsha iqu … qunsha iqu hteyux.
/And then they'd go after ground squirrel.

Qunsha qan idi eła ts'ełq'i qeyech'anghelket ch'q'u duqeynlax ha t'qeyghił'an.
/At the ground squirrel den, they'd take one (snare) out, and then they set the snares.

2B. Alexie Evan, Women Going for Ground Squirrels

Audio file name: 2b-1302-alxe-grndsqhunt.wav; *length* 1:02

K'i yada egh nuhtulnek?
/What else will he tell about?

Navunkda ina qighila, yina k'i ezhge gheli hghila.
/**Our mothers** the ones we had, they were really tough too.

Qunsha dach' qet'in qunsha iqu ch'el'ani.
/Around this time of the year [late summer], they used to hunt ground squirrels.

Lots qunsha chihdełt'ix.
/They'd kill a lot of ground squirrels.

Nuhałhtenghelket t'qeyghił'an shnughoł yi k'i.
/They used to pack them back down in my presence there.

Q'udi guhdi ts'ił hyit'ana k'i qisen.
/Nowadays, there are no persons who do that.

Hya dalts'ina hyan qeyghił'an qilan.
/There are only people who stay inside.

Shi k'i q'udi gu no more ey'uh t'esht'an.
/Even myself here, I can't do things outdoors anymore.

Dghiliq' qunughesdhyul t'esht'an ch'u k'i **shqa**
qisil ch'u k'qisil.
/I might try to go up onto the mountains, but **my
legs** are gone, there is nothing (strength).

Yaghelich' t'esht'ana t'esht'a qech' shqakena teh no
good qilani ghuda.
/I could do okay, but my legs are no good.

Nch'u q'et'i'est'al. Iqech' t'ghesht'an nizen iy
nda'ich' shu gu?
/I don't do that anymore. I might want to do
that, but how?

2C. Ruth Koktelash, Ground Squirrel Hunting

Audio file name: 2c-1337-rk-grndsqhunt.wav;
length: 1:30

Qunsha **k'nizek' qunsha quggila** duqeynelax ghu.
/The ground squirrel **trigger set**, the **ground
squirrel snare** they would set.

K"un ghu qegh niqelggish ch'uhdi **dehtets'a** eła
/They go up by the **dens**, and then with
their staffs

heyuqu qeq'eyedehch' qegh k'qegget.
/they would probe for them there, above them
[squirrel dens] and they would stab them through
(the ground) there.

Ch'u iy **qeytl'ila** ghin iy yet qegh qeyneggesh.
/And they put a **line** through them there.

[Andrew Balluta: They used the staff to push a
hole from the surface to the runway of the squirrel
den, and then to thread a line through the hole to
link to the snare pole.]

Q'uyehdi ts'inun nuk'ehdeyił.
/Then they set up the pole straight across.

Q'uyehdi k'eni…chik'a qeyeq' k'dechedi ghini,
/Then upon it [the pole], that [partially]
broken stick,

nch'u veq' ch'k'deshchet gheli hq'u,
/—we did not really break it [all the way through],

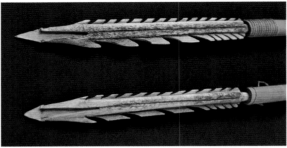

FIG 11.8

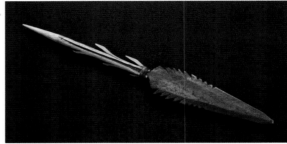

FIG 11.9

qeveł t'eych'idiyił.
/we would bend it [the pole] over.

Ch'uhdi **k'enizega** ghin vet'uh ch'idenghisex ch'u
dunch'enlax ch'u
/And then we place that **snare trigger** beneath it,
and we put in the snare, and

chik'a hnich'edi eła ghini nułuhch'ghełgheł ch'u
vat veł yeq'ach' hch'k'uyesh.
/we bend down that **embedded stick [snare pole]**,
and inside it [the den] we tie it [the stick)] down-
ward with it [the snare].

Q'uyehdi yi ghu daghiłtey sht'a veq'ach'eh
ch'k'uyesh.
/Then we tie it down in the notch quite strongly.

Vech' nuch'udyułi eła
/Then we come back to it [later], and

yidi yi gheli hdi qunsha veł t'gheł'ani quggił.
/with that is just how I would get squirrels
with a snare.

Vech' nugheshdyiłi eła yudeh dek'enał'un.
/As I walk back toward it, if it is sticking upright,

Yehdi I know chik'delt'exhch'.
/then I know that I have killed something.

Dach' shughu vegh duch'k'enghilak.
/That is how we set those snares for them.

3. Hunting Implements

Den'aina Topical Dictionary: 18.2, 18.3, 18.6 (hunting gear); 1.2 (animals)

3A. Antone Evan, Various Hunting Implements

Audio file name: 3a-1390-ae-hunting.wav; *length:* 3:11

Bow and Arrow Hunting for Caribou

N'ushna ghunahdi ts'ilten ela.
/Those menfolks had bows and arrows.

[James Kari: The term **ts'ilten** is used both for the bow and more generally for the bow and arrow.]

Ts'ilten ghini **vejex da** vejex da **veq'a diluha** t'qeyghil'ik.
/They used to have **caribou antler,** caribou antler **arrow points**.

Vekiyiq' ghu ts'ilten ghini k'da ghini qeydukik'eyel.
/On the tip of an arrow they put antler.

Ch'u vejex ghin qeyel ldex ha idghu
/And they shoot caribou with them, and then

Vekiyiq' q'u **vekidiluyi** ghu qeyldex hnuyu vekuy nitsix.
/The tip of that edged point, that **arrow point**, when they shoot it, it can penetrate its [caribou's] stomach.

Ts'elten ghinhdi nughel.
/The arrow [shaft] would drop off.

Dach' shughu vejex ghin qeyiqu ghel'ihi ts'elten.
/That is the way they used to hunt caribou with bow and arrow.

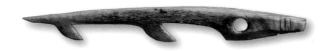

FIG 11.10

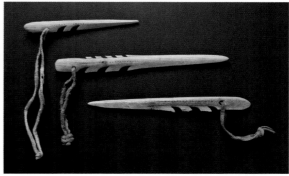

FIG 11.11

Hunting Bears with a Spear

Yeghedishla ggagga yehdi tets' **tets'** ghin k'i qeyiqu ghel'ih.
/For black bears and brown bears, they used to use a regular **spear**.

[James Kari: The terms **tets'** for "bear spear" is also the same term used for any staff, walking stick, or cane.]

Tets' ghini kisht'a ench'u dilnaz ha.
/The bear spear was not very long.

Vegh tastnik hqugh yan daghilnaz shughu tets' ghini qeydghighuk, **nanutset.**
/They made those spears only as long as the length of a person's outstretched arms **before our time**.

Caribou Snares

(Also in Evanoff 2010:171–172)

Yi vejex ghini nanutset K'qizaghetnu Htl'ughu Qayan...Qayantda qeyl dginihi yeq' vejex egh dek'enghiluh quggil ela.
/Before our time they used to set snares for caribou on this mountain at the head of Stony River which they call "dear open area" [ridge west of Telaquana Mountain].

Nunu… **nunutseq'i tl'ił** ghini nasdes ha, nasdes quggił qeynghighux vejex nułtu.
/They used to have that **rope of strips of twisted rawhide**, these were twisted, and they made snares out of it for caribou.

Yi Qayantda ghini qeyjench' ch'etl' ghin hnindaz'u ha.
/Over this ridge, Qayantda, they erected a willow brush fence all the way over it.

[Evan does not mention another term, *sex,* the caribou fence made of poles.]

Ghu ghu daghiłchuq'i ch'q'u qeyjenqineyiłch' ch'etl' ghini.
/It was broad in width there, and they would bend those willow stems up and over it.

Veghenqisdun ha t'qeyeł'ix ch'u iy ghu veghenqis-dun ghu yeh duqeynghilak.
/They used to fix openings [in the fence], and there in the openings they set the snares.

Dnaghelt'ayi qeyghilak łu.
/They used to snare a lot [of caribou].

Iqech' dach' **vejex** ghin yeh iqu ghel'ih qu… quggił eła.
/That's is how **caribou** were obtained with the snares.

[James Kari: The term **vił** is used to distin-guish "large game snare" from **quggił,** "small game snare." Note that two streams just south of Lime Village are called **Vił Qutnu,** "caribou snare creek."]

3B. Ruth Koktelash, Arrowheads and Spear Heads

Audio file name: 3b-1337-rk-hunting.wav; *length:* 2:22

Di **tl'ał q'ela.**
/That is a **white stone [arrowhead].**

Ts'iłten eł qeyghudighiłt'ahi yi gin shu qeyghudighiłt'ahi eł ts'iłten.
/They used it with a **bow,** that is what they used with a bow.

Vejex k'i chidełt'ex.
/They killed caribou.

Yada k'i ełdyin nihdi, q'ach'ema nihdi, nehvaya nihdi, q'anlcha nihdi.
/And whatever else, spruce hen, ptarmigan, hare, or fox.

Everything yada k'i qu'ih qeył chik'dghiłt'exi, tl'ał q'ela.
/Everything that they went for, they would kill things with it, the white stone arrowhead.

Detachable Barbed Spear Head

Estl'eni, **estl'eni** qeyłnihi gini.
/**Detachable barbed spear head** they call it.

estl'eni ghila'i.
/It was the barbed one.

Łiq'a veł chich'dełt'ex ch'uhdi veł ch'k'iggat ch'uhdi.
/We kill salmon with it, and we spear them with it.

Chik'a duk'idghi'u'i ghu veł ch'k'iggat hnuyu,
/It is **the one embedded upon a pole,** and when we stab something with it,

ch'a'ilchix ch'q'u na'eł ch'idełk'et, [łiq'a] ghini.
/it comes off and it gets pulled away, by the fish.

Hnu tuvugh veł niqashełch'dełtex ch'u ch'ach'ighelket ch'u
/Meanwhile we run with it along the shore, and we pull it out, and

ch'u chich'dełt'ex.
/and we kill it [the fish].

Tuvugh ghu nuch'uyuł Vonga eła.
/We were going along there on the beach with Vonga.

[Ruth's older brother, Vonga Bobby.]

Tuvugh q'uvugh nuch'uyuł ch'uhdi nch'u k'i ch'k'elqet hnuyu.
/As we go along the edge of the beach and we had not eaten anything.

FIG 11.12

FIG 11.13

11.12 *Tl'usts'eghi*, dagger, Alaska, 1818, collected by Vasilii Golovnin.
L 40.7 cm. Iron, abalone shell. Peter the Great Museum of Anthropology and Ethnography (Kunstkamera), 539-3. Photograph by Chris Arend.
This dagger is the oldest known iron dagger collected from the Dena'ina. The large size suggests it may have also been used as a spear point.

11.13 *Dayin q'aditin*, metal spear point, Tyonek, 1883.
L 35 cm. Iron. Ethnological Museum Berlin, IVA 6093. Photograph courtesy of Staatliche Museen zu Berlin, Ethnologisches Museum. Photograph by Chris Arend.
At the time Jacobsen collected this metal spear point, the Cook Inlet Dena'ina were moving away from using spears to hunt bears as the availability and reliability of guns made spears obsolete.

Ye ghu jan daghisedi ghini łiq'a chich'dułnah q'a.
/There all day long we are attempting to kill some salmon and failing.

Yik'i shi yan chik'dełt'ex ghu.
/So then I was the only one who killed anything.

Yi k'i veł qil.
/And that was bum.

Yi k'i sheł tseghateltlet.
/As for him, he got angry with me.

Yeghudahdi nt'i jan ghini vech'diłt'ah nch'u yu ch'k'elqat hnu nuch'edyux.
/The reason that we did that all day long is that we not had eaten anything, and then we returned.

Na'estl'ena nayi eshdech' q'u na'estl'ena qilan.
/Our toggle spears, each of us would have his/her own.

Yi k'i ghilna nch'u nayełket, nayeq' na'idi yi k'i.
/We would not lend them to other guys, each one has his own.

Estl'eni, fish veł chich'dełt'ex.
/The barbed spear, we harvest fish with it.

Shagela veł chich'dełt'ex.
/We get trout with it.

3C. Alexie Evan, Hunting Skills of His Grandfather and of En'ushen Gis

Audio file name: 3c-1302-alxe-hunting.wav; *length:* 3:13

Antone Evan:

N'izhi n'izhi ch'a'inzhi.
/Say your name.

Alexie Evan:

Alexie Sam, dach' dughu? Alexie Evan q'udi.
/Alexie Sam, thus? Now I am Alexie Evan.

Ighi shcheyatka **ezhge** ghila'en gheli shit.nt'i
/My grandpa was a really **tough/talented** guy.

[*Ed. note:* The word *ezhge* is an important word in Dena'ina that has no direct English equivalent. The *ezhege* is a man who is heroic, courageous, tough, skilled, and talented.]

Shcheyatkda nch'u t'i'eshdul shihdi.
/As for me, I don't live like my grandfather.

Nch'u ey k'i ezhge ghi'eshlal.
/I was not very talented/tough.

Shcheyatda **tets'** eł q'u k'ighiggat nihqeła.
/My grandfather used to spear things (various game) with a **spear**.

Iy qech' k'i nch'u t'i'esht'an shihdi.
/I can't do that myself.

Da'a **izin** eł yan k'iqu el'an yan shughu
t'esht'an da shi.
/I can just only hunt with **rifle**.

Q'udi gu k'i no more iqech' t'esht'an k'i łu k'qisil.
/And now here, I don't even do that anymore.

Yeshtan shi yan q'udi gu ki t'eshdyuq.
/I only just lie down now, so that is what has happened to me here.

Q'u nacheyatda tets' eł k'ighiggat.
/But our grandfather used to stab [game]
with a spear.

Shi shnugheł gheli k'i my **chada**
k'ezgget shnugheł.
/My **grandfather** actually speared [a brown bear]
right in my presence.

Brown bear zgget my chada.
/He speared a brown bear, my grandfather.

Nch'u veł k'daltetl' da t'ent'ayi zgget shnugheł.
/He did not shoot it; he speared it in my presence.

Yi ghuda ezhgech' shughu qut'an.
/These are the skillful things they used to do.

Chada En'ushen Gis qeył dghinihen.
/The old man "tattered old man," is what they
called him.

Ghunhdi shi shchada yich'a shna t'uht'an
yen ghunhdi.
/That person was more skillful than my
grandpa or me.

Yen yich'a ghu ezhge ghila'.
/He was tougher than him.

Dghiłjaq k'i łu t'ighit'a.
/He was light (fast) too.

Caribou moose łu yiłtani ghini yi k'i yejennultlet
yet'uh nu'idiltlet.
/A caribou or a moose that he found, he would
leap over it and then jump down beneath it.

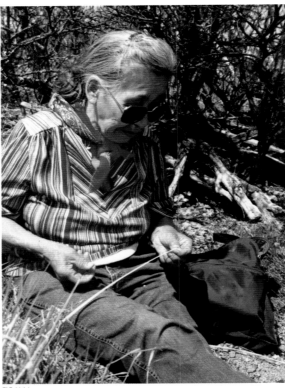

FIG 11.14

**11.14 Mary Hobson of
Nondalton splitting a gull
feather in May of 1992.** Gull
feathers were used to make
snares. Photograph courtesy of
Priscilla Russell.

Łik'a qa veghuy tadelgheł; ghu łu t'ghet'an łu ch'u
Chada En'ushen Gis.
/**The dogs** would corner it [a moose] in
water there; he would do that, the old man,
En'ushen Gis.

Q'uyehdi tets' eł k'iqu el'ihi eła izin k'i det q'u da'a
tets'gheli ghin yan.
/He went hunting with a spear, without any gun,
with only that spear.

Gu q'u ninlggex ch'u ch'k'u'ih qa t'et'ih t'et'ih.
/So he'd come up, [and] as we see something, he
would do that and he would do that.

[He would draw attention to himself.]

Ch'u ye eła veyi'igh ghu yi nal'an.
/And then it [the bear] saw him, it was in plain
view to him.

11.15 One method of snaring bears. Two poles of spruce (B,B) are erected to support the snare (C). A cross-piece (A) supports the snare, which is constructed like a noose with its loose end tied securely to the windfall, higher up the trunk (D). The bait, a birch basket of fish guts and fish eggs is tied high, out of reach of the snare. A bear (X) smelling the bait, climbs the windfall toward the bait, gets his head entangled in the snare and is either choked as he tries to reach the bait, or falls off the windfall, where he is helpless, just being able to claw the grass. This illustration comes from Cornelius Osgood's *Ingalik Material Culture* (1940), p. 45. After Osgood's work with the Dena'ina, he went on to work with and publish extensively on the Deg Hit'an (Ingalik). The Deg Hit'an are Athabascans who live west of Lime Village on the Kuskokwim. In Lime Village, there has been intermarriage, and this method of snaring bears is shared by both groups. Illustration courtesy of Yale University Press.

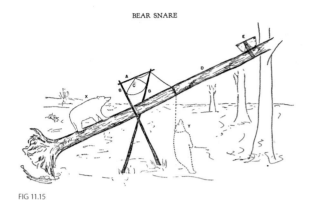

BEAR SNARE

FIG 11.15

Yi vel yitettes.
/It [the bear] would charge him.

Vel yitettes hnuyu yiggat.
/And when it charged him, then he'd spear it.

Tets' el q'u chiydelt'ix izin ch'u izin ch'u et q'u.
/With a spear, he would kill it, without a rifle.

Qech' t'ghet'an qeylnihi my chada.
/That's what he used to do, my grandfather, they would say of him.

Shi shchada gheli t'uhdi nch'u qech' t'it'e gheli qeylnihi yenhdi.
/My own grandpa could not really do that, they say.

Ch'tuhnighilnik', yen k'i ezhge gheli ghila.
/He was too slow, although he was a really quite skillful too.

En'ushen Gis ghun t'et'an nch'u t'it'al qeylni.
/As 'tattered old man' could do, he was not able to do that, they say.

Q'udi gu k'i t'ih t'et'an na qisen. Nothing.
/Nowadays, around here, there isn't a person that does that. No one.

Q'udi izin el yan k'uqu qel'an q'udi gu. Q'ach'dalchet.
/Now they only use rifles. We have quit that (tradition).

3D. Alexie Evan, Antone Evan, Making of Snares

Audio file name: 3d-1302-alxeae-snares.wav; *length:* 2:10

Antone Evan asking Alexie Evan:

Yi quggil yada **t'u** q'u **quggil** hdenghighux?
/For snares, which **feathers** did they make the **snares** from?

Alexie Evan:

Caribou k'iqu qul'ani ghinidi?
/For caribou hunting?

Antone Evan:

Shagela niltu quggil,
/Snares for fish,

quggil ndi k'et'u.
/or feathers for snares.

Ndalika'a t'u?
/[Did they use] bald eagle feathers?

Alexie Evan:

Yeah **ndalka'a t'u**.
/Yes, **bald eagle feathers**.

Any kind of k't'u ch'u yinch'en t'u nihdi t'ghet'an la.
/They would use the various rear sides of feather stems.

Qunsha ghinhdi yach' hyu k'iqu el'an.
/They would hunt for ground squirrels with them that way.

K't'u el yan shu ghu quggil hyiqu el'ani.
/They just used feathers only for [ground squirrel] snare hunting.

Yet hdi k'i **k't'u** hvu k'iqu qel'an k't'u.
/There they used **feathers** just for them [snares]

Antone Evan:

K't'u ghini ch'aqeydeges ch'u viqu dnaghelt'unh t'qeyl'ih.

/They used to split the feather stem and make it thin for that.

Alexie Evan:

Yeah.

Vequq' ghuy tikenq'atl'a duk'iljay shla sht'a.
/Along the outer side at the rear end [of the feather stem], it is a little shiny.

Yi k'i yi shughu qeyghudighiłt'a.
/That is the part they used.

Viq' ghu t'u yi nch'u qeyghudiłt'al.
/They did not use the inner side of the feather stem.

Yeah q'uyehdi yeah qeyghuch'dghiłt'ah ghu.
/Yes, that is what we used.

Yin t'u dach' dyit'an t'u nihdi yi shughu quggił qunsha eł k'iqu el'ihi nt'i.
/The **back feathers** [of bald eagles] are the ones used for the snare they would hunt ground squirrel with.

Vach t'u nihdi yi shughu qunsha eł k'iqu qel'ih.
/Also the various **seagull feather** stems they would obtain ground squirrel with.

Q'udi gu shi shqizdlan gu idiłdihdi quggił ghin yach' qeyk'nazk'et' ha.
/Now since I was born, around here they stretch out those (wire) snares and

Nehvaya nehvaya quggił eł de qunsha iqu l'an t'ghit'a.
/ For rabbit (hare) snares or for catching ground squirrels.

Dach' quggił ghini k'i veqisil t'edyuq.
/They don't have any more of the (traditional) snares.

Yi k't'u ghini niłch'en yut'e qeynghighux quggił.
/They would make feather stem (splitting) downward on both sides of the snares very carefully.

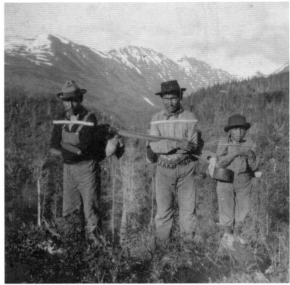

FIG 11.16

FIG 11.17

11.16 A trio of Dena'ina wearing *hał duten*. This photograph was taken in June 1896 by W.L. Frost in the mountains near Sunrise, Alaska. Shown are two Dena'ina men and the one boy using pack yokes to transport moose meat down to the settlement at Sunrise, where they hoped to sell or trade it for supplies. Dorothy Frost Collection. Courtesy of Rolfe Buzzell.

11.17 *Hał duten*, pack yoke, Iliamna, 1931–1932. L 41 cm. Wood, paint. Photograph © Peabody Museum of Natural History, Yale University, ANT.015860. Photograph by Chris Arend.
 The pack yoke went across the chest and was used to anchor loads that were tied together with babiche and carried on the back.

3E. Alexie Evan, The Use of Large Game Snares

Audio filename: 3e-jt13-alxerh-snares.wav; *length:* 1:22

On JT13-1, Alexie Evan was recorded in 1973 by Joan Townsend, with Rose Hedlund adding comments.

Ts'ełten ghini, yi ghini q'u eł jitshla chik'ehdełt'ix.
/With the bow, they could barely kill anything.

Q'u ghin tuk'ineh ghuda.
/Because that one [the arrow] would fall out (and not penetrate).

Q'u tl'ił kiq'u quggił dek'hnazdlu kiq'u. Caribou q'u dek'hnazdlu.
/They would set rope snares also. They set them for caribou.

11.18 Veł k'eltsałi, stone axe, Seldovia. L 24.2 cm. Stone. Alaska State Museum II-A-1674. Photograph by Chris Arend.

This stone axe head would have been attached to a wooden handle with babiche and was used by the Dena'ina to chop down trees. With the arrival of metal axes, stone axes quickly became obsolete. Numerous examples are held by museums, and stone axes are sometimes found at Dena'ina archaeological sites.

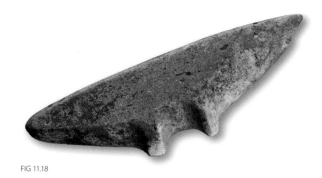

FIG 11.18

Yet ughasht'a chik'hdełt'ix hnuyu.
/With these they would kill them quickly there.

Nudyi nihdi k'i ghu dek'hnazdlu.
/They set **Dall sheep** snares too.

Black bear ghin k'i ghu kiq'u dek'hnazdlu.
/They also set snares for black bear there.

Kiq'u chiqeydałyuq, t'ehyighił'an.
/They were able to kill them also, they did that.

Rose Hedlund: They snared 'em. They snared 'em.

Joan Townsend: Every time they were catching animals, they were always snaring them.

Alexie Evan: Black bear ghinihdi ch'vala dach' tiq'u vehnazilyu.
/For those black bear, you set those [snares] that way in spruce trees.

Yudeq ghusht'a qeyduk'enlax.
/You would set it [the snare] way high up there.

Yudeq ghuhdi vava **vava** qilan ha.
/High up, there was some **dry fish** [as bait].

Yi qaghazdlu ch'ghu vava nihdi yiłket yethdi tl'ił ghinihdi yiq' tsaltsix.
/It was bundled there, the dry fish, and it [the bear] would grab it, and it sticks its head into that rope.

Yeah. Q'uyehdi yach' yudeh k'udelzex. Nu'ilk'et.
/Yes. Then it [the bear] would fall down from above. It got stretched [hanged].

Rose Hedlund:

There is a spruce tree like this. They'll put a dry fish here, and they put the snare here. The black bear comes along and puts its head in there and falls off there. And the reason why the Stony River people kept going back was they had more game than here. So they were going back up there for caribou.

4. Antone Evan, Various Tools and Implements

Dena'ina Topical Dictionary: 20.3 (packs); 17.2, 17.4, 17.5

Audio file name: 4-1390-ae-tools.wav; *length:* 5:50

Packs

Shanteh nuhałqułdeł ha'idghu
/During **summer** they used go around with back packs, but

q'udi gu q'udi gu nuhałch'ułdeł hk'uch' it.
/at that time they'd backpack differently from how we backpack today.

Tl'ił tl'ił eła łuhhałhniłdatl'.
/They packed things around with ropes.

Lghal ha hał duten **hał duten** eła.
/They used to bundle the pack-load to a **pack yoke** [with a rope].

Yi qeyeł qeyeł k'ughałi ghini hał duten qeyeł dghinihi.
/For packing something, they used to have what they called a pack yoke.

Hał duten ghini niłk'uch' qeydghighuk.
/They used to make the pack yokes in different ways.

N'ushna hał dutena ghini dendał…dendałdit.
/For adult men, the pack yokes were narrow.

Kisht'a ench'u diłtal ha qeydghighuk.
/They did not make them very wide.

FIG 11.19

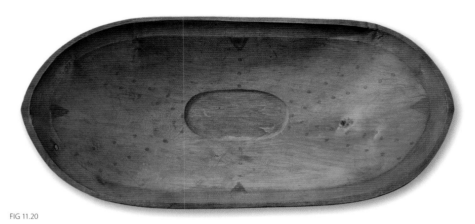

FIG 11.20

Deghk'isna hał dutena ghinhdi dendałtal dach' qeyghighuk.
/For **the women's pack yoke,** they used to make them wider.

Veq'ulugh ghuhdi hał duten ghinhdi **nidnast'un** ha t'qeyghił'ik, deghk'isna hał dutena ghini.
/On the edge of the [women's] pack yoke, they used to make **designs.**

Tuhghideł tuhtedeł ha'it ghu hałqułdeł hq'u t'an ha'it ghu,
/When they used to walk up, starting up somewhere, and were packing somewhere,

vava vava ghin k'i dizdlu ha k'eyes k'eyes yizdlu ha.
/they had that **dry fish** in a skin sack, inside a skin.

Yi shughu **duneyes** qeyeł dghinihi vava hyizdluyi.
/This one they used to call **food bag,** in which they keep the dry fish.

Duneyes qeyeł dghinih.
/They used to call it food bag.

Various Hand Tools

Yada htsast'a n'ushna qeyghudghiłt'ahi.
/This is something that the men used to use in the past.

Chu, **chu ghi ghelghet'i** qeyghel'an qeył k'eshaxi.
/They used to have a **beaver tooth crooked knife** that they carved with.

Yada **lugheshga** nih yi q'ent'ayi **aliggi** nihdi eła ghu qeyeł hyaqeshix, chu ghi ghin yi eła.
/They used to carve out various **spoons, wooden plates,** and such with that beaver tooth knife.

K'iztin, **k'iztin k'izhak'i** yan ghuhdghiłt'ah q'et' q'u.
/They used to use only a **bone knife** long ago.

Vejex **vejex jada k'iztin** yi k'izhagi tqul'ih.
/They used a **caribou shin bone** for a bone knife.

Qałnigi eł **dizeghi** qeył dghinihi k'eyes k'eyes ghin qeył dezah ha.
/With stones, with what they call a **rock scraper,** they used to scrape those hides.

Dghel'ich' ha' tqeył'ix yi qałnigi ghin eła.
/They would make them [the hides] soft with that rock.

Qałnigi duguli yan ghuhdghiłt'ah htsast'a.
/Long ago, they used to use nothing but stone axes.

Duguli nch'u qeyeł dinil.
/They didn't used to call it *duguli.*

[*Ed. note: Duguli* is a Russian loan word for axe.]

11.19 *Chik'a shquł,* **wooden spoon, Nondalton, c. 1970s.**
L 31 cm, W 14 cm. Wood. Janis Chambers Collection. Photograph by Chris Arend.
 The late Pete Koktelash of Nondalton carved this spoon.

11.20 *Beq' q'anch'k'elyashi,* **tray, Kenai, c. 1900.**
L 51 cm. Wood, ochre. Max Hess Collection, National Museum of the American Indian, Smithsonian Institution (236282.000). Photograph by Ernest Amoroso.
 This tray is a fine example of Dena'ina woodworking and design aesthetic.

11.21 *Ush*, snowshoes, Susitna Station, 1931–1932. L 147 cm. Wood, moose hide, babiche, sinew, ochre. Photograph © Peabody Museum of Natural History, Yale University, ANT.015904. Photograph by Chris Arend.

During the winter, snowshoes were an essential means by which the Dena'ina were able to travel across the landscape. Every man would have learned how to make snowshoes. During the late nineteenth century and early twentieth century, making and selling snowshoes to people who arrived in the Dena'ina homeland was a source of income for many Dena'ina.

11.22 *Ch'q'aynigen Uya*, child's snowshoes, Tyonek, 1931–1932. L 119 cm. Wood, moose hide, wool, babiche, sinew, ochre. Photograph © Peabody Museum of Natural History, Yale University, ANT.015893. Photograph by Chris Arend.

Within a few years of learning how to walk, children were taught how to use snowshoes. Every Dena'ina boy learned how to select the right type of wood and the proper way to bend and lash the wooden slats together to make snowshoes.

11.23 *Ush nchix*, snowshoe nose (detail), Kenai, made by Z (?) Mishikoff, 1894. L 125 cm. Wood, babiche, moose hide thongs, ochre. Photograph courtesy of the Burke Museum of Natural History and Culture, catalog no. 860. Photograph by Chris Arend. (See also figure 1.40.)

The Dena'ina have more than twenty different names for various parts of snowshoes. Many of the names carry deep spiritual meaning to the Dena'ina.

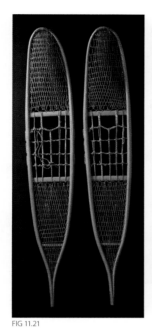

FIG 11.21

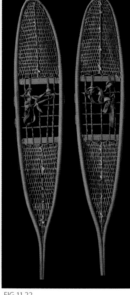

FIG 11.22

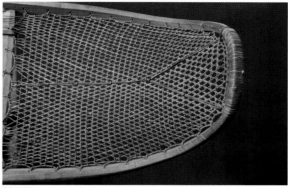

FIG 11.23

Veł k'eltsałi qeył dghinih qevedugula.
/They called it "thing that you chop with," their axe.

Dowels

Gu guzdi **guzdi** nihdi qevqighisen q'et' ghu.
/They didn't have these various **nails** long ago.

[*Ed. note: Guzdi* is a Russian loan word.]

Chik'a ghini qeyenildes ch'u **chik'a gguya** hdghushix.
/They used to drill a hole into the wood and carve **small wooden dowels**.

[Andrew Balluta: These were made out of birch; nowadays these are called dowels.]

Q'eytsayi yi shughu guzdi deheyighel'ani htsast'a.
/This **birch** was used as nails/dowels long ago.

Cooking Utensils, Cooking Techniques

Htsast'a yada **gudlik** nihdi qighisen ha ch'ghu
/Long ago, they didn't have any **buckets,** and

shanteh **ch'vala** deghenhdghela ha tqut'an.
/in summer they used to peel the **spruce trees**.

Yi ghini gudlik gudlik qeydghun ha tqeyghił'an.
/They used to make those buckets [out of spruce bark].

Yi shughu htsast'a hdi hyak'dedlach ha tqeyghił'an.
/That's what they used to cook things in long ago [spruce bark buckets].

K'eluch'ey gudlik minłni hya…minłni hyałtl'et ch'u
/They'd pour water into the **spruce bark bucket,** and

yada ghu tudlach ch'u k'tsen qeyatiłdeł ch'q'u,
/whatever they were going to cook, they would put meat in; and

qałnigi **nli tsaghałniga** ghin da' yus des-hdnełdeł.
/rocks, such as those **steambath (cooking) rocks,** they would put them on the fire.

Dnilqix gheli sht'a idi'eła qeyatuqeydnełdeł.
/When the rocks got really hot, then they put them in it [into the pot with the meat].

Nutih qech' it hqugh ghu idnelghuzh.
/Two [rocks] were enough to bring it to a boil.

Q'u ndnelghush hnuyu ki qeyatunk'denchet hnuyu,

/When it came to a boil, or when they put another [rock] in the water,

denlghech shu t'ehnudit'ah gheli ha k'elish.
/it might be enough to keep really boiling, and it would cook.

Nch'u k'i yus nch'u k'i desdiqe'.
/They did not put the containers out on the fire.

Ełneq' zqun hq'u idnelghuzh.
/The containers [sitting] on the ground would come to a boil.

Dach' shughu k'ehdudlish da.
/That's the way they used to cook for themselves.

Chaggesh t'u eł kiq'u k'qełt'as ha tqut'an.
/Also, they used to roast things with a **roasting stick/skewer**.

5. Antone Evan, Snowshoes and Sleds

Den'aina Topical Dictionary: 20.4, 20.5

Audio file name: 5-1390-ae-snowshoesled.wav; *length:* 4:15

Snowshoes

N'ushna ghuna heyteh ghu **hetl**, **ush** qeył ghutnuhi.
/Those menfolk in wintertime had tools for working on **sleds** and **snowshoes.**

Degh'i tuts'i yi eła k'egh qeldes ha qut'an.
/They had a **hand drill** for boring holes.

Ush ghini qeyet…**qeyetnughet** ha'it ghu heyegh…yus ghu heyegh neldis.
/The snowshoe, as **they would lace it**, they drilled holes in the front [edge].

Ts'ah eła shex daltl'il ha tqił'ix.
/With **sinew thread** they make the edge-hole lashing.

Yi **shex** hyideggat hdi yi ghinhdi **nitsexi** qeył dghinihi.
/They drill the **frame edge holes** in the snowshoe frame with the [**small**] **frame drill.**

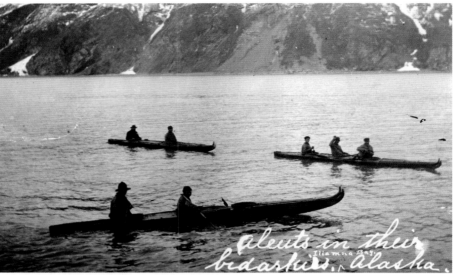

FIG 11.24

[James Kari: In Dena'ina, *shex* has a dual meaning: "holes in snowshoe frame" and "luck, health."]

Ghu dghiłdidi qeyeł…qeyegh neldets ha t'qeyghił'an q'et' q'u.
/That is a narrow one [drill] that they used for drilling small holes long ago.

Yi yeq' ush ts'ah ghini shex qeydeltl'ix ha
/they used to weave a sinew string for the frame holes and

Yi shughu **shex tl'ił** qeył dghinih.
/the one they called the **frame edge-hole lashing**.

Shex tl'ił veł hyenasdghedi.
/The edge string is for tying them out on the ends.

Nunutseq'i naghiłdidi ghini hdi **ush ghetl** qeył dghinih.
/A narrow **rawhide strip** [made out of caribou skin], that one in our language they call *ush ghetl* [**fine octagonal webbing**].

Ey **qałen** qeyeqadghilyuh itdghu yi hdi naghiłtsuzi tl'ił eła qałqeyałdił.
/To install that **rectangular center foot webbing,** they make a thick string for the foot place.

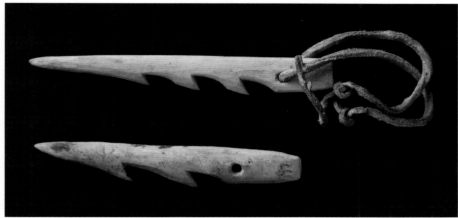

FIG 11.25

11.25 *Estl'eni*, spear points, Old Iliamna, 1931–1932.
L 17 cm. Bone. Photograph © Peabody Museum of Natural History, Yale University, ANT.015867. Photograph by Chris Arend.
 Spear points like these were used to harvest a variety of animals including fish, seals, and beaver.

11.26 *Dineh*, harpoon point, Tyonek, 1883. L 31 cm with thong. Sea lion hide (?), bone, metal point, boiled pitch, spruce roots. Ethnological Museum Berlin, IVA 6132. Photograph courtesy of Staatliche Museen zu Berlin, Ethnologisches Museum. Photograph by Chris Arend.
 John Adrian Jacobsen's notes on this particular item indicate that it was used for harpooning seals in Cook Inlet.

11.27 *Ts'iłten*, bow and arrows, Old Iliamna, 1931–1932. L of bow 137 cm. Spruce, cedar, eagle feathers, iron, bone, sinew. Photograph © Peabody Museum of Natural History, Yale University, left to right: ANT.015846, ANT.015845, and ANT.015844. Photograph by Chris Arend.
 Dena'ina hunters used this style of bow while out on the ocean. The bow would have been shot from a kayak.

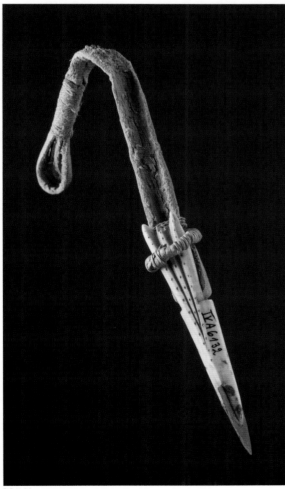

FIG 11.26

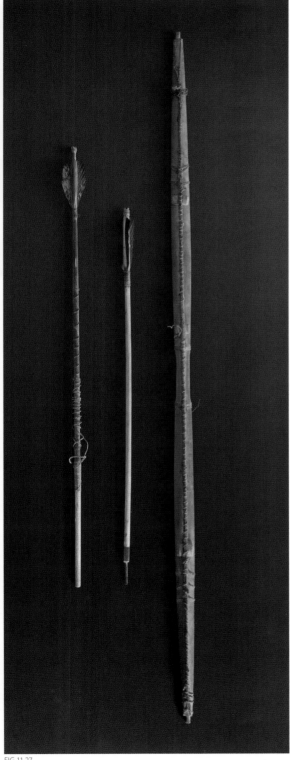

FIG 11.27

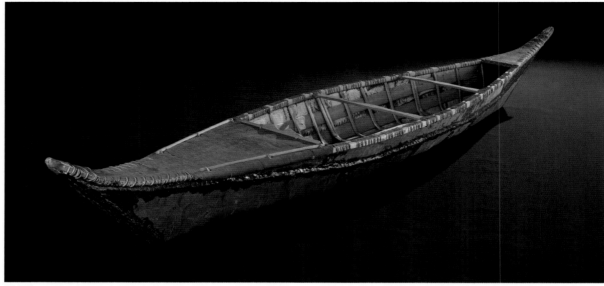

FIG 11.28

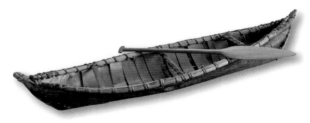

FIG 11.29

11.28 *Vanq'ashli*, **birch bark canoe, 1985, made by Randy Brown under the instruction of Pete Koktelash from Nondalton.** L 476.5 cm. Birch bark, spruce wood, spruce pitch, moose hair, spruce root. Anchorage Museum, 1985.044.001a. Photograph by Chris Arend.

 The Inland Dena'ina call birch bark canoes *vanq'ashli*. This versatile watercraft was used primarily in lakes and slow-moving streams and rivers.

11.29 *Baqay eł tagh'i*, **model canoe with paddle.** Fort Kenai, 1883. Boat: L 44 cm; paddle: L 27 cm. Birch bark, spruce root, sinew, cedar (?), pitch. Ethnological Museum Berlin, IVA 6153ab. Photograph courtesy of Staatliche Museen zu Berlin, Ethnologisches Museum. Photograph by Chris Arend.

 Baqay were primarily used by the Dena'ina to travel across small lakes, calm rivers, and streams. They were easily transportable by one person.

/in the front, the front of the snowshoe can hit their knees due to that.

Kisht'a ench'u nilyuh tqeyeł'ik.
/So they don't bend them too much [on front the end].

Sleds

(Also in Evanoff 2010:51)

Htsast'a hetl **hetl** qeyghighuni Q'udi gu hetl hetl hk'uch'.
/They used to build **sleds** long ago. Now there are different types of sleds.

Chik'a hetl qeył dghinih.
/They used to call it **wood sled**.

Niłq'a niłq'a q'u nalyuyi niłq'a q'u nalyuyi hetl.
/It's a double-ender; it's a sled bent on both ends.

Chik'a hetl qeyeł dghinih.
/They call it the "wood sled."

Tl'ił yus'e tl'ił vadnatk'et' ha', chik'a veq'ezhch'en ghe chik'a vedaltl'in.
/A rope was on the front end of it, and a pole was tied along side of it [the sled].

Yi eła qałghasdlen ha tqeył'ix.
/With this the center foot place is woven.

Ush ghini duqey…duqeylax ha' qeynelax ha'it dghu.
/When they build the snowshoes, they bend them.

Kisht'a nalyu ha ench'u tqeyeł'ik.
/But they don't bend them too much.

Jitq'u nalyu ha tqeyeł'ik.
/They bend them just a little.

Daghiłtiy nalyu ha qeył'ix hnuyu qeya hch'ashełdełtex idghu,
/If they get bent too much, when they start off running in them,

yus ghu, yus ghu ush ghini qeychish denłqey tqeyeł'ihi ghuda.

FIG 11.30

11.30 *Badi*, skin boat. This photograph was taken around 1915 in the yard of the home of Ch'k'idetnishen (Talkeetna Nicolie). At left, two skin boat frames are turned upside down. The *badi* was used by the Dena'ina in the ocean as well as to travel in swift freshwater and could carry a larger load then either the *baqay* or the *viqidin*. A. L. Harman Collection, Anchorage Museum, B.83.005.58.

Hyiqiten ha qeytsatdił'uh ha nuhetlqeyghulket eła tqeyghił'an.
/They used to hold onto that [pole], and they can pull it with the pole in front, and they used it to pull the sled with it.

[Andrew Balluta: This is called nowadays "gee pole." A man can pull the sled with the pole attached to a yoke around his neck and shoulders. Antone did not mention the Dena'ina name for **gee pole, *veł t'unutsihyeghułt'uyi*.**]

Htsast'a k'i qevelik'a ha ki kisht'a nch'u dnilt'al.
/Long ago, there were not very many dogs.

K'etsahdi łu gheli yan nuhetlqułdeł ha qut'an.
/They'd actually pull ahead of the sled by their own power.

Yeghuda shughu hetl ghin k'i niłq'a ghu nalyuh ha tqeyghił'ik.
/That's why they used sleds bent on both ends.

Veq'atl'ah ghu vehetl yena ghini ggek **ggek hetl yena** dilan ha tqeyghił'ik.
/For the **runners** and the sled beam ("spine") they used to use hard wood, a **hard wood sled beam.**

[Andrew Balluta: **Ggek**, that's the hardest wood that grows on the spruce.]

Ey hyiten eł nuhyułgheł eł yedghu hetl dghiłqet' ha t'ghit'ah ghuda.
/When holding or pulling it, those [runners] make the sled slide easier.

6. Antone Evan, Harpoons for Saltwater Hunting and Types of Boats

Dena'ina Topical Dictionary: 20.7

Audio file name: 6-1390-ae-boats.wav; *length:* 4:27

Spears and Harpoons

N'ushna ghuna nuti at k'iqu qul'ih **vanq'ashli** eł.
/The menfolk used to hunt in salt water with **boats.**

Vegh tetnexi hqugh dnghiłnazi vekiyiq' q'u veq'ak'di…**veq'a k'diluha** tqeyl'ix.
/They made [a spear handle]) as long as **outstretched arms** that had a **spear point** attached on the tip.

Yi shughu **ch'tełqexa** qeył dghinih, ch'tełqexa qeył dghinihi.
/That is what they called "one we throw," a **throwing spear/harpoon**; they call that "the one we throw."

Yada **quyeshi,** quyeshi nih **hutsaghił'i** nih eła qeyeł iqu ghel'ih.
/They would go for **beluga whales** or **seals,** etc., with that.

Ghu qeyełqux hnuyu ghu ch'a'idgheł ch'u vekiyiq' ghu yi ghini yi yegh n'e ki niqeyegget.
/When they throw it [and strike a seal or beluga whale], it [spear handle] came out, and its tip would penetrate [the animal].

Ch'u vetl'ila naghiłnaz ha vekiyiq' q'uhdi vejex **vejex lis** venghaztl'inh.
/and long rope is tied onto the end of it [the spear handle] which is tied to a **caribou bladder.**

Ts'ah ghin **nasdesi** ghu naghiłnaz gheli ha idghu tqeyghił'ik.
/They used really long **spun sinew** for that [harpoon line].

Yi shughu nuti at qeył k'iqu ghel'ih.
/That was for hunting on salt water.

Boats

Yutsit ts'iłt'an ghun qut'an vanq'ashli qeył dghinihi niłk'uch' qeyghighuk.
/In **the lowlands** [Lakes Iliamna and Clark], each man made boats in various ways.

[James Kari: It is interesting that Antone Evan regards as the "lowlands" Lake Clark and Iliamna Lake, as he was originally from the uplands of Stony River.]

Viqidin qeył dghinih ghini hdi tayanq' tayanq' q'u yan yihdazdu ghu yan viqidun ha qeyghighuk.
/For the one they call **baidarka** they sit only in the middle and they made that as "the one with a cavity inside."

Yi shughu viqidin qeył dghinih.
/That's what they used to call baidarka, "the one with a cavity inside."

Vanq'ashli qeył dghinihi ghin yehdi vech'ideh ghu k'i nch'u nih t'it'e ch'u vaqilan ch'yan t'ghit'a.
/That one they call *vanq'ashli* [an **open boat**, general term "open space inside it"] is not covered with anything on the top side, and it has an open space.

Yi shughu vanq'ashli qeył dghinih.
/That is why they call it "open space inside it."

Yi viqidin ghini **yus venada** ghu vanq'ashli k'uch' venada ghin nalchin ha tqeyghił'ik.
/The **bow piece** at front end of the baidarka they made differently from the bow of the open canoe.

Tagh'i **tagh'i** ghini k'i niłk'uch' niłk'uch'tagh'i qeghux hdi.
/The paddles, they used to make those **paddles** in different ways too.

Ch'iłch'en yan **tagh'i** qilan yach' nuqeyghelket ha taqeytsex ha tqeyghił'ik.
/The **single-blade paddle** they took over from one side and then stroked it over on the other side.

T'ighił…t'ighiłne'i nułtu tagh'i nił'egh k'uch'en q'u tagh'i hvegh qilan ha'
/For a speedy paddle, they had a doubled-bladed paddle, and

tayanq' ghu hyiten ch'u yach'en nch'u nuhyeghelket.
/they held onto it in the middle, and they did not pull it over to the other side.

Ch'u taqeytsex ha tqeyghił'ih.
/And they paddled like that.

Yi shughu niłq'a **niłq'a tagh'i** qeył dghinih, niłq'a tagh'i qeył dghinih.
/That's what they used to call it, the **double-bladed paddle**, the double-bladed paddle.

Qevedzastets'a yi viqidin **qevedzastets'a** hghila.
/In the baidarga [and other boats too] they used to have "shoulder canes" (**boat poles**).

[*Ed. note:* **Dzastets'** literally is "shoulder staff."]

Ch'u dendałdit ha dendałnaz nutiha nił'egh k'uch'en gu qeyeł dzasdeltets' ha.
/And they had two long narrow poles, and on either side they could pole a boat with those.

Tqeyghił'ik hnuyu k'etnu nuhghunex ghu.
/They used them whenever they go on the streams there.

[Andrew Balluta: They used those poles when they'd get to shallow water and were going upstream.]

Yi vanq'ashli qeyeghux ghu k'i nt'i veyes ghini.
/They would make the open boat with those skins.

Vejex yes k'i va'ighalnex ha' tqeyghił'ix.
/They used **caribou skins** to cover them.

K'eldunahdi **nichił** nichił va'ighalnex ha
tqeyghił'ik.
/Some people used **birch bark** to cover them.

7. Antone Evan, Calisthenics, Games, and Training

Dena'ina Topical Dictionary: 25.2, 25.1, 26.3

Audio file name: 7-1390-ae-training.wav;
length: 8:02

Exercises

Htsast'a **ch'q'ayna** kił kiłqa gguya, ghu
tqiłkeh ghu,
/Long ago, **children**, especially the boys, when
they are getting bigger,

hluzhun qevheya hdełax hqugh q'u
/when they'd turn ten years old, then

kiłqa gguya ghuna huł hdułtex ha t'ghił'an.
/the boys would start to strengthen themselves.

Qevqakena teh qevegguna teh hveyena
dehdaghiłtey dehdaghiłtey ha huqul'ik ghuna.
/They'd make themselves strengthen **their legs**,
their arms, and their back; they strengthened
themselves.

K'ejen nuqeltlet, nuhnułyeł.
/They would jump over poles, and they ran races.

Chik'a yudeh dani'iy hqiłket ch'q'u
nik'unuhuhghulket ha tqut'an.
/They used to grab an **elevated pole,** and they
used to pull themselves up.

[Andrew Balluta: A pole was tied across two trees
like a chinning bar.]

Qevegguna teh denhdałtiy ha tqet'ix łu.
/That's the way they'd strengthen **their arms**.

Hvey…**hveyena** daghiłtiy hqut'an ey
nik'uniłhghilket nik'uniłghilket ha tqut'an.
/To strengthen **their backs, they used to lift one
another up**, they used to lift one another up.

Yethdi hveniq' hveyena ghini daghiłtiy ha t'ix
nik'uniłhghilket.
/That's the way they exercised their backs and
spines by lifting one another up.

Dehqakena eła yach' niłqaniłqult'ih ey tqut'an.
Qevqakena ghini daghiłtiy ha t'ix.
/With their legs, they used to toss each other over.
That would to make their legs strong.

[Andrew Balluta: That is what we nowadays call
"Indian leg wrestle."]

Ch'q'ayna t'inch'iłdusna ghuna k'i ey hqiłket
ch'q'u ch'iłch'en qevegguna nik'uhghilket ch'q'u
qeł nik'uhdilchet ch'ełch'en dehgguna eł.
/They used to take **children** of equal weight and
pick one up with one arm and then lift one up
with the other arm.

Iy k'i **huhdeltex** huhdeltex ha qut'an.
/Thus **they would strengthen themselves**, they
would strengthen themselves.

Games

Yada **chi'ul** niłtuhghich'ik'i nihdi qeł chiqul'ul
niłtuhghich'ik'i qeyeł dghinihi.
/Among the various **games/sports**, they used to
play with strings—they called this **"stringing
back and forth."**

[Andrew Balluta: They'd make objects with the
string that is now called in English "cat's cradle."]

Ts'ah **ts'ah naltl'ili** niłtuhqeyghach'ix ch'u
/They would string sinew, **braided sinew** back and
forth, and

yada vejex, qunsha, tava, qut'ana, **jamyaq
dnutiłen**, nini, t'anch'q'u qeyghun ha' tqeyghił'an.
/they used to make everything, like a caribou, a
squirrel, a swan, a man, **a person drumming**, a
porcupine, they would do that.

Yi shughu niłtuhghich'ik'i qeyeł dghinihi.
/That's what they called "stringing back
and forth."

Niqan...**niqants'iłvesi** naqeliteh jan
diłggesh yedghu niqants'iłvesi yi eł chiqul'ił,
niłtuhghich'ik'i
/**Spinning tops**--in fall when the days get short,
they would play with tops, or the string game.

Q'u jan dnudilzet jan dnudilzet idiłhq'u
nik'unch'diłtl'eda, ch'tełt'eha.
/When the days get longer, then was **"we toss up
sticks,"** or the **"we toss spear."**

Qamga, ch'enlahi, niłlaq'a ch'ak'hdghelket.
/Or the **disc toss**, or **the hand game**, or **the
stick pull.**

[Andrew Balluta: that is, pulling a stick out of one
guy's hands.]

Yi eł chiqul'ił jan dnudilzet ha.
/They used to play these when days get longer [in
the spring season].

Naqeliteh jan diłggech'i dghu niłtuhghich'ik'i
ghini **qil** qyeł dghinih.
/**In fall time** when the days are getting short, they
would say [to play] the string game is **taboo.**

[Andrew Balluta: Also, they could not use the tops
in fall time. That was a superstition.]

Jan jan nudilzedi eł q'u niłtuhghich'ik'i ghini veł
chich'el'ula.
/When the days are getting longer, we play with
that string game.

N'uyi **n'uyi** qatuhk'tghighits'ex, n'uyi ghin
ch'itułnigh.
/You might tangle your feet up with **the sun,** and
the sun will disappear.

Yeghuda niłtuhch'k'ghach'ixa qeyeł dghinih jan
dnudilzet ha.
/That is why what they call the string game is for
when the days become longer.

Yada **vik'iyugi** yi k'i jan dnudilnes ha'it ghu
vik'iyugi nihdi eła eł chiqul'ił.
/Also the **bullroarer** "something walks into it"
when the days become long, they played with the
bullroarer.

[Andrew Balluta: That's a game of twirling a
string with like a propeller with holes in the
middle of it.]

Ch'q'ayna ghuna dach' tqghił'an.
/The young children would do things like this.

Huhdeltex ha qut'ih ghu.
/They would strengthen themselves doing this.

Other Training Rules for Young People

Kiłqa gguya deghk'isna gguya łu k'qelqat
ghu du k'i **nalqeni k'ta'a** ghin k'i nalqen ha
ench'u hyizhizh.
/The young boys and young girls, when they eat,
they did not sip hot soup.

K'ta'a ghin k'i **nazq'a** ha qeyeghizhish.
/When the soup had **cooled off**, they could sip it.

Nalqeni nalqeni k'ta'a qeyzhizh ha ida
ch'ggulhtinuldigh.
/If they drank hot food or hot soup, **they would be
poor runners.**

Nushełhdułtix ida qeyyich' daghilggech'h ha
t'eqet'ix.
/If they ran, it would make them shorten
their breath.

Yeghudadi ezhi k'ilanch' yan k'qelqat ha tqut'an
ch'q'ayna nlana htsast'a.
/That is why they would have them eat only cold
food, while they were children long ago.

[Andrew Balluta: That way, when they ran, they'd
have long wind. Their breathing was stronger
and better.]

Kiłqa gguya ghuna ghu tqiłkeh ch'u
/Those young boys, when they'd get big
enough and

k'iqu qel'anna ghuna k'iqu qel'ani ghini hqiłdih
ha t'ehgił'an.
/those **hunters** would teach about hunting.

Ighi **ts'ełten, tets'** nihdi łu qehqiłdih ha
t'ehgił'an łu.

/They used to train them to use **bow and arrow** and **spears** and so forth.

Tets' ghin k'i chik'a **chik'a tets'** gheli k'i ench'u ch'q'ayna qeyeł chil'ul ha ch'u.
/The spear, the actual **wooden spear**, the children did not play with that.

Chik'a chik'a daghiłnazi hdenghalzhagi.
/There was a long stick that was sharpened to a point.

K'chan k'chan ghini qeydełghił ha', daghiłchek'.
/**Grass**, they bundled grass, a small amount.

Yi eła qeyiqu tsahdetsex.
/And with that they would throw it [the stick] at it [the bundled grass].

[Andrew Balluta: They'd make a bundle of grass into a big ball.]

Qeyiqu tsahdetsex ch'u yi chik'a ghini eła ghu dehqeyiggat.
/They would throw that stick at it, and they would try to spear that [grass bundle].

K'elduna k'elduna yi ench'u hyisggat.
/Some of them, some of them could not spear that thing.

K'elduna hdi ghu qeyiqu tsahdetsex hnuyu hyiggat.
/Some of them, when they throw at it, they would spear it.

Dach' ghu tets' ghini ghuhdiłt'a'i hnu hehqełdih ha t'hghił'an.
/That's how they used to teach them how to use the spear.

12

Photo Essay: Making a Whitefish Trap

In June 2009, exhibition curators Suzi Jones and Aaron Leggett and photographer Chris Arend chartered a small plane and flew to Lime Village, 185 air miles west of Anchorage. Upon landing on the small gravel airstrip, they were met by Alan Dick and his grandson, Bryan, who had traveled downriver in small skiffs to greet them. After transferring their gear into the boats, they headed thirty miles up the Stony River to Helen and Alan Dick's home, located near Qeghnilen (Canyon village). The purpose of the trip was to document over two days the traditional construction of a Dena'ina whitefish trap that had been commissioned by the Anchorage Museum for the Dena'ina exhibition.

Stony River people harvest five species of whitefish: *q'untuq',* humpback whitefish; *hesten,* round whitefish; *telay,* broad whitefish; *ghelguts'i k'una,* least cisco; and *shish,* sheefish. These freshwater fishes have been important subsistence fishes for Inland Dena'ina villages, harvested in spring and fall when the fish are moving between the lakes and rivers. Fish traps are set in streams running from lakes after breakup in the spring and before freeze-up in the fall.

Prior to our arrival, the family had located and cut a long slender spruce tree with few knots. White spruce is the ideal wood for a fish trap because it does not rot as fast as other species. Helen Dick had also gathered spruce roots. Perhaps a hundred small coils of cleaned spruce roots were soaking in plastic buckets and pans full of water. Helen told us she always looked for tall, slender spruce trees because their roots will be long, slender, and strong. The tree and the roots had come from a forested site located on the other side of the Stony River from the Dick home.

The construction of the fish trap took place back at their home, near a covered shelter where they kept a small fire going to repel mosquitoes. This project involved three generations of the Dick family. Helen, who was raised by her grandparents in Lime Village, is a well-respected Dena'ina elder, and she and her husband Alan supervised the construction. Their son, Wayne, and Wayne's son, Bryan, were in charge of executing the overall building of the fish trap.

We are very fortunate that Helen still knows how to make these traps. Whitefish were once an important food source in the spring to avoid starvation before the arrival of the salmon. While whitefish are still harvested, whitefish traps are seldom used today because of uncertainty over fishing regulations regarding harvest methods, a greater use of nets, and a need for fewer fish with the decreased use of dogs for transportation. Although few, if any, Dena'ina make these traps any longer, Helen felt strongly it was an important technology to document and wanted to pass on this traditional knowledge handed down to her from her ancestors. Although the trap was not

completed during our two-day visit, Alan Dick has produced a video showing the creation of the fish trap, step by step, from start to finish. In addition to its use in the exhibition, the video is also available from the museum.

All photographs, except 12.3, are by Chris Arend.

The Dena'ina whitefish trap project was developed through the collaborative efforts of the Anchorage Museum, the Kenaitze Indian Tribe, Cook Inlet Region, Inc., and Cook Inlet Tribal Council, with funding from the U.S. Department of Agriculture, CFDA 10.6710.

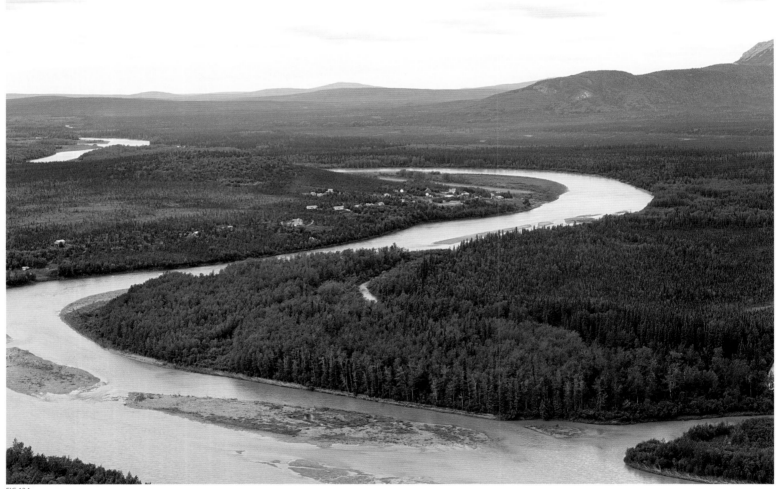

FIG 12.1

12.1 The Stony River and Lime Village seen from the air, upriver. Anchorage Museum, DH-W2K0224.

12.2 Helen and Alan Dick family home site on the Stony River. Anchorage Museum, DH-W2K1022.

12.3 Covered workspace with fire pit. Anchorage Museum, DH-IMG4106. Photograph by Suzi Jones.

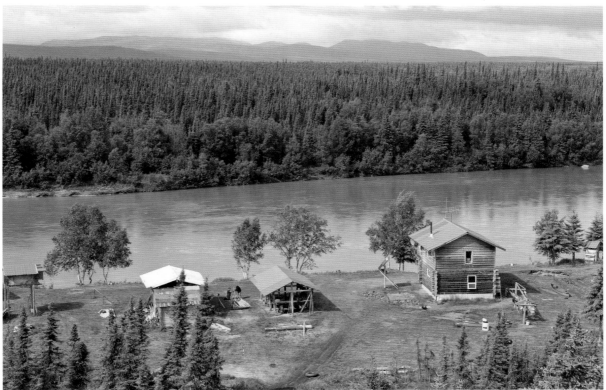

FIG 12.2

FIG 12.3

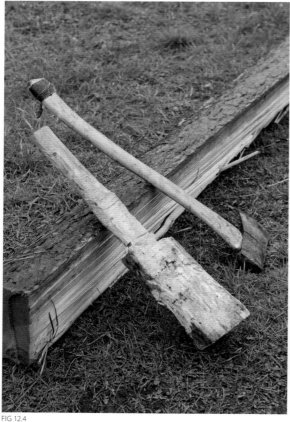

FIG 12.4

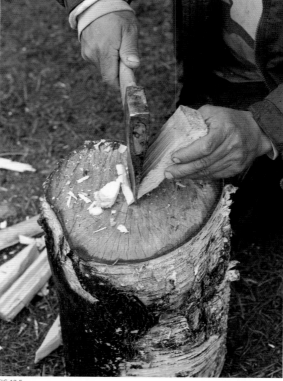

FIG 12.5

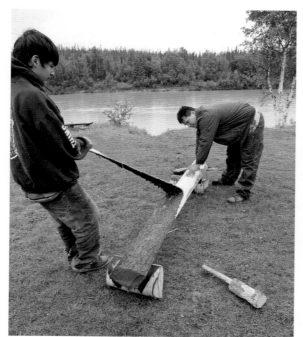

FIG 12.6

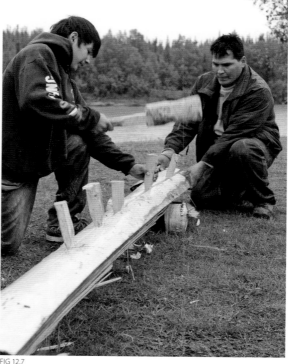

FIG 12.7

12.4 Mallet and axe used to split wood for the fish trap. Anchorage Museum, DH-W2K0321.

12.5 Wayne Dick using an axe to make wooden wedges for splitting spruce slats from a spruce tree. Anchorage Museum, DH-W2K0336.

12.6 Wayne Dick and Bryan Willis peeling spruce bark off the tree before splitting off the slats. Anchorage Museum, DH-W2K0343.

12.7 Wayne and Bryan Willis driving wooden wedges to make the slats. Anchorage Museum, DH-W2K0378.

12.8 Split spruce slats ready for use in making the fish trap funnel. Anchorage Museum, DH-W2K0317.

12.9 Bryan Willis watching his father split the ribs with a crooked knife. Anchorage Museum, DH-W2K0453.

12.10 Wayne Dick using the crooked knife to smooth the slats to the desired size. Anchorage Museum, DH-W2K0470.

12.11 Wayne Dick bending a slat to form the inside hoop for the fish trap. Anchorage Museum, DH-W2K0599.

FIG 12.8

FIG 12.9

FIG 12.11

FIG 12.10

FIG 12.12

FIG 12.13

FIG 12.14

FIG 12.15

12.12 Split spruce roots soaking in water to make the dip net and fish trap. Anchorage Museum, DH-W2K0535.

12.13 Wayne Dick flexing and shaping the hoop for the inside of the fish trap. Anchorage Museum, DH-W2K0622.

12.14 Helen Dick and Sarah Dick searching for spruce roots. Anchorage Museum, DH-W2K0812.

12.15 Helen Dick locating a long, strong spruce root. Anchorage Museum, DH-W2K0837.

12.16 Helen Dick smelling spruce roots, showing how to distinguish them from birch or other roots. Anchorage Museum, DH-W2K0803.

12.17 Helen Dick pulling a spruce root through a notch cut in top of a small alder stump to remove the outer layer of the root. Anchorage Museum, DH-W2K0864.

12.18 Helen Dick with spruce roots stripped of their outer layer. Anchorage Museum, DH-W2K0871.

FIG 12.16

FIG 12.17

FIG 12.18

FIG 12.19

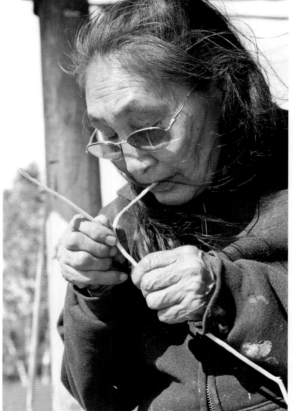

FIG 12.20

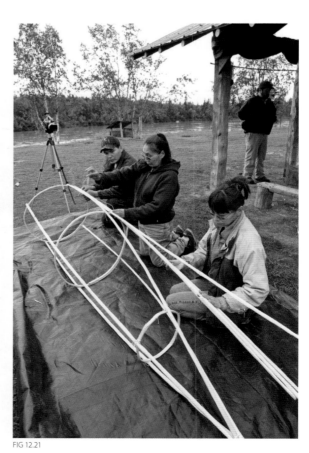

FIG 12.21

12.19 Wayne, Sarah, and Helen Dick in the boat. Anchorage Museum, DH-W2K0894.

12.20 Helen Dick cleaning and splitting large spruce root lashings. Anchorage Museum, DH-W2K0969.

12.21 Helen, Wayne, and Sarah Dick working to get the first slats and hoops straight. Anchorage Museum, DH-W2K0685.

12.22 Helen and Wayne Dick making certain that slats and hoops are spaced evenly. Anchorage Museum, DH-W2K0721.

12.23 Wayne Dick lashing the slats to the hoops of the fish trap. Anchorage Museum, DH-W2K0705.

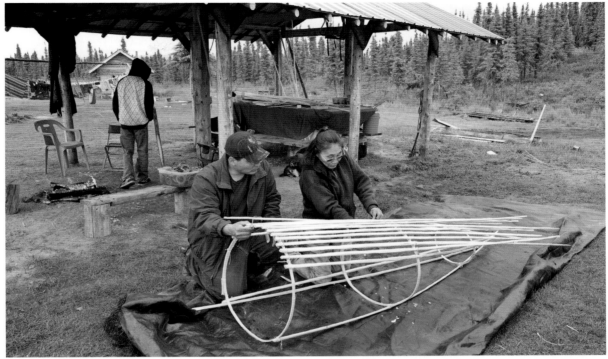

FIG 12.22

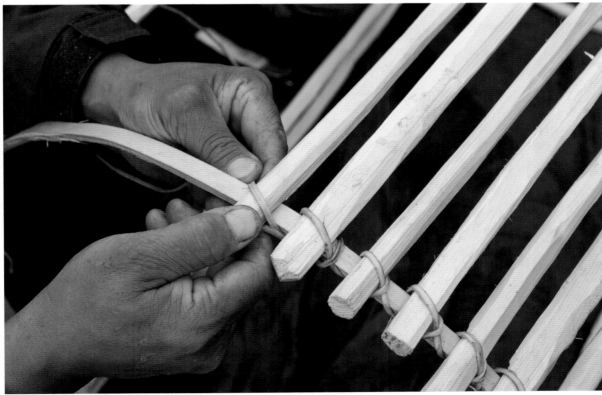

FIG 12.23

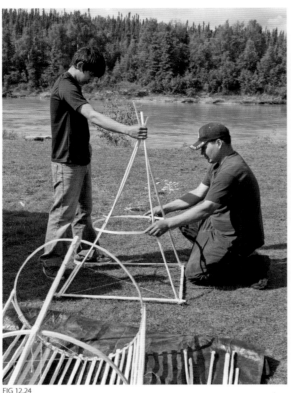

FIG 12.24

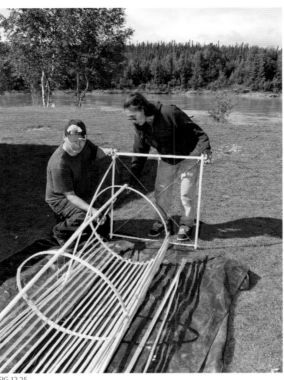

FIG 12.25

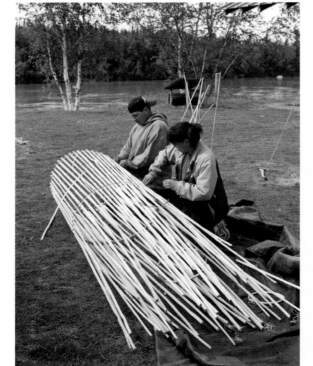

FIG 12.26

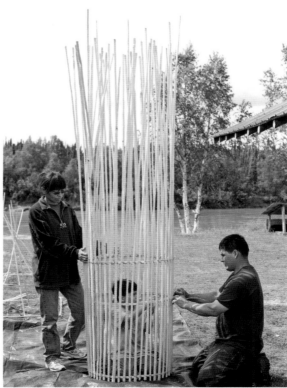

FIG 12.27

12.24 Wayne and Bryan constructing the funnel of the fish trap. Anchorage Museum, DH-W2K0977.

12.25 Helen and Wayne Dick positioning the top on the funnel trap. Anchorage Museum, DH-W2K0946.

12.26 Wayne and Sarah Dick lashing the slats to the funnel frame. Anchorage Museum, DH-W2K1246.

12.27 Sarah, Wayne, and Nathan Dick (inside the trap) lashing slats onto the frame. Anchorage Museum, DH-W2K1310.

12.28 Wayne Dick inspecting his work. Anchorage Museum, DH-W2K1325.

12.29 Looking up *Hek'dichen* ("Hungry Creek"). The name Hek'dichen is a euphemism in Dena'ina; you won't go hungry if you live near this creek. The Dena'ina used whitefish traps in this creek at the edge of Lime Village. Anchorage Museum, DH-W2K1452.

FIG 12.28

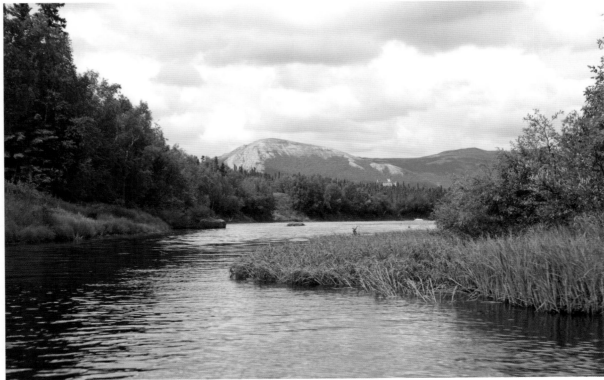

FIG 12.29

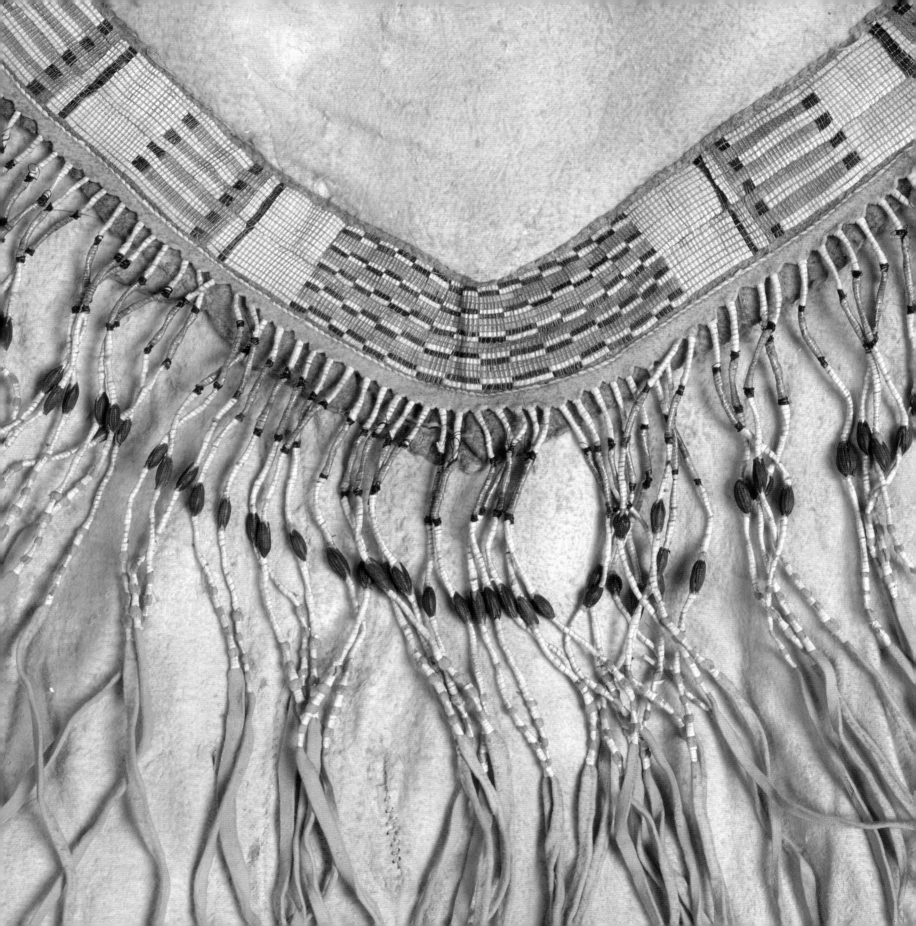

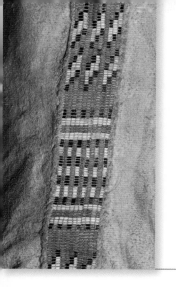

13

"Dressed as a Rich Person": Dena'ina Clothing in the Nineteenth Century

Judy Thompson

Now I think about it, I think of myself dressed as a very rich person.... I wish I had the clothes [now] that I had then. Fur clothes. Fur coat, handmade, handmade moccasins, even the skirt and shirt, all made out of hide and trimmed with porcupine quills, looked like beadwork.
—Alexandra Kaloa, Dena'ina elder, born 1910. (McClanahan 2002:86)

Clothing is a fundamental and distinctive element of Dena'ina traditional culture. Garments such as those recalled by elder Alexandra Kaloa speak to us of a time when the Dena'ina lived close to the land, deriving from it all that was necessary to sustain life. The land's resources, particularly animal hides, were central to clothing production. Other animal products also were important: bones were modified as scrapers to be used in cleaning and working hides; brains, spinal fluid, and grease were integral to the tanning process; and ochre, feathers, and porcupine quills dyed with plant and berry juices added color and beauty to garments. With these materials, the Dena'ina fashioned clothing that was both practical and attractive, well suited to their northern environment and mobile lifestyle.

The arrival of foreigners in Cook Inlet in the late eighteenth century and the involvement of the region's indigenous peoples in the European fur trade initiated a period of rapid cultural change for the Dena'ina. Clothing reflected these developments. During the nineteenth century, the Dena'ina first modified their hide garments by incorporating glass trade beads into their decoration, and then replaced them with new modes of dress.

It has been well over a century since the Dena'ina made clothing like that shown in figure 13.1, and much knowledge pertaining to it and other traditional styles has been lost. Nevertheless, a considerable amount of information on traditional dress can be gleaned from a variety of sources, including accounts written by explorers, missionaries, and traders; twentieth-century ethnographic studies, and Dena'ina oral histories. The more than one hundred examples of Dena'ina clothing preserved in museums are particularly important primary sources of information. Testimonials to the skill and artistry of generations of Dena'ina seamstresses, they come to us virtually unchanged from the hands of their makers, and embody a wealth of information about resources, technologies, lifestyle, and aesthetics.

First Glimpses

The earliest written references to Dena'ina clothing and adornment date from the time of Captain

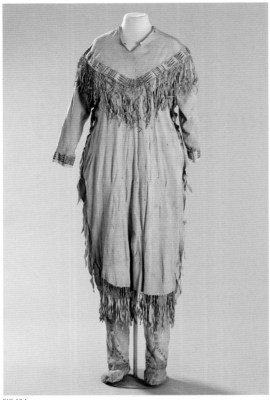

FIG 13.1

13.1 Woman's summer outfit: *k'isen dghak'a*, dress, and *Tl'useł*, moccasin-trousers, Kenai, early nineteenth century.
National Museum of Denmark, Ic.99bc. Photograph ©The National Museum of Denmark, Ethnographic Collection. Photograph by Arnold Mikkelsen.

James Cook's exploration of Cook Inlet. As his ships the *Resolution* and the *Discovery* neared the head of the inlet in late spring 1778, the crew had several encounters with Dena'ina. During one of the first meetings, Dena'ina responded to Cook's gifts of "beads & other Trifles" by hoisting a garment on a long pole up to the ship's deck (Beaglehole 1967:364). Cook referred to this garment as a "leather frock" (Beaglehole 1967:364); his officer, Samwell described it more precisely, as a "fur jacket…made of white hare skins" (Beaglehole 1967:1115). Other clothing items traded to the Englishmen included "fur dresses" made from "the Skins of Sea Beaver [otter], Martins, Hares, etc." (Beaglehole 1967:364). A shore party encountered men who were "well made," had "manly Countenances," and wore "loose…Cloaks" made from marten furs and "close jackets" made from bird or hare skins (Beaglehole 1967:1422).

Prior to sailing into Cook Inlet, the expedition had traveled to Prince William Sound, where the crews met and traded with Chugach Eskimo. In the eyes of the English mariners, the inhabitants of Cook Inlet were very like these earlier met indigenous peoples (Beaglehole 1967:1115). Nevertheless, they noted some differences in adornment styles and clothing decoration. Among the Dena'ina, lip ornaments were less "in fashion" and nose ornaments more so (Cook 1785:335). The Dena'ina hair style, a "queue" that hung down the back, was different from that of the people of Prince William Sound (Beaglehole 1967:1116 [Samwell's Journal]). Dena'ina "garments, quivers, knife-cases and other articles" had more "embroidered work" than similar items made by the Chugach (Cook and King 1785:335).

Further observations on Dena'ina clothing and personal adornment were recorded by Nathaniel Portlock and George Dixon, two members of Cook's crew who returned to the region in the summer of 1789 (Beresford 1789). They encountered Dena'ina who "had their faces daubed entirely over with red oker and black lead" and wore ornaments of "blue beads or teeth" in pierced noses, ears and lower lips (Portlock 1789:113). These people wore "coats" made of furred hides and, sometimes, "loose cloak[s]" or robes "tied with small leather strings" overtop (Dixon 1789:239). Women wore an "undergarment" that covered them "from the neck to the ancle" and was tied at various points "to make it fit close," and over this an apron-like garment that tied at the waist and a "coat" that resembled those worn by men (Dixon 1789:239). These women's garments were made from dehaired hide rather than furs. Another type of clothing, a robe made from the pelts of ground squirrels "sewed together very neatly," was among the goods traded to the Englishmen (Portlock 1789:113).

Captain George Vancouver's exploration of Cook Inlet in the spring of 1794 generated both written accounts and artifact collections relating to Dena'ina adornment and clothing. Archibald Menzies, naturalist and official collector for the expedition, described the wearing of Chugach-like

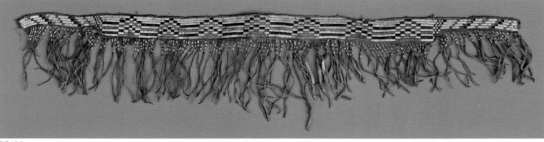

FIG 13.2

13.2 Breast band, collected by G. G. Hewett at "Cook's River" during the voyage of Captain George Vancouver in southern Alaska, 1794. L 80 cm, W 19.1 cm with fringe. Caribou hide, porcupine quills, ochre, sinew. British Museum, VAN 206. Photograph © The Trustees of the British Museum.

13.3 Legging bands, collected by G. G. Hewett at "Cook's River" during the voyage of Captain George Vancouver in southern Alaska, 1794. (a, left) L 65.5 cm, W 3 cm. Caribou hide, porcupine quills, sinew. British Museum, VAN 207a, b. Photograph © The Trustees of the British Museum.

facial ornaments: "Most of the men had their under lips slit across, in which they wore a piece of flat oblong ivory, but the women had their under lips perforated with a row of holes, from which appended thongs & other ornaments over their chin" (in Lamb 1984:1243n1). With respect to clothing, Menzies observed that the Dena'ina were "well-equipped to withstand the rigor of the Climate" (there was snow on the ground and ice in the inlet): they wore "long frocks of Raccoon Skins…fur mittens [and] leather boots" (in Lamb 1984:1219n2).[1] Some wore clothing made from a "white strong fur," identified by Menzies as from mountain sheep.

Menzies and George Hewett, surgeon's mate, both compiled inventories of collections they made (King 1994). References to clothing in these inventories and a few surviving artifacts shed further light on Dena'ina clothing styles during the early postcontact period. For example, Menzies's "Catalogue of Curiosities" includes "Camlico or Frocks made from the finer Membranes of the Intestines of Marine Animals & so ingeniously put together & sewd as to keep the Natives perfectly dry in wet weather"; "A pair of Boots & Garters curiously ornamented—a present of a Chief at the head of the Inlet"; "ornamented fringes for the Chief's War Dress"; and "two Skin Dresses—animal unknown" (King 1994:43).[2] Similarly, George Hewett's catalogue lists, from "Cook's River": "Stockings," "Ornament for Leather Slop" (a garment defined in the *Oxford Dictionary* as "a workman's loose outer garment") (Allen 1990:1145), and "[Ornament] for stockings" (King 1994:48).

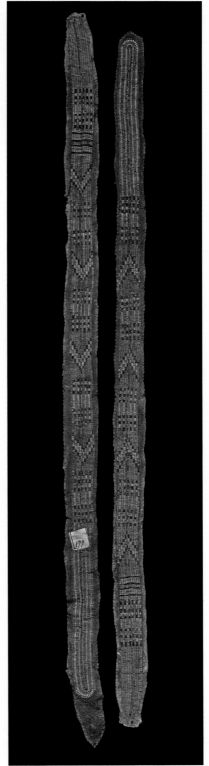

FIG 13.3

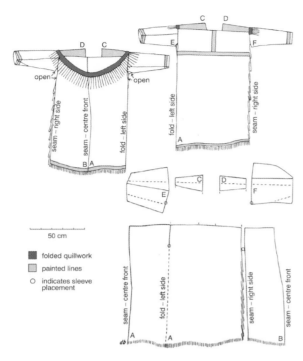

FIG 13.4a

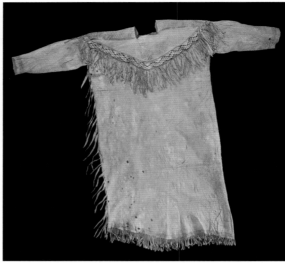

FIG 13.4b

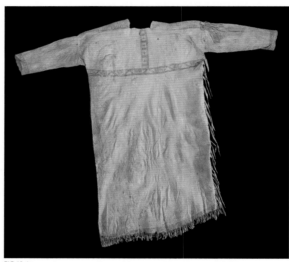

FIG 13.4c

13.4a Pattern drawing for tunic VI-Y-5. Drawing by Dorothy K. Burnham. © Canadian Museum of Civilization, Dorothy Burnham, E96.1/ E2001.3/ E2012.5.

13.4b, c *Kił dghak'a*, tunic (front and back views), Kenai Alaska, c. 1800. L 110 cm, W 65 cm. Caribou hide, porcupine quills, sinew, ochre. Canadian Museum of Civilization, VI-Y-5. © Canadian Museum of Civilization, VI-Y-5, IMG2012-0200-0016-Dm (front), IMG2012-0200-0014 (back).

Of these acquisitions, only two can be located today. These are Hewett's "ornaments"—one for "Stockings" and the other for a "Leather Slop" (British Museum Van 206 and Van 207). The former is a pair of long, narrow bands made from tanned caribou hide that has been stained red with ochre and worked on one side with woven porcupine quills (figure 13.3). Very similar bands decorate the leg fronts of nineteenth-century Dena'ina moccasin-trousers (see, e.g., figure 13.6). The other "ornament" is a curving, tapered band of tanned caribou hide decorated with folded, sewn quillwork and a fine fringe of thongs wrapped with porcupine quills (figure 13.2). In nineteenth-century collections, decorative bands like this are a distinctive feature of Dena'ina summer tunics, where they are attached in a curve across the upper front (see, for example, figures 13.5a–b).

In Cook Inlet, Menzies and Hewett may well have seen Dena'ina wearing garments that featured decorative work similar to that seen on the pieces they collected. As noted earlier, moccasin-trousers with decorative bands like those in Menzies's collection are relatively common in later collections. The quill-worked breast band for a "leather slop" collected by Hewett may have adorned a garment such as the tunic seen in figures 13.4a–c. This tunic, purported to be from "Kenai" and collected around 1800, likely is the oldest complete Dena'ina garment (Thompson, Hall, and Tepper 2001:67–89).

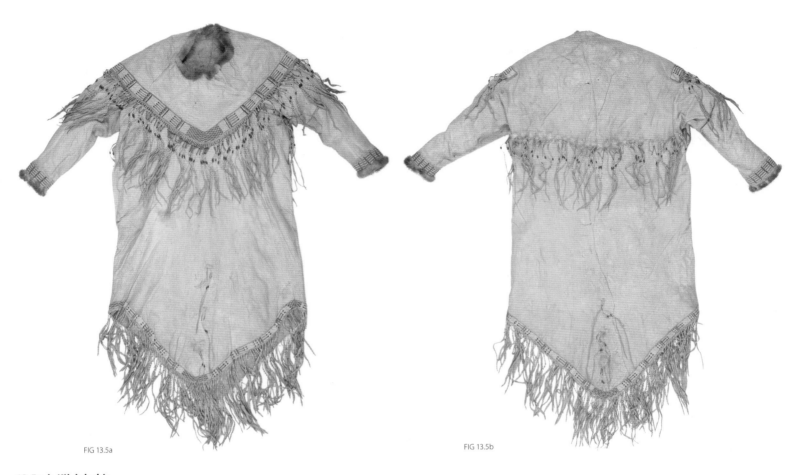

FIG 13.5a
FIG 13.5b

13.5a, b *Kił dghak'a*, summer tunic (front and back views), collected by Adolf Etholén, donated 1846. L 141 cm, W 103 cm. Caribou hide, porcupine quills, fur (otter?), silverberry seeds, feathers. Museum of Cultures, National Museum of Finland, VK167A. Photograph © Finland's National Board of Antiquities/ Picture Collections. Photograph by István Bolgár.

Nineteenth-Century Styles

While European maritime expeditions plied north Pacific Coast waters, Siberian fur hunters extended their search for sea otter east- and southward, first to the Aleutian Islands, then to Kodiak Island, and finally to the mainland of Alaska. By the end of the eighteenth century, Russian traders were a permanent presence in the region, and several trading posts had been established in locations accessible to Dena'ina. Early relations were often troubled, marked by animosity on the part of Dena'ina and intense rivalry among Russian traders. Nevertheless, within a few decades, many Dena'ina had become active participants in the fur trade. They provisioned posts with meat, fish, and edible plants, hunted and trapped fur-bearing animals for Russian traders, and served as middlemen

by obtaining furs from the Ahtna and other inland peoples (Davydov 1977 [1810–1812]:196). Dena'ina living in proximity to trading posts, in particular, became increasingly dependent on imported goods.

The work of Dena'ina seamstresses began to reflect these developments. Valuable pelts such as otter and beaver now were saved for the trade. Clothing was made from less marketable furs, particularly snowshoe hare, marmot and ground squirrel; it would have been worn by Dena'ina, but also was made for Russian traders, who used it as payment in their dealings with other aboriginal people of the region (Davydov 1977 [1810–1812]:197).

Judging from relatively extensive museum collections, seamstresses also produced traditionally styled summer outfits for sale to souvenir hunters and collectors of ethnographic material. More than seventy[3] Dena'ina garments collected by Russian

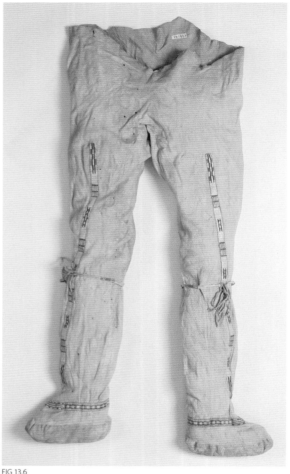

FIG 13.6

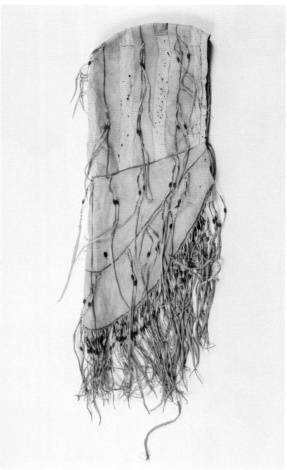

FIG 13.7

13.6 *Tl'useł*, man's summer moccasin-trousers, collected by Adolf Etholén, donated 1846. L 110 cm, W 43 cm. Caribou hide, porcupine quills, sinew. Museum of Cultures, National Museum of Finland, VK168B. Photograph © Finland's National Board of Antiquities/ Picture Collections. Photograph by István Bolgár.

13.7 *Chik'ish*, man's summer hood, collected by Adolf Etholén, donated 1846. L 80 cm, W 22 cm. Caribou hide, ochre, fur (trim now depilated), silverberry seeds, porcupine quills. Museum of Cultures, National Museum of Finland, VK179. Photograph © Finland's National Board of Antiquities/ Picture Collections. Photograph by István Bolgár.

administrators, seamen, and scientists prior to 1850 have been preserved, mainly in northern European museums.[4] These early clothing collections command attention because of the quality of their materials and workmanship and because of the garments' distinctive design. They are made from creamy white, dehaired caribou hide beautifully tanned to a soft, suede-like finish. The sewing was done with sinew thread made from caribou tendon that had been scraped clean, dried, and split into fine strands. The two principal garments are a sleeved tunic (figures 13.5a–b), which often is cut to a deep point at the front and back, and all-in-one moccasin-trousers (figure 13. 6). Smaller items

include hoods, which tie under the chin and are fringed around the neck edge (figure 13.7), and pairs of mittens and gloves, often attached by a long cord (figures 13.8, 13.9). All garments are decorated with bands of woven porcupine quills, fine thong fringing, and, often, red ochre paint. Individual strands on the fringed bands that cross the upper front and back of tunics are wrapped with porcupine quills and strung with a single silverberry seed.

Clothing similar to this in materials, design, and decoration also is found in collections originating from other Northern Athabascan peoples, including Tanana, Ahtna, Koyukon, Deg Hit'an, Gwich'in, Tutchone, and Tr'ondëk Hwëch'in. It is a

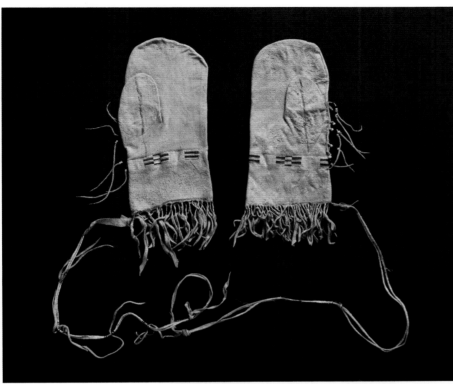

FIG 13.8

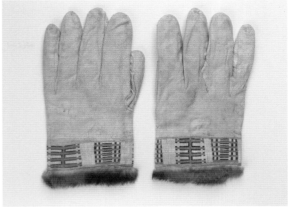

FIG 13.9

13.8 *Gech'*, summer mittens with string, Alaska, collected by I. Voznesensky, 1842. L 36 cm, W 22 cm. Caribou, sinew, porcupine quills, ochre, glass beads. Peter the Great Museum of Anthropology and Ethnography (Kunstkamera), 2667-10/1–2. Photograph by Chris Arend.

13.9 *Lugech'*, summer gloves, collected by Adolf Etholén, donated 1846. L 26 cm. Caribou, porcupine quills, fur (otter/beaver?). Museum of Cultures, National Museum of Finland, VK188. Photograph © Finland's National Board of Antiquities/ Picture Collections. Photograph by István Bolgár.

style that would have served all these peoples well. It efficiently used a widely available resource, caribou hide, which, with skillful tanning, could be transformed into a lightweight, flexible, and "breathable" clothing material. Individual components of an outfit were designed to fit and cover the body (thus providing protection from weather, rough terrain, and especially from stinging, biting insects) while enabling arms and legs to move freely. The high sides and pointed bottom edge of the tunic allowed unencumbered walking while also providing the wearer with added protection from cool breezes and an extra layer to sit on. Wrist and neck openings were small, to inhibit drafts and insects. The combination moccasin-trousers were soft and flexible, comfortable for walking, and suitable for summer travel in birch bark canoes. When the soles wore out, they could be replaced without sacrificing the body of the garment.

For both maker and wearer, summer clothing of this type would have satisfied aesthetic as well as practical needs. The seamstresses also were artists; they devoted time, skill, and creative energy to the making of clothing that was beautiful as well as practical. Their concern for quality began with the selection and careful preparation of sewing materials and carried through to the production of skillfully executed porcupine quillwork and the final assemblage of a garment. Athabascan girls began learning these skills at an early age, by watching and helping older women. As a Dena'ina elder, Feodoria Kallander Pennington, recalled in 1985, doll clothes were often the first items they made: "All the scraps and remnants were saved and the young girls made clothes and moccasins out of them for their dolls" (in McClanahan 2002:24).

A girl's training in sewing skills intensified at puberty, when she lived apart from her family and community for many months and observed strict food and behavioral taboos (Osgood 1937:162). Sewing was her chief occupation at this time.

While they conform to the general, widespread Athabascan style described above, Dena'ina garments also exhibit characteristics that have a more limited, regional distribution (Thompson, Hall, and Tepper 2001:16–66). For example, Dena'ina seamstresses appear often to have worked with caribou hides of larger than average size and to have

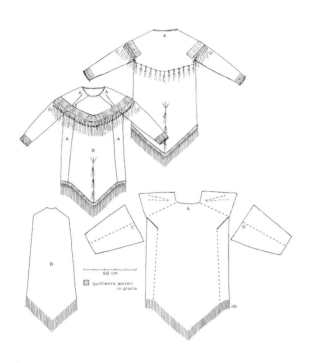

FIG 13.10a

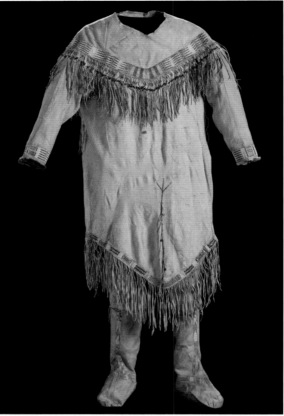

FIG 13.10c

13.10a Pattern drawing for man's summer tunic. Peter the Great Museum of Anthropology and Ethnography (Kunstkamera), 620.40a. © Canadian Museum of Civilization, Dorothy Burnham, IMG2012-0173-0039-Dm.

13.10b, c Man's summer outfit: *kił dghak'a*, summer tunic, and *Tl'useł*, moccasin-trousers (front and back views), Kenai Peninsula, collected by I. Voznesensky, 1842. L 138 cm, L 126 cm. Caribou hide, porcupine quill, silverberry seeds, mink (?) fur, beaver (?) fur, ochre, sinew. Peter the Great Museum of Anthropology and Ethnography (Kunstkamera), 620-40/ab. Photograph by Chris Arend.

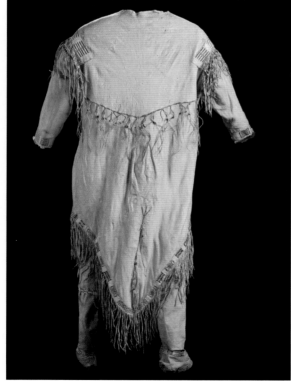

FIG 13.10b

developed special techniques to use the large hides most efficiently. For example, rather than cutting a tanned hide into the component parts required for a garment, a Dena'ina seamstress trimmed and shaped the skin so that it could be used almost in its entirety, without division. This expertise can be seen particularly in upper garments, such as the man's tunic in figures 13.10a, b, and c. As the pattern drawing for this garment shows, the piece forming the back of the garment wraps around the sides and over the shoulders to form part of the front as well. This results in a relatively small and straight armhole, different from the large and angular opening typically seen on Athabascan upper garments. Also unusual in a broader context are the darts, taken on either side of the upper front of the Dena'ina upper garment, to remove excess material and ensure a smooth fit.

13.11a Pattern drawing for dress L357.9. National Museum of Scotland, Canadian Museum of Civilization. © Canadian Museum of Civilization, Dorothy Burnham, IMG2012-0173-0042-Dm.

13.11b, c *K'isen dghak'a*, **woman's summer dress (front and back view), c. 1840.** L 138.5cm. Caribou hide, porcupine quills, sinew. National Museums Scotland, L.357.9. Photograph © National Museums Scotland.

13.12 *K'isen dghak'a*, **woman's summer dress, collected by Adolf Etholén, donated 1846.** L 142 cm; caribou hide, porcupine quills, sealskin (trim on neck and cuffs). Museum of Cultures, National Museum of Finland, VK174. Photograph © Finland's National Board of Antiquities/ Picture Collections. Photograph by István Bolgár.

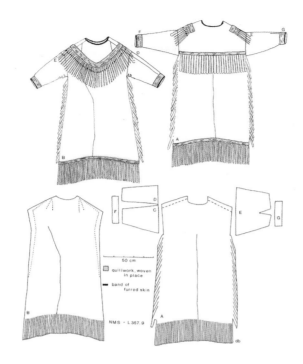

FIG 13.11a

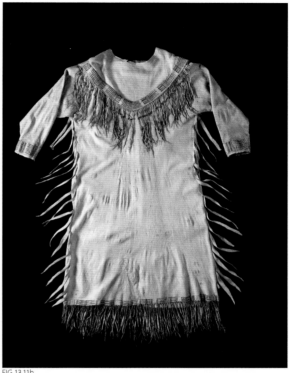

FIG 13.11b

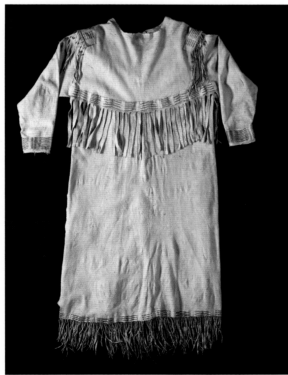

FIG 13.11c

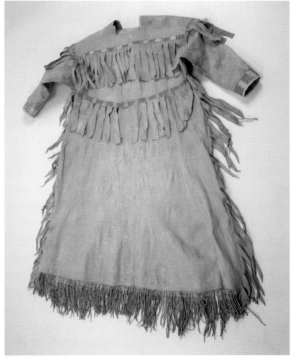

FIG 13.12

Dena'ina seamstresses also made long, loose-fitting women's dresses from large, undivided hides. Some of these dresses resembled men's tunics, with diagonal upper front seaming, darts, and set-in sleeves (figures 13.11a–c). Other dresses of similar outward appearance are made somewhat differently: the shoulders are formed from separate rectangular pieces of hide that join the body of the dress in horizontal seams high on the garment's front (figure 13.12). Below these, the main part of the dress is formed from two large, approximately rectangular, pieces of hide, one forming the front of the garment and the other the back.

Features of decoration also distinguish these Dena'ina summer garments. Porcupine quillwork is extensively used and executed with great skill. The principal technique is a form of weaving, worked directly on a hide backing. Bands of woven quillwork are attached to the upper fronts and backs, wrists, and lower edges of tunics; down leg fronts and around the ankles of moccasin-trousers; and around the opening edges of mittens and gloves. Another characteristic feature of Dena'ina garments is the finishing of neck and wrist edges with narrow bands of brown fur, usually stained red on the underside.[5] In addition to adding comfort and decoration to the garment, these furred bands would have prevented stretching of the opening edges.

The clothing collections described here are invaluable sources of information about an important Dena'ina summer clothing style. However, they represent only one facet of a more complex story of dress and adornment. Most significantly, these collections do not include garments made of furred hides, which would have been worn in winter, and probably often in spring and fall as well. There are, for instance, no examples of the various garments—"jackets," "dresses," "coats," "loose cloaks," and mittens—made from the furred hides of mountain sheep, snowshoe hare, sea otter, ground squirrel, and "gopher", which eighteenth-century explorers described Dena'ina wearing (Dixon 1789:239; Beaglehole 1967:364, 1115, 1422). Also absent—from written accounts as well as collections—is evidence of clothing made from furred caribou hide.

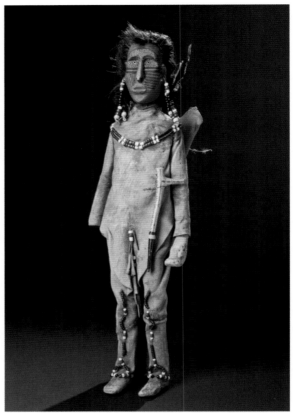

FIG 13.13

It seems almost certain, nevertheless, that this excellent clothing material was used by many, if not all, Dena'ina. The fall caribou hunts that were an important feature of the annual round for many Dena'ina were opportunities to obtain not only meat for winter consumption but also hides in prime condition for winter clothing. Groups whose hunting territories were poor in this resource could obtain caribou hides through trade with other aboriginal people of the region (Zagoskin 1967:3; VanStone 1981:3; Thompson, Hall, and Tepper 2001:38). On the Kenai Peninsula, for example, caribou were apparently never numerous, and by the end of the nineteenth century were no longer "of economic significance" (Townsend 1981:627).

Winter clothing of furred caribou hide may have been particularly important to groups in the Iliamna, inland, and upper Cook Inlet regions,

13.13 *Chik'a k'enin'a*, wooden doll, Kenai Peninsula, collected by I. Voznesensky, 1842.
L 39 cm, W 10.5 cm. Wood, paint, bone, caribou hide, beads, sinew, feathers, human hair. Peter the Great Museum of Anthropology and Ethnography (Kunstkamera), 2667-15. Photograph by Chris Arend.
This is a particularly rare and important item, embodying a wealth of information about male clothing in the early postcontact period and the ephemeral arts of hair dress and face painting. The function of this doll is unknown. The documentation associated with it reads "made to order by a Tanaina [Dena'ina] Indian," which suggests that it was a commissioned piece, made at the request of the collector. On the other hand, it is known that Dena'ina shamans carved dolls like this, dressed them in hide clothing, and used them to extract evil spirits from sick people (Osgood 1937:179). The care taken with the face painting and the application of red ochre at joints and over the heart suggest such a function for this item. However, it seems unlikely a shaman would willingly relinquish such a powerful, spiritually charged possession.

13.14 *Seł*, woman's boots, Knik, c. 1859. Collected by E. A. Borisov. L 45 cm. Caribou hide, glass beads, thread repair, sinew. Peter the Great Museum of Anthropology and Ethnography (Kunstkamera), 2667-16/1–2. Photograph by Chris Arend.

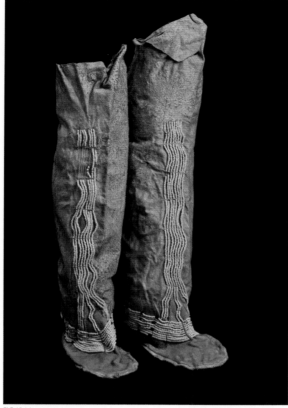

FIG 13.14

where climatic conditions were more severe than they were in the outer inlet. Furred caribou hide garments may have been worn in other seasons as well. When interviewed late in the twentieth century, Lime Village elders recalled that parkas, pants, and boots of furred caribou hide were worn for spring waterfowl hunting (Russell and West 2003:24). Hides from animals taken in late summer were preferred, as they provided enough warmth for spring conditions but were not too heavy.

Another aspect of clothing not represented in pre-1850 collections is the effect of contact with Europeans on Dena'ina styles of dress and adornment. From written sources, we know that trade materials—mainly glass beads and cloth—were incorporated into Dena'ina fashions from a very early date. Captains Cook and Portlock, for example, observed that the Dena'ina had a few blue glass beads,

which they prized highly and displayed in the most visible way possible, as ear, nose, and lip ornaments (Portlock 1789:115; Beaglehole 1967:364). As the fur trade stabilized and expanded in the late eighteenth and early nineteenth centuries, glass beads became available in quantities not previously seen. Russian traders also imported large supplies of dentalium shells, another luxury good much valued by the Dena'ina. It is very likely that glass beads and dentalium shells—symbols of wealth and prestige—soon were incorporated not only into adornment but also into the decoration of clothing, as illustrated by the doll of a hunter dressed in summer clothing, collected in 1842 (figure 13.13). However, perhaps because of collectors' biases in favor of clothing made solely from "traditional" (i.e., indigenous) materials, and possibly also because Dena'ina preferred not to waste precious beads on articles made for trade to Europeans, only a very few garments collected prior to 1850 reflect this development: the moccasin-leggings seen in figure 13.14 are one example.

Clothing made from cotton and other imported fabrics also is not represented in pre-1850 artifact collections, although it too was introduced to the Dena'ina at an early date. Transactions such as the one recorded by Cook, who offered "old Clothes, Beads [and] pieces of iron" to the Dena'ina he met in 1778, probably were common in the late eighteenth century (Beaglehole 1967:364). A Dena'ina story telling of the first encounter between their people and Cook's crew suggests that, on this historic occasion, the acquisition of European clothing had a long-term impact on local ceremonial wear. An outfit given by English seamen to the first, brave Dena'ina man to approach their ships "was faithfully copied down through the years" and worn in ceremonial dances (from story told by Simeon Chickalusion, in Stanek, Fall, and Holen 2006:11; also in Kari and Fall 2003:347).

This particular story notwithstanding, it seems that in the early days of the trade, the Dena'ina generally preferred beads and iron over imported cloth and ready-made fabric garments. Two Dena'ina men Captains Portlock and Dixon met with in 1786 wore cloth garments—a "very good Nankin

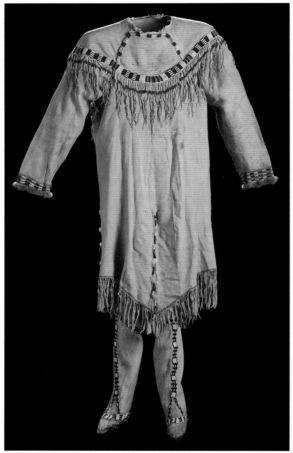

FIG 13.15

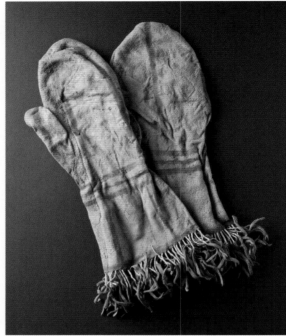

FIG 13.16

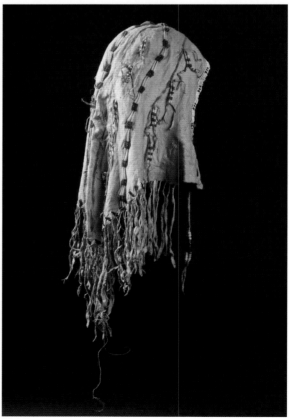

FIG 13.17

13.15 Man's summer outfit: *kił dghak'a*, tunic, and *Tl'useł*, moccasin-trousers, Tyonek, collected by Captain J. Adrian Jacobsen, 1883. Tunic: L 124 cm, W 54 cm. Caribou hide, beads, sinew, ochre, down (eagle?), fur trim (cuffs—beaver?) IVA 6147. Moccasin-trousers: L 128 cm, W 53 cm. Caribou hide, beads, sinew, ochre. Ethnological Museum Berlin, IVA 6146. Photograph courtesy of Staatliche Museen zu Berlin, Ethnologisches Museum. Photograph by Chris Arend. See also figures 5.2, 6.0.

13.16 *Gech'*, summer mittens, Tyonek, Cook Inlet, Knik River?, collected by Captain J. Adrian Jacobsen, 1883. L 35 cm, L 34 cm, W 13 cm. Caribou hide, ochre, porcupine quills. Ethnological Museum Berlin, IVA 6148ab. Photograph courtesy of Staatliche Museen zu Berlin, Ethnologisches Museum. Photograph by Chris Arend.

13.17 *Tsit'egha*, summer hood, Knik River, Cook Inlet, collected by Captain J. Adrian Jacobsen, 1883. L 59 cm, W 41 cm. Caribou hide, ochre, sinew, beads, dentalium shells, porcupine quills. Ethnological Museum Berlin, IVA 6150. Photograph courtesy of Staatliche Museen zu Berlin Ethnologisches Museum. Photograph by Chris Arend.

[a cotton cloth] frock" and a "blue frock"—but were anxious to trade these (Portlock 1789:115). For their part, Russian traders too must have favored beads, which were easy to transport and highly marketable. As a result, only small quantities of cloth and ready-made Euro-American clothing reached the Dena'ina, and these goods coexisted with, rather than replaced, aboriginal clothing materials and styles in the early days of the fur trade.

However, during the second half of the nineteenth century, the pace of fashion change accelerated, particularly among Dena'ina who had frequent contact with whites. In such cases, elaborate hair dress, face painting, tattoos, ornaments worn in the lips and nose piercings—practices the newcomers to the region did not find attractive—were abandoned

13.18 *Lugech' ełtl'ila,* **summer gloves with strap (pair), Tyonek, collected by Captain J. Adrian Jacobsen, 1883.** L 27.5 cm. Caribou, cloth, glass beads, dentalium shells, sinew. Ethnological Museum Berlin, IVA 6108. Photograph courtesy of Staatliche Museen zu Berlin, Ethnologisches Museum. Photograph by Chris Arend.

13.19 *Chijeł,* **feather headdress, Fort Kenai, collected by Captain J. Adrian Jacobsen, 1883.** L 34 cm, W 24 cm. Feathers, down, fabric (band: front plain red, lining a red print, edge binding black wool?), at least one eagle feather. Ethnological Museum Berlin, IVA 6167. Photograph courtesy of Staatliche Museen zu Berlin, Ethnologisches Museum. Photograph by Chris Arend.

13.20 *Viqizdluyi,* **fire bag for powder and lead with shoulder strap, Knik River, Cook Inlet, collected by Captain J. Adrian Jacobsen, 1883.** L 20.5 cm, W 12 cm. Sinew, thread, dentalium shells, caribou, beads, velvet strap, cotton cloth (strap lining). Ethnological Museum Berlin, IVA 6149. Photograph courtesy of Staatliche Museen zu Berlin, Ethnologisches Museum. Photograph by Chris Arend.

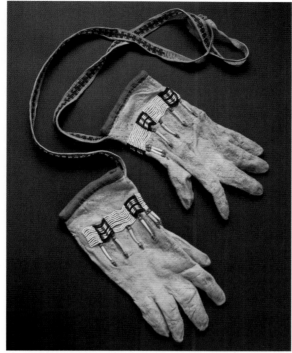

FIG 13.18

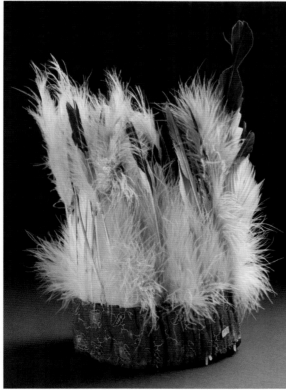

FIG 13.19

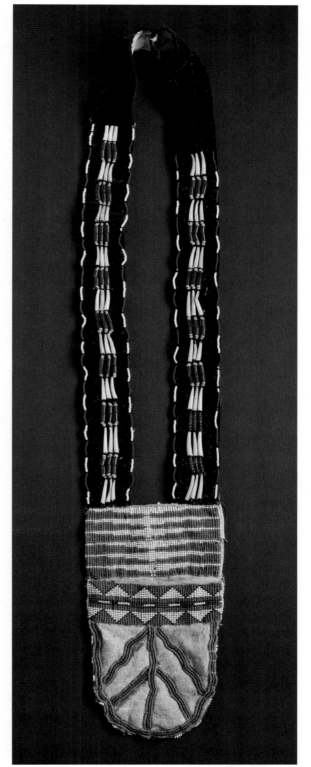

FIG 13.20

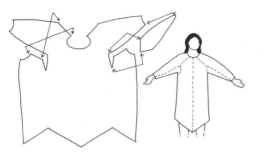

FIG 13.21a

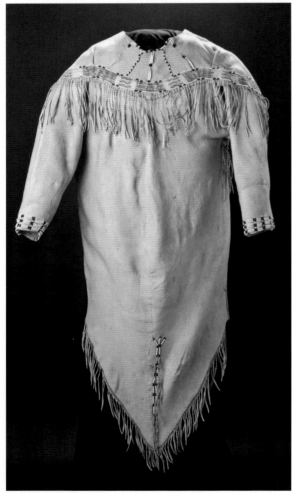

FIG 13.21b

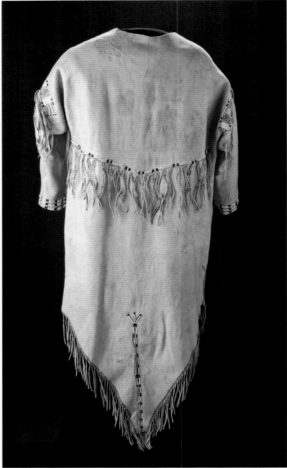

FIG 13.21c

13.21a Pattern drawing of *kił dghak'a*, summer tunic, Burke Museum 145 (see figs. 13.21b–c) (Conn 1991: 89). © Board of Regents of the University of Wisconsin System. Reproduced courtesy of the University of Wisconsin Press.

13.21b, c *Kił dghak'a*, summer tunic (front and back views) Cook Inlet, collected by James Swan for exposition at the Chicago World's Fair in 1893. L 125 cm, W 70 cm. Moose hide (?), porcupine quills, sinew, beads, ochre, dentalium shells. Photograph courtesy of the Burke Museum of Natural History and Culture, catalog no. 145. Photograph by Chris Arend.

(Rickman 1990:267). Increasingly, Euro-American clothing made of cotton and other textiles superseded aboriginal skin dress.

A number of factors contributed to a relinquishing of the old ways. Disease epidemics, particularly a devastating smallpox epidemic that raged through the region from 1836 to 1840, decimated indigenous populations. With the loss of leaders, providers, and role models, many traditional activities, including those related to clothing manufacture, were disrupted. A contemporary observer, P. A. Tikhmenev, wrote that in the wake of the epidemic, aboriginal people in the region increasingly adopted European styles of dress (Tikhmenev 1978:199). At this time, missionary attempts to convert Dena'ina to the

13.22 H. M. Wetherbee wearing a Dena'ina summer outfit, Kasilof, 1890–1892. H. M. Wetherbee Collection, University of Alaska Fairbanks, 1959.866.1.

Russian Orthodox faith also gained ground, and further altered traditional practices (Townsend 1965:58). On one occasion, "to make a pleasant surprise" for a Russian priest and "to prove that [his] sermons were not in vain," a group of Dena'ina cut their "thick, black queues" which they "valued so much" (Townsend 1974:11).

After the sale of Alaska to the United States in 1867, American presence in the Cook Inlet region increased, resulting in greater local demand for Western goods. American traders stocked more fabric and ready-made clothing than had their Russian predecessors, and Dena'ina with the means and opportunity to purchase these imports did so. William Abercrombie, a U.S. Army captain who made an exploratory expedition to the Copper River valley in 1884, noted that Dena'ina living "on the coast and toward the southern point of [Cook] inlet" (in proximity to trading posts) wore mainly "civilized garments" and had adopted "many other customs of the white men" (Abercrombie 1900:402). However, in more remote regions (Abercrombie mentions the valleys of the Knik and Sushitna [*sic*] Rivers) "deerskin shirts and trousers [were] still in use, [with] the men and women dressing nearly alike." One of his contemporaries, Ivan Petroff, who was in the region in 1881 taking a census for the U.S. government, made a similar observation. He wrote that the Native people living "at the head of Cook Inlet and on the rivers emptying into it" were "more primitive in their manners and customs." They wore "buckskin shirts and trousers…tastefully embellished with porcupine quills…bead embroidery and fringes" (Petroff 1900:85; see also Pierce 1968 for details and assessment of Petroff's work on the Kenai). Petroff also noted that these Dena'ina favored old-style approaches to hair dress and facial adornment.

A Dena'ina clothing collection acquired for the Museum für Völkerkunde in Berlin by Captain Johan Adrian Jacobsen in June 1883 provides tangible evidence to support Petroff's observations (Jacobsen and Woldt 1977). During a short stay in the village of Tyonek, and despite reluctance on the part of the Dena'ina to sell "ethnological"

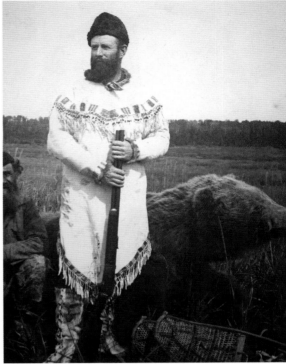

FIG 13.22

material, Jacobsen purchased twelve traditionally styled Dena'ina summer clothing items made from tanned, dehaired hide. Five items are identified as being from the Knik River (i.e., Upper Inlet); the rest are from the Dena'ina of Tyonek. The collection includes tunics, moccasin-trousers, moccasin-leggings, knee-high boots, hoods, mittens, and gloves (figures 13.15, 13.16, 13.17, 13.18). There are also highly decorated bags and a feather headdress (figures 13.19, 13.20). Most, if not all, items show evidence of wear and some soiling, suggesting prior use by their owners.

While confirming the ongoing manufacture and use within some Dena'ina communities of old-style clothing, this collection also documents two new trends. First, most of the items are made from moose hide, rather than caribou hide. (By the late nineteenth century, moose were "generally more common" than caribou throughout Dena'ina territory; Townsend 1981:626.) Second, instead of porcupine quills, glass beads are used for the clothing's

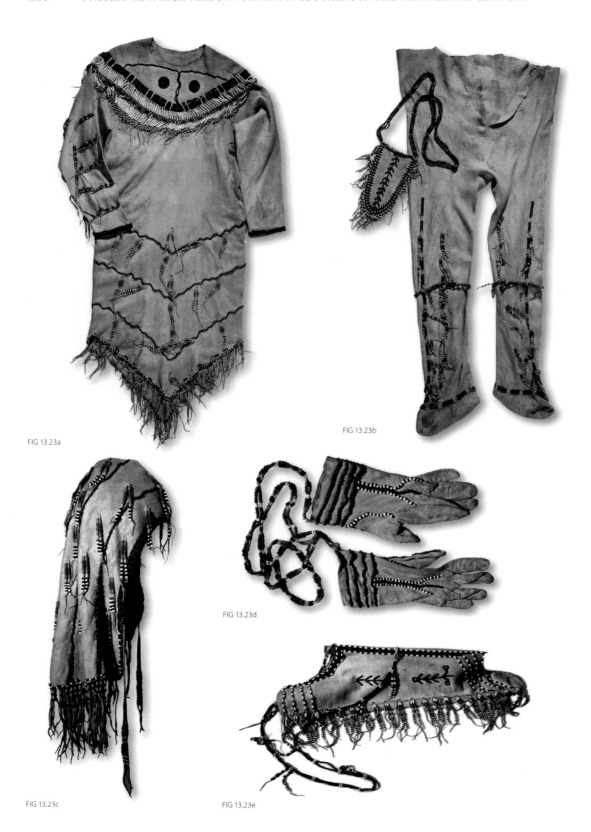

FIG 13.23a

FIG 13.23b

FIG 13.23d

FIG 13.23c

FIG 13.23e

13.23a–e Multipiece summer outfit

13.23a *Tsel duk*, tunic, Kenai, 1894. L 160 cm. Caribou hide, glass beads, sinew, thread. American Museum of Natural History, E/2383 A. Photograph © Division of Anthropology, American Museum of Natural History.

13.23b *Tl'useł*, moccasin-trousers and *k'izhagi yes*, knife sheath, Kenai, 1894. L moccasin-trousers 121 cm, L sheath 27 cm. Caribou hide, glass beads, sinew. American Museum of Natural History, E/2383 BD. Photograph © Division of Anthropology, American Museum of Natural History.

13.23c *Chik'ich'a*, hood, Kenai, 1894. L 61 cm, W 55 cm. Caribou hide, glass beads, sinew, thread. American Museum of Natural History, E/2383 C. Photograph © Division of Anthropology, American Museum of Natural History.

13.23d *Lugech' eł tl'ila*, gloves joined by beaded strap, Kenai, 1894. L 26 cm, W 14 cm. Caribou hide, glass beads, sinew, thread. American Museum of Natural History, E/2383 E. Photograph © Division of Anthropology, American Museum of Natural History.

13.23e *Q'us*, quiver, Kenai, 1894. L 67.5 cm, W 29 cm. Caribou hide, glass beads, wood, sinew, thread. American Museum of Natural History, E/2383 F. Photograph © Division of Anthropology, American Museum of Natural History.

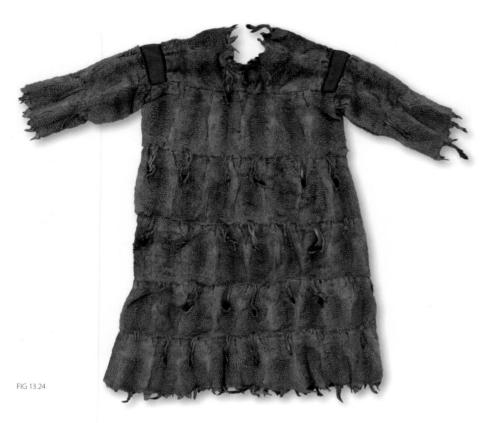

FIG 13.24

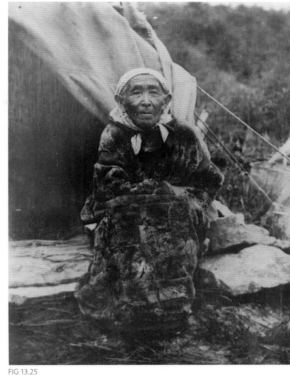

FIG 13.25

13.24 *Qunsha dghak,* **ground squirrel parka, Susitna River, collected by prospector A. Beverly Smith in 1898–1899.** L 124 cm, W 153 cm. Ground squirrel skins, sinew, wool cloth, thread. American Museum of Natural History, 16/6711. Photograph © Division of Anthropology, American Museum of Natural History. Photograph by Craig Chesek.

13.25 Old Daria of Iliamna wearing a ground squirrel parka, c. 1908. Photograph by Dr. Henry O. Schaleben. Mrs. Ray Schlaben Collection, courtesy of Mrs. Ray Schlaben and the National Park Service, NPS H-1216.

main decorative elements. Traditional artistic conventions are maintained, however, in the placement of bead decoration, and motifs are simplified versions (often, small rectangles alternating between white and a contrasting color) of designs that at an earlier time would have been executed in porcupine quills.

As the nineteenth century drew to a close and Dena'ina increasingly adopted Euro–North American styles of dress, it might be expected that skills and knowledge related to the making of traditionally styled hide clothing would be in decline. However, knowledge and practical skills in this area remained strong in the hands of at least some seamstresses, as evidenced by a number of garments collected in the late 1880s and 1890s. Outstanding among these is the tunic illustrated in figures 13.21a–c (Conn 1991:89). Collected for exposition at the Chicago World's Fair in 1893, this garment represents a veritable tour de force in traditional

garment design and sewing skills. Except for a small piece forming the underside of the left sleeve, the entire garment is cut from a single, undivided moose hide.

In some cases, seamstresses may have been encouraged to continue making "old style" clothing because there was a market for their work outside their own communities. Tourists, itinerant workers, seamen, and other visitors to the Kenai Peninsula region often were interested in purchasing examples of Native art and material culture, and they were attracted to the distinctive and decorative Dena'ina summer clothing outfits (figure 13.22). Some such acquisitions later were deposited in museums.[6] Knowledgeable professional collectors also actively sought traditionally styled Dena'ina clothing in the late nineteenth century. The garment illustrated in figures 13.21a–c was collected by James Swan, a schoolteacher-cum-ethnologist who lived in western Washington from 1852 to 1900 and collected for the Smithsonian Institution and other museums

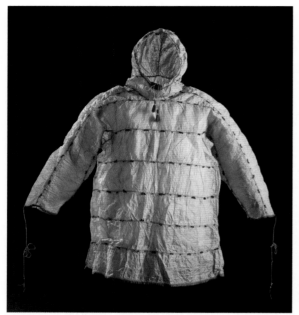

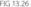
FIG 13.26

FIG 13.27

(Lohse and Sundt 1990:89). George Emmons, an officer in the U.S. Navy, another enthusiastic and informed collector of Northwest Coast ethnographic materials, also acquired examples of Dena'ina clothing. A multipiece summer outfit (tunic, moccasin-trousers, hood, gloves, knife sheath, and quiver) collected by him is in the American Museum of Natural History, New York (figures 13.23a–e).

As the nineteenth century drew to an end, elaborately beaded, traditionally styled clothing may have been most in evidence at important Dena'ina social or ceremonial occasions. Dena'ina interviewed by anthropologist Cornelius Osgood in the early 1930s recalled a "specially beaded suit of clothes" that was worn at potlatches (Osgood 1933:711).[7] Such clothing was prestigious, but so, increasingly, were imported Euro-American fashions. In 1883, the same year that Jacobsen collected old-style summer garments in Tyonek, the grave goods of a chief in the same village included "three pairs of gloves embroidered with beads and very much valued by Kenai people," and also a complete Euro-American clothing outfit comprising "suit, wool topcoat … hat, etc" (Townsend 1974:10). Similarly, in 1888, a headman

in the village of Kijik wore "cowhide top-boots and a blue swallow-tailed uniform coat with brass buttons," while others in his community wore a mixture of European and hide clothing (Townsend 1965:144).

As is the case with earlier collections, the late nineteenth-century clothing artifacts described above provide a valuable if narrow view of Dena'ina clothing and adornment, emphasizing as they do summer clothing of a particular style. A considerably more complex and diverse reality is indicated by Cornelius Osgood's research in the early 1930s. Although Osgood noted that "almost nothing" remained of traditional Dena'ina clothing (Osgood 1937:192), his fieldwork interviews yielded considerable information on the topic, particularly with respect to practices in the Kachemak Bay, Kenai, and Upper Inlet areas (Osgood 1933:697–699, 1937:46–55). Osgood aimed to reconstruct Dena'ina culture as it was at the time of first contact with Europeans, but it seems likely that, in the case of clothing, his findings pertain most particularly to the late

13.26 *Vak'izheghi*, **bear gut parka, made by Mary Evanoff, wife of Chief Zackar Evanoff, Nondalton, early 1900s.** L with hood 106.7 cm. Bear gut, sinew, wool yarn, beads. Photograph courtesy of the Seward Community Museum and Resurrection Bay Historical Society, 1967.003.001. Photograph by Chris Arend.

13.27 *Vak'izheghi*, **bear gut parka, group unknown, possibly Dena'ina, c. 1940.** L 83 cm. Bear gut (?), cotton cloth, wool yarn, string, sinew. Anchorage Museum, 1993.057.001. Photograph by Chris Arend.

13.28 Chief Nikaly and his family, Knik, 1918.
Photograph by H. G. Kaiser. Archives, University of Alaska Fairbanks, 1973.66.81.

FIG 13.28

nineteenth century. They indicate significant regional variation in clothing styles and materials—a logical consequence of differing local conditions and subsistence resources and of varying degrees of exposure to Alutiiq, Yup'ik, and nonaboriginal populations—and a greater range of garment types than is documented in artifact collections or other written sources.

According to Osgood's sources, the furred hides of caribou, mountain sheep, marmot, ground squirrel, lynx, marten, beaver, and land otter were used for winter clothing. Sea otter was used only by women. A winter outfit consisted of two layers of caribou hide clothing: a tunic and ankle-length trousers, and, over these, a furred "top dress and

over trousers." The latter garment was a combination moccasin-trouser, with soles made from bear skin. In mild weather, knee-high fur boots were worn instead of the moccasin-trouser. Mittens and fur caps also were worn. Men's and women's garments differed mainly in the length of the upper garment: men's reached only to the knee, women's were almost ankle-length.

The cut of these garments varied from one region to another. In the lower inlet and Iliamna regions, the parka was modeled after an Eskimo prototype: it had a hood and was cut straight across the lower edge. This parka style was worn in the middle inlet as well, but people there also wore hooded "coats" that opened in the front. In the upper inlet, parkas

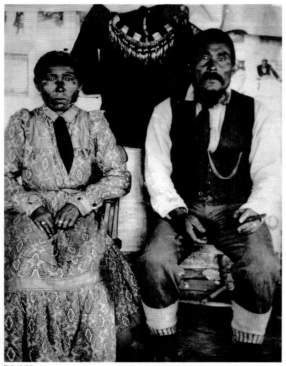

FIG 13.29

had fur collars rather than hoods. These hoodless parkas may have resembled the examples seen in figures 13.24 and 13.25. All groups wore fur robes.

Some garments had specialized functions. A short "Eskimo-type" parka made from ground squirrel skins was worn by hunters throughout the region. Clothing made from bear or whale intestines was worn in wet weather and for travel in kayaks. A parka of this type is illustrated in figures 13.26 and 13.27. Waterproof "wading boots" were made from a variety of materials: in Kachemak Bay, they were of dehaired bearskin coated with porcupine grease; in Kenai, they had "tops of sea lion esophagus and … soles from an unidentified sea mammal"; at Iliamna, they were made of "caribou skin soaked with fish oil." The Iliamna Dena'ina also made waterproof boots from salmon skins (Osgood 1933:698).

Osgood's informants' descriptions of summer clothing worn by Upper Inlet Dena'ina correspond most closely to the style represented in museum

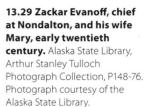

13.29 Zackar Evanoff, chief at Nondalton, and his wife Mary, early twentieth century. Alaska State Library, Arthur Stanley Tulloch Photograph Collection, P148-76. Photograph courtesy of the Alaska State Library.

13.30a, b *K'anyagi*, **Roehl dress (front and back views) Stony River/Old Iliamna.** L 116, W 79.5 cm. Wool, beads, dentalium shells, band of trim sewn on strip of caribou hide (?), fur, thread. Private collection, on loan to the Anchorage Museum, L1971.003.001. Photograph by Chris Arend.

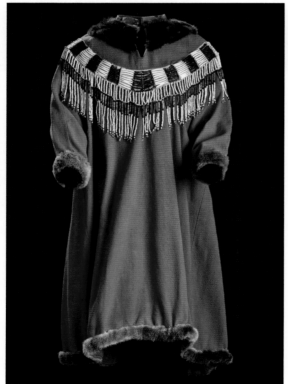

FIG 13.30a

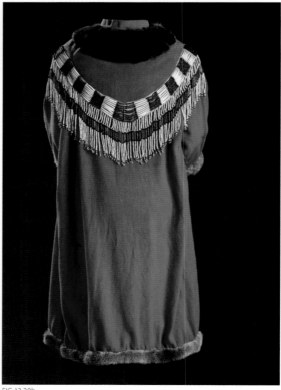

FIG 13.30b

13.31 *K'anyagi*, Hedlund dress, Chekok/Iliamna. L 86.4 cm, W 67.3 cm. Cotton, wool, dentalium shells, glass beads, beaver fur, thread. Private collection, on loan to the Anchorage Museum. Photograph by Chris Arend.

The beads and dentalium shells adorning this dress are attached to a strip of red wool, which is sewn onto the black cotton dress. When beaded garments wear out, the beadwork often is saved and reattached to new garments. This decorative band may originally have been part of a red wool dress similar to the Roehl dress.

13.32 Rose Kinney Hedlund (1917–2004) wearing the *k'anyagi* dress (shown in fig. 13.31). This photograph was taken in the 1930s when Rose was in her teens. Rose Hedlund was born in Chekok and was well known in the region for raising sled dogs and sewing dolls, beaver hats, and mittens. Photograph courtesy of Emma Hill.

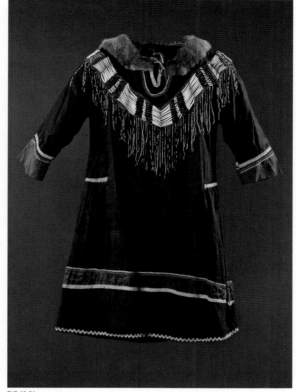

FIG 13.31

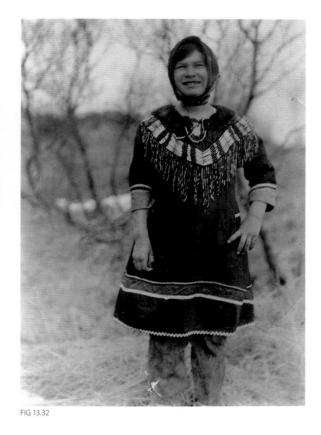

FIG 13.32

collections. These garments were made from tanned, dehaired hide. Men wore tunics that hung to the knee and were pointed "before and behind" and moccasin-trousers. Women's dresses were ankle-length and were worn with boots in camp and with moccasin-trousers when traveling. Children wore similarly styled upper garments and often went barefoot.

Change and Continuity: The Twentieth Century and Beyond

By the early twentieth century, particularly in summer, most Dena'ina dressed in cloth garments similar in style to those popular in many North American rural communities at the time (figure 13.28). Some of their clothing likely was acquired ready-made, but most would have been produced at home, by women accustomed to sewing for their families.

Running in parallel with such developments, however, was the ongoing production of distinctive, Native-style garments made from traditional clothing materials. This was particularly the case in more isolated communities. Hannah Breece, a schoolteacher in Old Iliamna and Nondalton from 1909 to 1912, observed that seamstresses made their own sinew thread for sewing hides (Jacobs 1995:107). One elderly woman, Daria (figure 13.25), was "forever busy" with sewing, making "fur clothing, boots of sealskin for cold weather and boots of dried fish skin for wet weather" for "the whole family."[8] Younger women in Daria's household also were "constantly busy," making "pretty, elaborately beaded" moccasins (a nontraditional style of footwear, probably introduced from Canada via the fur

trade). For winter wear, one of the women of the village made Breece a "beautiful" pair of fur boots, "white and gray, trimmed in beaver," and at night she slept under "a large squirrel skin robe" made by the wife of one of the village leaders. For kayak travel, Breece purchased a parka made from bear intestines that looked "like sheer oiled silk, puffed in four-inch strips" (Jacobs 1995:94).

Sometimes imported textiles were used to make clothing of traditional design. Posing for a photograph in 1907, a Nondalton chief, Zackar Evanoff, and his wife, Mary, wore cloth garments of Euro-American design (figure 13.29). However, prominently displayed behind them is a Dena'ina tunic, traditional in style but made from dark cloth. Similar garments (figures 13.30a–b) have been owned by several generations of Dena'ina women in the family of Parascovia Valun Rickteroff Roehl (McClanahan 2002:117) and also by the family of Rose Hedlund, who was from Chekok (figures 13.31 and 13.32).

For practical and economic reasons, hide clothing continued in use for winter wear until well into the twentieth century. Interviewed late in the century, an elder, Agnes Trefon, recalled that until 1930, when she was about nine years old, she wore "only moose and caribou skin boots." Another elder, Andrew Balluta, speaking of the same period, remembered "ground squirrel parkas, sheepskin or smoke-tanned moose hide mittens and boots, and caribou legging cold weather boots" hanging in the entryway to his family's log house. He noted also that the hides of Dall sheep were used to make "mittens, socks [and] lining for coats" (Ellanna and Balluta 1992:128, 174, 179).

Ceremonial clothing and adornment items with strong links to the past continued to play a role in Dena'ina communities in modern times. For example, elements of a chief's potlatch outfit were successively owned by several twentieth-century Susitna chiefs before being acquired by Shem Pete, a respected Dena'ina storyteller and historian, in 1957 (see figure 1.43) (Kari and Fall 2003). The outfit, transferred by Shem Pete to the Anchorage Museum in 1976, consists of necklaces and bracelets

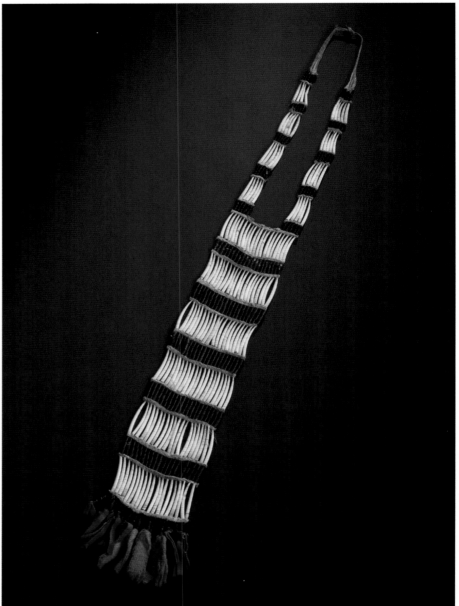

FIG 13.33

made from glass beads and dentalium shells, a cloth shirt, puffin beak rattles, and a headdress made from goose and eagle feathers (figures 1.44, 5.4, 5.5, 13.33; see also page 277.)

Garments such as those described and illustrated here stand as powerful symbols of a unique

13.33 *T'uyedi*, Big Chilligan's dentalium necklace, Susitna Station, c. 1902. L 86.5 cm. Dentalium shells, sinew, beads, wool cloth. Anchorage Museum, 1978.035.002. Photograph by Chris Arend.

cultural heritage. Their significance and meaning for many Dena'ina today were expressed poignantly and eloquently by Alexandra Kaloa, in the interview in which she made the statement that stands as the epigraph to this article (McClanahan 2002:85–90). In 1985, at the age of seventy-five, Mrs. Kaloa recalled that because her family was "very poor," they dressed in hide clothing made by her mother: "fur coat…moccasins, even the skirt and shirt" (McClanahan 2002:86). Traditional materials and skills were used to decorate these garments:

> [They were] trimmed with porcupine quills, looked like beadwork. They dyed the porcupine quills, and then they sewed into the skin. It's like embroidery work.

Although as a child she would have preferred store-bought clothing, in old age Alexandra Kaloa looked back on this aspect of her youth with nostalgia and appreciation: "Now I think about it, I think of myself dressed as a very rich person."

Notes

1. Raccoons are not native to this region; the "frocks" more likely were made from marmot or ground squirrel.
2. The "Chief at the head of the Inlet" probably was a Dena'ina man identified in Vancouver's journal as "a young chief, named Chatidooltz, who seemed to possess great authority and to be treated with much respect." Together with about twenty of his followers, Chatidooltz visited Vancouver's ships on April 26, and spent the night on board the *Discovery* (Lamb 1984:1231).
3. Not all garments included in the total of seventy have documented provenances; some are attributed to Dena'ina on stylistic grounds.
4. The largest and best-documented collections are those of the National Museum of Finland, Helsinki (Varjola 1990), and the Peter the Great Museum of Anthropology and Ethnography, St. Petersburg (Siebert 1980).
5. On extant garments, the fur often has shed, leaving a strip of parchment-like dehaired hide.
6. For example, the Field Museum of Natural History, Chicago, has three tunics and four moccasin-trousers acquired in 1887 by Edward Ayer, an American industrialist, during a voyage along the Alaskan coast. James VanStone (1981) describes this collection. Comparable clothing items, probably comprising two multipiece outfits, were acquired in 1888 by an American seaman, Ewald Schmieder; today, these are in the Alaska State Museum in Juneau.
7. A beaded and quill-worked arrow quiver of the type often found as part of a late-nineteenth-century traditionally styled summer outfit was collected in 1904, with the information that it was used as a "dress piece" in ceremonial dances (WM 1718, collected by George Emmons).
8. Townsend (1965:145) describes the preparation of salmon skins for boots: "The fish was left in the water until it floated. Then it was skinned and sewn into boots with waterproof seams. Apparently, these were very serviceable and quite popular. Their one drawback was that if the wearer stood close to a fire, the boots shrivelled up and were ruined."

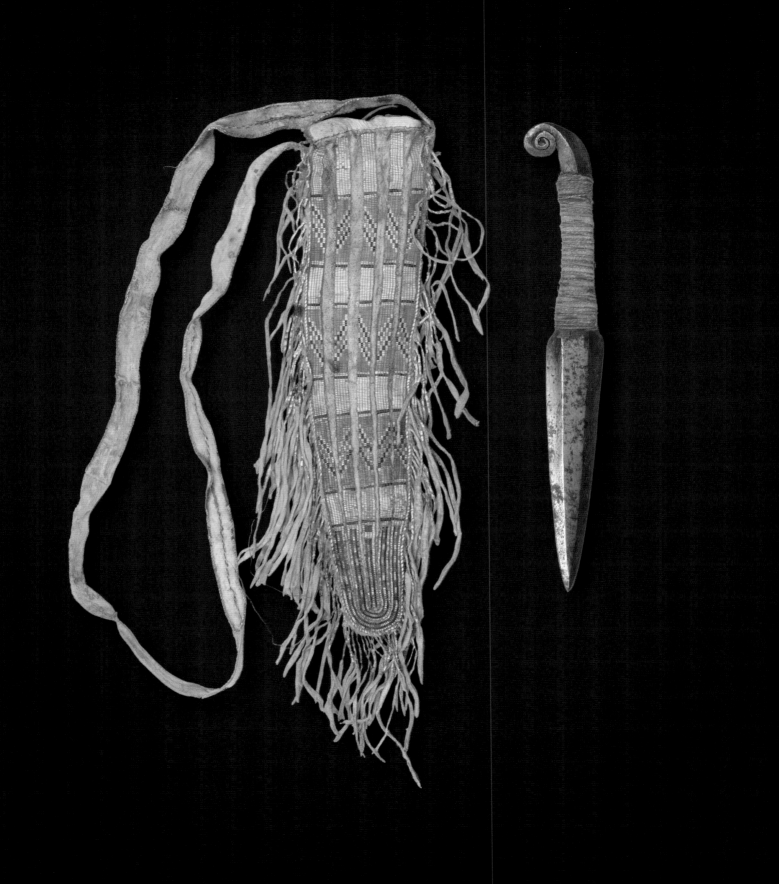

14

Silent Messaging: Quill and Bead Ornament on Nineteenth-Century Dena'ina Clothing

Kate C. Duncan

The ornamentation on traditional Dena'ina garments for special occasions distinguishes them from other Northern Athabascan clothing, as do their cut and construction. Everyday garments may have had little adornment, but those for special occasions were skillfully ornamented with porcupine quills and some, very late in the century, with glass beads. Both the technique and the patterning of the woven quill bands on early Dena'ina tunics, dresses, moccasin-trousers, boots, and other items are unique among Northern Athabascan clothing. As beads began to replace quills in the later nineteenth century, the technique for creating the bands changed, but the motifs and their positioning remained much the same, suggesting that the quilled and beaded bands on Dena'ina clothing functioned as more than simple garment decoration.

Early Clothing Ornamentation

The earliest Dena'ina quilled garments collected, summer outfits that exhibit exquisite workmanship, were acquired by Ilya Voznesensky, Arvid Adolf Etholén, and others involved in the administration of Russian America during the first decades of the nineteenth century. The long tunics (also called shirts) and moccasin-trousers were skillfully cut from caribou hides tanned to the softness of fine kid leather, and their seams were sinew-sewn with almost invisible stitches. The delicate ornamental

bands of porcupine quills that enhance them were precisely woven directly onto narrow hide strips that, when completed, were attached to the garments in prescribed locations. The oldest known examples of this type of quill weaving, two leggings bands collected in 1794 on George Vancouver's voyage, indicate that at that time, Dena'ina quill weaving skills and technique were fully developed (see figure 13.3 e.g.).

When Russian and Finnish museums began amassing collections from Russian America in the mid-nineteenth century, their emissaries eagerly sought beautifully quilled Dena'ina summer outfits of hide, even though by then, fabric shirts and pants were supplementing or beginning to displace caribou skin tunics and moccasin-trousers except in remote communities. These early quilled ensembles were handsome, skillfully constructed, and uniquely ornamented, as well as lightweight and easily portable. Some show wear, while others, including garments sent to the National Museum of Finland, do not, and may have been commissioned by collectors.

That collectors for museums appear to have interpreted garments made using only indigenous materials and techniques to be purely aboriginal and thus more authentic, while ignoring other clothing in use at the time, has limited our understanding of the totality of clothing types that would have been seen in Dena'ina communities day to day. Elegant

14.0 *Tl'usts'eghi ch'u k'izhagi yes,* **nife and sheath, Kenai Peninsula, 846.** L 30 cm. Metal, caribou, porcupine uills, sinew. Museum of Cultures, National useum of Finland, VK193ab. Photograph Finland's National Board of Antiquities/ cture Collections. Photograph by István olgár.

219

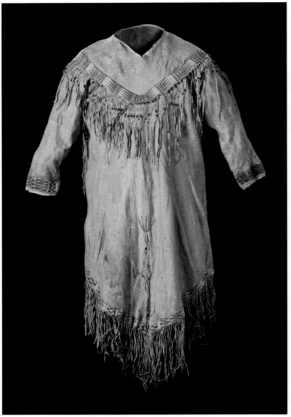

FIG 14.1a

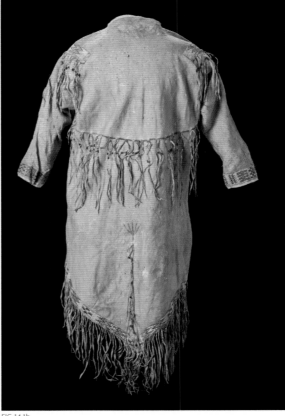

FIG 14.1b

14.1a, b *Kił dghak'a*, tunic (front and back views), Alaska, c. 1850. L 119 cm. Caribou hide, porcupine quills, silverberry seeds, sinew, ochre. Photograph © Russian Museum of Ethnography, 8762-17217. Photograph by Chris Arend.

quill-ornamented tunics, trousers, dresses, boots, hoods, gloves, and mittens predominate in early Dena'ina clothing collections. Some show evidence of use. Others, such as what the National Museum of Finland's curator Pirjo Varjola calls the "Indian shirts of tanned leather" in the Etholén Collection, show no sign of wear and appear to have been purchased (Varjola 1990:28).

When the Russians arrived in the Cook Inlet area, Dena'ina communities consisted of leaders—highly ranked individuals known as *qeshqa* and their close kin, who were distinguished in part by their display of wealth—and followers. A man acquired wealth, including dentalium shells and, later, glass beads, through trade, gift giving at potlatches, service to his community, and the productive effort of those bound to him through kinship or economic obligations. Commoners without wealth worked in

the households of wealthy men, who often had several wives. These would have been the men with whom museum representatives dealt, and it is likely that most of the garments collected for European museums were made by their wives.

Dena'ina weavers were particular about the materials they used when constructing important garments. When Iliamna Dena'ina made long trips into the Interior for trade, dyed porcupine quills were important among the things they acquired. In 1839, Ferdinand Petrovich von Wrangell wrote that "porcupine quills to be used for embroidery patterns on parka covers are considered best when brought from the Atna [Copper] River, and especially esteemed are those dyed red; for this the Mednovskiy [Ahtna] use small cranberries and the Kenay crowberries" (Wrangell 1970 [1839]). Colored quills were valuable in commerce as late as the 1890s.

14.2 *Svinits yes,* shot pouch, Kenai Peninsula, 1846. L 63 cm. Caribou, porcupine quills, sinew, wood. Museum of Cultures, National Museum of Finland, VK194. Photograph © Finland's National Board of Antiquities/Picture Collections. Photograph by István Bolgár.

14.3 *K'izhagi yes,* knife sheath with shoulder strap, Kenai Peninsula, 1846. 76 cm, 14 cm. Caribou, porcupine quills. Museum of Cultures, National Museum of Finland, VK195. Photograph © Finland's National Board of Antiquities/Picture Collections. Photograph by István Bolgár.

14.4 *K'izhagi yes,* knife sheath/strap, Kenai Peninsula, 1846. L 27 cm. Caribou hide, porcupine quills, ochre, bird quills (?). Museum of Cultures, National Museum of Finland, VK197. Photograph © Finland's National Board of Antiquities/Picture Collections. Photograph by István Bolgár.

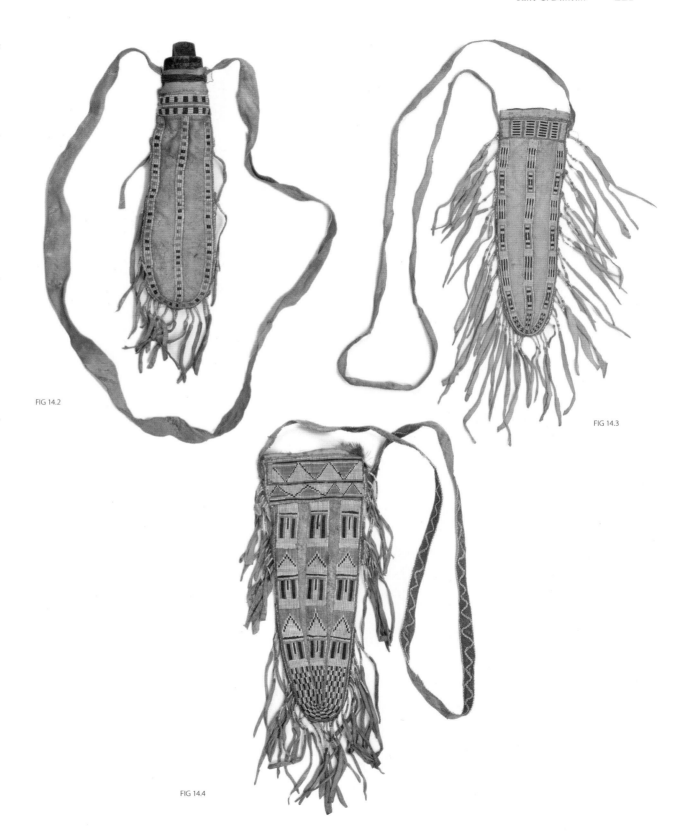

FIG 14.2

FIG 14.3

FIG 14.4

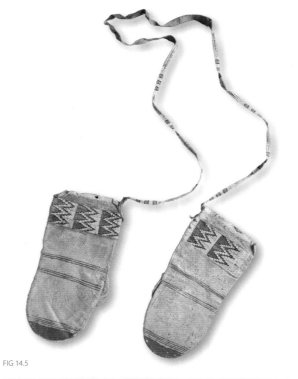

FIG 14.5

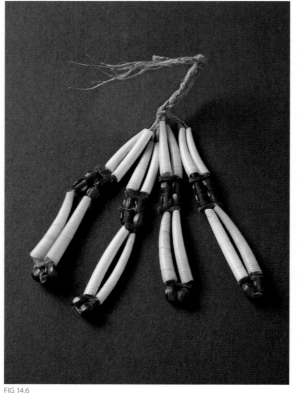

FIG 14.6

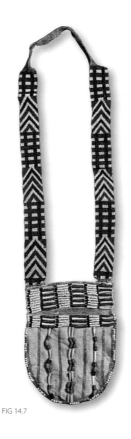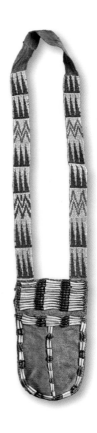

FIG 14.7

14.5 *Gech' eł tl'ila*, **mittens with strings, Alaska, c. 1850.** L 27 cm, W 12.5 cm. Caribou hide, sinew, ochre, porcupine quills. Photograph @ Russian Museum of Ethnography, 8762-19219. Photograph by Chris Arend.

14.6 *Jegh ch'elyi*, **woman's earrings, Tyonek, 1883.** L 18 cm, W 5 cm. Denatalium shells, skin, sinew, glass beads. Ethnological Museum Berlin, IVA 6111. Photograph courtesy of Staatliche Museen zu Berlin, Ethnologisches Museum. Photograph by Chris Arend.

14.7 *Viqizdluyi*, **fire bags for powder and lead with shoulder strap, Tyonek, 1883.** L 49 cm, L 48.5 cm. Caribou hide, ochre, dentalium shells, glass beads. Ethnological Museum Berlin, IVA 6103 and 6104. Photograph courtesy of Staatliche Museen zu Berlin, Ethnologisches Museum. Photograph by Chris Arend.

In the late eighteenth and early nineteenth centuries, the dentalium shells and glass beads that made their way to Cook Inlet were limited and costly. The quantity of beads and dentalium shells an individual wore overtly messaged the wealth of his or her family. Both beads and shells were worn, often combined, to create earrings, neckbands, and other accessories. As among some other western Athabascan groups, on appropriate occasions, a Dena'ina man of wealth and rank might wear a wide band of alternating blocks of dentalium shells and glass trade beads over his shoulder and across his chest. When Wrangell recorded Kenay (Dena'ina) clan names in 1839, they included Katlukhtana, meaning "fond of stringing beads." In the early 1840s, Zagoskin reported that Dena'ina were acting as intermediaries for trade between the Russians and Interior Athabascan tribes, setting

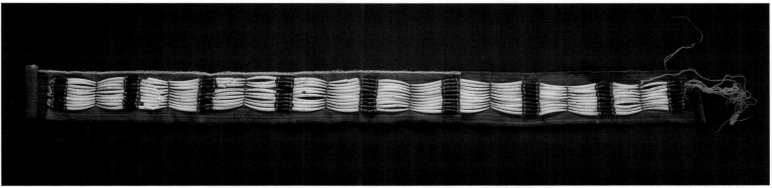

FIG 14.8

14.8 *K'enq'ena*, bandolier, Tyonek. L 160.5 cm. Cloth, dentalium shells, glass beads, sinew. Anchorage Museum, 1980.018.001. Photograph by Chris Arend.

14.9 *Ukaych'uk'a*, tunic, line of "tails" (see figure 14.10a b), Tyonek, 1862. L 123 cm, W 56 cm. Caribou, porcupine quills, sinew, fur (beaver or otter), eagle down puffs. Ethnological Museum Berlin, IVA 9086. Photograph courtesy of Staatliche Museen zu Berlin, Ethnologisches Museum. Photograph by Chris Arend.

out in the summer with "beads and other trifles for the interior…to trade there for animal hides and dressed caribou and moose skins with peoples still unknown to the Russians" (Zagoskin 1967:197).

Few examples of ornamented Dena'ina clothing were collected between the 1860s and 1880s. It has been suggested that the smallpox epidemic of 1836–1840 that decimated the coastal Dena'ina populations and disrupted the moiety and clan system was a factor. In addition, by mid-century, the main European museums with interests in the far north had received Dena'ina collections, and the Russian-American Company was struggling. Johan Adrian Jacobsen's collection made in 1883, principally at Tyonek, included mostly beaded items rather than quilled ones. When the Chicago industrialist Edward Ayer purchased a group of old-style Dena'ina outfits in the late 1880s for the 1893 Chicago World Columbian Exposition, they were beaded as well. Glass trade beads, especially those called necklace beads and pony beads, were more readily available at the end of the century, and beading was far faster than weaving quills. However, the beaded garments collected by Jacobsen and Ayer follow the established conventions of cut and placement of the patterned bands of quills on the 1830s garments. They also maintain some of the same motifs, though often in less complex versions, and the quality of workmanship typical of outfits made decades earlier.

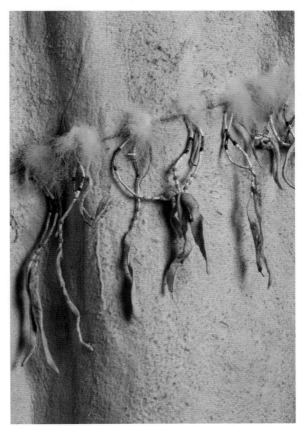

FIG 14.9

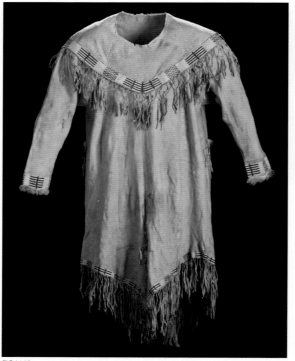

FIG 14.10a

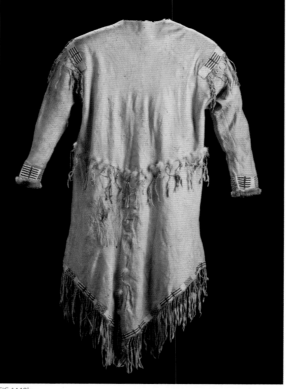

FIG 14.10b

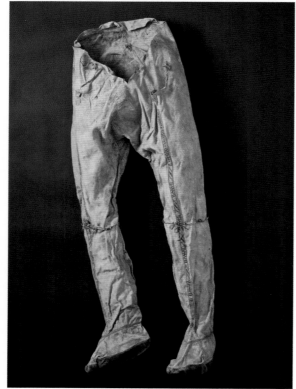

FIG 14.10c

14.10a, b *Ukaych'uk'a,* **tunic (front and back views), Tyonek, 1862.** L 123 cm, W 56 cm. Caribou, porcupine quills, sinew, fur (beaver or otter), eagle down puffs. Ethnological Museum Berlin, IVA 9086. Photograph courtesy of Staatliche Museen zu Berlin, Ethnologisches Museum. Photograph by Chris Arend.

14.10c *Tl'useł,* **moccasin-trousers, pre-1850.** L 112 cm. Caribou, sinew, ochre, porcupine quills. Ethnological Museum Berlin, IVB 258. Photograph courtesy of Staatliche Museen zu Berlin, Ethnologisches Museum. Photograph by Chris Arend.

Conventions of Ornament

Conventions govern the placement of motifs and ornament on nineteenth-century Dena'ina garments, whether they be quill-woven or beaded. On pre-1840 men's tunics, a wide band of woven quillwork from which hang long, thin, quill-wrapped fringes curves across the upper chest and over the shoulders, usually meeting a simple, slightly curved "line" of individual "tails" spaced at intervals across the back. Narrower woven quilled cuff and hem bands are customary. The footed moccasin-trousers worn with these tunics are normally ornamented down the front of the leg with a vertical woven quill band that usually splits into a narrow V as it meets an ankle band; a loose garter commonly encircles the knee. Men's outfits in museum collections usually include one or more quill-ornamented accessories: a fire bag, knife sheath, quiver, gloves or mittens,

14.11a, b *K'isen dghak'a,* **dress (front and back views), 1884.** L 132 cm. Caribou hide, porcupine quills, sinew, fur (otter or beaver), ochre. Ethnological Museum Berlin, IVA 9386. Photograph courtesy of Staatliche Museen zu Berlin, Ethnologisches Museum. Photograph by Chris Arend.

14.12 *Chik'ich'a,* **man's hood, Kenai Peninsula, 1846.** L 80 cm, W 22 cm; caribou hide, porcupine quills, sinew. Museum of Cultures, National Museum of Finland, VK180. Photograph © Finland's National Board of Antiquities/ Picture Collections. Photograph by Matti Huuhka.

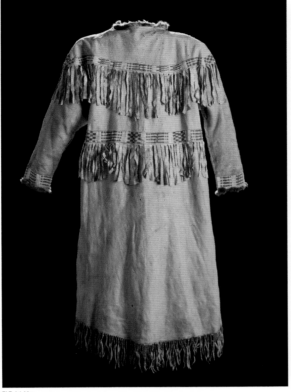

FIG 14.11a

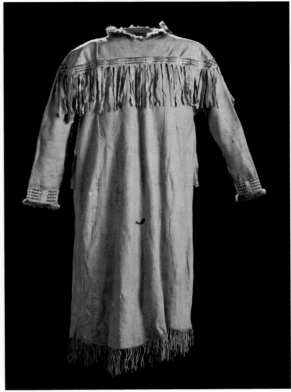

FIG 14.11b

and occasionally a hood. The patterning on these items normally relates to that of the main garment.

Far fewer early nineteenth-century women's summer outfits were collected than men's. The men assembling collections for museums abroad were likely more interested in men's outfits and had greater access to them. Also, there may have been far more men's outfits made. The earliest known Dena'ina dresses are long with nearly straight hems that taper slightly at the sides. A straight or slightly curved woven quill band ornaments the upper chest, and one or two straight quilled bands cross the upper back. The quilled bands are thinner than those on men's tunics, and both front and back bands are usually augmented with broad, flat, untwisted fringes rather than the long twisted fringes found on men's tunics.

Cuff bands and some hem bands are also quilled on women's garments, and some hoods include

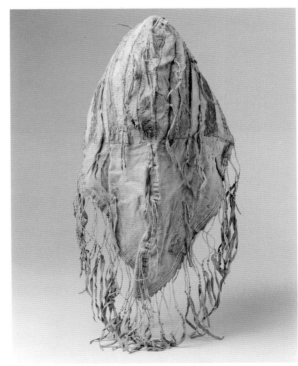

FIG 14.12

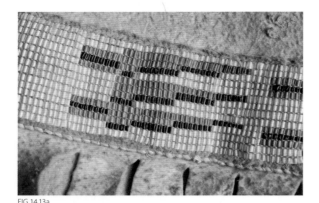

FIG 14.13a

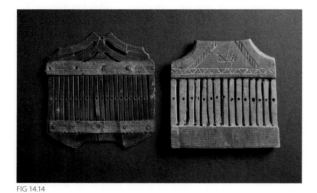

FIG 14.14

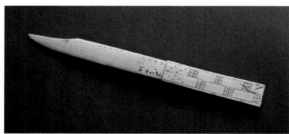

FIG 14.15

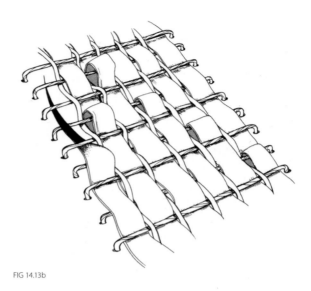

FIG 14.13b

14.13a *K'isen dghak'a*, dress (detail of woven quillwork) (see figures 14.11a, b). Ethnological Museum Berlin, IVA 9386. Photograph courtesy of Staatliche Museen zu Berlin, Ethnologisches Museum. Photograph by Chris Arend.

14.13b Unique Dena'ina quillwork technique with both warp and weft of sinew attached directly to the hide. Drawing by Susan Aldworth. © Kate Duncan.

14.14 Weaving tools (heddles), Tyonek, 1883. Left: H 10 cm. Baleen (?), copper (?), brass; right: H 9 cm. Wood, ochre. Ethnological Museum Berlin, IVA 6137 and IVA 6138. Photograph courtesy of Staatliche Museen zu Berlin, Ethnologisches Museum. Photograph by Chris Arend.

14.15 Weaving knife, Tyonek, 1883. L 18 cm, W 1.7 cm. Bone, pigment. Ethnological Museum Berlin, IVA 6140. Photograph courtesy of Staatliche Museen zu Berlin, Ethnologisches Museum. Photograph by Chris Arend.

porcupines survive even when other animals cannot, Northern Athabascan people do not over-harvest them, ensuring their availability in case of human starvation. Porcupine quill ornament on garments was considered protective. The late Peter Kalifornsky (1911–1993) recalled that during his time, some Dena'ina kept animal claws as medicine spirit: "They would also keep porcupine or beaver front teeth, or porcupine quills, sewn to a little skin, and they would wear it on their chests" (Kalifornsky 1991:14).

Early Dena'ina seamstresses used hair-thin caribou sinew and the fine, narrow quills of young porcupines to weave delicate bands directly onto strips of tanned caribou hide using a double warp technique. The quills were flexible, easily flattened, and allowed finely detailed woven motifs. On many garments, the flattened quills are just 0.2 to 0.3 mm wide. The evenness of the woven quillwork argues for the use of a heddle. It also indicates that before flattening the quills, weavers carefully sorted them to ensure they were of the same diameter. They also snipped off both ends of each quill, using stone knives until later in the Russian America period when scissors and metal knives would have been available. Scissors, thin needles, and a heddle

narrow quill bands as well. In the 1930s, Cornelius Osgood was told that in some areas, women had worn moccasin-trousers with their dresses in harsh weather and short boots with them in the summer.

The Materials and Techniques of Dena'ina Quill Weaving

Porcupine quills were the original medium of ornament on special Dena'ina clothing. Because

14.16a *Kił dghak'a*, **summer tunic, detail of chest band (see figures 13.21b–c).** Courtesy of the Burke Museum of Natural History and Culture, catalog no. 145. Photograph by Chris Arend.

14.16b *Kił dghak'a*, **summer tunic, detail of damaged quill band (see figures 13.21b, c).** Courtesy of the Burke Museum of Natural History and Culture, catalog no. 145. Photograph by Chris Arend.

14.17a *Kił dghak'a*, **summer tunic, detail of the expanded quill band on the left side (see figures 13.21 b, c).** Courtesy of the Burke Museum of Natural History and Culture, catalog no. 145. Photograph by Rebecca Andrews.

14.17b *Kił dghak'a*, **summer tunic, detail of the expanded quill band on the right side (see figures 13.21b, c).** Courtesy of the Burke Museum of Natural History and Culture, catalog no. 145. Photograph by Rebecca Andrews.

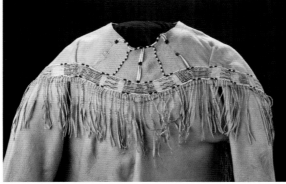

FIG 14.16a

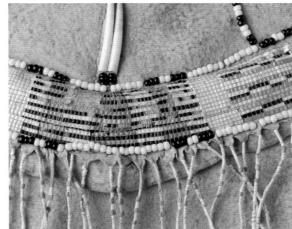

FIG 14.16b

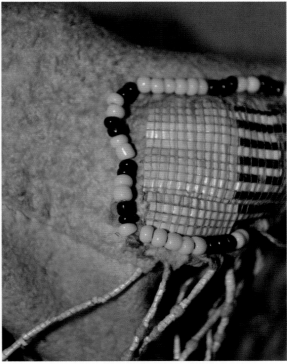

FIG 14.17a

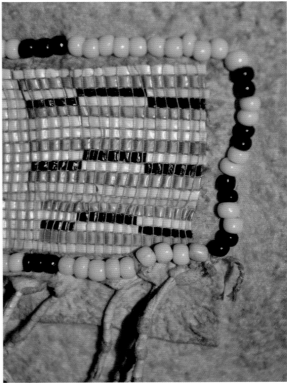

FIG 14.17b

simplified and speeded the unique technique that Dena'ina weavers developed.

Exactly how the weaver kept both ends of the warp taut during the weaving process is not certain. The bow loom that eastern Athabascans used to weave porcupine quill bands in the twentieth century could have worked for short bands, but it would have been awkward and unwieldy for long ones since the Dena'ina weaver attached her wefts directly to a hide strip as she wove the quills.[1] It is more likely that she knotted the free group of warp ends around something, perhaps a vertical or horizontal pole, and kept the start end of the weaving taut herself, possibly with some sort of backstrap-loom type of arrangement.

In Dena'ina quill weaving, extremely thin but strong threads of caribou tendon sinew form both the warp—the long horizontal stationary threads of the quill weaving—and the weft, the threads that are laid back and forth across the warp during the weaving process. The quills, when added, form a supplementary warp. To begin, using a needle, the weaver positioned a row of fine sinew warp threads equidistant from each other near the end of a hide strip, knotting them on the backside and threading them through to the front, then through some sort of heddle to separate and keep them evenly spaced. Two small wooden heddles and a weaving knife collected from the Dena'ina in 1883 are types used in an ancient kind of Russian weaving called *berdo,* which is still used to create narrow wool belts and decorative bands for folk costumes. Berdo weaving requires only a heddle and a way to secure both ends of the warp to keep it taut during the weaving process. When the tension is released, the weaving can be stored away as needed. Heddles like these may have been used in Dena'ina quill weaving.

When constructing a woven quill band, the maker affixed the quillwork to the hide strip as she wove. Damaged quillwork on the chest band of a late nineteenth-century tunic collected by James G. Swan for Seattle's 1909 Alaska–Yukon–Pacific Exposition exposes details of the technique. With the heddle in front of her to keep the warps equidistant from each other, the weaver worked forward from where the warp threads were affixed to the hide strip. To begin a band, with her warp threads stretched taut, she used a needle to attach a weft thread into the hide next to the start of the first warp thread, then laid the weft thread perpendicular across the warp threads and took a tiny stitch at the end to tighten and secure it. The weaver then positioned, flattened porcupine quills between the warp threads, neatly creased the quill ends over the initial weft thread, and tucked them underneath it, against the hide. She then ran the weft thread back across the row of quills, took a tiny stitch into the hide, then lifted the row of quills and ran the weft thread back underneath them, taking a tiny stitch at the opposite end. The process was repeated, folding

FIG 14.18

in new flattened quills as needed or to change color, until the quilled band was the desired length. On completing the weaving of the band, the maker creased the quill ends over the last weft thread and pulled the warp threads together in groups of two or three. Likely using a needle, she pulled them through to the underside of the hide and neatly knotted them. The hide strip with its woven quill band was then ready to be attached to a garment.

The narrower hem bands on tunics and dresses and the leg and ankle bands on moccasin-trousers were each woven as a single band, as were the quill bands on hoods and quivers. However, the wider chest bands on tunics (and sometimes gloves and mittens) were usually woven in two parts, with a second narrow band, usually four or five quills wide, added to the first band after it was completed. On the tunic collected by Swan, the weaver began constructing the additional narrow band at the completed end of the first band rather than at its beginning, and wove in the opposite direction, interlinking each weft thread of the second band with the adjacent weft of the first. After the expanded quill band was completed and the weft threads were secured on the underside, it was ready to be attached to the garment.

If the band was a chest band, fringes had to be added as well. The very long, thin fringes on Dena'ina quilled garments were angle-cut from a thin strip of finely tanned hide using a technique employed by many Northern Athabascan groups. With one end of the narrow hide strip secured, a very sharp knife, and a steady hand, the maker

14.19 *Ukaych'uk'a*, tunic, detail of fringes (see figures 14.10a, b). Ethnological Museum Berlin, IVA 9086. Photograph courtesy of Staatliche Museen zu Berlin, Ethnologisches Museum. Photograph by Chris Arend.

14.20 *Kił dghak'a*, tunic, detail of fringes (see figure 13.10b).** Peter the Great Museum of Anthropology and Ethnography (Kunstkamera), 620-40/a. Photograph by Chris Arend.

14.21 *Kił dghak'a*, tunic, detail of fringes (see figure 15.3.)** Peter the Great Museum of Anthropology and Ethnography (Kunstkamera), 518-2/a. Photograph by Chris Arend.

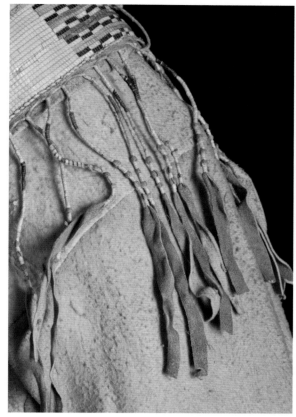

FIG 14.19

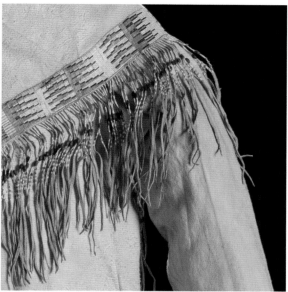

FIG 14.20

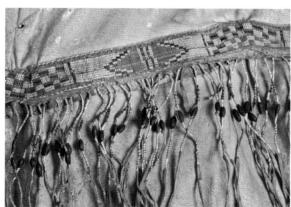

FIG 14.21

quickly slashes through the hide strip at a very shallow angle to create a fringe of the desired length. As one fringe drops, she cuts the next one and so on. When the fringe strip is the desired length, she removes the excess hide and quill-wraps a part of each fringe.

While hem fringes on tunics (long shirts) are relatively short and simply wrapped with a few quills, the fringes hanging below the chest band are normally more than a foot long and subtly elegant. Each fringe is tightly wrapped near the top with very thin quills on either side of a single silverberry (*Elaeagnus commutata*) seed. The quill wrapping below the seed alternates tightly wrapped segments with tiny open spaces of hide that bulge and create a beadlike effect above the remaining unwrapped fringe below. These fringes make an exquisite textural statement on special garments, leading the eye upward to the chest band and face of the wearer. They were important for other reasons as well. As the wearer walked, the moving fringes disturbed insects that swarm in the North in the summer, and also directed rain down and away from the garment.

The rhythms, repetitions, and textural contrasts on early quilled Dena'ina garments are subtle and refined. The suede-like softness of the garment body is interrupted by a row of long, thin fringes anchored at the base of the quill-woven chest band. The delicate quill patterning and restrained hues of browns and ochres against a background of natural white

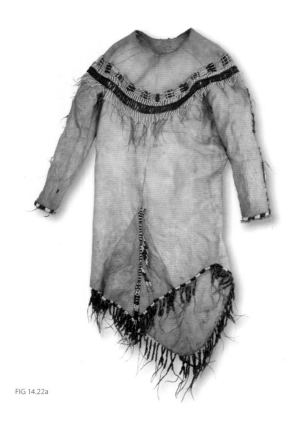

FIG 14.22a

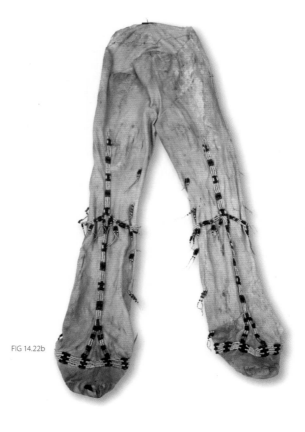

FIG 14.22b

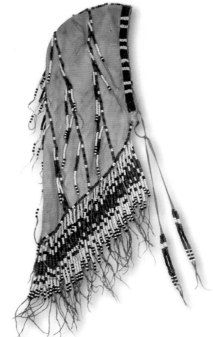

FIG 14.22c

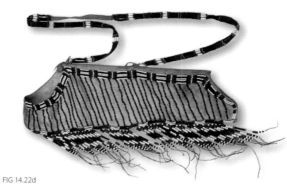

FIG 14.22d

14.22a *Kił dghak'a*, **tunic.** L 133.4 cm. Caribou hide, glass beads, sinew. Field Museum of Natural History, FM14944. Photograph courtesy Field Museum of Natural History, no. A106827. Photograph by Ron Testa.

14.22b *Tl'useł*, **moccasin-trousers.** Caribou hide, glass beads, sinew. Field Museum of Natural History, FM14932. Photograph courtesy Field Museum of Natural History, no. A106774. Photograph by Ron Testa.

14.22c *Chik'ish*, **hood.** L 76.2 cm. Caribou hide, glass beads, sinew. Field Museum of Natural History, FM14943. Photograph courtesy Field Museum of Natural History, no. A106771. Photograph by Ron Testa.

14.22d *Q'us*, **quiver.** Caribou hide, glass beads, sinew. Field Museum of Natural History, FM14933. Photograph courtesy Field Museum of Natural History, no. A106770. Photograph by Ron Testa.

14.23 Man's outfit: *kił dghak'a,* **tunic;** *Tl'useł,* **moccasin-trousers;** *lugech',* **gloves;** *tsit'egha,* **hood;** *k'izhagi yes,* **knife sheath.** L of tunic 141 cm. Caribou hide, glass beads, sinew. National Museum of the American Indian, Smithsonian Institution (151481.000). Photograph by Donald E. Hurlbert.

14.24 Man's outfit. Cook Inlet, early 20th century. Caribou hide, glass beads, thread. *Kił dghak'a,* tunic (a) L 147 cm, W 50.8 cm. *Tl'useł,* moccasin-trousers (b) L 111.8 cm. *Tsit'egha,* hood (c). L 60.5 cm, W 29 cm. Courtesy of the Burke Museum of Natural History and Culture, catalog no. 146a–c. Photograph by Chris Arend.

14.25 Man's outfit, Alaska c. 1900. Caribou hide, glass beads, sinew. *Kił dghak'a,* tunic (a). L 128.5 cm, W 57.3 cm. *Tl'useł,* moccasin-trousers (b). L 120.5 cm. *Q'us,* quiver (c). L 62.8 cm. *K'izhagi yes,* knife sheath (d). L 28.2 cm. *Tsit'egha,* hood (e). L 63 cm. Anchorage Museum, 1999.077.001a–e. Photograph by Chris Arend.

14.26 Man's and woman's outfits, Cook Inlet, 1888. Caribou hide, muskrat fur, glass beads, ochre.
 Man's outfit: *Lugech',* gloves, II-C-70. *Vaqilani,* caribou hide bag, II-C-72. *Q'us,* quiver, II-C-74. *Tl'useł,* moccasin-trousers, II-C-75. *Tsit'egha,* hood, II-C-78. *Kił dghak'a,* tunic, II-C-80.
 Woman's outfit: *K'isen dghak'a,* dress, II-C-76. *Gech',* mittens, II-C-77. *Seł,* boots, II-C-91. Alaska State Museum. Photograph by Chris Arend.

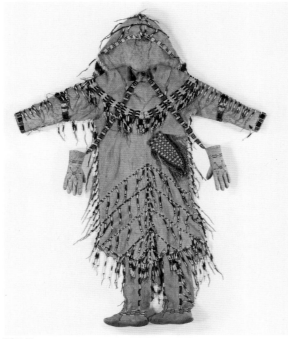

FIG 14.23

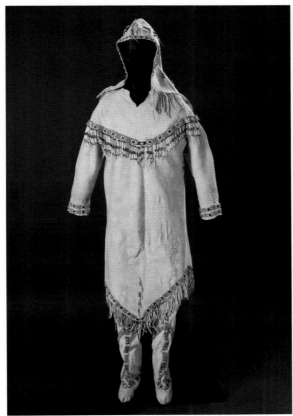

FIG 14.24

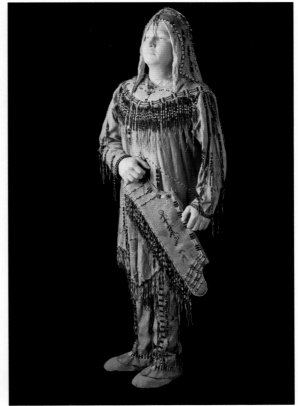

FIG 14.25

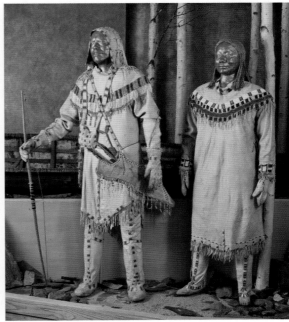

FIG 14.26

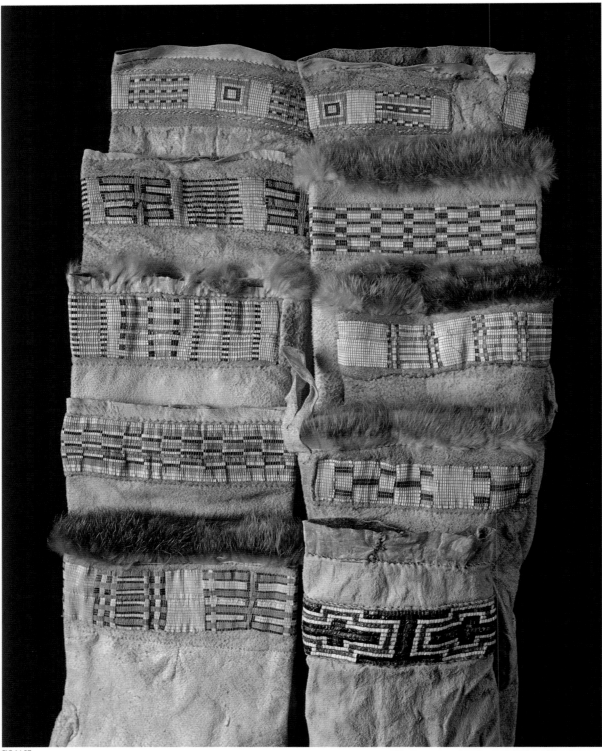

14.27 *Lugech'*, **gloves, Kenai Peninsula, 1846.** L 24–26.5 cm. Caribou hide, sealskin (?), porcupine quills, beaver fur, otter fur. One pair and eight individual gloves: at left from top to bottom: VK 187, 186, 192, 189, 188; at right from top to bottom: VK 187, 185, 191, 190, 184. Museum of Cultures, National Museum of Finland. Photograph © by Finland's National Board of Antiquities/ Picture Collections. Photograph by Matti Huuhka.

FIG 14.27

14.28 *Ukaych'uk'a*, tunic, detail of quillwork on chest band (see figure 14.10a, b). Ethnological Museum Berlin, IVA 9086. Photograph courtesy of Staatliche Museen zu Berlin, Ethnologisches Museum. Photograph by Chris Arend.

14.29 *K'isen dghak'a*, dress, detail of beadwork on chest band (see figure 14.26). Alaska State Museum, II-C-76. Photograph by Chris Arend.

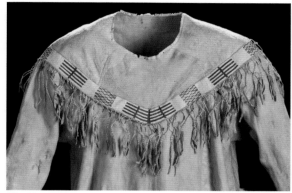

FIG 14.28

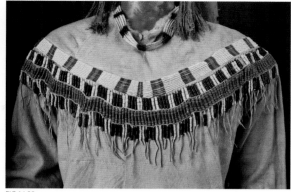

FIG 14.29

or cream-colored quills contribute to the refinement of the garments. On late nineteenth-century quilled garments, the motifs are some of those used early in the century, but there is less motif variety, and the colors are different. Black, a bright orange-red that appears to be a synthetic dye, and a dull green, possibly a plant dye, are the most common late-century quill colors.

Dena'ina Beaded Garments

In the summer of 1887, Chicago industrialist Edward Ayer sailed along Alaska's coast, purchasing "relics" for the planned 1893 World Columbian Exposition. Among the items he acquired was a group of old-style Dena'ina garments ornamented with beads rather than quills. The range in the collection suggests they may have been gathered together from items already in a village or several villages; some could have been commissioned. Exactly where they were made is not yet known, but the conventions of garment cut, quality of workmanship, placement of beading, and motifs on them testify that at the end of nineteenth century, some Dena'ina seamstresses were making beaded outfits. The collection includes beaded tunics, moccasin-trousers, a dress and several hoods, gloves, knife sheaths, and a quiver.

The beaded bands on the Ayer tunics themselves are formed of adjacent horizontal rows of glass pony beads strung on sinew and tacked down at intervals of nine or ten beads with a single stitch into the hide strip. The technique, now called lazy stitch, was used on beaded garments by other Alaska Athabascan tribes, but the motifs are generally those on early nineteenth-century Dena'ina quilled garments. Unlike the early nineteenth-century bands of two alternating motifs, almost all late-century bands feature but a single motif rather than two alternating ones. While the bands and fringes on early Dena'ina quilled tunics are subtly elegant, the beaded bands and fringes on the Ayer and other late nineteenth-century beaded garments state their presence boldly.

Other Dena'ina beaded garments from this period include a woman's full outfit from George Heye's Museum of the American Indian (now the Smithsonian Institution's National Museum of the American Indian) that is so similar to items in the Field Museum's Ayer Collection as to suggest that the dress, hood, and other outfit components were likely acquired in a trade with Heye. As anthropology museum collections were being built in the early twentieth century, curators and museum directors commonly sought to acquire item types from all North American Indian tribes. Directors often knew each other and sometimes exchanged items in order to broaden their collections.[2]

Silent Messaging

Dena'ina skin clothing provided both physical and spiritual protection. A caribou hide tunic wrapped

around the back and over the shoulders, meeting in a seam down the middle of the front, thus enclosing its wearer in a second skin. Hide clothing connected wearers to the animals that had provided the hide, sinew, and quills from which their garments were made, reminding them of the sacred reciprocity established between humans and animals at a time when it was said that animals were able to transform between the two states. The care with which Dena'ina women constructed and ornamented these garments honored the gifts of the animals that populated their world and assisted in their survival. This care also honored the high-ranking individuals who wore the garments, which conveyed their prosperity and prestige, accrued in part through their gifts to those in need.

Dena'ina quill weaving produces narrow horizontal bands of woven quills, each approximately the same height. The weft threads that cross these flattened quills create a grid of tiny blocks. To construct motifs, the weaver inserted sections of varying lengths of colored quills along the bands, stacking them in various ways. That a limited number of motifs appear on both the early nineteenth-century quilled and the late-century beaded bands on Dena'ina garments collected from different locations suggests that the motifs embed meaning, and that there were important reasons why they continued to be used.

Early accounts of Dena'ina people report that on some occasions they tattooed or painted their moiety and clan motifs on their faces, using combinations of lines and dots. The motifs on the face of a doll collected in 1842 record this (see figure 13.13). In the 1930s, Cornelius Osgood was told that three or four lateral lines of alternating red and black across the cheeks represented the Chisyi clan, while one red or black lateral line across the cheeks with dots below near the mouth was the symbol of the Nichisyi clan. Vertical lines scratched against a red background on one side of the face and small white dots painted on the other side marked members of the Tulchina. More recently, Peter Kalifornsky explained that the Ggahyi ("Cawing of Raven") clan was symbolized by red, the Tulchina ("Those Who Came from Sea")

by blue, and the Nulchina ("People Who Came from the Sky"—North Star) by white or clear.

In the mid-nineteenth century, non-Native influences, especially the Russian Orthodox Church and traders settling in Cook Inlet, forbade tattooing and discouraged face painting. However, it was important that the clan information once communicated via these motifs still be conveyed, especially in regard to opposite-clan marriage, an important social principle. As tattooing became unacceptable, clothing may have come to substitute as a primary means of communicating this critical information. The individual quilled and beaded motifs on early to mid-nineteenth-century Dena'ina garments are more complex than those earlier painted on the face, but both are constructed of lines and dots positioned in specific relationships. On early nineteenth-century Dena'ina outfits, two alternating motifs are usual on ornamented chest and hem bands, moccasin-trouser leg bands, and often on bands on garment cuffs, gloves, mittens, and hoods. In contrast, most late nineteenth-century examples repeat a single motif.

The smallpox epidemic of the late 1830s and the 1918 worldwide flu epidemic dramatically affected Alaskan Native populations and decimated the Dena'ina. Previously, like other Northern Athabascan peoples, their social organization recognized two moieties, and multiple clans within each.[3] With so many deaths during the nineteenth century, the kinship system, which, among other responsibilities, required opposite-clan marriage, was severely disrupted. Gradually over time, clans became the distinguishing societal division. The change from two alternating motifs on early nineteenth-century Dena'ina garments to one repeated motif near the end of the century appears to coincide with this change. The elegant quilled bands of geometric motifs that ornament early nineteenth-century Dena'ina clothing were not simply decorative. They performed as silent messengers and appear to have communicated specialized genealogical information via visual coding to those within the culture who had the knowledge, need, and right to know.

14.30 *Vaqilani*, Caribou Hide Bag, Cook Inlet. Caribou hide, glass beads, sinew. Alaska State Museum, II-C-71. Photograph © Alaska State Museum. Photograph by Chris Arend.

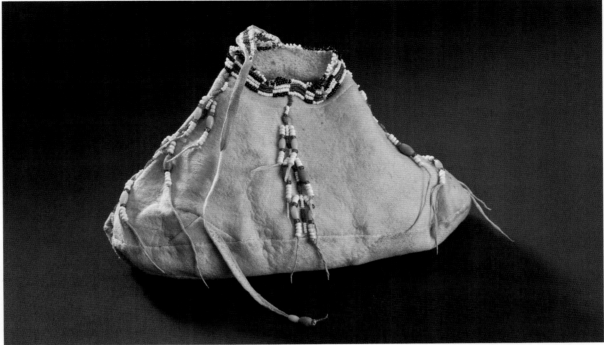

FIG 14.30

Notes

1. The eastern Athabascan bow loom is made of a sapling stripped of its bark and bent into a curve. The warp threads are attached to a small piece of hide with a hole that slips over a groove in one end of the bow and are passed through a cardboard heddle. The opposite (finish) ends of the warp threads, held tightly together, are knotted around a similar groove in the far end of the bow to hold them taut. During the weaving the quill ends are left hanging below to be trimmed off when the weaving is finished (see Duncan 1989, figs. 2.13, 2.14).

2. Dress NMAI 15/1481 and its accessory pieces relate closely to dress FM 14934 and related pieces.

3. Traditionally, most Northern Athabascans were born into a moiety, that of one's mother. Each moiety had responsibilities to the opposite moiety.

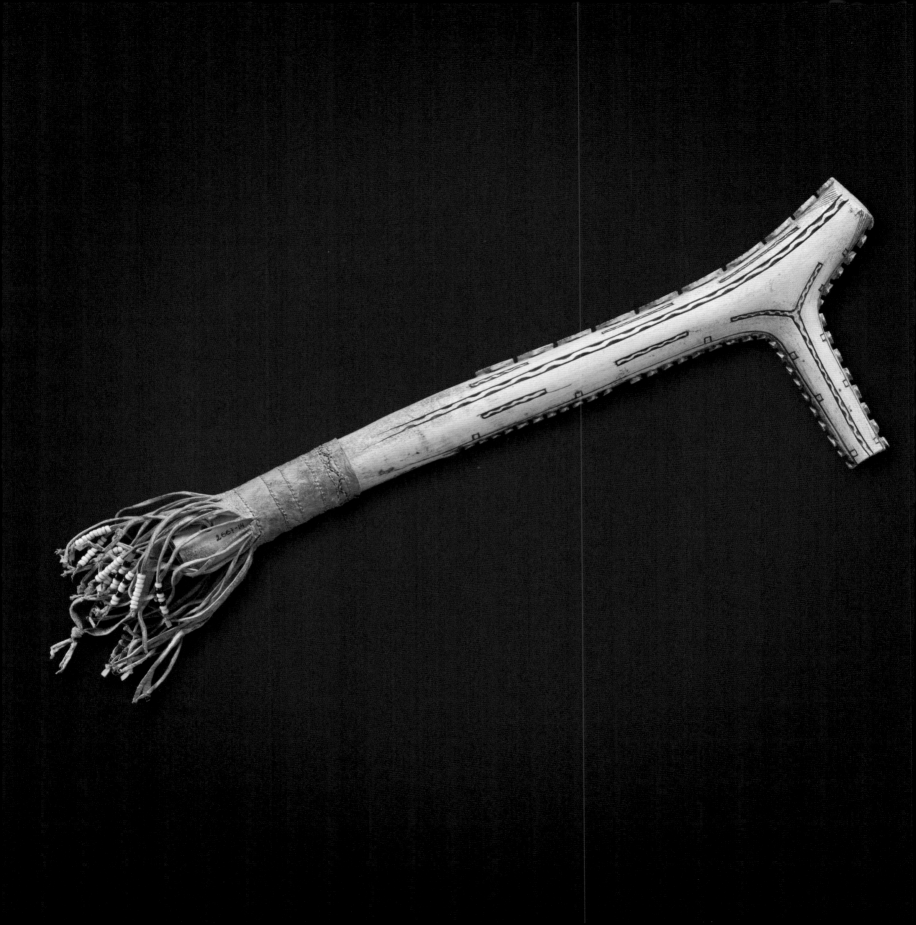

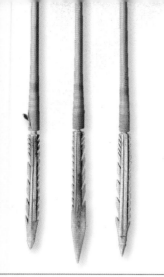

15

Dena'ina Collections in the Peter the Great Museum of Anthropology and Ethnography (Kunstkamera)

Sergei Korsun. Translated by Evguenia Anichtchenko

The Peter the Great Museum of Anthropology and Ethnography (Kunstkamera) is the successor to Russia's first state museum, the Kunstkamera, founded by order of Emperor Peter the Great in 1714. A special building was constructed for the Kunstkamera in 1718–1728, and the museum is still located in there. The museum has undergone several name changes. In 1836, the Kunstkamera was divided into seven independent museums, among which were ethnographic and anatomic museums. In 1879, these two museums were merged into the single museum, the Museum of Anthropology and Ethnography (MAE). Throughout its entire history, the museum has been located in the original museum building and has maintained its historical name, the Kunstkamera.

The museum has housed American collections from the time of its founding. The earliest collections pertaining to the people of Alaska were received from members of the Vitus Bering and Aleksei Chirikov expedition, which in 1741 was the first European expedition to explore the northwest coast of Alaska and the Aleutian Islands.

The first meeting between the Russians and the Dena'ina took place in the summer of 1785, when Grigorii Shelikhov dispatched from Kodiak a party of *promyshlenniki*,[1] fur traders and sailors, to explore Kenai (Cook) Inlet and Chugach (Prince William) Sound. In the following years, the Russians founded several trading posts in traditional Dena'ina

territory: in 1787 the Georgievsky Redoubt (Fort St. George) was founded at the mouth of the Kasilof River, and in 1791 the Nikolaevsky Redoubt (Fort St. Nicholas) was built at the mouth of the Kaknu (Kenai) River. Both these settlements belonged to the company of the merchant P. S. Lebedev-Lastochkin.

The first Dena'ina object arrived at the Kunstkamera in St. Petersburg in 1820. This was a metal dagger (539-3) from the collection of the explorer Vasiliy Mikhailovich Golovnin (1771–1831). Golovnin visited Alaska twice: during his voyage on the sloop *Diana* in 1809–1811 and again in 1818, during a round-the-world expedition aboard the ship *Kamchatka*. The dagger was collected during the latter expedition. Its split-end handle is characteristic of the daggers of Northern Athabascans (see figures 11.12 and 15.1).

In 1828, the Kunstkamera acquired the ethnographic collections of the Museum of State Admiralty Department. Founded in 1805, the Admiralty Museum received collections from many members of Russian international expeditions, including Y. F. Lisianski, P. V. Povalishin, V. M. Golovnin, L. A. Hagemeister, S. P. Khruschev, A. P. Lazarev, M. P. Lazarev, and many others. These seafarers brought zoological, botanical, ethnographic, mineral, and other collections from faraway countries. Accompanying these collections was an inventory titled "The register of rarities" and a card catalog, compiled by K. K. Gilzen in

15.0 *K'duheł*, war club, Kenai Peninsula, 1842. L 52 cm, W 14 cm. Caribou antler, caribou hide, glass beads, pigment, sinew. Peter the Great Museum of Anthropology and Ethnography (Kunstkamera), 2667-14. Photograph by Chris Arend.

237

FIG 15.1

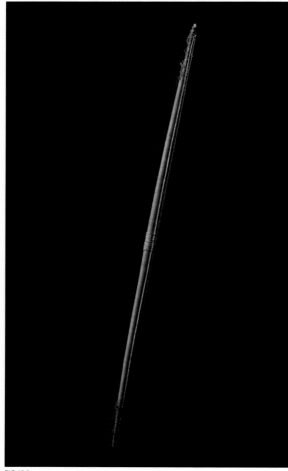

FIG 15.2

1901. The catalog includes original labels for the most of the objects. This and other museum documentation allows identification of the objects that were transferred from the Admiralty Museum to the Kunstkamera. The only Dena'ina object from this collection is a bow (no. 2667-18), which was acquired by the seaman Stepan Petrovich Khruschev (1790–1865) in 1823.

The ethnographic collection of Vasilii Ivanovich Kashevarov (?–1849) arrived at the Kunstkamera at the beginning of the 1840s. Kashevarov was the manager of the Kodiak office of the Russian-American Company from 1831 to 1838. Currently, several of the objects collected by Kashevarov are registered as collection no. 518. The collection includes four Chugach carved mountain goat horn spoons, a pair of Dena'ina pants, and two shirts. The shirts are decorated with porcupine quill embroidery and silverberry (*Elaeagnus commutata*) seeds. The use of seeds instead of glass beads demonstrates the antiquity of these items. Other objects from the Kashevarov Collection are currently cataloged as "old acquisitions."

The most significant group of Dena'ina objects is the collection of Ilya Gavrilovich Voznesensky (1816–1871). When the Ethnographic Museum was formed after the division of the Kunstkamera in 1836, the Academy of Science had difficulty finding a director for this new institution. None of the Russian academicians specialized in ethnography, and according to the policy of the Academy, only an academician could be the museum director. During the first several years, the new Ethnographic Museum was managed by Egor Ivanovich Shrader, the curator of the Zoological Museum. After the division of the Kunstkamera, it became apparent that the American collections of all newly formed museums were very meager. In 1839, the Imperial Academy of Science decided to send one of its staff members to Russian America to expand the Kunstkamera's American collections. The choice fell on Shrader's twenty-three-year-old assistant, I. G. Voznesensky. He was of lower middle-class origin. His father was a noncommissioned officer who worked at the Russian Academy of Sciences.

15.1 *K'iztin k'izhak'i*, **dagger with abalone (detail; see also figure 11.12), Kenai Peninsula, 1818.** L 40.7 cm. Iron, abalone shell inlay on handle. Peter the Great Museum of Anthropology and Ethnography (Kunstkamera), 539-3. Photograph by Chris Arend.

15.2 *Ts'iłten*, **reinforced bow, Alaska, 1823.** L 134.5 cm. Wood, hide, sinew. Peter the Great Museum of Anthropology and Ethnography (Kunstkamera), 2667-18. Photograph by Chris Arend.

15.3 Man's outfit, Nikolaevsky Redoubt, 1830–1838. Caribou hide, sinew, red ochre, silverberry seeds, porcupine quills. *Kił dghak'a*, man's tunic, L 139 cm. *Tl'useł*, man's moccasin-trousers, L 125 cm. Peter the Great Museum of Anthropology and Ethnography (Kunstkamera), 518-2/ab. Photograph by Chris Arend.

15.4 *Kił dghak'a*, man's tunic, Nikolaevsky Redoubt, 1830–1838. L 140 cm. Caribou hide, sinew, porcupine quills, silverberry seeds, ochre, fur, beads. Peter the Great Museum of Anthropology and Ethnography (Kunstkamera), 518-3/a. Photograph by Chris Arend.

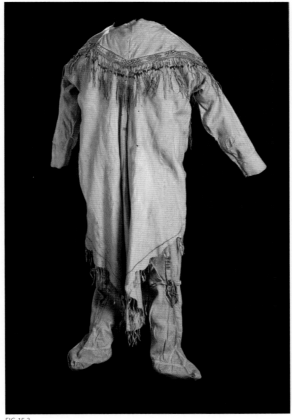

FIG 15.3

FIG 15.4

I. G. Voznesensky received "the most basic education," which was typical for people of his social status. He probably completed only two or three years of parish school, but his handwriting was even and beautiful. At the age of five, he was appointed a "press apprentice" at the Academic Publishing House. After working there for six years, he was transferred to the Zoological Museum. While still a child, Voznesensky taught himself French and German, and he was fluent in German. At that time, almost all staff members of the Imperial Academy of Science were German by birth, and German was an official language of the Russian Academy of Sciences.

Curator E. I. Shrader provided Voznesensky with instructions on collecting ethnographic material. According to these instructions, Voznesensky was to record the name of each object and mark its "value" to local indigenous people. In other words, Voznesensky was instructed to pay attention to the uniqueness of individual objects. In addition, he had to create labels for each item and compile detailed lists for each shipment. Throughout the entire ten years of his expedition, 1839–1849, Voznesensky followed Shrader's instructions diligently.

In May 1840, Voznesensky arrived in Novo-Arkhangelsk (Sitka), the capital of Russian America. Novo-Arkhangelsk became his main residence, where he would return after long journeys. During his five-year stay in Russian America, Voznesensky met many Russian-American Company employees, and some of them volunteered to assist him. The famous Alaska explorer Lavrentii Alikseevich Zagoskin wrote, "In addition to his labor for the benefit of the Imperial Academy of Sciences, the assistant zoologist Voznesensky succeeded in raising

in many of us the passion for collecting natural objects in the country, which up to this moment was very little known to the scientific world" (Zagoskin 1956:151–152). During his expedition in Russian America, Voznesensky visited almost all its regions—California, the Alexander Archipelago, the Kenai Peninsula, Kodiak Island, the Aleutian and Pribilof Islands, the coasts of Norton Sound and Bering Strait—acquiring collections in all these places.

On June 22, 1842, Voznesensky, accompanied by the Creole, F. Druzhinin, sailed aboard the brig *Promysel* to Kodiak Island. Aboard the same vessel was the general manager of the Russian-American Company, Adolf Karlovich Etolin (the Russianized name of Arvid Adolf Ethólen), traveling to Kodiak for an official inspection. In five days, the brig anchored in St. Paul's Harbor. At first, Voznesensky traveled with Etolin, or Ethólen, as he is better known. On July 7, the *Promysel,* with Ethólen, Voznesensky, and the manager of the Russian-American Company's Kodiak office, I. S. Kostromitinov, departed for Nikolaevsky Redoubt on the Kenai Peninsula. The ship reached its destination two days later, and Voznesensky parted ways with Ethólen. Nikolaevsky Redoubt became his base for several expeditions on the Kenai Peninsula. He hiked to the Kenai Mountains, paddled his *baidarka,* or kayak, to Kalgin Island in Cook Inlet, traveled by the Kenai and Kasilof Rivers to Tustamena Lake, and kayaked and hiked more than eighty versts (85.3 km or 53.3 miles) along the coast of Cook Inlet from Point Mikeshin to Kachemak Bay. He traveled the entire west shore of Cook Inlet, both north and south of Nikolaevsky Redoubt, up to Ninilchik, located on the point the Dena'ina called Sunit, and further to Point Starichkov (Stuk-tal-qhin [Shtuhtałent] in the Dena'ina language), and from there to Kachemak Bay.

In a diary entry dated July 29, 1842, Voznesensky described his trip north from Nikolaevsky Redoubt:

> This is the narrowest part of Cook Inlet, a flat point extends from the coast of Alaska in a sharp corner. The distance to it is insignificant—one can

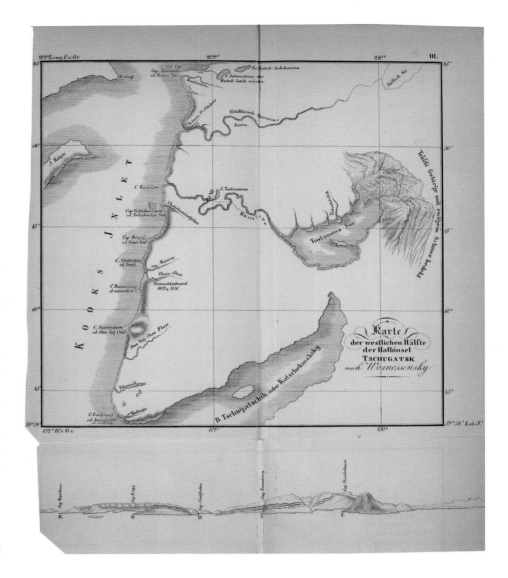

Map 15.1 Voznesensky's map of Cook Inlet (Grewingk 1850:iv). Courtesy of the Elmer E. Rasmuson Library, University of Alaska Fairbanks.

reach it in calm weather in baidarka in an hour and a half (9–10 verst [5.9 km; 6.6 miles]). Kenaitze call this point *Kustan* [*Kustatan*]. At the very edge of the point, there are two Kenaitze villages. The population of these villages is less than 100 people. In clear weather, one can see the smoke from their barabaras. The shore of this point is as high above the surface of water as on Kenai. From this point Cook Inlet

is becoming wider. I walked from the pasture to a Kenaitze village, which is located at the hour and a half walking distance from here…there is one large barabara here, in which about 30 Kenaitze live. These Kenaitze were going to go up to the mountains to hunt mountain sheep. This settlement which I visited today is called *Nuktaz-Kitat*. (St. Petersburg Division of the Russian Academy of Sciences, Collection 53, Binder 1: part 1, no.1/8 folio 19, verso)

During his stay on Kenai Peninsula, Voznesensky acquired collections of Dena'ina (Kenaitze), Tanana (Koltsan), Ahtna (Copper River), and Chugach Eskimo materials. While registering Voznesensky's collections at the end of the nineteenth century, Kunstkamera museum staff member K. K. Gilzen mistakenly recorded objects collected by E. A. Borisov (collected in 1856–1859) and A. F. Kashevarov (accessioned in 1868) as parts of the Voznesensky Collection. The Voznesensky Collection is one of the largest Dena'ina collections in the Kunstkamera. A close look at the objects in this collection reveals that they constitute several sets, likely purchased together to provide complete information about people's clothing and tools. For example, men's outfits in this collection are often completed with hide quivers and bows and arrows.

The most complete set of men's clothing consists of a caribou skin tunic (no. 2667-5), moccasin-trousers (no. 2667-8), a pair of mittens (no. 2667-13/1-2), and a pair of gloves (no. 2667-11/1-2) decorated with the geometric designs woven with porcupine quills.

The next men's outfit is represented by a tunic (no. 2667-3) and moccasin-trousers (no. 2667-7). Both are ornamented with porcupine quills. Voznesensky purchased these objects in 1840 in Novo-Archangelsk, and although he lists them as manufactured by Kenaitze (Dena'ina), the quilled design indicates they might have been made by Ahtna Athabascans.

Another Dena'ina outfit consists of a tunic (no. 620-40/a), moccasin-trousers (no. 620-40/b) (see fig. 13.10b, c, and a pair of gloves (no. 620-40/v 1–2).

A shirt (no. 2667-40) and pants (no. 2667-39) also belong to the Dena'ina collection. The museum paperwork lists them as Alutiiq objects of Katmai village on the east coast of the Alaska Peninsula. Katmai people and Dena'ina regularly traded with each other. The materials, cut, porcupine quill embroidery, and silverberry seed decorations of these items, however, indicate that they were made by Dena'ina. It is noteworthy that the ornamentation on these objects differs from the ornamentation on other items of clothing from the Voznesensky collection.

The last man's outfit consists of moccasin-trousers with porcupine quill decoration (no. 2667-6), a hide quiver (no. 593-60/a), and an arrow (no. 593-60/b). Regarding the use of arrows, Voznesensky wrote, "arrows with metal points are used to hunt bears and dears, the arrows with bone points are used to hunt fox, sable, and other animals, as well as birds" (St. Petersburg Division of the Russian Academy of Sciences, Collection 142, Binder 1: no.9, folio 144 verso). The similarity of the ring decorations on the arrow shafts makes it possible to suggest that along with the arrow no. 593-60/b, the arrows nos. 2890-13, 2890-14, and 2890-16 were at some point part of this set.

The hide cape or robe (no. 593-27), purchased by Voznesensky on Sitka Island in 1844, is also likely a Dena'ina object, as is evident from the material, ornamentation, and porcupine quill and silverberry seed embellishment.

Women's clothing is represented by a long dress with straight hem (no. 620-41/a) and matching gloves (no.620-41/b/1–2). It is noteworthy that in Voznesensky's collection of Northern Athabascan (Dena'ina, Ahtna, and Tanana) objects, the hems of all the women's dresses are straight, while all the men's tunics have V-shaped hems. Almost all items of clothing in this collection are decorated with porcupine quills and seeds. Voznesensky wrote in his journal,

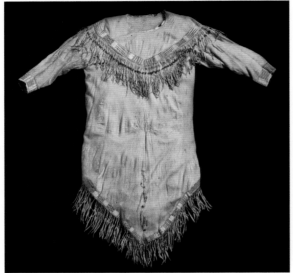

FIG 15.5

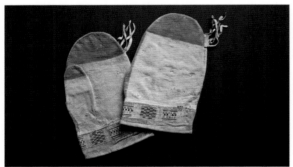

FIG 15.7

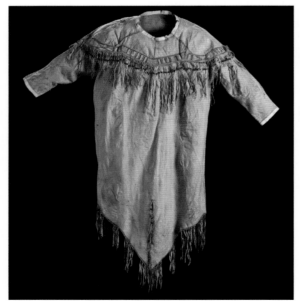

FIG 15.9

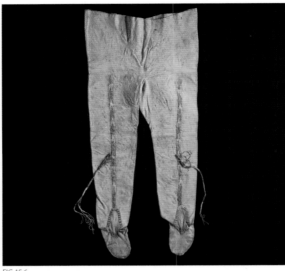

FIG 15.6

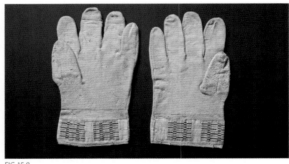

FIG 15.8

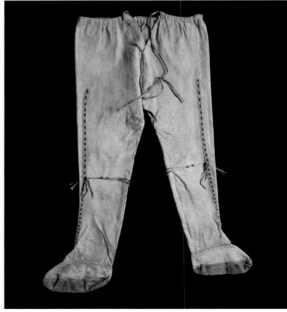

FIG 15.10

15.5 *Kił dghak'a*, tunic, Kenai Peninsula, 1842. L 130 cm. Caribou hide, porcupine quills, sinew, silverberry seeds, fur. Peter the Great Museum of Anthropology and Ethnography (Kunstkamera), 2667-5. Photograph by Chris Arend.

15.6 *Tl'useł*, man's moccasin-trousers, Kenai Peninsula, 1842. L 114 cm, W 49 cm. Caribou, quills, sinew. Peter the Great Museum of Anthropology and Ethnography (Kunstkamera), 2667-8. Photograph courtesy of the Peter the Great Museum of Anthropology and Ethnography (Kunstkamera). Photograph by Chris Arend.

15.7 *Gech'*, mittens, Kenai Peninsula, 1842. L 23 cm, W 13.5 cm. Caribou hide, porcupine quills, sinew, silverberry seeds, ochre. Peter the Great Museum of Anthropology and Ethnography (Kunstkamera), 2667-13/1–2. Photograph by Chris Arend.

15.8 *Lugech'*, gloves, Kenai Peninsula, 1842. L 25 cm, W 15 cm. Caribou hide, porcupine quills, sinew. Peter the Great Museum of Anthropology and Ethnography (Kunstkamera), 2667-11/1–2. Photograph by Chris Arend.

15.9 *Kił dghak'a*, man's tunic, Kenai Peninsula, 1840. L 137 cm, W 59 cm. Caribou hide, sinew, porcupine quills, silverberry seeds, ochre. Museum of Anthropology and Ethnography (Kunstkamera), 2667-3. Photograph by Chris Arend.

15.10 *Tl'useł*, man's moccasin-trousers, Kenai Peninsula, 1840. L 113 cm, W 48 cm. Caribou hide, ochre, porcupine quills, sinew. Peter the Great Museum of Anthropology and Ethnography (Kunstkamera), 2667-7. Photograph by Chris Arend.

15.11 *Lugech'*, gloves, Kenai Peninsula, 1842. L 24 cm, W 13 cm. Caribou hide, porcupine quills, sinew, fur, ochre. Peter the Great Museum of Anthropology and Ethnography (Kunstkamera), 620-40v/1–2. Photograph by Chris Arend.

15.12 *Tl'useł*, man's moccasin-trousers, Katmai, (Dena'ina?). L 128 cm, W 45 cm. Caribou hide, sinew, ochre, porcupine quills. Peter the Great Museum of Anthropology and Ethnography (Kunstkamera), 2667-39. Photograph by Chris Arend.

15.13 *Kił dghak'a*, man's tunic, Katmai, 1842. L 120 cm. Caribou hide, sinew, porucpine quills, ochre, silverberry seeds. Peter the Great Museum of Anthropology and Ethnography (Kunstkamera), 2667-40. Photograph by Chris Arend.

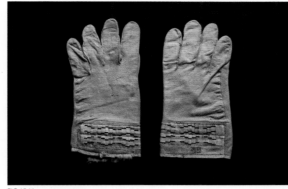

FIG 15.11

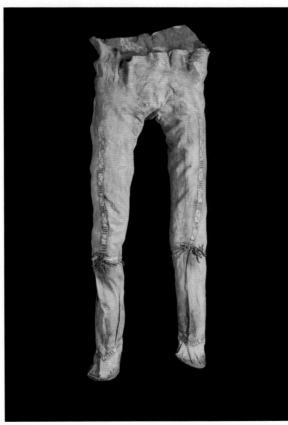

FIG 15.12

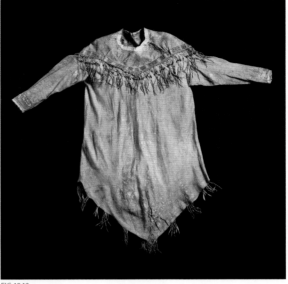

FIG 15.13

In Knik (at the top of Cook Inlet) there is a berry, which is quite tasty and sweet, and is much loved by Kenaitze, who make porridge out of it. This berry is round and smooth, white in color and in flesh. The seeds are black. Kenaitze thread them and use as decorations for their shirts. It is slightly larger than a pea. It grows in flat places, in the clayish soil close to rivers. The Kenaitze call it *tah'cheq'a*. (St. Petersburg Division of the Russian Academy of Sciences, Collection 53, Binder 1: no.1/6, folio 25 verso)

The Dena'ina hunting tools and weapons in the Voznesensky collection include several bows (nos. 2667-17, 2667-19, and 2667-20). Spears with stone points were used for hunting large animals and as weapons of war. The bow no. 2667-20 is a reinforced type of bow, while nos. 2667-17 and 2667-19 are basic bows. The basic bows were used for hunting land animals, while bows with shafts reinforced with sinew were used for hunting marine mammals. The reinforced bow no. 2667-20 has an antler wrist guard protruding from the inner side of the wooden

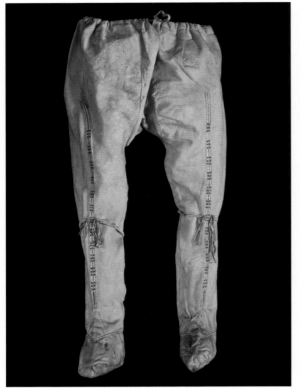

FIG 15.14a

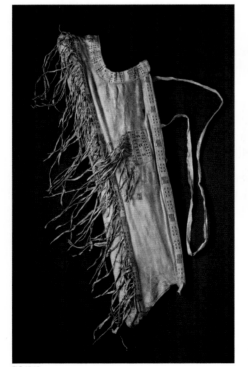

FIG 15.15

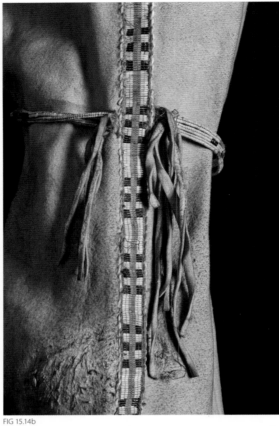

FIG 15.14b

FIG 15.16

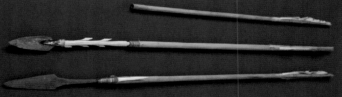

FIG 15.17

15.14a *Tl'useł*, **man's moccasin-trousers, Kodiak Island, 1842.** L 102 cm, W 50 cm. Caribou hide, porcupine quills, sinew. Peter the Great Museum of Anthropology and Ethnography (Kunstkamera), 2667-6. Photograph by Chris Arend.

15.14b *Tl'useł*, **man's moccasin-trousers, detail of figure 15.14a.** Peter the Great Museum of Anthropology and Ethnography (Kunstkamera), 2667-6. Photograph by Chris Arend.

15.15 *Q'us*, **quiver, Kenai Penninsula, 1842.** L 78 cm, W 22 cm. Wood, caribou hide, pocupine quills, sinew. Peter the Great Museum of Anthropology and Ethnography (Kunstkamera), 593-60/a. Photograph by Chris Arend.

15.16 *Izin*, **arrow, Kenai Peninsula, 1842.** L 74 cm. Wood, sinew, feathers, caribou antler, iron, pigment. Peter the Great Museum of Anthropology and Ethnography (Kunstkamera), 593-60/b. Photograph by Chris Arend.

15.17 *K'qes*, **arrow shaft and *Izin*, arrows, Alaska, Athabascan, 19th century.** L of shaft 54 cm; L of arrows 74 cm. Wood, sinew, feathers, caribou antler, iron, pigment. Peter the Great Museum of Anthropology and Ethnography (Kunstkamera), 2890-13, 2890-14, and 2890-16. Photograph by Chris Arend.

15.18 *Vejex ch'da*, Cape (robe), Sitka Island, 1844. L 190 cm. Caribou hide, ochre, silverberry seeds, porcupine quills, sinew. Peter the Great Museum of Anthropology and Ethnography (Kunstkamera), 593-27. Photograph © Peter the Great Museum of Anthropology and Ethnography (Kunstkamera)

15.19 *Lugech'*, woman's gloves, Kenai Peninsula, 1842. L 23 cm, W 14.5 cm. Caribou hide, porcupine quills, fur, sinew. Peter the Great Museum of Anthropology and Ethnography (Kunstkamera), 620-41/b/1–2. Photograph by Chris Arend.

15.20 *Kił dghak'a*, woman's dress, Kenai Peninsula, 1842. L 154 cm. Caribou hide, fur, porcupine quills, ochre, sinew. Peter the Great Museum of Anthropology and Ethnography (Kunstkamera), 620-41/a. Photograph by Chris Arend.

15.21 Detail of *Dehgega* (silverberry seeds) on man's tunic (figure 15.4), Nikolaevsky Redoubt, 1830–1838. Peter the Great Museum of Anthropology and Ethnography (Kunstkamera), 518-3/a. Photograph by Chris Arend.

FIG 15.18

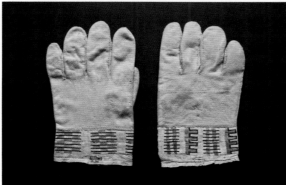

FIG 15.19

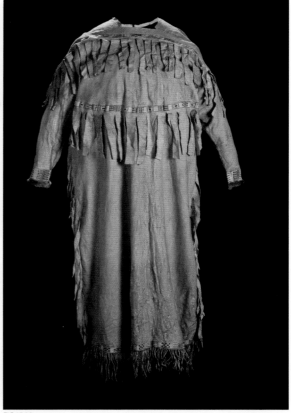

FIG 15.20

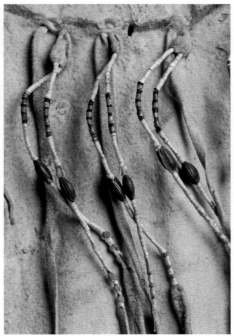

FIG 15.21

shaft. This guard prevents injury to the shooter's wrist from the bowstring.

All hatchets (clubs) in the Kunstkamera collection are customarily identified as Ahtna Indian objects, but the mid-nineteenth-century museum label of hatchet no. 2667-14 reads "Ancient Kenaitze Hatchet." To make a hatchet, Dena'ina used the heavy antler of young caribou, cutting out of it a large piece with the second lower branch. A hide strip was wrapped around its bottom part and served as a handle. The average length of Ahtna

FIG 15.22

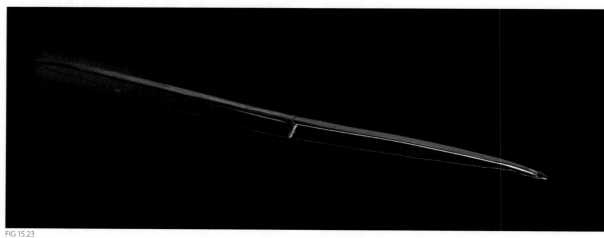

FIG 15.23

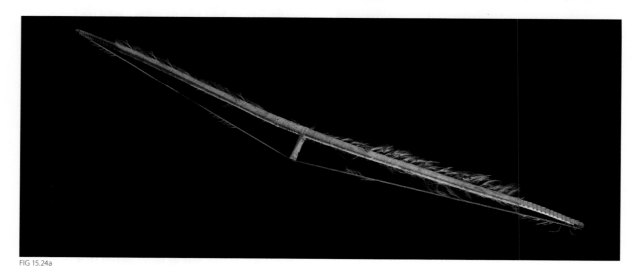

FIG 15.24a

15.22 *Ts'iłten*, **bow, Kenai Peninsula, 1842.** L 147 cm. Wood, sinew, ochre. Peter the Great Museum of Anthropology and Ethnography (Kunstkamera), 2667-17. Photograph by Chris Arend.

15.23 *Ts'iłten*, **bow, Kenai Peninsula, 1842.** L 141 cm. Wood, sinew, ochre. Peter the Great Museum of Anthropology and Ethnography (Kunstkamera), 2667-19. Photograph by Chris Arend.

15.24a *Ts'iłten*, **reinforced bow, Kenai Peninsula, 1842.** L 149.5 cm. Wood, ochre, hide, caribou antler, hair, fabric, porcupine quills, sinew. Peter the Great Museum of Anthropology and Ethnography (Kunstkamera), 2667-20. Photograph by Chris Arend. (See also figures 15.24b, c, d.)

15.24b *Ts'iłten*, **reinforced bow, detail of figure 15.24a.** Peter the Great Museum of Anthropology and Ethnography (Kunstkamera), 2667-20. Photograph by Chris Arend.

15.24c *Gguna delchedi*, **bow guard, detail of figure 15.24a.** Photograph courtesy of the Peter the Great Museum of Anthropology and Ethnography (Kunstkamera), 2667-20. Photograph by Chris Arend.

15.24d *Ts'iłten*, **reinforced bow, detail of figure 15.24a.** Peter the Great Museum of Anthropology and Ethnography (Kunstkamera), 2667-20. Photograph by Chris Arend.

FIG 15.24b

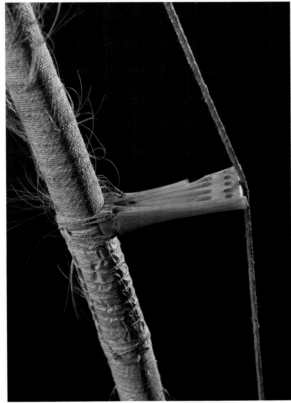

FIG 15.24c

FIG 15.24d

decorated with tufts made of narrow caribou hide strips. Voznesensky wrote, "Both young and old (men) were armed with such hatchets, hiding them under the collars of their hide shirts or parkas" (St. Petersburg Division of the Russian Academy of Science, Collection 142, Binder 1: no.9, folio 139).

Other Dena'ina artifacts in Voznesensky's collection are represented by singular objects. These are split willow branches with the bark peeled off, used by women for making baskets (no. 571-28), a vessel made of steamed mountain sheep horn (no. 571-27), two women's knife stone blades for cleaning skins (no. 2667-25 and 2667-38), and a woven-root fishing net (no. 2667-26). These nets were used on rivers during the salmon run (see figure 1.22). The wooden platforms on poles were built over the water specially for catching salmon. Elders and children sat on them and scooped fish from the water.

hatchets is 60–66 cm, while the length of hatchet no. 2667-14 is only 45 cm. Another difference is the lack of an opening for inserting a stone blade at the "working" end of the hatchet. The hide handle wrap is decorated with fringes, while the other North American hatchets in the Kunstkamera are

One of the rarest objects in the Voznesensky collection is the shaman's doll (no. 2667-15). It is fashioned as a Dena'ina man dressed in traditional clothes embellished with beads, his face painted with symbolic designs. He is armed with a hatchet and a quiver. According to traditional beliefs, such dolls housed the shaman's spirit helper, who acted on the shaman's orders. The dolls were used during shamanistic séances for exorcising evil spirits from a patient's body (see figures 13.13, 15.27a, b).

Voznesensky remained in Kenai until September 19, when he boarded the brig *Kvikhpakh* and departed for Kodiak. Describing the collections acquired during his Kenai expedition he wrote,

> The zoological, botanical, mineralogical and ethnographic collections I acquired consist of a remarkable number of interesting objects and specimen, collected in the Kenai mountains, which the local inhabitants call Tryyli, at the Tustamena Lake, from which Kasilof River takes its beginning, from Kalgin Island and many other places. (St. Petersburg Division of the Russian Academy of Sciences, Collection 53, Binder 1: no. 35, folio 8)

Several Dena'ina objects in the Kunstkamera collections were acquired by Mikhail Dmitrievich Tebenkov (1802–1872) who served as the general manager of the Russian possessions in America from 1845 to 1850. Tebenkov was acquainted with Voznesensky, whom he met on his way to Russian America, in the Siberian port of Aian. Like his predecessor, A. K. Etholén, he was interested in collecting objects pertaining to the traditional lifestyles of Alaska Native peoples.

After his return to St. Petersburg, Tebenkov donated his collection to the Museum of Arms and Armor—the Imperial Arsenal—in Tsarskoe Selo. In 1907, the arsenal's collection of indigenous armor was transferred to the Ethnographic Department of the Russian Museum, where it was registered as three different collections. Two of them, no. 1266 and no. 1267, are thematic collections of arms and

FIG 15.25

FIG 15.26

15.25 *Q'ey K'eda*, split willow branches, Kenai Peninsula, 1842. Coil: L 32 cm, W 16 cm. Peter the Great Museum of Anthropology and Ethnography (Kunstkamera), 571-28. Photograph by Chris Arend.

15.26 *Nuji da baqili*, large bowl, Kenai Peninsula, 1842. L 30 cm, W 12.5 cm. Dall sheep horn. Peter the Great Museum of Anthropology and Ethnography (Kunstkamera), 571-27. Photograph by Chris Arend.

armor of Alaska Native peoples. They consist of large numbers of similar spears, harpoons, fish spears, points, and throwing boards. The large number of similar objects indicates that these collections originated from different collectors. The third collection, no. 1298, differs from the other two in its comprehensive instead of thematic approach. It contains not only weapons but also shamanistic objects and clothing. The breadth of the collection suggests that it originated with one collector instead of being assembled from different sources according to a specific theme. Some of the objects in this collection can with some certainty be identified as mid-nineteenth century. It was accessioned by the Arsenal much later than the two collections mentioned above.

F. K. Volkov and S. I. Rudenko, researching the Alaska ethnographic collections in Russia in 1910,

15.27a, b *Chik'a q'enin'a,* **shaman's doll, Kenai Peninsula, 1842.** L 39 cm, W 10.5 cm. Wood, ochre, black pigment, bone, caribou hide, beads, sinew, feathers, human hair. Peter the Great Museum of Anthropology and Ethnography (Kunstkamera), 2667-15. Photograph by Chris Arend.

FIG 15.27a

FIG 15.27b

wrote, "regarding this later acquisition we learned that some of Arsenal objects were collected and delivered by Mr. Tebenkov, former General Manager of the Russian colonies in Alaska" (Volkov and Rudenko 1910:156). Although there is no direct evidence that this collection belonged to Tebenkov, this information suggests that some of the objects from his collection made their way to the Ethnographic Department of the Russian Museum. In 1938, they were transferred to the MAE and registered as nos. 5795 and 5801.

Another interesting collection was received from Petr Pavlovich Doroshin (1823–1875). In 1845, P. P. Doroshin graduated from the St. Petersburg Institute of the Corps of Mountain Engineers with the rank of lieutenant. After completing a mandatory internship, he was accepted into the service

of the Russian-American Company. He served in Russian America from 1848 to 1853, and collected throughout his entire stay in Alaska. He has also compiled some ethnographic notes. On returning to St. Petersburg, he gave his notes to the curator of Ethnographic Museum, Leopold Fedorovich Radlov (1818–1865). At the time, Radlov was working on a book about the Tlingit language, but his untimely death prevented its publication. In 1875, Radlov's manuscript came into the possession of the French researcher, Alphonse Pinart. It is possible that along with it, Pinart also received P. P. Doroshin's "informative ethnographic notes." Currently, the location of Doroshin's notes is not known.

In 1854, Doroshin donated his ethnographic collection to the newly formed Museum of the Imperial Russian Geographical Society. Doroshin's collection is listed in the 1879 catalog of this museum. When

the museum was closed in 1891, Doroshin's collection, along with other ethnographic collections, was accessioned by the Kunstkamera. Kunstkamera staff member L. Y. Shternberg wrote,

> Loads of collections from all parts of Russia, brought in 1891 from the former Geographical Society Museum, were piled in the basements, lacking both the description and object numbers with an exception of fragmentary notes and occasional labels, which were the only clue to this algebraic equation with many unknowns. (Shternberg 1917:248)

There are several Dena'ina objects in Doroshin's collection. The Russian Geographical Society catalog lists an arrow, no. 2667-22/a–b: "No. 539 Arrows and quiver; the latter is made of sealskin. The arrow points are made of green flint. They are used in bear and deer hunts. In the Kenaitze language, the arrow is *izin*." There are also two sets of gambling sticks, no. 337-15/1–2: "Gambling game (*tsindlyah*) of aboriginal people of America. From Kenaitze of North-West coast of America" (Russian Imperial Geographical Society 1879:23). In 1932, the arrow no. 2667-22/a–b was transferred to the Museum of the Religion and Atheism. The quiver and other arrows are likely registered as "old museum collections." The Russian Geographical Society catalog also lists a number of other objects from Doroshin's collection, which are not yet found. These are: "No. 536—an adze (*K'duheł*) made of deer antler, the weapon of Goltsan, one of Tanaina tribes. No. 537—bows of Kenaitze from the north shore of Iliamna, or Shelikhov, lake. In Kenaitze language, the bow is *tsylhten*. No.538—arrow used by Iliamna Kenaitze for bird hunt" (Russian Imperial Geographical Society 1879:23).

Doroshin spent most of his time on Kenai Peninsula, where he collected interesting ethnographic material. A. A. Shifner (director of the museum from 1845 to 1865) in his introduction to L. F. Radlov's article published six Tanaina (Dena'ina) songs, recorded by Doroshin, two of

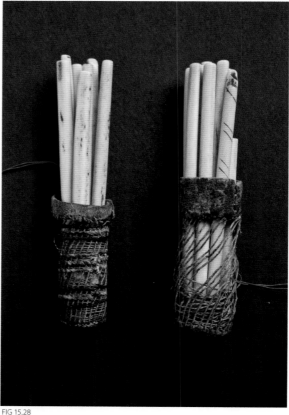

FIG 15.28

15.28 *Ch'enlahi k'enut'a,* **gambling sticks (7 in case and 9 in case), Kenai Peninsula, 1848–1853.** L 8.5–9 cm. Bone, sinew, hide. Peter the Great Museum of Anthropology and Ethnography (Kunstkamera), 337-15/1 and 337-15/2. Photograph by Chris Arend.

which are shamanistic (Blomkvist 1975:106). After his return to St. Petersburg, Doroshin published several articles about his research in Russian America. Most of them are about geology, and only one contains traveling notes with ethnographic information about the Chugach and the Ahtna. There is no information about the Dena'ina (Doroshin 1866).

In September 1859, the Kunstkamera received from I. G. Voznesensky the ethnographic collection of Efim Aleksandrovich Borisov, an employee of the Russian American Company and the manager of Nikolaevsky Redoubt from 1856 to 1859. Although the collection was quite numerous and included several dozen objects, its larger part was destined to go to the relatives of Borisov. The museum received a Dena'ina bow with painted hide quiver and nine arrows, another bow with four arrows without a quiver, a man's outfit with a shirt and pants,

15.29a, b *Ts'en zitl'i*, drinking tube, Knik, c. 1859. L 53 cm, W 2.3 cm; tube diam. 1.5 cm, L 21.5 cm. Animal bone, caribou skin, colored beads, sinew, pigment. Peter the Great Museum of Anthropology and Ethnography (Kunstkamera), 2667-29. Photograph courtesy of the Peter the Great Museum of Anthropology and Ethnography (Kunstkamera). Photograph by Chris Arend.

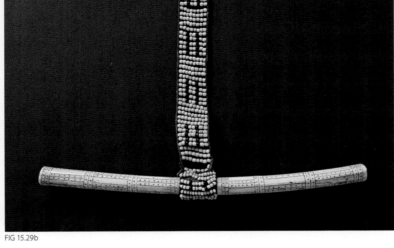

FIG 15.29b

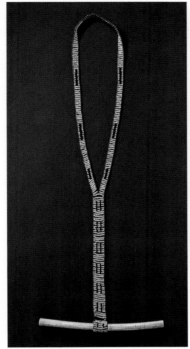

FIG 15.29a

gloves, hide headgear, a bone drinking tube, and a spear. All these objects were part of the clothing and hunting tools of a "distinguished" Dena'ina warrior from Knik village. The museum has also received the outfit of a "rich" Dena'ina woman, which consists of a shirt embellished with beads, a pair of mittens, and a pair of shoes (St. Petersburg Division of the Russian Academy of Sciences, Collection 46, Binder 1: no.3, folio 139 verso).

Voznesensky delivered the part of Borisov's collection intended for the museum immediately after his return to St. Petersburg. The other part of Borisov's collection was received in 1863. These were the objects that Borisov's relatives sold to the museum. The museum documentation allows the identification of objects from Borisov's collection accessioned both in 1859 and 1863. These are the Dena'ina bone drinking tube, no. 2667-29 ("A flute for drinking water, used during traveling and other times, with beads woven over the shoulder string [Ibid]"); a woman's shirt, no. 2667-1, with boots, no.

2667-16/1–2 ("An outfit of a distinguished Kenaitze woman: dressy hide tunic embellished with beads, a pair of ornamented gloves and a pair of boots decorated with beads [Ibid.]"); quiver no. 2667-30 and arrows no. 2667-31–36. In addition to these objects, Borisov's collection likely included one of the bows nos. 2667-17, 2667-19, and 2667-20, which are currently listed as part of the Voznesensky Collection (see figures 15.22, 15.23, and 15.24). The letter from Borisov to Voznesensky lists other Dena'ina objects, which have not yet been identified in the museum holdings. These are:

> Kenaitsy men's outfit, consisting of a jacket and pants with boots, called 'Galgana' made of suede with porcupine quills decorations, embroidered gloves, embellished suede and ground squirrel hat, spear used during the war…with the suede skin decorated with beads, with attached over the shoulder string. This set belongs to a distinguished warrior. Objects like this are used by today's Knik Kenaitze, who are located nearby Kolchan. There are also men's suede gloves embellished with porcupine quills, made

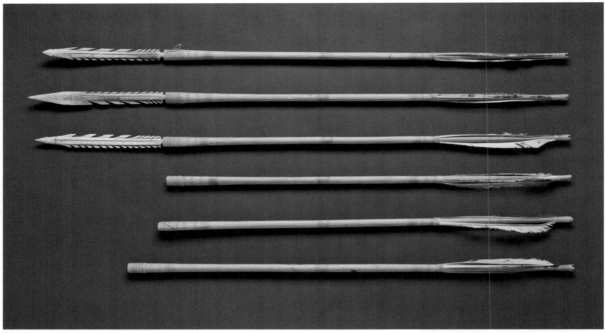

FIG 15.30

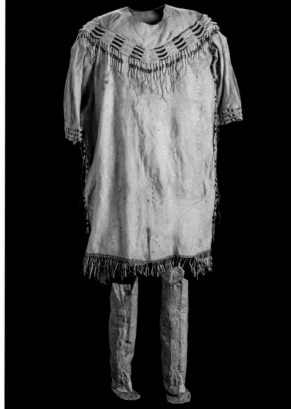

FIG 15.31

FIG 15.32

15.30 *Izin*, arrows (6), Knik, c. 1859. L 53.5–71.5 cm. Wood, caribou antler, feathers, ochre, sinew. Peter the Great Museum of Anthropology and Ethnography (Kunstkamera), From top: 2667-31, 2667-32, 2667-33, 2667-34, 2667-35, and 2667-36. Photograph by Chris Arend.

15.31 Woman's outfit: *K'isen dghak'a*, woman's dress, and *seł*, boots. Knik, c. 1859. Dress: L 110 cm, W 127 cm; boots: L 45 cm. Caribou hide, sinew, glass beads, porcupine quills, ochre, thread repair on boots. Peter the Great Museum of Anthropology and Ethnography (Kunstkamera), 2667-1 and 2667-16ab. Photograph by Chris Arend.

15.32 *Q'us*, quiver, detail of figure A.2. Peter the Great Museum of Anthropology and Ethnography (Kunstkamera), 2667-30. Photograph by Chris Arend.

by Kenaitsy. (St. Petersburg Division of the Russian Academy of Sciences, Collection 46, Binder 1: no.3, folio 139 verso)

The collection of Appolon Filippovich Kashevarov (1825–?) was shipped to the museum in August 1866 and received in St. Petersburg in 1868. Among the objects in this collection was "a suede parka, the Kenaitze clothes item" (St. Petersburg

15.33 *Kił dghak'a*, man's tunic, Alaska, 19th century. L 140 cm, W 136 cm. Caribou hide, sinew, porcupine quills, silverberry seeds, ochre. Peter the Great Museum of Anthropology and Ethnography (Kunstkamera), 2667-2. Photograph by Chris Arend.

15.34 *Tl'useł*, woman›s moccasin-trousers, Alaska, prior to 1844. L 95 cm, W 60 cm. Caribou hide, sinew, porcupine quills. Peter the Great Museum of Anthropology and Ethnography (Kunstkamera), 2667-9. Photograph by Chris Arend.

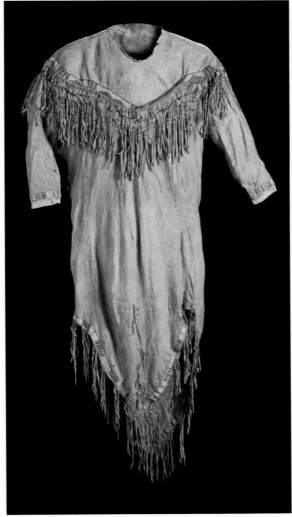

FIG 15.33

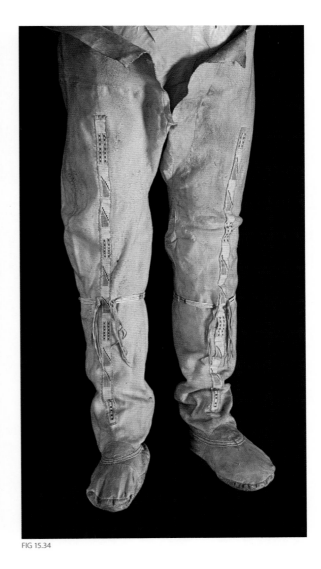

FIG 15.34

Division of the Russian Academy of Sciences, Collection 142, Binder 1: no. 8, folio. 29 verso). It has not yet been identified in the museum collections.

The provenance of several Dena'ina objects in the MAE collection is not known. These are a man's tunic no. 2667-2, moccasin-trousers no. 2667-9, boots no. 2667-37/1-2, mittens no. 2667-10/1–2, gloves no. 2667-12/1–2, and a quill-wrapped strip, possibly string for a pair of mittens, no. 2930-52. They might have been collected by I. G. Voznesensky,

V. I. Kashevarov, A. F. Kashevarov, P. P. Doroshin, or E. A. Borisov. Even without knowing who collected these objects, it is clear that they were made in the mid-nineteenth century.

In summary, all the Dena'ina objects in MAE collection were acquired during the period from 1818 to 1866, when the Dena'ina Indians maintained their traditional culture and the same lifestyle their ancestors had practiced for hundreds of years.

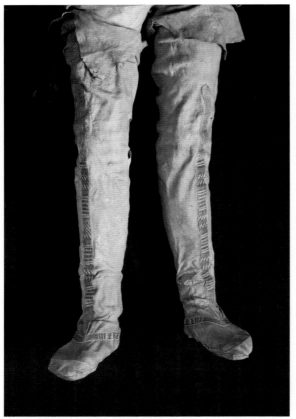

FIG 15.35a

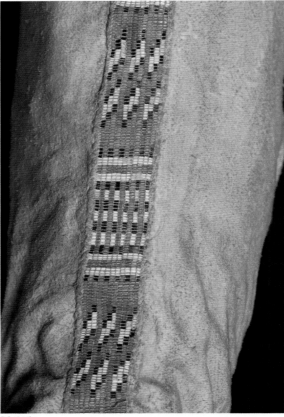

FIG 15.35b

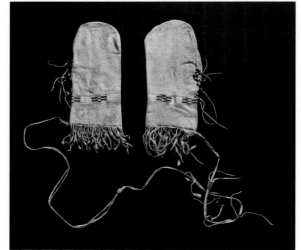

FIG 15.36

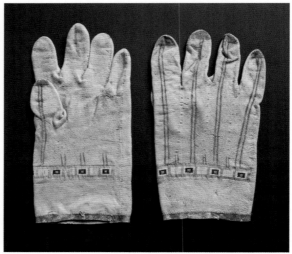

FIG 15.37

15.35a, b *Tl'useł*, woman's moccasin-trousers, Alaska, 19th century. L 103 cm, W 25 cm. Caribou hide, porcupine quills, ochre, sinew. Peter the Great Museum of Anthropology and Ethnography (Kunstkamera), 2667-37/1-2. Photograph by Chris Arend.

15.36 *Gech'*, mittens with string, Alaska, 19th century. L 36 cm, W 18.5 cm. Caribou hide, sinew, porcupine quills, ochre, beads. Peter the Great Museum of Anthropology and Ethnography (Kunstkamera), 2667-10/1–2. Photograph by Chris Arend.

15.37 *Lugech'*, gloves, Alaska, 19th century. L 26 cm, W 11 cm. Caribou hide, ochre, porcupine quills. Peter the Great Museum of Anthropology and Ethnography (Kunstkamera), 2667-12/1–2. Photograph by Chris Arend.

15.38 *Gech' tl'ila*, **quill-wrapped strip (mitten string?), Alaska, 19th century.** L 152 cm. Caribou hide, sinew, porcupine quills, beads. Peter the Great Museum of Anthropology and Ethnography (Kunstkamera), 2930-52. Photograph by Chris Arend.

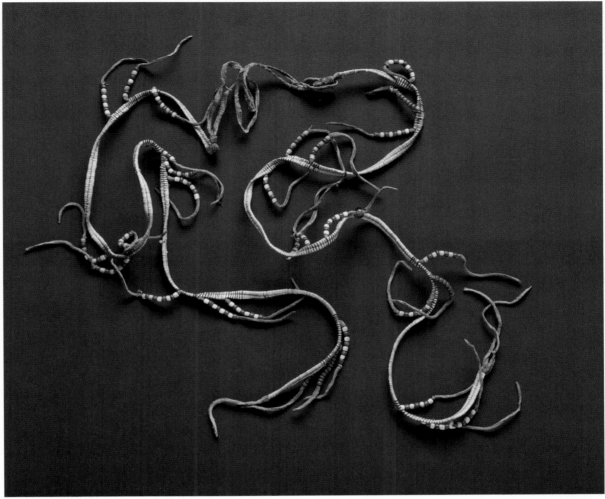

FIG 15.38

Appendix

List of the Dena'ina objects from the Peter the Great Museum of Anthropology and Ethnography (Kunstkamera)

Tools and Weapons

1. Dagger no. 539-3
People: Dena'ina
Dimensions: L 40.7 cm, W 12.5 cm
Materials: Iron, abalone shell
Collector: Vasilii Mikhailovich Golovnin, 1818, Alaska
See figures 11.12 and 15.1

2. War Club no. 2667-14
People: Most likely Dena'ina
Dimensions: L 52 cm, W 14 cm
Materials: Caribou antler, caribou hide, glass beads, pigment, sinew
Collector: I. G. Voznesensky, 1842, Kenai Peninsula
See figure 15.0

3. Quiver no. 593-60/a
People: Dena'ina
Dimensions: L 78 cm, W 22 cm
Materials: Wood, caribou hide, sinew, porcupine quills
Collector: I. G. Voznesensky, 1842, Kenai Peninsula
This quiver is a part of the set that includes arrow no. 593-60/b and possibly arrows nos. 2890-13, 2890-14, and 2890-16.
See figure 15.15

4. Arrow no. 593-60/b
People: Most likely Dena'ina
Dimensions: L 74 cm; W 2 cm
Materials: Wood, sinew, feathers, caribou antler, iron, pigment
Collector: I. G. Voznesensky, 1842, Kenai Peninsula
See figure 15.16

5. Arrow Shaft no. 2890-13
People: Most likely Dena'ina
Dimensions: L 54 cm, diam. 0.8 cm
Materials: Wood, pigment, feathers, sinew
Collector: No information, 19th century, Alaska
See figure 15.17

6. Arrow no. 2890-14
People: Most likely Dena'ina
Dimensions: L 74 cm, W 2 cm
Materials: Wood, pigment, sinew, caribou antler, feathers, iron
Collector: No information, 19th century, Alaska
See figure 15.17

7. Arrow no. 2890-16
People: Most likely Dena'ina
Dimensions: L 74.5 cm, W 2.2 cm
Materials: Wood, pigment, sinew, feathers, iron
Collector: No information, 19th century, Alaska
See figure 15.17

8. Bow no. 2667-17
People: Dena'ina
Dimensions: L 147 cm, W 2.8 cm
Materials: Wood, sinew, ochre
Collector: I. G. Voznesensky, 1842, Kenai Peninsula
See figure 15.22

9. Bow no. 2667-19
People: Dena'ina
Dimensions: L 141 cm, W 4.5 cm
Materials: Wood, sinew, ochre
Collector: I. G. Voznesensky, 1842, Kenai Peninsula
See figure 15.23

10. Reinforced Bow no. 2667-20
People: Dena'ina
Dimensions: L 149.5 cm, W 5.8 cm
Materials: Wood, pigment, hide, caribou antler, hair, fabric, porcupine quills, sinew
Collector: I. G. Voznesensky, 1842, Kenai Peninsula
See figures 15.24a–d

11. Reinforced Bow no. 2667-18
People: Dena'ina
Dimensions: L 134.5 cm, W 3.5 cm
Materials: Wood, hide, sinew
Collector: S. P. Khruschev, 1823, Alaska
See figure 15.2

12. Quiver no. 2667-30
People: Dena'ina
Dimensions: L 77 cm, W 24.5 cm
Materials: Caribou hide, pigment, bird feather quills, beads, sinew
Collector: E. A. Borisov, prior to 1859, Knik
See figures A.2 and 15.32
This quiver is a part of a set that includes arrows nos. 2667-31, 2667-32, 2667-33, 2667-34, 2667-35, and 2667-36, and arrow point no. 2667-28.

13. Arrow Point with Blade no. 2667-28
People: Dena'ina
Dimensions: L 19.5 cm, W 2.3 cm
Materials: Caribou antler, copper, sinew
Collector: No information, 19th century, Alaska
This arrow point is part of a set that includes arrows nos. 2667-31, 2667-32, 2667-33, 2667-34, 2667-35, and 2667-36.

14. Arrow with Arrow Point, without Blade, no. 2667-31
People: Dena'ina
Dimensions: L 70 cm, W 1.8 cm
Materials: Wood, ochre, caribou antler, feathers, sinew
Collector: E. A. Borisov, prior to 1859, Knik
See figure 15.30

15. Arrow no. 2667-32.
People: Dena'ina
Dimensions: L 71.5 cm, W 2 cm
Materials: Wood, pigment, caribou antler, feathers, sinew
Collector: E. A. Borisov, prior to 1859, Knik
See figure 15.30

16. Arrow without Blade no. 2667-33
People: Dena'ina
Dimensions: L 70.5 cm, W 1.5 cm
Materials: Wood, ochre, feathers, caribou antler, sinew
Collector: E. A. Borisov, prior to 1859, Knik
See figure 15.30

17. Arrow Shaft no. 2667-34
People: Dena'ina
Dimensions: L 53.5 cm, diam. 1.4 cm
Materials: Wood, ochre, feathers, sinew
Collector: E. A. Borisov, prior to 1859, Knik
See figure 15.30

18. Arrow shaft no. 2667-35
People: Dena'ina
Dimensions: L 54.5 cm, diam. 1.6 cm
Materials: Wood, ochre, feathers, sinew
Collector: E. A. Borisov, prior to 1859, Knik
See figure 15.30

19. Arrow Shaft no. 2667-36
People: Dena'ina
Dimensions: L 58 cm, diam. 1.4 cm
Materials: Wood, ochre, feathers, sinew
Collector: E. A. Borisov, prior to 1859, Knik
See figure 15.30

20. Bow no. 5801-1
People: Likely Dena'ina
Dimensions: L 138.5 cm, W 3 cm
Materials: Wood, hide, sinew
Collector: Likely M. D. Tebenkov, 1845–1850, Alaska

21. Quiver no. 5801-2.
People: Likely Dena'ina
Dimensions: L 65 cm, W 21 cm
Materials: Caribou hide, paint, wood, porcupine quills, beads, sinew
Collector: Likely M. D. Tebenkov, 1845–1850, Alaska

Clothing

22. Man's Tunic no. 518-2/a
People: Dena'ina.
Dimensions: L 139 cm with fringe, L 125 cm without fringe, W 76 cm
Materials: Caribou hide, ochre, porcupine quills, silverberry seeds, sinew
Collector: V. I. Kashevarov, 1830–1838, Nikolaevsky Redoubt
This tunic is a part of a set that includes moccasin-trousers no. 518-2/b.
See figure 15.3

23. Moccasin-Trousers no. 518-2/b
People: Dena'ina
Dimensions: L 125 cm, W 48 cm
Materials:Caribou hide, ochre, porcupine quills
Collector: V. I. Kashevarov, 1830–1838, Nikolaevsky Redoubt
See figure 15.3

24. Man's Tunic no. 518-3/a
People: Dena'ina
Dimensions: L 140 cm with fringe, L 128 cm without fringe, W 69 cm
Materials: Caribou hide, fur, ochre, porcupine quills, silverberry seeds, sinew
Collector: V. I. Kashevarov, 1830–1838, Nikolaevsky Redoubt
See figures 15.4 and 15.21

25. Man's Tunic no. 620-40/a
People: Dena'ina
Dimensions: L 138 cm with fringe, L 122 cm without fringe, W 70 cm
Materials: Caribou hide, fur, ochre, porcupine quills, silverberry seeds, sinew
Collector: I. G. Voznesensky, 1842, Kenai Peninsula
This tunic is a part of a set that includes moccasin-trousers no. 620-40/b and gloves no. 620-40/v/1-2.
See figure 13.10b, c

26. Moccasin-Trousers no. 620-40/b
People: Dena'ina
Dimensions: L 126 cm, W 56 cm
Materials: Caribou hide, porcupine quills, sinew
Collector: I. G. Voznesensky, 1842, Kenai Peninsula
See figure 13.10b, c

27. Gloves no. 620-40/v/1–2
People: Dena'ina
Dimensions: L 24 cm, W 13 cm
Materials: Caribou hide, fur, porcupine quills, sinew
Collector: I. G. Voznesensky, 1842, Kenai Peninsula
See figure 15.11

28. Woman's Dress no. 620-41/a
People: Dena'ina
Dimensions: L 154 cm with fringe, L 142 cm without fringe, W 90 cm
Materials: Caribou hide, fur, ochre, porcupine quills, sinew
Collector: I. G. Voznesensky, 1842, Kenai Peninsula
This dress is a part of a set that includes gloves no. 620-41/b/1–2.
See figure 15.20

29. Gloves no. 620-41/b/1–2
People: Dena'ina
Dimensions: L 23 cm, W 14.5 cm
Materials: Caribou hide, fur, porcupine quills, sinew
Collector: I. G. Voznesensky, 1842, Kenai Peninsula
See figure 15.19

30. Woman's Dress no. 2667-1
People: Dena'ina
Dimensions: L 110 cm with fringe, L 101 cm without fringe, W 79 cm
Materials: Caribou hide, ochre, porcupine quills, beads, sinew
Collector: E. A. Borisov, prior to 1859, Knik
This dress is a part of a set that includes boots no. 2667-16/1–2.
See figure 15.31

31. Boots no. 2667-16/1–2
People: Dena'ina
Dimensions: H 45 cm, W. 18 cm
Materials: Caribou hide, beads, sinew, thread repair
Collector: E. A. Borisov, prior to 1859, Knik
This pair of boots is a part of the set that includes dress
no. 2667-1.
See figures 13.14 and 15.31

32. Man's Tunic no. 2667-3
People: Dena'ina or Ahtna
Dimensions: L 137 cm with fringe, L 126 cm without
fringe, W 59 cm
Materials: Caribou hide, ochre, porcupine quills, silverberry
seeds, sinew
Collector: I. G. Voznesensky, 1842, purchased in Sitka
This tunic is a part of a set that includes a man's moccasin-
trousers no. 2667-7.
The provenance of this tunic is uncertain. It is possible that this
is an Ahtna object.
See figure 15.9

33. Man's Moccasin-Trousers no. 2667-7
People: Dena'ina or Ahtna
Dimensions: L 113 cm, W 48 cm
Materials: Caribou hide, ochre, porcupine quills, sinew
Collector: I. G. Voznesensky, 1842, purchased in Sitka
See figure 15.10

34. Man's Tunic no. 2667-5
People: Dena'ina
Dimensions: L 130 cm with fringe, L 120 cm without
fringe, W 54 cm
Materials: Caribou hide, fur, porcupine quills, silverberry
seeds, sinew
Collector: I. G. Voznesensky, 1842, Kenai Peninsula.
This tunic is a part of a set that includes a man's moccasin-
trousers no. 2667-8, gloves no. 2667-11/1–2, and mittens no.
2667-13/1–2.
See figure 15.5

35. Man's Moccasin-Trousers no. 2667-8
People: Dena'ina
Dimensions: L 114 cm, W 49 cm
Material: Caribou hide, porcupine quills, sinew
Collector: I. G. Voznesensky, 1842, Kenai Peninsula
See figure 15.6

36. Gloves no. 2667-11/1–2
People: Dena'ina
Dimensions: L 25 cm, W 15 cm
Material: Caribou hide, porcupine quills, sinew
Collector: I. G. Voznesensky, 1842, Kenai Peninsula
See figure 15.8

37. Mittens no. 2667-13/1–2
People: Dena'ina
Dimensions: L 23 cm, W 13.5 cm
Material: Caribou hide, ochre, sinew, porcupine quills
Collector: I. G. Voznesensky, 1842, Kenai Peninsula
See figure 15.7

38. Cape no. 593-27
People: Likely Dena'ina
Dimensions: L 190 cm with fringe, L 172 cm without fringe, W
190 cm with fringe, W 180 cm without fringe
Materials: Caribou hide, ochre, porcupine quills, silverberry
seeds, sinew
Collector: I. G. Voznesensky, 1844, Sitka Island
This cape was purchased by Voznesensky in 1844 from Sitka
Island Tlingits. According to the collector's information,
this cape was worn over armor. This is likely a Dena'ina-
made object.
See figure 15.18

39. Man's Tunic no. 2667-40
People: Dena'ina
Dimensions: L 120 cm with fringe, L 114 cm without
fringe, W 68 cm
Materials: Caribou hide, ochre, porcupine quills, silverberry
seeds, sinew
Collector: I. G. Voznesensky, 1842, Katmai
This tunic is a part of a set that includes moccasin-trousers no.
2667-39. According to the Voznesensky Collection inventory,
this set was purchased from Katmai Sugpiat. Katmai Sugpiat
likely obtained it in trade from the Dena'ina.
See figure 15.13

40. Moccasin-Trousers no. 2667-39
People: Likely Dena'ina
Dimensions: L 128 cm, W 45 cm
Materials: Caribou hide, sinew, ochre, porcupine quills
Collector: I. G. Voznesensky, 1842, Katmai
See figure 15.12

41. Man's Moccasin-Trousers no. 2667-6
People: Dena'ina
Dimensions: L 102 cm, W 50 cm
Materials: Caribou hide, porcupine quills, sinew
Collector: I. G. Voznesensky, 1842, Kodiak Island
See figures 15.14a, b

42. Man's Tunic no. 2667-2
People: Likely Dena'ina
Dimensions: L 136 cm with fringe, W 50 cm
Materials: Caribou hide, ochre, porcupine quills, silverberry
seeds, sinew
Collector: Unknown, 19th century, Alaska
The provenance is not clear. It might be an Ahtna object.
See figure 15.33

43. Moccasin-Trousers no. 2667-9
People: Dena'ina
Dimensions: L 95 cm, W 60 cm
Materials: Caribou hide, porcupine quills, sinew
Collector: Unknown, 19th century, Alaska
See figure 15.34

44. Mittens with Tie String no. 2667-10/1–2
People: Dena'ina.
Dimensions: mittens: L 36 cm, W 13.5 cm; tie: L 120 cm.
Materials: Caribou hide, ochre, porcupine quills, beads, sinew
Collector: Unknown, 19th century, Alaska
See figure 15.36

45. Quill-Wrapped Strip (Mitten String?) no. 2930-52
People: Dena'ina
Dimensions: L 152 cm
Materials: Caribou hide, porcupine quills, sinew, beads
Collector: Unknown, 19th century, Alaska
See figure 15.38

46. Gloves no. 2667-12/1–2
People: Dena'ina
Dimensions: L 26 cm, W 11 cm
Materials: Caribou hide, ochre, sinew, porcupine quills
Collector: Unknown, 19th century, Alaska
See figure 15.37

47. Boots no. 2667-37/1–2
People: Likely Dena'ina
Dimensions: L 103 cm, W 25 cm
Materials: Caribou hide, porcupine quills, ochre, sinew
Collector: Unknown, 19th century, Alaska
See figures 15.35a, b

Utensils

48. Drinking Tube no. 2667-29
People: Dena'ina
Dimensions: Tie string: L 53 cm, W 2.3 cm; tube: L 21.5 cm, diam. 1.5 cm
Materials: Caribou hide, bone, pigment, beads, sinew
Collector: E. A. Borisov, prior to 1859, Knik
See figure s 15.29a, b

49. Large Bowl no. 571-27
People: Dena'ina
Dimensions: L 30 cm, W 12.5 cm, H 9.5 cm
Materials: Dall sheep horn
Collector: I. G. Voznesensky, 1842, Kenai Peninsula
See figure 15.26

50. Willow Branches for Weaving no. 571-28
People: Dena'ina
Dimensions: coil L 32 cm, W 16 cm
Materials: Willow branches
Collector: I. G. Voznesensky, 1842, Kenai Peninsula
See figure 15.25

51. Dip Net (Fish Net) no. 2667-26
People: Dena'ina
Dimensions: L 110 cm, W 47 cm, depth 25 cm
Materials: Wood (alder?), spruce root?
Collector: I. G. Voznesensky, 1842, Kenai Peninsula
See figures 1.22, 1.23

52. Scraper Blade no. 2667-25
People: Dena'ina
Dimensions: L 14.5 cm, W 7.8 cm
Materials: Argillite
Collector: I. G. Voznesensky, 1842, Kenai Peninsula

53. Scraper Blade no. 2667-38
People: Dena'ina
Dimensions: L 11.4 cm, W 5.1 cm
Materials: Argillite
Collector: I. G. Voznesensky, 1842, Kenai Peninsula

54. Set of Gambling Sticks (7) in Case no. 337-15/1
People: Dena'ina
Dimensions: L 8.5 cm, diam. 1.5 cm
Materials: Bone, sinew, hide
Collector: P.P. Doroshin, 1848–1853, Kenai Peninsula
See figure 15.28

55. Set of Gambling Sticks (9) in Case no. 337-15/2
People: Dena'ina
Dimensions: L 9 cm, diam. 1.6 cm
Materials: Bone, hide, sinew
Collector: P. P. Doroshin, 1848–1853, Kenai Peninsula
See figure 15.28

Ceremonial Objects

56. Shaman's Doll no. 2667-15
People: Dena'ina
Dimensions: L 39 cm, W 10.5 cm
Materials: Wood, ochre and black pigment, bone, caribou hide, beads, sinew, feathers, human hair
Collector: I. G. Voznesensky, 1842, Kenai Peninsula
See figures 13.13, 15.27a, b

Notes

1. *Promyshlenniki* were free laborers from Siberia who provided contract services, often in crafts and maritime trades. They became an important element of the fur trade in Alaska, and many were eventually hired by the Russian-American Company.

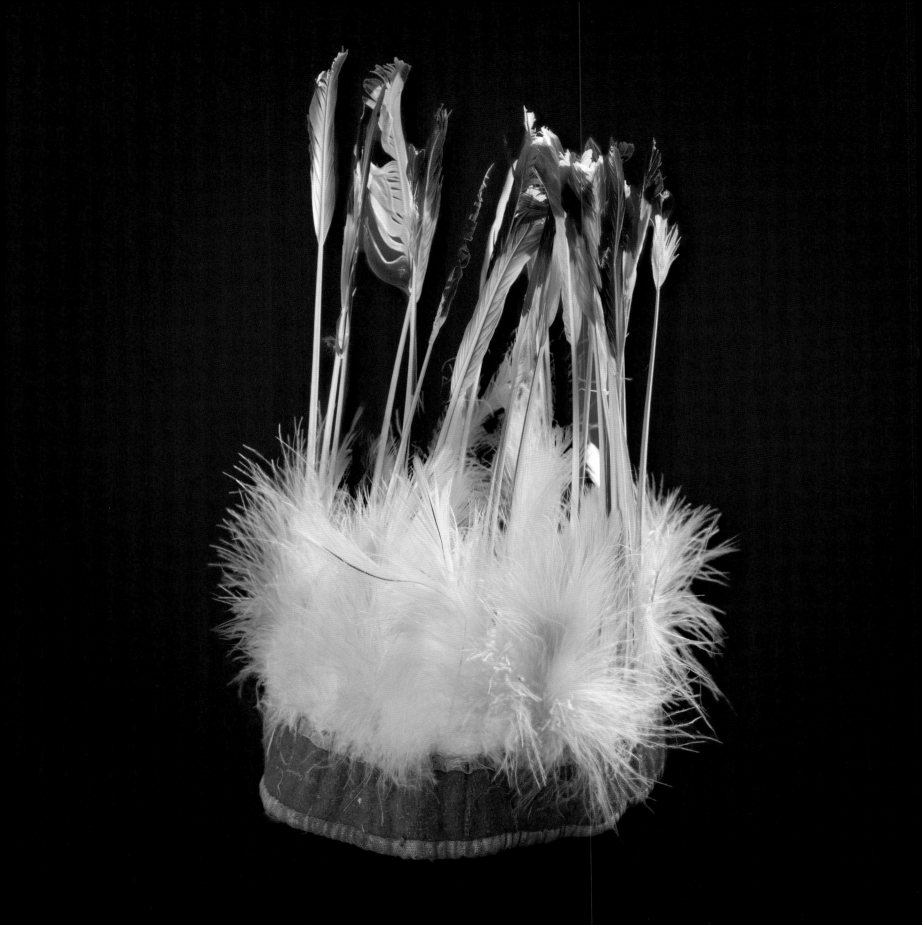

16

Adrian Jacobsen's Dena'ina Collection in the Ethnologisches Museum Berlin

Viola König

Twenty-eight objects in the *Dena'inaq' Huch'ulyeshi* exhibition come from the Ethnologisches Museum Berlin, Germany. All were acquired by the same collector, Johan Adrian Jacobsen, who visited Alaska in 1883. The particulars of his commission from the Ethnologisches Museum to collect ethnographic material are best viewed in the context of his time.

Johan Adrian Jacobsen's Institutional Background

Johan Adrian Jacobsen was one of several outstanding contemporaries of Adolf Bastian (1826–1905), the founding director of the Berlin Museum für Völkerkunde (today's Ethnologisches Museum), who contributed to the building up of its huge collections at the end of the nineteenth century. These collecting activities were personally promoted by Bastian, and their traces are still evident today, not only in the Ethnological Museum in Berlin but far beyond, in the world abroad. The course of these collectors' achievements and the reasons for the acquisition of the most important collections in the museum have been studied in depth.

The collectors who worked for the Ethnologische Museum were from diverse backgrounds; nonetheless, they all pursued a common goal, namely, amassing large collections, sometimes with an eye to quality as well. In the late nineteenth century, the ethnological museum was a new type of institution, and according to the historian Douglas Cole, this caused a "scramble" for objects to an extent that would never be repeated (Cole 1985). During this founding phase of ethnological museums, Berlin assumed a leading role both nationally and internationally, creating envy as well as criticism on the part of contemporary collectors.

Just a quarter century after the opening of Berlin's Ethnologisches Museum in 1886, however, and only six years after Adolf Bastian's death, the museum's general director, Wilhelm von Bode, issued an assessment that not only demoted the museum to an institution of strictly "natural" ethnological aspects but also limited its acquisition policies:

> A museum of ethnology must limit itself accordingly to the collection of products of natural peoples, if it is not to degenerate into a monstrous universal museum, that is, to a disorderly, completely overladen and useless collection of jumble....In general, the progressive development of the Ethnological Museum will depend not only upon the increment of its holdings, but far more in their rational limitation and purposeful arrangement....First the ethnographical departments must be freed from the

16.0 *Chijeł*, feather headdress, Tyonek, collected by Captain J. Adrian Jacobsen, 1883. W 23.5 cm, H 27.5 cm. Feathers, down, wool, cloth binding. Ethnological Museum Berlin, IVA 6107. Photograph courtesy of Staatliche Museen zu Berlin, Ethnologisches Museum. Photograph by Chris Arend.

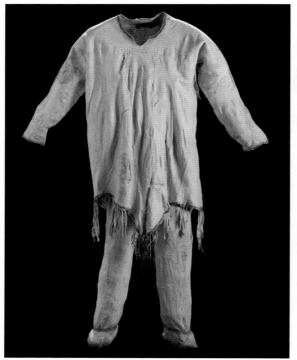

FIG 16.1a

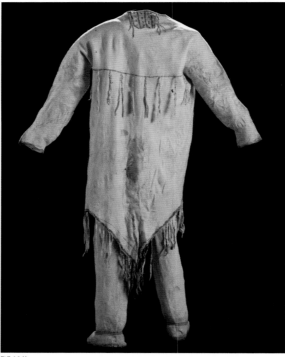

FIG 16.1b

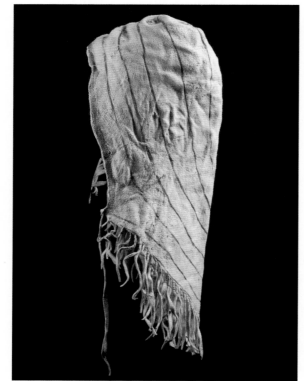

FIG 16.1c

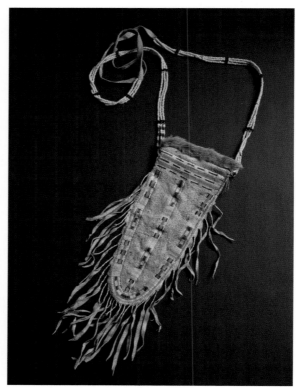

FIG 16.2

16.1a, b *Tl'useł*, moccasin-trousers and and *kił dghak'a*, tunic (front and back views), Tyonek, collected by Captain J. Adrian Jacobsen, 1883. L moccasin-trousers 110 cm, W 57 cm, L tunic 129 cm. Caribou hide, ochre, porcupine quills, sinew, thread. Ethnological Museum Berlin, IVA 6098, IVA 6096. Photograph courtesy of Staatliche Museen zu Berlin, Ethnologisches Museum. Photograph by Chris Arend.

16.1c *Chik'ish*, man's hood, Tyonek, collected by Captain J. Adrian Jacobsen, 1883. L 55 cm, W 22 cm; caribou hide, red ochre, sinew. Ethnological Museum Berlin, IVA 6099. Photograph courtesy of Staatliche Museen zu Berlin, Ethnologisches Museum. Photograph by Chris Arend.

16.2 *K'izhagi yes*, knife sheath, Athabascan from Yukon (?). L 34 cm, W 21 cm. Caribou hide, porcupine quills, beads, sinew, otter or beaver fur. Ethnological Museum Berlin, IVA 9088. Photograph courtesy of Staatliche Museen zu Berlin, Ethnologisches Museum. Photograph by Chris Arend.

16.3 *K'izhagi yes, chughi,* **knife sheath with beaver tooth, Tyonek, collected by Captain J. Adrian Jacobsen, 1883.** L 57 cm with strap, W 9 cm. Moose hide, beads, beaver tooth. Ethnological Museum Berlin, IVA 6101. Photograph courtesy of Staatliche Museen zu Berlin, Ethnologisches Museum. Photograph by Chris Arend.

16.4 *K'izhagi yes,* **knife sheath, Tyonek, collected by Captain J. Adrian Jacobsen, 1883.** L 75 cm. Moose hide, beads, dentalium shells, sinew. Ethnological Museum Berlin, IVA 6102. Photograph courtesy of Staatliche Museen zu Berlin, Ethnologisches Museum. Photograph by Chris Arend.

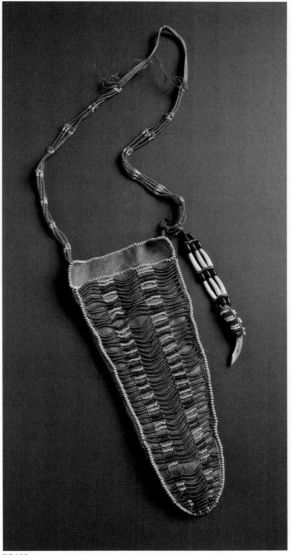

FIG 16.3

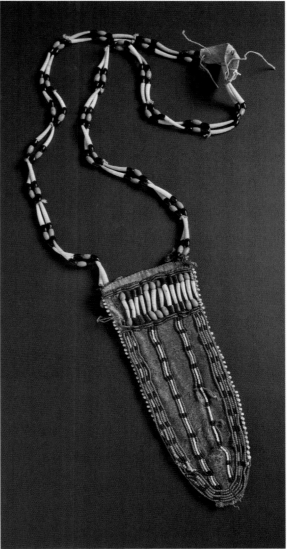

FIG 16.4

burden of duplicates, through sale, exchange or, if there is no other possibility, simply donation.[1] (Westphal-Hellbusch 1973:27)

In the ensuing decades, this "liberation" from the "burden of duplicates" led to activities that are hardly imaginable today, explainable at best by the enormous size of the collections acquired during Bastian's lifetime. Entire collections were torn apart and the contents distributed to other museums in Europe. Thus, the idea that a museum should free itself of duplicate materials accounts in large part for the widespread existence of collections and objects in European museums today.

Adolf Bastian, the Ethnologische Museum's founding director, is often portrayed as an odd person who was reserved when in the company

of others. Nevertheless, he was able to convince and enlist distinguished and effective persons as co-workers. The discovery, selection, and advancement of each individual collector must be seen as Bastian's special merit and recognized as his handiwork. For these persons carried on Bastian's work in a direct sequence and with considerable success. The museum and the field of ethnology continue to profit from the accomplishments of these collectors today.

Johan Adrian Jacobsen—Collector, Traveler, Adventurer

It was not only the academicians who contributed to the qualitative growth of the holdings of the Ethnologisches Museum Berlin. It was also individuals such as Johan Adrian Jacobsen, whose museum collecting work is internationally known today. Jacobsen, whose homeland was Norway, was a mariner, and he also worked as a collector under commission to Adolf Bastian. The museum owes no less than 11,000 objects to his collecting activities, some 7,000 of which he brought back from the Northwest Coast of North America and Alaska, thus representing the largest collection from that region. In addition, he procured 4,000 objects from Indonesia, forming the second largest collection in the subject area of South and Southeast Asia. The quality of the objects in both cases is beyond any doubt. The most comprehensive biography of Johan Adrian Jacobsen has been written by Ann Fienup-Riordan and appears in her book, *Yup'ik Elders at the Ethnologisches Museum Berlin* (2005).

Jacobsen was born October 9, 1853, on the island of Risö near Tromsö in northern Norway. He came from an ordinary fisherman's family and received no proper formal education. After attending a school of navigation in Tromsö, at the age of sixteen he assumed command of a fishing boat. In 1874, he traveled to Hamburg, where his brother had his own business. Soon thereafter Jacobsen undertook his first long voyage, to Valparaiso, Chile. On returning to Hamburg in 1877, he acquired an ethnographic collection from Greenland for Carl Hagenbeck. In

FIG 16.5

16.5 *Nk'itl'it*, girl's wristlets, Tyonek, collected by Captain J. Adrian Jacobsen, 1883. L 7 cm. Dentalium shells, beads, sinew, hide. Ethnological Museum Berlin, IVA 6127 ab. Photograph courtesy of Staatliche Museen zu Berlin, Ethnologisches Museum. Photograph by Chris Arend.

1878, Jacobsen traveled to Berlin with this collection, as well as with several indigenous persons from Lapland and three from Patagonia. Hagenbeck and Jacobsen toured these people together with one of the popular "folk shows" (*Völkerschau*), including eight Labrador Inuit; the tour, however, ended in disaster when the Inuit, who were not vaccinated, died of smallpox. Shocked by this experience, Hagenbeck and Jacobsen ceased conducting tours with exotic peoples for a time (Haberland 1987:337).

In 1881, Jacobsen seized the opportunity to carry out a collecting trip along the Northwest Coast of America under commission to Adolf Bastian for the Berlin museum. The previous year Bastian, during a return voyage from Polynesia via North America, had recognized that the indigenous cultures of the Northwest Coast, who had come into close contact with Europeans only at the end of the eighteenth century, were in transition and, he believed, already on the brink of extinction. The complex social structure of Northwest Coast cultures, together with an art style that was unique in North America and based on highly developed ornamental motifs and excellence in carving, moved Bastian to raise

16.6 *Seɫ*, woman's boots (pair), Tyonek, collected by Captain J. Adrian Jacobsen, 1883. L 52 cm,. Caribou hide, beads, dentalium shells, sinew, ochre. Ethnological Museum Berlin, IVA 6123 ab. Photograph courtesy of Staatliche Museen zu Berlin, Ethnologisches Museum. Photograph by Chris Arend.

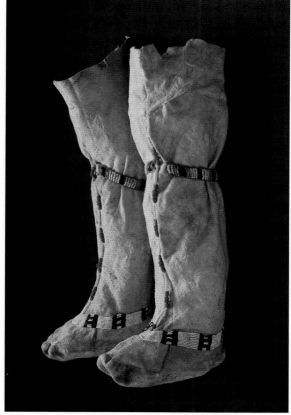

FIG 16.6

One must credit Jacobsen for not only possessing strong aesthetic criteria as a collector but also with farsighted judgment of the contemporary objects that surrounded him. He took the opportunity and stood witness to one of the most important periods in the transformation of the Indians of the Northwest Coast. Jacobsen competed both with travelers in search of curios as well as with the Indians themselves, who still made the objects for their own use: "Unfortunately," he wrote, "a scientific collector must take these circumstances into account and console himself with the fact that in the future the objects will become much more expensive" (Jacobsen in Woldt 1884:27).[2]

Jacobsen certainly shared in the common view, held by many in this great era of museum collecting, that North American Indians were in a period of transition and prospects were dim for the future of their arts and cultures. This is evident in Jacobsen's comments on Haida totem poles:

> A certain difference among the poles is also present on Queen Charlotte Island, insofar as the poles, the older [they are] are all the more beautifully and artistically made. This indicates that the artistic sense is gradually beginning to decrease. This is not at all surprising, for the Haida Indians are standing on a balance with extinction for more than one reason. (Jacobsen in Woldt 1884:28)[3]

Johan Adrian Jacobsen's documentation of the objects he acquired on the Northwest Coast left much to be desired—at least in the opinion of Franz Boas, who made use of the Jacobsen collection for his own ethnographic studies. Only with the later acquisitions from Indonesia did Jacobsen maintain a reliable documentation that earned praised on all sides. Today, however, scholars such as Peter Bolz and Ann Fienup-Riordan hold a more positive view of the value of Jacobsen's written commentaries.

After the great collecting trip for the Berlin Ethnologische Museum, Jacobsen remained active for years, traveling again to North America and

almost 25,000 marks to finance Jacobsen's two-year-long collecting trip.

Departing from San Francisco, Jacobsen traveled throughout the Northwest Coast region and into Alaska. He purchased objects from the Kwakwaka'wakw, the Haida, the Tlingit, and others; he acquired additional objects from the Yup'ik and Inupiaq peoples in the north and from the Athabascans in the Interior of Alaska. Stops on his journeys could last one hour or several weeks; thus, he was able to acquire collections from local artists themselves or their patrons, from their successors, and from local dealers. These indigenous objects were soon viewed as representative, even unique cultural artifacts. Before long, critical voices arose in the United States and Canada against "selling off" the work of indigenous cultures to a European (Cole 1985:37).

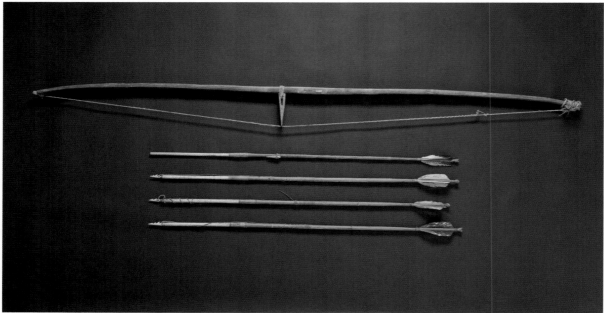

FIG 16.7

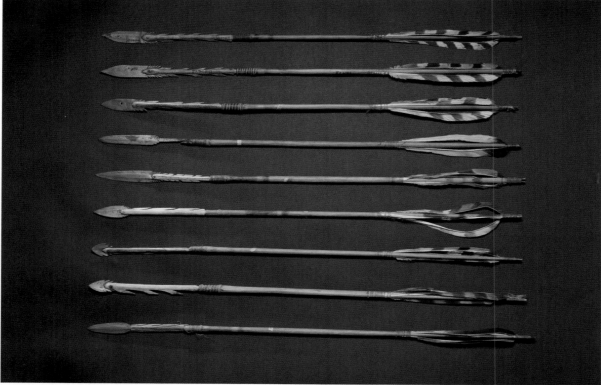

FIG 16.8

16.7 *Ts'iłten, tuqesi ts'iłq'u,* **bow and arrows, Fort Kenai, collected by Captain J. Adrian Jacobsen, 1883.** L bow 153.5 cm; L arrows 80–87 cm. Wood, bone, sinew, feathers, pigment, ochre. Ethnological Museum Berlin, from top: IVA 6164, 6161, 6162, 6160, and 6159. Photograph courtesy of Staatliche Museen zu Berlin, Ethnologisches Museum. Photograph by Chris Arend.

16.8 *Izin,* **arrows (9), Tyonek, collected by Captain J. Adrian Jacobsen, 1883.** Lengths vary; IVA 6082 is L 66 cm. Wood, metal, feathers, sinew, blue pigment, bone, ochre. Ethnological Museum Berlin, from top: IVA 6082, 6083, 6084, 6085, 6090, 6086, 6088, 6089, and 6092. Photograph courtesy of Staatliche Museen zu Berlin, Ethnologisches Museum. Photograph by Chris Arend.

16.9 *Ułkesa,* **bag for sewing, Tyonek, collected by Captain J. Adrian Jacobsen, 1883.** L 40.5 cm, W 27.5 cm; caribou hide, glass beads, ochre. Ethnological Museum Berlin, IVA 6134. Photograph courtesy of Staatliche Museen zu Berlin, Ethnologisches Museum. Photograph by Chris Arend.

16.10 *Chijeł,* **feather headdress, Tyonek, collected by Captain J. Adrian Jacobsen, 1883.** L 30 cm, W 15 cm. Feathers, sinew, downy feathers. Ethnological Museum Berlin, IVA 6106. Photograph courtesy of Staatliche Museen zu Berlin, Ethnologisches Museum. Photograph by Chris Arend.

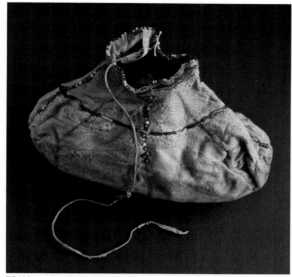

FIG 16.9

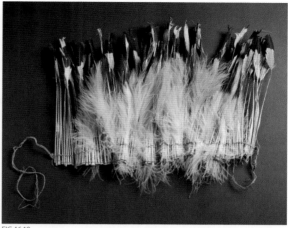

FIG 16.10

to Siberia. Later he returned to his involvement with "folk shows" and his association with Carl Hagenbeck. Jacobsen died on January 18, 1947. During his life, the Norwegian mariner and special collector for Adolf Bastian had carried out three major expeditions: to the Northwest Coast and Alaska (1881–1883), to Siberia and East Asia (1884–1885), and to Indonesia (1887–1888). However, while his collections from the Northwest Coast of British Columbia and the Yupiit in Alaska have been intensively studied, other parts remain almost unknown. Such is the case with the approximately eighty-three Dena'ina objects that Jacobsen collected. How did Jacobson acquire these artifacts?

Collecting and Digging in Dena'ina Country

Jacobsen's 1883 trip was almost completed when he finally reached Cook Inlet in June 1883. He stayed in the trading post of Tagunak (Tyonek), owned by the Alaska Commercial Company. He had noted difficulties he had in acquiring ethnographic objects on the south coast of Alaska, believing that people there no longer had any ritual requisites. At Tyonek, however, he was more successful, collecting a variety of most interesting objects, such as articles of

clothing made from reindeer and elk (caribou and moose) hide and wooden bows and arrows, among other things.

While collecting in Tyonek, Jacobsen noted that the prices he had to pay for the articles were considerable. Unlike in the far north, from where Jacobsen had just returned, acquiring objects through exchange and trade was not accepted in the southern part of Alaska. Jacobsen had to pay for objects with real money. He also noted that the Dena'ina were doing quite well hunting and fishing and were occupied with their seasonal hunting of the sea otter. "They were therefore difficult to access for my ethnographic options," he wrote.

On the eve of June 12, Jacobsen attended a feast in Tyonek, during which he observed that the Dena'ina way of dancing and singing was much "wilder and more emotional" than the Eskimo style. Jacobsen's description of the performance is worth reading:

> Whereas the Eskimo move their feet very little in their dances, the local… [Dena'ina] twist and bend their bodies with great force and liveliness and jump backward and forward. The dancers had painted their faces black, and instead of the feather ornaments of the Eskimo wore a handkerchief in

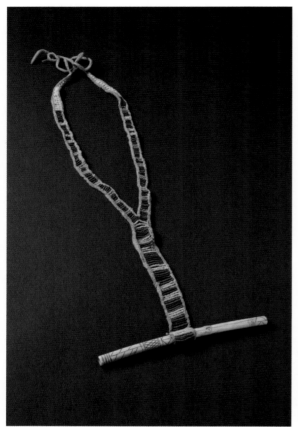

FIG 16.11

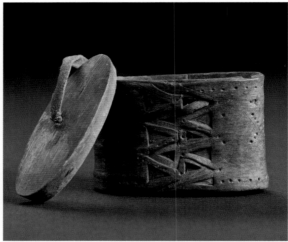

FIG 16.12

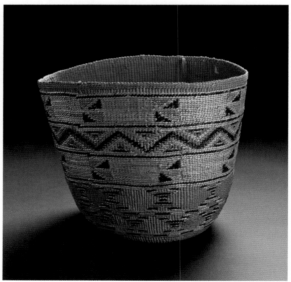

FIG 16.13

16.11 *Ts'en zitl'i*, drinking tube with strap, Tyonek, collected by Captain J. Adrian Jacobsen, 1883. L 44 cm with strap. Incised bone, caribou hide, sinew, glass beads. Ethnological Museum Berlin, IVA 6109. Photograph courtesy of Staatliche Museen zu Berlin, Ethnologisches Museum. Photograph by Chris Arend.

16.12 *Dabatnulgi*, snuff box with top, Fort Kenai collected by Captain J. Adrian Jacobsen, 1883. L 5.3 cm, W 3 cm. Wood, hide thong, ochre on lid, small nail or peg. Ethnological Museum Berlin, IVA 6166 ab. Photograph courtesy of Staatliche Museen zu Berlin, Ethnologisches Museum. Photograph by Chris Arend.

16.13 *Hagi*, twined basket, Knik River, collected by Captain J. Adrian Jacobsen, 1883. H 22.5 cm, diam. 26.5 cm. Spruce root, grass. Ethnological Museum Berlin, IVA 6151. Photograph courtesy of Staatliche Museen zu Berlin, Ethnologisches Museum. Photograph by Chris Arend.

their hair. The movements of the dancers became so wild and excited that the audience could only imagine that they were about to scalp one another. Every dancer held a feather in each hand. After the dance, in which five men participated together, gifts were distributed and received. (Jacobsen and Woldt 1977:193)

The next day, Jacobsen left for Fort Kenai and Kachemak Bay. He stopped at the Western Fur Trading Company's former trading post Akedaknak in Seldovia Bay to sail on to Fort Alexander, an Alaska Commercial Company trading post. Learning there about an abandoned archaeological site called Soonroodna, he immediately headed

back to Akedaknak to hire an elderly Indian as a guide (who sold Jacobsen an old stone lamp and a pair of rattles). Soonroodna, or Hardak/Hardanak, as the Eskimos called it, turned out to be a large, sprawling village. Though Jacobsen gave a detailed description of its position "below the third glacier at the south bank of Kachemak Bay," the site has not been located.

After three days of digging at the large site and in the surrounding area, Jacobsen returned

16.14 *Kinłvashi,* scraper, Fort Kenai, collected by Captain J. Adrian Jacobsen, 1883. L 13 cm, W 3 cm. Wood, bone, spruce root. Ethnological Museum Berlin, IVA 6154. Photograph courtesy of Staatliche Museen zu Berlin, Ethnologisches Museum. Photograph by Chris Arend.

16.15 *Ch'utl',* model of birch bark baby carrier, Fort Kenai, collected by Captain J. Adrian Jacobsen, 1883. W 18 cm, H 20 cm. Birch bark, split root or willow, thread, cloth, beads, yarn, dentalium shells, hide strips. Ethnological Museum Berlin, IVA 6157. Photograph courtesy of Staatliche Museen zu Berlin, Ethnologisches Museum. Photograph by Chris Arend.

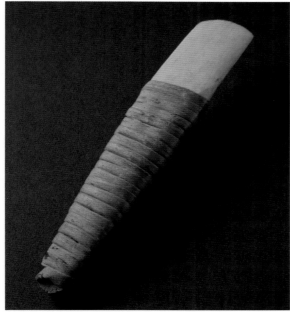

FIG 16.14

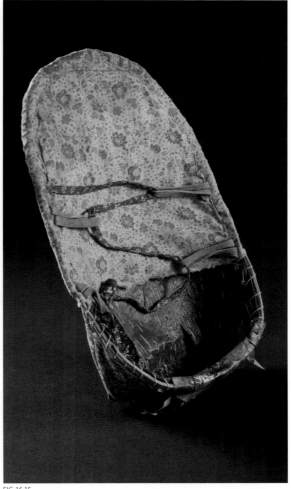

FIG 16.15

to the Alaska Commercial Company post at Fort Alexander, where he sorted his collection. On July 7, 1883, he sailed from Fort Alexander to Kodiak Island, where he continued his collections work.

Unfortunately, Jacobsen did not provide as much information on the Dena'ina as on the groups in the north that he had visited before. He did not feel that his collecting output was spectacular, and by then he had almost reached the end of his long trip. As Jacobsen repeatedly mentioned, he had to pay "real money," and the Dena'ina pieces were expensive. However, they were well worth it, and today we are delighted to house this small collection at the Ethnologische Museum Berlin.

A View to the Future

In 2005, Peter Bolz, curator of North American collections at the Ethnologische Museum Berlin, wrote in his foreword to Ann Fienup-Riordan's book:

> Recently, plans have been made to move Berlin's Ethnological Museum to the site of the former palace of the Prussian kings, into the city's center. Public discussion of these plans generated the perennial question: Why does the Ethnological Museum keep so many objects instead of just selecting and keeping the best, most artistic ones?

Bolz promptly answered that question himself:

> Each single piece that is preserved from the past is a unique document of a culture. This culture may have changed, but it has not disappeared, and each

FIG 16.16

16.16 *Ułkesa,* **gut bag, Tyonek, collected by Captain J. Adrian Jacobsen, 1883.** W 30 cm, H 28 cm. Seal intestine, thread, wool, fabric. Ethnological Museum Berlin, IVA 6121. Photograph courtesy of Staatliche Museen zu Berlin, Ethnologisches Museum. Photograph by Chris Arend.

16.17 *Ułkesa,* **gut bag, Tyonek, collected by Captain J. Adrian Jacobsen, 1883.** W 31 cm, H 35 cm. Intestine, wool (?). Ethnological Museum Berlin, IVA 6122. Photograph courtesy of Staatliche Museen zu Berlin, Ethnologisches Museum. Photograph by Chris Arend.

FIG 16.17

object is a witness of its people's rich heritage. For Native peoples these objects have become symbols of their history and important guideposts for their future. (Fienup-Riordan 2005:x)

These words respond to the words we hear from the Dena'ina of the twenty-first century. We are more than willing to lend objects of a hitherto unknown and unstudied collection to Alaska museums. More than this, the way the Berlin objects will be presented and interpreted in the Anchorage Museum's *Dena'inaq' Huch'ulyeshi* exhibition has great importance for our museum. In the near future, these objects will be exhibited in a new building in the center of Berlin called the Humboldt Forum. In this new museum, we wish to present our Alaska collections from the Alaska Native perspective to an international public. Creating this installation will require strong cooperation and regular collaboration between the Alaska and Berlin museums. *Dena'inaq' Huch'ulyeshi* is a perfect opportunity to commence such a partnership.

Notes

1. In a letter sent to the museum from Tokyo, September 16, 1911. The correspondence, "Ernest Grosse 16.9.1911" is housed under I/MV 0486 in the archives of the Ethnologisches Museum, Berlin.

2. "Diesem Umstande muss ein wissenschaftlicher Sammler leider Rechnung tragen und sich mit der Tatsache trösten, dass die Gegenstände in Zukunft sicherlich noch viel theurer werden werden."

3. "Ein gewisser Unterschied der Pfähle unter einander besteht auch auf den Königin Charlotte Inseln insofern, als die Pfähle, je älter, auch um so schöner und kunstfertiger hergestellt sind. Es beweist dies, dass der Kunstsinn allmählich abzunehmen beginnt. Zu verwundern ist dies keineswegs, denn die Haida-Indianer stehen aus mehr als einem Grunde auf dem Aussterbeetat."

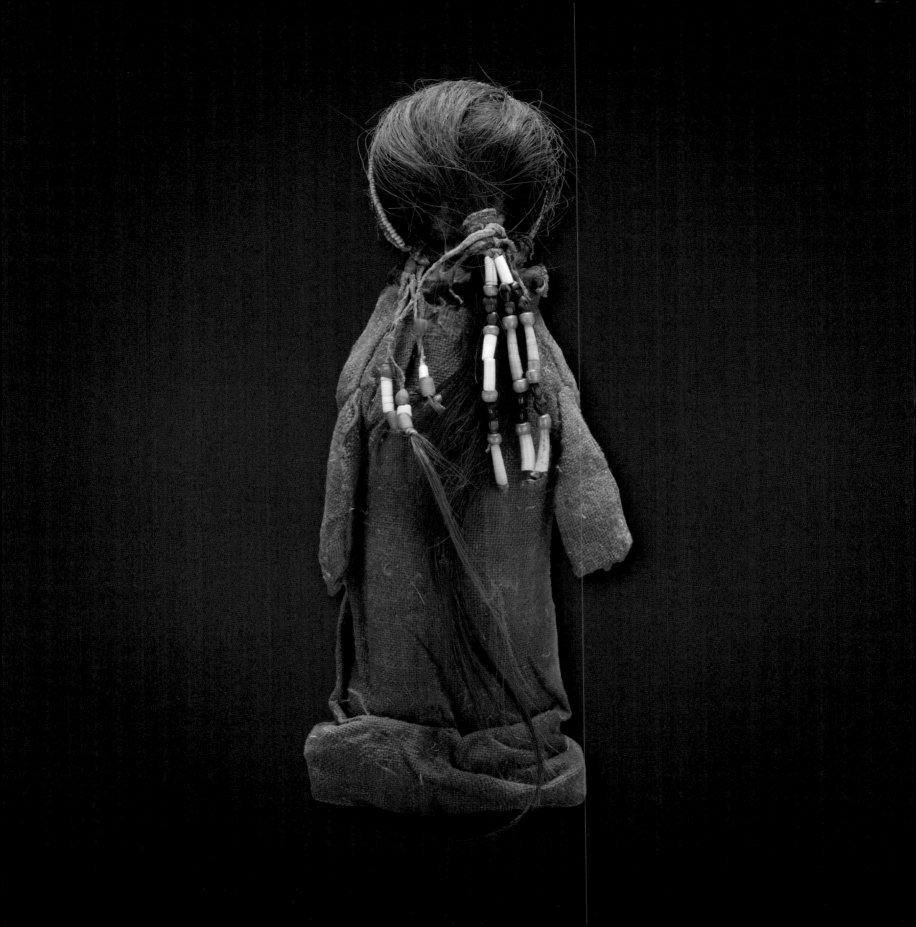

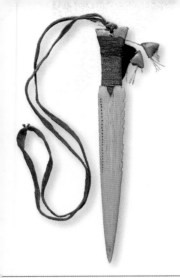

17

Catalog of Discovery: Dena'ina Material Culture in Museum Collections

During our initial collections survey to locate Dena'ina artifacts for the exhibition *Dena'inaq' Huch'ulyeshi: The Dena'ina Way of Living,* the exhibition's curators came to realize there may well be fewer than a thousand, perhaps fewer than seven hundred, Dena'ina artifacts in museum collections worldwide. For those of us accustomed to Alaska collections in museums with hundreds, and even thousands of Yup'ik or Northwest Coast artifacts, it was sobering to realize the scarcity of Dena'ina objects. Certainly there were enough objects to organize an excellent and fairly comprehensive exhibition on Dena'ina history and culture; that was not our concern.

This situation did, however, lead us to think further about the material culture heritage of the Dena'ina, and we began to conceive how this scarcity of artifacts might allow us to imagine a new approach to the exhibition catalog. Because there are not thousands of Dena'ina artifacts, might it be possible to publish all those we have identified, even if not all would be presented in the exhibition? Maybe this could also lead to a longer and fuller life for the exhibition catalog as a useful reference tool for Dena'ina people wanting to learn more of their own heritage, as well as for others engaged in ethnographic research.

The result is this section of the book, which we have named the "Catalog of Discovery." It is an illustrated listing of the Dena'ina objects we have "discovered" during our collections survey and through consultation with our advisers. The catalog does not include archaeological materials. It does not include lists of Dena'ina objects in private collections, although the exhibition does include some materials from these sources. It also does not feature every Dena'ina artifact in a museum, but it is a start. We think you will find it of interest and hope it will lead to new discoveries.

Note about Dena'ina Collections

On this list, some museums with only one or two Dena'ina garments were brought to our attention through our Dena'ina clothing consultants, Judy Thompson and Kate C. Duncan. While we have listed the items in the Catalog of Discovery and have provided photographs when available, in most cases we have not surveyed these collections further (most are in Europe) to see if they hold other types of Dena'ina artifacts, and so the information we provide for them is limited.

An asterisk designates the object is in the exhibition, *Dena'inaq' Huch'ulyeshi.*

Alaska Native Heritage Center, Anchorage

The Alaska Native Heritage Center, which opened in 1999, is located in the middle of the Dena'ina homeland in Anchorage, Alaska. Its collection tends to focus on contemporary pieces made by Alaska Natives. Its Dena'ina materials include a pair of boots made of king salmon and sheefish skins, which were made and donated by Helen Dick of Lime Village. The center has also been an active participant in recent efforts to reinvigorate the Dena'ina language and culture and has been an active partner in developing educational materials for this exhibition.

All photographs courtesy of the Alaska Native Heritage Center.
All photographs by Chris Arend.

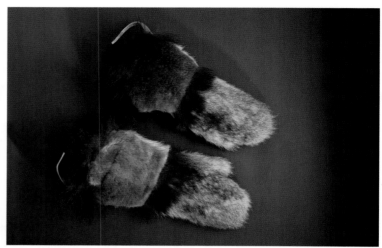

Marmot Mittens
2008.008.001
1950s, Made by Ruth Koktelash, Nondalton

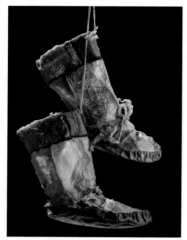

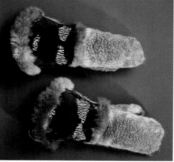

Loon Skin Mittens*
2008.008.002
1950s, Nondalton

Salmon Skin Boots
2004.034.001ab
Lime Village

Alaska State Museum

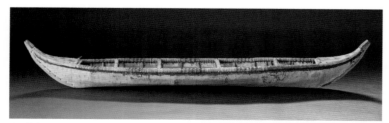

Model Canoe II-C-32
Late 19th century, collected by Lt. George Emmons
Dena'ina?

The Alaska State Museum has one of the most significant matching ensembles of late nineteenth-century Dena'ina clothing, including a complete man's and woman's summer outfit, with bags, a knife sheath, and a quiver. The Alaska State Museum's Dena'ina collection is also notable for having a very rare nineteenth-century birch bark canoe and for its collection of early twentieth-century counting cords from Kenai.

All photographs courtesy of the Alaska State Museum.
All photographs by Chris Arend.

Stone Lamp*
II-A-1776
Found 1913, Fish Creek, near Knik

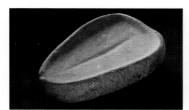

Stone Lamp
II-A-2607
Kenai

Girl's Dress*
2009.010.001
c. 1880, Cook Inlet?
See figure 1.5

Stone Axe
II-A-1674
Found at depth of 2 feet in a garden;
collected 1937–1944, Seldovia
See figure 11.18

Stone Lamp
II-A-2608
Kenai
See figure 1.48

Stone Lamp
II-A-2609
Kenai
See figure 1.48

Birch Bark Basket
II-A-4803
1945, Sleetmute

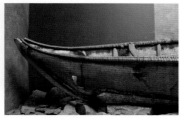

Birch Bark Canoe
II-C-197
c. 1850, Lake Iliamna

Drinking Tube and Comb
II-C-119
Sold by Hudson Bay Fur Company
to Nugget Shop, Juneau, 1932; later
purchased by museum
Alaska, Dena'ina?
See figure 1.8

Counting Cords and Box*
II-C-316 a–g
1907, Kenai
See figure 10.5

Gloves
II-C-70
1888, Cook Inlet, Southcentral Alaska
See figure 14.26

Caribou Hide Bag*
II-C-71
Late 19th century, Cook Inlet
See figure 14.30

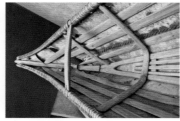

Birch Bark Canoe
II-C-197
c. 1850, Lake Iliamna

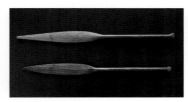

Model Paddles
II-C-34
Late 19th century, collected by Lt.
George Emmons
Dena'ina?

Caribou Hide Bag
II-C-72
1888, Cook Inlet, Southcentral Alaska
See figure 14.26

Quiver
II-C-74
1888, Cook Inlet, Southcentral Alaska
See figure 14.26

Moccasin-Trousers
II-C-75
1888, Cook Inlet, Southcentral Alaska
See figure 14.26

Dress
II-C-76
1888, Cook Inlet, Southcentral Alaska
See figure 14.26

Moccasins
II-C-73
1888, Cook Inlet, Southcentral Alaska

Mittens
II-C-77
1888, Cook Inlet, Southcentral Alaska
See figure 14.26

Hood
II-C-78
1888, Cook Inlet, Southcentral Alaska
See figure 14.26

Caribou Hide Bag
II-C-79
1888

Tunic
II-C-80
1888, Cook Inlet, Southcentral Alaska
See figure 14.26

Boots
II-C-91
1888, Cook Inlet, Southcentral Alaska
See figure 14.26

American Museum of Natural History, New York

The Dena'ina objects in the American Museum of Natural History date to the late nineteenth century, and several are of special note. There is an elaborately beaded six-piece Dena'ina man's summer outfit that was collected by Lieutenant George Emmons in 1894. Also collected by Emmons is an important Dena'ina shaman's figure. The museum ledger contains a hand-written account of how this piece was obtained from a Russian priest in Kenai, who had acquired it from a local shaman when the latter renounced his shamanic practices. A full-length ground squirrel parka that was collected at Susitna Station in 1898–1899 is of special significance as the only known Dena'ina winter parka that has been located in museum collections. This parka was among five specimens from "Sushitna River," Alaska, that were brought to the museum by A. Beverly Smith of Brooklyn, who had been prospecting in Alaska. A receipt signed by Smith on April 26, 1899, indicates that he received $12.50 in payment from Franz Boas for the specimens.

All photographs © the Division of Anthropology, American Museum of Natural History.

Beaded Knife Sheath
1/2732
Late 19th century, Kenai

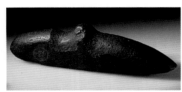

Stone Axe
16/6712
Late 19th century, Kenai

Arm Band and Beads (4 pieces)
1/2745 ab
Late 19th century, Kenai

Beaded Arm Bands (9 pieces)
1/2745 A–I
Late 19th century, Kenai

Earring
1/2750
Early 20th century, Kenai

Ground Squirrel Parka*
16/6711
1898–1899, Susitna River
See figure 13.24

Tunic
E/2383 A
1894, Kenai
See figure 13.23a

Moccasin-Trousers and Pouch (knife sheath)
E/2383 BD
1894, Kenai
See figure 13.23b

Hood*
E/2383 C
1894, Kenai
See figure 13.23c

Gloves Joined by Beaded Strap*
E/2383 E
1894, Kenai
See figure 13.23d

Quiver
E/2383 F
1894, Kenai
See figure 13.23e

Shaman's Figure*
E/2680
1894, Kenai
See figures 7.12, 17.0

The Anchorage Museum

The Anchorage Museum, founded in 1967, has a strong collection of early twentieth-century Dena'ina material, much of which came through two different acquisitions of materials from Shem Pete (1896–1989). Pete was born at Susitna Station and later resided at Willow, Alaska. He was the foremost tradition bearer of the Upper Inlet Dena'ina people, the lead singer of the Upper Inlet Dena'ina, and a gifted storyteller with an immense repertoire. Other Dena'ina items have come from miners, schoolteachers, and others who have spent time in Dena'ina areas. In addition, the museum has recently commissioned and purchased a number of items in conjunction with this exhibition, including a bear gut parka, fish trap, dip net, and Russian Christmas star. The museum's collection of Dena'ina materials currently numbers about seventy-five objects.

All photographs © the Anchorage Museum.
All photographs by Chris Arend.

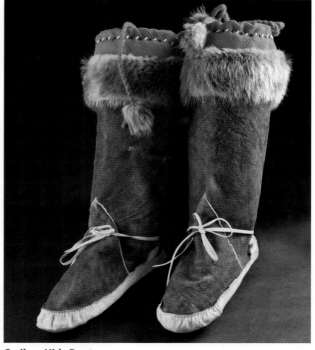

Caribou Hide Boots
2010.015.003ab
1970s–1980s, Ruth Koktelash, Nondalton

Mittens
1955.009.003ab
Early 20th century, Southcentral Alaska

Moccasin
1955.009.005
Early 20th century, Palmer area

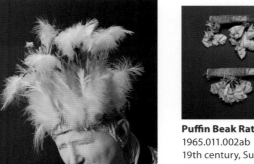

Feather Headdress
1965.011.001
Late 19th century, Susitna Station

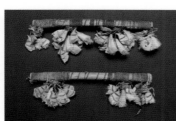

Puffin Beak Rattles*
1965.011.002ab
19th century, Susitna Station

Spoon
1972.086.001
c. 1900, Southcentral Alaska

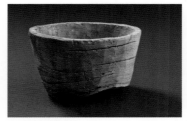

Tobacco Mortar
1974.036.001
c. 1880, Nondalton

Puffin Beak Rattles*
1978.035.004ab
c. 1900, Susitna Station

Bandolier
1978.052.002
c. 1900, Tyonek

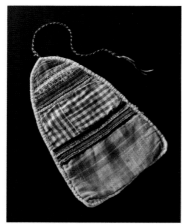

Bag
1985.047.001
c 1910, Eklutna

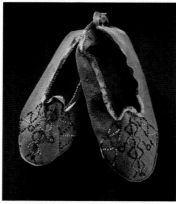

Moccasins
1987.004.008ab
c 1920, Anchorage

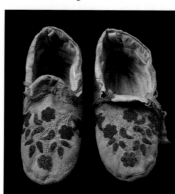

Moccasins
1987.004.009ab
c. 1920, Anchorage

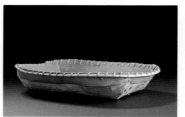

Birch Bark Basket
1995.093.001
1995, Louise Sagmoen, Stony River

Birth-related Amulet (bear claw)*
1997.002.013
c. 1900, Kenai Peninsula

Model Snowshoes*
1997.048.002ab
1916–1917, Susitna Station

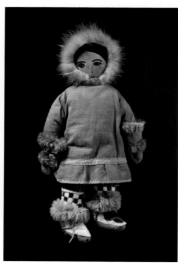

Child's Doll*
2006.005.038
c. 1940, Nondalton

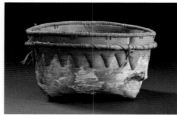

Birch Bark Basket
2002.025.056
c. 1900, Nushagak

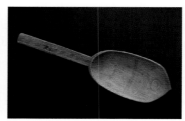

Ladle
2003.005.001
Early 20th century, Kenai Peninsula

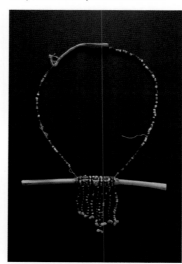

Drinking Tube
1997.048.005
1916–1917, Susitna Station

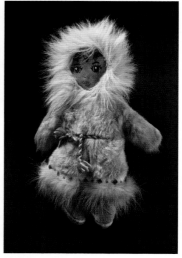

Child's Doll*
2006.005.039
c. 1940, Nondalton

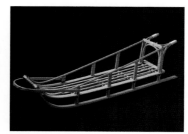

Model Sled*
2006.005.071
c. 1940, Nondalton

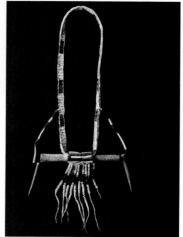

Drinking Tube
2008.036.001
Early 20th century, Southcentral Alaska

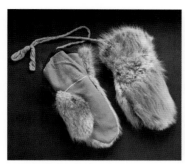

Mittens
2010.015.001ab
1970s–1980s, Ruth Koktelash, Nondalton

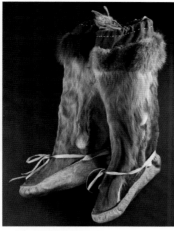

Caribou Hide Boots*
2010.015.002ab
1970s–1980s, Ruth Koktelash, Nondalton

Miniature Moccasins and One Pair of Mittens
Clockwise from center mittens:
1997.048.007ab, 1916–1917, Susitna Station
1997.048.006ab, 1916–1917, Susitna Station
1997.048.010ab, 1916–1917, Susitna Station
1997.048.008ab, 1916–1917, Susitna Station
1991.030.012ab, c. 1963, Nondalton, Bertha Simone
1997.048.009ab, 1916–1917, Susitna Station

Hat*
2010.015.004
1970s–1980s, Ruth Koktelash, Nondalton

Snowshoes
1955.009.004ab
Early 20th century

Ski Snowshoes
1965.011.004ab
Early 20th century
See figure 1.41

Bear Spear Point*
1969.062.001
19th century, Southcentral Alaska
See figure 1.36

Potlatch Shirt*
1978.035.001
c. 1902, Susitna Station
See figure 5.5

Dentalium Necklace*
1978.035.002
1880–1900, Kroto Creek or Susitna Station
See figure 13.33

Dentalium Wristlets
1978.035.003ab
c. 1900–1910, wife of Ely Stepan, Tyonek
See figure 5.4

Feather Headdress*
1978.035.005
Late 19th century, Willow, Alaska
See figure 1.44

Bandolier
1978.052.001
c. 1920, Tyonek

Dentalium Necklace
1979.085.003
Early 20th century, Kenai Peninsula

Bandolier
1980.018.001
Early 20th century?, Tyonek
See figure 14.8

Tunic
1981.025.001
Mid-19th century, Alaska?
Dena'ina?

Spoon
1983.076.001
c. 1900, Southcentral Alaska, Kenai?

Birch Bark Canoe*
1985.044.001ab
1985, Made by Randy Brown, Inland Dena'ina style
See figure 11.28

Sewing Bag*
1985.047.002
See figure 1.9

Gloves
1987.004.010ab
Early 20th century

Bear Gut Parka
1993.057.001
c. 1940, Lake Iliamna
See figure 13.27

Beaded String of Birth-related Amulets*
1997.002.004
c. 1900, Kenai Peninsula
See figure A.6

Birth-related Amulet (bird foot)*
1997.002.015
c. 1900, Kenai Peninsula

Fish Trap*
1997.023.001a
c. 1950, Sleetmute
See figures 11.1, 11.2

Birch Bark Basket*
1997.048.001
1916-1917, Susitna Station
See figure 1.28

Model Baidarka with Two Figures*
1997.048.003
1916-1917, Susitna Station
See figure 1.17

Beaded Drinking Tube*
1997.048.004
1916-1917, Susitna Station
See figure 1.6

Man's Outfit (5 pieces), Tunic, Moccasin-Trousers, Quiver, Knife Sheath, and Hood
1999.077.001a–e
c. 1900, Alaska
See figure 14.25

Woven Fish Trap*
2009.010.001a-f
2009, Helen Dick and family, Lime Village
See figure 12.0

Dip Net*
2009.010.002
2009, Helen Dick, Lime Village

Crooked Knife
2009.010.003
2009, Lime Village

Bear Gut Raincoat*
2010.010.001
2009, Helen Dick, Lime Village
See figure 10.8

Christmas Star*
2012, made by Steve "Butch" Hobson, Nondalton
See figure B.4

British Museum, London

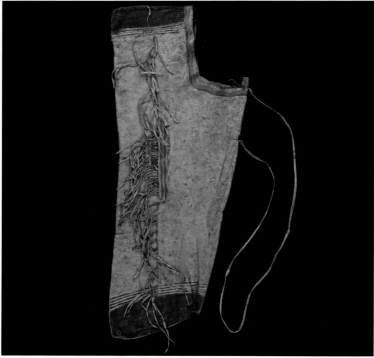

Quiver
Am1978, Q.21
1778, Cook Inlet

The British Museum holds the oldest Dena'ina materials, which were gathered on voyages by Captain James Cook (1778) and Captain George Vancouver (1791–1795) in the late eighteenth century. The history of the collections from Cook's voyage in particular is a complicated one, and these artifacts are now in quite a number of institutions in Europe. Researchers such as Jonathan C. H. King and Adrienne L. Kaeppler have made significant efforts to track and identify them. The quillwork on these earliest Dena'ina items reveals a technology and an aesthetic that were well advanced at this date.

All photographs © The Trustees of the British Museum.

Horn Bowl*
Am, NWC 33
1778, Cook Inlet
See figure B.5

Quilled Chest Band
Am, VAN 206
c. 1795, Cook Inlet
See figure 13.2

Quilled Legging Bands
Am, VAN 207 a–b
c. 1795, Cook Inlet
See figure 13.3

Tunic
Am1178
Pre-1865, Christy Collection, Dena'ina?

Bone Dagger
Am1972.q.46
1778?, Northern Forest?, Dena'ina?
See figure 1.51

Horn Bowl
Am1999, 03.3
c. 1780, Subarctic

Horn Bowl with Ladle
Am1999, 03.4
1800–1920, Alaska?

Horn Ladle
NWC 31
1778, Cook Inlet (Cook Banks)

Knife Sheath*
VAN 99
c. 1795, Cook Inlet (Cook Banks)
See figure 1.53

Burke Museum of Natural History and Culture, Seattle

Many of the Dena'ina items in the Burke Museum of Natural History and Culture came to the institution through two well-known nineteenth-century collectors, James G. Swan and George T. Emmons. Both these men are largely known for collecting among the Northwest Coast tribes; however, both also collected a number of Dena'ina artifacts. The artifacts range from a much-admired quill and bead-decorated tunic to a colorfully beaded, multipart outfit to snowshoes, birch baskets, and a birch baby carrier.

All photographs courtesy of the Burke Museum of Natural History and Culture. All photographs by Chris Arend.

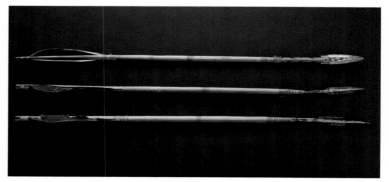

Arrows
2321
1904, Cook Inlet

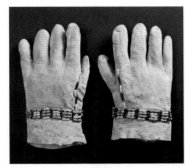

Gloves
146d
1892, Cook Inlet

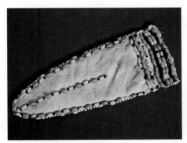

Knife Sheath
146e
1892, Cook Inlet

Quiver
1718
1904, Cook Inlet

Moccasin-Trousers
2280
1904, Cook Inlet

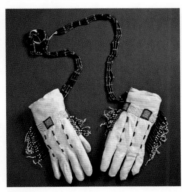

Gloves
2281
1904, Cook Inlet?

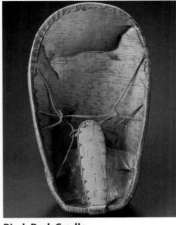

Birch Bark Cradle
2-2966
20th century, Chiltina River

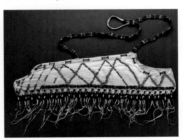

Quiver
2279
1904, Cook Inlet

Tray (moose antler)
2330
1904, Kenai Peninsula

Birch Bark Container*
1.2E1179
c. 1940, Stony River
See figure 1.29

Tunic
145
1893, Cook Inlet
See figures 13.21b, c

Man's Outift (3 pieces): Tunic, Moccasin-Trousers, Hood
146a–c
1892, Cook Inlet
See figure 14.24

Snowshoes*
860
1894, Kenai
See figure 1.40

California Academy of Sciences, San Francisco

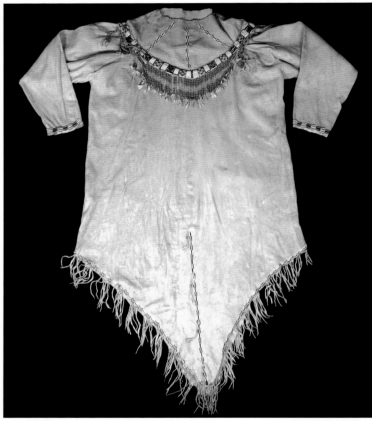

In its cultural anthropology collections, the California Academy of Sciences has two Dena'ina holdings, a notable multipart beaded man's outfit with interesting bead patterning and a pair of Dena'ina-made snowshoes that can be seen propped up in a well-known 1890s photograph of H. M. Wetherbee garbed in a Dena'ina hide tunic (figure 13.22).

All photographs courtesy of the California Academy of Sciences.
All photographs by Russell Hartman.

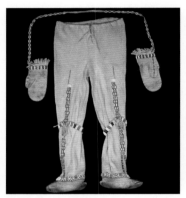

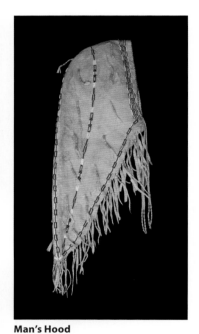

Man's Tunic
0146-0004
c. 1900, Cook Inlet

Man's Moccasin-Trousers and Mittens
0146-0003, 146-0006ab
c. 1900, Cook Inlet

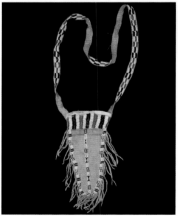

Man's Hood
0146-0007
c. 1900, Cook Inlet

Snowshoes
0100-0005AB
c. 1900, Cook Inlet
See figure 13.22

Knife Sheath
0146-0005
c. 1900, Cook Inlet

Canadian Museum of Civilization, Gattineau, Quebec

The Canadian Museum of Civilization, first founded as a geological collection in 1856, is one of North America's oldest museums. An anthropology division was added in 1910. The museum is Canada's national museum of human history and holds extensive collections of materials from Canada's First Nations. In the 1970s, the museum (then the National Museum of Man), in conjunction with the Royal Scottish Museum, organized the groundbreaking exhibition, *The Athapaskans: Strangers of the North*. It was the first major exhibition devoted to the northern Athabascans, combining the best materials from two of the foremost Athabascan collections. More recently, the museum has been home to one of the leading experts on northern Athabascan clothing, Judy Thompson, now curator emerita of Western subarctic ethnology. The museum has several Dena'ina items in its Athabascan collection, including what may be the "oldest" Athabascan garment, a caribou hide tunic with an attribution of "Kenai, circa 1800," which would make it the oldest Dena'ina garment in North American collections (Thompson, Hall, and Tepper 2001).

All photographs © the Canadian Museum of Civilization.

Gloves
VI-Y-2ab, IMG2012-0200-0030
Before 1821, Alaska

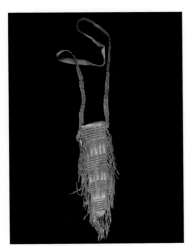

Knife Sheath
VI-Y-1, S86-1326
1821, Alaska

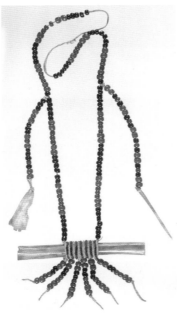

Drinking Tube/Puberty Necklace
VI-Z-219, S2003-1017
19th century, Subarctic

Arrows (2)
VI-Y-3bc, 575-547_548
Before 1821, Alaska

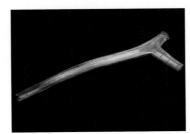

Club
VI-Y-4, 575-4096
Before 1821, Alaska

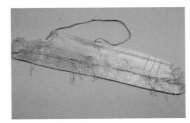

Quiver
VI-Y-3a, S75-546
Before 1821, Alaska

Tunic
VI-Y-5
1800, Kenai Alaska
See figures 13.4b, c

Cook Inlet Tribal Council, Inc., Anchorage

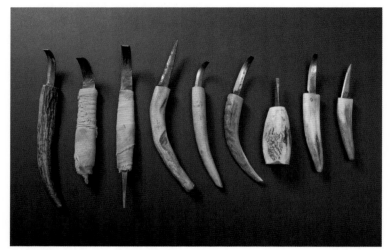

Carving Knives
11, 12,* 15,* 36, 37,* 38,* 39,* 40, 43*
c. 1900, Eklutna

Since its inception in 1983, Cook Inlet Tribal Council (CITC) has grown from a fledgling grassroots operation with only three employees to one of the nation's preeminent culturally responsive social service organizations, serving more than 12,000 people annually. In 2005, CITC moved into a new headquarters called Nat'uh, "Our Special Place." This building was the first in Anchorage to have a Dena'ina name. In 2007, A. Debbie Fullenwider donated a significant collection of more than forty Dena'ina artifacts that had been handed down to her from her grandfather, Eklutna Alex. Many of these pieces are exhibited at Nat'uh as a tangible representation of Dena'ina heritage. A number of culturally sensitive materials related to rituals and healing, which are included in the list below, were not photographed at CITC's request.

All photographs reprinted by permission of Cook Inlet Tribal Council, Inc. All photographs by Chris Arend.

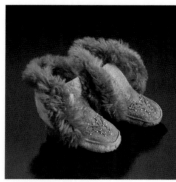

Small Moccasins
c. 1900, Eklutna

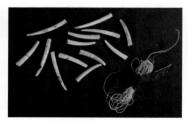

Dentalia and Sinew*
35
c. 1900, Eklutna

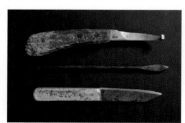

Carving Knives
14, 41, 42
c. 1900, Eklutna

Goat Horn*
13
c. 1900, Eklutna

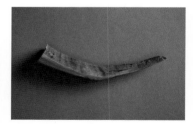

Sheep Horn*
16
c. 1900, Eklutna Alex, Eklutna

Chief Alex's Belt
27
c. 1900, Eklutna

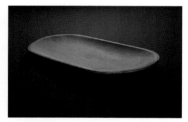

Oval Tray*
23
c. 1900, Eklutna Alex, Eklutna

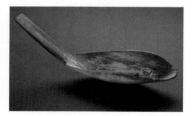

Spoon
24
c. 1900, Eklutna Alex, Eklutna

Chief Alex's Belt
25
c. 1900s, Eklutna

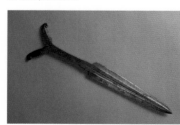

Chief Alex's Knife with Double Volute Handle*
9
c. 1900, Eklutna Alex, Eklutna

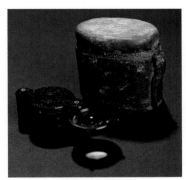

Small Oval Case for Magnifying Glass
33
c. 1900, Eklutna

Metal Icon*
44
c. 1900, Eklutna
See figure 7.13

Set of Golden Eagle Wings*
1
c. 1900, Eklutna

Red Ochre*
2
c. 1900, Eklutna

Brass Bell*
3
c. 1900, Eklutna

Single Volute Handled Chief's Knife
10
c. 1900, Eklutna Alex, Eklutna
See figure 10.2

Counting Cords and Cloth Bundle*
17, 18, 19, 20, 21, 22
c. 1900, Eklutna Alex, Eklutna
See figure 10.0

Chief Alex's Bandolier*
26
c. 1900, Eklutna
See figure 5.6

Healing Stones
28, 29*
c. 1900, Eklutna

Ermine Skin
30
c. 1900, Eklutna

U.S. Silver Quarter
31
c. 1900, Eklutna

Healing Herbs
34
c. 1900, Eklutna

Ethnological Museum Berlin
Ethnologisches Museum, Staatliche Museen zu Berlin

In 1873, Prussian king and German emperor Wilhelm I decreed the establishment of what was to become the Ethnologisches Museum Berlin. Under the leadership of its first director, Adolf Bastian, the museum built up an extensive collection of ethnological materials from around the world. The Dena'ina artifacts were collected by Johan Adrian Jacobsen, a mariner commissioned to travel to North America and collect for the museum along the Northwest Coast and in Alaska between 1881 and 1883. During his travels, Jacobsen collected in total more than 7,000 objects for the museum. This museum holds the largest and most diverse collection of nineteenth-century Dena'ina objects not associated with Russian America. Within the Jacobson Collection of Dena'ina artifacts are several one-of-a-kind objects, including a beluga spear and two heddles used for weaving quills or beads.

All photographs courtesy of Staatliche Museen zu Berlin, Ethnologisches Museum.
All photographs by Chris Arend.

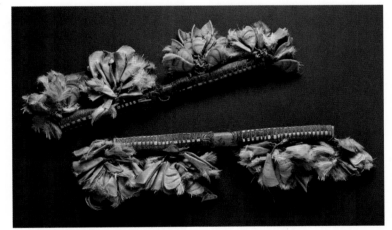

Puffin Beak Rattles
IVA 6105 ab
Collected by Jacobsen 1883, Tyonek

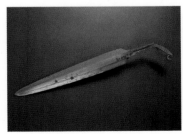

Iron Dagger
IVA 6094
Collected by Jacobsen 1883, Tyonek

Model Dip Net
IVA 6130
Collected by Jacobsen 1883, Kenai

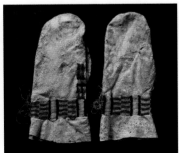

Mittens
IVA 6100
Collected by Jacobsen 1883, Tyonek

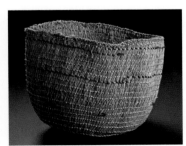

Basket for Sewing Kit
IVA 6114
Collected by Jacobsen 1883, Tyonek

Girl's Boots
IVA 6115 ab
Collected by Jacobsen 1883

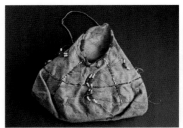

Bag with Short Strap
IVA 6119
Collected by Jacobsen 1883, Tyonek

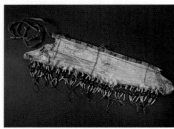

Quiver
IVA 6120
Collected by Jacobsen 1883, Tyonek

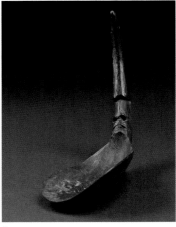

Spoon
IVA 6095
Collected by Jacobsen 1883, Tyonek

Sheep Horn Ladle
IVA 6131
Collected by Jacobsen 1883, Tyonek

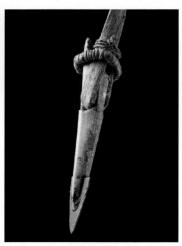

Harpoon Point with a Thong
IVA 6132
See figure 11.26
Collected by Jacobsen 1883, Tyonek

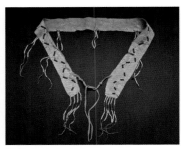

Belt
IVA 6141
Collected by Jacobsen 1883, Tyonek

Moccasin-Trousers
IVA 6145
Collected by Jacobsen 1883, Tyonek

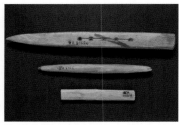

Fireboard with Top
IVA 6155 ac
Collected by Jacobsen 1883, Fort
Kenai

Birch Bark Basket
IVA 6156
Collected by Jacobsen 1883, Tyonek

Puffin Beak Rattles
IVA 6170 ab
Collected by Jacobsen 1883, Fort
Kenai

Puffin Beak Rattles
IVA 6171 ab
Collected by Jacobsen 1883, Fort
Kenai

War Club
IVA 9475
c. 1830, Alaska

Moccasin-Trousers
IVB 258
c. 1850
See figure 14.10c

Arrows*
IVA 6082, IVA 6083, IVA 6084, IVA 6085,
IVA 6086, IVA 6088, IVA 6089, IVA 6090,
IVA 6092
Collected by Jacobsen, 1883, Tyonek
See figures 1.35, 16.8

Metal Spear Point
IVA 6093
Collected by Jacobsen 1883, Tyonek
See figure 11.13

Man's Tunic and Moccasin-Trousers
IVA 6096, 6098
Collected by Jacobsen 1883, Tyonek
See figures 16.1a, b

Man's Hood
IVA 6099
Collected by Jacobsen 1883, Tyonek
See figure 16.1c

Beaver Tooth Knife Sheath*
IVA 6101
Collected by Jacobsen 1883, Tyonek
See figure 16.3

Knife Sheath
IVA 6102
Collected by Jacobsen 1883, Tyonek
See figure 16.4

**Fire Bags for Powder and Lead with
Shoulder Strap***
IVA 6103, IVA 6104
Collected by Jacobsen 1883, Tyonek
See figure 14.7

Feather Headdress
IVA 6106
Collected by Jacobsen 1883, Tyonek
See figure 16.10

Feather Headdress
IVA 6107
Collected by Jacobsen 1883, Tyonek
See figure 16.0

Gloves with Strap*
IVA 6108
Collected by Jacobsen 1883, Tyonek
See figure 13.18

Drinking Tube with Strap
IVA 6109
Collected by Jacobsen 1883, Tyonek
See figure 16.11

Woman's Belt*
IVA 6110
Collected by Jacobsen 1883, Kenai
Peninsula
See figures 1.54, 9.0

Woman's Earring
IVA 6111
Collected by Jacobsen 1883, Tyonek
See figure 14.6

Twined Basket
IVA 6113
Collected by Jacobsen 1883, Tyonek
See figure 1.59

Harpoon Point for Caribou*
IVA 6116
Collected by Jacobsen 1883, Tyonek
See figure 11.11

Harpoon Point*
IVA 6117
Collected by Jacobsen 1883, Tyonek
See figure 11.11

Point*
IVA 6118
Collected by Jacobsen 1883, Tyonek
See figure 11.11

Gut Bag
IVA 6121
Collected by Jacobsen 1883, Tyonek
See figure 16.16

Gut Bag
IVA 6122
Collected by Jacobsen 1883, Tyonek
See figure 16.17

Woman's Boots
IVA 6123 ab
Collected by Jacobsen 1883, Tyonek
See figure 16.6

Drinking Tube*
IVA 6125
Collected by Jacobsen 1883, Tyonek
See figure 1.7

Girl's Wristlets
IVA 6127 ab
Collected by Jacobsen 1883, Tyonek
See figure 16.5

Birch Bark Basket*
IVA 6128
Collected by Jacobsen 1883, Tyonek
See figure A.5

Model Dipnet and Club for Salmon*
IVA 6129
Collected by Jacobsen 1883, Kenai
See figure 1.24

Bag for Sewing
IVA 6134
Collected by Jacobsen 1883, Tyonek
See figure 16.9

Braided Cord
IVA 6135
Collected by Jacobsen 1883, Tyonek

Harpoon with Line and Float*
IVA 6136
Collected by Jacobsen 1883, Tyonek
See figure 2.0

Baleen and Wooden Weaving Tools*
IVA 6137, IVA 6138
Collected by Jacobsen 1883, Tyonek
See figure 14.14

Bone Weaving Knife*
IVA 6140
Collected by Jacobsen 1883, Tyonek
See figure 14.15

One Boot
IVA 6142
Collected by Jacobsen 1883, Tyonek

Ladle*
IVA 6143
Collected by Jacobsen 1883, Tyonek
See figure 1.46

Moccasin-Trousers*
IVA 6146
Collected by Jacobsen 1883, Tyonek,
Knik River
See figure 13. 15

Tunic*
IVA 6147
Collected by Jacobsen 1883, Tyonek
See figure 13.15

Mittens*
IVA 6148ab
Collected by Jacobsen 1883, Knik
River, Cook Inlet
See figure 13.16

**Fire Bag for Powder and Lead with
Shoulder Strap***
IVA 6149
Collected by Jacobsen 1883, Knik
River, Cook Inlet
See figure 13.20

Hood*
IVA 6150
Collected by Jacobsen 1883, Knik
River, Cook Inlet
See figure 13.17

Twined Basket
IVA 6151
Collected by Jacobsen 1883, Knik River
See figure 16.13

Hat with Brim*
IVA 6152
Collected by Jacobsen 1883, Fort
Kenai
See figure 1.58

Model Canoe and One Paddle*
IVA 6153 ab
Collected by Jacobsen 1883, Fort
Kenai
See figure 11.29

Scraper*
IVA 6154
Collected by Jacobsen 1883, Fort
Kenai
See figure 16.14

Model of Birch Bark Baby Carrier
IVA 6157
Collected by Jacobsen 1883, Fort
Kenai
See figure 16.15

Porcupine Trap*
IVA 6158 ad
Collected by Jacobsen 1883, Fort
Kenai
See figure 1.13

Arrow for Sea Otter*
IVA 6159
Collected by Jacobsen 1883, Fort
Kenai
See figures 1.18, 16.7

Toggle Arrow
IVA 6160
Collected by Jacobsen 1883, Fort
Kenai
See figures 1.18, 16.7

Hunting Toggle Arrow
IVA 6161
Collected by Jacobsen 1883, Fort
Kenai
See figures 1.18, 16.7

Toggle Arrow*
IVA 6162
Collected by Jacobsen 1883, Fort
Kenai
See figures 1.18, 16.7

Bow*
IVA 6164
Collected by Jacobsen 1883, Fort
Kenai
See figure 16.7

Stone Axe
IVA 6165
Collected by Jacobsen 1883, Kenai

Snuff Box with Top
IVA 6166 ab
Collected by Jacobsen 1883, Fort
Kenai
See figure 16.12

Feather Headdress
IVA 6167
Collected by Jacobsen 1883, Fort
Kenai
See figure 13.19

Puffin Beak Rattles
IVA 6168 ab
Collected by Jacobsen 1883, Fort
Kenai
See figure B.3

Tunic*
IVA 9086
Collected in 1857, Tyonek
See figures 14.10a, b

Knife Sheath
IVA 9088
Collected by Jacobsen 1883
See figure 16.2

Woman's Dress*
IVA 9386
c. 1884
See figures 14.11a, b

The Field Museum of Natural History, Chicago

The Field Museum was founded to house the biological and anthropological collections assembled for the World's Columbian Exposition of 1893. These objects form the core of the museum's collections, which have grown through worldwide expeditions, exchange, purchase, and gifts to more than 20 million specimens. Anthropology collections now number 600,000 objects. In 1981, James W. VanStone, then curator of North American archaeology and ethnology at the Field Museum, published *Athapaskan Clothing and Related Objects in the Collections of Field Museum of Natural History.* Most Athabascan items are late nineteenth century, purchased for the 1893 exposition, and none is specifically attributed to Dena'ina. Subsequent study of some of the clothing in the collection has led scholar Kate C. Duncan to attribute several clothing items to a Dena'ina origin (see figures 14.22a–d).

All photographs © The Field Museum.
All photographs by Ron Testa.

Moccasin-Trousers
FM 14932
Photograph © The Field Museum, no.
A106774
See figure 14.22b

Quiver
FM 14933
Photograph © The Field Museum, no.
A106770
See figure 14.22d

Hood
FM 14943
Photograph © The Field Museum, no.
A106771
See figure 14.22c

Tunic
FM 14944
Photograph © The Field Museum, no.
A106827
See figure 14.22a

Frankfurt Museum of World Cultures, Germany
Frankfurt Museum der Weltkulturen

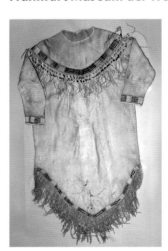

The Frankfurt Museum holds a Dena'ina tunic. Further information on Dena'ina objects in the museum's collections is not known.

Photograph © Frankfurt Museum of World Cultures, Germany. Photograph by Martin Schultz.

Tunic
NS47390

Furuhjelm Collection, Hämeenlinna High School, Finland
Hämeen Lyseon Lukio

This recently discovered collection of Alaska Native objects includes a stunning example of a painted Dena'ina quiver. The collection was donated to the Hämeenlinna School in Hämeenlinna, Finland, in the late nineteenth century by the Finnish mining engineer Hjalmar Furuhjelm. Furuhjelm worked for the Russian-America Company on the southern coast of Alaska. He was the younger brother of Johan H. Furuhjelm, who was the governor of Russian America from 1859 to 1863. Today, the Finnish scholar Marcus Lepola is researching this collection as part of a larger investigation of Alaska collections in Finland.

Quiver*
Collected in 1860, Cook Inlet
See figure 10.13

Geneva Ethnography Museum, Switzerland
Musée d'ethnographie de Genève

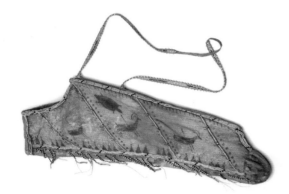

The Geneva Ethnography Museum collection includes a Dena'ina painted quiver. Further information on Dena'ina materials in the museum's collections is not known.

Photograph © Geneva Ethnography Museum (MEG). Image Etham K001564. Photograph by Johnathan Watts.

Painted Quiver
K1564

German Leather Museum, Offenbach
Deutsches Ledermuseum

A man's outfit of tunic and moccasin-trousers is in the collection of the German Leather Museum. According to Judy Thompson, information provided by the curator at the Leather Museum was that the collection came to Europe in 1821; was later purchased by a private collector, Arthur Speyer; and was subsequently purchased by the museum in 1962. Further information on Dena'ina materials in the collection is not known.

Photograph © German Leather Museum, Deutsches Ledermuseum.

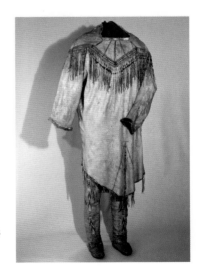

Tunic and Moccasin-Trousers
40.20.18ab
Collected in 1821

Hamburg Museum of Ethnology
Museum für Völkerkunde Hamburg

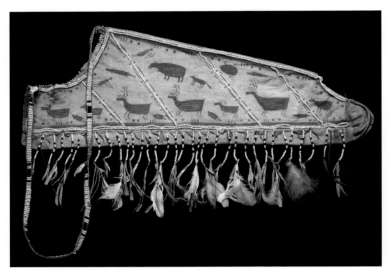

Painted Quiver
37:35:13

The Hamburg Museum of Ethnology has three striking Dena'ina clothing items. Further information regarding Dena'ina artifacts in the museum's collections is unknown.

All photographs courtesy of the Museum für Völkerkunde Hamburg.

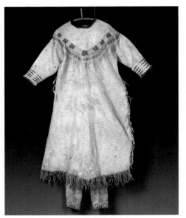

Dress with Beadwork and Moccasin-trousers
37.35:1+5

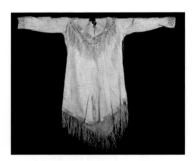

Tunic, Soleless Trousers, Hood
37:35:2,4,6

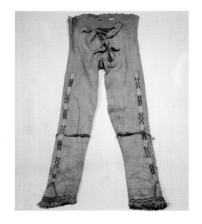

Kenai Visitors and Cultural Center, City of Kenai Collection

The Kenai Visitors and Cultural Center, which was built by the City of Kenai in 1991, houses the Kenai Chamber of Commerce, a visitors center, and a cultural center/museum. The museum collection features a small assortment of twentieth-century Dena'ina artifacts from the area, including several dentalium shell necklaces, a bashla, and a pair of caribou knee socks.

All photographs courtesy of the City of Kenai Collection, Kenai Visitors and Cultural Center.
All photographs by Chris Arend.

Cannery Token*
1997.002.002
1920s, Snug Harbor, Cook Inlet

Bashla*
1978.013.001
20th century, originally owned by
Feona Miller, Kenai
Gift of Mary Nissen and Mary Tweedy

Caribou Hide Socks*
1968.001.001ab
20th century, Kenai

Wooden Spoon
1976.010.003
Gift of Archie and Ann Ramsey

Bear Gut Bag
1992.019.000
1949, Kenai, made by Feona Miller for
Alex White

Tobacco Mortar
Kenai

Dentalium Necklace
1966.001.001
Kenai

Lübeck Museum, Germany, Ethnographic Collection
Völkerkundesammlung der Hansestadt Lübeck

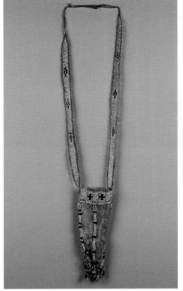

A full Dena'ina man's outfit, including a knife sheath, is in the Ethnographic Collection of the Lübeck Museum. According to Judy Thompson, the outfit came to the museum in 1888 as a purchase. Further information regarding Dena'ina materials in the collection is not known.

All photographs © Völkerkundesammlung der Hansestadt Lübeck.

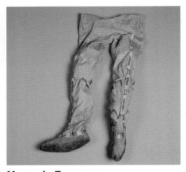

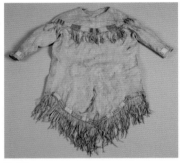

Moccasin-Trousers
5125
c. 1880, Alaska

Tunic
5126
c. 1880, Alaska

Knife Sheath
5127
c. 1880, Alaska

Mannheim Reiss-Englehorn Museum, Germany
Reiss-Engelhorn-Museen Mannheim

A man's summer outfit is in the collection of the Mannheim Reiss-Englehorn Museum. According to Judy Thompson, the museum acquired it from a private collector, Arthur Speyer, in 1968. Further information regarding Dena'ina materials in the collection is unknown.

Photograph © Mannheim Reiss-Englehorn Museum.
Photograph by Jean Christen/REM.

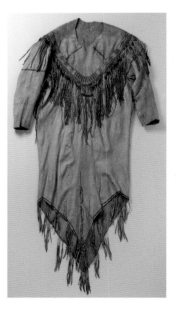

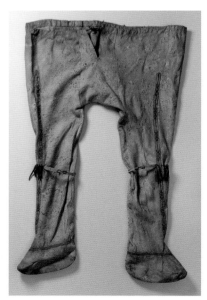

Tunic and Moccasin-Trousers
V Am 3219 a/b

Museum of Cultures, National Museum Finland, Helsinki
Kulttuurien Museo

The Kulttuurien Museo, or Museum of Cultures, in Helsinki houses one of the finest collections of Dena'ina artifacts in the world. From 1809 to 1917, Finland was part of the Russian Empire, and a number of Finns held prominent positions in Russian America. Most of the items in this collection came from the naval officer and explorer Arvid Adolf Etholén, who collected from many areas of Alaska between 1826 and 1845. Etholén served as the chief manager of the Russian-American Company in Sitka from 1840 to 1845, working under his Russianized name of Adolf Karlovich Etolin. The Etholén Collection as a whole consists of about 700 items, many of which may have been collected for Etholén by ships' crews; some were collected in Russian America for Etholén by the Russian explorer Lavrentii Alikseevich Zagoskin and some by Ilya Voznesensky, the great Russian collector for the Kunstkamera in St. Petersburg. The bulk of the Dena'ina collection, which arrived in Finland in 1846, consists of caribou skin clothing, with some spectacular examples of Dena'ina quillwork. A large traveling exhibition and catalog of the Etholén Collection of Alaska Native materials was organized in the 1990s and toured several museums in North America.

All photographs © Finland's National Board of Antiquities/Picture Collections.

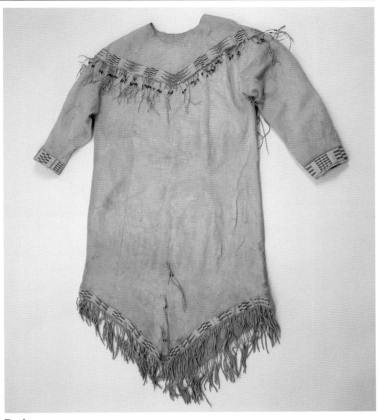

Tunic
VK5303.1
1854–1862, Kenai Peninsula
Photograph by István Bolgár

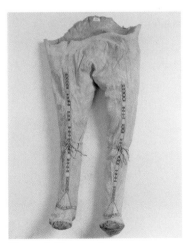

Moccasin-Trousers*
VK167B
1846 donation, Kenai Peninsula
Photograph by Matti Huuhka

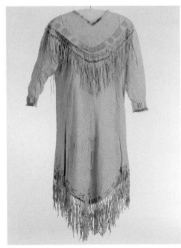

Tunic
VK 169A
1846 donation, Kenai Peninsula
Photograph by Matti Huuhka

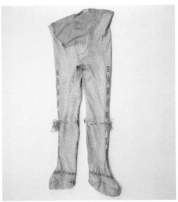

Moccasin-Trousers
VK169B
1846 donation, Kenai Peninsula
Photograph by István Bolgár

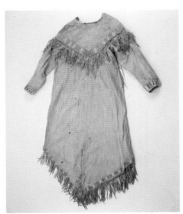

Tunic
VK170A
1846 donation, Kenai Peninsula
Photograph by István Bolgár

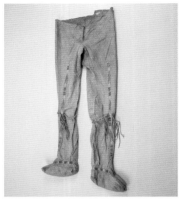

Moccasin-Trousers
VK170B
1846 donation, Kenai Peninsula
Photograph by István Bolgár

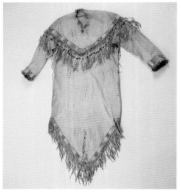

Tunic
VK171A
1846 donation, Kenai Peninsula
Photograph by István Bolgár

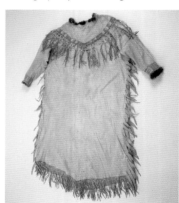

Dress
VK172
1846 donation, Kenai Peninsula
Photograph by István Bolgár

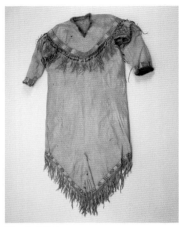

Man's Shirt
VK173A
1846 donation, Kenai Peninsula
Photograph by István Bolgár

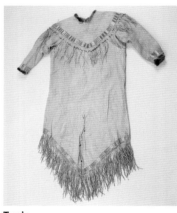

Tunic
VK175A
1846 donation, Kenai Peninsula
Photograph by István Bolgár

Moccasin-Trousers
VK175B
1846 donation, Kenai Peninsula
Photograph by István Bolgár

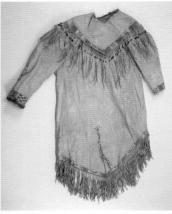

Tunic
VK176A
1846 donation, Kenai Peninsula
Photograph by István Bolgár

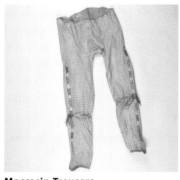

Moccasin-Trousers
VK176B
1846 donation, Kenai Peninsula
Photograph by István Bolgár

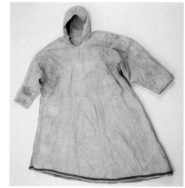

Tunic
VK178
pre-1846, Kenai Peninsula
Photograph by István Bolgár

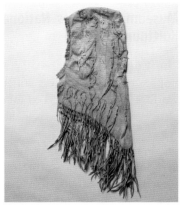

Man's Hood
VK181
1846 donation, Kenai Peninsula
Photograph by István Bolgár

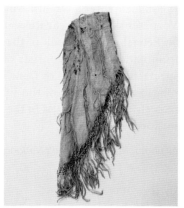

Man's Hood
VK182
1846 donation, Kenai Peninsula
Photograph by István Bolgár

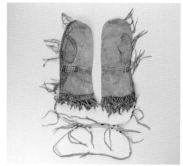

Man's Mittens
VK183
1846 donation, Kenai Peninsula
Photograph by István Bolgár

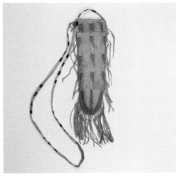

Knife Sheath
VK196
1846 donation, Kenai Peninsula
Photograph by István Bolgár

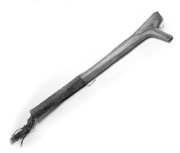

Club
VK200a
c. 1840, Copper River
Photograph by Matti Huuhka

Adze
VK200b
c. 1840, Kenai
Photograph by Lauri Olander

Bows
VK201/VK202
c. 1840, Kenai
Photograph by Matti Huuhka

Snowshoes
VK430
c. 1840, Kenai
Photograph by Matti Huuhka

Long Quillwork Band
VK5303.2
1846 donation, Kenai Peninsula
Photograph by István Bolgár

Several Quilled Strips
VK5303.3
1854–1862, Kenai Peninsula
Photograph by István Bolgár

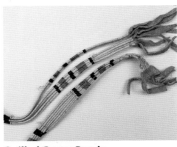

Quilled Garter Bands
VK5303.4
1846 donation, Kenai Peninsula
Photograph by István Bolgár

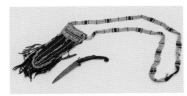

Knife and Knife Sheath
VK5465
c. 1840, Kenai Peninsula?
Photograph by Markku Haverinen

Man's Tunic
VK168A
1846 donaton, Kenai Peninsula

Tunic*
VK167A
1846 donation, Kenai Peninsula
See figures 13.5a–b

Man's Moccasin Trousers
VK168B
1846 donation, Kenai Peninsula
See figure 13.6

Dress
VK174
1846 donation, Kenai Peninsula
See figure 13.12

Dress*
VK177A
1846 donation, Kenai Peninsula
See figure 10.11

Moccasin-Trousers*
VK177B
1846 donation, Kenai Peninsula
See figure 10.12

Man's Hood*
VK179
1846 donation, Kenai Peninsula
See figure 13.7

Man's Hood
VK180
1846 donation, Kenai Peninsula
See figure 14.12

Gloves
VK184, VK185,* VK186, VK187,* VK188,*
VK189, VK190, VK191, VK192
1846 donation, Kenai Peninsula
Photographs by István Bolgár
See figure 14.27

Knife and Sheath*
VK193ab
1846 donation, Kenai Peninsula
See figure 14.0

Shot Pouch*
VK194
1846 donation, Kenai Peninsula
See figure 14.2

Knife Sheath with Shoulder Strap*
VK195
1846 donation, Kenai Peninsula
See figure 14.3

Knife Sheath/Strap*
VK197
1846 donation, Kenai Peninsula
See figure 14.4

The National Museum of Denmark, Ethnographic Collection, Copenhagen
Nationalmuseet, Etnografisk Samling

Basket
1853, Alaska
HC263

Most of the Dena'ina objects in the Nationalmuseet are in the Holmberg Collection and were collected in the nineteenth century. The woman's dress and moccasin-trousers were collected by Th. Branth during a trip to Kamchatka and are said to be pre-1845, an especially early date for Dena'ina clothing. Some of these items are pictured in Osgood's *Ethnography of the Tanaina* (1937). The quiver in the museum's collection is an exceptionally beautiful example, with many of its feathers still intact.

All photographs © by The National Museum of Denmark, Ethnographic Collection.
All photographs by Arnold Mikkelsen.

Bow
HB115
1853, Kenai Peninsula?

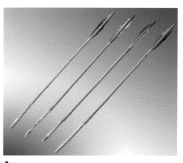

Arrows
HB116
1853, Kenai Peninsula?

War Club and Point*
Hb106a and H840
1853, Kenai Peninsula
See figure 1.49

War Club
Hb106B
1853, Kenai Peninsula
See figure 1.50

Dress and Moccasin-Trousers
E.1.C.99
1845
See figure 13.1

Quiver*
Hb117
1853, Kenai Peninsula?
See figure A.1

National Museum of Natural History, Smithsonian Institution

The National Museum of Natural History (NMNH) has pursued northern studies since the 1850s, and the Smithsonian possesses one of the world's finest anthropological collections from arctic and subarctic regions. Between 1858 and 1890, the majority of these collections were acquired by naturalists from the Mackenzie District, Ungava, Baffin Island, Coppermine, Alaska, and Siberia. Included is a small but important collection of Dena'ina artifacts. In 1988, the NMNH established the Arctic Studies Center, the only U.S. government program with a special focus on northern cultural research and education. In keeping with this mandate, the Arctic Studies Center specifically studies northern peoples, exploring history, archaeology, social change, and human lifeways across the circumpolar world. The Arctic Studies Center opened an Alaska office at the Anchorage Museum in 1993, and in 2010 it premiered a state-of-the-art exhibition of Alaska Native artifacts from Smithsonian collections.

All photographs courtesy Department of Anthropology, Smithsonian Institution.

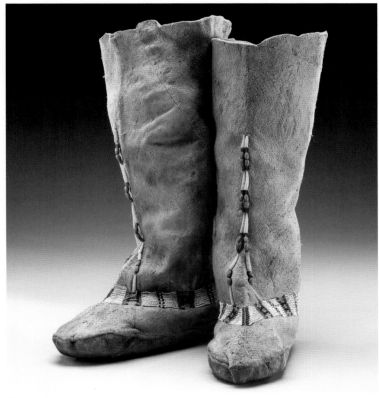

Woman's boots
E72504-0
1882, Knik River
Photograph by Donald E. Hurlbert

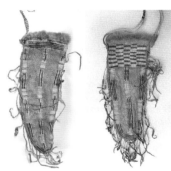

Knife Sheaths (2)
E009295-1 and E009295-2
1870, Alaska, attr. Dena'ina

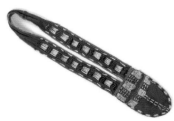

Fire bag
E073048
1883, Alaska, attr. Dena'ina
Photograph by Donald E. Hurlbert

Snowshoes
E38874-0
1879, Lake Iliamna
Photograph by Donald H. Hurlbert

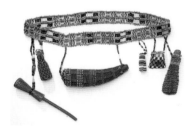

Beaded Hunting Belt, Powder Horn/ Measure, Ammunition Bag
E74722-0
1884, Cook Inlet
Photograph by Donald E. Hurlbert

Woman's boots
E72503-0
1883, Tyonek
Photograph by Donald E. Hurlbert

Feather Headdress
E90440-0
1884, Tyonek
Photograph by Aron Crowell

Beaded Hunting Belt, Powder Horn/ Measure, Ammunition Bag
E90454-0
1884, Tyonek
Photograph by Aron Crowell
See figure 1.62

Snowshoes
E90455-0
1884, Tyonek

National Museum of the America Indian, Smithsonian Institution, Washington DC

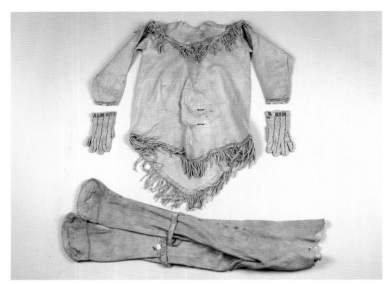

The National Museum of the American Indian, now part of the Smithsonian Institution, is dedicated to the life, languages, literature, history, and arts of Native Americans of the Western Hemisphere. The National Museum of the American Indian houses a dozen Dena'ina objects, including a Dena'ina shaman doll. A Dena'ina man's caribou skin outfit consisting of five heavily beaded pieces is currently on long-term exhibition in the Smithsonian Arctic Studies Center at the Anchorage Museum.

All photographs courtesy National Museum of the American Indian, Smithsonian Institution.

Tunic, Moccasin-Trousers, and Gloves
193266.000
1930s, Alaska
Photograph by Ernest Amoroso

Tunic and Moccasin-Trousers
051097.000
1916, Alaska, Dena'ina?

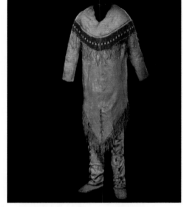

Tunic and Moccasin-Trousers
193265.000
1930s, Alaska, attr. Dena'ina

Shaman Doll*
10/6091
1840–1860, Cook Inlet
Photograph by Katherine Fogden
See figure 7.0

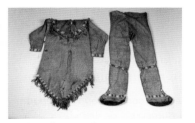

Tunic and Moccasin-Trousers
010616.000
c. 1900, Alaska, attr. Dena'ina

Bowl
236282.000
20th century?, Kenai
Photograph by Ernest Amoroso
See figure 11.20

Beaded Tunic, Hood, Moccasin-Trousers, Gloves, Knife Sheath
151481.000
1926, Alaska, attr. Dena'ina
Photograph by Donald E. Hurlbert
See figure 14.23

National Museums of Scotland, Edinburgh

In 1985, the National Museum of Antiquities merged with the Royal Scottish Museum to create the National Museums of Scotland. Their World Cultures collections include significant early northern Athabascan collections from the Candian Subarctic that were collected by Scottish traders. While most of the collection is from eastern Athabascan tribes, there are some western Athabascan items, including a beautiful woman's summer dress, which was featured in the 1974 exhibition, *The Athapaskans: Strangers of the North*, co-organized by the Royal Scottish Museum in collaboration with the National Museum of Man in Canada.

Photograph © National Museums of Scotland.

Dress
L.357.9
19th century?, Alaska?
See figures 13.11b, c

North American Native Museum, Zurich, Switzerland
Nordamerika Native Museum, Indianer und Inuit Kulturen

A shaman's figure or doll in the Nordamerika Native Museum is clothed in a beaded caribou hide tunic and moccasin-trousers. The style of the doll's clothing suggests a Dena'ina origin. Further information about Dena'ina materials in the museum's collection is not known.

Photograph © NONAM, the Nordamerika Native Museum, Zurich, Switzerland.

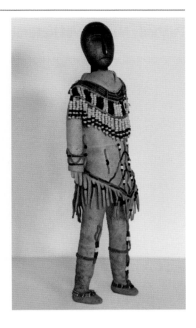

Shaman's Figurine
1946.NA.00204

Oldenburg State Museum, Germany
Staatliches Museum

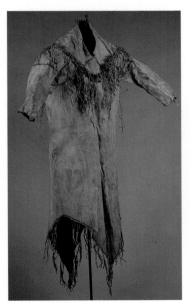

There are three nineteenth-century items attributed to Dena'ina in the Oldenburg State Museum, Germany. The clothing was collected in 1840. No further information regarding Dena'ina materials in this collection is known.

All photographs © Oldenburg Museum, Germany.

War Club
104
19th century

Moccasin-Trousers
19th century
2535

Tunic
2545
19th century

Peabody Museum of Natural History, Yale University, New Haven

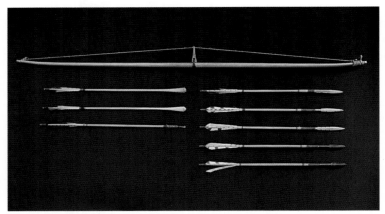

Cornelius Osgood (1905–1985), author of *The Ethnography of the Tanaina* (1937), was curator of anthropology at the Peabody Museum from 1934 to 1972. His ethnographic research among the Dena'ina included assembling for the Peabody Museum at Yale what is one of the most significant and best-documented early twentieth-century Den'aina collections. This collection of about eighty objects, principally from Tyonek and Iliamna (now Old Iliamna), contains a broad range of object types.

All photographs courtesy of the Peabody Museum of Natural History, Yale University.
All photographs by Chris Arend.

Bow*
ANT.015882
1931–1932, Eklutna

Blunt Arrow*
ANT.015883
1931–1932, Eklutna

Blunt Arrow*
ANT.015884
1931–1932, Eklutna

Arrows (6 pieces)
ANT.015885-ANT.015890
1931–1932, Eklutna

Boat Model
ANT.015842
1931–1932, Fitka, Seldovia

Dentalium Sash (belt)
ANT.015843
1931–1932, Iliamna

Tobacco Mortar
ANT.015847
1931–1932, Iliamna

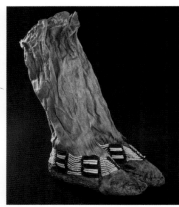

Chief's Boots
ANT.015848
1931–1932, Iliamna

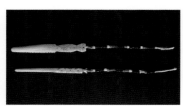

Hair Comb* and Scratcher*
ANT.015853, ANT.015854
1931–1932, Iliamna

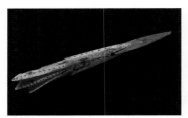

Spear Point
ANT.015855
1931–1932, Iliamna

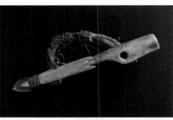

Detachable Spear Point
ANT.015856
1931–1932, Iliamna

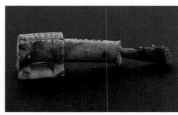

Spear Bladder Plug
ANT.015857
1931–1932, Iliamna

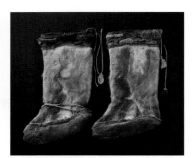

Caribou Boots
ANT.015858
1931–1932, Iliamna

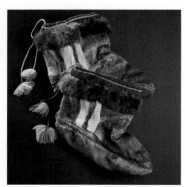

Boots
ANT.015859
1931–1932, Iliamna

Three Gut Raincoats
ANT.015861
1931–1932, Iliamna

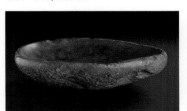

Stone Lamp
ANT.015862
1931–1932, Iliamna

Stone Scraper
ANT.015865
1931–1932

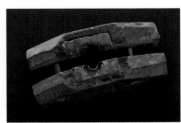

Bullet Mold
ANT.015868
1931–1932, Iliamna

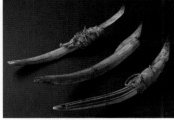

Crooked Knives (3 pieces)
ANT.015869, ANT.015870, ANT.015871
1931–1932, Iliamna

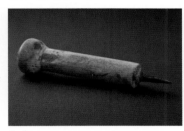

Awl
ANT.015872
1931–1932, Iliamna

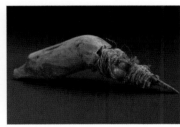

Awl
ANT.015873
1931–1932, Iliamna

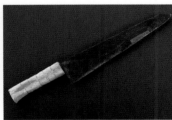

Knife
ANT.015874
1931–1932, Iliamna

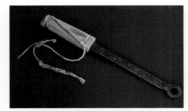

Spear Head with Sheath
ANT.015875
1931–1932, Iliamna

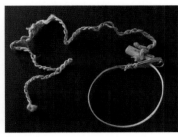

Snare
ANT.015876
1931–1932, Eklutna

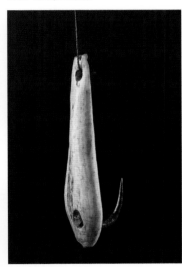

Fish Hook
ANT.015877
1931–1932, Iliamna

Bone Comb
ANT.015892
1931–1932, Eklutna, Knik River

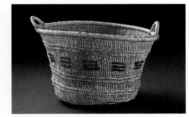

Basket
ANT.015894
1931–1932, Mary Barvel, Tyonek

Two Moose Babiche Bundles
ANT.015895
1931–1932, Tyonek

Six Fragments of Rock with Red Ochre Cave Painting
ANT.015926
1931–1932, Bear Cave, Kachemak Bay

Slippers (6 pairs)
ANT.015896, ANT.015897, ANT.015898,
ANT.015899, ANT.015900, ANT.015902
1931–1932, Tyonek

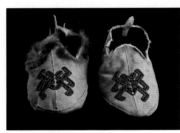

Man's Slippers
ANT.015901
1931-1932, Tyonek

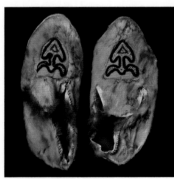

Child's Slippers
ANT.015903
1931–1932, Tyonek

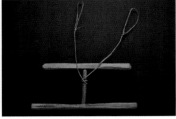

Fire Drill Set
ANT.015919
1931–1932, made by Fitka of Seldovia

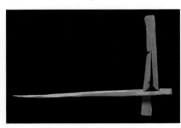

Trap Sticks for Mink and Marten
ANT.015922
1931–1932

Two Fragments of Red Ochre
ANT.015927
Bear Cave, Kachemak Bay

Dance Cap for Potlatch
ANT.015839
1931–1932, Seldovia
See figure 1.45

Bow
ANT.015844
1931–1932, Iliamna
See figure 11.27

Arrow with Metal Spike
ANT.015845
1931–1932, Iliamna
See figure 11.27

Arrow
1931–1932, Sevilla, Iliamna
ANT.015846
See figure 11.27

Bentwood Bowl*
ANT.015849
1931–1932, Iliamna
See figure 1.47

Wooden Bowls (3 pieces)
ANT.0158549, ANT.015851, ANT.015863
1931–1932, Iliamna
See figure 11.0

Drinking Tube*
ANT.015852
1931–1932, Iliamna
See figure 1.0

Pack Yoke
ANT.015860
1931–1932, Iliamna
See figure 11.17

Large Wooden Bowl
ANT.015864
1931–1932, Iliamna
See figure 3.3

Fish Spear Point*
ANT.015866
1931–1932, Iliamna
See figure 11.10

Two Bone Spear Points*
ANT.015867
1931–1932, Iliamna
See figure 11.25

Quiver
ANT.015891
1931–1932, Eklutna

Child's Snowshoes*
ANT.015893
1931–1932, Tyonek
See figure 11.22

Snowshoes
ANT.015904
1931–1932, Susitna
See figure 11.21

Mittens*
ANT.015905
1931–1932, Upper Susitna
See figure A.7

Copper Knife
ANT.015908
1931–1932, may have been traded
from the Ahtna to the Upper Inlet
Dena'ina
See figure 1.60

Gaming Discs*
ANT.015920
1931, Alaska
See figure 7.7

Game Sticks*
ANT.015921
1931–1932, made by Fitka of Seldovia
See figure 7.8

Peter the Great Museum of Anthropology and Ethnography (Kunstkamera), St. Petersburg

The Kunstkamera was founded in 1714 by the Russian czar, Peter the Great. Starting in the 1830s, the Kunstkamera was divided into a number of independent museums, and in 1878, the Museum of Anthropology and Ethnology was created and is dedicated to displaying the culture and traditions of the peoples of the world. Since Alaska was part of Russian America from 1733 to 1867, there was a concerted effort to collect materials from Alaska. The Dena'ina collection housed at the Kunstkamera holds some of the earliest known Dena'ina items and is considered to be one of the best in the world owing to the size and scope of the collection.

See also figures A.2, 1.22, 1.23, 7.9, 11.8, 11.9, 11.12, 13.8, 13.10b, c, 13.13, 13.14, 14.20, 14.21.

All Dena'ina objects in this collection are individually discussed in chapter 15, "Dena'ina Collections in the Peter the Great Museum of Anthropology and Ethnography (Kunstkamera)." Each object is illustrated with a photograph, and an appendix to the chapter lists the objects.

Phoebe A. Hearst Museum of Anthropology, University of California, Berkeley

The Hearst Museum's holdings include the Alaska Commercial Company Collection of nearly 2,300 objects, of which 102 are attributed to Athabascan Indians. The Alaska Commercial Company Collection dates from 1868, when a small number of artifacts were acquired from the company's takeover of the Russian-American Company's posts. Most of the collection consists of nineteenth-century materials purchased from Native makers. This collection was published in a catalogue raisonné by anthropologists Nelson H. Graburn, Molly Lee, and Jean-Loup Rousselot (1996). Researcher Kate C. Duncan worked on the Athabascan materials, of which about half are clothing. There are a few Dena'ina pieces, in particular a painted quiver and a man's summer tunic.

All photographs © Phoebe A. Hearst Museum of Anthropology and the Regents of the University of California, Berkeley.
All photographs by Alicja Egbert.

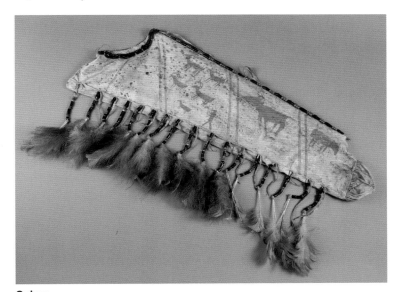

Quiver
2-6713

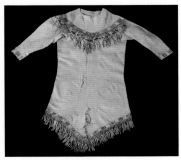

Dress
2-19045

Pratt Museum, Homer

Wood Platter
2010.007.001
1894?, Cook Inlet

The Dena'ina materials held at the Pratt Museum in Homer, Alaska, are mainly archaeological. Located on the Kenai Peninsula, the Pratt Museum serves a Dena'ina population and collaborates with the Dena'ina on a variety of ethnographic and historical projects, including a film and a recent fish camp exhibition. The Pratt Museum holds Dena'ina counting cords from the collections of the Alaska State Museum to make them more accessible to local Dena'ina. The museum has recently added a fine Dena'ina wood platter ornamented with red ochre to its collections.

Photograph courtesy of the Pratt Museum.
Photograph by Chris Arend.

Russian Museum of Ethnography, St. Petersburg

The Russian Museum of Ethnography is dedicated to the peoples of Russia. The museum collection of about half a million objects consists of objects of everyday life, archival material, drawings, and photographs reflecting the traditional cultures of the more than 150 peoples who during the eighteenth through twentieth centuries made up the various Russian empires, including Russian America. The Russian Museum of Ethnography was established in 1902 as the Ethnographic Department of the Russian Museum. It was first open to the public in 1923 and became independent of the Russian Museum in 1934. The museum has a small collection of Dena'ina artifacts that it inherited from the State Museum of the People of the USSR in Moscow (successor to the Dashkov Museum) when the latter closed in 1948. Several Dena'ina items of note include a men's sewing kit and a quill-decorated bag, which shows almost no sign of wear and likely has never been displayed.

All photographs courtesy of the Russian Ethnographic Museum.
All photographs by Chris Arend.

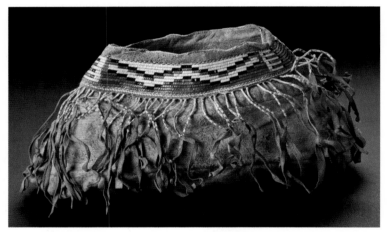

Bag with Quillwork
8762-17221
c. 1850, Alaska

Strips with Fringe
6780-30 1-2
c. 1850, Alaska

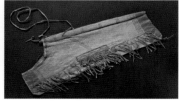

Quiver
8762-17224
c. 1850, Alaska

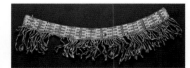

Strip of Quillwork on Skin
8762-17218
c.1850, Alaska

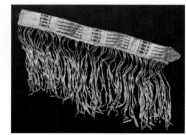

Quilled Strip with Fringe
6780-29
c. 1850, Alaska

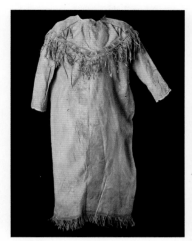

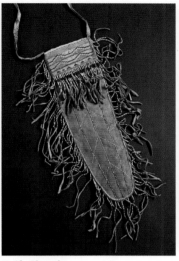

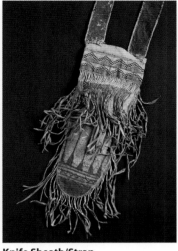

Sewing Kit
8762-17220/1–3
c. 1850, Alaska
See figure 3.0

Mittens with Strings
8762-19219
c. 1850, Alaska
See figure 14.5

Tunic
8672-17217
c. 1850, Alaska
See figure 14.1ab

Dress
8762-17216
c. 1850, Alaska

Knife Sheath
8762-17222
c. 1850, Alaska

Knife Sheath/Strap
8762-17223
c. 1850, Alaska

Seward Community Museum and the Resurrection Bay Historical Society

The Seward Community Museum and the Ressurection Bay Historical Society collections contain almost 5,000 objects, photographs, and archives pertaining to the history of Seward. Among the collections is a remarkable rain parka made of bear gut by a Dena'ina woman, Mary Evanoff of Nondalton.

Photograph courtesy of the Seward Community Museum and the Resurrection Bay Historical Society.

Bear Gut Parka*
1967.003.001
Early 1900s, Nondalton
Made by Mary Evanoff, wife of Chief Zackar Evanoff, Nondalton
See figure 13.26

Tebughna Foundation, Tebughna

The Tebughna Foundation is the nonprofit wing of Tyonek Native Corporation. It was founded in 2007 to preserve, enhance, educate, and serve the community of Tyonek and the shareholders of the Tyonek Native Corporation. It manages a scholarship program and supports community and cultural events. In 2010, when a rare Dena'ina hunter's amulet originally from the Tyonek area became available, the Tebughna Foundation acquired this artifact. The foundation has kindly loaned the amulet for the exhibition. The Tyonek Native Corporation is a generous contributor to the Dena'ina exhibition.

Photograph courtesy of the Tebughna Foundation.
Photograph by Chris Arend.

Hunter's Talismanic Pouch*
Early 20th century, Tyonek
See figure 7.2

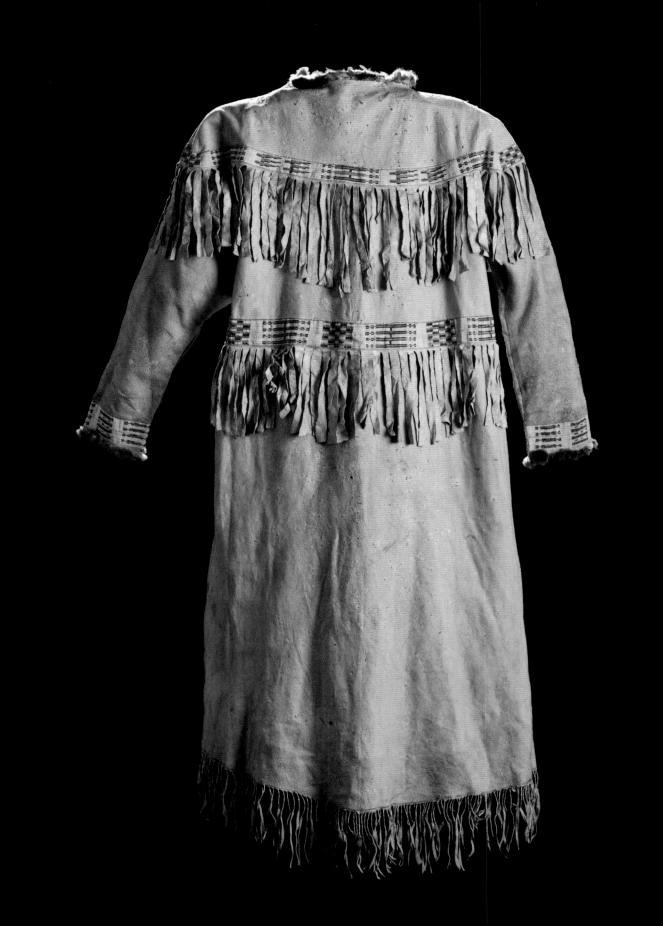

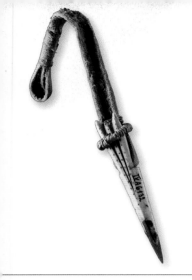

The Dena'ina Sound System and Orthography

James Kari

The Dena'ina sound system is written with a practical alphabet that has forty letters. For Dena'ina, we use the following alphabetical sequence when Dena'ina words are presented in an alphabetical morpheme list or alphabetized by computer.

' a b ch ch' d dl dz e g gg gh h ĥ i j k k' l ł m n q q' s sh t t' tl tl' ts ts' u v w x y ŷ z zh

Some single sounds have two or three symbols, such as **t'** to **ts'**. The most distinctive sounds are the *glottalized consonants,* which are written with **'**, as in **ch', k', q' t', ts'**.

In addition to the forty native Dena'ina sounds, a few distinct phonemes occur in some Russian words: **o é f r**.

A useful guide to the sounds of Dena'ina is Helen Dick's *Inland Dena'ina Key Words* (2007). Section1 below lists key words in alphabetical order. These same words can be viewed and heard online as said by Helen Dick of Lime Village on the Dena'ina language website.

1. Dena'ina Key Words (Lime Village Dialect) (See also http://qenaga.org/alphabet.html)

Sound	Dena'ina word	Meaning
(glottal stop)	sh'in	I don't know
a	ał	deadfall trap
b	libushgi	fry bread
ch	chida	grandmother
ch'	ch'da	blanket, robe
d	daz'i	fire
dl	dlin'a	mouse
dz	dzastets'	boat pole
e	el	spruce needles
f	gufi	coffee
g	giga	berries
gg	ggagga	brown bear
gh	gheljay	moon
h	hał	pack

ĥ (hh)	ĥuk	hurry!
i	itl'	clothes
j	jani	day
k	kisht'a	too much
k'	k'eh	porcupine quill
l	luts'egh	ring
ł	łik'a	dog
m	minłni	water
n	nini	porcupine
q	qil	it is no good
q'	q'in	fish eggs
r	Rayzestbu	Christmas
s	sem	star
sh	shan	summer
t	ten	ice
t'	t'ash	charcoal
tl	tlegh	oil
tl'	tl'ił	rope
ts	vetsa'a	his daughter
ts'	ts'ełq'i	one
u	ush	snowshoes
v	ven	lake
w	wen	lake (*Seldovia only*)
x	chix	red ochre, ochre paint
y	yuq'	sky
ŷ	nch'u eshch'eŷ	he is not breathing
z	izin	gun, rifle
zh	ezhi	it's cold

Section 2 presents the four-vowel system for Dena'ina: **a, e, i, u.** The vowels **a, i, u** are considered *full vowels.* These are slightly longer than the **e** vowel, the *reduced vowel* or *schwa*, which is the most common sound in the language.

2. The Dena'ina Vowel System

Vowel	Dena'ina word	Meaning	English sound equivalent
a	ał	deadfall trap	*in* father
i	itl'	clothing	[i] *in* each
u	ush	snowshoes	[u] *in* two
e	el	spruce needles	[ə] *in* gull

There is one common phonetic rule for vowels that should be noted. This affects the "coloring" of the high vowels **i** and **u**. Compare these words in section 3.

3. High Vowels i and u with Front and Back Velars

Dena'ina word	Meaning
kił	young man
qil [qīl]	it is no good
ush	snowshoe
yuq' [yoq']	sky

When these high vowels occur before or after a back velar consonant, they are lowered and sound like [ī], as in the English word *kind,* or [o], as in the English word *cold.* These are simply lowered variants of **i** and **u**, and there is no need to introduce extra vowel symbols into the Dena'ina alphabet to accommodate the sounds.

Dena'ina Dialects

Dena'ina dialect distinctions are a reflection of long-term occupation of different regions of the Dena'ina language area. There are four main dialect areas, as shown on the language map, map 1.1. The large Upper Inlet dialect area had several subdialects, and sometimes it is possible to assign words to a village-specific dialect. Section 4 summarizes the dialect abbreviations used in the *Dena'ina Topical Dictionary* (Kari 2007).

4. Dena'ina Dialect Abbreviations

(I) = Inland (Nondalton, Lime Village, often Iliamna)
 (L) = Lime Village
 (N) = Nondalton

(Il) = Iliamna (Pedro Bay, Old Iliamna)

(O) = Outer Cook Inlet (Kenai, Kaifornsky, Kustatan, Polly Creek)

(S) = Seldovia

(U) = Upper Cook Inlet (Tyonek, Susitna Station, Knik, Eklutna, Talkeetna)
 (Su) = Susitna Station
 (E) = Eklutna
 (Ty) = Tyonek
 (T) = Talkeetna
 (Kn) = Knik

Note: When there is no dialect difference, there is no abbreviation.

rope	tl'ił	no abbreviation = same word in all dialects
he is looking at it	yenił'an	

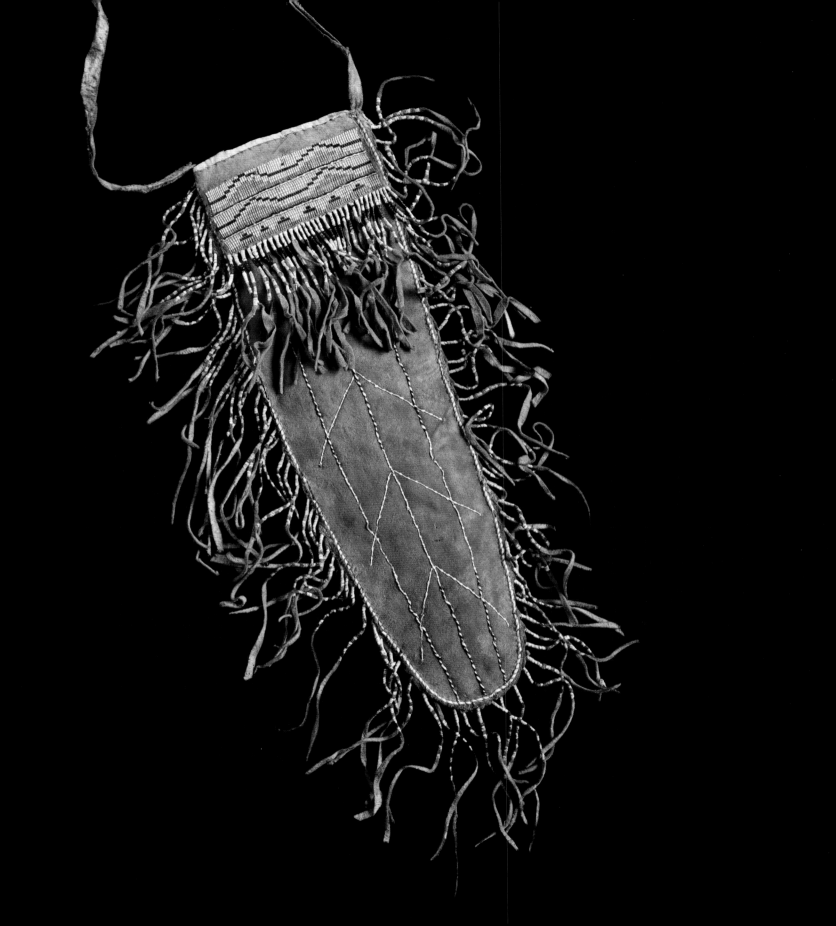

About the Authors

ALAN S. BORAAS, professor of anthropology at Kenai Peninsula College, received his PhD from Oregon State University in 1983. He is co-editor with James Kari of *A Dena'ina legacy, K'tl'egh'i Sukdu: The Collected Writings of Peter Kalifornsky* (Alaska Native Language Center, 1991 and 2001). This book was named Book of the Year in the American Book Awards in 1992 by the Before Columbus Foundation. In 2007, Boraas created "Kahtnuht'ana Qenaga" [The Kenai People's Language], with Michael Christian, an HTML-based Dena'ina language website: http://qenaga.org/kq/index.html.

KATE C. DUNCAN, professor emerita of art history at Arizona State University, received a PhD in art history from the University of Washington in 1982. Her special areas of research and teaching are Native American art and material culture, particularly of subarctic, arctic, northwest coast, and plateau regions. Duncan has written extensively on Athabascan art, including *Northern Athapaskan Art: A Beadwork Tradition* (University of Washington Press, 1989), and *Some Warmer Tone: Bead Embroidery of the Alaska Athabascans* (University of Alaska Museum, 2nd printing, 1992). She served as president of the Native American Art Studies Association from 2003 to 2007.

KAREN E. EVANOFF. Since 2007, Evanoff has worked as a cultural anthropologist in the Cultural Resource Program for Lake Clark National Park. Her publications include editing the 2009 Dena'ina place name study *Dena'ina Ełnena* (National Park Service). In 2005–2006, Evanoff was president/CEO/chairperson of Kijik Corporation, the ANCSA village corporation for Nondalton, Alaska. Evanoff received a BA in anthropology from the University of Alaska Fairbanks in 1998.

JAMES A. FALL is statewide program manager, Division of Subsistence, Alaska Department of Fish and Game. Fall is a recognized expert on Dena'ina social organization, leadership, and subsistence. He has worked with Dena'ina people for more than thirty years. Fall is the coauthor with James Kari of *Shem Pete's Alaska: The Territory of the Upper Cook Inlet Dena'ina* (2nd ed., University of Alaska Press, 2003). Fall received his PhD in anthropology from the University of Wisconsin-Madison in 1981.

SUZI JONES, a specialist in Alaska Native art, has served as deputy director of the Anchorage Museum since 1997. Prior to this, Jones served as a senior program officer for the National Endowment for the Humanities (1986–1997) and as the director

3.2 K'izhagi, knife sheath, Alaska, c. 1850. L 87 cm, W 30 cm; caribou hide, porcupine quills, ochre, sinew. Russian Museum of Ethnography, 8762-17222. Photograph © Russian Museum of Ethnography. Photograph by Chris Arend.

of the Traditional Native Arts Program for the Alaska State Council on the Arts (1980–1986). With more than thirty years' experience in public programming in the arts and humanities, her work has included curating exhibitions; managing international loan exhibitions; and producing exhibition catalogs, books, conferences, and a variety of public programs on Alaska Native art and culture and on the folklore of the American West. She received her PhD with honors from the University of Oregon in 1978.

JAMES M. KARI, professor emeritus, Alaska Native Language Center, University of Alaska Fairbanks, has received many awards for his lifetime work with Athabascan languages. Kari's work includes numerous publications on Athabascan languages and several major publications on Dena'ina: *Dena'ina Topical Dictionary* (Alaska Native Language Center, 2007); *Shem Pete's Alaska: The Territory of the Upper Cook Inlet Dena'ina*, edited with James A. Fall (2nd ed., University of Alaska Press, 2003); and *A Dena'ina Legacy, K'tl'egh'i Sukdu: The Collected Writings of Peter Kalifornsky*, edited with Alan S. Boraas (Alaska Native Language Center, 1991), which won the 1992 American Book Award. Kari received a PhD in curriculum and instruction and linguistics from the University of New Mexico in 1973. He served on the faculty of the University of Alaska from 1975 to 1997.

VIOLA KÖNIG has served as director of the Ethnologisches Museum in Berlin since 2001. König received a PhD from Universität Hamburg in 1978. Her main field of research is the writing systems and iconography of Mesoameria (Mixtec and Zapotec), with secondary interests in the ethnography and material culture of the Pacific Northwest Coast of America (Tlingit, Haida Gwaii, Eskimo) and transpacific cultural contacts. König is an honorary professor for precolumbian studies and cultural anthropology at Freie Universität Berlin. In 2000, she was a visiting professor in the Department of Art, Newcomb College, Tulane University.

SERGEI KORSUN is senior curator of American ethnography at the Peter the Great Museum of Anthropology and Ethnography (Kunstkamera) in St. Petersburg, Russia. Korsun holds an MA degree in ethnography and anthropology from the St. Petersburg State University and has been working at the Kunstkamera since 1988. In 2004, he defended his doctoral dissertation on the history of the Kunstkamera's holdings pertaining to the peoples of Russian America. Korsun is the author of over eighty publications on museum studies and history and ethnography of Native peoples of America.

AARON LEGGETT has served as special exhibitions curator at the Anchorage Museum since March 2011. He served as the Dena'ina cultural historian for the Alaska Native Heritage Center (2006–2011) and was assistant historian for Cook Inlet Region, Inc., from 2003 to 2006. Leggett has served as treasurer for the Native Village of Eklutna since 2007 and is a member of the board of directors, Cook Inlet Historical Society. He received his BA in anthropology from the University of Alaska Anchorage in 2006.

MICHELLE E. RAVENMOON has worked in the Cultural Resource Program of the Lake Clark National Park and Preserve as a cultural ethnographic program liaison lead and a subsistence coordinator and as a program manager for the Alaska Native/American Indian Program. She has carried out ethnohistorical research and written curriculum incorporating cultural preservation values. Also involved in Dena'ina language preservation activities, she served as a language instructor at the University of Alaska Fairbanks in 2005–2007. Ravenmoon received an BA in rural development/community research and cultural documentation in 2005 from the University of Alaska Fairbanks.

DOUGLAS REGER has conducted archaeological research in Cook Inlet and at Dena'ina sites since the 1970s. He is known for the discovery of Beluga Point, the oldest known archaeological site within the Municipality of Anchorage. Reger served as Alaska state archaeologist in the Alaska Division of Parks from 1975 to 1982; deputy Alaska state historic preservation officer from 1978 to 1982; archaeologist for the Alaska Division of Geological and Geophysical Surveys at Tazlina Lake, Kenai River drainage, lower Susitna/Matanuska valleys, and Price of Wales Island from 1982 to 1986; and archaeologist with the Alaska Division of Parks and Outdoor Recreation from 1986 to 2000. Currently, Reger's work includes private consulting and various archaeological survey projects in southcentral and southeastern Alaska. Reger received his PhD from Washington State University in 1981.

JOAN M. TENENBAUM received her PhD in anthropology and linguistics from Columbia University in 1978. She is editor and compiler of *Dena'ina Sukdu'a: Traditional Stories of the Tanaina Athabaskans* (Alaska Native Language Center, 1976, 1984, and 2006). An award-winning jewelry designer and metalsmith, Tenenbaum often draws inspiration from Alaska Native cultures, including Dena'ina, for her artwork.

JUDY THOMPSON served as curator of western subarctic ethnology at the Canadian Museum of Civilization from 1991 to 2012. Thompson's curatorial work has included exhibitions such as *The Spirit Sings* at the Glenbow Museum, 1998; *From the Land: Two Hundred Years of Dene Clothing* for the Canadian Museum of Civilization, 1996–1997; *Tradition and Innovation: Northern Athapaskan Footwear* for the Bata Shoe Museum, 1996; and *Long Ago Sewing We will Remember: The Story of the Gwich'in Traditional Caribou Skin Clothing Project* for the Prince of Wales Northern Heritage Centre, 2007–2008. Her numerous publications on Athabascan clothing include senior author with J. Hall and L. Tepper of *Fascinating Challenges: Studying Material Culture with Dorothy K. Burnham* (Mercury Series, Canadian Museum of Civilization, 2001), and *Women's Work, Women's Art: Nineteenth Century Athapaskan Clothing* (Canadian Museum of Civilization and McGill-Queen's University Press, 2013). Thompson received a BA in anthropology from the University of British Columbia in 1967.

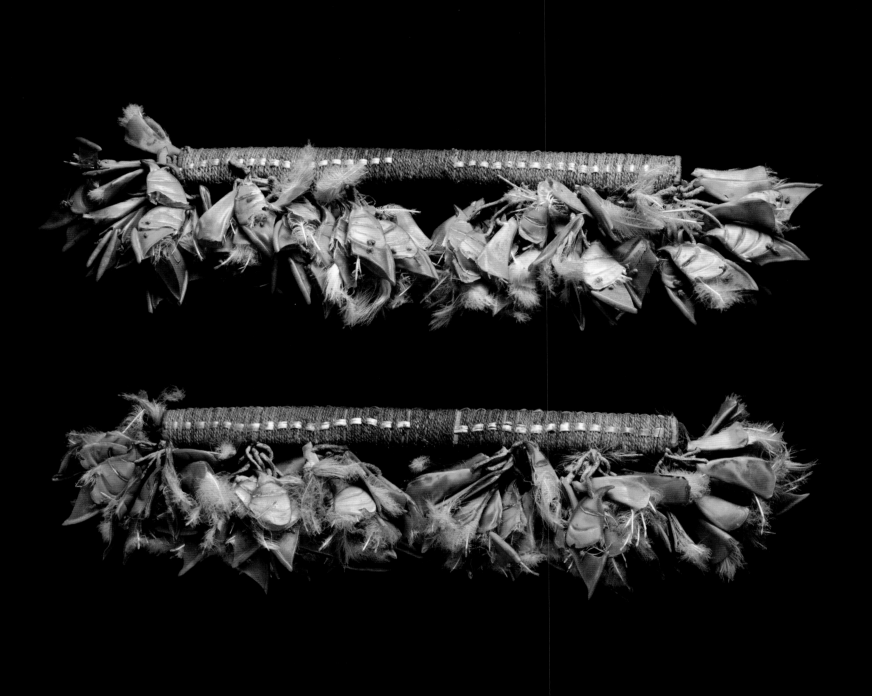

Bibliography

8.3 *Ch'dulaɫi,* **puffin beak rattles, Fort Kenai, 1883.** L 39–40 cm. Wood, puffin beaks, feathers, sinew, thread (wool?), long bird quills. Ethnological Museum Berlin, IVA 168 ab. Photograph courtesy of Staatliche Museen zu Berlin, Ethnologisches Museum. Photograph by Chris Arend.

Abercrombie, William R. 1900. "Report of a Supplementary Expedition into the Copper River Valley, Alaska, 1884." In *Compilation of Narratives of Explorations in Alaska,* 381–408. Washington, DC: U.S. Government Printing Office.

Ackerman, Robert E. 1975. *The Kenaitze People.* Phoenix, AZ: Indian Tribal Series.

Allen, R. E., ed. 1990. *The Concise Oxford Dictionary of Current English.* Oxford: Clarendon Press.

Alexan, Nickafor. n. d. Nickafor Alexan writings, c. 1957. Typescript. Archives of the Library of the University of Alaska Anchorage.

———. 1965a. "How Tyonek People Used to Eat." *Alaska Sportsman* 31 (1):38–39, 59–60.

———. 1965b. "Stories about How to Raise Children." *Alaska Sportsman* 31 (4):13–14.

———. 1981. "Fourth Chief of Tyonek." In *The Last Indian War in Tyonek and Other History,* 16–19. Kenai Peninsula Borough School District.

Anchorage Daily News. "Many Gather Here for Last Rite for Ruler First People of Land," January 22, 1935.

Attla, Catherine. 1990. *K'etetaalkkaanee: The One Who Paddled Among the People and Animals.* Fairbanks: Alaska Native Language Center.

Balluta, Andrew. 2008. *Shtutda'ina Da'a Sheɫ Qudeɫ: My Forefathers Are Still Walking with Me.* Transcribed and edited by James Kari. Anchorage: National Park Service, Lake Clark National Park and Preserve.

Beaglehole, J. C., ed. 1967. *The journals of Captain James Cook on his voyages of discovery. The voyage of the "Resolution" and "Discovery," 1776–1780.* Cambridge: Cambridge University Press, published for the Hakluyt Society.

Bean, Tarlton H. 1887. The Fishery Resource and Fishing Grounds of Alaska. In *The Fisheries and Fishery Industries of the United States,* G. B. Goode, ed., sec. III, pp. 81-116. Washington, DC: Government Printing Office.

Behnke, Steven R. 1982. "Wildlife Utilization and the Economy of Nondalton." Technical Paper no. 47. Division of Subsistence, Alaska Department of Fish and Game, Juneau.

Beresford, William. 1789. *A Voyage Round the World: But More Particularly to the North-west Coast of America Performed in 1785, 1786, 1787, and 1788. Performed in the* King George, *commanded by Captain Portlock; and the* Queen Charlotte, *commanded by Captain Dixon.* London: R. Randal.

Black, Lydia. 1981. "'The Daily Journal of Reverend Father Juvenal': A Cautionary Tale." *Ethnohistory* 28 (1):33–57.

Blomkvist, E. E. 1975. "Istoriya izucheniya v Rossii yazykov severoamerikanskih indeitsev (is arhiva MAE) [History of Russian research on languages of Indians of North America]," *Iz culturnogo naslediya narodov Ameriki i Afriki* [From the cultural heritage of the peoples of America and Africa]. St. Petersburg: Sbornik MAE, vol. 31, 94–117.

Boraas, Alan. 2007. "Dena'ina Origins and Prehistory." In *Nunutset ch'u Q'udi Gu: Before Our Time and Now: An Ethnohistory of Lake Clarke National Park and Preserve,* by Karen K. Gaul, 31–40. Anchorage: Lake Clark National Park and Preserve, National Park Service.

Boraas, Alan, and Aaron Leggett. 2010. "Dena'ina Resistance toward Russian Hegemony: Late 18th and 19th Centuries." Paper presented at the Society of Ethnohistory annual meeting, Ottawa, ON, October 16, 2010.

Boraas, Alan, and Donita Peter. 1996. "The True Believer among Kenai Peninsula Dena'ina." In *Adventures Through Time: Readings in the Anthropology of Cook Inlet, Alaska,* ed. Nancy Yaw Davis and William E. Davis, 181–195. Anchorage: Cook Inlet Historical Society.

———. 2009. "The Role of Beggesh and Beggesha in Pre-contact Dena'ina Culture." *Alaska Journal of Anthropology* 6 (1–2):211–224.

Branson, John. 1998. *Bristol Bay, Alaska: From the Hinterlands to Tidewater: A Grassroots Pictorial, 1885–1965.* Anchorage: National Park Service.

Bryson, George. 1988. "People in Peril: A Free Man Tells of His Life in Anchorage." *Anchorage Daily News,* February 17, F3.

Castner, Joseph C. 1899. Report of Lieutenant J. C. Castner, Fourth U. S. Infantry. In *Reports of Explorations in the Territory of Alaska,* ed. E.F. Glenn and W.R. Abercrombie, pp. 189–267. U. S. Adjutant General's Office Military Information Division, Publication 25. War Department Document 102. Washington, DC: U. S. Government Printing Office.

Chickalusion, Nellie. 1980. "The Rich Man's Good for Nothing Son." In *Q'udi Heyi Niłch'diluyi Sukdu'a: This Year's Collected Stories, Tyonek and Iliamna Lake,* ed. James Kari, 58–64. Anchorage: National Bilingual Materials Development Center.

Cole, Douglas. 1985. *Captured Heritage: The Scramble for Northwest Coast Artifacts.* Seattle: University of Washington Press.

Conn, Richard. 1991. "Some Design Concepts of Traditional Subarctic Clothing." *Arctic Anthropology* 28 (1):84–91.

Cook, Frederick. 1908. *To the Top of the Continent.* New York: Doubleday, Page and Company.

Cook, James, and J. King. 1785. *A Voyage to the Pacific Ocean Undertaken, by the Command of His Majesty, for Making Discoveries in the Northern Hemisphere, Performed Under the Direction of Captains Cook, Clarke, and Gore, in His Majesty's Ships the Resolution and Discovery; in the Years 1776, 1777, 1778, 1779, and 1780.* 3 vols. London: G. Nicol and T. Cadell.

Coray, John. 2007. *Dnaghelt'ana Qut'ana K'eli Ahdelyax:* They Sing the Songs of Many Peoples: The 1954 Nondalton Recordings of John Coray. Kijik Corporation, Anchorage.

Davis, Nancy Yaw. 1965. "A Tanaina Indian Village." Master's thesis, University of Chicago.

Davis, Nancy Yaw, and William E. Davis, eds. 1996. *Adventures Through Time: Readings in the Anthropology of Cook Inlet, Alaska.* Anchorage: Cook Inlet Historical Society.

Davydov, Gavriil Ivanovich. 1977 [1810–1812]. *Two Voyages to Russian America, 1802–1807.* Translated by Colin Bearne and edited by Richard A. Pierce. Kingston, ON: Limestone Press.

de Laguna, Frederica. 1934. *The Archaeology of Cook Inlet, Alaska.* Philadelphia: University of Pennsylvania Press.

———. 1969–1970. "The Atna of the Copper River, Alaska: The World of Men and Animals." *Folk* 11–12:17–26.

———. 1975. "Matrilineal Kin Groups in Northwestern North America." In *Proceedings: Northern Athapaskan Conference, 1971,* ed. A. McFadyen Clark, 17–145. National Museum of Man Mercury Series 27. Ottawa, ON: National Museums of Canada.

———. 1996. "Cook Inlet Adventures and Afterthoughts." In *Adventures Through Time: Readings in the Anthropology of Cook Inlet, Alaska,* ed. Nancy Yaw Davis and William E. Davis, 65–88. Anchorage: Cook Inlet Historical Society.

Dick, Helen, James M. Kari, and Andrea Berez. 2007. *Inland Dena'ina Key Words: Lime Village Dialect.* Anchorage: Alaska Native Heritage Center, Dena'ina Language Program.

Dixon, Captain George. 1789. *A Voyage Round the World: But More Particularly to the North-west Coast of America Performed in 1785, 1786, 1787, and 1788. Performed in the* King George, *commanded by Captain Portlock; and the* Queen Charlotte, *commanded by Captain Dixon.* London: Geo. Goulding.

Dixon, R. Greg. 1996. "Tiq'atl'ena Bena (Hewitt Lake) Archaeological Research Project." In *Adventures Through Time: Readings in the Anthropology of Cook Inlet, Alaska,* ed. Nancy Yaw Davis and William E. Davis, 93–107. Anchorage: Cook Inlet Historical Society.

Dixon, R. Greg, James Kari, and Alan Boraas, eds. 2005. *Bibliography of Sources on Dena'ina and Cook Inlet Anthropology, version 2.4.* Kenai, AK: Kenaitze Indian Tribe, Ts'itsatna Tribal Archives.

Documents Relative to the History of Alaska. n.d. Alaska History Research Project 1936–1938. Four volumes. Copies at Library at Congress, Washington, DC, and University of Alaska, Fairbanks.

Doroshin, P. P. 1866. "Iz zapisok vedennyh v Russkoi Amerike" [From the notes compiled in Russian America]. *Gornyi Zhurnal,* pt.1, no. 3, 365–400.

Dumond, Don E., and R. L. A. Mace. 1968. "An Archaeological Survey Along Knik Arm." *Anthropological Papers of the University of Alaska* 14 (1):1–21.

Duncan, Kate C. 1989. *Northern Athapaskan Art.* Seattle: University of Washington Press.

Ellanna, Linda J., ed. 1986. *Lake Clark Sociocultural Study: Phase I.* Anchorage: National Park Service, Lake Clark National Park and Preserve.

Ellanna, Linda J., and Andrew Balluta. 1992. *Nuvendaltin Quht'ana: The People of Nondalton.* Washington, DC: Smithsonian Institution Press.

Evanoff, Karen E., ed. 2010. *Dena'ina Ełnena: A Celebration.* Anchorage: National Park Service.

Fall, James A. 1981. "Patterns of Upper Inlet Tanaina Leadership." PhD diss., University of Wisconsin–Madison.

———. 1987. "The Upper Inlet Tanaina: Patterns of Leadership Among an Alaskan Athabaskan People, 1741–1918." *Anthropological Papers of the University of Alaska* 21 (1–2):1–80.

———. 1989. "The Subsistence King Salmon Fishery at Tyonek, Alaska: A Case Study of Alaska's Subsistence Law." Paper presented at the Symposium on Indian Fisheries, sponsored by the Native American Fisheries Committee of the American Fisheries Society, Western Division. Seattle, July 1989.

———. 1990a. "Upper Cook Inlet Dena'ina Oral Traditions: An Introduction to the Narrative Art of an Alaskan Athabaskan People." Report to the Alaska Humanities Forum. Anchorage.

———. 1990b. "The Division of Subsistence of the Alaska Department of Fish and Game: An Overview of Its Research Program and Findings: 1980–1990." *Arctic Anthropology* 27 (2):68–92.

———. 2009. "*Dena'ina Ełnena*: Dena'ina Country: The Dena'ina in Anchorage, Alaska." In *The Alaska Native Reader: History, Culture, Politics,* ed. Maria Sháa Tláa Williams, 67–84. Durham, NC: Duke University Press.

Fall, James A., Davin Holen, Brian Davis, Theodore Krieg, and David Koster. 2006. "Subsistence Harvests and Uses of Wild Resources in Iliamna, Newhalen, Nondalton, Pedro Bay, and Port Alsworth, Alaska, 2004." Technical Paper no. 302. Division of Subsistence, Alaska Department of Fish and Game, Juneau.

Fall, James A., Davin Holen, Theodore Krieg, Robbin La Vine, Karen Stickman, Michelle Ravenmoon, Jessica Hay, and Jory Stariwat. 2010. "The Kvichak Watershed Subsistence Salmon Fishery: An Ethnographic Study." Technical Paper no. 352. Division of Subsistence, Alaska Department of Fish and Game, Juneau.

Fall, James A., Ronald T. Stanek, and Dan J. Foster. 1984. "The Use of Fish and Wildlife Resources in Tyonek, Alaska." Technical Paper no. 105. Division of Subsistence, Alaska Department of Fish and Game, Juneau.

Fienup-Riordan, Ann. 2005. *Yup'ik Elders at the Ethnologisches Museum Berlin: Fieldwork Turned on Its Head.* Seattle: University of Washington Press in association with the Calista Elders Council, Bethel, AK.

Fried, Morton. H. 1967. *The Evolution of Political Society.* New York: Random House.

Gaul, Karen. K. 2007. *Nanutset ch'u Q'udi Gu: Before Our Time and Now. An Ethnohistory of Lake Clark National Park and Preserve.* Anchorage: National Park Service, Lake Clark National Park and Preserve.

Gaul, Karen K., and Gary Holton. 2005. "Speaking Across Generations: Dena'ina Language Revitalization in Southcentral Alaska." *Alaska Park Science* 4 (1):26–31.

Grewingk, Constantin Caspar Andreas. 1850. *Beitrag zur kenntniss der orographischen und geognostschen beschaffenheit der nord-west-küste Amerikas, mit den anliegenden inseln.* Gedruckt bey K. Kay.

Haberland, Wolfgang. 1987. "Nine Bella Coolas in Germany." In *Indians and Europe: An Interdisciplinary Collection of Essays,* by Christian F. Feest. Aachen: Forum 11.

Hodge, Frederick Webb, ed. 1907. "Knaiakhotana." In *Handbook of North American Indians North of Mexico,* vol. 1, 715–717. Smithsonian Institution, Bureau of American Ethnology Bulletin 30. Washington, DC: U.S. Government Printing Office.

Hulen, David. 1989. "Kenai Tribe Is No Longer Invisible." *Anchorage Daily News,* May 28, A1

Jacobs, Jane. 1995. *A School Teacher in Old Alaska: The Story of Hannah Breece.* New York: Random House.

Jacobsen, Johan Adrian. Papers. Letters and journals. Jacobsen Archives, Museum für Völkerkunde, Hamburg.

Jacobsen, Johan Adrian, and Adrian Woldt. 1977. *Alaskan Voyage, 1881–1883: An Expedition to the Northwest Coast of America for the Purpose of Making Ethnological Collections and Obtaining Information, as Well as Describing His Personal Experiences.* Translated by Erna Gunther. Chicago: University of Chicago Press.

Johnson, Walter. 2004. "*Sukdu Neł Nuhtghelnek*: I'll Tell You a Story. Stories I Recall from Growing Up on Iliamna Lake." Transcribed and edited by James Kari. Fairbanks: Alaska Native Language Center.

Kalifornsky, Peter. 1991. "A Dena'ina Legacy: *K'tl'egh'i Sukdu.*" In *The Collected Writings of Peter Kalifornsky,* ed. James Kari and Alan Boraas. Fairbanks: Alaska Native Language Center.

Kalifornsky, Peter, and Alan Boraas. 1989–1991. Dena'ina Legacy Tapes. Audio recordings of Peter Kalifornsky and Alan Boraas editing "A Dena'ina Legacy" (Kalifornsky 1991). Anthropology Lab Archives, Kenai Peninsula College, Soldotna, AK.

Kari, James. n.d. "Dena'ina Root-Morpheme Dictionary." Manuscript.

———. 1977. "Linguistic Diffusion Between Tanaina and Ahtna." *International Journal of American Linguistics* 43:274–289.

———. 1978. *The Heritage of Eklutna: Mike Alex 1908–1977.* Anchorage: Eklutna-Alex Associates, Inc.

———. 1988. "Some Linguistic Insights into Dena'ina Prehistory." In *Late Prehistoric Development of Alaska's Native People,* ed. Robert D. Shaw, Roger K. Harritt, and Don E. Dumond, 319–338. Aurora Monograph Series 4. Anchorage: Alaska Anthropological Association.

———. 1996a. "Linguistic Traces of Dena'ina Strategy at the Archaic Periphery." In *Adventures Through Time: Readings in the Anthropology of Cook Inlet, Alaska*, ed. Nancy Yaw Davis and William E. Davis, 49–64. Anchorage: Cook Inlet Historical Society.

———. 1996b. "Names as Signs: The Distribution of 'Stream' and 'Mountain.'" In *Athabaskan Language Studies: Essays in Honor of Robert W. Young*, ed. E. Jelinek, S. Midgette, K. Rice, and L. Saxon, 443–475. Albuquerque: University of New Mexico Press.

———. 2003a. "An Analysis of the Dena'ina-Upper Kuskokwim Interface over Time." In *Shem Pete's Alaska: The Territory of the Upper Cook Inlet Dena'ina*. 2nd ed., ed. James Kari and James A. Fall, 144–147. Fairbanks: University of Alaska Press.

———. 2003b. "The Dena'ina Language Area, Dena'ina Dialects, and Prehistoric Migrations." In *Shem Pete's Alaska, The Territory of the Upper Cook Inlet Dena'ina*. 2nd ed., ed. James Kari and James A. Fall, 10–14. Fairbanks: University of Alaska Press.

———. 2003c. "Notes on Dena'ina Watercraft." In *Shem Pete's Alaska, The Territory of the Upper Cook Inlet Dena'ina*. 2nd ed., ed. James Kari and James A. Fall, 102–104. Fairbanks: University of Alaska Press.

———. 2005. "Language Work in Alaskan Athabascan and Its Relationship to Alaskan Anthropology." *Alaska Journal of Anthropology* 3 (1):105–119.

———. 2007. *Dena'ina Topical Dictionary*. Fairbanks: Alaska Native Language Center.

———. Forthcoming. *The Ts'enhdghulyał Anthology: Dena'ina War Narratives from the Lake Clark/Iliamna Lake Area*. Told by Andrew Balluta and Others. Fairbanks, AK: Alaska Native Language Center.

Kari, James, Alan Boraas, Aaron Leggett, and R. Greg Dixon. 2011. "Bibliography of Sources on Dena'ina and Cook Inlet Anthropology." http://qenaga.org/DenBibliographyVersion2.4.pdf.

Kari, James, and James A. Fall. 1987. *Shem Pete's Alaska, the Territory of Upper Cook Inlet Dena'ina*, 1st ed. Fairbanks, AK: Alaska Native Language Center.

———. 2003. *Shem Pete's Alaska: The Territory of the Upper Cook Inlet Dena'ina*. 2nd ed. Fairbanks: University of Alaska Press.

Kari, James, and Priscilla Russell Kari. 1982. *Dena'ina Ełnena: Tanaina Country*. Fairbanks: Alaska Native Language Center.

Kari, Priscilla Russell. 1983. "Land Use and Economy of Lime Village." Technical Paper no. 80. Division of Subsistence, Alaska Department of Fish and Game, Juneau.

———. 1987. *Tanaina Plantlore: Dena'ina K'et'una. An Ethnobotany of the Dena'ina Indians of Southcentral Alaska*. 2nd ed., rev. Anchorage: National Park Service.

Keesing, Roger. 1976. *Cultural Anthropology: A Contemporary Perspective*. New York: Holt, Rinehart, and Winston.

King, J. C. H. 1994. "Vancouver's Ethnography: A Preliminary Description of Five Inventories from the Voyage of 1791–95." *Journal of the History of Collections* 6 (1):33–58.

Lake Clark National Park. 2003. Subsistence interviews, 2003, Lake Clark National Park and Preserve Archives, Anchorage: National Park Service.

Lamb, W. Kaye, ed. 1984. *George Vancouver: A Voyage of Discovery to the North Pacific Ocean and Round the World 1791–1795*. 4 vols. London: Hakluyt Society.

Langdon, Stephen J., and Aaron Leggett. 2009. "Dena'ina Heritage and Representation in Anchorage: A Collaborative Project." In *The Alaska Native Reader: History, Culture, Politics*, ed. Maria Sháa Tláa Williams, 163–175. Durham, NC: Duke University Press.

Lohse, E. S., and Frances Sundt. 1990. "History of Research: Museum Collections." In *Handbook of North American Indians*, vol. 7: *Northwest Coast*, ed. Wayne Suttles, 88–97. Washington, DC: Smithsonian Institution Press.

Lynch, Alice J. 1982. *Qizhjeh: The Historic Tanaina Village of Kijik and the Kijik Archeological District*. Occasional Paper no. 32. Anthropology and History Preservation CPSU. Fairbanks: University of Alaska Fairbanks and National Park Service, Alaska.

Mallott, Byron. 2004a. "Dena'ina Preceded Today's Metropolis." Anchorage Daily News, Feb. 18, B6.

———. 2004b. "Dena'ina offer knowledge, wisdom." Anchorage Daily News, Feb. 19, B6.

Mamaloff, Fred. 1993. Transcription of Cultural Resource Committee Meeting, Kenaitze Indian Tribe, I.R.A., Reverend Fred Mamaloff, guest speaker. Kenai, AK, February 10, 1993.

McClanahan, A. J. 2002. *Our Stories, Our Lives: A Collection of Twenty-Three Transcribed Interviews with Elders of the Cook Inlet Region*. Anchorage: CIRI Foundation. Reprint of 1986 edition.

McClellan, Catharine. 1975. *My Old People Say: An Ethnographic Survey of Southern Yukon Territory*. National Museum of Man Publications in Ethnology 6 (1–2). Ottawa, ON: National Museums of Canada.

McKennan, Robert A. 1959. *The Upper Tanana Indians*. Yale University Publications in Anthropology 59. New Haven, CT: Yale University Press.

Mishler, Craig. 2007. "Historical Demography and Genealogy: The Decline of the Northern Kenai Peninsula Dena'ina." *Alaska Journal of Anthropology* 5 (1):61–81.

Morris, Judith M. 1986. "Subsistence Production and Exchange in the Iliamna Lake Region, Southwest Alaska, 1982–1983." Technical Paper no. 136.

Division of Subsistence, Alaska Department of Fish and Game, Juneau.

Nelson, Richard. K. 1983. *Make Prayers to the Raven: A Koyukon View of the Northern Forest.* Chicago: University of Chicago Press.

Norris, Frank. 2002. *Alaska Subsistence: A National Park Service Management History.* Anchorage: National Park Service, Alaska Support Office.

Osgood, Cornelius. 1933. "Tanaina Culture." *American Anthropologist* 35 (4):695–717.

———. 1936. *The Distribution of the Northern Athapaskan Indians.* Yale University Publications in Anthropology 7. New Haven, CT: Yale University Press.

———. 1937. *The Ethnography of the Tanaina.* Yale University Publications in Anthropology 16. New Haven, CT: Yale University Press.

———. 1940. *Ingalik Material Culture.* New Haven, CT: Yale University Press.

———. 1976. *Lieutenant Zagoskin's Travels in Russian America 1842–1844: The First Ethnographic and Geographic Investigations in the Yukon and Kuskokwim Valleys of Alaska.* Toronto: University of Toronto Press.

Osgood, Wilfred A. 1901. *Natural History of the Cook Inlet Region.* U.S. Department of Agriculture Biological Survey, North American Fauna No. 21. Washington, D.C.: U.S. Government Printing Office.

Pesznecker, Katie. 2003. "Past Preserved: Cemetery Unveils Headstones for 3 Dena'ina Athabaskan Leaders Honoring Anchorage's Original Residents." *Anchorage Daily News,* August 7, A1.

Pete, Shem. 1977. "Diqelas Tukda: The Story of a Tanaina Chief." Translated by James Kari. Fairbanks, AK: Alaska Native Language Center.

———. 1989. "The Hunting Dog: A Dena'ina Tale of Subsistence Values." Translated by Billy Pete, James Kari, and James Fall. *Alaska Fish & Game* 21 (6):2–7.

Petroff, Ivan. 1884. "Report on the Population, Industries, and Resources of Alaska." 10th Census of the United States 1880. Washington, DC: U.S. Government Printing Office.

———. 1900. The Population and Resources of Alaska, 1880. In *Compilation of Narratives of Explorations in Alaska.* Washington, DC: U.S. Government Printing Office.

Pierce, Richard A. 1968. "New Light on Ivan Petroff, Historian of Alaska." *Pacific Northwest Quarterly* 59 (1):1–10.

Portlock, Nathaniel. 1789. *A Voyage Round the World: But More Particularly to the North-west Coast of America Performed in 1785, 1786, 1787, and 1788. Performed in the* King George, *commanded by Captain Portlock; and the* Queen Charlotte, *commanded by Captain Dixon.* London: J. Stockdale and G. Goulding.

Pratt, Kenneth L. 2009. *Chasing the Dark: Perspectives on Place, History and Alaska Native Land Claims.* Anchorage, Alaska: U.S. Dept. of the Interior, Bureau of Indian Affairs, Alaska Region, Division of Environmental and Cultural Resources Management, ANCSA Office.

Radloff, Leopold, and Anton Schiefner. 1874. "Leopold Radloff's Worterbuch der Kinai-Sprache." In *Mémoires de l'Acadèmia Imperialedes Sciences de St. Pétersbourg* XXI(8):1–33.

Ravenmoon, Michelle, and Betsy Webb, eds. 2007. *Dena'ina Qeshqa Collections and Reflections of Chief Gabriel Trefon.* Narrated by Frank Hill. Anchorage: Pratt Museum and Lake Clark National Park and Preserve. Film.

Reger, Douglas R. 1987. "Archaeology of a Late Prehistoric Subsistence Locality, the Clam Gulch Site (49KEN-045)." *Anthropological Papers of the University of Alaska* 21:89–103.

———. 1998. "Archaeology of the Northern Kenai Peninsula and Upper Cook Inlet." *Arctic Anthropology* 35 (1):160–171.

Reger, Douglas R., and Charles M. Mobley. 2008. "Dena'ina Use of Marine Resources for Food and Tools." *Alaska Journal of Anthropology* 6 (1–2):199–209.

Rickman, David. 1990. "Costume and Cultural Interaction in Russian America." In *Russia in North America: Proceedings of the 2nd International Conference on Russian America, Sitka, Alaska, August 19–22, 1987,* ed. Richard Pierce, 240–288. Kingston, ON: Limestone Press.

Rooth, Anna Birgitta. 1971. *The Alaska Expedition 1966: Myths, Customs, and Beliefs among the Athabascan Indians and the Eskimos of Northern Alaska. Acta Universitatis Lundensis,* Sectio I, 14.

Russell, Priscilla. 1987. *Tanaina Plantlore: Dena'ina K'et'una: An Ethnobotany of the Dena'ina Indians of Southcentral Alaska.* Anchorage: National Park Service, Alaska Region.

Russell, Priscilla N., and George C. West. 2003. *Bird Traditions of the Lime Village Area Dena'ina: Upper Stony River Ethno-Ornithology.* Chicago: University of Chicago Press.

Russian Imperial Geographical Society. 1879. *Katalog predmetov, sobrannyh ot raznyh ucherezhdenii, I lits Imperatorskim Russkim Geograficheskim Obschestvom* [Catalogue of objects collected by the Russian Imperial Society from different institutions and individuals]. St. Petersburg.

Sheldon, Charles. 1908. "The Cook Inlet Aborigines." In *To the Top of the Continent,* by Frederick Cook, Appendix C, pp. 269–277. New York: Doubleday, Page and Company.

Shternberg, Lev Ya. 1917. "Muzei antropologii I etnografii imeni imperatora Petra Velikogo" [Peter the Great's Museum of Anthropology and Ethnography named after the emperor].*Materialy dlya istorii Akademicheskih*

ucherezhdenii za 1889–1914. Petrograd, vol. 2, pt. 1, 241–308.

Siebert [Zibert], Erna. 1980. "Northern Athapaskan Collections of the First Half of the Nineteenth Century." *Arctic Anthropology* 17 (1):49–76.

Stanek, Ronald T., James A. Fall, and Davin L. Holen. 2006. "West Cook Inlet Ethnographic Overview and Assessment for Lake Clark National Park and Preserve." Anchorage: National Park Service, Lake Clark National Park and Preserve.

Steensby, H. P. 1917. An Anthrogeographical Study of the Origin of Eskimo Culture. *Meddelelser om Gronland* 53(2). Copenhagen.

Stephan, Alberta. 1994. "Athabascan Migration: Special Report." In *Draft Report, Ethnohistoric Land Use Patterns: Elemendorf Air Force Base (Knik Arm) Area, Alaska,* ed. by Nancy Yaw Davis and the Dena'ina Team, pp. 85-88. Anchorage: prepared for National Park Service and Elmendorf Air Force Base.

———. 1996. *The First Athabascans of Alaska: Strawberries.* Anchorage: Todd Communications.

———.1996a. "Athabaskan Natives of Upper Cook Inlet." In *Adventures through Time: Readings in the Anthropology of Cook Inlet, Alaska,* ed. Nancy Yaw Davis and William E. Davis, 147–150. Anchorage: Cook Inlet Historical Society.

———. 2001. *Cheda.* Anchorage: Todd Communications.

Stickman, Karen, Dan Young, Andrew Balluta, and Mary McBurney. 2003. "K'ezdlagh: Nondalton Traditional Ecological Knowledge of Freshwater Fish." Final report. U.S. Fish and Wildlife Service, Fisheries Information Service Project 01-075.

Swan, Clare. Excerpt from an interview with Dena'ina elder Clare Swan in the film, *Alaska, the Last Frontier?* Producer, Eleanor Morris, academic consultant, Philip Sarre, 1995. London: BBC for the Open University in association with the Annenberg Project; quote from transcript in De Blij, Harm J., Alexander B. Murphy, and Erin Hogan Fouberg. 2007. *Human Geography: People, Place, and Culture.* New York: J. Wiley, p. 177.

Tenenbaum, Joan M. 1976. *Dena'ina Sukdu'a.* 4 vols. Fairbanks: Alaska Native Language Center.

———. 1984. *Dena'ina Sukdu'a: Traditional Stories of the Tanaina Athabaskans.* Fairbanks: Alaska Native Language Center.

———. 2006. *Dena'ina Sukdu'a: Traditional Stories of the Tanaina Athabaskans.* Fairbanks: Alaska Native Language Center.

Thompson, Judy, Judy Hall, and Leslie Tepper. 2001. *Fascinating Challenges: Studying Material Culture with Dorothy Burnham.* Mercury Series, Ethnology Service Paper 136. Gatineau, QC: Canadian Museum of Civilization.

Tikhmenev, Petr Aleksandrovich. 1978. *A History of the Russian-American Company.* Edited and translated by Richard A. Pierce and Alton S. Donnelly. Seattle: University of Washington Press.

Townsend, Joan B. 1965. "Ethnohistory and Culture Change of the Iliamna Tanaina." PhD diss., University of California.

———. 1970. "Tanaina Ethnohistory: An Example of a Method for the Study of Culture Change." In *Ethnohistory in Southwestern Alaska and Southern Yukon,* ed. Margaret Lantis, 71–102. Lexington: University of Kentucky Press.

———. 1974. "Journals of Nineteenth Century Russian Priests to the Tanaina: Cook Inlet, Alaska." *Arctic Anthropology* 11 (1):1–30.

———. 1979 "Indian or Eskimo? Interaction and Identity in Southern Alaska." *Arctic Anthropology* 16 (2):160–182.

———. 1980. "Ranked Societies of the Alaska Pacific Rim." In *Senri Ethnological Studies 4: Alaska Native Culture and History,* ed. Yoshinobu Kotani and William B. Workman, 123–156. Osaka: National Museum of Ethnology.

———. 1981. "Tanaina." In *Handbook of North American Indians,* vol. 6: *Subarctic,* ed. June Helm, 623–640. Washington, DC: Smithsonian Institution.

"Travel Journal of Hieromonk Nikita," Kenai (1881–1882). Original in Alaska Church Collection, Box 490. Translated version in *Documents Relative to the History of Alaska,* n.d. Alaska History Research Project 1936–1938. Four volumes. Copies at Library at Congress, Washington, DC, and University of Alaska Fairbanks. vol. 1, pp. 60–67.

Vajda Edward J. 2010. "A Siberian Link with Na-Dene Languages." In *The Dene-Yeniseian Connection,* ed. J. Kari and B. Potter. *Anthropological Papers of the University of Alaska,* n.s., 5:33–99.

VanStone, James. 1974. *Athabaskan Adaptations.* Chicago: Aldine.

———. 1981. *Athapaskan Clothing and Related Objects in Field Museum of Natural History. Fieldiana: Anthropology,* n.s., 10. Chicago: Field Museum of Natural History.

Varjola, Pirjo. 1990. *The Etholén Collection: The Ethnographic Alaskan Collection of Adolf Etholén and His Contemporaries in the National Museum of Finland.* Helsinki: National Board of Antiquities of Finland.

Vaudrin, Bill. 1969. *Tanaina Tales from Alaska.* Norman: University of Oklahoma Press.

Volkov, F. K., and S. I. Rudenko. 1910. "Etnograficheskie kollektsii iz byvshih rossiisko-amerikanskih vladenii" [Ethnographic collections from former Russian-American possessions]. In *Materialy po etnografii Rossii.* St. Petersburg, vol. 1, 155–200.

Wassillie, Albert. 1979. *Dena'ina Qenaga Duch'duldih: Dena'ina Athabaskan Junior Dictionary,* ed. James Kari.

Anchorage: National Bilingual Materials Development Center.

———. 1980a. *Nuvendaltun Ht'ana Sukdu'a: Nondalton People's Stories,* ed. James Kari. Anchorage: National Bilingual Materials Development Center.

———. 1980b. *K'ich'ighi: Dena'ina Riddles.* Anchorage: National Bilingual Materials Development Center.

Westphal-Hellbusch, Sigrid. 1973. "Zur Geschichte des Museums." In *Hundert Jahre Museum für Völkerkunde Berlin.* Baessler-Archiv, vol. 21. Berlin: Kurt Krieger und Gerd Koch.

Woldt, Adrian, ed. 1884. *Capitain Jacobsens Reise an der Nordwestküste Amerikas 1881–1883.* Leipzig.

Workman, Karen W. 1996. "An Archaeological Definition of Dena'ina." In *Adventures Through Time: Readings in the Anthropology of Cook Inlet, Alaska,* ed. Nancy Yaw Davis and William E. Davis, 207–220. Anchorage: Cook Inlet Historical Society.

Workman, William B. 1998. "Archaeology of the Southern Kenai Peninsula." *Arctic Anthropology* 35 (1):146–159.

Wrangell, Ferdinand Petrovich von. 1970 [1839]. "The Inhabitants of the Northwest Coast of America." Translated and edited by James VanStone. *Arctic Anthropology* 6 (2):5–20.

———. 1980 [1839]. *Russian America: Statistical and Ethnographic Information.* Translated from the German edition of 1839 by Mary Sadouski; edited by Richard A. Pierce. Kingston, ON: Limestone Press.

Wyman, Leland. 1983. "Navajo Ceremonial System." In *Handbook of North American Indians,* vol. 10: *Southwest,* ed. Alfonzo Ortiz, 536–557. Washington, DC: Smithsonian Institution Press.

Zagoskin, Laurentii A. 1956. *Puteshestviya i issledovaniya leitenanta Lavrentiya Zagoskina v Russkoi Amerike v 1842–1844 gg* [Travels and studies of the lieutenant Lavrentii Zagoskin in Russian America in 1842–1844]. Moscow.

Zagoskin, Lavrentii Alikseevich. 1967. *Lieutenant Zagoskin's Travels in Russian America, 1842–1844.* Edited by Henry N. Michael. Toronto: University of Toronto Press, published for the Arctic Institute of North America.

Znamenski, Andrei A. 2003. *Through Orthodox Eyes: Russian Missionary Narratives of Travels to the Dena'ina and Ahtna, 1850s–1930s.* Fairbanks: University of Alaska Press.

B.4 *Sisda,* Christmas Star, created by Steve "Butch" Hobson, Nondalton, 2012. Diameter 31 cm; birch wood, garland (PVC), bows (polypropylene), cotton cloth, nylon string, paper (Russian Christmas card), yarn, nails, cotton, glue. Photograph by Chris Arend.

FIG B.4

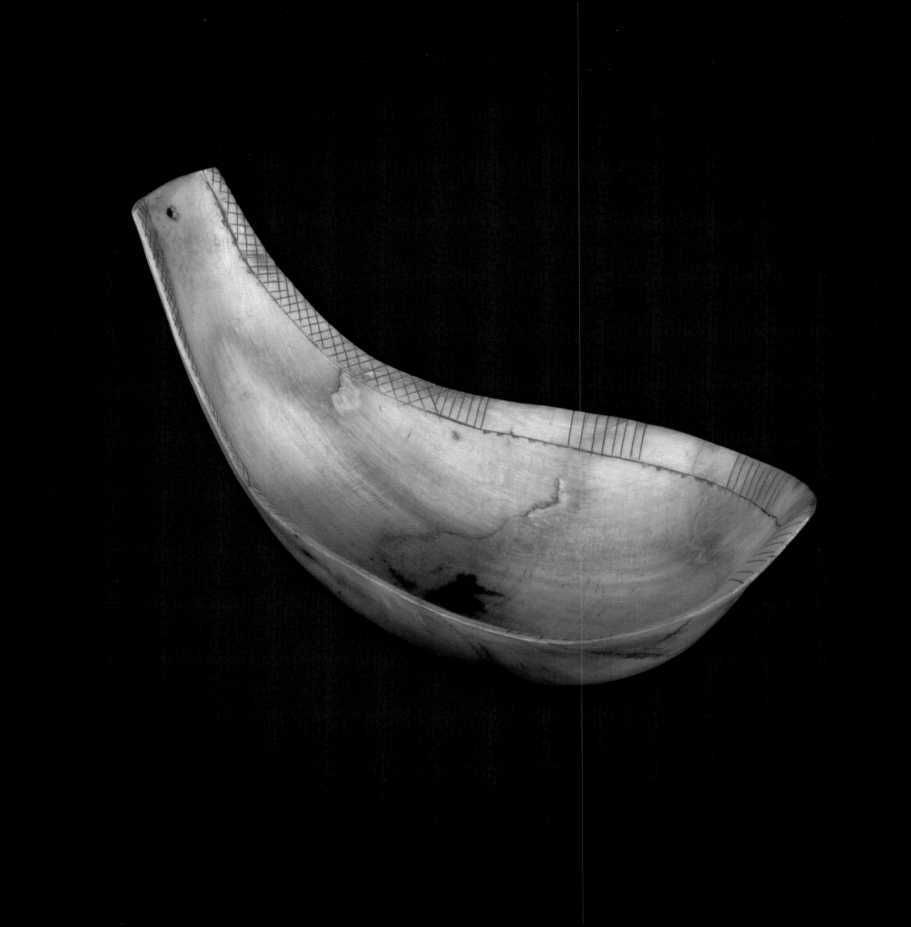

Index

Italicized page numbers indicate tables, illustrations, and their captions.